GARDNER'S

FRED S. KLEINER

through the

FOURTEENTH EDITION

Gardner's Art through the Ages: A Global History, Fourteenth Edition The Middle Ages, Book B Fred S. Kleiner

Publisher: Clark Baxter

Senior Development Editor: Sharon Adams Poore

Assistant Editor: Ashley Bargende Editorial Assistant: Elizabeth Newell

Associate Media Editor: Kimberly Apfelbaum

Senior Marketing Manager: Jeanne Heston Marketing Coordinator: Klaira Markenzon

Senior Marketing Communications Manager: Heather Baxley

Senior Content Project Manager: Lianne Ames

Senior Art Director: Cate Rickard Barr

Senior Print Buyer: Mary Beth Hennebury

Rights Acquisition Specialist, Images: Mandy Groszko

Production Service & Layout: Joan Keyes, Dovetail

Publishing Services

Text Designer: tani hasegawa

Cover Designer: tani hasegawa

Cover Image: © Bednorz-Images

Compositor: Thompson Type, Inc.

© 2013, 2009, 2005 Wadsworth, Cengage Learning

ALL RIGHTS RESERVED. No part of this work covered by the copyright herein may be reproduced, transmitted, stored, or used in any form or by any means graphic, electronic, or mechanical, including but not limited to photocopying, recording, scanning, digitizing, taping, Web distribution, information networks, or information storage and retrieval systems, except as permitted under Section 107 or 108 of the 1976 United States Copyright Act, without the prior written permission of the publisher.

For product information and technology assistance, contact us at Cengage Learning Customer & Sales Support, 1-800-354-9706

For permission to use material from this text or product, submit all requests online at www.cengage.com/permissions.

Further permissions questions can be emailed to permissionrequest@cengage.com.

Library of Congress Control Number: 2011931843 ISBN-13: 978-0-8400-3055-9 ISBN-10: 0-8400-3055-X

Wadsworth

20 Channel Center Street Boston, MA 02210 USA

Cengage Learning is a leading provider of customized learning solutions with office locations around the globe, including Singapore, the United Kingdom, Australia, Mexico, Brazil and Japan. Locate your local office at **international.cengage.com/region**

Cengage Learning products are represented in Canada by Nelson Education, Ltd.

For your course and learning solutions, visit **www.cengage.com.** Purchase any of our products at your local college store or at our preferred online store **www.cengagebrain.com.**

Instructors: Please visit **login.cengage.com** and log in to access instructor-specific resources.

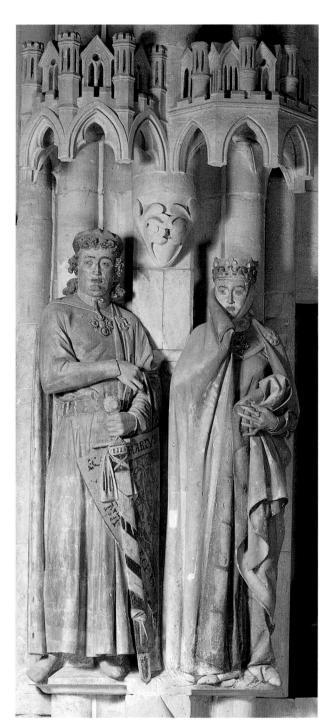

NAUMBURG MASTER, Ekkehard and Uta, west choir, Naumburg Cathedral, Naumburg, Germany, ca. 1249–1255. Painted limestone, Ekkehard 6' 2" high.

The sculptures in the choir of Naumburg Cathedral are among the finest of the Middle Ages—and among the most unusual because they are portraits, not images of the Virgin Mary, Christ, or saints. Illustrated here are Ekkehard II of Meissen and his wife Uta. The statues are attached to columns and stand beneath architectural canopies, following the pattern of French Gothic portal statuary, but they project from the architecture more forcefully and move more freely. The period costumes and the individualized features and personalities give the impression the couple posed for their portraits, although Ekkehard and Uta lived well before the sculptor's time. Ekkehard, the intense knight, contrasts

with the beautiful and aloof Uta, who gracefully draws the collar of her cloak partly across her face while she gathers up a soft fold of drapery with a jeweled, delicate hand. The sculptor subtly revealed the shape of Uta's right arm beneath her cloak and rendered the fall of drapery folds with an accuracy suggesting the sculptor used a living model. The two statues are arresting images of real people, even if they bear the names of aristocrats the artist never met. The Naumburg choir statues are remarkable too because, unlike almost all other medieval statues, much of the original paint is preserved. Contrary to popular belief today, virtually all ancient and medieval statues featured bright coloration.

Art historians call the sculptor of these statues the Naumburg Master because the artist's name is lost. That absence, however, is the norm in the history of art before the Renaissance, when the modern notion of individual artistic genius took root. *Art through the Ages* surveys the art of all periods from prehistory to the present, and worldwide, and examines how artworks of all kinds have always reflected the historical contexts in which they were created.

BRIEF CONTENTS

PREFACE ix

CHAPTER 8
LATE ANTIQUITY 232

CHAPTER 9
BYZANTIUM 254

CHAPTER 10
THE ISLAMIC WORLD 282

CHAPTER 11
EARLY MEDIEVAL EUROPE 306

CHAPTER 12
ROMANESQUE EUROPE 332

CHAPTER 13
GOTHIC EUROPE 364

CHAPTER 14
LATE MEDIEVAL ITALY 400

NOTES 422
GLOSSARY 425
BIBLIOGRAPHY 431
CREDITS 435
MUSEUM INDEX 437
SUBJECT INDEX 439

CONTENTS

PREFACE ix

CHAPTER 8 LATE ANTIQUITY 232

FRAMING THE ERA | Romans, Jews, and Christians 233

TIMELINE 234

The Late Antique World 234

Dura-Europos and Jewish Art 234

The Catacombs and Funerary Art 237

Architecture and Mosaics 242

Luxury Arts 248

- RELIGION AND MYTHOLOGY: Jewish Subjects in Christian Art 238
- RELIGION AND MYTHOLOGY: The Life of Jesus in Art 240
- MATERIALS AND TECHNIQUES: Mosaics 245
- MATERIALS AND TECHNIQUES: Medieval Manuscript Illumination 249
- MATERIALS AND TECHNIQUES: Ivory Carving 251

MAP 8-1 The Mediterranean world in late antiquity 234

THE BIG PICTURE 253

CHAPTER 9

BYZANTIUM 254

FRAMING THE ERA | Church and State United 255

TIMELINE 256

The Christian Roman Empire 256

Early Byzantine Art 257

Middle Byzantine Art 270

Late Byzantine Art 278

- WRITTEN SOURCES: The Emperors of New Rome 259
- ARCHITECTURAL BASICS: Pendentives and Squinches 262
- ART AND SOCIETY: Icons and Iconoclasm 269
- ART AND SOCIETY: Born to the Purple: Empress Zoe 273

MAP 9-1 The Byzantine Empire at the death of Justinian in 565 256

THE BIG PICTURE 281

CHAPTER 10

THE ISLAMIC WORLD 282

FRAMING THE ERA | The Rise and Spread of Islam 283

TIMELINE 284

Early Islamic Art 284

Later Islamic Art 294

- RELIGION AND MYTHOLOGY: Muhammad and Islam 285
- ARCHITECTURAL BASICS: The Mosque 288

- WRITTEN SOURCES: Sinan the Great and the Mosque of Selim II 298
- MATERIALS AND TECHNIQUES: Islamic Tilework 299
- ART AND SOCIETY: Christian Patronage of Islamic Art 304

MAP 10-1 The Islamic world around 1500 284

THE BIG PICTURE 305

CHAPTER 11

EARLY MEDIEVAL EUROPE 306

FRAMING THE ERA | Missionaries Spread | Christian Art | 307

TIMELINE 308

Art of the Warrior Lords 308

Hiberno-Saxon Art 311

Visigothic and Mozarabic Art 315

Carolingian Art 317

Ottonian Art 324

- ART AND SOCIETY: Medieval Books 312
- RELIGION AND MYTHOLOGY: The Four Evangelists 314
- ART AND SOCIETY: Charlemagne's Renovatio Imperii Romani 317
- RELIGION AND MYTHOLOGY: Medieval Monasteries and Benedictine Rule 322
- ART AND SOCIETY: Theophanu, a Byzantine Princess in Ottonian Germany 328

MAP 11-1 The Carolingian Empire at the death of Charlemagne in 814 308

THE BIG PICTURE 331

CHAPTER 12

ROMANESQUE EUROPE 332

FRAMING THE ERA | The Rebirth of Monumental | Sculpture | 333

TIMELINE 334

European Culture in the New Millennium 334

France and Northern Spain 334

Holy Roman Empire 349

Italy 355

Normandy and England 357

- ART AND SOCIETY: Pilgrimage Roads in France and Spain 335
- RELIGION AND MYTHOLOGY: The Veneration of Relics 336
- WRITTEN SOURCES: Timber Roofs and Stone Vaults 339
- WRITTEN SOURCES: Bernard of Clairvaux on Cloister Sculpture 342
- ARCHITECTURAL BASICS: The Romanesque Church Portal 344
- RELIGION AND MYTHOLOGY: The Crusades 346
- ART AND SOCIETY: Romanesque Countesses, Queens, and Nuns 352
- MATERIALS AND TECHNIQUES: Embroidery and Tapestry 362

MAP 12-1 Western Europe around 1100 335

THE BIG PICTURE 363

CHAPTER 13

GOTHIC EUROPE 364

FRAMING THE ERA | The Age of the Great Cathedrals 365

TIMELINE 366

France 366

England 389

Holy Roman Empire 392

- WRITTEN SOURCES: Abbot Suger and the Rebuilding of Saint-Denis 367
- ARCHITECTURAL BASICS: The Gothic Rib Vault 368
- ART AND SOCIETY: Paris, Schoolmen, and Scholasticism 372
- ARCHITECTURAL BASICS: The Gothic Cathedral 373
- MATERIALS AND TECHNIQUES: Stained-Glass Windows 375
- ART AND SOCIETY: Louis IX, the Saintly King 385

MAP 13-1 Europe around 1200 366

THE BIG PICTURE 399

vii

CHAPTER 14 LATE MEDIEVAL ITALY 400

FRAMING THE ERA | Late Medieval or | Proto-Renaissance? 401

TIMELINE 402

13th Century 402

14th Century 406

■ RELIGION AND MYTHOLOGY: The Great Schism, Mendicant Orders, and Confraternities 404

■ ART AND SOCIETY: Italian Artists' Names 405

■ MATERIALS AND TECHNIQUES: Fresco Painting 408

■ WRITTEN SOURCES: Artists' Guilds, Artistic Commissions, and Artists' Contracts 410

■ ART AND SOCIETY: Artistic Training in Renaissance Italy 414

MAP 14-1 Italy around 1400 405

THE BIG PICTURE 421

NOTES 422

GLOSSARY 425

BIBLIOGRAPHY 431

CREDITS 435

MUSEUM INDEX 437

SUBJECT INDEX 439

PREFACE

THE GARDNER LEGACY IN THE 21ST CENTURY

I take great pleasure in introducing the extensively revised and expanded 14th edition of *Gardner's Art through the Ages: A Global History*, which, like the enhanced 13th edition, is a hybrid art history textbook—the first, and still the only, introductory survey of the history of art of its kind. This innovative new kind of "Gardner" retains all of the best features of traditional books on paper while harnessing 21st-century technology to increase by 25% the number of works examined—without increasing the size or weight of the book itself and at very low additional cost to students compared to a larger book.

When Helen Gardner published the first edition of *Art through the Ages* in 1926, she could not have imagined that more than 85 years later instructors all over the world would still be using her textbook in their classrooms. Indeed, if she were alive today, she would not recognize the book that, even in its traditional form, long ago became—and remains—the most widely read introduction to the history of art and architecture in the English language. During the past half-century, successive authors have constantly reinvented Helen Gardner's groundbreaking global survey, always keeping it fresh and current, and setting an ever-higher standard with each new edition. I am deeply gratified that both professors and students seem to agree that the 13th edition, released in 2008, lived up to that venerable tradition, for they made it the number-one choice for art history survey courses. I hope they will find the 14th edition of this best-selling book exceeds their high expectations.

In addition to the host of new features (enumerated below) in the book proper, the 14th edition follows the enhanced 13th edition in incorporating an innovative new online component. All new copies of the 14th edition are packaged with an access code to a web site with bonus essays and bonus images (with zoom capability) of more than 300 additional important paintings, sculptures, buildings, and other art forms of all eras, from prehistory to the present and worldwide. The selection includes virtually all of the works professors have told me they wished had been in the 13th edition, but were not included for lack of space. I am extremely grateful to Cengage Learning/Wadsworth for the considerable investment of time and resources that has made this remarkable hybrid textbook possible.

In contrast to the enhanced 13th edition, the online component is now fully integrated into the 14th edition. Every one of the

more than 300 bonus images is cited in the text of the traditional book and a thumbnail image of each work, with abbreviated caption, is inset into the text column where the work is mentioned. The integration extends also to the maps, index, glossary, and chapter summaries, which seamlessly merge the printed and online information. The 14th edition is in every way a unified, comprehensive history of art and architecture, even though the text is divided into paper and digital components.

KEY FEATURES OF THE 14TH EDITION

In this new edition, I have added several important features while retaining the basic format and scope of the previous edition. Once again, the hybrid Gardner boasts roughly 1,700 photographs, plans, and drawings, nearly all in color and reproduced according to the highest standards of clarity and color fidelity, including hundreds of new images, among them a new series of superb photos taken by Jonathan Poore exclusively for Art through the Ages during three photographic campaigns in France and Italy in 2009, 2010, and 2011. The online component also includes custom videos made at each site by Sharon Adams Poore. This extraordinary new archive of visual material ranges from ancient Roman ruins in southern France to Romanesque and Gothic churches in France and Tuscany to Le Corbusier's modernist chapel at Ronchamp and the postmodern Pompidou Center and the Louvre Pyramide in Paris. The 14th edition also features the highly acclaimed architectural drawings of John Burge. Together, these exclusive photographs, videos, and drawings provide readers with a visual feast unavailable anywhere else.

The captions accompanying those illustrations contain, as before, a wealth of information, including the name of the artist or architect, if known; the formal title (printed in italics), if assigned, description of the work, or name of the building; the provenance or place of production of the object or location of the building; the date; the material(s) used; the size; and the present location if the work is in a museum or private collection. Scales accompany not only all architectural plans, as is the norm, but also appear next to each photograph of a painting, statue, or other artwork—another unique feature of the Gardner text. The works discussed in the 14th edition of *Art through the Ages* vary enormously in size, from colossal sculptures carved into mountain cliffs and paintings that cover

entire walls or ceilings to tiny figurines, coins, and jewelry that one can hold in the hand. Although the captions contain the pertinent dimensions, it is difficult for students who have never seen the paintings or statues in person to translate those dimensions into an appreciation of the real size of the objects. The scales provide an effective and direct way to visualize how big or how small a given artwork is and its relative size compared with other objects in the same chapter and throughout the book.

Also retained in this edition are the Quick-Review Captions introduced in the 13th edition. Students have overwhelmingly reported that they found these brief synopses of the most significant aspects of each artwork or building illustrated invaluable when preparing for examinations. These extended captions accompany not only every image in the printed book but also all the digital images in the online supplement. Another popular tool introduced in the 13th edition to aid students in reviewing and mastering the material reappears in the 14th edition. Each chapter ends with a full-page feature called The Big Picture, which sets forth in bulletpoint format the most important characteristics of each period or artistic movement discussed in the chapter. Small illustrations of characteristic works accompany the summary of major points. The 14th edition, however, introduces two new features in every chapter: a timeline summarizing the major developments during the era treated (again in bullet-point format for easy review) and a chapteropening essay on a characteristic painting, sculpture, or building. Called Framing the Era, these in-depth essays are accompanied by a general view and four enlarged details of the work discussed.

The 14th edition of Art through the Ages is available in several different traditional paper formats—a single hardcover volume; two paperback volumes designed for use in the fall and spring semesters of a yearlong survey course; a six-volume "backpack" set; and an interactive e-book version. Another pedagogical tool not found in any other introductory art history textbook is the Before 1300 section that appears at the beginning of the second volume of the paperbound version of the book and at the beginning of Book D of the backpack edition. Because many students taking the second half of a survey course will not have access to Volume I or to Books A, B, and C, I have provided a special set of concise primers on architectural terminology and construction methods in the ancient and medieval worlds, and on mythology and religion—information that is essential for understanding the history of art after 1300, both in the West and the East. The subjects of these special boxes are Greco-Roman Temple Design and the Classical Orders; Arches and Vaults; Basilican Churches; Central-Plan Churches; The Gods and Goddesses of Mount Olympus; The Life of Jesus in Art; Buddhism and Buddhist Iconography; and Hinduism and Hindu Iconography.

Boxed essays once again appear throughout the book as well. This popular feature first appeared in the 11th edition of *Art through the Ages*, which in 2001 won both the Texty and McGuffey Prizes of the Text and Academic Authors Association for a college textbook in the humanities and social sciences. In this edition the essays are more closely tied to the main text than ever before. Consistent with that greater integration, almost all boxes now incorporate photographs of important artworks discussed in the text proper that also illustrate the theme treated in the boxed essays. These essays fall under six broad categories:

Architectural Basics boxes provide students with a sound foundation for the understanding of architecture. These discussions are concise explanations, with drawings and diagrams, of the major aspects of design and construction. The information included

is essential to an understanding of architectural technology and terminology. The boxes address questions of how and why various forms developed, the problems architects confronted, and the solutions they used to resolve them. Topics discussed include how the Egyptians built the pyramids; the orders of classical architecture; Roman concrete construction; and the design and terminology of mosques, stupas, and Gothic cathedrals.

Materials and Techniques essays explain the various media artists employed from prehistoric to modern times. Since materials and techniques often influence the character of artworks, these discussions contain essential information on why many monuments appear as they do. Hollow-casting bronze statues; fresco painting; Chinese silk; Andean weaving; Islamic tilework; embroidery and tapestry; engraving, etching, and lithography; and daguerreotype and calotype photography are among the many subjects treated.

Religion and Mythology boxes introduce students to the principal elements of the world's great religions, past and present, and to the representation of religious and mythological themes in painting and sculpture of all periods and places. These discussions of belief systems and iconography give readers a richer understanding of some of the greatest artworks ever created. The topics include the gods and goddesses of Egypt, Mesopotamia, Greece, and Rome; the life of Jesus in art; Buddha and Buddhism; Muhammad and Islam; and Aztec religion.

Art and Society essays treat the historical, social, political, cultural, and religious context of art and architecture. In some instances, specific monuments are the basis for a discussion of broader themes, as when the Hegeso stele serves as the springboard for an exploration of the role of women in ancient Greek society. Another essay discusses how people's evaluation today of artworks can differ from those of the society that produced them by examining the problems created by the contemporary market for undocumented archaeological finds. Other subjects include Egyptian mummification; Etruscan women; Byzantine icons and iconoclasm; artistic training in Renaissance Italy; 19th-century academic salons and independent art exhibitions; the Mesoamerican ball game; Japanese court culture; and art and leadership in Africa.

Written Sources present and discuss key historical documents illuminating important monuments of art and architecture throughout the world. The passages quoted permit voices from the past to speak directly to the reader, providing vivid and unique insights into the creation of artworks in all media. Examples include Bernard of Clairvaux's treatise on sculpture in medieval churches; Giovanni Pietro Bellori's biographies of Annibale Carracci and Caravaggio; Jean François Marmontel's account of 18th-century salon culture; as well as texts that bring the past to life, such as eyewitness accounts of the volcanic eruption that buried Roman Pompeii and of the fire that destroyed Canterbury Cathedral in medieval England.

Finally, in the *Artists on Art* boxes, artists and architects throughout history discuss both their theories and individual works. Examples include Sinan the Great discussing the mosque he designed for Selim II; Leonardo da Vinci and Michelangelo debating the relative merits of painting and sculpture; Artemisia Gentileschi talking about the special problems she confronted as a woman artist; Jacques-Louis David on Neoclassicism; Gustave Courbet on Realism; Henri Matisse on color; Pablo Picasso on Cubism; Diego Rivera on art for the people; and Judy Chicago on her seminal work *The Dinner Party*.

For every new edition of *Art through the Ages*, I also reevaluate the basic organization of the book. In the 14th edition, the un-

folding narrative of the history of art in Europe and America is no longer interrupted with "excursions" to Asia, Africa, and Oceania. Those chapters are now grouped together at the end of Volumes I and II and in backpack Books D and F. And the treatment of the art of the later 20th century and the opening decade of the 21st century has been significantly reconfigured. There are now separate chapters on the art and architecture of the period from 1945 to 1980 and from 1980 to the present. Moreover, the second chapter (Chapter 31, "Contemporary Art Worldwide") is no longer confined to Western art but presents the art and architecture of the past three decades as a multifaceted global phenomenon. Furthermore, some chapters now appear in more than one of the paperbound versions of the book in order to provide enhanced flexibility to instructors who divide the global history of art into two or three semester-long courses. Chapter 14—on Italian art from 1200 to 1400—appears in both Volumes I and II and in backpack Books B and D. The Islamic and contemporary art chapters appear in both the Western and non-Western backpack subdivisions of the full global text.

Rounding out the features in the book itself is a greatly expanded Bibliography of books in English with several hundred new entries, including both general works and a chapter-by-chapter list of more focused studies; a Glossary containing definitions of all italicized terms introduced in both the printed and online texts; and, for the first time, a complete museum index listing all illustrated artworks by their present location .

The 14th edition of *Art through the Ages* also features a host of state-of-the-art online resources (enumerated on page xv).

WRITING AND TEACHING THE HISTORY OF ART

Nonetheless, some things have not changed in this new edition, including the fundamental belief that guided Helen Gardner so many years ago-that the primary goal of an introductory art history textbook should be to foster an appreciation and understanding of historically significant works of art of all kinds from all periods and from all parts of the globe. Because of the longevity and diversity of the history of art, it is tempting to assign responsibility for telling its story to a large team of specialists. The original publisher of Art through the Ages took this approach for the first edition prepared after Helen Gardner's death, and it has now become the norm for introductory art history surveys. But students overwhelmingly say the very complexity of the global history of art makes it all the more important for the story to be told with a consistent voice if they are to master so much diverse material. I think Helen Gardner would be pleased to know that Art through the Ages once again has a single storyteller—aided in no small part by invaluable advice from well over a hundred reviewers and other consultants whose assistance I gladly acknowledge at the end of this Preface.

I continue to believe that the most effective way to tell the story of art through the ages, especially to anyone studying art history for the first time, is to organize the vast array of artistic monuments according to the civilizations that produced them and to consider each work in roughly chronological order. This approach has not merely stood the test of time. It is the most appropriate way to narrate the *history* of art. The principle underlying my approach to every period of art history is that the enormous variation in the form and meaning of the paintings, sculptures, buildings, and other artworks men and women have produced over the past 30,000 years is largely the result of the constantly changing contexts in which

artists and architects worked. A historically based narrative is therefore best suited for a global history of art because it enables the author to situate each work discussed in its historical, social, economic, religious, and cultural context. That is, after all, what distinguishes art history from art appreciation.

In the 1926 edition of Art through the Ages, Helen Gardner discussed Henri Matisse and Pablo Picasso in a chapter entitled "Contemporary Art in Europe and America." Since then many other artists have emerged on the international scene, and the story of art through the ages has grown longer and even more complex. As already noted, that is reflected in the addition of a new chapter at the end of the book on contemporary art in which developments on all continents are treated together for the first time. Perhaps even more important than the new directions artists and architects have taken during the past several decades is that the discipline of art history has also changed markedly—and so too has Helen Gardner's book. The 14th edition fully reflects the latest art historical research emphases while maintaining the traditional strengths that have made previous editions of Art through the Ages so popular. While sustaining attention to style, chronology, iconography, and technique, I also ensure that issues of patronage, function, and context loom large in every chapter. I treat artworks not as isolated objects in sterile 21st-century museum settings but with a view toward their purpose and meaning in the society that produced them at the time they were produced. I examine not only the role of the artist or architect in the creation of a work of art or a building, but also the role of the individuals or groups who paid the artists and influenced the shape the monuments took. Further, in this expanded hybrid edition, I devote more space than ever before to the role of women and women artists in societies worldwide over time. In every chapter, I have tried to choose artworks and buildings that reflect the increasingly wide range of interests of scholars today, while not rejecting the traditional list of "great" works or the very notion of a "canon." Indeed, the expanded hybrid nature of the 14th edition has made it possible to illustrate and discuss scores of works not traditionally treated in art history survey texts without reducing the space devoted to canonical works.

CHAPTER-BY-CHAPTER CHANGES IN THE 14TH EDITION

All chapters feature many new photographs, revised maps, revised Big Picture chapter-ending summaries, and changes to the text reflecting new research and discoveries.

- **8: Late Antiquity.** New Framing the Era essay "Romans, Jews, and Christians" and new timeline. Villa Torlonia Jewish catacomb and Mildenhall treasure added.
- **9: Byzantium.** New Framing the Era essay "Church and State United" and new timeline. Revised discussion of iconoclasm and of Byzantine women. New box on "Born to the Purple: Empress Zoe."
- **10: The Islamic World.** New Framing the Era essay "The Rise and Spread of Islam" and new timeline. Muqarnas tilework of Imam Mosque, Isfahan, added.
- 11: Early Medieval Europe. New Framing the Era essay "Missionaries and the Spread of Christian Art" and new timeline. Detail photos of Book of Kells added.

12: Romanesque Europe. New Framing the Era essay "The Rebirth of Monumental Sculpture" and new timeline. New photos of newly cleaned Autun tympanum and many other French churches. Revised boxes on "Pilgrimage Roads in France and Spain" and "The Veneration of Relics." Reliquary of St. Foy added.

13: Gothic Europe. New Framing the Era essay "The Age of the Great Cathedrals" and new timeline. Extensive new photographic documentation of French churches and portal sculpture. Expanded treatment of German Gothic art and architecture.

14: Late Medieval Italy. New Framing the Era essay "Late Medieval or Proto-Renaissance?" and new timeline. New series of photos of architecture and sculpture in Florence, Orvieto, Pisa, and Siena. Andrea Pisano Baptistery doors added.

Go to the online instructor companion site or PowerLecture for a more detailed list of chapter-by-chapter changes and the figure number transition guide.

ACKNOWLEDGMENTS

A work as extensive as a global history of art could not be undertaken or completed without the counsel of experts in all areas of world art. As with previous editions, Cengage Learning/Wadsworth has enlisted more than a hundred art historians to review every chapter of Art through the Ages in order to ensure that the text lives up to the Gardner reputation for accuracy as well as readability. I take great pleasure in acknowledging here the important contributions to the 14th edition made by the following: Michael Jay Adamek, Ozarks Technical Community College; Charles M. Adelman, University of Northern Iowa; Christine Zitrides Atiyeh, Kutztown University; Gisele Atterberry, Joliet Junior College; Roann Barris, Radford University; Philip Betancourt, Temple University; Karen Blough, SUNY Plattsburgh; Elena N. Boeck, DePaul University; Betty Ann Brown, California State University Northridge; Alexandra A. Carpino, Northern Arizona University; Anne Walke Cassidy, Carthage College; Harold D. Cole, Baldwin Wallace College; Sarah Cormack, Webster University, Vienna; Jodi Cranston, Boston University; Nancy de Grummond, Florida State University; Kelley Helmstutler Di Dio, University of Vermont; Owen Doonan, California State University Northridge; Marilyn Dunn, Loyola University Chicago; Tom Estlack, Pittsburgh Cultural Trust; Lois Fichner-Rathus, The College of New Jersey; Arne R. Flaten, Coastal Carolina University; Ken Friedman, Swinburne University of Technology; Rosemary Gallick, Northern Virginia Community College; William V. Ganis, Wells College; Marc Gerstein, University of Toledo; Clive F. Getty, Miami University; Michael Grillo, University of Maine; Amanda Hamilton, Northwest Nazarene University; Heather Jensen, Brigham Young University; Martina Hesser, Grossmont College; Mark Johnson, Brigham Young University; Jacqueline E. Jung, Yale University; John F. Kenfield, Rutgers University; Asen Kirin, University of Georgia; Joanne Klein, Boise State University; Yu Bong Ko, Tappan Zee High School; Rob Leith, Buckingham Browne & Nichols School; Adele H. Lewis, Arizona State University; Kate Alexandra Lingley, University of Hawaii-Manoa; Ellen Longsworth, Merrimack College; Matthew Looper, California State University-Chico; Nuria Lledó Tarradell, Universidad Complutense, Madrid; Anne McClanan, Portland State University; Mark Magleby, Brigham Young University; Gina Miceli-Hoffman, Moraine Valley Community College; William Mierse, University of Vermont; Amy Morris, Southeastern Louisiana University; Charles R. Morscheck, Drexel University; Johanna D. Movassat, San Jose State University; Carola Naumer, Truckee Meadows Community College; Irene Nero, Southeastern Louisiana University; Robin O'Bryan, Harrisburg Area Community College; Laurent Odde, Kutztown University of Pennsylvania; E. Suzanne Owens, Lorain County Community College; Catherine Pagani, The University of Alabama; Martha Peacock, Brigham Young University; Mabi Ponce de Leon, Bexley High School; Curtis Runnels, Boston University; Malia E. F. Serrano, Grossmont College; Molly Skjei, Normandale Community College; James Swensen, Brigham Young University; John Szostak, University of Hawaii-Manoa; Fred T. Smith, Kent State University; Thomas F. Strasser, Providence College; Katherine H. Tachau, University of Iowa; Debra Thompson, Glendale Community College; Alice Y. Tseng, Boston University; Carol Ventura, Tennessee Technological University; Marc Vincent, Baldwin Wallace College; Deborah Waite, University of Hawaii-Manoa; Lawrence Waldron, Saint John's University; Victoria Weaver, Millersville University; and Margaret Ann Zaho, University of Central Florida.

I am especially indebted to the following for creating the instructor and student materials for the 14th edition: William J. Allen, Arkansas State University; Ivy Cooper, Southern Illinois University Edwardsville; Patricia D. Cosper, The University of Alabama at Birmingham; Anne McClanan, Portland State University; and Amy M. Morris, Southeastern Louisiana University. I also thank the members of the Wadsworth Media Advisory Board for their input: Frances Altvater, University of Hartford; Roann Barris, Radford University; Bill Christy, Ohio University-Zanesville; Annette Cohen, Great Bay Community College; Jeff Davis, The Art Institute of Pittsburgh–Online Division; Owen Doonan, California State University-Northridge; Arne R. Flaten, Coastal Carolina University; Carol Heft, Muhlenberg College; William Mierse, University of Vermont; Eleanor F. Moseman, Colorado State University; and Malia E. F. Serrano, Grossmont College.

I am also happy to have this opportunity to express my gratitude to the extraordinary group of people at Cengage Learning/ Wadsworth involved with the editing, production, and distribution of Art through the Ages. Some of them I have now worked with on various projects for nearly two decades and feel privileged to count among my friends. The success of the Gardner series in all of its various permutations depends in no small part on the expertise and unflagging commitment of these dedicated professionals, especially Clark Baxter, publisher; Sharon Adams Poore, senior development editor (as well as videographer extraordinaire); Lianne Ames, senior content project manager; Mandy Groszko, rights acquisitions specialist; Kimberly Apfelbaum, associate media editor; Robert White, product manager; Ashley Bargende, assistant editor; Elizabeth Newell, editorial assistant; Amy Bither and Jessica Jackson, editorial interns; Cate Rickard Barr, senior art director; Jeanne M. Heston, senior marketing manager, Heather Baxley, senior marketing communications manager, and the incomparable group of local sales representatives who have passed on to me the welcome advice offered by the hundreds of instructors they speak to daily during their visits to college campuses throughout North America.

I am also deeply grateful to the following out-of-house contributors to the 14th edition: the peerless and tireless Joan Keyes, Dovetail Publishing Services; Helen Triller-Yambert, development editor; Ida May Norton, copy editor; Do Mi Stauber and Michael Brackney, indexers; Susan Gall, proofreader; tani hasegawa, designer; Catherine Schnurr, Mary-Lise Nazaire, Lauren McFalls,

and Corey Geissler, PreMediaGlobal, photo researchers; Alma Bell, Scott Paul, John Pierce, and Lori Shranko, Thompson Type; Jay and John Crowley, Jay's Publishing Services; Mary Ann Lidrbauch, art manuscript preparer; and, of course, Jonathan Poore and John Burge, for their superb photos and architectural drawings.

Finally, I owe thanks to my former co-author, Christin J. Mamiya of the University of Nebraska–Lincoln, for her friendship and advice, especially with regard to the expanded contemporary

art section of the 14th edition, as well as to my colleagues at Boston University and to the thousands of students and the scores of teaching fellows in my art history courses since I began teaching in 1975. From them I have learned much that has helped determine the form and content of *Art through the Ages* and made it a much better book than it otherwise might have been.

Fred S. Kleiner

FRED S. KLEINER (Ph.D., Columbia University) is the author or coauthor of the 10th, 11th, 12th, and 13th editions of *Art through the Ages: A Global History*, as well as the 1st, 2nd, and 3rd editions of *Art through the Ages: A Concise History*, and more than a hundred publications on Greek and Roman art and architecture, including *A History of Roman Art*, also published by Wadsworth, a part of Cengage Learning. He has taught the art history survey course for more than three decades, first at the University of Virginia and, since 1978, at Boston University, where he is currently Professor of Art History and Archaeology and Chair of the Department of History of Art and Architecture. From 1985 to 1998, he was Editor-in-Chief of the *American Journal of Archaeology*. Long acclaimed for his inspiring lectures and dedication to students, Professor Kleiner

won Boston University's Metcalf Award for Excellence in Teaching as well as the College Prize for Undergraduate Advising in the Humanities in 2002, and he is a two-time winner of the Distinguished Teaching Prize in the College of Arts and Sciences Honors Program. In 2007, he was elected a Fellow of the Society of Antiquaries of London, and, in 2009, in recognition of lifetime achievement in publication and teaching, a Fellow of the Text and Academic Authors Association.

Also by Fred Kleiner: *A History of Roman Art, Enhanced Edition* (Wadsworth 2010; ISBN 9780495909873), winner of the 2007 Texty Prize for a new college textbook in the humanities and social sciences. In this authoritative and lavishly illustrated volume, Professor Kleiner traces the development of Roman art and architecture from Romulus's foundation of Rome in the eighth century BCE to the death of Constantine in the fourth century CE, with special chapters devoted to Pompeii and Herculaneum, Ostia, funerary and provincial art and architecture, and the earliest Christian art. The enhanced edition also includes a new introductory chapter on the art and architecture of the Etruscans and of the Greeks of South Italy and Sicily.

RESOURCES

FOR FACULTY

PowerLecture with Digital Image Library

This flashdrive is an all-in-one lecture and class presentation tool that makes it easy to assemble, edit, and present customized lectures for your course using Microsoft® PowerPoint®. The Digital Image Library provides high-resolution images (maps, diagrams, and most of the fine art images from the text, including the over 300 new images) for lecture presentations, either in PowerPoint format, or in individual file formats compatible with other image-viewing software. A zoom feature allows you to magnify selected portions of an image for more detailed display in class, or you can display images side by side for comparison. You can easily add your own images to those from the text. The Google Earth™ application allows you to zoom in on an entire city, as well as key monuments and buildings. There are links to specific figures for every chapter in the book. PowerLecture also includes an Image Transition Guide, an electronic Instructor's Manual and a Test Bank with multiplechoice, matching, short-answer, and essay questions in ExamView® computerized format. The text-specific Microsoft® PowerPoint® slides are created for use with JoinIn™, software for classroom personal response systems (clickers).

WebTutor™ with eBook on WebCT® and Blackboard®

WebTutor™ enables you to assign preformatted, text-specific content that is available as soon as you log on. You can also customize the WebTutor™ environment in any way you choose. Content includes the Interactive ebook, Test Bank, Practice Quizzes, Video Study Tools, and CourseMate™.

To order, contact your Cengage Learning representative.

FOR STUDENTS

CourseMateTM with eBook

Make the most of your study time by accessing everything you need to succeed in one place. Open the interactive eBook, take notes, review image and audio flashcards, watch videos, and take practice quizzes online with CourseMate[™]. You will find hundreds of zoomable, high-resolution bonus images (represented by thumbnail images in the text) along with discussion of the images, videos created specifically to enhanced your reading comprehension, audio chapter summaries, compare-and-contrast activities, Guide to Studying, and more.

Slide Guides

The Slide Guide is a lecture companion that allows you to take notes alongside thumbnails of the same art images that are shown in class. This handy booklet includes reproductions of the images from the book with full captions, page numbers, and space for note taking. It also includes Google Earth™ exercises for key cities, monuments, and buildings that will take you to these locations to better understand the works you are studying.

To order, go to www.cengagebrain.com

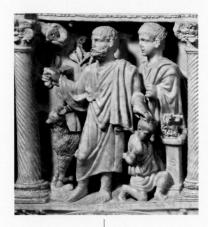

Episodes from the Hebrew scriptures, including Abraham's sacrifice of Isaac, appear side by side with scenes from the life of Jesus on this sarcophagus of a recent convert to Christianity.

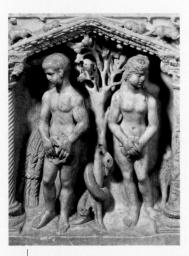

The Jewish scenes on Junius Bassus's sarcophagus had special significance for Christians. Adam and Eve's original sin of eating the apple in the Garden of Eden necessitated Christ's sacrifice.

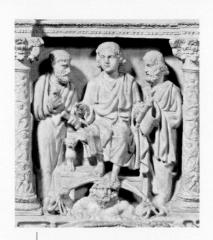

Christ, long-haired and youthful in the Early Christian tradition, sits above a personification of the Roman sky god. Flanking the new ruler of the universe are Saints Peter and Paul.

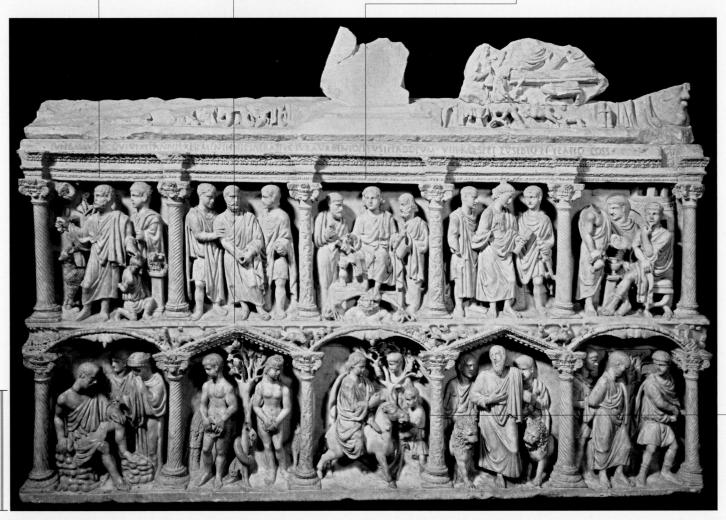

1 ft.

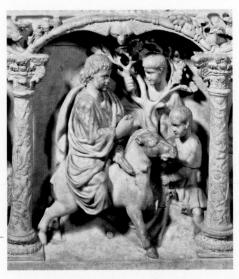

The compositions of many Early Christian reliefs derive from Greco-Roman art. The scene of Jesus entering Jerusalem on a donkey recalls portrayals of Roman emperors entering conquered cities.

8

LATE ANTIQUITY

ROMANS, JEWS, AND CHRISTIANS

During the third and fourth centuries, a rapidly growing number of Romans rejected polytheism (belief in multiple gods) in favor of monotheism (the worship of a single all-powerful god)—but they did not stop commissioning works of art. A prominent example is Junius Bassus, the mid-fourth-century city prefect of Rome who converted to Christianity and, according to the inscription on his sarcophagus (FIG. 8-1), was baptized just before his death in 359. He grew up immersed in traditional Roman culture and initially paid homage to the old Roman gods, but when he died, he chose to be buried in a sarcophagus decorated with episodes from the Hebrew scriptures and the life of Jesus.

The sculptor of Junius Bassus's sarcophagus decorated it with reliefs only on the front and two short sides in the western Roman manner (see Chapter 7). The front has 10 figural scenes in two registers of five compartments, each framed by columns in the tradition of Asiatic sarcophagi (FIG. 7-61). The deceased does not appear in any of those compartments. Instead, Jewish and Christian biblical stories fill the niches. Jesus has pride of place and appears in the central compartment of each register: as a teacher enthroned between Saints Peter and Paul (top niche), and entering Jerusalem on a donkey (bottom niche). Both compositions owe a great deal to official Roman art. In the upper zone, Christ, like an enthroned Roman emperor, sits above a personification of the sky god holding a billowing mantle over his head, indicating Christ is ruler of the universe. The scene below derives in part from portrayals of Roman emperors entering conquered cities on horseback, but Jesus' steed and the absence of imperial attributes contrast sharply with the imperial models the sculptor used as compositional sources.

The Jewish scenes on the Junius Bassus sarcophagus include the stories of Adam and Eve and Abraham and Isaac, which took on added significance for Christians as foretelling events in the life of their Savior. Christians believe Adam and Eve's original sin of eating the apple in the Garden of Eden ultimately necessitated Christ's sacrifice for the salvation of humankind. At the upper left, Abraham is about to sacrifice Isaac. Christians view this Genesis story as a prefiguration of God's sacrifice of his son, Jesus.

The crucifixion, however, does not appear on the sarcophagus and was rare in Early Christian art. Artists emphasized Christ's divinity and exemplary life as teacher and miracle worker, not his suffering and death at the hands of the Romans. This sculptor, however, alluded to the crucifixion in the scenes at the upper right showing Jesus led before Pontius Pilate for judgment. The Romans condemned Jesus to death, but he triumphantly overcame it. Junius Bassus hoped for a similar salvation.

THE LATE ANTIQUE WORLD

The Roman Empire was home to an extraordinarily diverse population. In Rome alone on any given day, someone walking through the city's various quarters would have encountered people of an astonishing range of social, ethnic, racial, linguistic, and religious backgrounds. This multicultural character of Roman society became only more pronounced as the Romans expanded their territories throughout Europe, Africa, and Mesopotamia (MAP 7-1). Chapter 7 focused on the public and private art and architecture of Romans through the time of Constantine, who worshiped the traditional gods and embraced the values of the classical world.* This chapter treats primarily Late Antique Jewish and Christian artworks, created both before and after Constantine. These sculptures, paintings, mosaics, and other art forms are no less Roman than imperial

*Note: In *Art through the Ages*, the adjective "Classical," with uppercase *C*, refers specifically to the Classical period of ancient Greece, 480-323 BCE. Lowercase "classical" refers to Greco-Roman antiquity in general, that is, the period treated in Chapters 5, 6, and 7.

portraits, statues of gods and heroes, or sarcophagi with mythological scenes. Indeed, the artists may in some cases have been the same. But although they are Roman in style and technique, the Jewish and Christian sculptures, paintings, and buildings of Late Antiquity differ significantly in subject and often in function from contemporaneous Roman secular and religious art and architecture. For that reason, and because these Late Antique artworks and sacred buildings formed the foundation of the art and architecture of the Middle Ages, they are the subject of a separate chapter.

DURA-EUROPOS AND JEWISH ART

The powerful religious crosscurrents of Late Antiquity may be seen in microcosm in a distant outpost of the Roman Empire on a promontory overlooking the Euphrates River in Syria (MAP 8-1). Called Europos by the Greeks and Dura by the Romans, the town probably was founded shortly after the death of Alexander the Great by one of his successors. By the end of the second century BCE, Dura-Europos was in the hands of the Parthians. Trajan captured the city

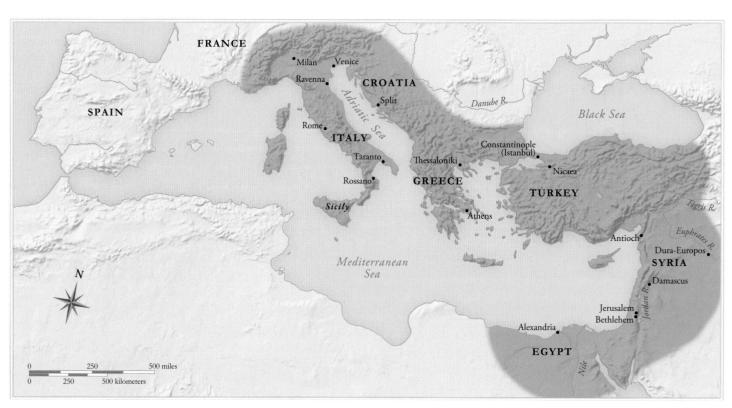

MAP 8-1 The Mediterranean world in late antiquity.

LATE ANTIQUITY

■ Biblical murals in the Dura-Europos including Old Saint Peter's

306

I Earliest Christian sarcophagi and catacomb paintings

Pre-Constantinian

I Construction of the first churches in Rome,

Constantine

- Dedication of Constantinople as the New Rome
- Capital of Western Roman Empire moved

337

Sons of Constantine

to Justinian

526

- I Mosaics become the primary medium for church decoration
- Earliest preserved illustrated manuscripts with biblical themes

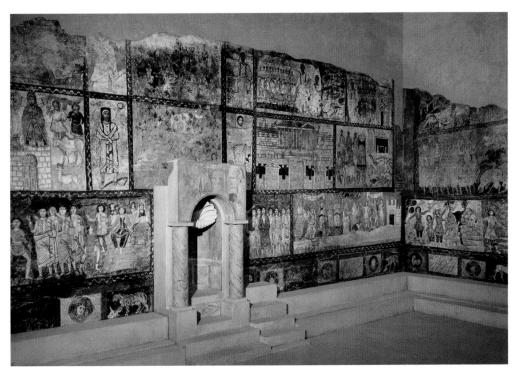

8-2 Interior of the synagogue, Dura-Europos, Syria, with wall paintings of biblical themes, ca. 245–256. Tempera on plaster. Reconstruction in National Museum of Damascus, Damascus.

The Dura-Europos synagogue was a converted private house. The niche housing the sacred Torah is at the center of one long wall with paintings depicting episodes from the Hebrew scriptures.

in 115,† but Dura reverted to Parthian control shortly thereafter. In 165, under Marcus Aurelius, the Romans retook the city and placed a permanent garrison there. Dura-Europos fell in 256 to Rome's new enemy in the East, the Sasanians, heirs to the Parthian Empire (see Chapter 2). The Sasanian siege of Dura is an important fixed point in the chronology of Late Antiquity because the inhabitants evacuated the town, leaving its buildings largely intact. This "Pompeii of the desert" has revealed the remains of more than a dozen different cult buildings, including many shrines of the polytheistic religions of the Mediterranean and Mesopotamia. But the excavators also discovered places of worship for the monotheistic creeds of Judaism and Christianity.

SYNAGOGUE PAINTINGS Dura-Europos's synagogue is remarkable not only for its very existence in a Roman garrison town but also for its extensive cycle of mural paintings depicting episodes from the sacred Jewish Torah (the scroll containing the Pentateuch, the first five books of the Hebrew scriptures). The Jews of Dura-Europos converted a private house with a central courtyard into a synagogue during the latter part of the second century. The main room (FIG. 8-2) has a niche for the Torah at the center of one long wall. The paintings cover all the remaining wall surfaces. The discovery of an elaborate mural cycle in a Jewish temple initially surprised scholars because they had assumed the Second Commandment (Exodus 20:4-6) prohibiting Jews from worshiping images precluded the decoration of synagogues with figural scenes. Narrative scenes like those at Dura must have appeared in many Late Antique synagogues as well as in Jewish manuscripts, although no illustrated Bible of this period survives (see "Medieval Manuscript Illumination," page 249). God (YHWH, or Yahweh in the Torah), however, never appears in the Dura paintings, except as a hand emerging from the top of the framed panels.

The Dura murals are mostly devoid of action, even when the subject is a narrative theme. The artists told the stories through

†In this chapter, all dates are CE unless otherwise indicated.

stylized gestures, and the figures, which have expressionless features and, in most of the panels, lack both volume and shadow, tend to stand in frontal rows. The painting from the book of Samuel in which Samuel Anoints David (FIG. 8-3) exemplifies this Late Antique style, also seen in the friezes of the Arch of Septimius Severus (FIG. 7-65) at Lepcis Magna

and the Arch of Constantine (FIG. 7-76) in Rome. The episode is on the main wall just to the right of the Torah niche. The prophet anoints the future king of Israel, as David's six older brothers look on. The painter drew attention to Samuel by depicting him larger than all the rest, a familiar convention of Late Antique art. David and his brothers are frontal figures looking out at the viewer. They seem almost weightless, and their bodies do not even have enough feet. The painter distinguished David from his brothers by the purple toga he wears. Purple was the color associated with the Roman emperor, and the Dura artist borrowed the imperial toga to signify David's royalty.

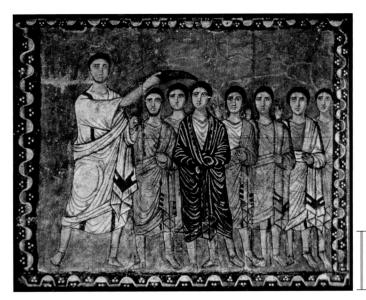

8-3 Samuel Anoints David, detail of main interior wall of the synagogue, Dura-Europos, Syria, ca. 245–256. Tempera on plaster, 4′ 7″ high.

The figures in this scene from the book of Samuel lack volume, stand in frontal rows, and exhibit stylized gestures, features characteristic of Late Antique art, regardless of subject matter.

8-4 Ark of the Covenant and two menorahs, painted wall in a Jewish catacomb, Villa Torlonia, Rome, Italy, third century. Fresco, 3' 11" high.

Some of the oldest catacombs in Rome were Jewish burial places. This example features mural paintings that include depictions of the sacred Ark of the Covenant and two menorahs.

VILLA TORLONIA Mural paintings of similar date depicting Jewish themes have also been found in Rome, most notably in underground chambers on the grounds of the present Villa Torlonia, where Jewish families buried their dead beginning in the second century. Perhaps the finest of the Torlonia paintings (FIG. 8-4) depicts two seven-branched menorahs, modest versions of the sumptuous meno-

rah (FIG. 7-41) Roman soldiers brought back from Jerusalem after Titus sacked the great Hebrew temple there. At the center is the Ark of the Covenant of the Jerusalem temple, which contained the sacred stone tablets of Moses with the Ten Commandments. These important emblems of their faith appropriately decorated one wall of the tomb in which these Roman Jews were laid to rest.

CHRISTIAN COMMUNITY HOUSE The Christian community at Dura-Europos also had a place to gather for worship and to conduct important ceremonies. As was the synagogue, the Christian meeting house (FIG. 8-5) was a remodeled private residence with a central courtyard (FIG. 8-5, no. 1). Its meeting hall (no. 2)—created by breaking down the partition between two rooms on the court's south side—could accommodate no more than about 70 people at a time. It had a raised platform at one end where the leader of the congregation sat or stood. Another room (no. 3), on the opposite side of the courtyard, had a font for *baptismal* rites, the all-important ceremony initiating a new convert into the Christian community.

Although the *baptistery* had mural paintings (poorly preserved), the place where Christians gathered to worship at Dura, as elsewhere in the Roman Empire, was a modest secondhand house, in striking contrast to the grand temples of the Roman gods. Without the approval of the state, Christian as well as Jewish communities remained small in number. Nonetheless, the emperor Diocletian (FIG. 7-73) was so concerned by the growing popularity of Christianity in the Roman army ranks that he ordered a fresh round of persecutions in 303 to 305, a half century after the last great persecutions under Trajan Decius (FIG. 7-68). As Christianity's appeal grew, so too did the Roman state's fear of weakening imperial authority, because the Christians refused to pay even token homage to the Roman state's official gods (which included deified emperors as well as the traditional pantheon of gods and goddesses). Persecution ended only in 311, when Galerius issued an edict of toleration,

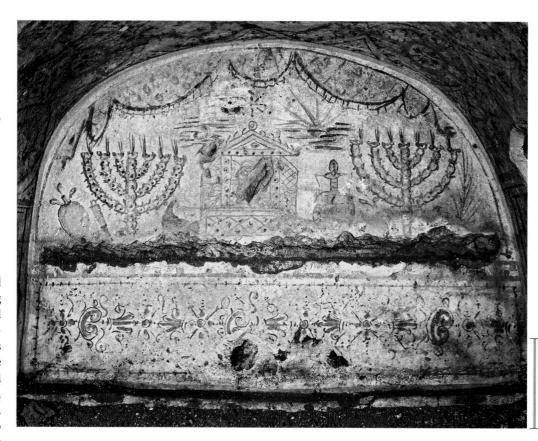

and especially in 313, when Constantine (FIG. 7-77), who believed the Christian God was the source of his power rather than a threat to it (see pages 225–226), issued the Edict of Milan, which established Christianity as a legal religion with equal or superior standing to the traditional Roman cults.

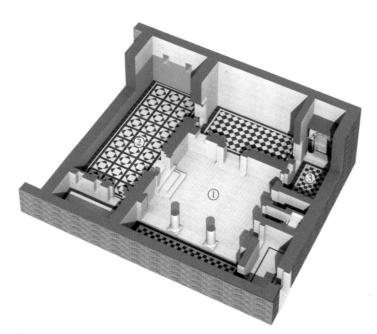

8-5 Restored cutaway view of the Christian community house, Dura-Europos, Syria, ca. 240–256 (John Burge). (1) former courtyard of private house, (2) meeting hall, (3) baptistery.

The Christian community at Dura-Europos met in a remodeled private home that could accommodate only about 70 people. The house had a central courtyard, a meeting hall, and a baptistery.

THE CATACOMBS AND FUNERARY ART

Very little is known about the art of the first Christians. When art historians speak about "Early Christian art," they are referring to the earliest preserved artworks with Christian subjects, not the art of Christians at the time of Jesus. Most Early Christian art in Rome dates to the third and fourth centuries and is found in the catacombs—vast subterranean networks of galleries (passageways) and chambers designed as cemeteries for burying Christians and, to a lesser extent, Jews (FIG. 8-4) and others. The name derives from the Latin ad catacumbas, which means "in the hollows." The Christian and Jewish communities tunneled the catacombs out of the tufa bedrock, much as the Etruscans created the underground tomb chambers (FIGS. 6-7 and 6-8) in the Cerveteri necropolis. The catacombs are less elaborate than the Etruscan tombs but much more extensive. The known catacombs in Rome (others exist elsewhere), which ring the outskirts of the city, comprise galleries estimated to run for 60 to 90 miles. From the second through the fourth centuries, these burial complexes were in constant use, accommodating as many as four million bodies.

In accordance with Roman custom, the dead had to be buried outside a city's walls on private property. Christian families often pooled funds in a burial association, or *confraternity*. Each of the now-labyrinthine catacombs was initially of modest extent. First, the workers dug a gallery three to four feet wide around the perimeter of the burial ground at a convenient level below the surface. In

the walls of these galleries, they cut *loculi* (openings to receive the bodies of the dead, one above another, like shelves). Often, small rooms carved out of the rock, called *cubicula* (as in Roman houses of the living), served as mortuary chapels. Once the original perimeter galleries were full of loculi and cubicula, the excavators cut other galleries at right angles to them. This process continued as long as lateral space permitted, at which point the confraternities opened lower levels connected by staircases to those above. Some Roman catacomb systems extend as deep as five levels. When adjacent burial areas belonged to members of the same confraternity, or by gift or purchase fell into the same hands, the owners opened passageways between the respective cemeteries. The galleries thus spread laterally and gradually acquired a vast extent.

After Christianity received official approval under Constantine, churches rose on the land above the catacombs so the pious could worship openly at the burial sites of some of the earliest Christian *martyrs* (men and women who chose to die rather than deny their religious beliefs), whom the Church had declared *saints*.

Painting

As already noted, Late Antique Jewish and Christian works of art do not differ from contemporaneous secular Roman artworks in style or technique, only in content. Some catacomb paintings, including many of those in the fourth-century Via Dino Compagni Catacomb (FIG. 8-5A) on the Via Latina in Rome,

8-5A Via Dino Compagni Catacomb, Rome, ca. 320–360.

even depict traditional Greco-Roman myths. It is not surprising, therefore, that the painted ceiling

(FIG. 8-6) of a cubiculum in the Catacomb of Saints Peter and Marcellinus in Rome, for example, is similar in format to the painted vaults (FIG. 7-54A) of some third-century apartment houses at Ostia that have a circular frame with a central medallion and lunettes (semicircular frames) around the circumference. The lunettes in the Early Christian cubiculum illustrated here (FIG. 8-6) contain the key episodes from the biblical story of Jonah. Sailors throw him from his ship on the left. He emerges on the right from the "whale." (The Greek word is ketos, or sea dragon, and that is how the artist represented the monstrous marine creature that swallowed Jonah; compare the sea dragon, FIG. 7-30, right.) At the bottom, safe on land,

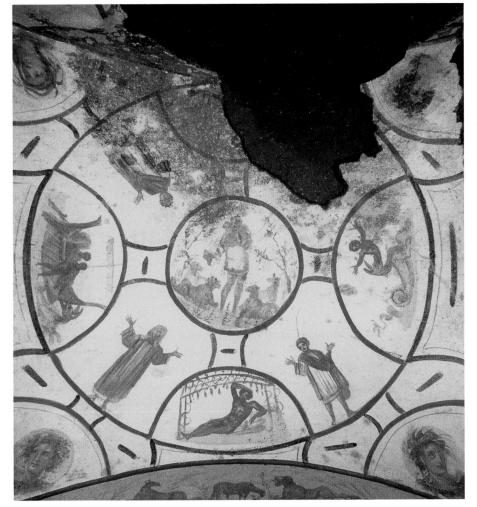

8-6 The Good Shepherd, the story of Jonah, and orants, frescoed ceiling of a cubiculum in the Catacomb of Saints Peter and Marcellinus, Rome, Italy, early fourth century.

This ceiling in a Roman catacomb is similar in format to the painted vaults of some Ostian apartment houses, but the subjects come from the Hebrew scriptures and the New Testament.

Jewish Subjects in Christian Art

7 hen the Christians codified the Bible in its familiar form, they incorporated the Hebrew Torah and other writings, and designated the Jewish books as the "Old Testament" in contrast to the Christian books of the "New Testament." From the beginning, the Hebrew scriptures played an important role in Christian life and Christian art, in part because Jesus was a Jew and so many of the first Christians were converted Jews, but also because Christians came to view many of the persons and events of the Old Testament as prefigurations of New Testament persons and events. Christ himself established the pattern for this kind of biblical interpretation, called typology, when he compared Jonah's spending three days in the belly of the sea dragon (usually translated as "whale" in English) to the comparable time he would be entombed in the earth before his resurrection (Matt. 12:40). In the fourth century, Saint Augustine (354-430) confirmed the validity of this typological approach to the Old Testament when he stated that "the New Testament is hidden in the Old; the Old is clarified by the New."* Thus the Hebrew scriptures figured prominently in Early Christian art in all media. Biblical tales of Jewish faith and salvation were especially common in funerary contexts but appeared also in churches and on household objects.

*Augustine, City of God, 16.26.

The following are three of the most popular Jewish biblical stories depicted in Early Christian art:

- **Adam and Eve.** Eve, the first woman, tempted by a serpent, ate the forbidden fruit of the tree of knowledge, and fed some to Adam, the first man. As punishment, God expelled Adam and Eve from Paradise. This "original sin" ultimately led to Christ's sacrifice on the cross so that all humankind could be saved. Christian theologians often consider Christ the new Adam and his mother, Mary, the new Eve.
- **I** Sacrifice of Isaac. God instructed Abraham, the father of the Hebrew nation, to sacrifice Isaac, his only son with his wife Sarah, as proof of his faith. (The mother of Abraham's first son, Ishmael, was Sarah's handmaiden.) When it became clear that Abraham would obey, the Lord sent an angel to restrain him and provided a ram for sacrifice in Isaac's place. Christians view this episode as a prefiguration of the sacrifice of God's only son, Jesus.
- Jonah. The Old Testament prophet Jonah had disobeyed God's command. In his wrath, the Lord caused a storm while Jonah was at sea. Jonah asked the sailors to throw him overboard, and the storm subsided. A sea dragon then swallowed Jonah, but God answered his prayers, and the monster spat out Jonah after three days, foretelling Christ's resurrection.

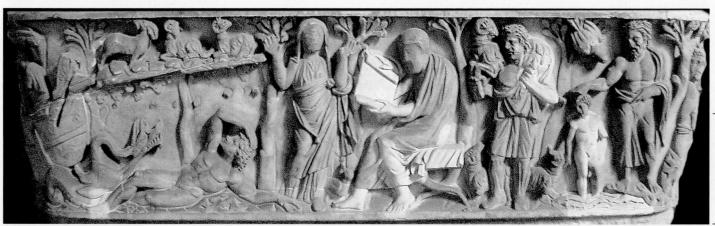

8-7 Sarcophagus with philosopher, orant, and Old and New Testament scenes, ca. 270. Marble, 1' $11\frac{1}{4}'' \times 7'$ 2". Santa Maria Antiqua, Rome.

Early Christian sarcophagi often mixed Old and New Testament themes. Jonah was a popular subject because he emerged safely from a sea monster after three days, prefiguring Christ's resurrection.

Jonah contemplates the miracle of his salvation and the mercy of God. Jonah was a popular figure in Early Christian painting and sculpture, especially in funerary contexts. The Christians honored him as a *prefiguration* (prophetic forerunner) of Christ, who rose from death as Jonah had been delivered from the belly of the ketos, also after three days. Hebrew miracles prefiguring Christ's resurrection abound in the catacombs and in Early Christian art in general (see "Jewish Subjects in Christian Art," above).

A man, a woman, and at least one child occupy the compartments between the Jonah lunettes. They are *orants* (praying figures), raising their arms in the ancient attitude of prayer. Together they make up a cross-section of the Christian family seeking a heavenly afterlife, although they may be generic portraits of the owners of the cubiculum. The central medallion shows Christ as the Good Shepherd, whose powers of salvation the painter underscored by placing the four episodes of the Jonah story around him. The motif of the Good Shepherd can be traced back to Archaic Greek art, but there the calf bearer (FIG. 5-8) was a bearded man offering his animal in sacrifice to Athena. In Early Christian art, Christ is the youthful and loyal protector of the Christian flock, who said to his disciples, "I am the good shepherd; the good shepherd gives his life for the sheep" (John 10:11). In the Christian motif, the sheep on Christ's shoulders is not a sacrificial offering.

8-6A Catacomb of Commodilla, Rome, ca. 370–385.

It is one of the lost sheep Christ has retrieved, symbolizing a sinner who has strayed and been rescued. Early Christian artists almost invariably represented Christ either as the Good Shepherd or as a teacher. Only after Christianity became the Roman Empire's official religion in 380 did Christ take on in art such impe-

rial attributes as the halo, the purple robe, and the throne, which denoted rulership. Eventually, artists depicted Christ with the beard of a mature adult—as in the late-fourth-century Catacomb of Commodilla in Rome (FIG. 8-6A)—which has been the standard form for centuries, supplanting the youthful imagery of most Early Christian portrayals of the Savior.

Sculpture

Most Christians rejected cremation because they believed in the resurrection of the body, and the wealthiest Christian faithful, as other well-to-do Romans, favored impressive marble sarcophagi. Many of these coffins have survived in the catacombs and elsewhere. As expected, the most common themes painted on the walls and vaults of the Roman subterranean cemeteries were also the subjects that appeared on Early Christian sarcophagi. Often, the decoration of the marble coffins was a collection of significant Jewish and Christian themes, just as on the painted ceiling (FIG. 8-6) in the Catacomb of Saints Peter and Marcellinus.

SANTA MARIA ANTIQUA SARCOPHAGUS On the front of a sarcophagus (FIG. 8-7) in Santa Maria Antiqua in Rome, the story of Jonah occupies the left third. At the center are an orant and a seated philosopher, the latter a motif borrowed directly from Roman sarcophagi (FIG. 7-71) and popular also in Roman painting (FIG. 7-25B) and statuary. The heads of both the praying woman and the seated man reading from a scroll are unfinished. Roman workshops often produced sarcophagi before knowing who would purchase them. The sculptors added the portraits at the time of burial, if they added them at all. This practice underscores the universal appeal of the themes chosen.

At the right are two different, yet linked, representations of Jesus—as the Good Shepherd and as a child receiving baptism in the Jordan River, though he really was baptized at age 30 (see "The Life of Jesus in Art," pages 240–241). In the early centuries of Christianity, baptism was usually delayed almost to the moment of death because it cleansed the Christian of all sin. One of those who was baptized on his deathbed was the emperor Constantine. On this sarcophagus, the newly baptized child Jesus turns his head toward the Good Shepherd and places his right hand on one of the sheep—perhaps the sculptor's way of suggesting Jesus' future ministry.

GOOD SHEPHERD STATUETTE Apart from the reliefs on privately commissioned sarcophagi such as the Santa Maria Antiqua sarcophagus and that of the city prefect Junius Bassus (FIG. 8-1), monumental sculpture became increasingly uncommon in the fourth century. Roman emperors and other officials continued to set up portraits, and sculptors still carved and cast statues of Greco-Roman gods and mythological figures, but the number of freestanding sculptures decreased sharply. In his *Apologia*, Justin Martyr, a second-century philosopher who converted to Christianity, condemned the traditional Greco-Roman practice of worshiping statues as gods, which the Second Commandment prohibited. Christians tended to suspect the freestanding statue, linking it with the false gods of the Romans, so Early Christian houses of worship, like Late

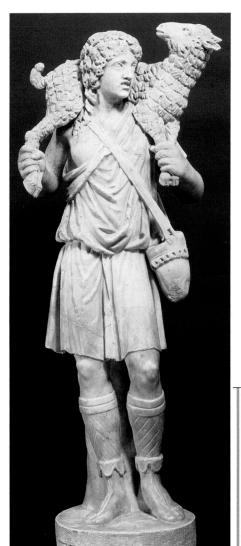

8-8 Christ as the Good Shepherd, ca. 300–350. Marble, 3′ ¼ high. Musei Vaticani, Rome.

Although freestanding images of Christ were uncommon in Late Antiquity, several statuettes exist representing the Good Shepherd. The patrons were probably recent converts to Christianity.

1 ft

Antique synagogues (FIG. 8-2), had no cult statues. Nor did churches or synagogues have any equivalent of the pedimental statues and relief friezes of Greco-Roman temples.

The Greco-Roman experience, however, was still a living part of the Mediterranean mentality, and many recently converted Christians retained some of the traditional values of the Greco-Roman world. This may account for those rare instances of freestanding Early Christian sculptures, such as the fourth-century statuettes representing Christ as the Good Shepherd (FIG. 8-8) or as a seated philosopher (FIG. 8-8A). As in Early

8-8A Christ seated, ca. 350-375.

Christian catacomb paintings (FIG. 8-6) and sarcophagi (FIG. 8-7), Christ is a long-haired young man dressed in a simple tunic. In the Good Shepherd statuette, he stands in a classical contrapposto stance with his right hip outthrust and his left leg bent. Several other marble statuettes of Christ bearing a sheep on his shoulders have been found, including one now in the Cleveland Museum of Art. It was part of a cache of sculptures from Turkey that included portraits and four marble statuettes illustrating episodes of the story of Jonah. Like the Good Shepherd statues, the Jonah figures are freestanding versions of the narrative scenes popular on Early Christian sarcophagi.

The Life of Jesus in Art

hristians believe Jesus of Nazareth is the son of God, the *Messiah* (Savior, *Christ*) of the Jews prophesied in the Hebrew scriptures. His life—his miraculous birth from the womb of a virgin mother, his preaching and miracle working, his execution by the Romans and subsequent ascent to Heaven—has been the subject of countless artworks from Roman times through the present day. The primary literary sources for these representations are the Gospels of the New Testament attributed to the four evangelists, Saints Matthew, Mark, Luke, and John (see "The Four Evangelists," Chapter 11, page 314); later apocryphal works; and medieval theologians' commentaries on these texts.

The life of Jesus dominated the subject matter of Christian art to a far greater extent than Greco-Roman religion and mythology ever did classical art. Whereas images of athletes, portraits of statesmen and philosophers, narratives of war and peace, genre scenes, and other secular subjects were staples of the classical tradition, Christian iconography held a near monopoly in the art of the Western world in the Middle Ages.

Although during certain periods artists rarely, if ever, depicted many of the events of Jesus' life, the cycle as a whole has been one of the most frequent subjects of Western art, even after the widespread revival of classical and secular themes during the Renaissance. Thus it is useful to summarize at the outset the entire cycle of events as they usually appear in artworks.

INCARNATION AND CHILDHOOD

The first "cycle" of the life of Jesus consists of the events of his conception (incarnation), birth, infancy, and childhood.

- **Annunciation to Mary.** The archangel Gabriel announces to the Virgin Mary that she will miraculously conceive and give birth to God's son Jesus. Artists sometimes indicated God's presence at the incarnation by a dove, the symbol of the Holy Spirit, the third "person" of the *Trinity* with God the Father and Jesus.
- Visitation. The pregnant Mary visits Elizabeth, her older cousin, who is pregnant with the future Saint John the Baptist. Elizabeth is the first to recognize that the baby Mary is bearing is the son of God, and they rejoice.
- Nativity, Annunciation to the Shepherds, and Adoration of the Shepherds. Jesus is born at night in Bethlehem and placed in a basket. Mary and her husband, Joseph, marvel at the newborn in a stable or, in Byzantine art, in a cave. An angel announces the birth of the Savior to shepherds in the field, who rush to adore the infant Jesus.
- Adoration of the Magi. A bright star alerts three wise men (magi) in the East that the king of the Jews has been born. They travel 12 days to find the holy family and present precious gifts to the infant Jesus.
- Presentation in the Temple. In accordance with Jewish tradition, Mary and Joseph bring their firstborn son to the temple in

Jerusalem, where the aged Simeon, who God said would not die until he had seen the Messiah, recognizes Jesus as the prophesied savior of humankind.

- Massacre of the Innocents and Flight into Egypt. King Herod, fearful a rival king has been born, orders the massacre of all infants in Bethlehem, but an angel warns the holy family and they escape to Egypt.
- *Dispute in the Temple.* Joseph and Mary travel to Jerusalem for the feast of *Passover* (the celebration of the release of the Jews from bondage to the pharaohs of Egypt). Jesus, only 12 years old at the time, engages in learned debate with astonished Jewish scholars in the temple, foretelling his ministry.

PUBLIC MINISTRY

The public-ministry cycle comprises the teachings of Jesus and the miracles he performed.

- **Baptism.** Jesus' public ministry begins with his baptism at age 30 by John the Baptist in the Jordan River, where the dove of the Holy Spirit appears and God's voice is heard proclaiming Jesus as his son.
- Calling of Matthew. Jesus summons Matthew, a tax collector, to follow him, and Matthew becomes one of his 12 disciples, or apostles (from the Greek for "messenger"), and later the author of one of the four Gospels of the New Testament.
- **Miracles.** In the course of his teaching and travels, Jesus performs many miracles, revealing his divine nature. These include acts of healing and raising the dead, turning water into wine, walking on water and calming storms, and creating wondrous quantities of food. In the miracle of loaves and fishes, for example, Jesus transforms a few loaves of bread and a handful of fishes into enough food to feed several thousand people.
- Delivery of the Keys to Peter. The fisherman Peter was one of the first men Jesus summoned as a disciple. Jesus chooses Peter (whose name means "rock") as his successor. He declares Peter is the rock on which his church will be built, and symbolically delivers to Peter the keys to the kingdom of Heaven.
- Transfiguration. Jesus scales a high mountain and, in the presence of Peter and two other disciples, James and John the Evangelist, transforms into radiant light. God, speaking from a cloud, discloses Jesus is his son.
- Cleansing of the Temple. Jesus returns to Jerusalem, where he finds money changers and merchants conducting business in the temple. He rebukes them and drives them out of the sacred precinct.

PASSION

The passion (from Latin *passio*, "suffering") cycle includes the episodes leading to Jesus' trial, execution, resurrection, and ascent to Heaven.

- Entry into Jerusalem. On the Sunday before his crucifixion (Palm Sunday), Jesus rides into Jerusalem on a donkey, accompanied by disciples. Crowds of people enthusiastically greet Jesus and place palm fronds in his path.
- **Last Supper and Washing of the Disciples' Feet.** In Jerusalem, Jesus celebrates Passover with his disciples. During this last supper, Jesus foretells his imminent betrayal, arrest, and death and invites the disciples to remember him when they eat unleavened bread (symbol of his body) and drink wine (his blood). This ritual became the celebration of *Mass (Eucharist)* in Christian liturgy. At the same meal, Jesus sets an example of humility for his apostles by washing their feet.
- Agony in the Garden. Jesus goes to the Mount of Olives in the Garden of Gethsemane, where he struggles to overcome his human fear of death by praying for divine strength. The apostles who accompanied him there fall asleep despite his request they stay awake with him while he prays.
- **Betrayal and Arrest.** One of the disciples, Judas Iscariot, agrees to betray Jesus to the Jewish authorities in return for 30 pieces of silver. Judas leads the soldiers to Jesus and identifies the "king of the Jews" by kissing him, whereupon the soldiers arrest Jesus. Later, a remorseful Judas hangs himself from a tree.
- leaves before Caiaphas, the Jewish high priest, who interrogates Jesus about his claim to be the Messiah. Meanwhile, the disciple Peter thrice denies knowing Jesus, as Jesus predicted he would. Jesus is then brought before the Roman governor of Judaea, Pontius Pilate, on the charge of treason because he had proclaimed himself as the Jews' king. Pilate asks the crowd to choose between freeing Jesus or Barabbas, a murderer. The people choose Barabbas, and the judge condemns Jesus to death. Pilate then washes his hands, symbolically relieving himself of responsibility for the mob's decision.
- Flagellation and Mocking. The Roman soldiers who hold Jesus captive tie him up, whip (flagellate) him, and mock him by dressing him as king of the Jews and placing a crown of thorns on his head.
- Carrying of the Cross, Raising of the Cross, and Crucifixion. The Romans force Jesus to carry the cross on which he will be crucified from Jerusalem to Mount Calvary (Golgotha, the "place of

- the skull," Adam's burial place). Jesus falls three times, and his robe is stripped along the way. Soldiers erect the cross—often labeled in art *INRI* (the initial letters of "Jesus of Nazareth, King of the Jews" in Latin)—and nail his hands and feet to it. Jesus' mother, John the Evangelist, and Mary Magdalene mourn at the foot of the cross, while the Roman soldiers torment Jesus. One of them (the centurion Longinus) stabs Jesus in the side with a spear. After suffering great pain, Jesus dies. The crucifixion occurred on a Friday, and Christians celebrate the day each year as Good Friday.
- **Deposition, Lamentation, and Entombment.** Two disciples, Joseph of Arimathea and Nicodemus, remove Jesus' body from the cross (the deposition). Sometimes those present at the crucifixion look on. His mother and his followers take Jesus to the tomb Joseph had purchased for himself, and Joseph, Nicodemus, the Virgin Mary, Saint John the Evangelist, and Mary Magdalene mourn over the dead Jesus (the lamentation). (When in art the isolated figure of the Virgin Mary cradles her dead son in her lap, it is called a *Pietà*—Italian for "pity.") In portrayals of the entombment, his followers lower Jesus into a sarcophagus in the tomb.
- Descent into Limbo. During the three days he spends in the tomb, Jesus (after death, Christ) descends into Hell, or Limbo, and triumphantly frees the souls of the righteous, including Adam, Eve, Moses, David, Solomon, and John the Baptist. In Byzantine art, the label Anastasis (Greek, "resurrection") often identifies this episode, although the event precedes Christ's emergence from the tomb and reappearance on earth.
- Resurrection and Three Marys at the Tomb. On the third day after his burial (Easter Sunday), Christ rises from the dead and leaves the tomb while the Roman guards sleep. The Virgin Mary, Mary Magdalene, and Mary, the mother of James, visit the tomb but find it empty. An angel informs them Christ has been resurrected.
- Noli Me Tangere, Supper at Emmaus, and Doubting of Thomas. During the 40 days between Christ's resurrection and his ascent to Heaven, he appears on several occasions to his followers. When he encounters Mary Magdalene weeping at his tomb, Christ warns her with the words "Don't touch me" (Noli me tangere in Latin), but he tells her to inform the apostles of his return. At Emmaus he eats supper with two of his astonished disciples. Later, Christ invites Thomas, who cannot believe Jesus has risen, to touch the wound in his side that he received at his crucifixion.
- **Ascension.** On the 40th day, on the Mount of Olives, with his mother and apostles as witnesses, Christ gloriously ascends to Heaven in a cloud.

ARCHITECTURE AND MOSAICS

Although the Christians conducted some ceremonies in the catacombs, regular services took place in private community houses of the type found at Dura-Europos (FIG. 8-5). Once Christianity achieved imperial sponsorship under Constantine, an urgent need suddenly arose to construct churches. The new buildings had to meet the requirements of Christian *liturgy* (the official ritual of public worship), provide a suitably monumental setting for the celebration of the Christian faith, and accommodate the rapidly growing numbers of worshipers.

Constantine believed the Christian god had guided him to victory over Maxentius, and in lifelong gratitude he protected and advanced Christianity throughout the Empire. As emperor, he was, of course, obliged to safeguard the ancient Roman religion, traditions, and monuments, and he was (for his time) a builder on a grand scale in the heart of the city (FIGS. 7-75 and 7-78). But Constantine, eager to provide buildings to house the Christian rituals

and venerated burial places, especially the memorials of founding saints, also was the first major patron of Christian architecture. He constructed elaborate basilicas, memorials, and mausoleums not only in Rome but also in Constantinople, his "New Rome" in the East, and at sites sacred to Christianity, most notably Bethlehem, the birthplace of Jesus, and Jerusalem, the site of the crucifixion.

Rome

The major Constantinian churches in Rome stood on sites associated with the graves of Christian martyrs, which, in keeping with Roman burial practice, were all on the city's outskirts. The decision to erect churches at those sites also enabled Constantine to keep the new Christian shrines out of the city center and avoid any confrontation between Rome's Christians and those who continued to worship the old gods.

OLD SAINT PETER'S The greatest of Constantine's churches in Rome was Old Saint Peter's (FIG. 8-9), probably begun as early as 319. The present-day church (FIGS. 24-3 and 24-4), one of the master-

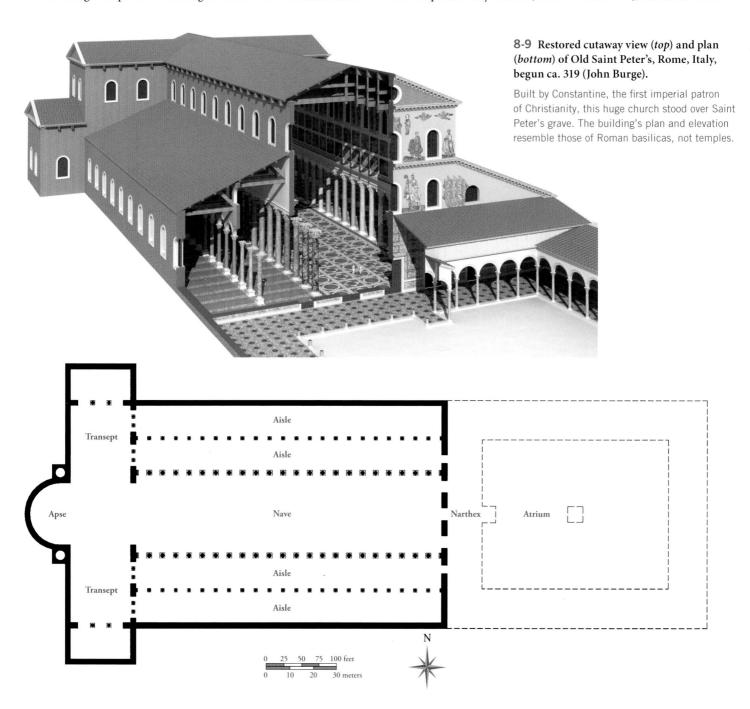

pieces of Italian Renaissance and Baroque architecture, is a replacement for the Constantinian structure. Old Saint Peter's stood on the western side of the Tiber River on a terrace on the irregular slope of the Vatican Hill over the ancient cemetery in which Constantine and Pope Sylvester (r. 314-335) believed Peter, the founder of the Christian community in Rome, had been buried. Excavations in the Roman cemetery beneath the church have in fact revealed a secondcentury memorial erected in honor of the Christian martyr at his reputed grave. Capable of housing 3,000 to 4,000 worshipers at one time, the immense church enshrined Peter's tomb, one of the most hallowed sites in Christendom, second only to the Holy Sepulcher in Jerusalem, the site of Christ's resurrection. The project also fulfilled the figurative words of Christ himself, when he said, "Thou art Peter, and upon this rock I will build my church" (Matt. 16:18). Peter was Rome's first bishop and the head of the long line of popes extending to the present.

The plan and elevation (FIG. 8-9) of Old Saint Peter's resemble those of Roman basilicas and audience halls, such as the Basilica Ulpia (FIG. 7-44, no. 4) in the Forum of Trajan and Constantine's own Aula Palatina (FIGS. 7-79 and 7-80) at Trier, rather than the design of any Greco-Roman temple. The Christians, understandably, did not want their houses of worship to mimic the form of polytheistic shrines, but practical considerations also contributed to their shunning the classical temple type. Greco-Roman temples housed only the cult statue of the deity. All rituals took place outside at open-air altars. Therefore, architects would have found it difficult to adapt the classical temple as a building accommodating large numbers of people within it. The Roman basilica, in contrast, was ideally suited as a place for congregation.

Like most Roman basilicas, Old Saint Peter's had a wide central *nave* (FIG. 8-9, *bottom*) with flanking *aisles* and an *apse* at the end. But unlike Roman basilicas, which sometimes had doorways on one long side opening onto an aisle (FIG. 7-44, no. 4), Early Christian basilicas all had a pronounced *longitudinal* axis. Worshipers entered the basilica through a *narthex*, or vestibule. When they emerged in Saint Peter's 300-foot-long nave, they had an unobstructed view of the altar in the apse, framed by the *chancel arch* dividing the nave from the transept. The *transept*, or transverse

aisle, an area perpendicular to the nave between the nave and apse, was a special feature of this Constantinian church. It housed Saint Peter's *relics*, which attracted hordes of pilgrims. (Relics are body parts, clothing, or objects associated with a saint or Christ himself; see "The Veneration of Relics," Chapter 12, page 336.) The transept became a standard element of church design in the West only much later, when it also took on, with the nave and apse, the symbolism of the Christian cross. Saint Peter's basilica also had a colonnaded courtyard in front of the narthex, very much like the forum proper in the Forum of Trajan (FIG. 7-44, no. 5) but called an *atrium*, like the central room in a Roman private house (FIG. 7-15).

Compared with Roman temples, which usually displayed statuary in pediments on their facades, most Early Christian basilicas were quite austere on the exterior. Inside, however, were frescoes and mosaics, marble columns (taken from older Roman buildings, as was customary at the time), and costly ornaments. The *Liber pontificalis*, or *Book of the Pontiffs (Popes)*, compiled by an anonymous sixth-century author, lists Constantine's gifts to Old Saint Peter's. They included altars, chandeliers, candlesticks, pitchers, goblets, and plates fashioned of gold and silver and sometimes embellished with jewels and pearls, as well as jeweled altar cloths for use in the Mass and gold foil to sheathe the vault of the apse. A huge marble *baldacchino* (domical canopy over an altar), supported by four spiral porphyry columns, marked the spot of Saint Peter's tomb.

SANTA SABINA Some idea of the character of the timber-roofed interior of Old Saint Peter's can be gleaned from the interior (FIG. 8-10) of Santa Sabina in Rome. Santa Sabina, built a century later, is a basilican church of much more modest proportions than Constantine's immense Vatican basilica, but it still retains its Early Christian character, as well as its original carved wooden doors (FIG. 8-10A). The Corinthian columns of its nave *arcade* produce a steady rhythm that focuses all attention on the

8-10A West doors, Santa Sabina, Rome, ca. 432.

chancel arch and the apse, which frame the altar. In Santa Sabina, as in Old Saint Peter's, light drenched the nave from the *clerestory*

windows piercing the thin upper wall beneath the timber roof. The same light would have illuminated the frescoes and mosaics that commonly adorned the nave and apse of Early Christian churches. Outside, Santa Sabina has plain brick walls. They closely resemble the exterior of Trier's Aula Palatina (FIG. 7-79).

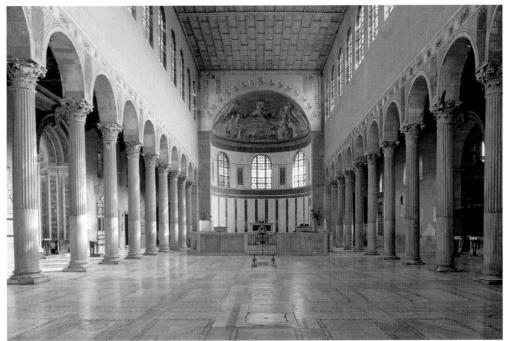

8-10 Interior of Santa Sabina (looking northeast), Rome, Italy, 422–432. ■

Santa Sabina and other Early Christian basilican churches were timber-roofed and illuminated by clerestory windows. The nave arcade focused attention on the apse, which framed the altar.

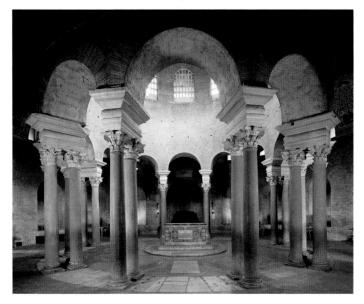

8-11 Interior of Santa Costanza (looking southwest), Rome, Italy, ca. 337–351. ■◀

Possibly built as the mausoleum of Constantine's daughter, Santa Costanza later became a church. Its central plan, featuring a domed interior, would become the preferred form for Byzantine churches.

SANTA COSTANZA The rectangular basilican church design was long the favorite of the Western Christian world. But Early Christian architects also adopted another classical architectural type: the *central-plan* building, in which the parts are of equal or almost equal dimensions around the center. Roman central-plan buildings were usually round or polygonal domed structures. Byzantine architects developed this form to monumental proportions and amplified its theme in numerous ingenious variations (see Chapter 9). In the West, builders generally used the central plan for structures adjacent to the main basilicas, such as mausoleums, baptisteries, and private chapels, rather than for churches, as in the East.

A highly refined example of the central-plan design is Santa Costanza (FIGS. **8-11** and **8-12**), built on the northern outskirts of

Rome in the mid-fourth century, possibly as the mausoleum for Constantina, the emperor Constantine's daughter. Recent excavations have called the traditional identification into question, but the building housed Constantina's monumental porphyry sarcophagus, even if the structure was not originally her tomb. The mausoleum, later converted into a church, stood next to the basilican church of Saint Agnes, who was buried in a nearby catacomb. Santa Costanza's antecedents are traceable to the tholos

8-13 Detail of the mosaic in the ambulatory vault of Santa Costanza, Rome, Italy, ca. 337–351. ■

The ambulatory mosaics of Santa Costanza depict putti harvesting grapes and making wine, motifs associated with Bacchus, but for a Christian, the scenes evoked the Eucharist and Christ's blood.

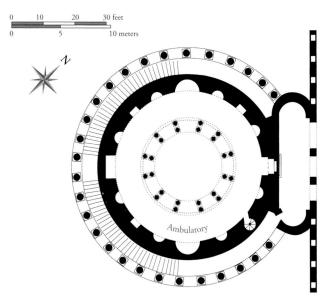

8-12 Plan of Santa Costanza, Rome, Italy, ca. 337-351.

Santa Costanza has antecedents in the domed temples (Fig. 7-51) and mausoleums (Fig. 7-74) of the Romans, but its plan, with 12 pairs of columns and a vaulted ambulatory, is unique.

tombs (FIGS. 4-20 and 4-21) of the Mycenaeans, but its immediate predecessors were the domed structures of the Romans, such as the Pantheon (FIGS. 7-49 to 7-51) and especially imperial mausoleums such as Diocletian's (FIG. 7-74, *right*) at Split. At Santa Costanza, the architect modified the interior design of those Roman buildings to accommodate an *ambulatory*, a ringlike barrel-vaulted corridor separated from the central domed cylinder by a dozen pairs of columns.

Like most Early Christian basilicas, Santa Costanza has a severe brick exterior. Its interior was once richly adorned with mosaics, although most are lost. Old and New Testament themes appeared side by side, as in the catacombs and on Early Christian sarcophagi. The Santa Costanza mosaic program, however, also included subjects

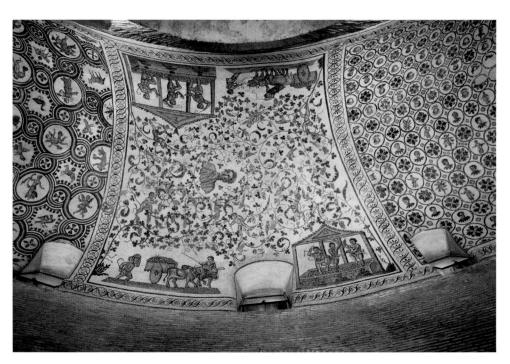

Mosaics

s an art form, mosaic had a rather simple and utilitarian beginning, seemingly invented primarily to provide an inexpensive and durable flooring. Originally, mosaicists set small beach pebbles, unaltered from their natural form and color, into a thick coat of cement. Artisans soon discovered, however, that the stones could be arranged in decorative patterns. At first, these pebble mosaics were uncomplicated and confined to geometric shapes. Generally, the artists used only black and white stones. Examples of this type, dating to the eighth century BCE, have been found at Gordion in Asia Minor. Eventually, artists arranged the stones to form more complex pictorial designs, and by the fourth century BCE the technique had developed to a high level of sophistication. Mosaicists depicted elaborate figural scenes using a broad range of colors red, yellow, and brown in addition to black, white, and gray-and shaded the figures, clothing, and setting to suggest volume. Thin strips of lead provided linear definition (FIG. 5-68).

By the middle of the third century BCE, artists had invented a new kind of mosaic that enabled the best mosaicists to create designs more closely approximating true paintings. The new technique employed *tesserae* (Latin for "cubes" or "dice"). These tiny cut stones gave artists much greater flexibility because they could adjust the size and shape of the tesserae, eliminating the need for lead strips to indicate contours and interior details. More gradual gradations of color also became possible (FIG. 5-70), and mosaicists finally could aspire to rival the achievements of painters.

In Early Christian mosaics (FIGS. 8-13, 8-13A, 8-14, and 8-16 to 8-19A), the tesserae are usually made of glass, which reflects light and makes the surfaces sparkle. Ancient mosaicists occasionally used glass tesserae, but the Romans preferred opaque marble pieces. Mosaics quickly became the standard means of decorating walls and vaults in Early Christian buildings, although mural paintings were also popular. The mosaics caught the light flooding through the windows in vibrant reflection, producing sharp contrasts and concentrations of color that could focus attention on a composition's central, most relevant features. Early Christian mosaics were not meant to incorporate the subtle tonal changes a naturalistic painter's

approach would require. Artists "placed," rather than blended, colors. Bright, hard, glittering texture, set within a rigorously simplified pattern, became the rule. For mosaics situated high in an apse or ambulatory vault or over the nave colonnade, far above the observer's head, the painstaking use of tiny tesserae seen in Roman floor and wall mosaics (FIGS. 5-70 and 7-24) would be meaningless. Early Christian mosaics, designed to be seen from a distance, employed larger tesserae. The mosaicists also set the tesserae unevenly so that their surfaces could catch and reflect the light. Artists favored simple designs for optimal legibility. For several centuries, mosaic, in the service of Christian theology, was the medium of some of the supreme masterpieces of medieval art.

8-14 *The Parting of Abraham and Lot*, mosaic in the nave of Santa Maria Maggiore, Rome, Italy, 432–440.

In this Early Christian glass-tessera mosaic depicting *The Parting of Abraham and Lot*, the artist included the yet-unborn Isaac because of his importance as a prefiguration of Christ.

8-13A Christ as Sol Invictus, late third century.

common in Roman funerary art, although they were susceptible to a Christian interpretation. In one section (FIG. 8-13) of the mosaic in the ambulatory vault, for example, are scenes of putti harvesting grapes and making wine. (Similar scenes decorate Constantina's sarcophagus.) A portrait bust is at the center of a rich vine scroll. A second bust appears in another section of the mosaic vault, but both are heavily restored, and the identification of

the pair as Constantina and her husband is uncertain. In the Roman world, wine was primarily associated with Bacchus, but for a Christian, the vineyards brought to mind the wine of the Eucharist and the blood of Christ. Already in the third century, however, mosaics of explicitly Christian content had been used in tombs, for example, in the Mausoleum of the Julii (FIG. 8-13A) in the ancient cemetery beneath Saint Peter's in Rome.

SANTA MARIA MAGGIORE Mosaic decoration (see "Mosaics," above) played an important role in the interiors of Early Christian buildings of all types. In churches, mosaics not only provided a beautiful setting for the Christian liturgy, but also were vehicles for instructing the congregation about biblical stories and Christian dogma. Old Testament themes are the focus of the extensive fifth-century mosaic cycle in the nave of the basilican church of Santa Maria Maggiore in Rome, the first major church in the West dedicated to the Virgin Mary. Construction of the church began in 432, the year after the Council of Ephesus officially designated Mary as the Mother of God (*Theotokos*, "bearer of god" in Greek). The council, convened to debate whether Mary had given birth to the man Jesus or to God as man, ruled that the divine and human coexisted in Christ and that Mary was indeed the Mother of God.

One mosaic panel (FIG. 8-14) dramatically represents *The Parting of Abraham and Lot*, as set forth in Genesis, the Bible's opening book. Agreeing to disagree, Abraham's nephew Lot leads his

family and followers to the right, toward the city of Sodom, while Abraham heads for Canaan, moving toward a basilica-like building (perhaps symbolizing the Church) on the left. Lot's is the evil choice, and the instruments of the evil (his two daughters) stand in front of him. The figure of the yet-unborn Isaac, the instrument of good (and, as noted earlier, a prefiguration of Christ), stands before his father, Abraham.

The cleavage of the two groups is emphatic, and the mosaicist represented each group using a shorthand device called a head cluster, which had precedents in antiquity and a long history in Christian art. The figures engage in a sharp dialogue of glance and gesture. The wide eyes turn in their sockets, and the enlarged hands make broad gestures. This kind of simplified motion, which is characteristic of Late Antique narrative art of Roman, Jewish, and Christian subject matter alike, has great power to communicate without ambiguity. But the Abraham and Lot mosaic also reveals the heritage of classical art. The town in the background of the Abraham and Lot mosaic would not be out of place in a Roman mural (FIG. 7-19, left) or on the Column of Trajan (FIG. 7-1), and the figures themselves are modeled in light and dark, cast shadows, and still loom with massive solidity. Another century had to pass before Western Christian mosaicists portrayed figures as flat images, rather than as three-dimensional bodies, finally rejecting the norms of classical art in favor of a style better suited for a focus on the spiritual instead of the natural world. Early Christian art, like Late Antique Roman art in general, vacillates between these two stylistic poles.

Ravenna

In the decades after the 324 founding of Constantinople, the New Rome in the East, and the death of Constantine in 337, the pace of Christianization of the Roman Empire quickened. In 380 the emperor Theodosius I (r. 379–395) issued an edict finally establishing Christianity as the state religion. In 391 he enacted a ban against worship of the old Roman gods, and in 394 he abolished the Olympic Games, the enduring symbol of the classical world and its values.

Theodosius died in 395, and imperial power passed to his two sons, Arcadius (r. 395–408), who became Emperor of the East, and

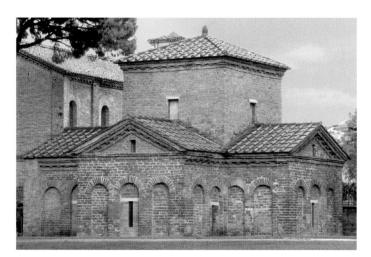

8-15 Mausoleum of Galla Placidia, Ravenna, Italy, ca. 425.

This cruciform chapel with a domed crossing is an early example of the combination of central and longitudinal plans. The unadorned brick shell encloses a rich ensemble of mosaics.

Honorius (r. 395–423), Emperor of the West. In 404, when the Visigoths, under their king, Alaric (r. 395–410), threatened to overrun Italy from the northwest, Honorius moved his capital from Milan to Ravenna, an ancient Roman city (perhaps founded by the Etruscans) near Italy's Adriatic coast, some 80 miles south of Venice. In 410, Alaric captured Rome, and in 476, Ravenna fell to Odoacer (r. 476–493), the first Germanic king of Italy. Odoacer was overthrown in turn by Theodoric (r. 471–526), king of the Ostrogoths, who established his capital at Ravenna in 493. Ravenna fell to the Byzantine emperor Justinian in 539, and the subsequent history of the city belongs with that of Byzantium (see Chapter 9).

MAUSOLEUM OF GALLA PLACIDIA The so-called Mausoleum of Galla Placidia, Honorius's half-sister, is a rather small cruciform (cross-shaped) structure (FIG. 8-15) with barrel-vaulted arms and a tower at the crossing. Built shortly after 425, almost a quarter century before Galla Placidia's death in 450, it was probably originally a chapel to the martyred Saint Lawrence. The building was once thought to be Galla Placidia's tomb, however, hence its name today. The chapel adjoined the narthex of the now greatly altered palace-church of Santa Croce (Holy Cross), which was also cruciform in plan. The chapel's cross arms are of unequal length, so that the building has a longitudinal orientation, unlike the centrally planned Santa Costanza (FIGS. 8-11 and 8-12), but because all four arms are very short, the emphasis is on the tall crossing tower with

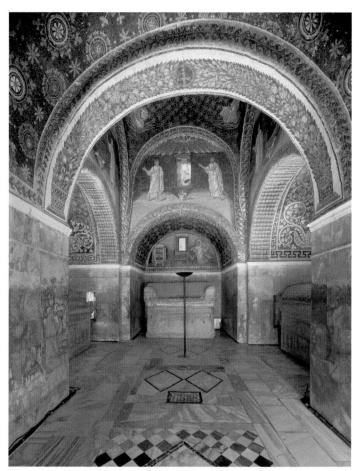

8-16 Interior of the Mausoleum of Galla Placidia, Ravenna, Italy, ca. 425.

Before Late Antiquity, mosaics were usually confined to floors. Inside the so-called Mausoleum of Galla Placidia, mosaics cover every square inch of the interior above the marble-faced walls.

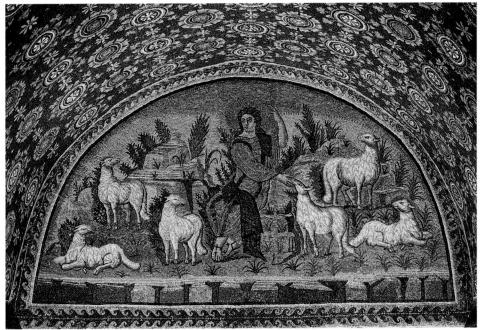

its vault resembling a dome. This small, unassuming building thus represents one of the earliest successful fusions of the two basic Late Antique plans—the longitudinal, used for basilican churches, and the central, used primarily for baptisteries and mausoleums. It in-

troduced, on a small scale, a building type that was to have a long

history in church architecture: the longitudinally planned building

with a vaulted or domed crossing.

The chapel's unadorned brick shell encloses one of the richest mosaic ensembles (FIG. 8-16) in Early Christian art. Mosaics cover every square inch of the interior surfaces above the marble-faced walls. Garlands and decorative medallions resembling snowflakes on a dark blue ground adorn the barrel vaults of the nave and cross arms. The tower has a large golden cross set against a star-studded sky. Representations of saints and apostles cover the other surfaces. At the end of the nave is a mosaic representing Saint Lawrence next to the gridiron on which he was tortured. The martyred saint car-

ries a cross, suggesting faith in Christ led to his salvation.

8-17 Christ as Good Shepherd, mosaic from the entrance wall of the Mausoleum of Galla Placidia, Ravenna, Italy, ca. 425. ■

Jesus sits among his flock, haloed and robed in gold and purple. The landscape and the figures, with their cast shadows, are the work of a mosaicist still rooted in the naturalistic classical tradition.

Christ as Good Shepherd is the subject of the lunette (FIG. 8-17) above the entrance. No earlier version of the Good Shepherd is as regal as this one. Instead of carrying a lamb on his shoulders (FIGS. 8-6 to 8-8), Jesus sits among his flock, haloed and robed in gold and purple. To his left and right, the sheep are distributed evenly in groups of three. But their arrangement is rather loose and informal, and they occupy a carefully described landscape extending from foreground to background beneath a blue sky. As at Santa Maria Maggiore (FIG. 8-14), all

the forms have three-dimensional bulk and are still deeply rooted in the classical tradition.

SANT'APOLLINARE NUOVO Ravenna is famous for its treasure trove of Early Christian and Byzantine mosaics. About 30 years later than the Galla Placidia mosaics are those of Raven-

na's Orthodox Baptistery (FIG. 8-17A). An especially large cycle of mosaics adorns the palace-church Theodoric built in 504, soon after he settled in Ravenna. A three-aisled basilica originally dedicated to "Our Lord Jesus Christ," the church was rededicated in the ninth century as Sant'Apollinare Nuovo, when it acquired the relics of Saint Apollinaris. The rich mosaic decoration of the nave walls (FIG. 8-18) fills three zones. Only the upper two date from Theodoric's time. Hebrew patriarchs

8-17A Orthodox Baptistery, Ravenna, ca. 458.

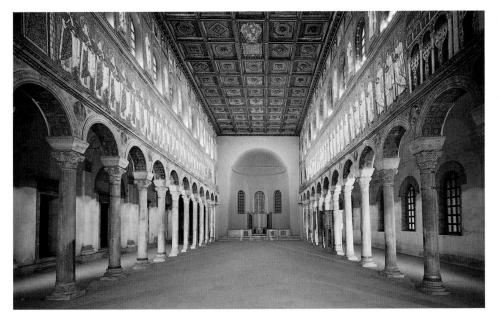

8-18 Interior of Sant'Apollinare Nuovo (looking east), Ravenna, Italy, dedicated 504. ■4

Theodoric, king of the Ostrogoths, established his capital at Ravenna in 493. His palace-church features an extensive series of mosaics depicting Hebrew prophets and scenes from the life of Christ.

8-19 Miracle of the Loaves and Fishes, mosaic from the top register of the nave wall (above the clerestory windows in FIG. 8-18) of Sant'Apollinare Nuovo, Ravenna, Italy, ca. 504.

In contrast to Fig. 8-17, Jesus here faces directly toward the viewer. Blue sky has given way to the otherworldly splendor of heavenly gold, the standard background color for medieval mosaics.

and prophets stand between the clerestory windows. Above them, scenes from Christ's life alternate with decorative panels.

The Miracle of the Loaves and Fishes mosaic (FIG. 8-19) stands in sharp contrast to the 80-year-earlier mosaics of the Mausoleum of Galla Placidia. Jesus, beardless, in the imperial dress of gold and purple, and now distinguished by the cross-inscribed nimbus (halo) that signifies his divinity, faces directly toward the viewer. With extended arms he directs his disciples to distribute to the great crowd the miraculously increased supply of bread and fish he has produced. The mosaicist told the story with the least number of figures necessary to make its meaning

explicit, aligning the figures laterally, moving them close to the foreground, and placing them in a shallow picture box. The composition, so different from those in the lunettes of the Mausoleum of Galla Placidia, is similar to that of the Samuel and David mural (FIG. 8-3) in the Dura-Europos synagogue two and a half centuries earlier as well as

8-19A Hagios Georgios, Thessaloniki, ca. 390-450.

the late-fourth-century mosaics (FIG. 8-19A) in Hagios Georgios in Thessaloniki, Greece, illustrating once again that Early Christian artists inherited both classical naturalism and Late Antique abstraction from Roman art. But the Sant'Apollinare Nuovo mosaic, like those in Hagios Georgios, differs from the Dura murals as well as the Galla Placidia mosaics in having a golden background,

which lifts the mosaic out of time and space and emphasizes the spiritual over the physical. The landscape setting, which the artist who decorated the Mausoleum of Galla Placidia so explicitly described (FIG. 8-17), is here merely a few rocks and bushes enclosing the figure group like parentheses. The blue sky of the physical world has given way to the otherworldly splendor of heavenly gold. The ethereal golden background as well as the weightless figures with their flat, curtainlike garments would soon become the norm in Byzantine art, although even in Byzantium echoes of classical naturalism persisted (see Chapter 9).

LUXURY ARTS

Throughout history, artists have produced so-called "minor arts"—jewelry, metalwork, cameos, ivories, among other crafts—alongside the "major arts" of sculpture and painting. Although the terminology seems to suggest a difference in importance or quality, "minor" refers only to size. Indeed, the artists who fashioned jewelry, carved ivories and cameos, and produced gold and silver vessels by casting or hammering (repoussé) employed the costliest materials known. Some of them, for example, Dioscurides, official gem cutter of the emperor Augustus, are among the few Roman artists whose names survive. In Late Antiquity and the Middle Ages, the minor arts—

more appropriately called "luxury arts"—enjoyed high status, and they figure prominently in the history of art through the ages.

Illuminated Manuscripts

Although few examples survive, illustrated books were common in public and private libraries in the ancient world. The long tradition of placing pictures in manuscripts began in pharaonic Egypt (FIG. 3-37) and continued in Greek and Roman times.

VATICAN VERGIL The oldest preserved painted Greek or Latin manuscript is the Vatican Vergil, which dates from the early fifth century and is among the earliest preserved illustrated medieval books (see "Medieval Manuscript Illumination," page 249). It originally contained more than 200 pictures illustrating all of Vergil's works. Today, only 50 painted folios (leaves or pages) of the Aeneid and Georgics survive. The manuscript is important not only because of its age. The Vatican Vergil is a prime example of traditional Roman iconography and of the classical style long after Theodosius banned worship of the old gods.

The page illustrated here (FIG. 8-20) includes a section of text from the *Georgics* at the top and a framed illustration below. Vergil recounts his visit to a modest farm near Taranto in southern Italy belonging to an old man from Corycus in Asia Minor. In the illustration, the old farmer sits at the left. His rustic farmhouse is in the background, rendered in three-quarter view. The farmer speaks about the pleasures of the simple life in the country—a recurrent theme in Latin poetry—and on his methods of gardening. His audience is two laborers and, at the far right, Vergil himself in the guise of a farmhand. The style is reminiscent of Pompeian landscapes, with quick touches that suggest space and atmosphere. In fact, the heavy, dark frame has close parallels in the late Pompeian styles of mural painting (FIG. 7-22).

VIENNA GENESIS The oldest well-preserved painted manuscript containing biblical scenes is the early-sixth-century *Vienna Genesis*, so called because of its present location. The book is sumptuous. The pages are fine calfskin dyed with rich purple, the same dye used to give imperial cloth its distinctive color. The Greek text is in silver ink.

Medieval Manuscript Illumination

are as medieval books are, they are far more numerous than their ancient predecessors. An important invention during the Early Roman Empire was the codex, which greatly aided the dissemination of manuscripts as well as their preservation. A codex is much like a modern book, composed of separate leaves (folios) enclosed within a cover and bound together at one side. The new format superseded the long manuscript scroll (rotulus) of the Egyptians, Greeks, Etruscans, and Romans. (The Etruscan magistrate Lars Pulena, FIG. 6-15; the philosophers on Roman and Early Christian sarcophagi, FIGS. 7-71 and 8-7; and Christ himself in his role as teacher, FIGS. 8-1 and 8-8A, all hold rotuli in their hands.) Much more durable vellum (calfskin) and parchment (lambskin), which provided better surfaces for painting, also replaced the comparatively brittle papyrus used for ancient scrolls. As a result, luxuriousness of ornamentation became increasingly typical of sacred books in the Middle Ages, and at times the material beauty of the pages

and their illustrations overwhelm or usurp the spiritual beauty of the text. Art historians refer to the luxurious painted books produced before the invention of the printing press as *illuminated manuscripts*, from the Latin *illuminare*, meaning "to adorn, ornament, or brighten." The oldest preserved examples (FIGS. 8-20 to 8-22) date to the fifth and sixth centuries.

Illuminated books were costly to produce and involved many steps. Numerous artisans performed very specialized tasks, beginning with the curing and cutting (and sometimes the dyeing; FIGS. 8-21, 8-21A, and 8-22) of the animal skin, followed by the sketching of lines to guide the scribe and to set aside spaces for illumination, the lettering of the text, the addition of paintings, and finally the binding of the pages and attachment of covers, buckles, and clasps. The covers could be even more sumptuous than the book itself. Many preserved covers are fashioned of gold and decorated with jewels, ivory carvings, and repoussé reliefs (FIG. 11-16).

8-20 Old Farmer of Corycus, folio 7 verso of the Vatican Vergil, ca. 400–420. Tempera on parchment, $1'\frac{1''}{2}\times 1'$. Biblioteca Apostolica Vaticana, Rome.

The earliest surviving painted Latin manuscript is a collection of the poet Vergil's works. This page includes part of the text of the *Georgics* and a pastoral scene reminiscent of Roman landscape murals.

8-21 Rebecca and Eliezer at the Well, folio 7 recto of the Vienna Genesis, early sixth century. Tempera, gold, and silver on purple vellum, $1^{'}\frac{1}{4''}\times 9\frac{1}{4''}$. Österreichische Nationalbibliothek, Vienna.

This sumptuously painted book of Genesis is the oldest well-preserved manuscript containing biblical scenes. Two episodes of the Rebecca story appear in a single setting filled with classical motifs.

Folio 7 (FIG. 8-21) of the *Vienna Genesis* illustrates *Rebecca* and Eliezer at the Well (Gen. 24:15–61). When Isaac, Abraham's son, was 40 years old, his parents sent their servant Eliezer to find a wife for him. Eliezer chose Rebecca, because when he stopped at a well, she was the first woman to draw water for him and his camels. As elsewhere in the manuscript (FIG. 8-21A), the painter presented

more than one episode of the story within a single frame, employing an ancient manner of pictorial storytelling called *continuous narration* (compare Fig. 7-44A). In the first episode, at the left, Rebecca leaves the city of Nahor to fetch water from the well.

8-21A Story of Jacob, Vienna Genesis, early sixth century.

8-22 *Christ before Pilate*, folio 8 verso of the *Rossano Gospels*, early sixth century. Tempera on purple vellum, $11'' \times 10^{\frac{1}{4}''}$. Museo Diocesano d'Arte Sacra, Rossano.

The sources for medieval manuscript illustrations were diverse. The way the people form an arch around Pilate on this page suggests the composition derives from a painting in an apse.

In the second episode, she offers water to Eliezer and his camels, while one of them already laps water from the well. The artist painted Nahor as a walled city seen from above, like the cityscapes in the Santa Maria Maggiore mosaics (FIG. 8-14), the Column of Trajan (FIG. 7-1), and innumerable earlier Roman representations of cities in painting and relief sculpture. Rebecca walks to the well along the colonnaded avenue of a Roman city. A seminude female personification of a spring is the source of the well water. These are further reminders of the persistence of classical motifs and stylistic modes in Early Christian art.

Contemporaneous with, but radically different from, the mosaic panels (FIG. 8-19) of Sant'Apollinare Nuovo, the *Vienna Genesis* incorporates many anecdotal details, such as the drinking camel and Rebecca bracing herself with her raised left foot on the rim of the well as she tips up her jug for Eliezer. Nonetheless, the illuminator placed the figures in a blank landscape except for the miniature city and the road to the well. As at Ravenna, only those elements necessary to tell the story and set the scene are present, nothing else.

ROSSANO GOSPELS Closely related to the Vienna Genesis is another early-sixth-century Greek manuscript, the Rossano Gospels, the earliest preserved illuminated book containing illustrations of the New Testament. By this time a canon of New Testament iconography had been fairly well established. As in the Vienna Genesis, the text of the Rossano Gospels is in silver ink on purple-dyed vellum. The Rossano artist, however, attempted with considerable success to harmonize the colors with the purple

background. The subject of folio 8 (FIG. 8-22) is the appearance of Jesus before Pilate, who asks the Jews to choose between Jesus and Barabbas (Matt. 27:2-26). The vividly gesturing figures are on two levels separated by a simple ground line, which not only separates the figures spatially but also temporally. In the upper level, Pilate presides over the tribunal. He sits indoors on an elevated dais, following a long-established pattern in Roman art (FIG. 7-76). The people form an arch around Pilate. (The artist may have based the composition on a painting in an apse—an appropriate setting for a seated magistrate.) They demand the death of Jesus, while a court scribe records the proceedings. Below, and outdoors, are Jesus (here a bearded adult, as soon became the norm for medieval and later depictions of Christ; compare FIG. 8-6A) and the bound Barabbas. The painter explicitly labeled Barabbas to avoid any possible confusion and make the picture as readable as the text. Neither the haloed Christ nor Pilate on his magistrate's dais, flanked by painted imperial portraits, needed any further identification.

Metalwork

Especially prized in antiquity and throughout the Middle Ages were items of tableware fashioned out of precious metals, for example, the gold Achaemenid rhyton (FIG. 2-26A) from Hamadan and the Mycenaean drinking cups (FIG. 4-23A) from Vapheio, discussed earlier.

MILDENHALL TREASURE In 1942, a farmer plowing his fields near Mildenhall, England, discovered a hoard of silver tableware dating to the mid-fourth century CE. The "Mildenhall Treasure" must have been the proud possession of a wealthy local family. The hoard consists of 34 silver pieces, including bowls, platters, ladles, and spoons. The most spectacular item is a large platter known as the "Great Dish" (FIG. 8-23). At the center is the bearded head of the god Oceanus, framed by a ring of Nereids (sea nymphs).

8-23 Oceanus and Nereids, and drinking contest between Bacchus and Hercules, "Great Dish," from Mildenhall, England, mid-fourth century CE. Silver, 1' $11\frac{3}{4}$ diameter. British Museum, London.

Part of a hoard of silver tableware owned by a Christian family, this large platter nonetheless features sea deities and a drinking contest between Bacchus, the Roman god of wine, and Hercules.

Ivory Carving

T vory has been prized since the earliest times, ■ when sculptors fashioned the tusks of Ice Age European mammoths into pendants, beads, and other items for body adornment, and, occasionally, statuettes (FIGS. 1-4 and 1-5A). The primary ivory sources in the historical period have been the elephants of India and especially Africa, where the species is larger than the Asian counterpart and the tusks longer, heavier, and of finer grain. African elephant tusks 5 to 6 feet in length and weighing 10 pounds are common, but tusks of male elephants can be 10 feet long or more and weigh well over 100 pounds. Carved ivories are familiar, if precious, finds at Mesopotamian and Egyptian sites, and ivory objects were also coveted in the prehistoric Aegean (FIG. 4-24) and throughout the classical world. Most frequently employed then for household objects, small votive offerings, and gifts to the deceased, ivory also could be used for grandiose statues such as Phidias's Athena Parthenos (FIG. 5-46).

In the Greco-Roman world, people admired ivory both for its beauty and because of its exotic origin. Elephant tusks were costly imports, and Roman generals proudly displayed them in triumphal processions when they paraded the spoils of war before the people. (In FIG. 9-4, a

barbarian brings tribute to a Byzantine emperor in the form of an ivory tusk.) Adding to the expense of the material itself was that only highly skilled artisans were capable of working in ivory. The tusks were very hard and of irregular shape, and the ivory workers needed a full toolbox of saws, chisels, knives, files, and gravers close at hand to cut the tusks into blocks for statuettes or thin plaques decorated with relief figures and ornamentation.

In Late Antiquity and the early medieval period, artists chose ivory most frequently for book covers, chests and boxes (FIG. 8-24),

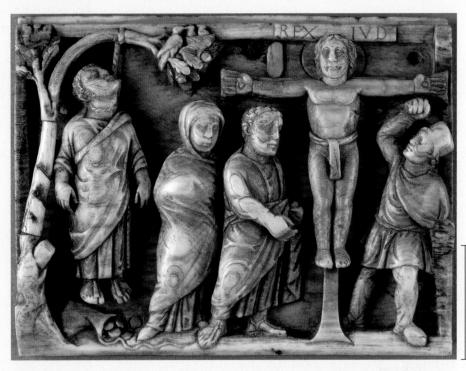

8-24 Suicide of Judas and Crucifixion, plaque from a box, ca. 420. Ivory, $3'' \times 3\frac{7}{8}''$. British Museum, London.

This plaque from a luxurious ivory box is the first known representation of the *Crucifixion of Christ*, shown here as a beardless youth who experiences no pain. At the left, Judas, his betrayer, hangs himself.

and diptychs (FIGS. 8-25 and 9-2). A *diptych* is a pair of hinged tablets, usually of wood, with a wax layer on the inner sides for writing letters and other documents. (The court scribe recording Jesus' trial in the *Rossano Gospels*, FIG. 8-22, and the women in two painted portraits from Pompeii, FIGS. 7-25 and 7-25A, both hold wooden diptychs.) Diptychs fashioned from ivory generally were reserved for ceremonial and official purposes—for example, to announce the election of a consul or a marriage between two wealthy families or to commemorate the death of an elevated member of society.

A larger outer band celebrates the consumption of wine and features a drinking contest between Bacchus (with his left foot resting on a panther) and Hercules, who is so drunk two satyrs struggle to support him. Three of the spoons bear the Greek letters *chi*, *rho*, *alpha*, and *omega*—explicit references to Christ (FIG. 8-6A)—but the figural decoration of all the items in the treasure illustrates classical mythology. The hoard attests to the survival of the Roman gods and of classical iconography during the Late Antique period even in Christian contexts.

Ivory Carving

Among the other important luxury arts of Late Antiquity was ivory carving, which has an even longer history in the ancient world than does metalwork (see "Ivory Carving," above).

SUICIDE OF JUDAS AND CRUCIFIXION A century before a manuscript painter illuminated the pages of the Rossano Gospels (FIG. 8-22) with scenes from the passion cycle, a Roman or northern Italian sculptor produced a series of ivory plaques for a small box that dramatically recount the suffering and triumph of Christ. The narrative on the box begins with Pilate washing his hands, Jesus carrying the cross on the road to Calvary, and the denial of Peter, all compressed into a single panel. The plaque illustrated here, Suicide of Judas (FIG. 8-24), is the next in the sequence and shows, at the left, Judas hanging from a tree with his open bag of silver dumped on the ground beneath his feet. The Crucifixion is at the right. The Virgin Mary and Joseph of Arimathea are to the left of the cross. On the other side, Longinus thrusts his spear into the side of the "king of the Jews" (the inscribed letters REX IVD appear above Jesus' head).

1 in

8-25 Woman sacrificing at an altar, right leaf of the diptych of the Nicomachi and the Symmachi, ca. 400. Ivory, $11_4^{3''} \times 5_2^{1''}$. Victoria & Albert Museum, London.

Even after Theodosius banned all pagan cults in 391, some Roman families still practiced the ancient rites. The sculptor who carved this ivory plaque also carried on the classical artistic style.

The two remaining panels show two Marys and two soldiers at the open doors of a tomb with an empty coffin within and the doubting Thomas touching the wound of the risen Christ.

The series is one of the oldest cycles of passion scenes preserved today. It dates to the period when artists were beginning to establish the standard iconographical types for medieval narratives of Christ's life. On these plaques, Jesus always appears as a beardless youth. In the *Crucifixion* scene (FIG. 8-24, *right*), the earliest known rendition of the subject in the history of art, Jesus exhibits a superhuman imperviousness to pain. He is a muscular, nearly nude, heroic figure who appears virtually weightless. Jesus does not *hang* from the cross. He is *displayed* on it—a divine being with open eyes who has conquered death. The striking contrast between the powerful frontal unsuffering Jesus on the cross and the limp hanging body of his betrayer with his snapped neck is highly effective, both visually and symbolically.

DIPTYCH OF THE SYMMACHI Although Constantine endorsed Christianity and dedicated his New Rome in the East to the Christian God, not everyone converted to the new religion, even after Theodosius banned all ancient cults and closed all temples in 391. An ivory plaque (FIG. 8-25), probably produced in Rome around 400, strikingly exhibits the endurance of the traditional Roman gods and of the classical style on the eve of Alaric's sack of the "eternal city." The ivory, one of a pair of leaves of a diptych, may commemorate either the marriage of members of two powerful Roman families of the senatorial class, the Nicomachi and the Symmachi, or the passing within a decade of two prominent male members of the two families. Whether or not the diptych refers to any specific event(s), the Nicomachi and the Symmachi here ostentatiously reaffirmed their faith in the old gods. Certainly, they favored the aesthetic ideals of the classical past, as exemplified by the stately processional friezes of the Greek Parthenon (FIG. 5-50, bottom) and the Roman Ara Pacis (FIG. 7-31).

The leaf inscribed "of the Symmachi" (FIG. 8-25) represents a woman sacrificing at an altar in front of a tree. She wears ivy in her hair and seems to be celebrating the rites of Bacchus—the same wine god featured on the Mildenhall silver platter (FIG. 8-23). Some scholars dispute the identity of the divinity honored, but no one questions that the deity is one of the Roman gods whose worship had been banned. The other diptych panel, inscribed "of the Nicomachi," also shows a woman at an open-air altar. On both panels, the precise yet fluent and graceful line, the relaxed poses, and the mood of spiritual serenity reveal an artist who practiced within a still-vital classical tradition that idealized human beauty as its central focus. The great senatorial magnates of Rome, who resisted the Empire-wide imposition of the Christian faith at the end of the fourth century, probably deliberately sustained the classical tradition. Despite the widespread adoption during the third and fourth centuries of the new non-naturalistic Late Antique aesthetic featuring wafer-thin frontal figures, the classical tradition in art lived on

and was never fully extinguished in the Middle Ages. Classical art survived in intermittent revivals, renovations, and restorations side by side and in contrast with the opposing nonclassical medieval styles until it rose to dominance once again in the Renaissance.

LATE ANTIQUITY

PRE-CONSTANTINIAN 192-306

- The Second Commandment prohibition against worshiping images once led scholars to think the Jews of the Roman Empire had no figural art, but the synagogue at Dura-Europos contains an extensive series of mural paintings illustrating episodes from the Hebrew scriptures. The Dura synagogue, like the Christian community house at the same site, was a remodeled private home.
- Christ was crucified ca. 33, but very little Christian art or architecture survives from the first centuries of Christianity. "Early Christian art" means the earliest art of Christian content, not the art of Christians at the time of Jesus, and comes primarily from the catacombs of Rome.
- During the second half of the third century, Christian sarcophagi adorned with a mixture of Old and New Testament scenes began to appear.

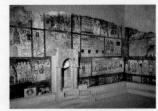

Synagogue, Dura-Europos, ca. 245-256

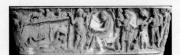

Santa Maria Antiqua sarophagus, ca. 270

CONSTANTINE 306-337

- Constantine's Edict of Milan of 313 granted Christianity legal status equal or superior to the cults of the traditional gods. The emperor was the first great patron of Christian art and built the first churches in Rome, including Old Saint Peter's.
- In a Christian ceremony, Constantine dedicated Constantinople as the new capital of the Roman Empire in 330. He was baptized on his deathbed in 337.
- Early Christian artists profusely decorated the walls and ceilings of the catacombs with frescoes. Popular themes were Christ as Good Shepherd and the salvation of Jonah.

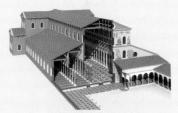

Old Saint Peter's, Rome, begun ca. 319

SONS OF CONSTANTINE TO JUSTINIAN 337-526

- The emperor Theodosius I (r. 379–395) proclaimed Christianity the official religion of the Roman Empire in 380 and banned worship of the old Roman gods in 391.
- Honorius (r. 395–423) moved the capital of his Western Roman Empire to Ravenna in 404. Rome fell to the Visigothic king Alaric in 410.
- Mosaics became a major vehicle for the depiction of Christian themes in churches. Extensive mosaic cycles are preserved in the nave of Santa Maria Maggiore in Rome and especially in Sant'Apollinare Nuovo in Rayenna.
- The earliest preserved manuscripts featuring illustrations of the Old and New Testaments date to the early sixth century. Illuminated manuscripts, such as the Vienna Genesis, would become one of the major art forms of the Middle Ages.
- Late Antique artists excelled in producing luxurious items for domestic use in silver and ivory, such as tableware, boxes, and diptychs, and decorated them with reliefs depicting both Christian and traditional Roman themes.

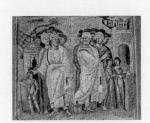

Santa Maria Maggiore, Rome, 432–440

Vienna Genesis, early sixth century

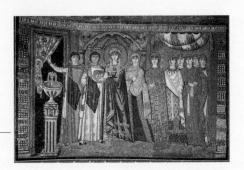

The Byzantine empress Theodora holds the golden cup of wine for the Eucharist as her husband carries the platter of bread. But neither she nor Justinian was ever in Ravenna.

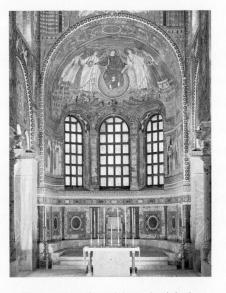

The apse mosaics celebrate Justinian's right to rule on earth. Christ, dressed in the purple robe worn by Byzantine emperors, sits on the orb of the world at the time of his second coming.

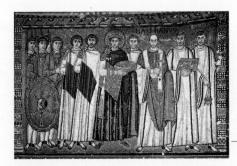

The emperor Justinian and Maximianus, the bishop who dedicated the church, appear in the apse. The mosaic program of San Vitale underscores the Byzantine emperor's dual political and religious roles.

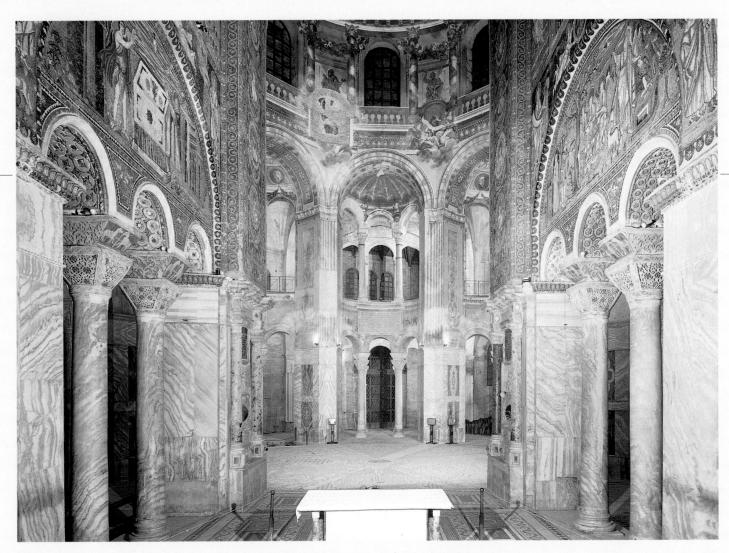

9-1 Interior of San Vitale (looking from the apse into the choir), Ravenna, Italy, 526-547.

San Vitale is a central-plan church with an octagonal plan modeled on churches in Constantinople. Its austere facade gives no hint of its sumptuous marble- and mosaic-covered interior.

9

BYZANTIUM

CHURCH AND STATE UNITED

San Vitale (FIG. 9-1), dedicated by Bishop Maximianus in 547 in honor of Saint Vitalis, who died a martyr at the hands of the Romans at Ravenna in the second century, is the most spectacular building in that northern Italian outpost of the Byzantine Empire. The church is an unforgettable experience for all who have entered it and marveled at its intricate design and magnificent mosaics.

The exterior's octagonal regularity is not readily apparent inside the centrally planned church. The design features two concentric octagons. The dome-covered inner octagon rises above the surrounding octagon to provide the interior with clerestory lighting. Eight large rectilinear piers alternate with curved, columned exedrae, pushing outward into the surrounding two-story ambulatory. A rich diversity of ever-changing perspectives greets visitors walking through the building. Arches looping over arches, curving and flattened spaces, and wall and vault shapes all seem to change constantly with the viewer's position. Light filtered through alabaster-paned windows plays over the glittering mosaics and glowing marbles covering the building's complex surfaces, producing a sumptuous effect.

The mosaics in San Vitale's choir and apse, like the building itself, must be regarded as one of the greatest achievements of Byzantine art. Completed less than a decade after the Ostrogoths surrendered Ravenna (see Chapter 8), the apse and choir decorations form a unified composition, whose theme is the holy ratification of the emperor Justinian's right to rule. In the apse vault, Christ sits on the orb of the world at the time of his second coming. On the choir wall to the left of the apse mosaic appears Justinian. He stands on the Savior's right side. The two are united visually and symbolically by the imperial purple they wear and by their haloes. A dozen attendants accompany Justinian, paralleling Christ's 12 apostles. Thus, the mosaic program underscores the dual political and religious roles of the Byzantine emperor. The laws of the Church and the laws of the state, united in the laws of God, manifest themselves in the person of the emperor, whose right to rule was God-given.

Justinian's counterpart on the opposite wall of the apse is his empress, Theodora, with her corresponding retinue. Both processions move into the apse, Justinian proceeding from left to right and Theodora from right to left, in order to take part in the Eucharist. Justinian carries the paten containing the bread, and Theodora the golden cup with the wine. Neither she nor Justinian ever visited Ravenna, however. Their participation in the liturgy at San Vitale is pictorial fiction. The mosaics are proxies for the absent sovereigns. Justinian is present because he was the head of the Byzantine state, and his appearance in the mosaic underscores that his authority extends over his territories in Italy.

THE CHRISTIAN ROMAN EMPIRE

In 324, when Constantine I founded Constantinople (Greek, "Constantine's city") on the site of ancient Byzantium, he legitimately could claim to be ruler of a united Roman Empire. But when Theodosius I (r. 379–395) died, he divided the Empire between his sons. Arcadius, the elder brother, became Emperor of the East, and Honorius, Emperor of the West. Arcadius ruled from Constantinople. After the sack of Rome in 410, Honorius moved the Western capital to Milan and later to Ravenna. Though not formally codified, Theodosius's division of the Empire (which paralleled Diocletian's century-earlier division of administrative responsibility) became permanent. Centralized government soon disintegrated in the Western half and gave way to warring kingdoms (see Chapter 11).

The Eastern half of the Roman Empire, only loosely connected by religion to the West and with only minor territorial holdings there, had a long and complex history of its own. Centered at Constantinople—dubbed the New Rome—the Eastern Christian Empire remained a cultural and political entity for a millennium, until the last of a long line of Eastern Roman emperors, ironically named Constantine XI, died at Constantinople in 1453, defending the city in vain against the Ottoman Turks.

Historians refer to that Eastern Christian Roman Empire as Byzantium (MAP 9-1), employing Constantinople's original name, and use the term *Byzantine* to identify whatever pertains to Byzantium—its territory, its history, and its culture. The Byzantine emperors, however, did not use the term to define themselves. They called their empire Rome and themselves Romans. Though they spoke Greek and not Latin, the Eastern Roman emperors never

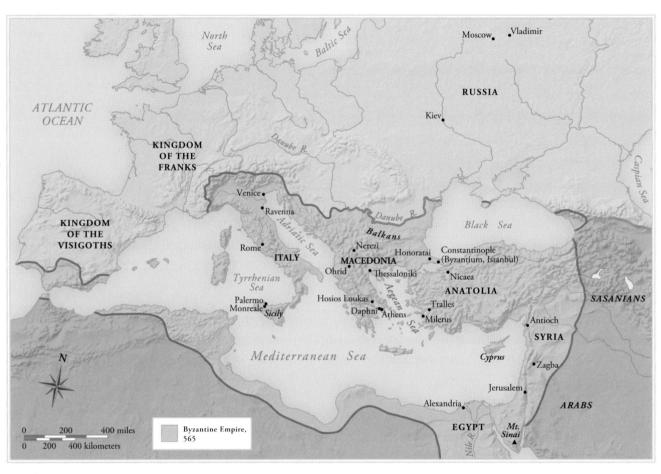

MAP 9-1 The Byzantine Empire at the death of Justinian in 565.

BYZANTIUM

Sinai until Leo III bans picturing

the divine in 726

324 Early Byzantine 726 843 Middle Byzantine 1204 1261 Late Byzantine 1453 I Theodora repeals iconoclasm, 843 Michael VIII recaptures Constantine founds Constantinople. Constantinople after the Crusader I Churches feature exterior walls with sack of 1204 I Justinian builds Hagia Sophia with decorative patterning, Greek-cross a 180-foot-high dome resting on plans, and domes on drums resting I Revival of mural and icon painting pendentives, 532-537 on pendentives or squinches ■ Fall of Constantinople to the ■ Dedication of San Vitale at Ravenna I Ivory triptychs for personal prayer Ottoman Turks, 1453 with its rich mosaic program, 547 become popular I Icon painting flourishes at Mount

relinquished their claim as the legitimate successors to the ancient Roman emperors (see "The Emperors of New Rome," page 259). During the long course of its history, Byzantium was the Christian buffer against the expansion of Islam into central and northern Europe, and its cultural influence was felt repeatedly in Europe throughout the Middle Ages. Byzantium Christianized the Slavic peoples of the Balkans and of Russia, giving them its Orthodox religion and alphabet, its literary culture, and its art and architecture. Byzantium's collapse in 1453 brought the Ottoman Empire into Europe as far as the Danube River, but Constantinople's fall had an impact even farther to the west. The westward flight of Byzantine scholars from the Rome of the East introduced the study of classical Greek to Italy and helped inspire there the new consciousness of antiquity historians call the Renaissance (see Chapter 14).

Art historians divide the history of Byzantine art into three periods. The first, Early Byzantine, extends from the founding of Constantinople in 324 to the onset of *iconoclasm* (the destruction of images used in religious worship) in 726 under Leo III. The Middle Byzantine period begins with the renunciation of iconoclasm in 843 and ends with the Western Crusaders' occupation of Constantinople in 1204. Late Byzantine corresponds to the two centuries after the Byzantines recaptured Constantinople in 1261 until its final loss in 1453 to the Ottoman Turks and the conversion of many churches to mosques (see Chapter 10).

EARLY BYZANTINE ART

The golden age of Early Byzantine art began with the accession of Justinian in 537, but important Byzantine artworks survive from the century before Justinian's reign, especially ivories and illuminated manuscripts—costly, treasured objects, as in the Late Antique West (see Chapter 8).

Before Justinian

ARCHANGEL MICHAEL In the early sixth century, a master carver, probably working in Constantinople, produced the largest extant Byzantine ivory panel (FIG. 9-2). It is probably the right half of a hinged diptych and depicts Saint Michael the Archangel. The inscription opens with the words "Receive these gifts." The dedication is perhaps a reference to the cross-surmounted orb of power the archangel once offered to a Byzantine emperor depicted on the missing diptych leaf. The prototype of Michael must have been a classical winged Victory, although Victory was personified as a woman in Greco-Roman art and usually carried the palm branch of victory, as she does on a somewhat later Byzantine ivory (FIG. 9-4). The Christian artist here ingeniously adapted a classical personification and imbued it with new meaning.

The archangel's flowing drapery, which reveals the body's shape, the delicately incised wings, and the facial type and coiffure are other indications the artist who carved this ivory was still working in the classical tradition. Nonetheless, the Byzantine sculptor had little concern for the rules of naturalistic representation. The archangel dwarfs the architectural setting. Michael's feet rest on three steps at once, and his upper body, wings, and arms are in front of the column shafts, whereas his lower body is behind the column bases at the top of the receding staircase. These spatial ambiguities do not detract from the figure's striking beauty, but they do signify the emergence in Byzantium of the same aesthetic already noted in the Late Antique mosaics of Thessaloniki (FIG. 8-19A). Here, as there, the Byzantine artist rejected the goal

9-2 Saint Michael the Archangel, right leaf of a diptych, early sixth century. Ivory, 1' $5'' \times 5\frac{1}{2}''$. British Museum, London.

The sculptor who carved this largest extant Byzantine ivory panel modeled Saint Michael on a classical winged Victory, but the archangel seems to float in front of the architecture rather than stand in it.

of most classical artists: to render the three-dimensional world in convincing and consistent fashion and to people that world with fully modeled figures firmly rooted on the ground. Michael seems more to float in front of the architecture than to stand in it.

9-3 Anicia Juliana between Magnanimity and Prudence, folio 6 verso of the *Vienna Dioskorides*, from Honoratai, near Constantinople (Istanbul), Turkey, ca. 512. Tempera on vellum, 1' $3'' \times 1'$ 11''. Österreichische Nationalbibliothek, Vienna.

In gratitude for her generosity, the people of Honoratai presented Anicia Juliana, a great art patron, with a book in which she appears enthroned with personifications of Magnanimity and Prudence.

9-3A Blackberry bush, *Vienna Dioskorides*, 512.

VIENNA DIOSKORIDES The physical world was, however, the focus of one of the rare surviving early medieval secular books. In the mid-first century, a Greek physician named Dioskorides compiled an encyclopedia of medicinal herbs called *De materia medica*. An early-sixth-century copy (FIGS. 9-3 and 9-3A) of this medical manual, nearly a thousand pages in length, is in the Austrian National Library. The so-called *Vienna Dioskorides* was a gift from the people of

Honoratai, near Constantinople, to Anicia Juliana, daughter of the short-lived Emperor of the West, Anicias Olybrias (r. 472). Anicia Juliana was a leading patron of the arts and had built a church dedicated to the Virgin Mary at Honoratai in 512. She also provided the funds to construct Saint Polyeuktos in Constantinople between 524 and 527. The excavated ruins of that church indicate it was a domed basilica—an important forerunner of the pioneering design of Justinian's Hagia Sophia (FIGS. 9-5 to 9-8).

The *Vienna Dioskorides* contains 498 illustrations, almost all images of plants (FIG. 9-3A) rendered with a scientific fidelity to nature that stands in stark contrast to contemporaneous Byzantine paintings and mosaics of religious subjects. It is likely the *Vienna Dioskorides* painters copied the illustrations as well as the text of a classical manuscript. One page, however, cannot be a copy—the

dedication page (FIG. 9-3) featuring a portrait of Anicia Juliana in an eight-pointed star and circle frame. This earliest known illustrated dedication page shows Anicia Juliana enthroned between personifications of Magnanimity and Prudence, with a kneeling figure labeled Gratitude of the Arts at her feet. The princess holds a book in her left hand, probably this *De material medica*. The shading and modeling of the figures, the heads seen at oblique angles, the rendering of the throne's footstool in perspective, and the use of personifications establish that the painter still worked in the classical tradition most other Byzantine artists had by then rejected.

Justinianic Art and Architecture

Historians and art historians alike regard the reign of the emperor Justinian (r. 527–565) as Byzantium's first golden age, during which the Christian Roman Empire briefly rivaled the old Roman Empire in power and extent (MAP 9-1). Justinian's generals, Belisarius and Narses, drove the Ostrogoths out of Italy, expelled the Vandals from the African provinces, beat back the Bulgars on the northern frontier, and held the Sasanians at bay on the eastern borders. At home, the emperor put down a dangerous rebellion in 532 of political and religious factions in the city (the Nika revolt) and supervised the codification of Roman law in a great work known as the *Corpus juris civilis* (*Code of Civil Law*), which became the foundation of the law systems of many modern European nations. Justinian could claim, with considerable justification, to have revived the glory of Old Rome in New Rome.

At the beginning of the fourth century, Constantine recognized Christianity and became its first imperial sponsor. By the end of the century, Theodosius had established Christianity as the Roman Empire's official religion. It was Justinian, however, who proclaimed Christianity the Empire's only lawful religion, specifically the Orthodox Christian doctrine. In Orthodox Christianity, the central article of faith is the equality of the three aspects of the Trinity of Father, Son, and Holy Spirit (as stated in Roman Catholic, Protestant, and Eastern Orthodox creeds today). All other versions of Christianity were heresies, especially the Arian, which asserted that the Father and Son were distinct entities and that the Father created the Son. Therefore, Christ was not equal to God. Also classified as a heresy was the Monophysite view that Christ had only one nature, which was divine, contrary to both the Orthodox and Arian belief that Christ had a dual divine-human nature. Justinian considered it his first duty not only to stamp out the few surviving polytheistic cults but also to crush all those who professed any Christian doctrine other than the Orthodox.

BARBERINI IVORY Justinianic art, like Late Antique art, was both religious and secular. A masterwork of political art is the ivory plaque known today as the Barberini Ivory (FIG. 9-4) because it was once part of the 17th-century collection of Cardinal Barberini in Rome. Carved in five parts (one is lost), the panel shows at the center an emperor, usually identified as Justinian, riding triumphantly on a rearing horse, while a startled, half-hidden barbarian recoils in fear behind him. The dynamic twisting postures of both horse and rider and the motif of the spear-thrusting equestrian emperor are familiar motifs in Roman imperial works (see "The Emperors of New Rome," page 259), as are the personifications of bountiful Earth (below the horse) and palm-bearing Victory (flying in to crown the conqueror). Also borrowed from the art of Old Rome are the barbarians at the bottom of the plaque bearing tribute and seeking clemency. Accompanying them are a lion, elephant, and tiger—exotic animals native to Africa and Asia, sites of Justinianic

The Emperors of New Rome

he emperors of Byzantium, the New Rome on the Bosporus, **L** considered themselves the direct successors of the emperors of the Old Rome on the Tiber. Although they proclaimed Orthodox Christianity as the official state religion and suppressed all of Old Rome's polytheistic cults, the political imagery of Byzantine art displays a striking continuity between ancient Rome and medieval Byzantium. Artists continued to portray emperors sitting on thrones holding the orb of the earth in their hands, battling foes while riding on mighty horses, and receiving tribute from defeated enemies. In the Early Byzantine period, official portraits continued to be set up in great numbers throughout the territories Byzantium controlled. But, as was true of the classical world, much of imperial Byzantine statuary is forever lost. Nonetheless, some of the lost portraits of the Byzantine emperors can be visualized from miniature versions of them on ivory reliefs such as the Barberini Ivory (FIG. 9-4) and from descriptions in surviving texts.

One especially impressive portrait in the Roman imperial tradition, melted down long ago, depicted the emperor Justinian on horseback atop a grandiose column. Cast in glittering bronze, like the equestrian statue of Marcus Aurelius (FIG. 7-59) set up nearly 400 years earlier, it attested to the continuity between the art of Old and New Rome, where pompous imperial images were commonly displayed at the apex of freestanding columns. (Compare FIG. 7-45, where a statue of Saint Peter has replaced a lost statue of the emperor Trajan.) Procopius, the historian of Justinian's reign, described the equestrian portrait:

Finest bronze, cast into panels and wreaths, encompasses the stones [of the column] on all sides, both binding them securely together and covering them with adornment. . . . This bronze is in color softer than pure gold, while in value it does not fall much short of an equal weight of silver. At the summit of the column stands a huge bronze horse turned towards the east, a most noteworthy sight. . . . Upon this horse is mounted a bronze image of the Emperor like a colossus. . . . He wears a cuirass in heroic fashion and his head is covered with a helmet . . . and a kind of radiance flashes forth from there. . . . He gazes towards the rising sun, steering his course, I suppose, against the Persians. In his left hand he holds a globe, by which the sculptor has signified that the whole earth and sea were subject to him, yet he carries neither sword nor spear nor any other weapon, but a cross surmounts his globe, by virtue of which alone he has won the kingship and victory in war. Stretching forth his right hand towards the regions of the East and spreading out his fingers, he commands the barbarians that dwell there to remain at home and not to advance any further.*

9-4 Justinian as world conqueror (*Barberini Ivory*), mid-sixth century. Ivory, 1' $1\frac{1}{2}$ " \times $10\frac{1}{2}$ ". Musée du Louvre, Paris.

Classical style and motifs lived on in Byzantine art in ivories such as this one. Justinian rides a rearing horse accompanied by personifications of Victory and Earth. Above, Christ blesses the emperor.

Statues such as this one are the missing links in an imperial tradition that never really died and that lived on also in the Holy Roman Empire (FIG. 11-12) and in Renaissance Italy (FIGS. 21-16 and 21-17).

*Cyril Mango, trans., *The Art of the Byzantine Empire, 312–1453: Sources and Documents* (reprint of 1972 ed., Toronto: Toronto University Press, 1986), 110–111.

conquest. At the left, a Roman soldier carries a statuette of another Victory, reinforcing the central panel's message. The source of the emperor's strength, however, comes not from his earthly armies but from God. The uppermost panel depicts two angels holding aloft a youthful image of Christ carrying a cross in his left hand. Christ blesses Justinian with a gesture of his right hand, indicating approval of the emperor's rule.

HAGIA SOPHIA Like the emperors of Old Rome, Justinian was an ambitious builder. In Constantinople alone, he built or restored more than 30 churches of the Orthodox faith. The historian Procopius of Caesarea (ca. 500–ca. 565) declared the emperor's extravagant building program was an obsession that cost his subjects dearly in taxation. But Justinian's monuments defined the Byzantine style in architecture forever after.

9-5 ANTHEMIUS OF TRALLES and ISIDORUS OF MILETUS, aerial view of Hagia Sophia (looking west), Constantinople (Istanbul), Turkey, 532-537. ■4

Justinian's reign was the first golden age of Byzantine art and architecture. Hagia Sophia was the most magnificent of the more than 30 churches Justinian built or restored in Constantinople alone.

9-6 ANTHEMIUS OF TRALLES and ISIDORUS OF MILETUS, restored cutaway view of Hagia Sophia (looking northwest), Constantinople (Istanbul), Turkey, 532–537 (John Burge). ■◀

Hagia Sophia is a domed basilica. Buttressing the great dome are eastern and western half-domes whose thrusts descend, in turn, into smaller halfdomes surmounting columned exedrae.

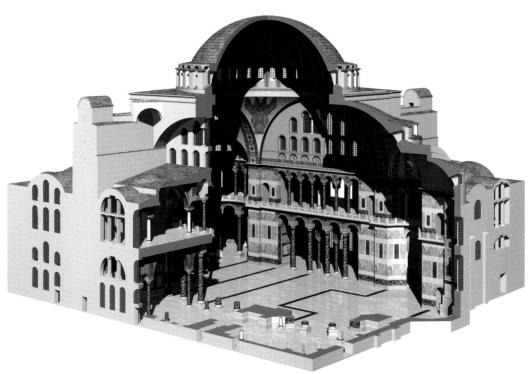

The emperor's most important project was the construction of Hagia Sophia (FIGS. 9-5 and 9-6), the church of Holy Wisdom, in Constantinople. Anthemius of Tralles and Isidorus of Miletus, a mathematician and a physicist (neither man an architect in the modern sense of the word), designed and built the church for Justinian between 532 and 537. They began work immediately after fire destroyed an earlier church on the site during

the Nika riot in January 532. Justinian intended the new church to rival all other churches ever built and even to surpass in scale and magnificence the Temple of Solomon in Jerusalem. The result was Byzantium's grandest building and one of the supreme accomplishments of world architecture.

Hagia Sophia's dimensions are formidable for any structure not made of steel. In plan (FIG. 9-7), it is about 270 feet long and

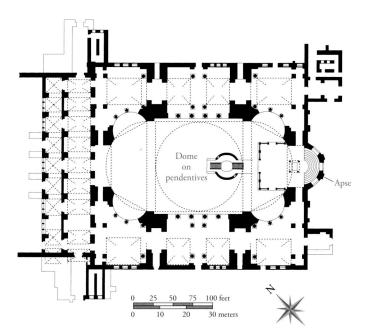

9-7 Anthemius of Tralles and Isidorus of Miletus, plan of Hagia Sophia, Constantinople (Istanbul), Turkey, 532–537.

In Hagia Sophia, Justinian's architects succeeded in fusing two previously independent architectural traditions: the vertically oriented central-plan building and the longitudinally oriented basilica.

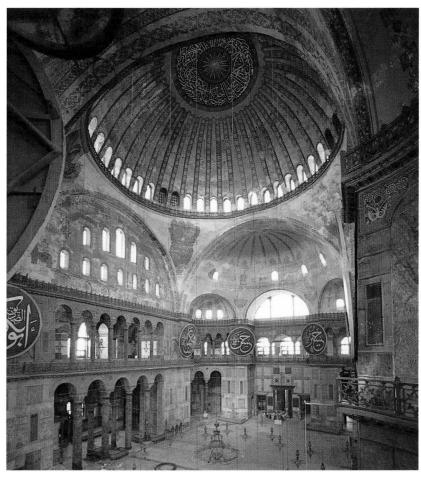

9-8 Anthemius of Tralles and Isidorus of Miletus, interior of Hagia Sophia (looking southwest), Constantinople (Istanbul), Turkey, 532–537. ■4

Pendentive construction made possible Hagia Sophia's lofty dome, which seems to ride on a halo of light. A contemporary said the dome seemed to be suspended by "a golden chain from Heaven."

240 feet wide. The dome is 108 feet in diameter, and its crown rises some 180 feet above the pavement (FIG. 9-8). (The first dome collapsed in 558. Its replacement required repair in the 9th and 14th centuries. The present dome is steeper and more stable than the original.) In scale, Hagia Sophia rivals the architectural wonders of Rome: the Pantheon, the Baths of Caracalla, and the Basilica of Constantine (see Chapter 7). In exterior view (FIG. 9-5), the great dome dominates the structure, but the building's external aspects today are much changed from their original appearance. The huge buttresses are later additions to the Justinianic design, and after the Ottoman conquest of 1453, when Hagia Sophia became a *mosque*, the Turks constructed four towering *minarets* (see Chapter 10) at the corners of the former church. The building is now a museum.

The characteristic Byzantine plainness and unpretentiousness of the exterior scarcely prepare visitors for the building's interior (FIG. 9-8). A poet and *silentiary* (an usher responsible for maintaining silence in the palace) at Justinian's court, Paul Silentiarius, vividly described the original magnificence of Hagia Sophia's interior:

Who... shall sing the marble meadows gathered upon the mighty walls and spreading pavement.... [There is stone] from the green flanks of Carystus [and] the speckled Phrygian stone, sometimes rosy mixed with white, sometimes gleaming with purple and silver flowers. There is a wealth of porphyry stone, too, besprinkled with

little bright stars. . . . You may see the bright green stone of Laconia and the glittering marble with wavy veins found in the deep gullies of the Iasian peaks, exhibiting slanting streaks of blood-red and livid white; the pale yellow with swirling red from the Lydian headland; the glittering crocus-like golden stone [of Libya]; . . . glittering [Celtic] black [with] here and there an abundance of milk; the pale onyx with glint of precious metal; and [Thessalian marble] in parts vivid green not unlike emerald. . . . It has spots resembling snow next to flashes of black so that in one stone various beauties mingle. 1

The feature that distinguishes Hagia Sophia from equally lavishly revetted Roman buildings such as the Pantheon (FIG. 7-51) is the special mystical quality of the light flooding the interior. The soaring canopy-like dome that dominates the inside as well as the outside of the church rides on a halo of light from windows in the dome's base. Visitors to Hagia Sophia from Justinian's time to today have been struck by the light within the church and its effect on the human spirit. The 40 windows at the base of the dome create the illusion the dome rests on the light pouring through them.

Procopius observed that the dome looked as if it were suspended by "a golden chain from Heaven" and that "the space is not illuminated by the sun from the outside, but that the radiance is generated within, so great an abundance of light bathes this shrine all around." Paul the Silentiary compared the dome to "the firmament which rests on air" and described the vaulting as covered with "gilded tesserae from which a glittering stream of golden rays pours abundantly and strikes men's eyes with irresistible force. It is as if one were gazing at the midday sun in spring." Thus, Hagia Sophia has a vastness of space shot through with light, and a central dome that appears to be supported by the light it admits. Light is the mystic element—light that

Pendentives and Squinches

Perhaps the most characteristic feature of Byzantine architecture is the placement of a dome, which is circular at its base, over a square, as in the Justinianic church of Hagia Sophia (FIGS. 9-6 to 9-8) and countless later structures (for example, FIGS. 9-21, 9-22, and 9-26). Two structural devices that are hallmarks of Byzantine engineering made this feat possible: *pendentives* and *squinches*.

In pendentive construction (from the Latin pendere, "to hang"), a dome rests on what is, in effect, a second, larger dome (FIG. 9-9, left). The builders omit the top portion and four segments around the rim of the larger dome, producing four curved triangles, or pendentives. The pendentives join to form a ring and four arches whose planes bound a square. The pendentives and arches transfer the weight of the dome not to the walls but to the four piers from which the arches spring. The first use of pendentives on a monumental scale was in Hagia Sophia (FIGS. 9-6 and 9-8) in the mid-sixth century, although Mesopotamian architects had experimented with them earlier. In Roman and Early Christian central-plan buildings, such as the Pantheon (FIGS. 7-50 and 7-51) and Santa Costanza (FIG. 8-11), the domes spring directly from the circular top of a cylinder (FIG. 7-6*d*).

The pendentive system is a dynamic solution to the problem of setting a round dome over a square, making possible a union of centralized and longitudinal or basilican structures. A similar effect can be achieved using squinches (FIG. 9-9, *right*)—arches, corbels,

or lintels—that bridge the corners of the supporting walls and form an octagon inscribed within a square. To achieve even greater height, a builder can rest a dome on a cylindrical drum that in turn rests on either pendentives or squinches (FIG. 9-22), but the principle of supporting a dome over a square is the same.

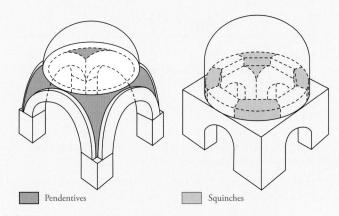

9-9 Dome on pendentives (left) and on squinches (right).

Pendentives (triangular sections of a sphere) make it possible to place a dome on a ring over a square. Squinches achieve the same goal by bridging the corners of the square to form an octagonal base.

glitters in the mosaics, shines forth from the marbles, and pervades and defines spaces that escape definition. Light seems to dissolve material substance and transform it into an abstract spiritual vision. Pseudo-Dionysius, perhaps the most influential mystic philosopher of the age, wrote in *The Divine Names*: "Light comes from the Good and . . . light is the visual image of God."⁴

PENDENTIVES To achieve this illusion of a floating "dome of Heaven," Anthemius and Isidorus used *pendentives* (see "Pendentives and Squinches," above) to transfer the weight from the great dome to the piers beneath rather than to the walls. With pendentives (FIG. 9-9, *left*), not only could the space beneath the dome be unobstructed but scores of windows also could puncture the walls. The pendentives created the impression of a dome suspended above, not held up by, walls. Experts today can explain the technical virtuosity of Justinian's builders, but it remained a mystery to their contemporaries. Procopius communicated the sense of wonderment experienced by those who entered Justinian's great church: "No matter how much they concentrate their attention on this and that, and examine everything with contracted eyebrows, they are unable to understand the craftsmanship and always depart from there amazed by the perplexing spectacle." "5

By placing a hemispherical dome on a square base instead of on a circular base, as in the Pantheon (FIGS. 7-50 and 7-51), Anthemius and Isidorus succeeded in fusing two previously independent and seemingly mutually exclusive architectural traditions: the vertically oriented central-plan building and the longitudinally oriented

basilica. Hagia Sophia is, in essence, a domed basilica (FIG. 9-6)—a uniquely successful conclusion to several centuries of experimentation in Christian church architecture. However, the thrusts of the pendentive construction at Hagia Sophia made external buttresses necessary, as well as huge internal northern and southern wall piers and eastern and western half-domes (FIG. 9-5). The semidomes' thrusts descend, in turn, into still smaller half-domes surmounting columned exedrae (FIG. 9-8) that give a curving flow to the design.

The diverse vistas and screenlike ornamented surfaces mask the structural lines. The columnar arcades of the nave and second-story galleries have no real structural function. Like the walls they pierce, they are only part of a fragile "fill" between the huge piers. Structurally, although Hagia Sophia may seem Roman in its great scale and majesty, the organization of its masses is not Roman. The very fact the "walls" in Hagia Sophia are concealed (and barely adequate) piers indicates the architects sought Roman monumentality as an *effect* and did not design the building according to Roman principles. Using brick in place of concrete was a further departure from Roman practice and marks Byzantine architecture as a distinctive structural style. Hagia Sophia's eight great supporting piers are ashlar masonry, but the screen walls are brick, as are the vaults of the aisles and galleries and the dome and semicircular half-domes.

The ingenious design of Hagia Sophia provided the illumination and the setting for the solemn liturgy of the Orthodox faith. The large windows along the rim of the great dome poured light down upon the interior's jeweled splendor, where priests staged the sacred spectacle. Sung by clerical choirs, the Orthodox equivalent of the Latin Mass celebrated the sacrament of the Eucharist at the altar in the apsidal sanctuary, in spiritual reenactment of Jesus' crucifixion. Processions of chanting priests, accompanying the patriarch (archbishop) of Constantinople, moved slowly to and from the sanctuary and the vast nave. The gorgeous array of their vestments (compare FIG. 9-35A) rivaled the interior's polychrome marbles, complementing the interior's finely wrought, gleaming candlesticks and candelabra; the illuminated books bound in gold or ivory and inlaid with jewels and enamels; and the crosses, sacred vessels, and processional banners. Each, with its great richness of texture and color, glowing in shafts of light from the dome, contributed to the majestic ambience of Justinian's great church.

The nave of Hagia Sophia was reserved for the clergy, not the congregation. The laity, segregated by sex, had only partial views of the brilliant ceremony from the shadows of the aisles and galleries, restrained in most places by marble parapets. The emperor was the only layperson privileged to enter the sanctuary. When he participated with the patriarch in the liturgical drama, standing at the pulpit beneath the great dome, his rule was again sanctified and his person exalted. Church and state were symbolically made one (see "Church and State United," page 255). The church building was then the earthly image of the court of Heaven, its light the image of God and God's holy wisdom.

At Hagia Sophia, the intricate logic of Greek theology, the ambitious scale of Rome, the vaulting tradition of Mesopotamia, and the mysticism of Eastern Christianity combined to create a monument that is at once a summation of antiquity and a positive assertion of the triumph of Christian faith.

RAVENNA In 493, Theodoric, the Ostrogoths' greatest king, chose Ravenna, an Etruscan and later a Roman city near the Adriatic coast of Italy south of Venice, as the capital of his kingdom, which encompassed much of the Balkans and all of Italy (see Chapter 8). During the short history of Theodoric's unfortunate successors, Ravenna's importance declined. But in 539, Justinian's general Belisarius captured the city, initiating an important new chapter in its history. Ravenna remained the Eastern Empire's foothold in Italy for two centuries, until the Lombards and then the Franks overtook it. During Justinian's reign, Ravenna enjoyed great prosperity at a time when repeated sieges, conquests, and sackings threatened the "eternal city" of Rome with extinction. As the seat of Byzantine dominion in Italy, Ravenna and its culture became an extension of Constantinople. Its art, even more than that of the Byzantine capital (where relatively little outside of architecture has survived), clearly reveals the transition from the Early Christian to the Byzantine style.

SAN VITALE Construction of Ravenna's greatest shrine, San Vitale (FIGS. 9-1, 9-10, and 9-11), began under Bishop Ecclesius (r. 522–532) shortly after Theodoric's death in 526. A wealthy citizen, Julianus Argentarius (Julian the Banker), provided the enormous sum of 26,000 *solidi* (gold coins weighing in excess of 350 pounds) required to proceed with the work. San Vitale is unlike any of the Early Christian churches (FIG. 8-18) of Ravenna. It is not a basilica. Rather, it is centrally planned, like Justinian's churches in Constantinople, and it seems, in fact, to have been loosely modeled on the earlier Church of Saints Sergius and Bacchus there.

As already discussed (FIG. 9-1), San Vitale's design features a dome-covered clerestory-lit central space defined by piers alternating with curved, columned exedrae, creating an intricate eightleafed plan (FIG. 9-11). The exedrae closely integrate the inner and

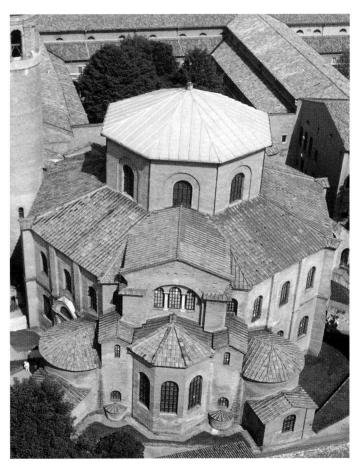

9-10 Aerial view of San Vitale (looking northwest), Ravenna, Italy, 526-547. ■◀

Justinian's general Belisarius captured Ravenna from the Ostrogoths. The city became the seat of Byzantine dominion in Italy. San Vitale honored Saint Vitalis, a second-century Ravenna martyr.

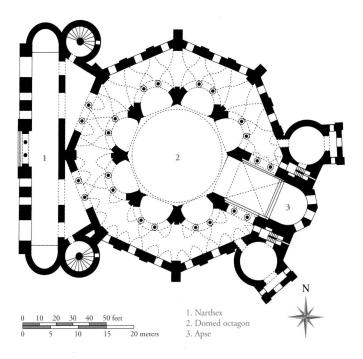

9-11 Plan of San Vitale, Ravenna, Italy, 526-547.

Centrally planned like Justinian's churches in Constantinople, San Vitale has a design featuring an off-axis narthex and two concentric octagons. A dome crowns the taller, inner octagon.

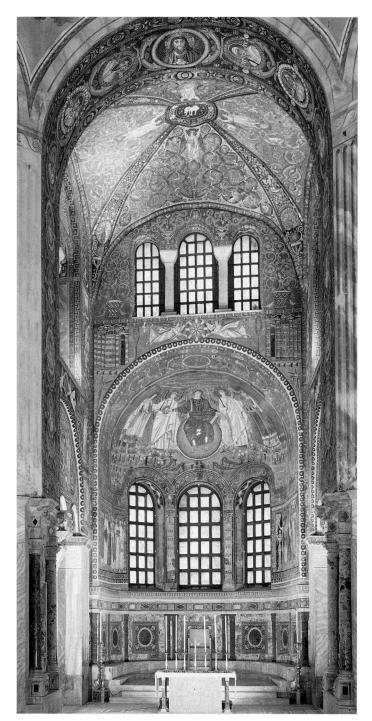

9-12 Choir and apse of San Vitale with mosaic of Christ between two angels, Saint Vitalis, and Bishop Ecclesius, Ravenna, Italy, 526-547. ■◆

In the apse vault, a youthful Christ, seated on the orb of the world at the time of his second coming, extends the gold martyr's wreath to Saint Vitalis. Bishop Ecclesius offers Christ a model of San Vitale.

outer spaces that otherwise would have existed simply side by side as independent units. A cross-vaulted *choir* (FIG. 9-12) preceding the apse interrupts the ambulatory and gives the plan some axial stability. Weakening this effect, however, is the off-axis placement of the narthex, whose odd angle never has been explained fully. (The atrium, which no longer exists, may have paralleled a street running in the same direction as the angle of the narthex.)

The mosaic-clad walls and vaults of San Vitale's interior are dazzling. In the apse vault is a vision of the second coming. Christ,

youthful in the Early Christian tradition, sits atop the world and holds a scroll with seven seals (Rev. 5:1). The four rivers of Paradise flow beneath him, and rainbow-hued clouds float above. Christ extends the golden martyr's wreath to Vitalis, the patron saint of the church, whom an angel introduces. At Christ's left, another angel presents Bishop Ecclesius, who offers a model of San Vitale to Christ. The arrangement recalls Christ's prophecy of the last days of the world: "And then shall they see the Son of Man coming in the clouds with great power and glory. And then shall he send his angels, and shall gather together his elect from the four winds, from the uttermost part of Heaven" (Mark 13:26–27).

Images and symbols covering the entire sanctuary express the single idea of Christ's redemption of humanity and the reenactment of it in the Eucharist. For example, the lunette mosaic over the two columns on the northern side of the choir depicts the story of Abraham and the three angels. Sarah, Abraham's wife, was 90 years old and childless when three angels visited Abraham. They announced Sarah would bear a son, and she later miraculously gave birth to Isaac. Christians believe the Old Testament angels symbolize the Holy Trinity. Immediately to the right in the lunette is the sacrifice of Isaac, a prefiguration of Christ's crucifixion (see "Jewish Subjects in Christian Art," Chapter 8, page 238).

JUSTINIAN AND THEODORA The most distinctive elements of the mosaic program of San Vitale are the facing panels in the choir depicting Justinian (FIG. 9-13) and Theodora (FIG. 9-14). The positions of the figures are all-important. They express the formulas of precedence and rank. In the Justinian mosaic, the emperor is at the center, distinguished from the other dignitaries by his purple robe and halo, which connect him with the Savior in the vault above. At Justinian's left (at right in the mosaic)

9-14A Throne of Maximianus, ca. 546-556.

is Bishop Maximianus (r. 546–556), the man responsible for San Vitale's completion. (His magnificent ivory throne [FIG. 9-14A] is on display today in one of Ravenna's museums.) The mosaicist stressed the bishop's importance by labeling his figure with the only identifying inscription in the composition. (Some scholars think Maximianus added the inscription and the bishop represented was originally Ecclesius.)

The artist divided the figures into three groups: the emperor and his staff; the clergy; and the imperial guard, bearing a shield with the chi-rho-iota (*) monogram of Christ. Each group has a leader whose feet precede (by one foot overlapping) the feet of those who follow. The positions of Justinian and Maximianus are curiously ambiguous. Although the emperor appears to be slightly behind the bishop, the golden paten (large shallow bowl or plate for the Eucharist bread) he carries overlaps the bishop's arm. Thus, symbolized by place and gesture, the imperial and churchly powers are in balance. The emperor's paten, the bishop's cross, and the attendant clerics' book and censer produce a slow forward movement that strikingly modifies the scene's rigid formality. The artist placed nothing in the background, wishing the observer to understand the procession as taking place in this very sanctuary. Thus, the emperor appears forever as a participant in the sacred rites and as the proprietor of this royal church and the ruler of the Western Empire.

The procession at San Vitale recalls but contrasts with that of Augustus and his entourage (FIG. 7-31) on the Ara Pacis, built more than a half millennium earlier in Rome. There, the fully modeled marble figures have their feet planted firmly on the ground. The

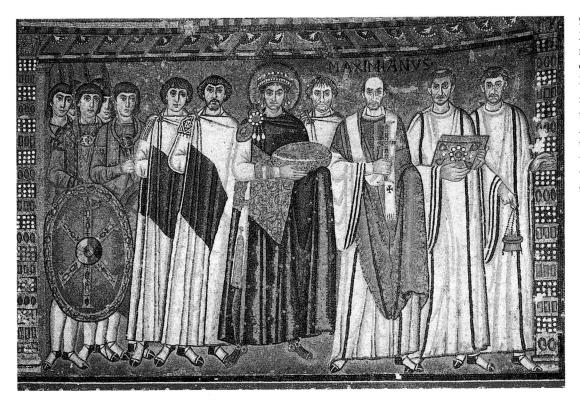

9-13 Justinian, Bishop
Maximianus, and attendants,
mosaic on the north wall
of the apse, San Vitale,
Ravenna, Italy, ca. 547.

San Vitale's mosaics reveal the new Byzantine aesthetic. Justinian is foremost among the weightless and speechless frontal figures hovering before the viewer, their positions in space uncertain.

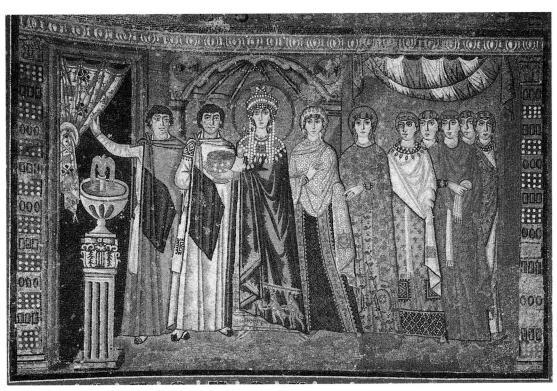

9-14 Theodora and attendants, mosaic on the south wall of the apse, San Vitale, Ravenna, Italy, ca. 547.

Justinian's counterpart on the opposite wall is the powerful Empress Theodora. Neither she nor Justinian ever visited Ravenna. San Vitale's mosaics are proxies for the absent sovereigns.

Romans talk among themselves, unaware of the viewer's presence. All is anecdote, all very human and of this world, even if the figures themselves conform to a classical ideal of beauty that cannot be achieved in reality. The frontal figures of the Byzantine mosaic hover before viewers, weightless and speechless, their positions in space uncertain. Tall, spare, angular, and elegant, they have lost the rather squat proportions characteristic of much Early Christian figural art. The garments fall straight, stiff, and thin from the narrow shoulders. The organic body has dematerialized, and, except for the heads, some of which seem to be true portraits, viewers see a procession of solemn spirits gliding silently in the presence of the

sacrament. Indeed, the theological basis for this approach to representation was the idea that the divine was invisible and that the purpose of religious art was to stimulate spiritual seeing. Theodulf of Orleans summed up this idea around 790: "God is beheld not with the eyes of the flesh but only with the eye of the mind." The mosaics of San Vitale reveal this new Byzantine aesthetic, one very different from that of the classical world but equally compelling. Byzantine art disparages matter and material values. It is an art in which blue sky has given way to heavenly gold, an art without solid bodies or cast shadows, and with the perspective of Paradise, which is nowhere and everywhere.

9-15 Saint Apollinaris amid sheep, apse mosaic, Sant'Apollinare in Classe, Ravenna, Italy, ca. 533–549.

Saint Apollinaris stands beneath Christ's cross, his arms raised in prayer. Although the scene is set in a landscape, the Byzantine artist rejected the classical illusionism of early mosaics (compare Fig. 8-17).

The figures in the Theodora mosaic (FIG. 9-14) exhibit the same stylistic traits as those in the Justinian mosaic, but the artist represented the women within a definite architecture, perhaps the atrium of San Vitale. The empress stands in state beneath an imperial canopy, waiting to follow the emperor's procession. An attendant beckons her to pass through the curtained doorway. The fact she is outside the sanctuary in a courtyard with a fountain and only about to enter attests that, in the ceremonial protocol, her rank was not quite equal to her consort's. But the very presence of Theodora at San Vitale is significant. She, like many other Byzantine empresses (see "Zoe," page 273), wielded enormous influence

in the Byzantine state. Of humble origin, Theodora, who was 15 years younger than Justinian, initially attracted his attention because of her beauty, but she soon became his most trusted adviser. John the Lydian, a civil servant at Constantinople at the time, described her as "surpassing in intelligence all men who ever lived." For example, during the Nika revolt in Constantinople in 532, when all of her husband's ministers counseled flight from the city, Theodora, by the sheer force of her personality, persuaded Justinian and his generals to hold their ground—and they succeeded in suppressing the uprising. In the mosaic, the artist underscored Theodora's elevated rank by decorating the border of her garment with a representation of the three magi, suggesting the empress belongs in the company of the three monarchs bearing gifts who approached the newborn Jesus.

SANT'APOLLINARE IN CLASSE Until the ninth century, the Church of Sant'Apollinare in Classe housed the body of Saint Apollinaris, who suffered his martyrdom in Classe, Ravenna's port. The church itself is Early Christian in type, a basilica with a nave and flanking aisles, like Theodoric's palace-church (FIG. 8-18) dedicated to the same saint in Ravenna. As in the earlier church, the Justinianic building's exterior is plain and unadorned, but inside sumptuous mosaics fill the apse (FIG. 9-15). The mosaic decorating the semidome above the apse was probably in place by the time of the church's dedication in 549. The mosaics of the framing arch are of later date.

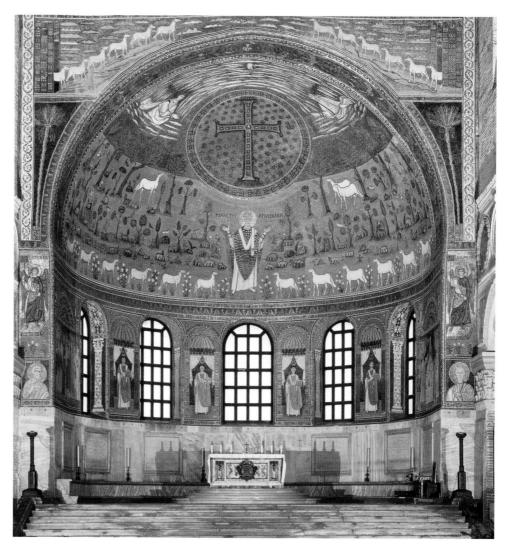

Against a gold ground, a large medallion with a jeweled cross dominates the composition. This may represent the cross Constantine erected on the hill of Calvary to commemorate the martyrdom of Jesus. Visible just above the cross is the hand of God. On either side of the medallion, in the clouds, are the Old Testament prophets Moses and Elijah, who appeared before Jesus during his Transfiguration (FIG. 9-16). Below these two figures are three sheep, symbols of the disciples John, Peter, and James, who accompanied Jesus to the foot of the mountain he ascended in order to converse with the prophets. Beneath, amid green fields with trees, flowers, and birds, stands the church's patron saint, Apollinaris. The mosaicist portrayed him in the Early Christian manner as an orant with uplifted arms. Accompanying Apollinaris are 12 sheep, perhaps representing the Christian congregation under the saint's protection, and forming, as they march in regular file across the apse, a wonderfully decorative base.

Comparison of the Early Byzantine Sant'Apollinare in Classe mosaic with the Galla Placidia mosaic (FIG. 8-17) from the Early Christian period at Ravenna shows how the style and artists' approach to the subject changed during the course of a century. Both mosaics portray a human figure and some sheep in a landscape. But in Classe, in the mid-sixth century, the artist did not try to represent voluminous figures in a naturalistic setting, but instead treated the saint, the animals, and the plants as flat symbols, lined up side by side. The mosaicist carefully avoided overlapping in what must have been an intentional effort to omit all reference to the three-

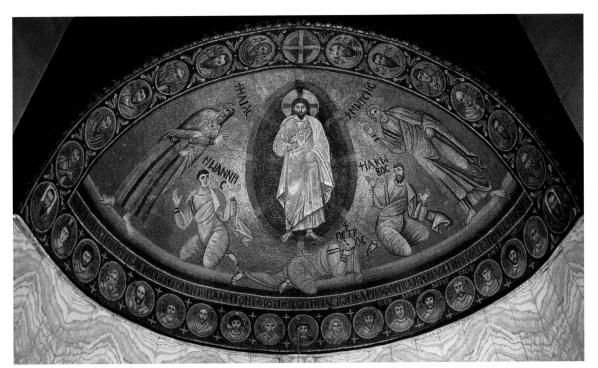

9-16 Transfiguration of Jesus, apse mosaic, Church of the Virgin, monastery of Saint Catherine, Mount Sinai, Egypt, ca. 548–565.

In this apse mosaic, unlike FIG. 9-15, the artist swept away all traces of landscape for a depthless field of gold. The prophets and disciples cast no shadows even though bathed in divine light.

dimensional space of the material world and physical reality. Shapes have lost the volume seen in the earlier mosaic and instead are flat silhouettes with linear details. The effect is that of an extremely rich, flat tapestry without illusionistic devices. This new Byzantine style became the ideal vehicle for conveying the extremely complex symbolism of the fully developed Christian dogma.

Indeed, the Classe apse mosaic is much richer in meaning than first meets the eye. The cross symbolizes not only Christ's own death, with its redeeming consequences, but also the death of his martyrs (in this case, Saint Apollinaris). The lamb, also a symbol of martyrdom, appropriately represents the martyred apostles. The whole scene expands above the altar, where the priests celebrated the sacrament of the Eucharist—the miraculous recurrence of the supreme redemptive act. The altars of Christian churches were, from early times, sanctified by the bones and relics of martyrs (see "The Veneration of Relics," Chapter 12, page 336). Thus, the mystery and the martyrdom joined in one concept. The death of the martyr, in imitation of Christ, is a triumph over death that leads to eternal life. The images above the altar present an inspiring vision, delivered with overwhelming force, to the eyes of believers. Looming above their eyes is the apparition of a great mystery, ordered to make perfectly simple and clear that humankind's duty is to seek salvation. Even the illiterate, who might not grasp the details of the complex theological program, could understand that the way of the martyr is open to the Christian faithful and that the reward of eternal life is within their reach.

MOUNT SINAI During Justinian's reign, almost continuous building took place, not only in Constantinople and Ravenna but throughout the Byzantine Empire. At about the time mosaicists in Ravenna were completing their work at San Vitale and Sant'Apollinare in Classe, Justinian's builders were rebuilding an important early *monastery* (an enclosed compound for monks) at Mount Sinai in Egypt where Moses received the Ten Commandments from God. Now called Saint Catherine's, the monastery marked the spot at the foot of the mountain where the Bible says God first spoke to the Hebrew prophet from a burning bush.

Monasticism began in Egypt in the third century and spread rapidly to Palestine and Syria in the East and as far as Ireland in the West (see Chapter 11). It began as a migration to the wilderness by those who sought a more spiritual way of life, far from the burdens, distractions, and temptations of town and city. In desert places, these refuge seekers lived austerely as hermits, in contemplative isolation, cultivating the soul's perfection. So many thousands fled the cities that the authorities became alarmed—noting the effect on the tax base, military recruitment, and business in general.

The origins of the monastic movement are associated with Saints Anthony and Pachomius in Egypt in the fourth century. By the fifth century, many of the formerly isolated monks had begun to live together within a common enclosure and formulate regulations governing communal life under the direction of an abbot (see "Medieval Monasteries and Benedictine Rule," Chapter 11, page 322). The monks typically lived in a walled monastery, an architectural complex that included the monks' residence (an alignment of single cells), an oratory (monastic church), a *refectory* (dining hall), a kitchen, storage and service quarters, and a guest house for pilgrims (FIG. 11-19).

Justinian rebuilt the monastery at Mount Sinai between 548 and 565 and constructed imposing walls around it. The site had been an important pilgrimage destination since the fourth century, and Justinian's fortress protected not only the monks but also the lay pilgrims during their visits. The Mount Sinai church was dedicated to the Virgin Mary, whom the Orthodox Church had officially recognized in the mid-fifth century as the Mother of God (*Theotokos*, "she who bore God" in Greek), putting to rest a controversy about the divine nature of Christ.

In the church's apse is the *Transfiguration of Jesus* mosaic (FIG. 9-16). (Other mosaics in the church depict Moses receiving the Law and standing before the burning bush.) Jesus appears in a deep-blue almond-shaped *mandorla* (almond-shaped aureole of light). At his feet are John, Peter, and James. At the left and right are Elijah and Moses. Portrait busts of saints and prophets in medallions frame the whole scene. The artist stressed the intense

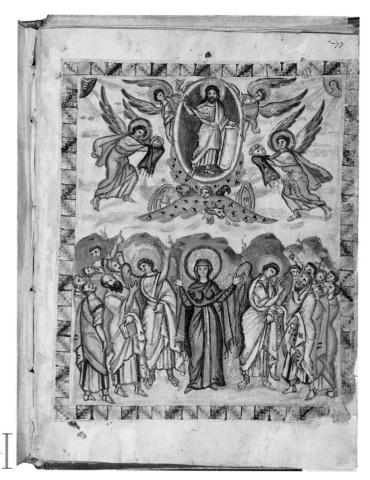

9-17 Ascension of Christ, folio 13 verso of the Rabbula Gospels, from Zagba, Syria, 586. Tempera on parchment, 1' $1'' \times 10^{\frac{1}{2}''}$. Biblioteca Medicea-Laurenziana, Florence.

The Gospels do not mention the Virgin as a witness of Christ's Ascension. Her prominent position in the *Rabbula Gospels* is an early example of the important role Mary played in medieval art.

whiteness of Jesus' transfigured, spiritualized form, from which rays stream down on the disciples. The stately figures of the prophets and the static frontality of Jesus set off the frantic terror and astonishment of the gesticulating disciples. These distinctions dramatically contrast the eternal composure of heavenly beings with the distraught responses of the earthbound. At Mount Sinai, the mosaicist swept away all traces of landscape and architectural setting for a depthless field of gold, fixing the figures and their labels in isolation from one another. A rainbow band of colors graduating from yellow to blue bounds the golden field at its base. The relationship of the figures to this multicolor ground line is ambiguous. The artist placed some figures behind it, whereas others overlap it. The bodies cast no shadows, even though supernatural light streams over them. This is not the natural world Jesus and his disciples inhabited. It is a world of mystical vision. The mosaicist subtracted all substance that might suggest the passage of time or motion through physical space, enabling the devout to contemplate the eternal and motionless world of religious truth.

Manuscript and Icon Painting

As in the Early Christian period, manuscript painting was an important art form during the Early Byzantine era. This period also marked the beginning of another Byzantine pictorial tradition with a long and distinguished history—icon painting.

RABBULA GOSPELS One of the essential Christian beliefs is that following his execution at the hands of the Romans, Christ rose from his tomb after three days and, on the 40th day, ascended from the Mount of Olives to Heaven. The Crucifixion, Resurrection, and Ascension are all subjects of full-page paintings (FIGS. 9-17 and 9-17A) in a manuscript known as the Rabbula Gospels. Written in Syriac by the monk Rabbula at the monastery of Saint John the Evangelist at Zagba in

9-17A Crucifixion and Resurrection, Rabbula Gospels, 586.

Syria, it dates to 586. The page depicting the *Ascension of Christ* (FIG. 9-17) shows Christ, bearded and surrounded by a mandorla, as in the Mount Sinai *Transfiguration* (FIG. 9-16), but here angels bear the mandorla aloft. Below, Mary, other angels, and various apostles look on. The artist set the figures into a mosaic-like frame (compare FIGS. 9-13 and 9-14), and many art historians think the model for the manuscript page was a mural painting or mosaic in a Byzantine church somewhere in the Eastern Empire.

The account of Christ ascending to Heaven is not part of the accompanying text of the Rabbula Gospels but comes from the book of Acts. In the latter, the Virgin is not present at the miraculous event. In the Rabbula Gospels representation, however, the Theotokos occupies a prominent position, central and directly beneath Christ. It is an early example of the important role the Mother of God played in medieval art, both in the East and in the West. Frontal, with a nimbus, and posed as an orant, Mary stands apart from the commotion all about her and looks out at the viewer. Other details also depart from the Gospel texts. Christ, for example, does not rise in a cloud. Rather, as in the vision of Ezekiel in the book of Revelation, he ascends in a mandorla above a fiery winged chariot. The chariot carries the symbols of the four evangelists—the man, lion, ox, and eagle (see "The Four Evangelists," Chapter 11, page 314). This page therefore does not illustrate the Gospels. Rather, its purpose is to present one of the central tenets of Christian faith. Similar compositions appear on pilgrims' flasks from Palestine that were souvenir items reproducing important monuments visited. They reinforce the theory that the Byzantine painter based the Ascension of Christ in the Rabbula Gospels on a lost painting or mosaic in a major church.

ICONS Gospel books such as the *Rabbula Gospels* played an important role in monastic religious life. So, too, did *icons*, which also figured prominently in private devotion (see "Icons and Iconoclasm," page 269). Unfortunately, few early icons survive. Two of the finest examples come from Saint Catherine's monastery at Mount Sinai. One represents the enthroned Theotokos (FIG. 9-18), and the other (FIG. 9-18A) Christ blessing the viewer of the icon. The medium used for both icons is encaustic on wood, continuing a tradition of panel painting in Egypt that, like so much else in the Byzantine world,

9-18A Christ blessing, Mount Sinai, sixth century.

dates to the Roman Empire (FIGS. 7-62, 7-62A, 7-62B, and 7-63).

The smaller of the two illustrated icons (FIG. 9-18) is more ambitious in the number of figures depicted. In a composition reminiscent of the portrait of Anicia Juliana (FIG. 9-3) in the *Vienna Dioskorides*, the Sinai icon painter represented the enthroned Theotokos and Child with Saints Theodore and George. The two guardian saints intercede with the Virgin on the viewer's behalf. Behind

Icons and Iconoclasm

L cons ("images" in Greek) are small portable paintings depicting Christ, the Virgin, or saints (or a combination of all three, as in FIG. 9-18). Icons survive from as early as the fourth century. From the sixth century on, they became enormously popular in Byzantine worship, both public and private. Eastern Christians considered icons a personal, intimate, and indispensable medium for spiritual transaction with holy figures. Some icons (for example, FIG. 9-31) came to be regarded as wonder-working, and believers ascribed miracles and healing powers to them.

Icons, however, were by no means universally accepted. From the beginning, many Christians were deeply suspicious of the practice of imaging the divine, whether on portable panels, on the walls of churches, or especially as statues that reminded them of ancient idols. The opponents of Christian figural art had in mind the Old Testament prohibition of images the Lord dictated to Moses in the Second Commandment: "Thou shalt not make unto thee any graven image or any likeness of anything that is in heaven above, or that is in the earth beneath, or that is in the water under the earth. Thou shalt not bow down thyself to them, nor serve them" (Exod. 20:4, 5). For example, early in the fourth century, Constantia, sister of the emperor Constantine, requested an image of Christ from Eusebius of Caesarea (ca. 263–339), the first great historian of the Church. He rebuked her, referring to the Second Commandment:

Can it be that you have forgotten that passage in which God lays down the law that no likeness should be made of what is in heaven or in the earth beneath? . . . Are not such things banished and excluded from churches all over the world, and is it not common knowledge that such practices are not permitted to us . . . lest we appear, like idol worshipers, to carry our God around in an image?*

Opposition to icons became especially strong in the eighth century, when the faithful often burned incense and knelt before the icons in prayer to seek protection or a cure for illness. Although their purpose was only to evoke the presence of the holy figures addressed in prayer, in the minds of many, icons became identified with the personages represented. Icon veneration became confused with idol worship, and this brought about an imperial ban not only on the making of icons but of all sacred images as well as edicts ordering the destruction of existing images (*iconoclasm*). The *iconoclasts* (breakers of images) and the *iconophiles* (lovers of images) became bitter and irreconcilable enemies. The anguish of the latter is evident in the following graphic description of the deeds of the iconoclasts, written in about 754:

In every village and town one could witness the weeping and lamentation of the pious, whereas, on the part of the impious, [one saw] sacred things trodden upon, [liturgical] vessels turned to other use, churches scraped down and smeared with ashes because they contained holy images. And wherever there were venerable images of Christ or the Mother of God or the saints, these were consigned to the flames or were gouged out or smeared over.

9-18 Virgin (Theotokos) and Child between Saints Theodore and George, icon, sixth or early seventh century. Encaustic on wood, 2' $3'' \times 1'$ $7\frac{3}{8}$ ". Monastery of Saint Catherine, Mount Sinai, Egypt.

Byzantine icons are the heirs to the Roman tradition of portrait painting on small wood panels, but their Christian subjects and function as devotional objects broke sharply from classical models.

The consequences of iconoclasm for the early history of Byzantine art are difficult to overstate. For more than a century, not only did the portrayal of Christ, the Virgin, and the saints cease, but the iconoclasts also destroyed countless works from the first several centuries of Christendom. For this reason, writing a history of Early Byzantine art presents a great challenge to art historians.

*Cyril Mango, trans., *The Art of the Byzantine Empire, 312–1453: Sources and Documents* (reprint of 1972 ed., Toronto: University of Toronto Press, 1986), 17–18.

†Mango, 152.

1 ft

them, two angels gaze upward to a shaft of light where the hand of God appears. The foreground figures are strictly frontal and have a solemn demeanor. Background details are few and suppressed. The shallow forward plane of the picture dominates. Traces of the Greco-Roman illusionism noted in the Anicia Juliana portrait remain in the Virgin's rather personalized features, in her sideways glance, and in the posing of the angels' heads. But the painter rendered the saints' bodies in the new Byzantine manner.

ICONOCLASM The preservation of the Early Byzantine icons at the Mount Sinai monastery is fortuitous but ironic, for opposition to icon worship was especially prominent in the Monophysite provinces of Syria and Egypt. There, in the seventh century, a series of calamities erupted, indirectly causing an imperial ban on images. The Sasanians (see Chapter 2), chronically at war with Rome, swept into the Eastern provinces, and between 611 and 617 they captured the great cities of Antioch, Jerusalem, and Alexandria. The Byzantine emperor Heraclius (r. 610-641) had hardly defeated them in 627 when a new and overwhelming power appeared unexpectedly on the stage of history. The Arabs, under the banner of the new Islamic religion, conquered not only Byzantium's Eastern provinces but also Persia itself, replacing the Sasanians in the ageold balance of power with the Christian West (see Chapter 10). In a few years the Arabs were launching attacks on Constantinople, and Byzantium was fighting for its life.

These were catastrophic years for the Eastern Roman Empire. They terminated once and for all the long story of imperial Rome, closed the Early Byzantine period, and inaugurated the medieval era of Byzantine history. The Byzantine Empire lost almost two-thirds of its territory—many cities and much of its population, wealth, and material resources. The shock of these events may have persuaded the emperor Leo III (r. 717-741) that God was punishing the Christian Roman Empire for its idolatrous worship of icons by setting upon it the merciless armies of the infidel—an enemy that, moreover, shunned the representation not only of God but of all living things in holy places (see Chapter 10). Some scholars believe another motivation for Leo's 726 ban on picturing the divine was to assert the authority of the state over the Church. In any case, for more than a century, Byzantine artists produced little new religious figurative art. In place of images of holy figures, the iconoclasts used symbolic forms already familiar in Early Christian art, for example, the cross (FIG. 9-15).

MIDDLE BYZANTINE ART

In the late eighth and ninth centuries, a powerful reaction against iconoclasm set in. The case in favor of icons had been made forcefully earlier in the eighth century by Saint John of Damascus (ca. 675–ca. 749), who argued that the invisible God the Father had made an image of himself in the son Jesus and in humankind in general and that although icons were likenesses of holy figures, they were not identical to their prototypes. To oppose making images of holy figures was contrary to the actions of God. Two female regents in particular led the movement to restore image-making in the Byzantine Empire: the empresses Irene in 780 and Theodora in 843, after the death of her husband Theophilos (r. 829–842). Unlike Irene's short-lived repeal of the prohibition against icons, Theodora's opposition proved to be definitive and permanent and led to the condemnation of iconoclasm as a heresy.

Shortly thereafter, a new line of emperors, the Macedonian dynasty, resuscitated the Early Byzantine tradition of lavish imperial patronage of religious art and architecture and the making of images of Christ, the Virgin, and saints. Basil I (r. 867–886), head

of the new dynasty, regarded himself as the restorer of the Roman Empire. He denounced as usurpers the Carolingian monarchs of the West (see Chapter 11) who, since 800, had claimed the title "Roman Empire" for their realm. Basil bluntly reminded their emissary that the only true emperor of Rome reigned in Constantinople. They were not Roman emperors but merely "kings of the Germans." Iconoclasm had forced Byzantine artists westward, where doubtless they found employment at the courts of these Germanic kings (see "Theophanu, a Byzantine Princess in Ottonian Germany," Chapter 11, page 328). These Byzantine "refugees" strongly influenced the character of Western European art.

Architecture and Mosaics

The triumph of the iconophiles over the iconoclasts meant Byzantine mural painters, mosaicists, book illuminators, ivory carvers, and metalworkers once again received plentiful commissions. Basil I and his successors also undertook the laborious and costly task of refurbishing the churches the iconoclasts defaced and neglected.

THEOTOKOS, HAGIA SOPHIA In 867, the Macedonian dynasty dedicated a new mosaic (FIG. 9-19) depicting the enthroned Virgin with the Christ Child in her lap in the apse of the Justinianic church of Hagia Sophia. In the vast space beneath the dome of the great church, the figures look undersized, but the seated Theotokos is more than 16 feet tall. An accompanying inscription, now fragmentary, announced "pious emperors" (the Macedonians) had commissioned the mosaic to replace one the "impostors" (the

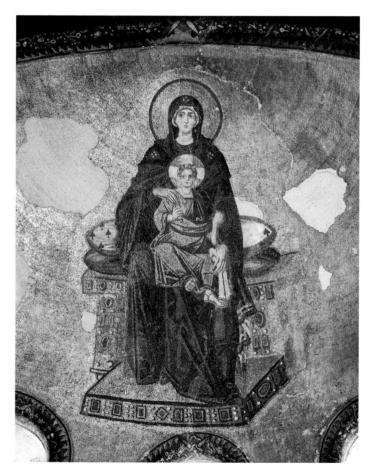

9-19 Virgin (Theotokos) and Child enthroned, apse mosaic, Hagia Sophia, Constantinople (Istanbul), Turkey, dedicated 867. ■

After the repeal of iconoclasm, Basil I dedicated a huge new mosaic in the apse of Hagia Sophia depicting the Virgin and Child enthroned. An inscription says it replaced one the iconoclasts destroyed.

iconoclasts) had destroyed. The declaration may be purely rhetorical, however. There was probably no comparable image of the Virgin and Child in the sixth-century apse.

The ninth-century mosaic echoes the style and composition of the Early Byzantine Mount Sinai icon (FIG. 9-18) of the Theotokos, Christ, and saints. Here, however, the angular placement of the throne and footstool alleviate the strict frontality of Mother and (much older) Child. The mosaicist rendered the furnishings in a perspective that, although imperfect, recalls once more the Greco-Roman roots of Byzantine art. The treatment of the folds of Christ's robes is, by contrast, even more schematic and flatter than in earlier mosaics. These seemingly contradictory stylistic features are not uncommon in Byzantine paintings and mosaics.

9-20 Katholikon (looking northeast), Hosios Loukas, Greece, first quarter of 11th century.

Middle Byzantine churches typically are small and high-shouldered, with a central dome on a drum and exterior wall surfaces with decorative patterns, probably reflecting Islamic architecture.

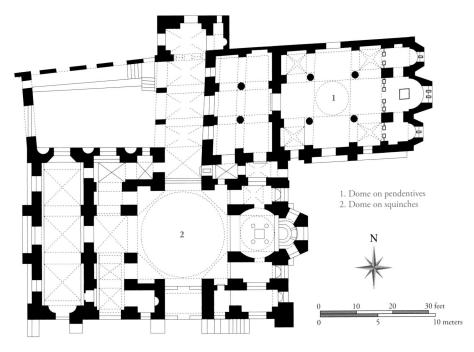

Most significant about the images in the Hagia Sophia apse is their very existence, marking the end of iconoclasm in the Byzantine Empire.

HOSIOS LOUKAS Although the new emperors did not wait long to redecorate the churches of their predecessors, they undertook little new church construction in the decades after the renunciation of iconoclasm in 843. But in the 10th century and through the 12th, a number of monastic churches arose that are the flowers of Middle Byzantine architecture. They feature a brilliant series of variations on the domed central plan. From the exterior, the typical later Byzantine church building is a domed cube, with the dome rising above the square on a kind of cylinder or *drum*. The churches

are small, vertical, high-shouldered, and, unlike earlier Byzantine buildings, have exterior wall surfaces decorated with vivid patterns, probably reflecting Islamic architecture.

The Katholikon (FIGS. 9-20 and 9-21, bottom) at Hosios Loukas (Saint Luke) in Greece, near ancient Delphi, dates to the early 11th century. One of two churches at the site—the other is the Church of the Theotokos (FIG. 9-21, top) built during the second half of the 10th century the Katholikon exemplifies church design during this second golden age of Byzantine art and architecture. Light stones framed by dark red bricks—the so-called *cloisonné* technique, a term borrowed from enamel work (FIG. 11-3)—make up the walls. The interplay of arcuated windows, projecting apses, and varying roof lines further enhances this surface dynamism. The plans of both Hosios Loukas churches show the form of a domed cross in a square with four equal-length, vaulted cross arms (the Greek cross). The dome of the smaller Church of the Theotokos rests on pendentives. In the larger and later Katholikon, the architect placed the dome over an octagon inscribed within a square. The octagon was formed by squinches (FIG. 9-9, right), which play the same role as pendentives in making the transition from a square base to a round dome but create a different visual effect on the interior. This arrangement departs from the older designs, such as Santa Costanza's circular plan (FIG. 8-12), San Vitale's octagonal plan (FIG. 9-11), and Hagia Sophia's dome on pendentives rising from a square (FIGS. 9-6 to 9-8). The Katholikon's complex core lies within two rectangles, the outermost one forming the exterior walls. Thus, in plan from the center out, a circle-octagon-square-oblong series exhibits an intricate interrelationship that is at once complex and unified.

9-21 Plan of the Church of the Theotokos (*top*) and the Katholikon (*bottom*), Hosios Loukas, Greece, second half of 10th and first quarter of 11th century respectively.

The plans of the pair of monastic churches at Hosios Loukas in Greece take the form of a domed square at the center of a cross with four equal-length vaulted arms (the Greek cross).

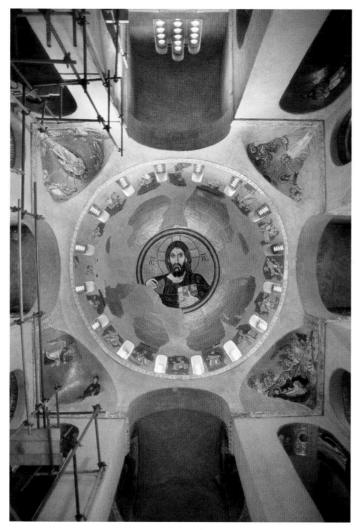

9-22 Interior of the Church of the Dormition (looking into the dome), Daphni, Greece, ca. 1090–1100.

The Daphni dome rests on an octagon formed by squinches, which play the same role as pendentives in making the transition from a square base to a round dome but create a different visual effect.

DAPHNI Similar in general design to the Katholikon, but constructed at the end of the 11th century, is the monastic Church of the Dormition (from the Latin for "sleep," referring to the ascension of the Virgin Mary to Heaven at the moment of her death) at Daphni, near Athens. Like the Katholikon, the church's interior (FIG. **9-22**) creates a mystery out of space, surface, light, and dark. High and narrow, the design forces the viewer's gaze to rise and revolve. The eye is drawn upward toward the dome, but much can distract it in the interplay of flat walls and concave recesses; wide and narrow openings; groin and barrel vaults; and illuminated and dark spaces. Middle Byzantine architects aimed for the creation of complex interior spaces with dramatically shifting perspectives.

At Daphni, the main elements of the late-11th-century pictorial program are intact, although the mosaics underwent restoration in the 19th century. Gazing down from on high in the dome is the fearsome image (FIG. 9-23) of Christ as *Pantokrator* (literally "ruler of all" in Greek but usually applied to Christ in his role as last judge of humankind). The dome mosaic is the climax of an elaborate hierarchical mosaic program including several New Testament episodes below. The Daphni Pantokrator is like a gigantic icon hovering dramatically in space. The image serves to connect the awestruck worshiper in the church below with Heaven through Christ.

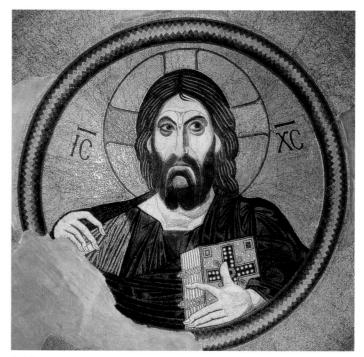

9-23 *Christ as Pantokrator*, dome mosaic in the Church of the Dormition, Daphni, Greece, ca. 1090–1100.

The mosaic of Christ as last judge in the Daphni dome is like a gigantic icon hovering dramatically in space, connecting the awestruck worshiper below with Heaven through Christ.

9-24 *Crucifixion*, mosaic in the north arm of the east wall of the Church of the Dormition, Daphni, Greece, ca. 1090–1100.

The Daphni *Crucifixion* is a subtle blend of Hellenistic style and the more abstract Byzantine manner. The Virgin Mary and Saint John point to Christ on the cross as if to a devotional object.

Born to the Purple: Empress Zoe

A lthough rarely rulers in their own right, Byzantine empresses often wielded great power and influence. Theodora (ca. 500–548) was Justinian's most trusted adviser. In 780, Irene (ca. 755–802) became regent for her 10-year-old son, Constantine VI (r. 780–797), and briefly repealed the imperial ban against icons. In 843, another empress, Theodora (ca. 815–867), convened a religious council, which permanently put an end to iconoclasm. Theodora achieved sainthood as a result.

The most influential Byzantine empress of the 11th century was Zoe Porphyrogenita ("born to the purple"), the elder daughter of Constantine VIII (r. 1025-1028). Born around 978, Zoe was not permitted to marry until just before her father's death, and she remained childless throughout her life. In 1028, Zoe married Romanos III Argyros (r. 1028-1034), Constantine's chosen successor, but she soon fell in love with another member of the court, with whom she may have plotted the drowning of Romanos in his bath. In any case, Zoe married Michael IV (r. 1034-1041) the same day, even though by law widows were supposed to wait a full year before remarrying. Toward the end of Michael's reign, the couple adopted a son, Michael V (r. 1042), who succeeded his father and banished his adoptive mother to a convent. With the support of her subjects, Zoe returned to Constantinople, deposed the emperor, and ruled briefly in 1042 in her own name before marrying Constantine IX Monomachos (r. 1042-1054), who outlived her by four years. Thus, four successive emperors of Byzantium owed their coronations to Zoe.

A mosaic portrait of Zoe and her last husband flanking the enthroned Christ (FIG. 9-25) adorns the east wall of the south gallery of Hagia Sophia. The emperor holds a purse, signifying the generous donation Constantine made to the church. Zoe holds a scroll, also a reference to her gifts to the church. Inscriptions next to the portraits describe Constantine as "pious emperor and king of the Romans" and Zoe as "pious empress." Many scholars believe that the mosaic

9-25 Christ between Constantine IX Monomachus and the empress Zoe, mosaic on the east wall of the south gallery, Hagia Sophia, Constantinople (Istanbul), Turkey, ca. 1028–1035.

Zoe, who was the wife of three emperors, here appears with the enthroned Christ and her third husband. Constantine IX's portrait may have replaced successive portraits of Zoe's previous two husbands.

dates to the reign of Romanos and bore his portrait, and that Zoe twice asked the imperial artists to update the mosaic with new portraits and labels upon each of her subsequent marriages.

The Pantokrator theme was a common one in churches throughout the Byzantine Empire. A mosaic of the Pantokrator also once adorned the dome of the Hosios Loukas Katholikon.

Below the Daphni dome, on the wall beneath the barrel vault of one arm of the Greek cross, is the *Crucifixion* mosaic (FIG. 9-24) in a pictorial style characteristic of the posticonoclastic Middle Byzantine period. Like the Pantokrator mosaic in the dome, the Daphni *Crucifixion* is a subtle blend of the painterly naturalistic style of Late Antiquity and the later, more abstract and formalistic Byzantine style. The Byzantine artist fully assimilated classicism's simplicity, dignity, and grace into a perfect synthesis with Byzantine piety and pathos. The figures have regained the classical organic structure to a surprising degree, particularly compared with figures from the Justinianic period (compare FIGS. 9-13 and 9-14). The style is a masterful adaptation of classical statuesque qualities to the linear Byzantine manner.

In quiet sorrow and resignation, the Virgin and Saint John flank the crucified Christ. A skull at the foot of the cross indicates Golgotha, the "place of skulls." The artist needed nothing else to set the scene. Symmetry and closed space combine to produce an effect of the motionless and unchanging aspect of the deepest mystery of

the Christian religion, as recalled in the ceremony of the Eucharist. The picture is not a narrative of the historical event of Jesus' execution, the approach taken by the carver of the Early Christian ivory panel (FIG. 8-24) examined in the previous chapter. Nor is Christ a triumphant, beardless youth, oblivious to pain and defiant of the laws of gravity. Rather, he has a tilted head and sagging body, and although the Savior is not overtly in pain, blood and water spurt from the wound Longinus inflicted on him, as recounted in Saint John's Gospel. The Virgin and John point to the figure on the cross as if to a devotional object. They act as intercessors between the viewer below and Christ, who, in the dome, appears as the last judge of all humans. The mosaic decoration of the church is the perfect complement to Christian liturgy.

EMPRESS ZOE As in the Early Byzantine period, Middle Byzantine mosaicists also produced portraits of their imperial patrons for church interiors. Several such portraits grace the interior walls of Hagia Sophia (FIG. 9-8) in Constantinople. Perhaps the finest of these is on the east wall of the south gallery. It depicts Constantine IX and Zoe (see "Born to the Purple: Empress Zoe," above) flanking the enthroned Christ (FIG. 9-25). Like the much earlier

imperial portraits (FIGS. 9-13 and 9-14) in San Vitale at Ravenna, the emperor and empress are haloed, but no longer is there a separation between the human and the divine, as in the sixth-century apse. Other Middle Byzantine mosaics depict the imperial couple flanking the Virgin.

9-25A Saint Sophia, Kiev, begun 1037.

SAINT MARK'S, VENICE The Middle Byzantine revival of church building and of figural mosaics extended beyond the Greekspeaking East in the 10th to 12th centuries. The marriage of Anna, the sister of Basil II (r. 976–1025), to the Russian prince Vladimir (r. 980–1015) in 989, marked the introduction of Orthodox Christianity to Russia. Construction of the vast five-apse, 13-dome Cathedral of Saint Sophia (FIG. 9-25A) at Kiev

followed within a half century. A resurgence of religious architecture and of the mosaicist's art also occurred in areas of the former Western Roman Empire where the ties with Constantinople were the strongest. In the Early Byzantine period, Venice, about 80 miles north of Ravenna on the eastern coast of Italy, was a dependency of that Byzantine stronghold. In 751, Ravenna fell to the Lombards,

9-26 Interior of Saint Mark's (looking east), Venice, Italy, begun 1063.

Modeled on a church in Constantinople, Saint Mark's has a central dome over the crossing, four other domes over the arms of the Greek cross, and 40,000 square feet of Byzantine-style mosaics.

who wrested control of most of northern Italy from Constantinople. Venice, however, became an independent power. Its *doges* (dukes) enriched themselves and the city through seaborne commerce, serving as the crucial link between Byzantium and the West.

Venice had obtained the relics of Saint Mark from Alexandria in Egypt in 829, and the doges constructed the first Venetian shrine dedicated to the evangelist-a palace chapel and martyrium (martyr's shrine)—shortly thereafter. Fire destroyed the ninth-century chapel in 976. The Venetians then built a second shrine on the site, but a grandiose new Saint Mark's (FIG. 9-26) begun in 1063 by Doge Domenico Contarini (r. 1043-1071) replaced it. The model for Contarini's church was the Church of the Holy Apostles at Constantinople, built in Justinian's time. That shrine no longer exists, but its key elements were a cruciform plan with a central dome over the crossing and four other domes over the four equal arms of the Greek cross, as at Saint Mark's. Because of its importance to the city, the doges furnished the church's interior with costly altarpieces, such as the Pala d'Oro (FIG. 9-26A), and other liturgical objects and deposited there many of the treasures, including icons (FIG. 9-26B),

9-26A Pala d'Oro, Saint Mark's, Venice, ca. 1105.

9-26B Archangel Michael icon, Venice, ca. 1100.

they brought back as booty from the sack of Constantinople in 1204.

The interior (FIG. 9-26) of Saint Mark's is, like its plan, Byzantine in effect. Light enters through a row of windows at the bases of all five domes, vividly illuminating a rich cycle of mosaics. Both Byzantine and local artists worked on Saint Mark's mosaics over the course of several centuries. Most of the mosaics date to the 12th and 13th centuries. Cleaning and restoration on a grand scale have returned the mosaics to their original splendor, enabling visitors to experience the full radiance of 40,000 square feet of mosaics covering all the walls, arches, vaults, and domes like a gold-brocaded figured fabric.

In the vast central dome, 80 feet above the floor and 42 feet in diameter, Christ ascends to Heaven in the presence of the Virgin Mary and the 12 apostles. In the great arch framing the church crossing are mosaics of the *Crucifixion* and *Resurrection* and Christ's liberation from death (*Anastasis*) of Adam and Eve, Saint John the Baptist, and other biblical figures. The mosaics have explanatory labels in both Latin and Greek, reflecting Venice's position as the key link between Eastern and Western Christendom in the later Middle Ages. The insubstantial figures on the walls, vaults, and domes appear weightless, and they project no farther from their flat field than do the elegant Latin and Greek letters above them. Nothing here reflects on the world of matter, of solids, of light and shade, of perspective space. Rather, the mosaics reveal the mysteries of the Christian faith.

NORMAN SICILY Matching Venetian success in the western Mediterranean were the Normans, the northern French descendants of the Vikings who, having driven the Arabs from Sicily, set up a powerful kingdom there. Though they were the enemies of Byzantium, the Normans, like the Venetians, assimilated Byzantine culture and even employed Byzantine artisans. They also incorporated in their monuments elements of the Islamic art of the Arabs they had defeated. The Normans' Palatine (palace) Chapel (FIG. 9-27A) at Palermo with its prismatic (muqarnas) ceiling, a characteristic Muslim form (see

9-27 Pantokrator, Theotokos and Child, angels, and saints, apse mosaic in the cathedral, Monreale, Italy, ca. 1180–1190.

In centrally planned Byzantine churches, the image of the Pantokrator usually appears in the main dome, but Monreale's cathedral is a longitudinal basilica. The semidome of the apse is its only vault.

Chapter 10), is one example of the rich interplay of Western Christian, Byzantine, and Islamic cultures in Norman Sicily.

The mosaics of the great basilican church of Monreale (FIG. 9-27), not far from Palermo, are striking evidence of Byzantine influence. They rival those of Saint Mark's in both quality and extent. One scholar has estimated the Monreale mosaics required more than 100 million glass and stone tes-

9-27A Cappella Palatina, Palermo, begun 1142.

serae. The Norman king William II (r. 1087–1100) paid for the mosaics, and the artists portrayed him twice in the church, continuing the theme of royal presence and patronage of the much earlier Ravenna portraits of Justinian and Theodora (FIGS. 9-13 and 9-14) at San Vitale and the Middle Byzantine portraits of Constantine IX and Zoe (FIG. 9-25) in Hagia Sophia in Constantinople. In one panel, William stands next to the enthroned Christ, who places his hand on William's crown. In the second, the king kneels before the Virgin and presents her with a model of the Monreale church.

The apse mosaics (FIG. 9-27) are especially impressive. The image of Christ as Pantokrator is in the vault. In Byzantium, the Pantokrator's image usually appears in the main dome (FIGS. 9-22 and 9-23). But the Monreale church is a basilica, longitudinally planned in the Western tradition. The semidome of the apse, the only vault in the building and its architectural focus, was the logical choice for the most important element of the pictorial program. Below the Pantokrator in rank and dignity is the enthroned Theotokos, flanked by archangels and the 12 apostles, symmetrically arranged in balanced groups. Lower on the wall (and less elevated in the church hierarchy) are popes, bishops, and other saints. The artists observed the stern formalities of Byzantine style here, far from Constantinople. The Monreale mosaics, like those at Saint Mark's (FIG. 9-26) in Venice and in the Palatine Chapel (FIG. 9-27A) in Palermo, testify to the stature of Byzantium and of Byzantine art in medieval Italy.

Ivory Carving and Painting

Middle Byzantine artists also produced costly carved ivories in large numbers. The three-part *triptych* replaced the earlier diptych as the standard format for ivory panels.

HARBAVILLE TRIPTYCH One example of this type is the *Harbaville Triptych* (FIG. 9-28), a portable shrine with hinged wings used for private devotion. Ivory triptychs were very popular—among those who could afford such luxurious items—and they often replaced icons for use in personal prayer. Carved on

9-28 Christ enthroned with saints (*Harbaville Triptych*), ca. 950. Ivory, central panel $9\frac{1}{2}$ " \times $5\frac{1}{2}$ ". Musée du Louvre, Paris.

In this small three-part shrine with hinged wings used for private devotion, the ivory carver depicted the figures with looser classical stances, in contrast to the frontal poses of most Byzantine figures.

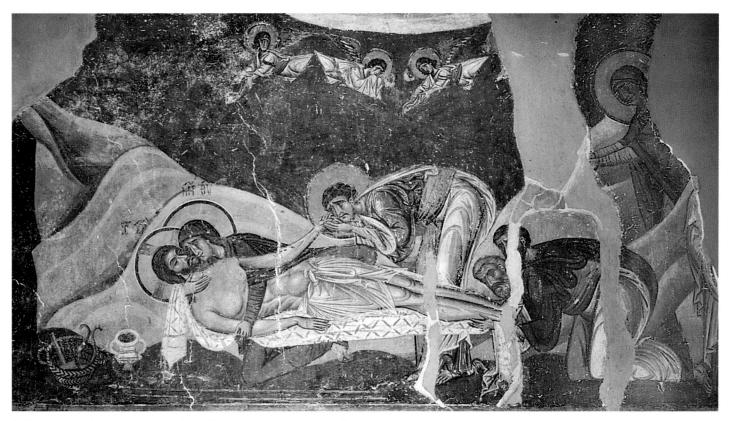

9-29 Lamentation, wall painting, Saint Pantaleimon, Nerezi, Macedonia, 1164.

Working in the Balkans in an alternate Byzantine mode, this painter staged the emotional scene of the *Lamentation* in a hilly landscape below a blue sky and peopled it with fully modeled figures.

the wings of the *Harbaville Triptych*, both inside and out, are four pairs of full-length figures and two pairs of medallions depicting saints. A cross dominates the central panel on the back of the triptych (not illustrated). On the inside is a scene of *Deësis* (supplication). Saint John the Baptist and the Theotokos appear as intercessors, praying on behalf of the viewer to the enthroned Savior. Below them are five apostles.

The formality and solemnity usually associated with Byzantine art, visible in the mosaics of Ravenna and Monreale, yielded here to a softer, more fluid technique. The figures may lack true classical contrapposto, but the looser stances (most stand on bases, like freestanding statues) and three-quarter views of many of the heads relieve the hard austerity of the customary frontal pose. This more natural, classical spirit was a second, equally important stylistic current of the Middle Byzantine period. It also surfaced in mural painting and book illumination.

NEREZI When the emperors lifted the ban against religious images and again encouraged religious painting at Constantinople, the impact was felt far and wide. The style varied from region to region, but a renewed enthusiasm for picturing the key New Testament figures and events was universal. In 1164, at Nerezi in Macedonia, Byzantine painters embellished the church of Saint Pantaleimon with murals of great emotional power. One of these, *Lamentation* (FIG. 9-29), is an image of passionate grief over the dead Christ. The artist captured Christ's followers in attitudes, expressions, and gestures of quite human bereavement. Joseph of Arimathea and the disciple Nicodemus kneel at his feet. Mary presses her cheek against her dead son's face. Saint John clings to Christ's left hand. In the Gospels, neither Mary nor John was present at the entombment of Christ. Their inclusion here, as elsewhere in Middle Byzantine art, intensified for the viewer the emotional impact of Christ's death. These

representations parallel the development of liturgical hymns recounting the Virgin lamenting her son's death on the cross.

At Nerezi, the painter set the scene in a hilly landscape below a blue sky—a striking contrast to the abstract golden world of the mosaics favored for church walls elsewhere in the Byzantine Empire. This Balkan artist strove to make utterly convincing an emotionally charged realization of the theme by staging the *Lamentation* in a more natural setting and peopling it with fully modeled actors. This alternate representational mode is no less Byzantine than the frontal, flatter figures at Constantinople and Ravenna. In time, this more naturalistic style would also be emulated in Italy (FIG. 14-8).

PARIS PSALTER Another example of this classical-revival style is a page from a book of the Psalms of David. The so-called Paris Psalter (FIG. 9-30) reasserts the artistic values of the Greco-Roman past with astonishing authority. Art historians believe the manuscript dates from the mid-10th century—the so-called Macedonian Renaissance, a time of enthusiastic and careful study of the language and literature of ancient Greece, and of humanistic reverence for the classical past. It is not surprising that artists would once again draw inspiration from the Hellenistic naturalism of the pre-Christian Mediterranean world.

David, the psalmist, surrounded by sheep, goats, and his faithful dog, plays his harp in a rocky landscape with a town in the background. Similar settings appeared frequently in Pompeian murals. Befitting an ancient depiction of Orpheus, the Greek hero who could charm even inanimate objects with his music, allegorical figures accompany the Old Testament harpist. Melody looks over his shoulder, and Echo peers from behind a column. A reclining male figure points to a Greek inscription identifying him as representing the mountain of Bethlehem. These allegorical figures do not appear in the Bible. They are the stock population of Greco-Roman painting.

9-30 David Composing the Psalms, folio 1 verso of the Paris Psalter, ca. 950–970. Tempera on vellum, 1' $2\frac{1}{8}$ " \times $10\frac{1}{4}$ ". Bibliothèque Nationale, Paris.

During the Macedonian Renaissance, Byzantine artists revived the classical style. This painter portrayed David as if a Greek hero, accompanied by personifications of Melody, Echo, and Bethlehem.

Apparently, the artist had seen a work from Late Antiquity or perhaps earlier and partly translated it into a Byzantine pictorial idiom. In works such as this, Byzantine artists kept the classical style alive in the Middle Ages.

VLADIMIR VIRGIN Nothing in Middle Byzantine art better demonstrates the rejection of the iconoclastic viewpoint than the painted icon's return to prominence. After the restoration of images, such icons multiplied by the thousands to meet public and private demand. In the 11th century, the clergy began to display icons in hierarchical order (Christ, the Theotokos, John the Baptist, and then other saints, as on the *Harbaville Triptych*) in tiers on the *templon*, the low columnar screen separating the sanctuary from the main body of a Byzantine church.

The Vladimir Virgin (FIG. 9-31) is the most renowned Middle Byzantine icon produced in Russia. Unfortunately, the revered image has been repainted many times, and only traces of the original surface remain. Descended from works such as the Mount Sinai icon (FIG. 9-18), the Vladimir Virgin clearly reveals the stylized abstraction resulting from centuries of working and reworking the conventional image. Probably the work of a painter from Constantinople, the Vladimir Virgin displays all the characteristic traits of the Byzantine icon of the Virgin and Child: the Virgin's long,

9-31 Virgin of Compassion icon (*Vladimir Virgin*), late 11th or early 12th century, with later repainting. Tempera on wood, 2' $6^{\frac{1}{2}''} \times 1'$ 9''. Tretyakov Gallery, Moscow.

In this icon, the artist depicted Mary as the Virgin of Compassion, who presses her cheek against her son's as she contemplates his future. The reverse side shows the instruments of Christ's passion.

straight nose and small mouth; the golden rays in the infant's drapery; the decorative sweep of the unbroken contour that encloses the two figures; and the flat silhouette against the golden ground. But this is a much more tender and personalized image of the Virgin than that in the Mount Sinai icon. Here Mary is the Virgin of Compassion, who presses her cheek against her son's in an intimate portrayal of Mother and Child. A deep pathos infuses the image as Mary contemplates the future sacrifice of her son. (The back of the icon bears images of the instruments of Christ's Passion.)

The icon of Vladimir, like most icons, has seen hard service. Placed before or above altars in churches or private chapels, the icon became blackened by the incense and smoke from candles that burned before or below it. It was taken to Kiev (Ukraine) in 1131, then to Vladimir (Russia) in 1155 (hence its name), and in 1395, as a wonder-working image, to Moscow to protect that city from Timur (Tamerlane) and his Mongol armies (see Chapter 10). The Russians believed the sacred picture saved the city of Kazan from later Tartar invasions and all of Russia from the Poles in the 17th century. The *Vladimir Virgin* is a historical symbol of Byzantium's religious and cultural mission to the Slavic world.

LATE BYZANTINE ART

When rule passed from the Macedonian to the Comnenian dynasty in the later 11th and 12th centuries, three events of fateful significance changed Byzantium's fortunes for the worse. The Seljuk Turks conquered most of Anatolia. The Byzantine Orthodox Church broke finally with the Church of Rome. And the Crusades brought the Latins (a generic term for the peoples of the West) into Byzantine lands on their way to fight for the Christian cross against the Saracens (Muslims) in the Holy Land (see "The Crusades," Chapter 12, page 346).

Crusaders had passed through Constantinople many times en route to "smite the infidel" and had marveled at its wealth and magnificence. Envy, greed, religious fanaticism (the Latins called the Greeks "heretics"), and even ethnic enmity motivated the Crusaders when, during the Fourth Crusade in 1203 and 1204, the Venetians persuaded them to divert their expedition against the Muslims in Palestine and to attack Constantinople instead. They took the city and sacked it. Nicetas Choniates, a contemporaneous historian, expressed the feelings of the Byzantines toward the Crusaders: "The accursed Latins would plunder our wealth and wipe out our race. . . . Between us there can be only an unbridgeable gulf

of hatred. . . . They bear the Cross of Christ on their shoulders, but even the Saracens are kinder."⁷

The Latins set up kingdoms within Byzantium, notably in Constantinople itself. What remained of Byzantium split into three small states. The Palaeologans ruled one of these, the kingdom of Nicaea. In 1261, Michael VIII Palaeologus (r. 1259–1282) succeeded

in recapturing Constantinople. One of the gems of Late Byzantine architecture the church dedicated to Saint Catherine (FIG. 9-32A) in Constantinople—dates to his reign. But Michael's empire was no more than a fragment, and even that disintegrated during the next two centuries. Isolated from the Christian West by Muslim conquests in the Balkans and

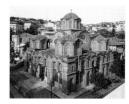

9-32A Saint Catherine, Thessaloniki, ca. 1280.

besieged by Muslim Turks to the East, Byzantium sought help from the West. It was not forthcoming. In 1453, the Ottoman Turks, then a formidable power, took Constantinople and brought to an end the long history of Byzantium (see Chapter 10). But despite the state's grim political condition under the Palaeologan dynasty, the arts flourished well into the 14th century.

9-32 Anastasis, fresco in the apse of the parekklesion of the Church of Christ in Chora (now the Kariye Museum), Constantinople (Istanbul), Turkey, ca. 1310–1320.

In this Late Byzantine funerary chapel, Christ, a white apparition surrounded by a luminous mandorla, raises Adam and Eve from their tombs as John the Baptist and Kings David and Solomon look on.

Painting

During the 14th and 15th centuries, artists throughout the Byzantine world produced masterpieces of mural and icon painting rivaling those of the earlier periods. Four characteristic examples from the old capital of Constantinople and as far away as Russia illustrate the range and quality of painting during the Late Byzantine period.

CHRIST IN CHORA A fresco of the *Anastasis* (FIG. 9-32) is in the apse of the *parekklesion* (side chapel, in this instance a funerary chapel) of the Church of Christ in Chora in Constantinople. One of many subsidiary subjects that made up the complex mosaic program of Saint Mark's (FIG. 9-26) in Venice, the *Anastasis* is here central to a cycle of pictures portraying the themes of human mortality and redemption by Christ and of the intercession of the Virgin, both appropriate for a funerary chapel. Christ, trampling Satan and all the locks and keys of his prison house of Hell, raises Adam and Eve from their tombs. Looking on are John the Baptist, King David, and King Solomon on the left, and various martyr saints on the right. Christ, central and in a luminous mandorla, reaches out equally to Adam and Eve. The action is swift and smooth, the

supple motions executed with the grace of a ballet. The figures float in a spiritual atmosphere, spaceless and without material mass or shadow-casting volume. This same smoothness and lightness also characterize the modeling of the figures and the subtly nuanced coloration. The jagged abstractions of drapery found in many earlier Byzantine frescoes and mosaics are gone in a return to the fluid delineation of drapery characteristic of the long tradition of classical illusionism.

Throughout the centuries, Byzantine artists looked back to Greco-Roman illusionism. But unlike classical artists, Byzantine painters and mosaicists did not believe the systematic observation of material nature should be the source of their representations of the eternal. They drew their images from a persistent and conventionalized vision of a spiritual world unsusceptible to change. That consistent vision is what unites works as distant in time as the sixth-century apse mosaic (FIG. 9-16) at Mount Sinai and the 14th-century fresco in the Church of Christ in Chora.

OHRID ICONS Icon painting may most intensely reveal Byzantine spirituality. In the Late Byzantine period, the Early Byzantine templon developed into an *iconostasis* (icon stand), a high screen with doors. As its name implies, the iconostasis supported tiers of painted

devotional images, which began to be produced again in large numbers, both in Constantinople and throughout the diminished Byzantine Empire.

One example (FIG. 9-33), notable for the lavish use of finely etched silver foil to frame the painted figure of Christ as Savior of Souls, dates to the beginning of the 14th century. It comes from the church of Saint Clement at Ohrid in Macedonia, where many Late Byzantine icons imported from the capital have been preserved. The painter of the Ohrid Christ, in a manner consistent with Byzantine art's conservative nature, adhered to an iconographical and stylistic tradition dating to the earliest icons from the monastery at Mount Sinai. As elsewhere (FIGS. 9-18A, 9-23, and 9-25), the Savior holds a bejeweled Bible in his left hand while he blesses the faithful with his right hand. The mixture of styles is typical of Byzantine painting. Note especially the juxtaposition of Christ's fully modeled head and neck, which reveal the Byzantine artist's Greco-Roman heritage, with the schematic linear folds of Christ's garment, which do not envelop the figure but rather seem to be placed in front of it.

Late Byzantine icons often have paintings on two sides because they were carried in processions. When the clergy brought the icons into the church, they did not mount them on the iconostasis but exhibited them on stands so they could be viewed from both sides. The Ohrid icon of Christ has a painting of the *Crucifixion* on its reverse. Another double icon

9-33 Christ as Savior of Souls, icon from Saint Clement, Ohrid, Macedonia, early 14th century. Tempera, linen, and silver on wood, $3'\frac{1}{4}'' \times 2'2\frac{1}{2}''$. Icon Gallery of Saint Clement, Ohrid.

Notable for the lavish use of finely etched silver foil, this icon typifies Byzantine stylistic complexity. Christ's fully modeled head and neck contrast with the schematic linear folds of his garment.

1 ft

9-34 *Annunciation*, reverse of two-sided icon from the Church of the Virgin Peribleptos, Ohrid, Macedonia, early 14th century. Tempera and linen on wood, $3'\frac{5}{8}'' \times 2'2^{\frac{3}{4}''}$. Icon Gallery of Saint Clement, Ohrid.

Late Byzantine icons often have two painted sides because they were carried in processions. On this icon the Virgin Mary appears on the front and this *Annunciation* scene on the back.

from Ohrid, also imported from Constantinople, represents the Virgin on the front as Christ's counterpart as Savior of Souls. The Annunciation (FIG. 9-34) is the subject of the reverse. With a commanding gesture of heavenly authority, the angel Gabriel announces to Mary that she is to be the Mother of God. She responds with a simple gesture conveying both astonishment and acceptance. The gestures and attitudes of the figures are again conventional, as are the highly simplified architectural props. The painter rendered the latter in inconsistent perspective derived from classical prototypes, but set the sturdy three-dimensional forms against an otherworldly golden sky, suggesting the sacred space in which the narrative unfolds. This icon therefore also exemplifies the diversity of stylistic sources that characterizes Byzantine art throughout its long history.

ANDREI RUBLYEV Icon painting flourished also in Russia. Russian icons usually have strong patterns, firm lines, and intense contrasting colors, which serve to heighten the legibility of the icons in the wavering candlelight and clouds of incense worshipers encountered in church interiors. For many art historians, Russian painting reached a climax in the work of Andrei Rublyev (ca. 1370–1430). His nearly five-foot-tall panel (FIG. 9-35) depicting the three Old Testament angels who appeared to Abraham is a work of great spiritual power. Painted during the tenure of Photius as Metropolitan (Orthodox archbishop) of Russia (FIG. 9-35A), it is

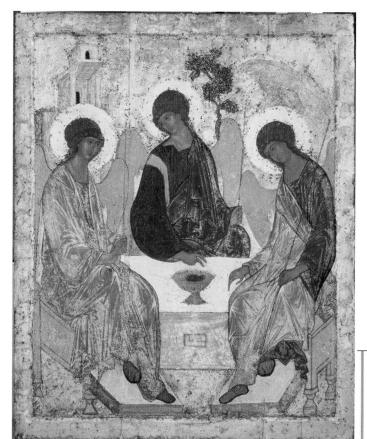

9-35 Andrei Rublyev, *Three Angels* (Old Testament Trinity), ca. 1410. Tempera on wood, 4′ 8″ × 3′ 9″. Tretyakov Gallery, Moscow. ■

This exceptionally large icon featuring subtle line and vivid colors is one of the masterworks of Russian painting. It depicts the three angels who appeared to Abraham, prefiguring the Trinity.

an unsurpassed example of subtle line in union with what once were intensely vivid colors, now faded. The angels sit about a table, each framed with a halo and sweeping wings, three nearly identical figures distinguished primarily by their garment colors. The light linear play of the draperies sets off the tranquil demeanor of the figures. Juxtapositions of complementary hues add intensity to the coloration. The blue and green folds of the central figure's

9-35A Large sakkos of Photius, ca. 1417.

cloak, for example, stand out starkly against the deep-red robe and the gilded orange of the wings. In the figure on the left, the highlights of the orange cloak are an opalescent blue-green. The unmodulated saturation, brilliance, and purity of the color harmonies are the hallmark of Rublyev's style.

THE THIRD ROME With the fall of Constantinople in 1453, Russia became Byzantium's self-appointed heir, defending Christendom against the infidel. The court of the tsar (derived from Caesar) declared: "Because the Old Rome has fallen, and because the Second Rome, which is Constantinople, is now in the hands of the godless Turks, thy kingdom, O pious Tsar, is the Third Rome. . . . Two Romes have fallen, but the Third stands, and there shall be no more." Rome, Byzantium, Russia—Old Rome, New Rome, and Third Rome—were a continuum, spanning two and a half millennia during which artists and architects produced many of the most significant paintings, sculptures, and buildings in the long history of art through the ages.

BYZANTIUM

EARLY BYZANTINE ART 324-726

- Constantine founded Constantinople on the site of the ancient Greek city of Byzantium in 324 and dedicated this "New Rome" to the Christian God in 330.
- The first golden age of Byzantine art was the result of the lavish patronage of Justinian (r. 527–565). In Constantinople alone, Justinian built or restored more than 30 churches. The greatest was Hagia Sophia, which rivaled the architectural wonders of Old Rome. A brilliant fusion of central and longitudinal plans, its 180-foot-high dome rests on pendentives but seemed to contemporaries to be suspended "by a golden chain from Heaven."

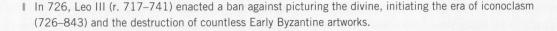

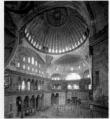

Hagia Sophia, Constantinople, 532–537

San Vitale, Ravenna, 526-547

MIDDLE BYZANTINE ART 843-1204

- Empress Theodora repealed iconoclasm in 843, and in 867, Basil I (r. 867–886) dedicated a new mosaic depicting the Theotokos (Mother of God) in Hagia Sophia. It marked the triumph of the iconophiles over the iconoclasts.
- I Ivory carving and manuscript painting flourished during the Middle Byzantine period, as during the preceding era. Hinged ivory shrines, such as the *Harbaville Triptych*, were popular for use in private prayer. The *Paris Psalter* is noteworthy for the conscious revival of classical naturalism.
- Middle Byzantine churches, such as those at Hosios Loukas and Daphni, have highly decorative exterior walls and feature domes that rest on drums above the center of a Greek cross. The climax of the interior mosaic programs was often an image of Christ as Pantokrator in the dome.

Paris Psalter, ca. 950-970

Church of the Dormition, Daphni, ca. 1090-1100

LATE BYZANTINE ART 1261-1453

- In 1204, Latin Crusaders sacked Constantinople, bringing to an end the Middle Byzantine era. In 1261, Michael VIII Palaeologus (r. 1259–1282) succeeded in recapturing the city. Constantinople remained in Byzantine hands until its capture by the Ottoman Turks in 1453.
- I Important mural paintings of the Late Byzantine period are in the Church of Christ in Chora. An extensive picture cycle portrays Christ as redeemer. In the apse, he raises Adam and Eve from their tombs.
- Late Byzantine icons were displayed in tiers on an iconostasis or on individual stands so that the paintings on both sides could be seen. Christ or the Virgin usually appeared on the front. The reverse depicted a narrative scene from the life of Christ.

Annunciation, Ohrid, early 14th century

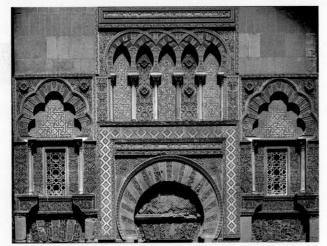

The horseshoe and multilobed arches of the gates to the Mezquita at Córdoba were part of the expansion and remodeling of the mosque carried out by the Umayyad caliph al-Hakam II.

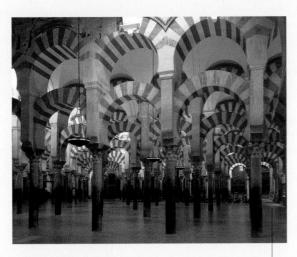

Islamic architecture draws on diverse sources. The horseshoe arches of the Córdoba mosque's prayer hall may derive from Visigothic architecture. The Arabs overthrew that Christian kingdom in 711.

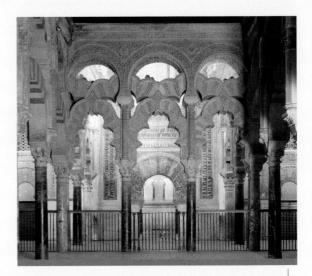

In the 10th century, al-Hakam II also added a maqsura to the Córdoba Mezquita. The hall highlights Muslim architects' bold experimentation with curvilinear shapes and different kinds of arches.

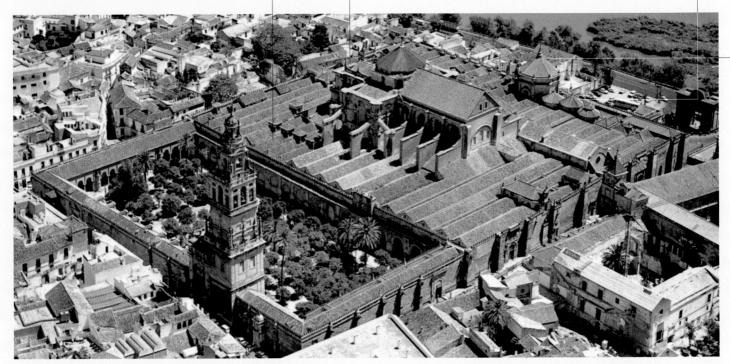

10-1 Aerial view of the Mezquita (Great Mosque), Córdoba, Spain, 8th to 10th centuries; rededicated as the Cathedral of Saint Mary, 1236.

Byzantine artists installed the mosaics in the mihrab dome in the Córdoba mosque, but the decorative patterns formed by the crisscrossing ribs and the multilobed arches are distinctly Islamic.

10

THE ISLAMIC WORLD

THE RISE AND SPREAD OF ISLAM

At the time of Muhammad's birth around 570, the Arabian peninsula was peripheral to the Byzantine and Sasanian empires. The Arabs, nomadic herders and caravan merchants who worshiped many gods, resisted the Prophet's teachings of Islam, an Arabic word meaning "submission to the one God (Allah in Arabic)." Within a decade of Muhammad's death in 632, however, Muslims ("those who submit") ruled Arabia, Palestine, Syria, Iraq, and northern Egypt. From there, the new religion spread rapidly both eastward and westward.

With the rise of Islam also came the birth of a compelling new worldwide tradition of art and architecture. In the Middle East and North Africa, Islamic art largely replaced Late Antique art. In India, the establishment of Muslim rule at Delhi in the early 13th century brought Islamic art and architecture to South Asia (see Chapter 32). In fact, perhaps the most famous building in Asia, the Taj Mahal (Fig. 32-6) at Agra, is an Islamic mausoleum. At the opposite end of the then-known world, Abd al-Rahman I (r. 756–788) founded a Spanish Muslim dynasty at Córdoba, which became the center of a brilliant court culture that profoundly influenced medieval Europe.

The jewel of the capital at Córdoba was its Great Mosque (FIG. 10-1), begun in 784 and enlarged several times during the 9th and 10th centuries until it eventually became one of the largest mosques in the Islamic West. In 1236, the Christians rededicated and remodeled the shrine as a church (the tallest part of the complex, at the center of the aerial view, is Córdoba's cathedral) after they recaptured the city from the Muslims.

A visual feast greets all visitors to the mosque. Its Muslim designers used overlapping horseshoeshaped arches (which became synonymous with Islamic architecture in Europe) in the uppermost zone of the eastern and western gates to the complex. Double rows of arches surmount the more than 500 columns in the mosque's huge prayer hall. Even more elaborate multilobed arches on slender columns form dazzling frames for other areas of the mosque, especially in the *maqsura*, the hall reserved for the ruler, which at Córdoba connects the mosque to the palace. Crisscrossing ribs form intricate decorative patterns in the complex's largest dome.

The Córdoba Mezquita (Spanish, "mosque") typifies Islamic architecture both in its conformity to the basic principles of mosque design and in its incorporation of distinctive regional forms.

EARLY ISLAMIC ART

The religion of Islam arose in Arabia early in the seventh century, after the Prophet Muhammad began to receive God's revelations (see "Muhammad and Islam," page 285). At that time, the Arabs were not major players on the world stage. Yet within little more than a century, the eastern Mediterranean, which Byzantium once ringed and ruled, had become an Islamic lake, and the armies of Muhammad's successors had subdued the Middle East, long the seat of Persian dominance and influence. The swiftness of the Islamic advance is among the wonders of history. By 640, Muslims ruled Syria, Palestine, and Iraq. In 642, the Byzantine army abandoned Alexandria, marking the Muslim conquest of Lower (northern) Egypt. In 651, Islamic forces ended more than 400 years of Sasanian rule in Iran (see Chapter 2). All of North Africa was under Muslim control by 710. A victory at Jerez de la Frontera in southern Spain in 711 seemed to open all of western Europe to the Muslims. By 732, they had advanced north to Poitiers in France. There, however, an army of Franks under Charles Martel (r. 714-741), the grandfather of Charlemagne, opposed them successfully (see Chapter 11), halting Islamic expansion at the Pyrenees. In Spain, in contrast, the Muslim rulers of Córdoba (FIG. 10-1) flourished until 1031, and not until 1492 did Islamic influence and power end in Iberia. That year the army of King Ferdinand II of Aragon (r. 1479-1516) and Queen Isabella, the sponsors of Columbus's voyage to the New World, overthrew the caliphs of Granada. In the East, the Muslims reached the Indus River by 751 (see Chapter 32). Only in Anatolia did stubborn Byzantine resistance slow their advance. Relentless Muslim pressure against the shrinking Byzantine Empire eventually brought about its collapse in 1453, when the Ottoman Turks entered Constantinople (see Chapter 9).

Military might alone cannot, however, account for the irresistible and far-ranging sweep of Islam from Arabia to India to North Africa and Spain (MAP 10-1). That Islam endured in the lands Muhammad's successors conquered can be explained only by the nature of the Islamic faith and its appeal to millions of converts. Islam remains today one of the world's great religions, with adherents on all continents. Its sophisticated culture has had a major influence around the globe. Arab scholars laid the foundations of arithmetic and algebra and made significant contributions to astronomy, medicine, and the natural sciences. During the 12th and 13th centuries, Christian scholars in the West eagerly studied Arabic translations of Aristotle and other ancient Greek writers. Arabic love lyrics and poetic descriptions of nature inspired the early French troubadours.

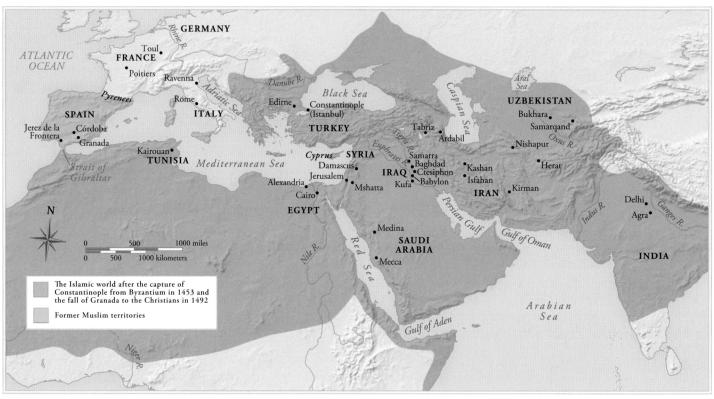

MAP 10-1 The Islamic world around 1500.

622

THE ISLAMIC WORLD

I Muhammad abandons Mecca for Medina, 622 Kufic calligraphy

756

- I Umayyads (r. 661-750), the first Islamic dynasty, build Dome of the Rock in Jerusalem and Great Mosque in Damascus
- Abbasids produce earliest Korans with
- Spanish Umayyad dynasty builds Great Mosque in capital of Córdoba
- I Nasrids embellish Alhambra with magnificent palaces
- I Fatimid, Ayyubid, and Mamluk dynasties in Egypt are lavish art patrons
- Ottomans capture Byzantine Constantinople in 1453 and develop the domed central-

1924

■ Flowering of Timurid book illumination under Shah Tahmasp

1453

Safavid artisans perfect the manufacture of cuerda seca and mosaic tiles

Muhammad and Islam

uhammad, revered by Muslims as the Final Prophet in the line including Abraham, Moses, and Jesus, was a native of Mecca on the west coast of Arabia. Born around 570 into a family of merchants in the great Arabian caravan trade, Muhammad was critical of the polytheistic religion of his fellow Arabs. In 610, he began to receive the revelations of God through the archangel Gabriel. Opposition to Muhammad's message among the Arabs was strong and led to persecution. In 622, the Prophet and his followers abandoned Mecca for a desert oasis eventually called Medina ("City of the Prophet"). Islam dates its beginnings from this flight, known as the Hijra (emigration).* Barely eight years later, in 630, Muhammad returned to Mecca with 10,000 soldiers. He took control of the city, converted the population to Islam, and destroyed all the idols. But he preserved as the Islamic world's symbolic center the small cubical building that had housed the idols, the Kaaba (from the Arabic for "cube"). The Arabs associated the Kaaba with the era of Abraham and Ishmael, the common ancestors of Jews and Arabs. Muhammad died in Medina in 632.

The essential tenet of Islam is acceptance of and submission to God's will. Muslims must live according to the rules laid down in the collected revelations communicated through Muhammad during his lifetime. The *Koran*, Islam's sacred book, codified by the Muslim ruler Uthman (r. 644–656), records Muhammad's revelations. The word "Koran" means "recitations"—a reference to Gabriel's instructions to Muhammad in 610 to "recite in the name of God." The Koran is composed of 114 *surahs* (chapters) divided into verses.

The profession of faith in the one God is the first of five obligations binding all Muslims. In addition, the faithful must worship five times daily facing Mecca, give alms to the poor, fast during the month of Ramadan, and once in a lifetime—if possible—make a

pilgrimage to Mecca. The revelations in the Koran are not the only guide for Muslims. Muhammad's words and exemplary ways and customs, the *Hadith*, recorded in the *Sunnah*, offer models to all Muslims on ethical problems of everyday life. The reward for the faithful is Paradise.

Islam has much in common with Judaism and Christianity. Muslims think of their religion as a continuation, a completion, and in some sense a reformation of those other great monotheisms. Islam, for example, incorporates many Old Testament teachings, with their sober ethical standards and rejection of idol worship. But, unlike Jesus in the New Testament Gospels, Muhammad did not claim to be divine. Rather, he was God's messenger, the Final Prophet, who purified and perfected the common faith of Jews, Christians, and Muslims in one God. Islam also differs from Judaism and Christianity in its simpler organization. Muslims worship God directly, without a hierarchy of rabbis, priests, or saints acting as intermediaries.

In Islam, as Muhammad defined it, the union of religious and secular authority was even more complete than in Byzantium. Muhammad established a new social order, replacing the Arabs' old decentralized tribal one, and took complete charge of his community's temporal as well as spiritual affairs. After Muhammad's death, the *caliphs* (from the Arabic for "successor") continued this practice of uniting religious and political leadership in one ruler.

*Muslims date events beginning with the Hijra in the same way Christians reckon events from Christ's birth and the Romans before them began their calendar with Rome's founding by Romulus and Remus in 753 BCE. The Muslim year is, however, a 354-day year of 12 lunar months, and thus dates cannot be converted by simply adding 622 to Christian-era dates.

Architecture

During the early centuries of Islamic history, the Muslim world's political and cultural center was the Fertile Crescent of ancient Mesopotamia. The caliphs of Damascus (capital of modern Syria) and Baghdad (capital of Iraq) appointed provincial governors to rule the vast territories they controlled. These governors eventually gained relative independence by setting up dynasties in various territories and provinces, including the Umayyads in Syria (661–750) and in Spain (756–1031), the Abbasids in Iraq (750–1258, largely nominal after 945), the Samanids in Uzbekistan (819–1005), the Fatimids in Egypt (909–1171), and others.

Like other potentates before and after, the Muslim caliphs were builders on a grand scale. The first Islamic buildings, both religious and secular, are in the Middle East, but important early examples of Islamic architecture still stand also in North Africa, Spain, and Central Asia.

DOME OF THE ROCK The first great Islamic building was the Dome of the Rock (FIG. 10-2) in Jerusalem. The Muslims had taken the city from the Byzantines in 638, and the Umayyad caliph Abd al-Malik (r. 685–705) erected the monumental shrine between 687 and 692 as an architectural tribute to the triumph of Islam. The Dome of the Rock marked the coming of the new religion to the city that had been, and still is, sacred to both Jews and

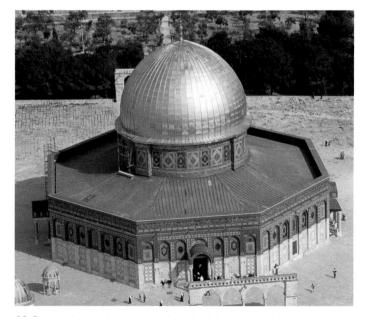

10-2 Aerial view (looking southwest) of the Dome of the Rock, Jerusalem, 687-692.

Abd al-Malik built the Dome of the Rock to mark the triumph of Islam in Jerusalem on a site sacred to Muslims, Christians, and Jews. The shrine takes the form of an octagon with a towering dome.

10-3 Interior of the Dome of the Rock, Jerusalem, 687-692.

On the interior of the Dome of the Rock, the original mosaics are largely intact. At the center of the rotunda is the rocky outcropping later associated with Adam, Abraham, and Muhammad.

Christians. The structure rises from a huge platform known as the Noble Enclosure, where in ancient times the Hebrews built the Temple of Solomon that the Roman emperor Titus destroyed in the year 70 (see Chapter 7). In time, the site acquired additional significance as the reputed location of Adam's grave and the spot where Abraham prepared to sacrifice Isaac. The rock (FIG. 10-3) that gives the building its name also later came to be identified with the place where Muhammad began his miraculous journey to Heaven (the *Miraj*) and then, in the same night, returned to his home in Mecca.

In its form, construction, and decoration, the Dome of the Rock is firmly in the Late Antique tradition of the Mediterranean world. It is a domed central-plan structure descended from the Pantheon (FIG. 7-49) in Rome and Hagia Sophia (FIG. 9-5) in Constantinople, but it more closely resembles the octagonal San Vitale (FIG. 9-10) in Ravenna. In all likelihood, a neighboring Christian monument, Constantine's Church of the Holy Sepulcher, inspired the Dome of the Rock's designers. That fourth-century domed rotunda bore a family resemblance to the roughly contemporaneous Constantinian mausoleum later rededicated as Santa Costanza (FIGS. 8-11 and 8-12) in Rome. Crowning the Islamic shrine is a 75-foot-tall double-shelled

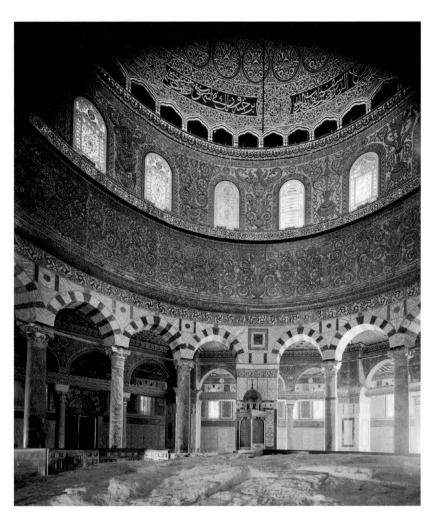

10-4 Aerial view (looking southeast) of the Great Mosque, Damascus, Syria, 706-715. ■4

The Umayyads constructed Damascus's Great Mosque after they transferred their capital from Mecca in 661. The mosque owes a debt to Late Antique architecture in its plan and decoration.

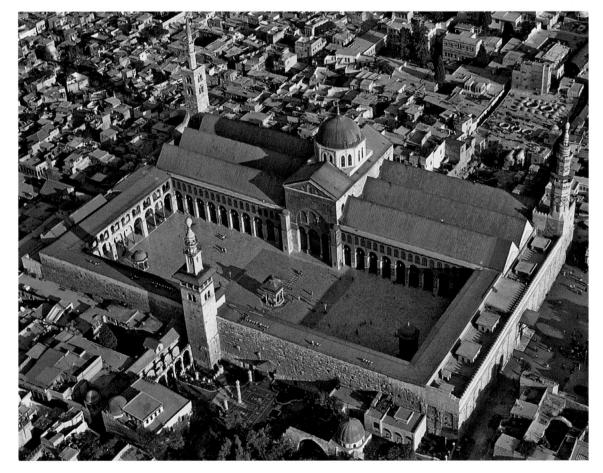

wooden dome, which so dominates the elevation as to reduce the octagon to function merely as its base. This soaring, majestic unit creates a decidedly more commanding effect than that of similar Late Antique and Byzantine domical structures (FIGS. 9-5 and 9-10). The silhouettes of those domes are comparatively insignificant when seen from the outside.

The building's exterior has been much restored. Tiling from the 16th century and later has replaced the original mosaic. Yet the vivid, colorful patterning wrapping the walls like a textile is typical of Islamic ornamentation. It contrasts markedly with Byzantine brickwork and Greco-Roman sculptured decoration. The interior's rich mosaic ornamentation (FIG. 10-3) is largely intact and suggests the original appearance of the exterior walls. Against a lush vegetal background, Abd al-Malik's mosaicists depicted crowns, jewels, chalices, and other royal motifs—probably a reference to the triumph of Islam over the Byzantine and Persian empires. Inscriptions, mostly from the Koran, underscore Islam as the superior new monotheism, superseding both Judaism and Christianity in Jerusalem. (Curiously, no inscription refers to the rock within the shrine.)

GREAT MOSQUE, DAMASCUS The Umayyads transferred their capital from Mecca to Damascus in 661. There, Abd al-Malik's son, the caliph al-Walid (r. 705–715), purchased a Byzantine church dedicated to John the Baptist (formerly a Roman temple of Jupiter) and built an imposing new mosque for the expanding Muslim population (see "The Mosque," page 288). The Umayyads demolished the church, but they used the Roman precinct walls as a foundation for their construction. Like the Dome of the Rock, Damascus's Great Mosque (FIG. 10-4) owes much to Roman and Early Christian archi-

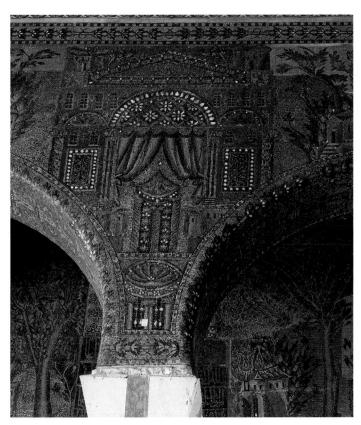

10-5 Detail of a mosaic in the courtyard arcade of the Great Mosque, Damascus, Syria, 706-715.

The mosaics of the Great Mosque at Damascus are probably the work of Byzantine artists and include buildings and landscapes, though not zoomorphic forms, common in Late Antique art.

tecture. The Islamic builders incorporated stone blocks, columns, and capitals salvaged from the earlier structures on the land acquired by al-Walid. Pier *arcades* reminiscent of Roman aqueducts (FIG. 7-33) frame the courtyard. The *minarets*, two at the southern corners and one at the northern side of the enclosure—the earliest in the Islamic world—are modifications of the preexisting Roman square towers. The grand prayer hall, taller than the rest of the complex, is on the south side of the courtyard (facing Mecca). The hall's facade, with its pediment and arches, recalls Roman and Byzantine models and faces into the courtyard, like a temple in a Roman forum (FIG. 7-12), a plan maintained throughout the long history of mosque architecture. The Damascus mosque synthesizes elements received from other cultures into a novel architectural unity, which includes the distinctive Islamic elements of *mihrab*, mihrab dome, *minbar*, and minaret.

An extensive cycle of glass mosaics once covered the walls of the Great Mosque. In one of the surviving sections (FIG. 10-5), a conch-shell niche "supports" an arcaded pavilion with a flowering rooftop flanked by structures shown in perspective. Like the architectural design, the mosaics owe much to Roman, Early Christian, and Byzantine art. Indeed, some evidence indicates they were the work of Byzantine mosaicists. Characteristically, temples, clusters of houses, trees, and rivers compose the pictorial fields, bounded by stylized vegetal designs also found in Roman, Early Christian, and Byzantine ornamentation. No zoomorphic forms, human or animal, appear either in the pictorial or ornamental spaces. This is true of all the mosaics in the Great Mosque as well as the mosaics in the earlier Dome of the Rock (FIG. 10-3). Although there is no prohibition against figural art in the Koran, Islamic tradition, based on the Hadith, shuns the representation of fauna of any kind in sacred places. Accompanying (but now lost) inscriptions explained the world shown in the Damascus mosaics, suspended miragelike in a featureless field of gold, as an image of Paradise. The imagery is consistent with many passages from the Koran describing the gorgeous places of Paradise awaiting the faithful—gardens, groves of trees, flowing streams, and "lofty chambers."

BAGHDAD The Umayyad caliphs maintained power for nearly a century, during which they constructed numerous palatial residences throughout their domains. Perhaps the most impressive was the palace (FIGS. 10-5A and 10-5B) at Mshatta in Jordan datable just before 750 when, after years of civil war, the Abbasids, who claimed descent from Abbas, an uncle of Muhammad, overthrew the Umayyad caliphs. The new rulers moved the capital from Damascus to a site in Iraq near the old Sasanian capital of Ctesiphon (FIG. 2-28). There the caliph al-Mansur (r. 754-775) established a new capital, Baghdad, which he called Madina al-Salam, the City of Peace. Laid out in 762 at a time astrologers determined was favor-

10-5A Plan, Umayyad palace, Mshatta, 740-750.

10-5B Frieze, Umayyad palace, Mshatta, 740-750.

able, Baghdad had a circular plan, about a mile and a half in diameter. The shape, which had precedents in ancient Assyria, Parthia, and Persia, signified the new capital was the center of the universe. The city had a moat and four gates oriented to the four compass points. At the center was the caliph's palace. No traces of al-Mansur's Round City remain today, but for almost 300 years, Baghdad was the hub of Arab power and of a brilliant Islamic culture. The Abbasid caliphs amassed great wealth and established diplomatic relations

The Mosque

Islamic religious architecture is closely related to Muslim prayer, an obligation laid down in the Koran for all Muslims. In Islam, worshiping can be a private act and requires neither prescribed ceremony nor a special locale. Only the *qibla*—the direction (toward Mecca) Muslims face while praying—is important. But worship also became a communal act when the first Muslim community established a simple ritual for it. To celebrate the Muslim sabbath, which occurs on Friday, the community convened each Friday at noon, probably in the Prophet's house in Medina. The main feature of Muhammad's house was a large square court with rows of palm trunks supporting thatched roofs along the north and south sides. The southern side, which faced Mecca, was wider and had a double row of trunks. After the prayer, the *imam*, or leader of collective worship, stood on a stepped pulpit, or *minbar*, set up in front of the southern (qibla) wall, and preached the sermon.

These features became standard in the Islamic house of worship, the *mosque* (from Arabic "masjid," a place of prostration), where the faithful gather for the five daily prayers. The *congregational mosque* (also called the *Friday mosque* or *great mosque*) was ideally large enough to accommodate a community's entire population for the Friday noon prayer. An important feature both of ordinary mosques and of congregational mosques is the *mihrab* (FIG. 10-6, no. 2), a semicircular niche usually set into the qibla wall. Often a dome over the bay in front of the mihrab marked its position (FIGS. 10-4 and 10-6, no. 3). The niche was a familiar Greco-Roman architectural

feature, generally enclosing a statue. Scholars still debate its origin, purpose, and meaning in Islamic architecture. The mihrab originally may have honored the place where the Prophet stood in his house at Medina when he led communal worship.

In some mosques, a *maqsura* precedes the mihrab. The maqsura, the area generally reserved for the ruler or his representative, can be quite elaborate in form (FIG. 10-11). Many mosques also have one or more *minarets* (FIGS. 10-4, 10-7, and 10-23), towers used to call the faithful to worship. When the Muslims converted buildings of other faiths into mosques, they clearly signaled the change on the exterior by the construction of minarets (FIG. 9-5). *Hypostyle halls*, communal worship halls with roofs held up by a multitude of columns (FIGS. 10-6, no. 4, and 10-10), are characteristic features of early mosques. Later variations include mosques with four *iwans* (vaulted rectangular recesses), one on each side of the courtyard (FIGS. 10-13 and 10-14), and *central-plan* mosques with a single large dome-covered interior space (FIGS. 10-23 and 10-24), as in Byzantine churches, some of which later became mosques (FIG. 9-8).

Today, despite many variations in design and detail (see, for example, the adobe-and-wood mosque in Mali, FIG. 19-9) and the employment of building techniques and materials unknown in Muhammad's day, the mosque's essential features remain unchanged. The orientation of all mosques everywhere, whatever their plan, is Mecca, and the faithful worship facing the qibla wall.

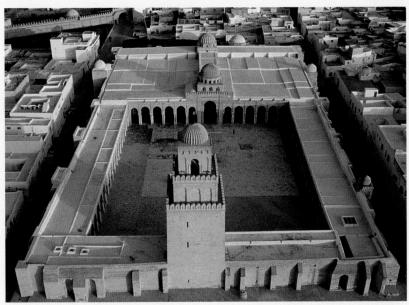

10-6 Aerial view (looking south; *left*) and plan (*right*) of the Great Mosque, Kairouan, Tunisia, ca. 836-875. ■4

Kairouan's Great Mosque is a hypostyle mosque with forecourt and columnar prayer hall. The plan most closely resembles the layout of Muhammad's house in Medina.

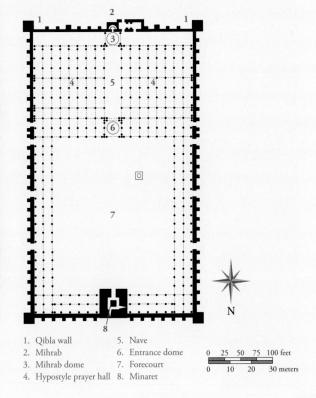

throughout the world, even with Charlemagne in Germany. They spent lavishly on art, literature, and science and were responsible for the translation of numerous Greek texts that otherwise would have been lost. In fact, many of these ancient works first became known in medieval Europe through their Arabic versions.

GREAT MOSQUE, KAIROUAN Several decades after the founding of Baghdad, the Abbasids constructed at Kairouan in Tunisia one of the best preserved early mosques (FIG. 10-6). Of hypostyle design, it most closely reflects the mosque's supposed precursor, Muhammad's house in Medina (see "The Mosque," page 288). Still in use today, the Kairouan mosque retains its carved wooden minbar of 862, the oldest known. The precinct takes the form of a slightly askew parallelogram of huge scale, some 450 by 260 feet. Built of stone, its walls have sturdy buttresses, square in profile. Lateral entrances on the east and west lead to an arcaded forecourt (FIG. 10-6, no. 7) resembling a Roman forum (FIG. 7-44), oriented north-south on axis with the mosque's impressive minaret (no. 8) and the two domes of the hypostyle prayer hall (no. 4). The first dome (no. 6) is over the entrance bay, the second (no. 3) over the bay that fronts the mihrab (no. 2) set into the qibla wall (no. 1). A raised nave (no. 5) connects the domed spaces and prolongs the north-south axis of the minaret and courtyard. Eight columned aisles flank the nave on either side, providing space for a large congregation.

MALWIYA MINARET, SAMARRA The three-story minaret of the Kairouan mosque is square in plan and believed to be a near-copy of a Roman lighthouse, but minarets take a variety of

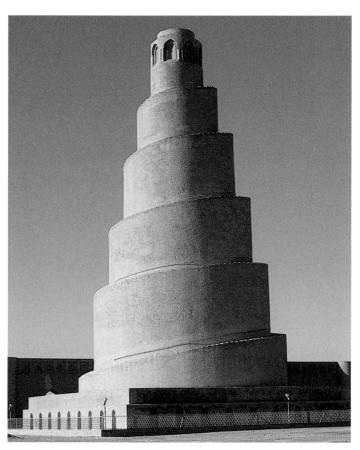

10-7 Malwiya Minaret, Great Mosque, Samarra, Iraq, 848-852.

The unique spiral Malwiya (snail shell) Minaret of Samarra's Great Mosque is more than 165 feet tall and can be seen from afar. It served to announce the presence of Islam in the Tigris Valley.

forms. Perhaps the most striking and novel is the minaret of the immense (more than 45,000 square yards) Great Mosque at Samarra, Iraq, on the east bank of the Tigris River north of Baghdad. Samarra was the capital of the Abbasid caliph al-Mutawakkil (r. 847-861), who built the mosque between 848 and 852. At the time of its construction the Samarra mosque was the largest in the world. Known as the Malwiya ("snail shell" in Arabic) Minaret (FIG. 10-7), it is more than 165 feet tall. Although it now stands alone, originally a bridge linked the minaret to the mosque. The distinguishing feature of the brick tower is its stepped spiral ramp, which increases in slope from bottom to top. Once thought to be an ancient Mesopotamian ziggurat, the Samarra minaret inspired some European depictions of the biblical Tower of Babel (Babylon's ziggurat; see "Babylon, City of Wonders," Chapter 2, page 49). Because it is too tall to have been used to call Muslims to prayer, the Abbasids probably intended the Malwiya Minaret, visible from a considerable distance in the flat plain around Samarra, to announce the presence of Islam in the Tigris Valley. Unfortunately, since 2005 the minaret has suffered damage at the hands of various parties during the continuing unrest in Iraq.

SAMANID MAUSOLEUM, BUKHARA Dynasties of governors who exercised considerable independence while recognizing the ultimate authority of the Baghdad caliphs oversaw the eastern realms of the Abbasid Empire. One of these dynasties, the Samanids (r. 819–1005), presided over the eastern frontier beyond the Oxus River (Transoxiana) on the border with India. In the early 10th century, the Samanids erected an impressive domed brick mausoleum (FIG. 10-8) at Bukhara in modern Uzbekistan. Monumental tombs were virtually unknown in the early Islamic period. Muhammad had been opposed to elaborate burials and instructed his followers to bury him in a simple unmarked grave. In time, however, the

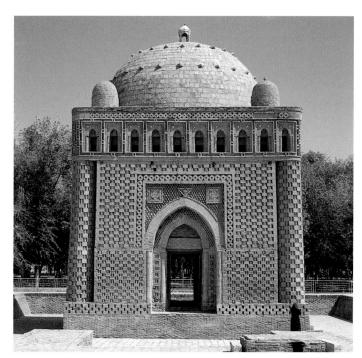

10-8 Mausoleum of the Samanids, Bukhara, Uzbekistan, early 10th century.

Monumental tombs were almost unknown in the early Islamic period. The Samanid mausoleum at Bukhara is one of the oldest. Its dome-on-cube form had a long afterlife in Islamic funerary architecture.

10-9 Prayer hall of the Mezquita (Great Mosque), Córdoba, Spain, 8th to 10th centuries.

Córdoba was the capital of the Spanish Umayyad dynasty. In the Great Mosque's hypostyle prayer hall, 36 piers and 514 columns support a unique series of doubletiered horseshoe-shaped arches.

Prophet's resting place in Medina acquired a wooden screen and a dome. By the ninth century, Abbasid caliphs were laid to rest in dynastic mausoleums.

The Samanid mausoleum at Bukhara is one of the earliest preserved tombs in the Islamic world. Constructed of baked bricks, it takes the form of a dome-capped cube with slightly sloping sides. With exceptional skill, the builders painstakingly shaped the bricks to create a vivid and varied surface pattern. Some of the bricks form *engaged columns* (half-round, attached columns) at the corners. A brick blind arcade (a series of arches in relief, with blocked openings) runs around

all four sides. Inside, the walls are as elaborate as the exterior. The brick dome rests on arcuated brick squinches (see "Pendentives and Squinches," Chapter 9, page 262) framed by engaged *colonnettes* (thin columns). The dome-on-cube form had a long and distinguished future in Islamic funerary architecture (FIGS. 10-22 and 32-6).

table to escape the Abbasid massacre of his clan in Syria, fled to Spain in 750. There, the Arabs had overthrown the Christian kingdom of the Visigoths in 711 (see Chapter 11). The Arab military governors accepted the fugitive as their overlord, and he founded the Spanish Umayyad dynasty, which lasted nearly three centuries. The capital of the Spanish Umayyads was Córdoba, which became the center of a brilliant culture rivaling that of the Abbasids at Baghdad and exerting major influence on the civilization of the Christian West.

The jewel of the capital at Córdoba was its Great Mosque (FIG. 10-1), begun in 784 by Abd al-Rahman I and enlarged

10-10 Detail of the upper zones of the east gate of the Mezquita (Great Mosque), Córdoba, Spain, 961–965.

The caliph al-Hakam II expanded and renovated Córdoba's Mezquita. The new gates to the complex feature intricate surface patterns of overlapping horseshoe-shaped and multilobed arches.

several times during the 9th and 10th centuries. Córdoba's Mezquita eventually became one of the largest mosques in the Islamic West. The hypostyle prayer hall (FIG. 10-9) has 36 piers and 514 columns topped by a unique system of double-tiered arches that carried a wooden roof (later replaced by vaults). The two-story system was the builders' response to the need to raise the roof to an acceptable height using short columns that had been employed earlier in other structures. The lower arches are horseshoe-shaped, a form perhaps adapted from earlier Mesopotamian architecture or

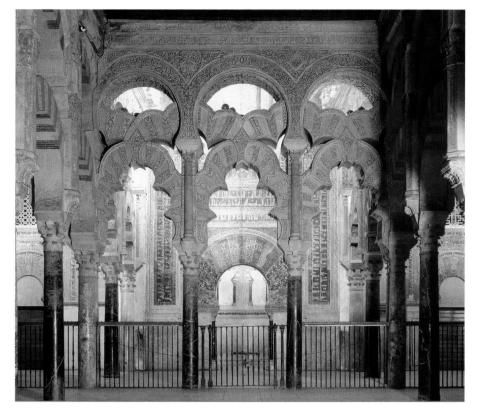

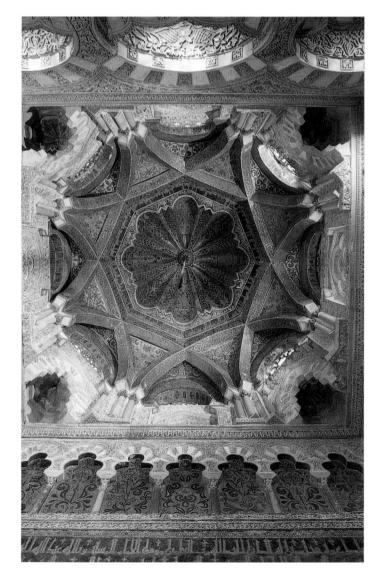

10-11 Maqsura of the Mezquita (Great Mosque), Córdoba, Spain, 961-965.

Reserved for the caliph, the magsura of the Córdoba mosque connected the mosque to his palace. It is a prime example of Islamic experimentation with highly decorative multilobed arches.

of Visigothic origin (FIG. 11-10). In the West, the horseshoe arch quickly became closely associated with Muslim architecture. Visually, these arches seem to billow out like windblown sails, and they contribute greatly to the light and airy effect of the Córdoba mosque's interior.

In 961, al-Hakam II (r. 961–976) became caliph. A learned man who amassed a library of 400,000 volumes, he immediately undertook major renovations to the mosque. His builders expanded the prayer hall, added a series of domes, and constructed monumental gates on the complex's eastern (FIG. 10-10) and western facades. The gates are noteworthy for their colorful masonry and intricate surface patterns, especially in the uppermost zone, with its series of overlapping horseshoe-shaped arches springing from delicate colonnettes.

Also dating to the caliphate of al-Hakam II is the mosque's extraordinary maqsura (Fig. 10-11), the area reserved for the caliph and connected to his palace by a corridor in the qibla wall. The Córdoba maqsura is a prime example of Islamic experimentation with highly decorative multilobed arches (which are subsidiary motifs in the contemporaneous gate, Fig. 10-10). The Muslim builders created rich and varied abstract patterns and further enhanced the magnificent effect of the complex arches by sheathing the walls with marbles and mosaics. Al-Hakam II wished to emulate the great mosaic-clad monuments his Umayyad predecessors had erected in Jerusalem (Fig. 10-3) and Damascus (Fig. 10-5), and he brought the mosaicists and even the *tesserae* (cubical pieces) to Córdoba from Constantinople.

The same desire for decorative effect also inspired the design of the dome (FIG. 10-12) covering the area in front of the mihrab, one of the four domes built during the 10th century to emphasize the axis leading to the mihrab. The dome rests on an octagonal base of arcuated squinches. Crisscrossing ribs form an intricate pattern centered on two squares set at 45-degree angles to each other. The mosaics are the work of the same Byzantine artists responsible for the magsura's decoration.

FRIDAY MOSQUE, ISFAHAN Muslim rulers built mosques of the hypostyle type throughout their realms during the early centuries of the new religion, but other mosque plans gradually gained favor in certain regions (see "The Mosque," page 288). At Isfahan, the third-largest city in Iran today, the Abbasids constructed the first mosque

10-12 Dome in front of the mihrab of the Mezquita (Great Mosque), Córdoba, Spain, 961-965.

The dome in front of the Córdoba mihrab rests on an octagonal base of arcuated squinches. Crisscrossing ribs form an intricate decorative pattern. Byzantine artists fashioned the mosaic ornamentation.

10-13 Aerial view (looking southwest) of the Friday Mosque, Isfahan, Iran, 11th to 17th centuries. ■4

The typical Iranian mosque plan with four vaulted iwans and a courtyard was perhaps first used in the mosque Sultan Malik Shah I built in the late 11th century at his capital of Isfahan.

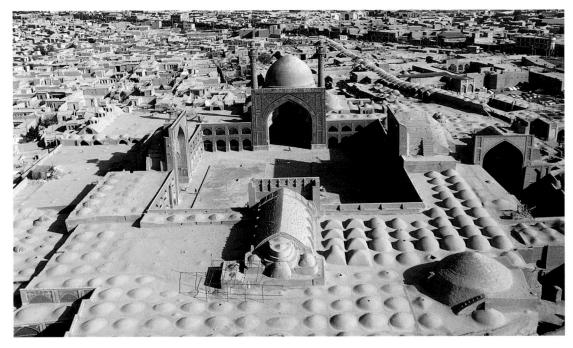

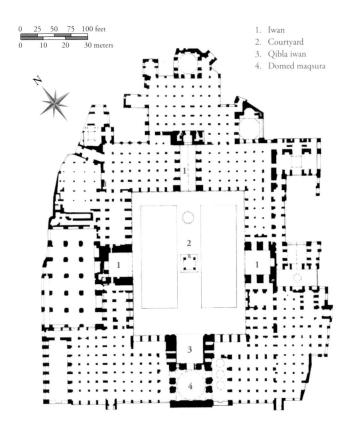

10-14 Plan of the Friday Mosque, Isfahan, Iran, 11th to 17th centuries.

In Isfahan's Friday Mosque, as in other four-iwan mosques, the qibla iwan is the largest. Its size and the dome-covered magsura in front of it indicated the proper direction to face for Muslim prayer.

of hypostyle design in that formerly Sasanian city during the eighth century. In the 11th century, the Seljuks, a Turkic people who had converted to Islam, built an extensive, although short-lived empire that stretched eastward from Anatolia and included Iran. At that time, the Seljuk *sultan* (ruler) Malik Shah I (r. 1072–1092) made Isfahan his capital and transformed the Abbasid mosque in stages.

The Seljuk Friday Mosque (FIGS. 10-13 and 10-14) underwent further modification over subsequent centuries, but still retains its basic 11th-century plan, consisting of a large courtyard bordered by a two-story arcade on each side. Four vaulted iwans open onto the courtyard, one at the center of each side. The southwestern iwan (FIG. 10-14, no. 3) leads into a dome-covered room (no. 4) in front of the mihrab that functioned as a maqsura reserved for the sultan and his attendants. It is uncertain whether Isfahan's Friday Mosque is the earliest example of a four-iwan mosque, but that plan became standard in Iranian religious architecture. In this type of mosque, the qibla iwan is always the largest. Its size (and the dome that often accompanied it) immediately indicated to worshipers the proper direction for prayer.

Luxury Arts

The furnishings of Islamic mosques and palaces reflect a love of sumptuous materials and rich decorative patterns. Muslim artisans artfully worked ivory (FIG. 10-15), metal, wood, and glass into a great variety of objects for sacred spaces or the home. They used colored glass with striking effect in mosque lamps (FIG. 10-28) and produced ceramics (FIG. 10-18) of high quality in large numbers. Muslim metalwork-

10-14A Silk textile from Zandana, eighth century.

ers created elaborate ewers (FIG. 10-16), basins (FIG. 10-31), jewel cases, writing boxes, and other portable items (FIG. 10-32) made of bronze or brass, engraved, and inlaid with silver. Weavers employed silk (FIGS. 10-14A and 10-26A) and wool (FIG. 10-27) to fashion textiles featuring both abstract and pictorial motifs. Because wood is scarce in most of the Islamic world, the kinds of furniture used in the West—beds, tables, and chairs—are rare in Muslim buildings. Movable furnishings, therefore, do not define Islamic architectural spaces. A room's function (eating or sleeping, for example) can change simply by rearranging the carpets and cushions.

IVORY The centers of production for these luxurious art forms were usually the courts of the Muslim caliphs and sultans. One

10-15 Pyxis of al-Mughira, from Medina al-Zahra, near Córdoba, Spain, 968. Ivory, $5\frac{7}{8}$ high. Musée du Louvre, Paris.

The royal workshops of Abd al-Rahman III produced luxurious objects such as this ivory pyxis decorated with hunting motifs and vine scrolls. It belonged to al-Mughira, the caliph's younger son.

was Córdoba (FIGS. 10-1 and 10-9 to 10-12). Abd al-Rahman III (r. 912–961), a descendant of the founder of the Umayyad dynasty in Spain, became *emir* (ruler) when he was 22. In 929, he declared himself caliph, a title previously restricted to the Muslim rulers who controlled the holy cities of Mecca and Medina. During his nearly 50-year reign, he constructed a lavish new palace for himself and his successors at Medina al-Zahra, about five miles from Córdoba. The palace complex housed royal workshops for the production of luxury items for the caliph's family and for use as diplomatic gifts, including richly carved ivory boxes (FIG. 10-15). Befitting their prospective owners, Spanish Umayyad ivory *pyxides* (singular, *pyxis*; a cylindrical box with a hemispherical lid) usually featured motifs symbolic of royal power and privilege, including hunting scenes and musical entertainments.

The pyxis shown here (FIG. 10-15) belonged to al-Mughira, the younger son of Abd al-Rahman III. The inscription carved at the base of the lid is a prayer for the 18-year-old prince's wellbeing: "God's blessing, favors, and happiness to al-Mughira, son of the commander of the faithful, may God have mercy upon him,

10-16 SULAYMAN, ewer in the form of a bird, 796. Brass with silver and copper inlay, 1' 3" high. Hermitage, Saint Petersburg.

Signed and dated by its maker, this bird ewer resembles a freestanding statuette. The engraved decoration of the body combines natural feathers with abstract motifs and Arabic calligraphy.

in the year 357 [968 ce]." The anonymous ivory carver decorated the pyxis with a rich array of animals and hunters amid lush vine scrolls surrounding four eight-lobed figural medallions. In one medallion, lions attack bulls. In another (not visible in FIG. 10-15), the prince himself appears, serenaded by a lutenist.

METALWORK One striking example of early Islamic metalwork is the cast brass ewer (FIG. 10-16) in the form of a bird signed by Sulayman and dated 796. Some 15 inches tall, the ewer is nothing less than a freestanding statuette, although the holes between the eyes and beak function as a spout and betray its utilitarian purpose. The decoration on the body, which bears traces of silver and copper inlay, takes a variety of forms. In places, the incised lines seem to suggest natural feathers, but the rosettes on the neck, the large medallions on the breast, and the inscribed collar have no basis in anatomy. Similar motifs appear in Islamic textiles, pottery, and architectural tiles. The ready adaptability of motifs to various scales and to various techniques illustrates both the flexibility of Islamic design and its relative independence from its carrier.

10-17 Koran page with beginning of surah 18, 9th or early 10th century. Ink and gold on vellum, $7\frac{1}{4}'' \times 10\frac{1}{4}''$. Chester Beatty Library and Oriental Art Gallery, Dublin.

84

The script used in the oldest-known Korans is the stately rectilinear Kufic. This page has five text lines and a palm-tree finial but characteristically does not include depictions of animals or humans.

1 in.

KORANS In the Islamic world, the art of *calligraphy*, ornamental writing, held a place of honor. The faithful wanted to reproduce the Koran's sacred words in a script as beautiful as human hands could contrive. Passages from the Koran adorned not only the fragile pages of books but also the walls of buildings—for example, in the mosaic band above the outer ring of columns inside the Dome of the Rock (FIG. 10-3). The practice of calligraphy was itself a holy task and required long, arduous training. The scribe had to possess exceptional spiritual refinement. An ancient Arabic proverb proclaims, "Purity of writing is purity of soul." Only in China does calligraphy hold as elevated a position among the arts (see "Calligraphy and Inscriptions on Chinese Paintings," Chapter 33, page 997).

Arabic script predates Islam. It is written from right to left with certain characters connected by a baseline. Although the codification of the chief Islamic book, the sacred Koran, occurred in the mid-seventh century, the earliest preserved Korans date to the ninth century. Koran pages were either bound into books or stored as loose sheets in boxes. Most of the early examples feature texts written in the script form called *Kufic*, after the city of Kufa, one of the renowned centers of Arabic calligraphy. Kufic script—used also for the inscription on al-Mughira's 10th-century pyxis (FIG. 10-15)—is quite angular, with the uprights forming almost right angles with the baseline. As with Hebrew and other Semitic languages, the usual practice was to write in consonants only. But to facilitate recitation of the Koran, scribes often indicated vowels by red or yellow symbols above or below the line.

10-17A Blue Koran, from Kairouan, 9th to mid-10th century.

All of these features are present in a 9th- or early-10th-century Koran page (FIG. 10-17) now in Dublin and in the blue-dyed page (FIG. 10-17A) of a contemporaneous Koran now at Harvard University. The Dublin page carries the heading and opening lines of surah 18 of the Koran. The five text lines are in black ink with red vowels below a decorative

band incorporating the chapter title in gold and ending in a palmtree *finial* (a crowning ornament). This approach to page design has parallels at the extreme northwestern corner of the then-known world—in the early medieval manuscripts of Britain and Ireland, where text and ornamentation are similarly united (FIG. 11-1). But the stylized human and animal forms that populate those Christian books never appear in Korans.

CERAMICS Around the same time, potters in Nishapur in Iran and in Samarqand in Uzbekistan developed a simple but elegant type of glazed dish with calligraphic decoration. One of the best-preserved examples of *Samarqand ware* is a large dish (FIG. 10-18) from the Nishapur region in Khurasan province of northeastern Iran. To produce dishes such as this, the ceramists formed the shape from the local dark pink clay and then immersed the dish in a tub of white slip. When the slip dried, a painter-calligrapher wrote a Kufic text in black or brown paint around the flat rim of the dish, usually, as here, extending the angular letters both horizontally and vertically to create a circular border and to fill the full width of the rim. A transparent glaze, applied last, sealed the decoration and, after firing, gave the dish an attractive sheen.

The text on this dish is an Arabic proverb, which reads: "Knowledge is bitter-tasting at first, but in the end it is sweeter than honey. Good health [to the owner of this dish]." Because the Arabic words are so similar, recently some scholars have translated "knowledge" as "magnanimity." In either case, this and similar proverbs with practical advice for secular life would have appealed to cultured individuals such as successful merchants. The proverb's reference to food is, of course, highly appropriate for the decoration of tableware.

LATER ISLAMIC ART

In 1192, a Muslim army under the command of Muhammad of Ghor won a decisive battle at Tarain, which led to the formation in 1206 of an Islamic sultanate at Delhi and eventually to the greatest Muslim

10-18 Dish with Arabic proverb, from Nishapur, Iran, 10th century. Painted and glazed earthenware, 1' $2\frac{1}{2}$ " diameter. Musée du Louvre, Paris.

An Arabic proverb in Kufic calligraphy is the sole decoration of this dish made for a cultured owner. It states that knowledge, although bitter at first taste, is ultimately sweeter than honey.

empire in Asia, the Mughal Empire. But no sooner did the Muslims establish a permanent presence in South Asia than the Mongols, who had invaded northern China in 1210 (see Chapter 33), overthrew the Abbasid caliphs in Central Asia and Persia. Isfahan fell to the Mongols in 1236, Baghdad in 1258, and Damascus in 1260. Islamic art continued to flourish, however, and important new regional artistic centers emerged. The rest of this chapter treats the art and architec-

ture of the Nasrids (1232–1492) in Spain, the Ayyubids (1171–1250) and Mamluks (1250–1517) in Egypt, the Timurids (1370–1501) and Safavids (1501–1732) in Iran, and the Ottomans (1281–1924) in Turkey. For Islamic art in South Asia, see Chapter 32.

Architecture

In the early years of the 11th century, the Umayyad caliphs' power in Spain unraveled, and their palaces fell prey to Berber soldiers from North Africa. The Berbers ruled southern Spain for several generations but could not resist the pressure of Christian forces from the north. Córdoba fell to the Christians in 1236, the same year the Mongols captured Isfahan. From then until the final Christian triumph in 1492, the Nasrids, an Arab dynasty that had established its capital at Granada in 1232, ruled the remaining Muslim territories in Spain.

ALHAMBRA On a rocky spur at Granada, the Nasrids constructed a huge palace-fortress called the Alhambra ("the Red" in Arabic), named for the rose color of the stone used for its walls and 23 towers. By the end of the 14th century, the complex had a population of 40,000 and included at least a half dozen royal residences. Only two of these fared well over the centuries. Paradoxically, they owe their preservation to the Christian victors, who maintained a few of the buildings as trophies commemorating the expulsion of the Nasrids. The two palaces present a vivid picture of court life in Islamic Spain before the Christian reconquest.

The Palace of the Lions takes its name from its courtyard (FIG. 10-19), which contains a fountain with 12 marble lions carrying a water basin on their backs. Colonnaded courtyards with fountains and statues have a long history in the Mediterranean world, especially in the houses and villas of the Roman Empire (FIG. 7-16A). The Alhambra's lion fountain is an unusual instance of freestanding stone sculpture in the Islamic world, unthinkable in a sacred setting. But the design of the courtyard is distinctly Islamic and features many multilobed pointed arches and lavish stuccoed walls with interwoven abstract motifs and Arabic calligraphy. The palace was the residence of Muhammad V (r. 1354–1391), and its courtyards, lush gardens, and luxurious carpets and other furnishings served to conjure the image of Paradise.

10-19 Court of the Lions (looking east), Palace of the Lions, Alhambra, Granada, Spain, 1354–1391.

The Nasrid Palace of the Lions takes its name from the fountain in this courtyard, a rare Islamic example of stone sculpture. Interwoven abstract ornamentation and Arabic calligraphy cover the stucco walls.

10-20 Muqarnas dome, Hall of the Abencerrajes, Palace of the Lions, Alhambra, Granada, Spain, 1354–1391.

The structure of this dome on an octagonal drum is difficult to discern because of the intricately carved stucco muqarnas. The prismatic forms reflect sunlight, creating the effect of a starry sky.

The Palace of the Lions is noteworthy also for its elaborate stucco ceilings. A spectacular example is the dome (FIG. 10-20) of the Hall of the Abencerrajes (a leading Spanish family). The dome rests on an octagonal drum supported by squinches and pierced by eight pairs of windows, but its structure is difficult to discern because of the intricate carved stucco decoration. Some 5,000 mugarnas-tier after tier of stalactite-like prismatic forms that seem aimed at denying the structure's solidity—cover the ceiling. The muqarnas catch and reflect sunlight as well as form beautiful abstract patterns. The lofty vault in this hall and others in the palace symbolize the dome of Heaven. The flickering light and shadows create the effect of a starry sky as the sun's rays glide from window to window during the day. To underscore the symbolism, the palace walls bear inscriptions with verses by the court poet Ibn Zamrak (1333-1393), who compared the Alhambra's lacelike muqarnas ceilings to "the heavenly spheres whose orbits revolve."

MAUSOLEUM OF SULTAN HASAN After the Mongol conquests, the center of Islamic power moved from Baghdad to Egypt. The lords of Egypt at the time were former Turkish slaves ("mamluks" in Arabic) who converted to Islam. The capital of the Mamluk sultans was Cairo, which became the largest Muslim city of the late Middle Ages. The Mamluks were prolific builders, and Sultan Hasan, although not an important figure in Islamic history, was the most ambitious of all. He ruled briefly as a child and was deposed but regained the sultanate from 1354 until his assassination in 1361.

Hasan's major building project in Cairo was a huge madrasa complex (FIGS. 10-21 and 10-22) on a plot of land about 8,000

square yards in area. A *madrasa* ("place of study" in Arabic) is a theological college devoted to the teaching of Islamic law. Hasan's complex was so large it housed not only four madrasas for the study of the four major schools of Islamic law but also a mosque, mausoleum, orphanage, and hospital, as well as shops and baths. Like all Islamic building complexes incorporating religious, educational, and charitable functions, this one depended on an endowment funded by rental properties. The income from these paid the salaries of attendants and faculty, provided furnishings and supplies such as oil for the lamps or free food for the poor, and supported scholarships for needy students.

The grandiose structure has a large central courtyard (FIG. 10-21, no. 5) with a monumental fountain in the center and four vaulted iwans opening onto it, as in Iranian mosques (FIG. 10-14). In each corner of the main courtyard, between the iwans (FIG. 10-21, no. 3), is a madrasa (no. 4) with its own courtyard and four or five stories of rooms for the students. The largest iwan (no. 2) in the complex, on the southern side, served as a mosque. Contemporaries believed the soaring vault that covered this iwan was taller than the arch of the Sasanian palace (FIG. 2-28) at Ctesiphon, which was then one of the most admired engineering feats in the world. Behind the qibla wall stands the sultan's mausoleum (FIGS. 10-21, no. 1, and 10-22), a gigantic version of the Samanid tomb (FIG. 10-8) at Bukhara but with two flanking minarets. The builders intentionally placed the dome-covered cube south of the mosque so that the prayers of the faithful facing Mecca would be directed toward Hasan's tomb. (The tomb houses only the bodies of the sultan's two sons, however. They could not recover their father's remains after his assassination.)

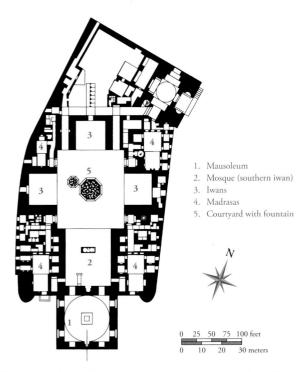

10-21 Plan of the madrasa-mosque-mausoleum complex of Sultan Hasan, Cairo, Egypt, begun 1356.

Sultan Hasan's complex included his tomb, four madrasas, and a mosque. The plan with four iwans opening onto a central courtyard derives from Iranian mosques (FIG. 10-14).

A muqarnas cornice crowns the exterior walls of Hasan's complex, and marble plaques of several colors cover the mihrab in the mosque and the walls of the mausoleum. The complex as a whole is relatively austere, however. Its massiveness and geometric clarity present a striking contrast to the filigreed elegance of the contemporaneous Alhambra (FIGS. 10-19 and 10-20) and testify to the diversity of regional styles within the Islamic world, especially after the end of the Umayyad and Abbasid dynasties.

OTTOMAN EMPIRE After the downfall of the Seljuks (FIGS. 10-13 and 10-14), several local dynasties established themselves in Anatolia, among them the Ottomans, founded by Osman I (r. 1281–1326). Under Osman's successors, the Ottoman state expanded throughout vast areas of Asia, Europe, and North Africa. By the middle of the 15th century, the Ottoman Empire had become one of the great world powers.

The Ottoman emperors were lavish patrons of architecture, and the builders in their employ developed a new type of mosque, the core of which was a dome-covered square prayer hall. The combination of dome and square had an appealing geometric clarity and became the nucleus of all Ottoman architecture. At first used singly, the domed units came to be used in multiples, the distinctive feature of later Ottoman architecture.

After the Ottoman Turks conquered Constantinople (Istanbul) in 1453, they firmly established their architectural code. Hagia Sophia (FIGS. 9-5 to 9-8) especially impressed the new lords of Constantinople. In some respects, Justinian's great church conformed to their own ideals, and they converted the Byzantine church into a mosque with minarets. But the longitudinal orientation of Hagia Sophia's interior never satisfied Ottoman builders, and Anatolian development moved instead toward the central-plan mosque.

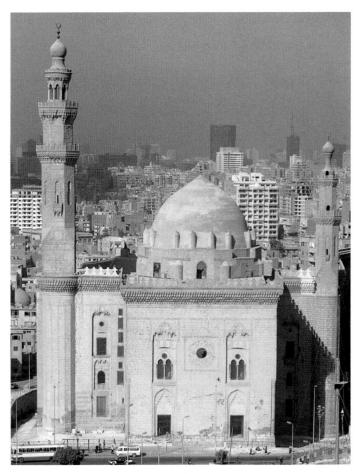

10-22 Madrasa-mosque-mausoleum complex of Sultan Hasan (looking northwest with the mausoleum in the foreground), Cairo, Egypt, begun 1356.

Hasan's mausoleum is a gigantic version of the earlier Samanid mausoleum (Fig. 10-8). Because of its location south of the complex's mosque, praying Muslims faced the Mamluk sultan's tomb.

SINAN THE GREAT The first Ottoman central-plan mosques date to the 1520s, but the finest examples are the designs of the most famous Ottoman architect, SINAN (ca. 1491–1588), who worked for one of the greatest Ottoman sultans, Suleyman the Magnificent (r. 1520–1566; FIG. 10-22A). Sinan perfected the Ottoman architectural style. By his time, Ottoman

10-22A Tughra of Suleyman the Magnificent, ca. 1555–1560.

builders almost universally employed the basic domed unit, which could be multiplied, enlarged, or contracted as needed, and almost any number of units could be combined. Thus, the typical 16th-century Ottoman mosque was a creative assemblage of domical units and artfully juxtaposed geometric spaces. Architects usually designed domes with an extravagant margin of structural safety that has since served them well in earthquake-prone Istanbul and other Turkish cities. (Vivid demonstration of the sound construction of the Ottoman mosques came in August 1999 when a powerful earthquake centered 65 miles east of Istanbul toppled hundreds of modern buildings and killed thousands of people but caused no damage to the centuries-old mosques.) Working within this architectural tradition, Sinan searched for solutions to the problems of unifying the additive elements and of creating a monumental centralized space with harmonious proportions.

Sinan the Great and the Mosque of Selim II

S inan, called "the Great," was truly the greatest Ottoman architect. Born a Christian around 1491, he converted to Islam, served in the Ottoman government, and trained in engineering and the art of building while in the Ottoman army. Officials quickly recognized Sinan's talent and entrusted him with increasing responsibility until, in 1538, he became chief court architect for Suleyman the Magnificent, a generous patron of art and architecture. He retained that position for a half century. Tradition associates Sinan with hundreds of building projects, both sacred and secular, although he could not have been involved with all of them.

The capstone of Sinan's distinguished career was the Edirne mosque (FIGS. 10-23 and 10-24) of Suleyman's son, Selim II, which Sinan designed when he was almost 80 years old. In it, he sought to surpass the greatest achievements of Byzantine architects, just as Sultan Hasan's builders in Cairo (FIG. 10-22) attempted to rival and exceed the Sasanian architects of antiquity. Sa'i Mustafa Çelebi, Sinan's biographer, recorded the architect's accomplishment in his own words:

Sultan Selim Khan ordered the erection of a mosque in Edirne.... His humble servant [I, Sinan] prepared for him a drawing depicting, on a dominating site in the city, four minarets on the four

10-23 SINAN, Mosque of Selim II, Edirne, Turkey, 1568-1575. ■4

The Ottomans developed a new type of mosque with a dome-covered square prayer hall. The dome of Sinan's Mosque of Selim II is taller than Hagia Sophia's (Fig. 9-8) and is an engineering triumph.

corners of a dome. . . . Those who consider themselves architects among Christians say that in the realm of Islam no dome can equal that of the Hagia Sophia; they claim that no Muslim architect would be able to build such a large dome. In this mosque, with the help of God and the support of Sultan Selim Khan, I erected a dome six cubits higher and four cubits wider than the dome of the Hagia Sophia.*

The Edirne dome is, in fact, higher than Hagia Sophia's (Fig. 9-8) when measured from its base, but its crown is not as far above the pavement as that of the dome of Justinian's church. Nonetheless, Sinan's feat won universal acclaim as a triumph. The Ottomans considered the Mosque of Selim II proof they finally had outshone the Christian emperors of Byzantium in the realm of architecture.

*Aptullah Kuran, *Sinan: The Grand Old Master of Ottoman Architecture* (Washington, D.C.: Institute of Turkish Studies, 1987), 168–169.

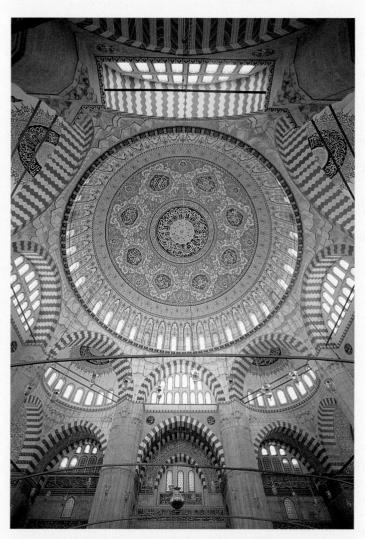

10-24 SINAN, interior of the Mosque of Selim II, Edirne, Turkey, 1568-1575. ■◀

The interior of Sinan's Edirne mosque is a fusion of an octagon and a dome-covered square with four half-domes at the corners. The plan features geometric clarity and precise numerical ratios.

Islamic Tilework

From the Dome of the Rock (FIGS. 10-2 and 10-3), the earliest major Islamic building, to the present day, Muslim builders have used mosaics or ceramic tiles to decorate the walls and vaults of mosques, madrasas, palaces, and tombs. The golden age of Islamic tilework was the 16th and 17th centuries. At that time, artists used two basic techniques to enliven building interiors with brightly colored tiled walls and to sheathe their exteriors with gleaming tiles that reflected the sun's rays.

In *mosaic tilework* (for example, FIG. 10-26), potters fire large ceramic panels of single colors in the kiln and then cut them into smaller pieces and set the pieces in plaster in a manner similar to the laying of mosaic *tesserae* of stone or glass (see "Mosaics," Chapter 8, page 245).

Cuerda seca (dry cord) tilework was introduced in Umayyad Spain during the 10th century—hence its Spanish name even in Middle Eastern and Central Asian contexts. Cuerda seca tiles (for example, FIG. 10-25) are polychrome and can more easily bear complex geometric and vegetal patterns as well as Arabic script than can mosaic tiles. They are also more economical to use because vast surfaces can be covered with large tiles much more quickly than they can with thousands of smaller mosaic tiles. But when builders use cuerda seca tiles to sheathe curved surfaces (vaults, domes, minarets), the ceramists must fire the tiles in the exact shape required—a daunting challenge. Polychrome tiles have other drawbacks. Because the ceramists fire all the glazes at the same temperature, cuerda seca tiles are not as brilliant in color as mosaic tiles and do not reflect light the way the more irregular surfaces of tile

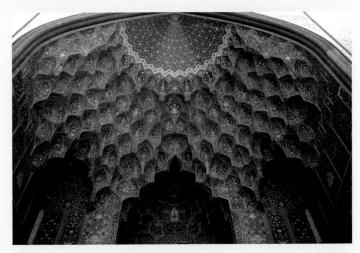

10-25 Muqarnas tilework of the entrance portal of the Imam (Shah) Mosque, Isfahan, Iran, 1611-1638. ■◀

The ceramists who produced the cuerda seca tiles of the muqarnas-filled portal to the Imam mosque had to manufacture a wide variety of shapes with curved surfaces to cover the prismatic, pointed half dome.

mosaics do. The preparation of the multicolored tiles also requires greater care. To prevent the colors from running together during firing, the potters outline the motifs on cuerda seca tiles with cords containing manganese, which leaves a matte black line between the colors after firing.

Sinan's vision found ultimate expression in the Mosque of Selim II (FIGS. 10-23 and 10-24) at Edirne, which had been the capital of the Ottoman Empire from 1367 to 1472 and where Selim II (r. 1566-1574) maintained a palace. There, Sinan designed a mosque with a massive dome set off by four slender pencil-shaped minarets (each more than 200 feet high, among the tallest ever constructed). The dome's height surpasses that of Hagia Sophia's dome (see "Sinan the Great and the Mosque of Selim II," page 298). But it is the organization of the Edirne mosque's interior space that reveals Sinan's genius. The mihrab is recessed into an apselike alcove deep enough to permit window illumination from three sides, making the brilliantly colored tile panels of its lower walls sparkle as if with their own glowing light. The plan of the main hall is an ingenious fusion of an octagon with the dome-covered square. The octagon, formed by the eight massive dome supports, is pierced by the four half-dome-covered corners of the square. The result is a fluid interpenetration of several geometric volumes that represents the culminating solution to Sinan's lifelong search for a monumental, unified interior space. Sinan's forms are clear and legible, like mathematical equations. Height, width, and masses relate to one another in a simple but effective ratio of 1:2, and precise numerical ratios similarly characterize the complex as a whole. The forecourt of the building, for example, covers an area equal to that of the mosque proper. Most architectural historians regard the Mosque of Selim II as the climax of Ottoman architecture. Sinan proudly proclaimed it his masterpiece.

IMAM MOSQUE, ISFAHAN While the Ottomans held sway in Turkey, the Safavids (r. 1501–1732) ruled the ancient Persian domains formerly under the control of the Abbasids, Seljuks, and Timurids (FIG. 10-29). The Safavids installed the ceramic-tile revetment on the walls and vaults of the Seljuks' Friday Mosque (FIG. 10-13) at Isfahan and built the Imam Mosque (formerly the Shah, or Royal, Mosque) in the early 17th century, which boasts some of the finest examples of Iranian tilework (FIG. 10-25). The use of glazed tiles has a long history in the Middle East. Even in ancient Mesopotamia, builders sometimes covered walls and gates with colorful baked bricks (FIG. 2-24).

In the Islamic world, the art of ceramic tilework reached its peak in the 16th and 17th centuries in Iran and Turkey (see "Islamic Tilework," above), when, for example, the Ottomans replaced the exterior mosaics of the Dome of the Rock (FIG. 10-2) in Jerusalem with glazed tiles. In the Imam Mosque in Isfahan, Safavid tiles cover almost every surface. For the entrance portal (FIG. 10-25), the cera-

10-26 Mihrab, from the Madrasa Imami, Isfahan, Iran, ca. 1354. Glazed mosaic tilework, 11' $3'' \times 7'$ 6''. Metropolitan Museum of Art, New York.

This Iranian mihrab is a masterpiece of mosaic tilework. Every piece had to be cut to fit its specific place in the design. It exemplifies the perfect aesthetic union of Islamic calligraphy and ornamentation.

mists had to manufacture a wide variety of shapes with curved surfaces to sheathe the complex forms of the muqarnas-filled, pointed half dome. The result was a technological triumph as well as a dazzling display of abstract decoration.

MADRASA IMAMI, ISFAHAN As already noted, verses from the Koran appeared in the mosaics of the Dome of the Rock (FIG. 10-3) in Jerusalem and in mosaics and other media on the walls of countless later Islamic structures. Indeed, some of the masterworks of Arabic calligraphy are not in manuscripts but on walls. A 14th-century mihrab (FIG. 10-26) from the Madrasa Imami in Isfahan exemplifies the perfect aesthetic union between the Islamic calligrapher's art and abstract ornamentation. The pointed arch framing the mihrab niche bears an inscription

from the Koran in Kufic, the stately rectilinear script employed for the earliest Korans (FIGS. 10-17 and 10-17A). Many supple cursive styles also make up the repertoire of Islamic calligraphy. One of these styles, known as Muhaqqaq, fills the mihrab's outer rectangular frame. The mosaic tile decoration on the curving surface of the niche and the area above the pointed arch consists of tighter and looser networks of geometric and abstract floral motifs. The mosaic technique is masterful. Every piece had to be cut to fit its specific place in the mihrab—even the tile inscriptions. The ceramist smoothly integrated the subtly varied decorative patterns with the framed inscription in the center of the niche-proclaiming that the mosque is the domicile of the pious believer. The mihrab's outermost inscription-detailing the five pillars of Islamic faith (see "Muhammad and Islam," page 285)—serves as a fringelike extension, as well as a boundary, for the entire design. The unification of calligraphic and geometric elements is so complete that only the practiced eye can distinguish them. The artist transformed the architectural surface into a textile surface—the three-dimensional wall into a two-dimensional hanging-weaving the calligraphy into it as another cluster of motifs within the total pattern.

Luxury Arts

The tile-covered mosques of Isfahan, Sultan Hasan's madrasa complex in Cairo, and the architecture of Sinan the Great in Edirne are enduring testaments to the brilliant artistic culture of the Safavid, Mamluk, and Ottoman rulers of the Muslim world. Still, these are but some of the most conspicuous public manifestations of the greatness of later Islamic art and architecture (see Chapter 32 for the achievements of the Muslim rulers of India). In the smaller-scale, and often private, realm of the luxury arts, Muslim artists also excelled. From the vast array of manuscript paintings, ceramics, and metalwork, the six masterpieces illustrated here (FIGS. 10-27 to 10-32) suggest both the range and the quality of the inappropriately dubbed Islamic "minor arts" of the 13th to 16th centuries.

ARDABIL CARPETS The first of these artworks (FIG. 10-27) is by far the largest, one of a pair of carpets from Ardabil in Iran. The carpets come from the funerary mosque of Shaykh Safi al-Din (1252–1334), the

founder of the Safavid line, but they date to 1540, two centuries after the construction of the mosque, during the reign of Shah Tahmasp (r. 1524–1576). Tahmasp elevated carpet weaving to a national industry and set up royal factories at Isfahan, Kashan, Kirman, and Tabriz. The name Maqsud of Kashan appears as part of the design of the carpet illustrated here. Maqsud must have been the artist who supplied the master pattern to two teams of royal weavers (one for each of the two carpets). The carpet, almost 35 by 18 feet, consists of roughly 25 million knots, some 340 to the square inch. (Its twin has even more knots.)

The design consists of a central sunburst medallion, representing the inside of a dome, surrounded by 16 pendants. Mosque lamps (appropriate motifs for the Ardabil funerary mosque) hang from two pendants on the long axis of the carpet. The lamps are

10-27 Maqsud of Kashan, carpet from the funerary mosque of Shaykh Safi al-Din, Ardabil, Iran, 1540. Wool and silk, 34' $6'' \times 17'$ 7''. Victoria & Albert Museum, London.

Maqsud of Kashan's enormous Ardabil carpet required roughly 25 million knots. It presents the illusion of a heavenly dome with mosque lamps reflected in a pool of water filled with floating lotus blossoms.

of different sizes. This may be an optical device to make the two appear equal in size when viewed from the end of the carpet at the room's threshold (the bottom end in FIG. 10-27). Covering the rich, dark blue background are leaves and flowers attached to delicate stems that spread over the whole field. The entire composition presents the illusion of a heavenly dome with lamps reflected in a pool of water full of floating lotus blossoms. No human or animal figures appear, as befits a carpet intended for a mosque, although they can be found on other Islamic textiles used in secular contexts, both earlier (FIG. 10-15A) and later.

10-28 Mosque lamp of Sayf al-Din Tuquztimur, from Egypt, 1340. Glass with enamel decoration, 1' 1" high. British Museum, London.

The enamel decoration of this glass mosque lamp includes a quotation from the Koran comparing God's light with the light in a lamp. The burning wick dramatically illuminated the sacred verse.

MOSQUE LAMPS The kind of mosque lamps depicted on the Ardabil carpets were usually made of glass and lavishly decorated. Islamic artists perfected this art form, and fortunately, despite their exceptionally fragile nature, many examples survive, in large part because those who handled them did so with reverence and care. One of the finest is the mosque lamp (FIG. 10-28) made for Sayf al-Din Tuquztimur (d. 1345), an official in the court of the Mamluk sultan al-Nasir Muhammad (r. 1309-1341). The glass lamps hung on chains from mosque ceilings. The shape of Tuquztimur's lamp is typical of the period, consisting of a conical neck, a wide body with six vertical handles, and a tall foot. Inside, a small glass container held the oil and wick. The enamel (colors fused to the surfaces) decoration includes Tuquztimur's emblem—an eagle over a cup (Tuquztimur served as the sultan's cup-bearer)—and cursive Arabic calligraphy giving the official's name and titles as well as a quotation of the Koranic verse (24:35) that compares God's light with the light in a lamp. The lamplight dramatically illuminated that verse (and Tuquztimur's name).

10-29 Bihzad, Seduction of Yusuf, folio 52 verso of the Bustan of Sultan Husayn Mayqara, from Herat, Afghanistan, 1488. Ink and color on paper, $11\frac{7}{8}$ " × $8\frac{5}{8}$ ". National Library, Cairo.

The most famous Timurid manuscript painter was Bihzad. This page displays vivid color, intricate decorative detailing, and a brilliant balance between two-dimensional patterning and perspective.

TIMURID BUSTAN In the late 14th century, a new Islamic empire arose in Central Asia under the leadership of Timur (r. 1370–1405), known in the Western world as Tamerlane. Timur, a successor of the Mongol conqueror Genghis Khan, quickly extended his dominions to include Iran and parts of Anatolia. The Timurids, who ruled until 1501, were great patrons of art and architecture in Herat, Bukhara, Samarqand, and other cities. Herat in particular became a leading center for the production of luxurious books under the patronage of the Timurid sultan Husayn Mayqara (r. 1470–1506).

The most famous Persian painter of his age was Bihzad, who worked at the Herat court before migrating to Tabriz. At Herat, he illustrated the sultan's copy of *Bustan* (*The Orchard*) by the Persian poet Sadi (ca. 1209–1292). One page (Fig. 10-29) represents a story in both the Bible and the Koran—the seduction of Yusuf (Joseph) by Potiphar's wife, Zulayhka. Bihzad dispersed Sadi's text throughout the page in elegant Arabic script in a series of beige panels. According to the tale as told by Jami (1414–1492), an influential mystic theologian and poet whose Persian text appears in blue in the white pointed arch of the composition's lower center, Zulaykha

lured Yusuf into her palace and led him through seven rooms, locking each door behind him. In the last room she threw herself at Yusuf, but he resisted and was able to flee when the seven doors opened miraculously. Bihzad's painting of the story highlights all the stylistic elements that brought him great renown: vivid color, intricate decorative detailing suggesting luxurious textiles and tiled walls, and a brilliant balance between two-dimensional patterning and perspective depictions of balconies and staircases. Bizhad's apprentices later worked for the Mughal court in India and introduced his distinctive style to South Asia (see Chapter 32).

SAFAVID *SHAHNAMA* The successors of the Timurids in Iran were the Safavids. Shah Tahmasp (FIG. 32-5), the Safavid ruler who commissioned the Ardabil carpets (FIG. 10-27), was also a great patron of books. Around 1525, he commissioned an ambitious decade-long project to produce an illustrated 742-page copy of the *Shahnama* (*Book of Kings*). The *Shahnama*, the Persian national epic poem by Firdawsi (940–1025), recounts the history of

Iran from creation until the Muslim conquest. Tahmasp's *Shahnama* contains 258 illustrations by many artists, including some of the most admired painters of the day. It was eventually presented as a gift to Selim II, the Ottoman sultan who was the patron of Sinan's mosque (FIGS. 10-23 and 10-24) at Edirne. The manuscript later entered a private collection in the West and ultimately was auctioned as a series of individual pages, destroying its integrity but underscoring that Western collectors viewed each page as an independent masterpiece.

The page reproduced here (FIG. 10-30) is the work of SULTAN-MUHAMMAD and depicts Gayumars, the legendary first king of Iran, and his court. According to tradition, Gayumars ruled from a mountaintop when humans first learned to cook food and clothe themselves in leopard skins. In Sultan-Muhammad's representation of the story, Gayumars presides over his court (all the figures wear leopard skins) from his mountain throne. The king is surrounded by light amid a golden sky. His son and grandson perch on multicolored rocky outcroppings to the viewer's left and right, respectively.

10-30 Sultan-Muhammad, Court of Gayumars, folio 20 verso of the Shahnama of Shah Tahmasp, from Tabriz, Iran, ca. 1525–1535. Ink, watercolor, and gold on paper, 1' $1'' \times 9''$. Prince Sadruddin Aga Khan Collection, Geneva.

Sultan-Muhammad painted the legend of King Gayumars for the Safavid ruler Shah Tahmasp. The off-center placement on the page enhances the sense of lightness that permeates the painting.

The court encircles the ruler and his heirs. Dozens of human faces appear within the rocks, and many species of animals populate the lush landscape. According to the *Shahnama*, wild beasts became instantly tame in the presence of Gayumars. Sultan-Muhammad rendered the figures, animals, trees, rocks, and sky with an extraordinarily delicate touch. The sense of lightness and airiness that permeates the painting is enhanced by its placement on the page—floating, off center, on a speckled background of gold leaf. The painter gave his royal patron a singular vision of Iran's fabled past.

BAPTISTÈRE DE SAINT LOUIS Metalwork was another early Islamic art form (FIG. 10-16) that continued to play an important role in the later period. An example of the highest quality is a brass basin (FIG. 10-31) from Egypt inlaid with gold and silver and signed—six times—by the Mamluk artist Muhammad Ibn Al-Zayn. The basin, used for washing hands at official ceremonies, must have been fashioned for a specific Mamluk patron. Some scholars think a court official named Salar ordered the piece as a gift for his sultan, but no inscription identifies him. The central band depicts Mamluk hunters and Mongol enemies. Running animals fill the friezes above and below. Stylized vegetal forms of inlaid silver fill the background of all the bands and roundels.

10-31 MUHAMMAD IBN AL-ZAYN, basin (*Baptistère de Saint Louis*), from Egypt, ca. 1300. Brass, inlaid with gold and silver, $8\frac{3}{4}$ " high. Musée du Louvre, Paris.

Muhammad ibn al-Zayn proudly signed (six times) this basin used for washing hands at official ceremonies. The central band, inlaid with gold and silver, depicts Mamluk hunters and Mongol enemies.

1 in.

Christian Patronage of Islamic Art

uring the 11th through 13th centuries, large numbers of Christians traveled to Islamic lands, especially to the Christian holy sites in Jerusalem and Bethlehem, either as pilgrims or as Crusaders (see "Pilgrimages" and "The Crusades," Chapter 12, pages 335 and 346). Many returned with mementos of their journey, usually in the form of inexpensive mass-produced souvenirs. But some wealthy individuals commissioned local Muslim artists to produce custommade pieces using costly materials.

A unique brass canteen (FIG. 10-32) inlaid with silver and decorated with scenes of the life of Jesus appears to be the work of a 13th-century Ayyubid metalsmith in the employ of a Christian patron. The canteen is a luxurious version of the "pilgrim flasks" Christian visitors to the Holy Land often carried back to Europe. Four inscriptions in Arabic promise eternal glory, secure life, perfect prosperity, and increasing good luck to the canteen's unnamed owner, who must have been a Christian, not only because of the

type of object but especially the choice of scenes engraved into the canteen. The Madonna and Christ Child appear enthroned in the central medallion, and three panels depicting New Testament events (see "The Life of Jesus in Art," Chapter 8, pages 240-241) fill most of the band around the medallion. The narrative unfolds in a counterclockwise sequence (Arabic is read from right to left), beginning with the Nativity (at 2 o'clock) and continuing with the Presentation in the Temple (10 o'clock) and Jesus' Entry into Jerusalem (6 o'clock). The scenes may have been chosen because the patron had visited their locales (Bethlehem and Jerusalem). Most scholars believe the artist used Syrian Christian manuscripts as the source for the canteen's Christian iconography. Many of the decorative details, however, are common in contemporaneous Islamic metalwork inscribed with the names of Muslim patrons. Whoever the owner was, the canteen testifies to the fruitful artistic interaction between Christians and Muslims in 13th-century Syria.

10-32 Canteen with episodes from the life of Jesus, from Syria, ca. 1240–1250. Brass, inlaid with silver, $1' 2_2^{1''}$ high. Freer Gallery of Art, Washington, D.C.

This unique canteen is the work of an Ayyubid metalsmith in the employ of a Christian pilgrim to the Holy Land. The three scenes from the life of Jesus appear in counterclockwise sequence.

1 in.

Figures and animals also decorate the inside and underside of the basin, which has long been known as the *Baptistère de Saint Louis*. The association with the famous French king (see "Louis IX, the Saintly King," Chapter 13, page 385) is a myth, however. Louis died before Muhammad ibn al-Zayn made the piece. Nonetheless, the *Baptistère*, taken to France long ago, was used in the baptismal rites

of newborns of the French royal family as early as the 17th century. Like the Zandana silk (FIG. 10-14A) in Toul Cathedral and a canteen (FIG. 10-32) featuring scenes of the life of Christ (see "Christian Patronage of Islamic Art," above), the *Baptistère de Saint Louis* testifies to the prestige of Islamic art well beyond the boundaries of the Islamic world.

THE ISLAMIC WORLD

UMAYYAD SYRIA AND ABBASID IRAQ 661-1258

- The Umayyads (r. 661–750) were the first Islamic dynasty. They ruled from their capital at Damascus (Syria) until the Abbasids (r. 750–1258) overthrew them and established a new capital at Baghdad (Iraq).
- The first great Islamic building was the Dome of the Rock, a domed octagon commemorating the triumph of Islam in Jerusalem, which the Muslims captured from the Byzantines in 638.
- Umayyad and Abbasid mosques, for example those in Damascus and Kairouan (Tunisia), are of the hypostyle-hall type and incorporate arcaded courtyards and minarets. The mosaic decoration of early mosques was often the work of Byzantine artists but excluded zoomorphic forms.
- The earliest preserved Korans date to the ninth century and feature Kufic calligraphy and decorative motifs but no figural illustrations.

Dome of the Rock, Jerusalem, 687–692

ISLAMIC SPAIN 756-1492

- Abd-al-Rahman I established the Umayyad dynasty (r. 756–1031) in Spain when he escaped the Abbasid massacre of his clan in 750.
- The Umayyad capital was at Córdoba, where the caliphs constructed and expanded the Great Mosque between the 8th and 10th centuries. The mosque features horseshoe and multilobed arches and mosaic-clad domes resting on arcuated squinches.
- The last Spanish Muslim dynasty was the Nasrid (r. 1232–1492), whose capital was at Granada. The Alhambra is the best surviving example of Islamic palace architecture. It is famous for its stuccoed walls and arches and its muqarnas decoration on vaults and domes.

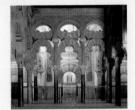

Great Mosque, Córdoba, 8th to 10th centuries

ISLAMIC EGYPT 909-1517

- The Fatimids (r. 909–1171) established their caliphate at Cairo (Egypt) in 909. Their successors were the Ayyubids (r. 1171–1250) and the Mamluks (r. 1250–1517).
- The most ambitious Mamluk builder was Sultan Hasan, whose madrasa-mosque-mausoleum complex in Cairo derives from Iranian four-iwan mosque designs.
- Egyptian artists excelled in glassmaking, metalwork, and other luxury arts and produced magnificent mosque lamps and engraved basins.

Mosque lamp of Sayf al-Din Tuquztimur, 1340

TIMURID AND SAFAVID IRAN AND CENTRAL ASIA 1370-1732

- The Timurid (r. 1370–1501) and Safavid (r. 1501–1732) dynasties, which ruled Iran and Central Asia for almost four centuries, were great patrons of art and architecture.
- The Timurid court at Herat (Afghanistan) employed the most skilled painters of the day, who specialized in illustrating books. The most famous was Bihzad.
- Persian painting also flourished in Safavid Iran under Shah Tahmasp (r. 1524–1576), who in addition set up royal carpet factories in several cities.
- The art of tilework reached its peak under the patronage of the Safavid dynasty. Builders of the time frequently used cuerda seca and mosaic tiles to cover the walls, vaults, and domes of mosques, madrasas, palaces, and tombs.

Bihzad, Seduction of Yusuf, 1488

OTTOMAN TURKEY 1281-1924

- Osman I (r. 1281–1326) founded the Ottoman dynasty in Turkey. By the middle of the 15th century, the Ottomans had become a fearsome power and captured Byzantine Constantinople in 1453.
- The greatest Ottoman architect was Sinan (ca. 1491–1588), who perfected the design of the domed central-plan mosque. His Mosque of Selim II at Edirne is also an engineering triumph. Its dome is taller than Hagia Sophia's.

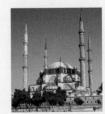

Sinan, Mosque of Selim II, Edirne, 1568–1575

In this opening page to the Gospel of Saint Matthew, the painter transformed the biblical text into abstract pattern, literally making God's words beautiful. The intricate design recalls early medieval metalwork.

The *chi-rho-iota* (XPI) page is not purely embellished script and abstract pattern. Half-figures of winged angels appear to the left of *chi*, accompanying the monogram as if accompanying Christ himself.

11-1 Chi-rho-iota (XPI) page, folio 34 recto of the Book of Kells, probably from Iona, Scotland, late eighth or early ninth century. Tempera on vellum, 1' 1" \times 9½". Trinity College Library, Dublin.

The only unadorned letters in the opening of the passage read on Christmas Eve are the two words *autem* (abbreviated simply as *h*) and *generatio*: "Now this is how the birth of Christ came about."

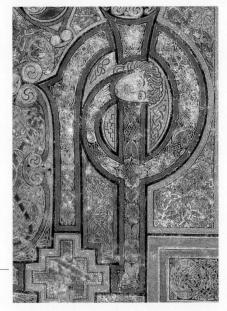

The other figural elements on this page of the *Book of Kells* include a male head growing out of the end of the curve in the letter *rho*. Animals are at the base of *rho* to the left of *h generatio*.

11

EARLY MEDIEVAL EUROPE

MISSIONARIES SPREAD CHRISTIAN ART

The half millennium between 500 and 1000 was the great formative period of western medieval art, a time of great innovation. The patrons of many of these works were Christian missionaries, who brought to the non-Christian peoples of the former northwestern provinces of the Roman Empire not only the Gospel but the culture of the Late Antique Mediterranean world as well.

In Ireland, the most distant European outpost, the Christianization of the Celts began in the fifth century. By the end of the seventh century, monks at several Irish monasteries were producing magnificent illuminated books for use by the clergy and for impressing the illiterate with the beauty of God's words. The greatest early medieval Irish book is the *Book of Kells*, which one commentator described in the *Annals of Ulster* for 1003 as "the chief relic of the western world." The manuscript was probably the work of scribes and illuminators at the monastery at Iona. The monks kept the book in an elaborate metalwork box, as befitted a greatly revered "relic," and likely displayed it on the church altar.

The page reproduced here (FIG. 11-1) opens the account of the nativity of Jesus in the Gospel of Saint Matthew. The initial letters of Christ in Greek (XPI, *chi-rho-iota*) occupy nearly the entire page, although two words—*autem* (abbreviated simply as *h*) and *generatio*—appear at the lower right. Together they read: "Now this is how the birth of Christ came about." The page corresponds to the opening of Matthew's Gospel, the passage read in church on Christmas Eve. The illuminator transformed the holy words into extraordinarily intricate, abstract designs recalling metalwork (FIG. 11-3), but the page is not purely embellished script and abstract pattern. The letter *rho*, for example, ends in a male head, and animals are at the base of *rho* to the left of *h generatio*. Half-figures of winged angels appear to the left of *chi*. Close observation reveals many other figures, human and animal. When the priest Giraldus Cambrensis visited Ireland in 1185, he described a manuscript he saw that, if not the *Book of Kells* itself, must have been very much like it:

Fine craftsmanship is all about you, but you might not notice it. Look more keenly at it and you . . . will make out intricacies, so delicate and subtle, so exact and compact, so full of knots and links, with colors so fresh and vivid, that you might say that all this was the work of an angel, and not of a man. For my part, the oftener I see the book, the more carefully I study it, the more I am lost in ever fresh amazement, and I see more and more wonders in the book.¹

In the early Middle Ages, the monasteries of northern Europe were both the repositories of knowledge in the midst of an almost wholly illiterate population and the greatest centers of art production.

ART OF THE WARRIOR LORDS

Early medieval art* in western Europe (MAP 11-1) was the result of a unique tripartite fusion of the classical heritage of Rome's northwestern provinces, the cultures of the non-Roman peoples north of the Alps, and Christianity. Although the Romans called everyone who lived beyond their empire's frontiers "barbarians," many northerners had risen to prominent positions within the Roman army and government during Late Antiquity. Others established their own areas of rule, sometimes with Rome's approval, sometimes in opposition to imperial authority. Over the centuries the various population groups merged, and a new order gradually replaced what had been the Roman Empire, resulting eventually in today's European nations.

As Rome's power waned, armed conflicts and competition for political authority became commonplace among the Huns, Vandals, Merovingians, Franks, Goths, and other non-Roman peoples of Europe. Once one group established itself in Italy or in one of Rome's European provinces, another often pressed in behind and compelled the first one to move on. The Visigoths, for example, who at one time controlled part of Italy and formed a kingdom in what is today southern France, were forced southward into Spain under pressure from the Franks, who had crossed the lower Rhine River and established themselves firmly in France, Switzerland, the Netherlands, and parts of

Germany. The Ostrogoths moved from Pannonia (at the junction of modern Hungary, Austria, and the former Yugoslavia) to Italy. Under Theodoric (see page 246), they established their kingdom there, only to have it fall less than a century later to the Lombards, the last of the early Germanic powers to occupy land within the limits of the old Roman Empire. Anglo-Saxons controlled what had been Roman Britain. Celts inhabited France and parts of the British Isles, including Ireland. In Scandinavia, the seafaring Vikings held sway.

Art historians do not know the full range of art and architecture these non-Roman cultures produced. What has survived is

*The adjective *medieval* and the noun *Middle Ages* are very old terms stemming from an outmoded view of the roughly 1,000 years between the adoption of Christianity as the Roman Empire's official religion and the rebirth (Renaissance) of interest in classical antiquity. Earlier historians, following the lead of the humanist scholars of Renaissance

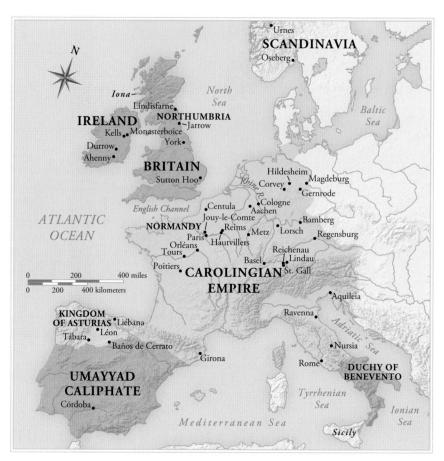

MAP 11-1 The Carolingian Empire at the death of Charlemagne in 814.

919

probably not fully representative and consists almost exclusively of small portable "status symbols"—weapons and items of personal adornment such as bracelets, pendants, and belt buckles that archaeologists have discovered in lavish burials. Earlier scholars, who viewed medieval art through a Renaissance lens, ignored these "minor arts" because of their small scale, seemingly utilitarian nature, and abstract ornamentation, and because their makers rejected the classical idea that naturalistic representation should be the focus of artistic endeavor. In the early Middle Ages, people regarded these objects, which often display a high degree of technical and stylistic

Italy, viewed this period as a long and artistically crude interval between—in the middle of—two great civilizations. The force of tradition dictates the retention of both terms to describe this period and its art, although scholars long ago ceased judging medieval art as unsophisticated or inferior.

410

EARLY MEDIEVAL EUROPE

After the fall of Rome, artists produce portable items of personal adornment featuring cloisonné ornamentation and intertwined animal and interlace patterns

Warrior Lords

768

I Christian missionaries commission sumptuous illuminated manuscripts featuring full pages devoted to embellishing the Word of God

Hiberno-Saxon

and Carolingian

- Charlemagne and his Carolingian successors (768–877) initiate a conscious revival of the art and culture of Early Christian Rome
- Carolingian architects introduce the twintower westwork and modular plans for basilican churches
- Ottonian painters and sculptors produce illuminated manuscripts and ivory reliefs inspired by Late Antique and Byzantine sources

Ottonian

1024

Ottonian architects introduce the alternatesupport system and galleries into the naves of churches

11-2 Pair of Merovingian looped fibulae, from Jouy-le-Comte, France, mid-sixth century. Silver gilt worked in filigree, with inlays of garnets and other stones, 4" high. Musée d'Archéologie Nationale, Saint-Germain-en-Laye.

Jeweled fibulae were status symbols among early medieval warlords. This pair, probably owned by a Merovingian woman, features eagle heads and fish integrated into a highly decorative design.

sophistication, as treasures. The objects enhanced their owners' prestige and testified to the stature of those buried with them. In the great early (possibly seventh-century) Anglo-Saxon epic *Beowulf*, after Beowulf dies, his comrades cremate the hero and place his ashes in a huge *tumulus* (burial mound) overlooking the sea. As an everlasting tribute to Beowulf's greatness, they "buried rings and brooches in the barrow, all those adornments that brave men had brought out from the hoard after Beowulf died. They bequeathed the gleaming gold, treasure of men, to the earth."²

MEROVINGIAN FIBULAE Most characteristic, perhaps, of the prestige adornments of the early medieval period was the fibula, a decorative pin the Romans wore (and the Etruscans before them; FIG. 6-2). Men and women alike used fibulae to fasten their garments. Made of bronze, silver, or gold, these pins often featured profuse decoration, sometimes incorporating inlaid precious or semiprecious stones. The pair of fibulae illustrated here (FIG. 11-2) formed part of a find of jewelry of the mid-sixth century, when Merovingian kings (r. 482-751) ruled large parts of what is now France. The pins, probably once the proud possession of a wealthy Merovingian woman, accompanied their owner into the afterlife. They resemble, in general form, the roughly contemporaneous but plain fibulae used to fasten the outer garments of some of the attendants flanking the Byzantine emperor Justinian in the apse mosaic (FIG. 9-13) of San Vitale in Ravenna. (Note how much more elaborate is the emperor's clasp. In Rome, Byzantium, and early medieval Europe alike, these fibulae were emblems of office and of prestige.)

Covering almost the entire surface of each of the Merovingian fibulae are decorative patterns adjusted carefully to the basic shape of the object. They thus describe and amplify the fibula's form and structure, becoming an organic part of the pin itself. Often the early medieval metalworkers so successfully integrated zoomorphic elements into this type of highly disciplined, abstract decorative design that the animal forms became almost unrecognizable. For example, the fibulae in FIG. 11-2 incorporate a fish just below the center of each pin. The looped forms around the edges are stylized eagles' heads with red garnets forming the eyes.

SUTTON HOO SHIP BURIAL The *Beowulf* saga also recounts the funeral of the warrior lord Scyld, whom his comrades laid to rest in a ship overflowing with arms and armor and costly adornments set adrift in the North Sea.

They laid their dear lord, the giver of rings, deep within the ship by the mast in majesty; many treasures and adornments from far and wide were gathered there. I have never heard of a ship equipped more handsomely with weapons and war-gear, swords and corselets; on his breast lay countless treasures that were to travel far with him into the waves' domain.³

In 1939, archaeologists uncovered a treasure-laden ship in a burial mound at Sutton Hoo, near the sea, in Suffolk, England. Although the Sutton Hoo ship never set out to sea, it epitomizes the early medieval

tradition of burying great lords in ships with rich furnishings, as recorded in *Beowulf*. Among the many precious finds were a purse cover (FIG. 11-3) with gold, glass, and garnet ornamentation, a gold belt

11-3 Purse cover, from the Sutton Hoo ship burial in Suffolk, England, ca. 625. Gold, glass, and cloisonné garnets, $7^{1''}_2$ long. British Museum, London (gift of Mrs. E. M. Pretty).

This purse cover comes from a treasure-laden royal burial ship. The combination of abstract interlace ornamentation with animal figures is the hallmark of the art of the early Middle Ages in western Europe.

1 in

11-3A Belt buckle, Sutton Hoo. ca. 625. ■◀

buckle (FIG. 11-3A), 10 silver bowls, a silver plate with the imperial stamp of the Byzantine emperor Anastasius I (r. 491–518), and 40 gold coins (perhaps to pay the 40 oarsmen who would row the deceased across the sea on his final voyage). Also placed in the ship

were two silver spoons inscribed "Saulos" and "Paulos," Saint Paul's names in Greek before and after his baptism. They may allude to a conversion to Christianity. Some historians have associated the ship with the East Anglian king Raedwald (r. 599?–625), who was baptized a Christian before his death in 625, but the identity of the king buried at Sutton Hoo is uncertain.

The most extraordinary item found in the Sutton Hoo ship is the purse cover (FIG. 11-3). The decoration consists of seven *cloisonné* plaques within a cloisonné border. The cloisonné technique, a favorite of the early medieval "treasure givers," dates at least as early as the New Kingdom in Egypt. Metalworkers produced cloisonné jewelry by soldering small metal strips, or *cloisons* (French for "partitions"), edge up, to a metal background, and then filling the compartments with semiprecious stones, pieces of colored glass, or glass paste fired to resemble sparkling jewels. The edges of the cloisons are an important part of the design. Cloisonné is a cross between mosaic and stained glass (see "Mosaics," Chapter 8, page 245, and "Stained-Glass Windows," Chapter 13, page 375), but medieval artists used it only on a miniature scale.

On the Sutton Hoo purse cover, four symmetrically arranged groups of figures make up the lower row. The end groups consist of a man standing between two beasts. He faces front, and they appear in profile. This heraldic type of grouping has a venerable heritage in the ancient world (FIG. 2-10) but must have delivered a powerful contemporary message. It is a pictorial parallel to the epic sagas of the era in which heroes such as Beowulf battle and conquer horrific monsters. The two center groups represent eagles attacking ducks. The metalworker ingeniously composed the animal figures. For example, the convex beaks of the eagles (compare the Merovingian fibulae, FIG. 11-2) fit against the concave beaks of the ducks. The two figures fit together so snugly they seem at first to be a single dense abstract design. This is true also of the man-animals motif.

Above these figures are three geometric designs. The outer ones are purely linear, although they also rely on color contrasts for their effect. The central design is an interlace pattern in which the interlacements evolve into writhing animal figures. Elaborate intertwining linear patterns are characteristic of many times and places, notably in the art of the Islamic world (see Chapter 10). But the combination of interlace with animal figures was uncommon outside the realm of the early medieval warlords. In fact, metalcraft with interlace patterns and other motifs beautifully integrated with the animal form was, without doubt, the premier art of the early Middle Ages in northwestern Europe. Interest in it was so great that artists imitated the colorful effects of jewelry designs in the painted decorations of manuscripts (FIG. 11-1), in the masonry of churches, and in sculpture in stone and in wood, the last an especially important medium of Viking art.

VIKINGS In 793, the pre-Christian traders and pirates of Scandinavia known as Vikings (named after the *viks*—coves or "trading places"—of the Norwegian shoreline) landed in the British Isles. They destroyed the Christian monastic community on Lindisfarne Island off the Northumbrian (northeastern) coast of England. Shortly after, these Norsemen (North men) attacked the monastery

at Jarrow in England as well as that on Iona Island, off the west coast of Scotland. From then until the mid-11th century, the Vikings were the terror of western Europe. From their great ships they seasonally harried and plundered harbors and river settlements. Their fast, seaworthy longboats took them on wide-ranging voyages, from Ireland eastward to Russia and westward to Iceland and Greenland and even, briefly, to Newfoundland in North America, long before Columbus arrived in the New World.

The Vikings were intent not merely on a hit-and-run strategy of destruction but also on colonizing the lands they occupied by conquest. Their exceptional talent for organization and administration, as well as for war, enabled them to conquer and govern large territories in Ireland, England, and France, as well as in the Baltic regions and Russia. For a while, in the early 11th century, the whole of England was part of a Danish empire. When Vikings settled in northern France in the early 10th century, their territory came to be called Normandy—home of the Norsemen who became Normans. (Later, a Norman duke, William the Conqueror, sailed across the English Channel and invaded and became the master of Anglo-Saxon England; FIG. 12-38.)

OSEBERG SHIP BURIAL Much of the preserved art of the Viking sea-rovers consists of decoration of their great wooden ships (FIGS. 11-4 and 11-4A). Striking examples of Viking woodcarving come from a ship burial near the sea at Oseberg, Norway. The ship, discovered beneath an

11-4A Viking ship burial, Oseberg, ca. 815–820.

earthen mound as was the earlier Sutton Hoo burial, is more than 70 feet long. The vessel contained the remains of two women. The size of the burial alone and the lavishly carved wooden ornamentation of the sleek ship attest to the importance of those laid to rest

11-4 Animal-head post, from the Viking ship burial, Oseberg, Norway, ca. 825. Wood, head 5" high. Viking Ship Museum, University of Oslo, Bygdoy.

The Vikings were master wood-carvers. This Viking ship post combines in one composition the head of a roaring beast with surface ornamentation in the form of tightly interwoven writhing animals.

there. The vessel also once must have carried many precious objects robbers stole long before its modern discovery.

An animal-head post (FIG. 11-4) is characteristic of the masterfully carved decoration of the Oseberg ship. It combines in one composition the image of a roaring beast with protruding eyes and flaring nostrils and the complex, controlled pattern of tightly interwoven animals that writhe, gripping and snapping, in serpentine fashion. The Oseberg animal head is a powerfully expressive example of the union of two fundamental motifs of the warrior lords' art—the animal form and the interlace pattern.

STAVE CHURCH, URNES By the 11th century, much of Scandinavia had become Christian, but Viking artistic traditions persisted. Nowhere is this more evident than in the decoration of the portal (FIG. 11-5) of the stave church (*staves* are wedge-shaped timbers placed vertically) at Urnes, Norway. The portal and a few staves are almost all that remain from the mid-11th century church. Builders later incorporated these fragments into the walls of the 12th-century church. Gracefully elongated animal forms intertwine with flexible plant stalks and tendrils in spiraling rhythm. The effect of natural growth is astonishing, yet the designer subjected

11-5 Wooden portal of the stave church at Urnes, Norway, ca. 1050–1070.

By the 11th century, Scandinavia had become mostly Christian, but Viking artistic traditions persisted, as in the intertwining animal-and-plant decoration of this Norwegian church portal.

the organic forms to a highly refined abstract sensibility. This intricate Urnes style was the culmination of three centuries of Viking inventiveness.

HIBERNO-SAXON ART

At the same time that powerful Merovingian, Anglo-Saxon, and Scandinavian warlords were amassing artworks dominated by abstract and animal motifs, Christian missionaries were establishing monasteries in northern Europe and sponsoring artworks of Christian content. The early medieval art of these monasteries, however, differs dramatically from contemporaneous works produced in Italy and the Byzantine Empire. These Christian artworks are among the most distinctive ever created and testify to the fruitful fusion of native and imported artistic traditions.

In Ireland, in part because of their isolation, the Celts who converted to Christianity, although nominally subject to the Roman popes, quickly developed a form of monastic organization that differed from the Church of Rome's. The monks often selected inaccessible and inhospitable places where they could carry on their duties far from worldly temptations and distractions. Before long, Irish monks, filled with missionary zeal, set up monastic establishments in Britain and Scotland. In 563, Saint Columba founded an important monastery on the Scottish island of Iona, where he successfully converted the native Picts to Christianity. Iona monks established the monastery at Lindisfarne off the northern coast of Britain in 635 and around 800 produced the extraordinary *Book of Kells* (FIG. 11-1).

The *Book of Kells* (named after the abbey in central Ireland that once owned it) is the outstanding example of the style art historians have named *Hiberno-Saxon* (Hibernia was the Roman name of Ireland) or *Insular* to denote the monastic art of the Irish-English islands. The most distinctive products of the Hiberno-Saxon monasteries were illuminated Christian books (see "Medieval Books," page 312). Books were the primary vehicles in the effort to Christianize Britain, Scotland, and Ireland. Indeed, they brought the word of God to a predominantly illiterate population who regarded the monks' sumptuous volumes with awe. Books were scarce and jealously guarded treasures of the libraries and *scriptoria* (writing studios) of monasteries and major churches. Illuminated books are the most important extant monuments of the brilliant artistic culture that flourished in Ireland and Northumbria during the seventh and eighth centuries.

BOOK OF DURROW Among the earliest Hiberno-Saxon illuminated manuscripts is the Book of Durrow, a Gospel book that may have been written and decorated in the monastic scriptorium at Iona, although it has no documented provenance. In the late Middle Ages, it was in the monastery in Durrow, Ireland—hence its modern name. The Durrow Gospels already display one of the most characteristic features of Insular book illumination-full pages devoted neither to text nor to illustration but to pure embellishment. The Hiberno-Saxon painters must have felt beautiful decoration lent prestige to books just as ornamental jewelry lent status to those who wore it. Interspersed between the Durrow text pages are so-called carpet pages, resembling textiles, made up of decorative panels of abstract and zoomorphic forms (compare FIG. 11-7). The Book of Durrow also contains pages where the illuminator enormously enlarged the initial letters of an important passage of sacred text and transformed those letters into elaborate decorative patterns (compare FIG. 11-1). Such manuscript pages have no precedents in Greco-Roman books. They reveal the striking independence of Insular artists from the classical tradition.

Medieval Books

The central role books played in the medieval Church led to the development of a large number of specialized types for priests, monks and nuns, and laypersons.

The primary sacred text came to be called the Bible ("the Book"), consisting of the Hebrew scriptures (the "Old Testament") and the Christian "New Testament," written in Greek. In the late fourth century, Saint Jerome produced the canonical Latin, or *Vulgate* (vulgar, or common tongue), version of the Bible, which incorporates 46 Old and 27 New Testament books. Before the invention of the printing press in the 15th century, all books were handwritten ("manuscripts," from the Latin *manu scriptus*). Bibles were major undertakings, and few early medieval monasteries possessed a complete Bible. Instead, scribes usually

11-6 Man (symbol of Saint Matthew), folio 21 verso of the Book of Durrow, possibly from Iona, Scotland, ca. 660-680. Ink and tempera on parchment, $9\frac{5}{8}'' \times 6\frac{1}{8}''$. Trinity College Library, Dublin.

This early Hiberno-Saxon Gospel book has four pages devoted to the symbols of the four evangelists. The cloak of Saint Matthew's man resembles a cloisonné brooch filled with abstract ornamentation.

produced separate volumes containing several biblical books.

The *Pentateuch* contains the five books of the Jewish Torah, beginning with the story of Adam and Eve (Genesis). The *Gospels* ("good news") are the New Testament works of Saints Matthew, Mark, Luke, and John (see "The Four Evangelists," page 314) and tell the story of the life of Christ (see "The Life of Jesus in Art," Chapter 8, pages 240–241). Medieval Gospel books often contained *canon tables*—a concordance, or matching, of the corresponding passages of the four Gospels, which Eusebius of Caesarea compiled in the fourth century. *Psalters* collected the 150 psalms of King David, written in Hebrew and translated into both Greek and Latin.

The Church also frequently employed other types of books. The *lectionary* contains passages from the Gospels reordered to appear in the sequence that priests read them during the celebration of Mass throughout the year. *Breviaries* include the texts required for monks' daily recitations. *Sacramentaries* incorporate the prayers priests recite during Mass. *Benedictionals* contain bishops' blessings. In the later Middle Ages, scribes developed books for the private devotions of the laity, patterned after monks' readers. The

most popular was the *Book of Hours*, so called because it contains the prayers to be read at specified times of the day.

Medieval scribes produced many other types of books—compilations of saints' lives (*passionals*), theological treatises, secular texts on history and science, and even some classics of Greco-Roman literature—but these contained illustrations less frequently than did the various sacred texts.

In the *Book of Durrow*, each of the four Gospel books has a carpet page facing a page dedicated to the symbol of the evangelist who wrote that Gospel. An elaborate interlace design similar to those found on contemporaneous belt buckles and brooches frames each symbol. These pages served to highlight the major divisions of the text. The symbol of Saint Matthew (FIG. 11-6) is a man (more commonly represented later as winged; see "The Four Evangelists," page 314), but the only human parts the artist—a seventh-century monk—chose to render are a schematic frontal head and two profile feet. A cloak of yellow, red, and green squares—resembling cloisons filled with intricate abstract designs and outlined in dark brown or black—envelops the rest of the "body." The *Book of Durrow* weds the abstraction of northern European early medieval personal

adornment with the Christian pictorial imagery of Italy and Byzantium. The vehicle for the transmission of those Mediterranean forms was the illustrated book itself, which Christian missionaries brought to Ireland.

LINDISFARNE GOSPELS The marriage between Christian imagery and the animal-interlace style of the northern warlords is evident in the cross-inscribed carpet page (FIG. 11-7) of the Lindisfarne Gospels. Produced in the Northumbrian monastery on Lindisfarne Island, the book contains several ornamental pages and exemplifies Hiberno-Saxon art at its best. According to a later colophon (an inscription, usually on the last page, providing information regarding a book's manufacture), Eadfrith, bishop of Lindisfarne

11-7 Cross-inscribed carpet page, folio 26 verso of the *Lindisfarne Gospels*, from Northumbria, England, ca. 698–721. Tempera on vellum, $1' \, 1\frac{1}{2}'' \times 9\frac{1}{4}''$. British Library, London.

The cross-inscribed carpet page of the *Lindisfarne Gospels* exemplifies the way Hiberno-Saxon illuminators married Christian imagery and the animal-interlace style of the early medieval warlords.

between 698 and his death in 721, wrote the *Lindisfarne Gospels* "for God and Saint Cuthbert." Cuthbert's relics recently had been deposited in the Lindisfarne church (see "The Veneration of Relics," Chapter 12, page 336).

The patterning and detail of this Lindisfarne ornamental page are much more intricate than the *Book of Durrow* pages. Serpentine interlacements of fantastic animals devour each other, curling over and returning on their writhing, elastic shapes. The rhythm of expanding and contracting forms produces a vivid effect of motion and change, but the painter held it in check by the regularity of the design and by the dominating motif of the inscribed cross. The cross—the all-important symbol of the imported religion—stabilizes the rhythms of the serpentines and, perhaps by contrast with

its heavy immobility, seems to heighten the effect of motion. The illuminator placed the motifs in detailed symmetries, with inversions, reversals, and repetitions the viewer must study closely to appreciate not only their variety but also their mazelike complexity. The zoomorphic forms intermingle with clusters and knots of line, and the whole design vibrates with energy. The color is rich yet cool. The painter adroitly adjusted shape and color to achieve a smooth and perfectly even surface.

Like most Hiberno-Saxon artworks, the Lindisfarne cross page displays the artist's preference for small, infinitely complex, and painstaking designs. Even the Matthew symbol (FIG. 11-6) in the *Book of Durrow* reveals the illuminator's concern was abstract design, not the depiction of the natural world. But exceptions exist. In some

The Four Evangelists

vangelist derives from the Greek word for "one who announces good news," namely the Gospel of Christ. The authors of the Gospels, the first four books of the New Testament, are Saints Matthew, Mark, Luke, and John, collectively known as the four evangelists. The Gospel books provide the authoritative account of the life of Jesus, differing in some details but together constituting the literary basis for the iconography of Christian art (see "The Life of Jesus in Art," Chapter 8, pages 240-241). Each evangelist has a unique symbol derived from passages in Ezekiel (1:5-14) and the Apocalypse (4:6-8).

11-8 Saint Matthew, folio 25 verso of the *Lindisfarne Gospels*, from Northumbria, England, ca. 698–721. Tempera on vellum, $1'\frac{1}{2}'' \times 9\frac{1}{4}''$. British Library, London.

Portraits of the four evangelists frequently appeared in Gospel books. A Mediterranean book probably inspired this Hiberno-Saxon depiction of Saint Matthew with his symbol, a winged man.

- Matthew was a tax collector in Capernaum before Jesus called him to become an apostle. Little else is known about him, and accounts differ as to how he became a martyr. Matthew's symbol is the winged man or angel, because his Gospel opens with a description of the human ancestry of Christ.
- Mark was the first bishop of Alexandria in Egypt, where he suffered martyrdom. He was a companion of both Saint Peter and Saint Paul. One tradition says Peter dictated the Gospel to Mark, or at least inspired him to write it. Because Mark's Gospel begins with a voice crying in the wilderness, his symbol is the lion, the king of the desert.
- Luke was a disciple of Saint Paul, who refers to Luke as a physician. A later tradition says Luke painted a portrait of the Virgin Mary and the Christ Child. Consequently, late medieval painters' guilds often chose Luke as their patron saint. Luke's symbol is the ox, because his Gospel opens with a description of the priest Zacharias sacrificing an ox.
- I John was one of the most important apostles. He sat next to Jesus at the last supper and was present at the crucifixion, lamentation, and transfiguration. John was also the author of the Apocalypse, the last book of the New Testament, which he wrote in exile on the Greek island of Patmos. The Apocalypse records John's visions of the end of the world, the last judgment, and the second

coming. John's symbol is the eagle, the soaring bird connected with his apocalyptic visions.

The four evangelists appear frequently in medieval art, especially in illuminated Gospel books where they regularly serve as frontispieces to their respective Gospels. Often, artists represented them as seated authors, with or without their symbols (FIGS. I-8, 11-8, 11-13, and 11-14). In some instances, all four evangelists appear together (FIG. I-8). Frequently, both in painting and in sculpture, artists represented only the symbols (FIGS. 9-14A, 11-6, 12-1, 12-8, 12-18, and 13-6).

Insular manuscripts, the artists based their compositions on classical pictures in imported Mediterranean books. This is the case with the author portrait of Saint Matthew (FIG. 11-8) in the *Lindisfarne Gospels*. The Hiberno-Saxon illuminator's model probably was an illustrated Gospel book a Christian missionary brought from Italy to England. Author portraits were familiar features of Greek and Latin books, and similar representations of seated philosophers or poets

writing or reading (FIGS. 7-25B, 7-71, and 8-7) abound in ancient art. The Lindisfarne Matthew sits in his study composing his account of the life of Christ. A curtain sets the scene indoors, as in classical art (FIG. 5-58), and Matthew's seat is at an angle, which also suggests a Mediterranean model employing classical perspective. The painter (or the scribe) labeled Matthew in a curious combination of Greek (*O Agios*, "saint"—written, however, using Latin rather than Greek

11-9 High Cross of Muiredach (east face), Monasterboice, Ireland, 923. Sandstone, 18' high.

Early medieval Irish high crosses are exceptional in size. The cross marking Muiredach's grave bears reliefs depicting the *Crucifixion* and *Last Judgment*, themes suited to a Christian burial.

letters) and Latin (*Mattheus*), perhaps to lend the page the prestige of two classical languages. The former was the language of the New Testament, the latter that of the Church of Rome. Accompanying Matthew is his symbol, the winged man, labeled *imago hominis*, "image of the man" (see "The Four Evangelists," page 314). The identity of the figure—represented as a disembodied head and shoulders—behind the curtain is uncertain. Among the possibilities are Christ, Saint Cuthbert, and Moses holding the closed book of the Old Testament

in contrast with the open book of Matthew's New Testament, a common juxtaposition in medieval Christian art and thought.

Although a Mediterranean manuscript inspired the Lindisfarne composition, the Northumbrian painter's goal was not to copy the model faithfully. Instead, uninterested in the emphasis on volume, shading, and perspective that are the hallmarks of the pictorial illusionism of Greco-Roman painting, the Lindisfarne illuminator conceived the subject exclusively in terms of line and color. In the Hiberno-Saxon manuscript, the drapery folds are a series of sharp, regularly spaced, curving lines filled in with flat colors. The painter converted fully modeled forms bathed in light into the linear idiom of Insular art. The result is a vivid new vision of Saint Matthew.

HIGH CROSSES Surpassing the *Lindisfarne Gospels* in richness is the *Book of Kells*, which boasts an unprecedented number of full-page illuminations, including carpet pages, evangelist symbols, portrayals of the Virgin Mary and of Christ, New Testament narrative scenes, canon tables, and several instances (for example, FIG. 11-1, already discussed) of monumentalized and embellished words from the Bible. The *Book of Kells* is a relatively small object, however, designed for display on an altar. In the Hiberno-Saxon world, the high crosses of Ireland and northern England, set up between the 8th and 10th centuries, are exceptional in their mass and scale. These majestic monuments, some more than 20 feet in height, preside over burial grounds adjoining monasteries. Freestanding and unattached to any architectural fabric, the high crosses have the imposing unity, weight, and presence of both building and statue—architecture and sculpture combined.

The High Cross of Muiredach (FIG. 11-9) at Monasterboice and the South Cross (FIG. 11-9A) at Ahenny are two of the largest and finest early medieval high crosses. The Monasterboice cross is larger and more unusual because of its extensive narrative relief decoration. An inscription on the bottom of the west face of the shaft asks a prayer for a man named Muiredach. Most scholars identify him as the influential Irish cleric of the same name who was abbot of Monasterboice and died in 923. The monastery he headed was one of Ireland's oldest, founded in the late fifth century. The cross probably marked the abbot's grave. Four

11-9A South Cross Ahenny, late eighth century.

arcs forming a circle loop the concave arms, which expand into squared terminals (compare FIG. 11-7). The circle intersecting the cross identifies the type as Celtic. At the center of the west side of Muiredach's cross is a depiction of the crucified Christ. On the east side (FIG. 11-9), the risen Christ stands as judge of the world, the hope of the dead. Below him is a depiction of the weighing of souls on scales—a theme that two centuries later sculptors of church portals (FIG. 12-1) pursued with extraordinary force.

VISIGOTHIC AND MOZARABIC ART

The Romans never ruled Ireland, but Spain was a province of the Roman Empire for hundreds of years. The Roman conquest brought new roads to the Iberian peninsula and new cities with Roman temples, forums, theaters, and aqueducts. But in the early fifth century, the Roman cities fell to Germanic invaders, most notably the Visigoths, who had converted to Christianity. Many of the stone churches the Visigoths built in the sixth and seventh centuries still stand.

11-10 San Juan Bautista (looking northeast), Baños de Cerrato, Spain, 661.

This three-aisled basilican church dedicated to Saint John the Baptist is typical of Visigothic architecture in Spain. It features three square apses and an entrance portal crowned by a horseshoe arch.

BAÑOS DE CERRATO An outstanding example is the church of San Juan Bautista (Saint John the Baptist,

FIG. 11-10) at Baños de Cerrato, which the Visigothic king Recceswinth (r. 649–672) constructed in 661 in thanksgiving for a cure after bathing in the waters there. The Visigothic churches are basilican in form but often have multiple square apses. (The Baños de Cerrato church has three.) They also regularly incorporate horseshoe arches, a form usually associated with Islamic architecture (FIGS. 10-9 and 10-10) but that in Spain predates the Muslim conquest of 711.

TÁBARA Although the Islamic caliphs of Córdoba swept the Visigoths away (see Chapter 10), they never succeeded in gaining control of the northernmost parts of the peninsula. There, the Christian culture called *Mozarabic* (referring to Christians living in Arab territories) continued to flourish, as did some Jewish communities. One northern Spanish monk, Beatus (ca. 730–798), abbot of San Martín at Liébana, wrote *Commentary on the Apocalypse* around 776. This influential work was widely copied and illustrated in the monastic scriptoria of medieval Europe. One copy was produced at the monastery of San Salvador at Tábara in the kingdom of Léon in 970. The colophon (FIG. 11-11) to the illustrated *Commentary* presents the earliest known depiction of a medieval scriptorium. Because the artist provided a composite of exterior and interior views of the building, it is especially informative.

At the left is a great bell tower with a monk on the ground floor ringing the bells. The painter carefully recorded the Islamic-style glazed-tile walls of the tower, its interior ladders, and its elegant windows with their horseshoe arches, the legacy of the Visigoths. To the right, in the scriptorium proper, three monks perform their respective specialized duties. The colophon identifies the two monks in the main room as the scribe Senior and the painter Emeterius. To the right, a third monk uses shears to cut sheets of parchment. The colophon also pays tribute to Magius, "the worthy master painter. . . . May he deserve to be crowned with Christ," who died before he could complete his work on the book. His pupil Emeterius took his place and brought the project to fruition. He probably was the painter of the colophon.

The colophon of another Beatus manuscript, dated 975 and today in Girona Cathedral, also names Emeterius as coilluminator with the nun Ende, a "painter and servant of God." Ende's is one of the few recorded names of a woman artist in the Middle Ages, a rarity also in the ancient world (see "Iaia of Cyzicus," Chapter 7, page 218).

11-11 EMETERIUS, the tower and scriptorium of San Salvador de Tábara, colophon (folio 168) of the *Commentary on the Apocalypse* by Beatus, from Tábara, Spain, 970. Tempera on parchment, 1' $2\frac{1}{8}'' \times 10''$. Archivo Histórico Nacional, Madrid.

In this earliest known depiction of a medieval scriptorium, the painter carefully recorded the tower's Islamic-style glazed-tile walls and elegant windows with horseshoe arches, a Visigothic legacy.

Charlemagne's Renovatio Imperii Romani

harlemagne's official seal bore the phrase *renovatio imperii Romani* (renewal of the Roman Empire). As the pope's designated Roman emperor, Charlemagne sought to revive the glory of Early Christian Rome. He accomplished this in part through artistic patronage, commissioning imperial portrait statues (FIG. 11-12) and large numbers of illustrated manuscripts (FIGS. 11-12A and 11-13), and by fostering a general revival of learning.

To make his empire as splendid as Rome's, Charlemagne invited to his court at Aachen the best minds and the finest artisans of western Europe and the Byzantine East. Among them were Theodulf of Orléans (d. 821), Paulinus of Aquileia (d. 802), and Alcuin (d. 804), master of the cathedral school at York, the center of Northumbrian learning. Alcuin brought Anglo-Saxon scholarship to the Carolingian court.

Charlemagne himself, according to Einhard (d. 840), his biographer, could read and speak Latin fluently, in addition to Frankish, his native tongue. He also could understand Greek, and he studied rhetoric and mathematics with the learned men he gathered around him. But he never learned to write properly. That was a task best left to professional scribes. In fact, one of Charlemagne's dearest projects was the recovery of the true text of the Bible, which, through centuries of errors in copying, had become quite corrupted. Various scholars undertook the great project, but Alcuin of York's revision of the Bible, prepared at the new monastery at Tours, became the most widely used.

Charlemagne's scribes also were responsible for the development of a new, more compact, and more easily written and legible version of Latin script called *Caroline minuscule*. The letters on this page are descendants of the alphabet Carolingian scribes perfected. Later generations also owe to Charlemagne's patronage the restoration and copying of important classical texts. The earliest known manuscripts of many Greek and Roman authors are Carolingian in date.

11-12 Equestrian portrait of Charlemagne or Charles the Bald, from Metz, France, ninth century. Bronze, originally gilt, $9\frac{1}{2}''$ high. Musée du Louvre, Paris.

The Carolingian emperors sought to revive the glory and imagery of the Roman Empire. This equestrian portrait depicts a crowned emperor holding a globe, the symbol of world dominion.

CAROLINGIAN ART

On Christmas Day of the year 800, Pope Leo III (r. 795–816) crowned Charles the Great (Charlemagne), king of the Franks since 768, as emperor of Rome (r. 800–814). In time, Charlemagne came to be seen as the first Holy (that is, Christian) Roman Emperor, a title his successors did not formally adopt until the 12th century. The setting for Charlemagne's coronation, fittingly, was Saint Peter's basilica (FIG. 8-9) in Rome, built by Constantine, the first Roman emperor to embrace Christianity. Born in 742, when northern Europe was still in chaos, Charlemagne consolidated the Frankish kingdom his father and grandfather bequeathed him, defeated the Lombards in Italy (MAP 11-1), and laid claim to reviving the glory of the Roman Empire. He gave his name (Carolus Magnus in Latin) to an entire era, the *Carolingian* period.

The "Carolingian Renaissance" was a remarkable historical phenomenon, an energetic, brilliant emulation of the art, culture, and political ideals of Early Christian Rome (see "Charlemagne's *Renovatio Imperii Romani*," above). Charlemagne's (Holy) Roman Empire, waxing and waning for a thousand years and with many hiatuses, existed in central Europe until Napoleon destroyed it in 1806.

Sculpture and Painting

When Charlemagne returned home from his coronation in Rome, he ordered the transfer of an equestrian statue of the Ostrogothic king Theodoric from Ravenna to the Carolingian palace complex at Aachen. That portrait is lost, as is the grand gilded-bronze statue of the Byzantine emperor Justinian that once crowned a column in Constantinople (see "The Emperors of New Rome," Chapter 9, page 259). But in the early Middle Ages, both statues stood as reminders of ancient Rome's glory and of the pretensions and aspirations of the medieval successors of Rome's Christian emperors.

EQUESTRIAN STATUETTE The portrait of Theodoric may have been the inspiration for a ninth-century bronze statuette (FIG. 11-12) of a Carolingian emperor on horseback. Charlemagne greatly admired Theodoric, the first Germanic ruler of Rome. Many scholars have identified the small bronze figure as Charlemagne himself, although others think it portrays his grandson, Charles the Bald (r. 840–877). The ultimate model for the statuette was the equestrian portrait (FIG. 7-59) of Marcus Aurelius in Rome. In the Middle Ages, people mistakenly thought the bronze

statue represented Constantine, another revered predecessor of Charlemagne and his Carolingian successors. Both the Roman and the medieval sculptors portrayed their emperor as overly large so that the ruler, not the horse, is the center of attention. But unlike Marcus Aurelius, who extends his right arm in a gesture of clemency to a foe who once cowered beneath the raised foreleg of his horse, Charlemagne (or Charles the Bald) is on parade. He wears imperial robes rather than a general's cloak, although his sheathed sword is visible. On his head is a crown, and in his outstretched left hand he holds a globe, symbol of world dominion. The portrait proclaimed the *renovatio* of the Roman Empire's power and trappings.

11-12A Christ enthroned, *Godesalc Lectionary*, 781–783.

CORONATION GOSPELS Charlemagne was a sincere admirer of learning, the arts, and classical culture, even before his coronation as emperor of Rome. He placed high value on books, both sacred and secular, importing many and producing far more. One of the earliest is the Godesalc Lectionary (FIG. 11-12A), securely dated to 781 to 783, but the most famous is the early-ninth-century purple vellum Coronation Gospels (also known as the Gospel Book of Charlemagne), which has a text written in handsome

gold letters. The major full-page illuminations, which show the four Gospel authors at work, reveal that Carolingian manuscript painters

brought a radically different stylistic sensibility to their work compared with their Hiberno-Saxon counterparts. For example, for the page depicting Saint Matthew (FIG. 11-13), the Coronation Gospels painter, in contrast to the Northumbrian illuminator who painted the portrait of the same evangelist in the Lindisfarne Gospels (FIG. 11-8), used color and modulation of light and shade, not line, to create shapes, and deft, illusionistic brushwork to define the massive drapery folds wrapped around Matthew's body. The cross-legged chair, the lectern, and the saint's toga are familiar Roman accessories. In fact, this Carolingian evangelist portrait closely follows the format and style of Greco-Roman author portraits, as exemplified by the seated Menander (FIG. 7-25B) at Pompeii. The Coronation Gospels landscape background also has many parallels in Roman painting, and the frame consists of the kind of acanthus leaves found in Roman temple capitals and friezes (FIG. 7-32). Almost nothing is known in the Hiberno-Saxon or Frankish world that could have prepared the way for this portrayal of Saint Matthew. If a Frankish, rather than an Italian or a Byzantine, artist painted the evangelist portraits of the Coronation Gospels, the Carolingian artist had fully absorbed the classical manner. Classical painting style was one of the many components of Charlemagne's program to establish Aachen as the capital of a renewed Christian Roman Empire.

11-13 Saint Matthew, folio 15 recto of the Coronation Gospels (Gospel Book of Charlemagne), from Aachen, Germany, ca. 800–810. Ink and tempera on vellum, $1'\frac{3''}{4}\times 10''$. Schatzkammer, Kunsthistorisches Museum, Vienna.

The books produced for Charlemagne's court reveal the legacy of classical art (Fig. 7-25B). The Carolingian painter used light, shade, and perspective to create the illusion of three-dimensional form.

11-14 Saint Matthew, folio 18 verso of the *Ebbo Gospels* (Gospel Book of Archbishop Ebbo of Reims), from Hautvillers, France, ca. 816–835. Ink and tempera on vellum, $10\frac{1}{4}^{"} \times 8\frac{3}{4}^{"}$. Bibliothèque Municipale, Épernay.

Saint Matthew writes frantically, and the folds of his drapery writhe and vibrate. Even the landscape rears up alive. The painter merged classical illusionism with the northern European linear tradition.

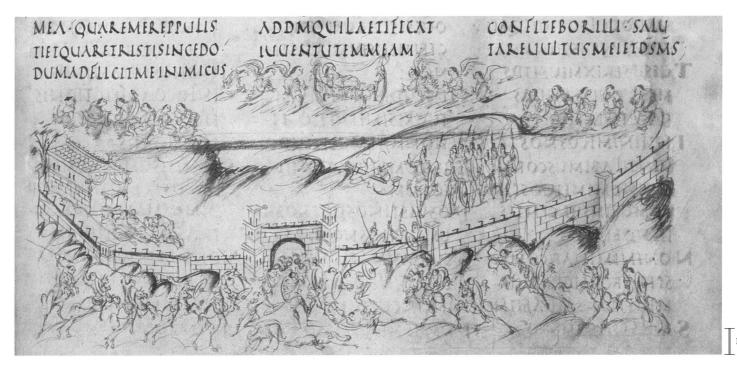

11-15 Psalm 44, detail of folio 25 recto of the *Utrecht Psalter*, from Hautvillers, France, ca. 820–835. Ink on vellum, full page, $1' 1'' \times 9\frac{7}{8}''$; detail, $4\frac{1}{2}''$ high. University Library, Utrecht.

The drawings in the *Utrecht Psalter* are rich in anecdotal detail and show figures acting out—literally—King David's psalms. The vivid animation resembles that of the *Ebbo Gospels* Matthew (Fig. 11-14).

EBBO GOSPELS The classical-revival style evident in the Coronation Gospels was by no means the only one that appeared suddenly in the Carolingian world. Court school and monastic scriptoria employed a wide variety of styles derived from Late Antique prototypes. Another Saint Matthew (FIG. 11-14), in a Gospel book made for Archbishop Ebbo of Reims, France, may be an interpretation of an author portrait very similar to the one the Coronation Gospels master used as a model. The Ebbo Gospels illuminator, however, replaced the classical calm and solidity of the Coronation Gospels evangelist with an energy approaching frenzy. Matthew (the winged man in the upper right corner identifies him) writes in frantic haste. His hair stands on end, his eyes open wide, the folds of his drapery writhe and vibrate, the landscape behind him rears up alive. The painter even set the page's leaf border in motion. Matthew's face, hands, inkhorn, pen, and book are the focus of the composition. This presentation contrasts strongly with the settled pose of the Saint Matthew of the Coronation Gospels with its even stress so that no part of the composition jumps out at viewers to seize their attention. Just as the painter of the Lindisfarne Gospels Matthew (FIG. 11-8) transformed an imported model into an original Hiberno-Saxon idiom, so the Ebbo Gospels artist translated a classical prototype into a new Carolingian vernacular. This master painter brilliantly merged classical illusionism and the northern linear tradition.

UTRECHT PSALTER One of the most extraordinary medieval manuscripts is the *Utrecht Psalter* (FIG. 11-15). The text reproduces the psalms of David in three columns of Latin capital letters (FIG. 11-15A) in emulation of the script and page organization of ancient books. The artist illustrated each psalm with a pen-and-ink drawing stretching across the entire width of the page. Some scholars have argued that the costumes and other details indicate the artist followed one or more manuscripts created 400 years before. Even if

the *Utrecht Psalter* is not a copy, the artist's intention was to evoke earlier artworks and to make the book appear ancient.

The painter of the *Utrecht Psalter* displayed a genius for anecdotal detail throughout the manuscript. On one page (FIG. 11-15), the figures act out—literally—Psalm 44 (Psalm 43 of the Vulgate text of the Carolingian era), in which the psalmist laments the plight of the oppressed Israelites. For example, the artist drew some slain sheep fallen to the ground ("We are counted")

11-15A Psalm 23, *Utrecht Psalter*, ca. 820-835.

as sheep for slaughter") in front of a walled city reminiscent of cities on the Column of Trajan (FIG. 7-1) in Rome and in Early Christian mosaics (FIG. 8-14) and manuscripts (FIG. 8-21). At the left, the faithful grovel on the ground before a temple ("Our soul is bowed down to the dust; our belly cleaveth unto the earth"). In response to the six pleading angels ("Awake, why sleepest thou, O Lord?"), the artist depicted the Lord reclining in a canopied bed overlooking the slaughter below. But "the Lord" is Jesus, complete with cruciform halo, instead of David's Hebrew God. The drawing shows a vivid animation of much the same kind as the *Ebbo Gospels* Saint Matthew (FIG. 11-14). The bodies of the *Utrecht Psalter* figures are tense, with shoulders hunched and heads thrust forward. As in the *Ebbo Gospels*, even the earth heaves up around the figures. The rapid, sketchy techniques used to render the figures convey the same nervous vitality as found in the *Ebbo* evangelists.

LINDAU GOSPELS The taste for sumptuously wrought and portable objects, the hallmark of the art of the early medieval warlords, persisted under Charlemagne and his successors. The Carolingians commissioned numerous works employing costly materials, including book covers made of gold and jewels and sometimes

11-16 Crucifixion, front cover of the Lindau Gospels, from Saint Gall, Switzerland, ca. 870. Gold, precious stones, and pearls, $1' 1\frac{3}{8}'' \times 10\frac{3}{8}''$. Pierpont Morgan Library, New York.

This sumptuous Carolingian book cover revives the Early Christian imagery of the youthful Christ (FIG. 8-24). The statuesque, crucified Christ, heedless of pain, is classical in conception and execution.

also ivory or pearls. Gold and gems not only glorified the word of God but also evoked the heavenly Jerusalem. One of the most luxurious Carolingian book covers (FIG. 11-16) is the one later added to the Lindau Gospels. The gold cover, fashioned in one of the workshops of Charles the Bald's court, is monumental in conception. A youthful Christ in the Early Christian tradition, nailed to the cross, is the central motif. Surrounding Christ are pearls and jewels (raised on golden claw feet so they can catch and reflect the light even more brilliantly and protect the delicate metal relief from denting). The statuesque open-eyed figure, rendered in repoussé (hammered or pressed relief), recalls the beardless, unsuffering Christ of a fifthcentury ivory plaque (FIG. 8-24) from Italy. In contrast, the four angels and the personifications of the Moon and the Sun above and the crouching figures of the Virgin Mary and Saint John (and two other figures of uncertain identity) in the quadrants below display the vivacity and nervous energy of the Utrecht Psalter figures (FIGS. 11-15 and 11-15A). The Lindau Gospels cover highlights the stylistic diversity of early medieval art in Europe. Here, however, the translated figural style of the Mediterranean prevailed, in keeping with the classical tastes and imperial aspirations of the Frankish emperors of Rome.

Architecture

In his eagerness to reestablish the imperial past, Charlemagne also encouraged the use of Roman building techniques. In architecture, as in sculpture and painting, innovations made in the reinterpretation of earlier Roman Christian sources became fundamental to the subsequent development of northern European architecture. For his models, Charlemagne looked to Rome and Ravenna. One was the former heart of the Roman Empire, which he wanted to renew. The other was the long-term western outpost of Byzantine might and splendor, which he wanted to emulate in his own capital at Aachen, a site chosen because of its renowned hot springs.

AACHEN Charlemagne often visited Ravenna, and the equestrian statue of Theodoric he brought from there to display in his

11-17 Restored plan (*left*) and west facade (*right*) of the Palatine Chapel of Charlemagne, Aachen, Germany, 792–805.

Charlemagne sought to emulate Byzantine splendor in Germany. The plan of his Aachen palace chapel is based on that of San Vitale (FIG. 9-11) at Ravenna, but the west facade is distinctly Carolingian.

palace complex at Aachen served as a model for Carolingian equestrian portraits (FIG. 11-12). Charlemagne also imported porphyry (purple marble) columns from Ravenna to adorn his Palatine Chapel, and historians long have thought he chose one of Ravenna's churches as the model for the new structure. The plan (FIG. 11-17, *left*) of the Aachen chapel resembles that of San Vitale (FIG. 9-11), and a direct relationship very likely exists between the two.

A comparison between the Carolingian chapel, the first vaulted structure of the Middle Ages north of the Alps, and its southern counterpart is instructive. The Aachen plan is simpler. The architect omitted San Vitale's apselike extensions reaching from the central octagon into the ambulatory. At Aachen, the two main units stand in greater independence of each other. This solution may lack the subtle sophistication of the Byzantine building, but the Palatine Chapel gains geometric clarity. A view of its interior (FIG. 11-18) shows that Charlemagne's builders converted the "floating" quality of San Vitale (FIG. 9-1) into massive geometric form.

The Carolingian conversion of a complex and subtle Byzantine prototype into a building that expresses robust strength and clear structural articulation foreshadows the architecture of the 11th and 12th centuries and the style called Romanesque (see Chapter 12). So, too, does the treatment of the Palatine Chapel's exterior, where two cylindrical towers with spiral staircases flank the entrance portal (FIG. 11-17, right). This was a first step toward the great dualtower facades of western European churches from the 10th century to the present. Above the portal, Charlemagne could appear in a large framing arch and be seen by those gathered in the atrium in front of the chapel. (The plan includes only part of the atrium.) Directly behind that second-story arch was Charlemagne's marble throne. From there he could peer down at the altar in the apse. Charlemagne's imperial gallery followed the model of the imperial gallery at Hagia Sophia (FIGS. 9-6 to 9-8) in Constantinople. The Palatine Chapel was in every sense a royal chapel. The coronation of Charlemagne's son, Louis the Pious (r. 814-840), took place there when he succeeded his father as emperor.

11-18 Interior of the Palatine Chapel of Charlemagne (looking east), Aachen, Germany, 792-805.

Charlemagne's chapel is the first vaulted medieval structure north of the Alps. The architect transformed the complex, glittering interior of San Vitale (Fig. 9-1) into simple, massive geometric form.

Medieval Monasteries and Benedictine Rule

Since Early Christian times, monks who established monasteries also made the rules that governed communal life. The most significant of these monks was Benedict of Nursia (Saint Benedict, ca. 480–547), who founded the Benedictine Order in 529. By the ninth century, the "Rule" Benedict wrote (*Regula Sancti Benedicti*) had become standard for all western European monastic communities, in part because Charlemagne had encouraged its adoption throughout the Frankish territories.

Saint Benedict believed the corruption of the clergy that accompanied the increasing worldliness of the Church had its roots in the lack of firm organization and regulation. As he saw it, idleness and selfishness had led to neglect of the commandments of God and of the Church. The cure for this was communal association in an abbey under the absolute rule of an abbot the monks elected (or an abbess the nuns chose), who would ensure the clergy spent each hour of the day in useful work and in sacred reading. The emphasis on work and study and not on meditation and austerity is of great historical significance. Since antiquity, manual labor had been considered unseemly, the business of the lowborn or of slaves. Benedict raised it to the dignity of religion. The core idea of what many people today call the "work ethic" found early expression in Benedictine monasteries as an essential feature of spiritual life. By thus exalting the virtue of manual labor, Benedict not only rescued it from its age-old association with slavery but also recognized it as the way to self-sufficiency for the entire religious community.

Whereas some of Saint Benedict's followers emphasized spiritual "work" over manual labor, others, most notably the Cistercians (see "Bernard of Clairvaux," Chapter 12, page 342), put Benedictine teachings about the value of physical work into practice. These monks reached into their surroundings and helped reduce the vast areas of daunting wilderness of early medieval Europe. They cleared dense forest teeming with wolves, bear, and wild boar, drained swamps, cultivated wastelands, and built roads, bridges, and dams, as well as monastic churches and their associated living and service quarters.

The ideal monastery (FIG. 11-19) provided all the facilities necessary for the conduct of daily life—a mill, bakery, infirmary, vegetable garden, and even a brewery—so the monks would feel no need to wander outside its protective walls. These religious communities were centrally important to the revival of learning. The clergy, who were also often scribes and scholars, had a monopoly on the skills of reading and writing in an age of almost universal illiteracy. The monastic libraries and scriptoria (FIG. 11-11), where the monks and nuns read, copied, illuminated, and bound books with ornamented covers, became centers of study. Monasteries were almost the sole

11-19 Schematic plan for a monastery, from Saint Gall, Switzerland, ca. 819. Red ink on parchment, 2' $4'' \times 3'$ $8\frac{1}{8}''$. Stiftsbibliothek, Saint Gall.

The purpose of this plan for an ideal, self-sufficient Benedictine monastery was to separate the monks from the laity. Near the center is the church with its cloister, the monks' earthly paradise.

repositories of what remained of the literary culture of the Greco-Roman world and early Christianity. Saint Benedict's requirements of manual labor and sacred reading came to include writing and copying books, studying music for chanting daily prayers, and—of great significance—teaching. The monasteries were the schools of the early Middle Ages as well as self-sufficient communities and production centers.

SAINT GALL The emperor was not the only important builder of the Carolingian age. With prosperity also came the construction and expansion of many monasteries. A unique document, the ideal plan (FIG. 11-19) for a Benedictine monastery (see "Medieval Monasteries and Benedictine Rule," above) at Saint Gall in Switzerland, provides precious information about the design of Carolingian monastic communities. Haito, the abbot of Reichenau and bishop of Basel, ordered the preparation of the plan and sent it to the abbot of Saint Gall around 819 as a guide for the rebuilding of the Saint Gall

monastery. The design's fundamental purpose was to separate the monks from the laity (nonclergy) who also inhabited the community. Variations of the scheme may be seen in later monasteries all across western Europe. Near the center, dominating everything, was the church (*oratory*) with its *cloister*, a colonnaded courtyard not unlike the Early Christian atrium (FIG. 8-9) but situated to the side of the church instead of in front of its main portal. Reserved for the monks alone, the cloister was a kind of earthly paradise removed from the world at large. The Saint Gall cloister is an early example. Clustered

11-19A Torhalle, Lorsch, late eighth or ninth century.

around the cloister were the most essential buildings: dormitory, refectory, kitchen, and storage rooms. Other structures, including an infirmary, school, guest house, bakery, brewery, and workshops, filled the areas around this central core of church and cloister. In at least one Carolingian monastery, at Lorsch in Germany, a monumental freestanding gateway (FIG. 11-19A) stood in front of the church.

Haito invited the abbot of Saint Gall to adapt the plan as he saw fit, and indeed, the Saint Gall builders did not follow the Reichenau model precisely. Nonetheless, had the abbot wished, Haito's plan could have served as a practical guide for the Saint Gall masons because it was laid out using a *module* (standard unit) of 2.5 feet. The designer consistently employed that module, or multiples or fractions of it, for all elements of the plan. For example, the nave's width, indicated on the plan as 40 feet, is equal to 16 modules. Each monk's bed is 2.5 modules long, and the paths in the vegetable garden are 1.25 modules wide.

11-19B Saint-Riquier, Centula, 790-799.

The prototypes carrying the greatest authority for Charlemagne and his builders were those from the Christian phase of the Late Roman Empire. The widespread adoption of the Early Christian basilica, at Saint Gall and elsewhere, rather than the domed central plan of Byzantine churches, was crucial to the subsequent development of western European church architecture. Unfortunately, no Carolingian basilica has survived in its original form. Nevertheless, it is possible to reconstruct the appearance of some of them with fair accuracy, for example,

the abbey of Saint-Riquier (FIG. 11-19B) at Centula, France, which an 11th-century illuminator reproduced in a now-lost manuscript. Some Carolingian structures followed their Early Christian models quite closely. But in other instances, the ninth-century builders significantly modified the basilica plan, converting it into a much more complex form. The monastery church at Saint Gall, for example, was essentially a traditional basilica, but it had features not found in any Early Christian church. Most obvious is the addition of a second apse on the west end of the building, perhaps to accommodate additional altars and to display relics (see "The Veneration of Relics," Chapter 12, page 336). Whatever its purpose, this feature remained a characteristic regional element of German churches until the 11th century.

Not quite as evident but much more important to the subsequent development of church architecture in northern Europe was the presence of a transept at Saint Gall, a very rare feature but one that characterized the two greatest Early Christian basilicas in Rome, Saint Peter's (FIG. 8-9) and Saint Paul's, as well as the main church at the Centula abbey (FIG. 11-19B). The Saint Gall transept is as wide as the nave on the plan and was probably the same height. Early Christian builders had not been concerned with proportional relationships. On the Saint Gall plan, however, the various parts of the building relate to one another by a geometric scheme that ties them together into a tight and cohesive unit. Equalizing the widths of nave and transept automatically makes the area where they cross (the crossing) a square. Most Carolingian churches shared this feature. But Haito's planner also used the crossing square as the unit of measurement for the remainder of the church plan. The transept arms are equal to one crossing square, the distance between transept and apse is one crossing square, and the nave is 4.5 crossing squares long. In addition, the two aisles are half as wide as the nave, integrating all parts of the church in a rational and orderly plan.

The Saint Gall plan also reveals another important feature of many Carolingian basilicas, including Saint-Riquier (FIG. 11-19B) at Centula: towers framing the end(s) of the church. Haito's plan shows only two towers, both cylindrical and on the west side of the church, as at Charlemagne's Palatine Chapel (FIG. 11-17), but they stand apart from the church facade. If a tower existed above the crossing, the silhouette of Saint Gall would have shown three towers, altering the horizontal profile of the traditional basilica and identifying the church even from afar. Saint-Riquier had six towers.

CORVEY Other Carolingian basilicas had towers incorporated in the fabric of the west end of the building, thereby creating a unified monumental facade greeting all those who entered the church. Architectural historians call this feature of Carolingian and some later churches the *westwork* (from the German *Westwerk*, "western entrance structure"). Early medieval writers referred to it as a *castellum* (Latin, "castle" or "fortress") or *turris* ("tower"). The sole surving example is the abbey church (FIG. 11-20) at Corvey. The uppermost parts are 12th-century additions (easily distinguishable from

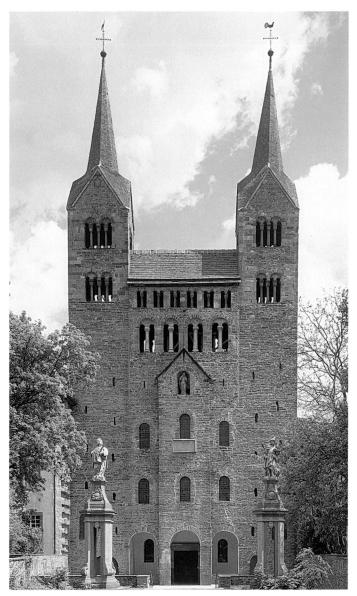

11-20 Westwork of the abbey church, Corvey, Germany, 873-885.

An important new feature of Carolingian church architecture was the westwork, a monumental western facade incorporating two towers. The sole surviving example is the abbey church at Corvey.

the original westwork by the differing masonry technique). Stairs in each tower provided access to the upper stories of the westwork. On the second floor was a two-story chapel with an aisle and a gallery on three sides. As at Aachen, the chapel opened onto the nave, and from it the visiting emperor and his entourage could watch and participate in the service below. Not all Carolingian westworks, however, served as seats reserved for the emperor. They also functioned as churches within churches, housing a second altar for special celebrations on major feast days. Boys' choirs stationed in the westwork chapel participated from above in the services conducted in the church's nave.

OTTONIAN ART

Louis the Pious laid Charlemagne to rest in the Palatine Chapel at Aachen in 814. Charlemagne had ruled for 46 years, but his empire survived him by fewer than 30. When Louis died in 840, his three sons-Charles the Bald, Lothair, and Louis the Germandivided the Carolingian Empire among themselves. After bloody conflicts, the brothers signed a treaty at Verdun in 843 partitioning the Frankish lands into western, central, and eastern areas, very roughly foreshadowing the later nations of France and Germany and a third realm corresponding to a long strip of land stretching from the Netherlands and Belgium to Rome. Intensified Viking incursions in the west helped bring about the collapse of the Carolingians. The empire's breakup into weak kingdoms, ineffectual against the invasions, brought a time of confusion to Europe. Complementing the Viking scourge in the west were the invasions of the Magyars in the east and the plundering and piracy of the Saracens (Muslims) in the Mediterranean.

Only in the mid-10th century did the eastern part of the former empire consolidate under the rule of a new Saxon line of German emperors called, after the names of the three most illustrious family members, the *Ottonians*. The pope crowned the first Otto (r. 936–973) in Rome in 962, and Otto assumed the title "Emperor of Rome" that Charlemagne's weak successors held during most of the previous century. The Ottonian emperors made headway against the eastern invaders, remained free from Viking attacks, and not only preserved but also enriched the culture and tradition of the Carolingian period. The Church, which had become corrupt and disorganized, recovered in the 10th century under the influence of a great monastic reform the Ottonians encouraged and sanctioned. The new German emperors also cemented ties with Italy and the papacy as well as with Byzantium (see "Theophanu," page 328). The Ottonian line ended in the early 11th century with the death of Henry II (r. 1002–1024).

Architecture

Ottonian architects followed the course of their Carolingian predecessors, building basilican churches with towering spires and imposing westworks, but they also introduced new features that would have a long future in Western church architecture.

GERNRODE The best-preserved 10th-century Ottonian basilica is Saint Cyriakus at Gernrode, begun in 961 and completed in 973. In the 12th century, a large apse replaced the western entrance, but the upper parts of the westwork, including the two cylindrical towers, are intact. The interior (FIG. 11-21), although heavily restored in the 19th century, retains its 10th-century character. Saint Cyriakus reveals how Ottonian architects enriched the Early Christian and Carolingian basilica. The church has a transept at the east with a square choir in front of the apse. The nave is one of the first in western Europe to incorporate a gallery between the

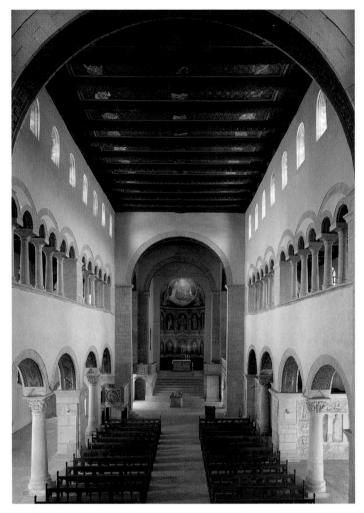

11-21 Nave of the church of Saint Cyriakus (looking east), Gernrode, Germany, 961-973.

Ottonian builders modified the interior elevation of Early Christian basilicas. The Gernrode designer added a gallery above the nave arcade and adopted an alternate-support system of piers and columns.

ground-floor arcade and the clerestory, a design that became very popular in the succeeding Romanesque era (see Chapter 12). Scholars have reached no consensus on the function of these galleries in Ottonian churches. They cannot have been reserved for women, as some think they were in Byzantium, because Saint Cyriakus is the centerpiece of a convent exclusively for nuns, founded the same year construction of the church began. The galleries may have housed additional altars, as in the westwork at Corvey, or the singers in the church's choir. The Gernrode builders also transformed the nave arcade itself by adopting the alternate-support system, in which heavy square piers alternate with columns, dividing the nave into vertical units. The division continues into the gallery level, breaking the smooth rhythm of the all-column arcades of Early Christian and Carolingian basilicas and leading the eye upward. Later architects would carry this verticalization of the basilican nave much further (FIG. 13-19).

HILDESHEIM A great patron of Ottonian art and architecture was Bishop Bernward (r. 993–1022) of Hildesheim, Germany. He was the tutor of Otto III (r. 983–1002) and builder of the abbey church of Saint Michael (FIGS. 11-22 and 11-23) at Hildesheim. Bernward, who made Hildesheim a center of learning, was an eager scholar, a lover of the arts, and, according to Thangmar of

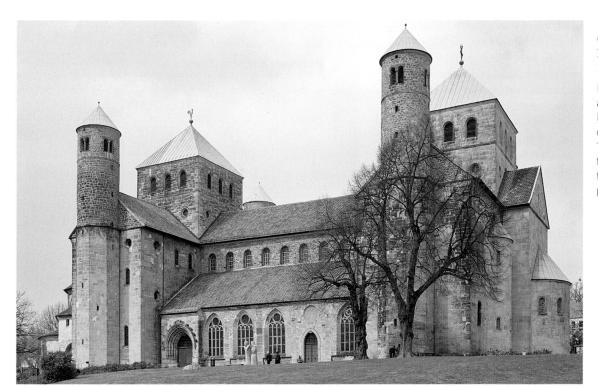

11-22 Saint Michael's (looking northwest), Hildesheim, Germany, 1001-1031. ■4

Built by Bishop Bernward, a great art patron, Saint Michael's is a masterpiece of Ottonian basilica design. The church's two apses, two transepts, and multiple towers give it a distinctive profile.

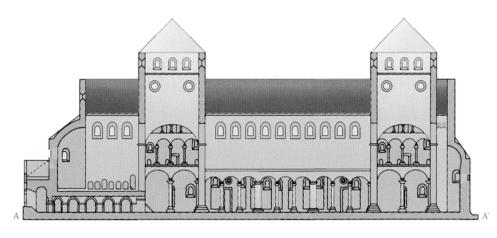

11-23 Longitudinal section (top) and plan (bottom) of the abbey church of Saint Michael's, Hildesheim, Germany, 1001-1031.

Saint Michael's entrances are on the side. Alternating piers and columns divide the space in the nave into vertical units. These features transformed the tunnel-like horizontality of Early Christian basilicas.

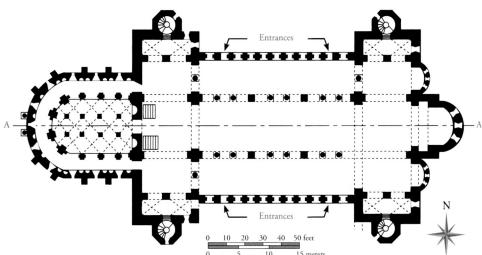

Heidelberg, his biographer, an expert craftsman and bronze-caster. In 1001, Bernward traveled to Rome as the guest of Otto III. During this stay, he studied at first hand the monuments of the ancient empire the Carolingian and Ottonian emperors revered.

Constructed between 1001 and 1031 (and rebuilt after a bombing raid during World War II), Saint Michael's has a double-transept plan (FIG. 11-23, *bottom*), six towers, and a westwork. The two transepts create eastern and western centers of gravity. The nave

11-23A Nave, Saint Michael's, Hildesheim, 1001-1031.

(FIG. 11-23A) merely seems to be a hall connecting them. Lateral entrances leading into the aisles from the north and south additionally make for an almost complete loss of the traditional basilican orientation toward the east. Some ancient Roman basilicas, such as the Basilica Ulpia (FIG. 7-44, no. 4) in Trajan's Forum, also had two apses and entrances on the side, and Bernward probably was familiar with this variant basilican plan.

At Hildesheim, as in the plan of the monastery at Saint Gall (FIG. 11-19), the builders adopted a modular approach. The crossing squares, for example, are the basis for the nave's dimensions—three crossing squares long and one square wide. The placement of heavy piers at the corners of each square gives visual emphasis to the three units. These piers alternate with pairs of columns (FIG. 11-23A) as wall supports in a design similar to that of Saint Cyriakus (FIG. 11-21) at Gernrode.

Sculpture and Painting

In 1001, when Bishop Bernward was in Rome visiting the young Otto III, he resided in Otto's palace on the Aventine Hill in the neighborhood of Santa Sabina, an Early Christian church renowned for its carved wooden doors (FIG. 8-10A). Those doors, decorated with episodes from both the Old and New Testaments, may have inspired the remarkable bronze doors the bishop had cast for his new church in Germany.

HILDESHEIM DOORS The doors (FIG. 11-24) to Saint Michael's, dated by inscription to 1015, are more than 15 feet tall. They are technological marvels, because the Ottonian metalworkers cast each giant door in a single piece with the figural sculpture. Carolingian sculpture, like most sculpture since Late Antiquity, consisted primarily of small-scale art executed in ivory and precious metals, often for book covers (FIG. 11-16). The Hildesheim doors are huge in comparison, but the 16 individual panels stem from this tradition.

11-24A Column, Saint Michael's, Hildesheim, ca. 1015-1022.

Bernward placed the bronze doors in the portal to Saint Michael's from the cloister, where the monks would see them each time they entered the church. The panels of the left door illustrate highlights from Genesis, beginning with the Creation of Eve (at the top) and ending with the murder of Adam and Eve's son Abel by his brother, Cain (at the bottom). The right door recounts the life of Jesus (reading from the bottom up), starting with the Annunciation and terminating with the appearance to Mary Magdalene of Christ after his resurrection (see "The Life of Jesus in Art," Chapter 8, pages 240-241). Together, the doors tell the story of original sin and ultimate redemption, showing the expulsion from the Garden of Eden and the path back to Paradise through the Church. (Reliefs depicting ad-

ditional episodes from Jesus' life decorate a bronze column [FIG. 11-24A] that Bernward also commissioned for Saint Michael's.) As in Early Christian times, the Ottonian clergy interpreted the Hebrew scriptures as prefiguring the New Testament (see "Jewish Subjects in Christian Art," Chapter 8, page 238). For example, the Hildesheim designer juxtaposed the panel depicting the Fall of Adam and Eve on the left door with the Crucifixion on the right door. Eve nursing the infant Cain is opposite Mary with the Christ Child in her lap.

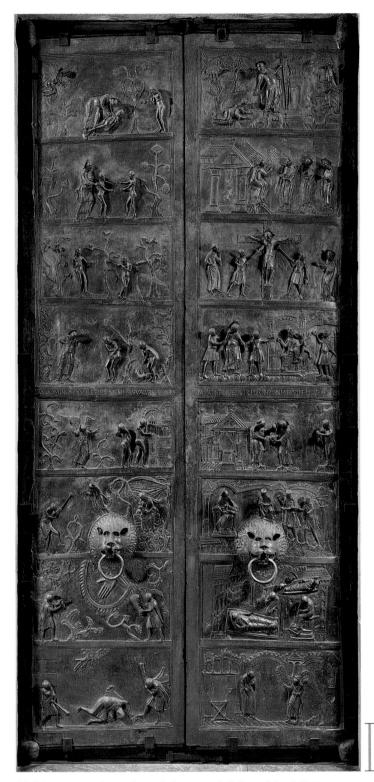

11-24 Doors with relief panels (Genesis, left door; life of Christ, right door), commissioned by Bishop Bernward for Saint Michael's, Hildesheim, Germany, 1015. Bronze, 15′ 5¾ high. Dom-Museum, Hildesheim. ■4

Bernward's doors tell the story of original sin and redemption, and draw parallels between the Old and New Testaments, as in the expulsion from Paradise and the infancy and suffering of Christ.

The composition of many of the scenes on the doors derives from Carolingian manuscript illumination, and the style of the figures has an expressive strength that brings to mind the illustrations in the *Utrecht Psalter* (FIGS. 11-15 and 11-15A). For example, in the fourth panel (FIG. 11-25) from the top on the left door, God,

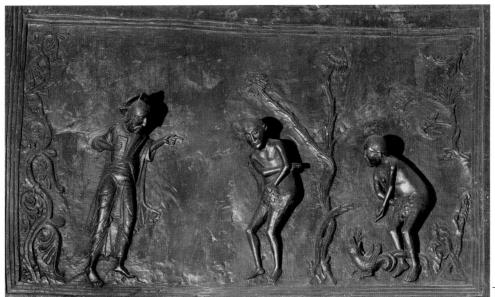

11-25 God accusing Adam and Eve, detail of the left door of Saint Michael's, Hildesheim, Germany, 1015. Bronze, $1' 10\frac{1}{8}''$ high. Dom-Museum, Hildesheim.

The Hildesheim bronze-caster recounted the story of original sin with a flair for anecdote. With vivid gestures, God accuses Adam, who passes the blame to Eve, who points in turn to the serpent.

1 in

portrayed as a man, accuses Adam and Eve after their fall from grace. He jabs his finger at them with the force of his whole body. The force is concentrated in the gesture, which becomes the psychic focus of the entire composition. The frightened pair crouch, not only to hide their shame but also to escape the lightning bolt of divine wrath. Each passes the blame—Adam pointing backward to Eve and Eve pointing downward to the deceitful serpent. The starkly flat setting throws into relief the gestures and attitudes of rage, accusation, guilt, and fear. The sculptor presented the story with simplicity, although with great emotional impact, as well as a flair for anecdotal detail. Adam and Eve both struggle to point with one arm while attempting to shield their bodies from view with the other. With an instinct for expressive pose and gesture, the artist brilliantly communicated their newfound embarrassment at their nakedness and their unconvincing denials of wrongdoing.

MAGDEBURG IVORIES The figural panels of the bronze doors of Saint Michael's at Hildesheim constitute a unique ensemble, but they are not the only series of small-scale narrative relief panels made for display in an Ottonian church. Sixteen ivory plaques remain from a set of perhaps as many as 50 that once decorated the altar, pulpit, or another important item of church furniture in Magdeburg Cathedral. The cathedral housed the relics of Saint Mauritius (Maurice), a Christian army commander from Africa whom the Romans executed in Gaul during the third century when he refused to sacrifice to the old gods. Otto transferred the saint's relics from France to Magdeburg in 960. A former monastic community on the eastern frontier of the Ottonian Empire, Magdeburg became an archbishopric in 968, the year Otto I dedicated the city's new cathedral. The 10th-century church burned down in 1207. The present cathedral is a Gothic replacement.

Most of the plaques depict scenes from the life of Jesus. The one illustrated here (FIG. 11-26), however, features Otto I presenting Magdeburg Cathedral to Christ, who sits on a large wreath and extends his right hand to the emperor to indicate he welcomes the gift. Ottonian representations of the emperor usually depict him as the central figure and of large stature (FIG. 11-29), but the artist here represented the bearded and crowned Otto to one side and as the size of a child. The age-old principle of hierarchy of scale dictated that the artist depict the only mortal as the smallest figure.

Christ is largest, and the saints are intermediate in size. The two most prominent are Saint Peter, at the right holding the key to the kingdom of Heaven, and Saint Mauritius, who introduces the emperor to Christ. Art historians believe the plaques are the work of Milanese ivory carvers. Lombardy was part of Otto I's empire.

11-26 Otto I presenting Magdeburg Cathedral to Christ, from an altar or pulpit in Magdeburg Cathedral, Magdeburg, Germany, 962–968. Ivory, $5'' \times 4\frac{1}{2}''$. Metropolitan Museum of Art, New York (gift of George Blumenthal, 1941).

This ivory panel from an altar or pulpit Otto I dedicated in Magdeburg Cathedral shows Saint Mauritius introducing the emperor to Christ, whom Otto presents with the new church.

1 i

Theophanu, a Byzantine Princess in Ottonian Germany

The bishop of Mainz crowned Otto I king of the Saxons at Aachen in 936, but it was not until 962 that Pope John XII (r. 955-964) conferred the title of Emperor of Rome upon him in Saint Peter's basilica. Otto, known as the Great, had ambitions to restore the glory of Charlemagne's Christian Roman Empire and to enlarge the territory under his rule. In 951, he defeated a Roman noble who had taken prisoner Adelaide, the widow of the Lombard king Lothar. Otto then married Adelaide, assumed the title of King of the Lombards, and extended his power south of the Alps. Looking eastward, in 972 he arranged the marriage of his son (and coemperor since 967), Otto II, to Theophanu (ca. 955-991), probably the niece of Emperor Nikephoros II Phokas (r. 963-969). Otto was 17 years old, his bride 16. They wed in Saint Peter's in Rome, with Pope John XIII (r. 965-972) presiding. When Otto the Great died the next year, Otto II became sole emperor (r. 973-983). The second Otto died in Italy a decade later and was buried in the atrium of Saint Peter's. His son, Otto III, only three years old at the time, nominally became king, but it was his mother, Theophanu, coregent with Adelaide until 985 and sole regent thereafter, who wielded power in the Ottonian Empire until her death in 991. Adelaide then served as regent until Otto III was old enough to rule on his own. He became Roman emperor in 996 and died six years later.

Theophanu brought the prestige of Byzantium to Germany. Artistic ties between the Ottonian court and Constantinople became even stronger, and the Ottonians imported Byzantine luxury goods, including ivory plaques, in great quantities. One surviving ivory panel (FIG. 11-27) commemorates the marriage between Otto II and Theophanu. It shows Christ, central and the largest figure, extending both arms to bless the crowned emperor and his empress. (Otto appears much older than 17, consistent with his imperial stature.) The artist depicted all three standing rigidly and looking directly at the viewer. The frontality of the figures, the tripartite composition, and the style of carving suggest the work is an import from Constantinople, as does the lengthy Greek dedicatory inscription. A few words are in Latin, however, and the inscription also identifies the donor—the tiny bowing figure clinging to Christ's stool—as an Italian bishop. Some art historians therefore think the artist may have been an Ottonian ivory carver in Lombardy. Nonetheless, the iconography is distinctively Byzantine because the imagery declares that Otto's authority to rule comes directly

11-27 Christ blessing Otto II and Theophanu, 972–973. Ivory, $7\frac{1''}{8} \times 4''$. Musée National du Moyen Age, Paris.

Commemorating the marriage of Otto II and Theophanu, this ivory plaque is Byzantine in style and iconography. The princess promoted Byzantine art and culture at the Ottonian court.

from Christ, not from the pope. Whether of Byzantine or Ottonian manufacture, the ivory is an Ottonian commission in Byzantine style. The influence of Byzantine art is also evident in Ottonian manuscript painting (FIGS. 11-29A and 11-30).

OTTO II AND THEOPHANU On April 14, 972, Otto I arranged the marriage of his son Otto II to the Byzantine princess Theophanu (see "Theophanu, a Byzantine Princess in Ottonian Germany," above). The wedding secured the important political alliance between the Ottonian and Byzantine empires. Because the couple married in Rome with the pope administering the vows, the wedding simultaneously reaffirmed the close relationship between the Ottonians and the papacy. The marriage, commemorated on a unique ivory plaque (FIG. 11-27), also enhanced the already strong artistic and cultural ties between Germany and Constantinople.

GERO CRUCIFIX During the Ottonian period, interest in freestanding statuary, which had been exceedingly rare for the pre-

ceding half millennium, also revived. The outstanding example of Ottonian monumental sculpture is the crucifix (FIG. 11-28) Archbishop Gero (r. 969–976) commissioned and presented to Cologne Cathedral in 970. Carved in oak, then painted and gilded, the 6-foot-tall image of Christ nailed to the cross is both statue and reliquary (a shrine for sacred relics; see "The Veneration of Relics," Chapter 12, page 336). A compartment in the back of the head held bread for the Eucharist. According to one story, a crack developed in the wood of Gero's crucifix but miraculously healed. Similar tales of miracles surround many sacred Christian objects, for example, some Byzantine icons (see "Icons," Chapter 9, page 269).

The Gero crucifix presents a dramatically different conception of Christ from that seen on the *Lindau Gospels* cover (FIG. 11-16),

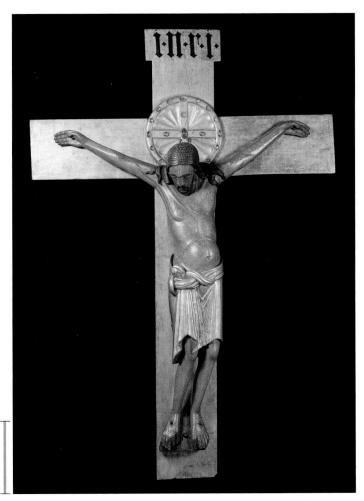

11-28 Crucifix commissioned by Archbishop Gero for Cologne Cathedral, Cologne, Germany, ca. 970. Painted wood, height of figure 6′ 2″. Cathedral, Cologne. ■

In this early example of the revival of monumental sculpture in the Middle Ages, an Ottonian sculptor depicted with unprecedented emotional power the intense agony of Christ's ordeal on the cross.

with its Early Christian imagery of the youthful Christ triumphant over death. Consistent with the strong Byzantine element in Ottonian art, the bearded Christ of the Cologne crucifix is more akin to Byzantine representations (FIG. 9-24) of the suffering Jesus, but the emotional power of the Ottonian work is greater still. The sculptor depicted Christ as an all-too-human martyr. Blood streaks down his forehead from the (missing) crown of thorns. His eyelids are closed, his face is contorted in pain, and his body sags under its weight. The muscles stretch to their limit—those of the right shoulder and chest seem almost to rip apart. The halo behind Christ's head may fore-tell his subsequent resurrection, but the worshiper can sense only his pain. Gero's crucifix is the most powerful characterization of intense

agony of the early Middle Ages.

1 ft.

11-29A Jesus and Peter, Gospel Book of Otto III, 997–1000.

GOSPEL BOOK OF OTTO III In a Gospel book containing some of the finest early medieval paintings of the life of Jesus (for example, Fig. 11-29A), one full-page representation (Fig. 11-29) stands apart from the rest. The page shows Otto III, son of Otto II and Theophanu, enthroned and holding the scepter and cross-inscribed orb that signify his universal authority, conforming to a Christian impe-

11-29 Otto III enthroned, folio 24 recto of the *Gospel Book of Otto III*, from Reichenau, Germany, 997–1000. Tempera on vellum, $1' 1'' \times 9\frac{3}{8}''$. Bayerische Staatsbibliothek, Munich.

Emperor Otto III, descended from both German and Byzantine imperial lines, appears in this Gospel book enthroned and holding the scepter and cross-inscribed orb signifying his universal authority.

rial iconographic tradition that began with Constantine (FIG. 7-81, *right*). At the emperor's sides are the clergy and the barons (the Church and the state), both aligned in his support. On the facing page (not illustrated), also derived from ancient Roman sources, female personifications of Slavinia, Germany, Gaul, and Rome—the provinces of the Ottonian Empire—bring tribute to the young emperor.

Of the three Ottos, the last most fervently dreamed of a revived Christian Roman Empire. Indeed, it was his life's obsession. The boy-emperor was keenly aware of his descent from both German and Byzantine imperial lines, but he apparently was prouder of his Constantinopolitan than his German roots. He moved his court, with its Byzantine rituals, to Rome and there set up theatrically the symbols and trappings of Roman imperialism. Otto's romantic dream of imperial unity for Europe, the conceit behind his self-aggrandizing portrayal in the *Gospel Book of Otto III*, never materialized, however. He died prematurely, at age 21, and, at his request, was buried beside Charlemagne at Aachen.

LECTIONARY OF HENRY II Otto III's successor, Henry II, was the last Ottonian emperor. Of the artworks produced during his reign, the Lectionary of Henry II is the most noteworthy. A product of the leading Ottonian scriptorium at Reichenau, as was Otto III's Gospel book, Henry's lectionary (a book of Gospel readings for the Mass; see "Medieval Books," page 312) was a gift to Bamberg Cathedral. In the full-page illumination of the announcement of Christ's

11-30 Annunciation to the Shepherds, folio in the Lectionary of Henry II, from Reichenau, Germany, 1002–1014. Tempera on vellum, 1' $5'' \times 1$ ' 1". Bayerische Staatsbibliothek, Munich.

The full-page illuminations in the *Lectionary of Henry II* fuse elements of Late Antique landscapes, the Carolingian-Ottonian anecdotal narrative tradition, and the golden background of Byzantine art.

birth to the shepherds (FIG. 11-30), the angel has just alighted on a hill, his still-beating wings agitating his draperies. The angel looms immense above the startled and terrified shepherds, filling the golden sky. He extends his hand in a gesture of authority and instruction. Emphasized more than the message itself are the power and majesty of God's authority. The painting is a summation of the stylistic complexity of Ottonian art. It is a highly successful fusion of the Carolingian-Ottonian anecdotal narrative tradition, elements derived from Late Antique painting—for example, the rocky landscape setting with grazing animals (FIG. 8-17)—and the golden background of Byzantine book illumination and mosaic decoration.

UTA CODEX Another lectionary (FIG. 11-31), one of the finest Ottonian books produced for the clergy, as opposed to the imperial court, was the work of scribes and illuminators at Regensburg. Their patron was Uta, abbess of Niedermünster from 1003 to 1025, a leading nun well known in royal circles. Uta was instrumental in bringing Benedictine reforms to the Niedermünster convent, whose nuns were usually the daughters of the local nobility. Near the end of her life, she presented the nunnery with a sumptuous manuscript containing many full-page illuminations interspersed with Gospel readings, the so-called Uta Codex. The lectionary's gold-jewel-and-enamel case also survives, underscoring the nature

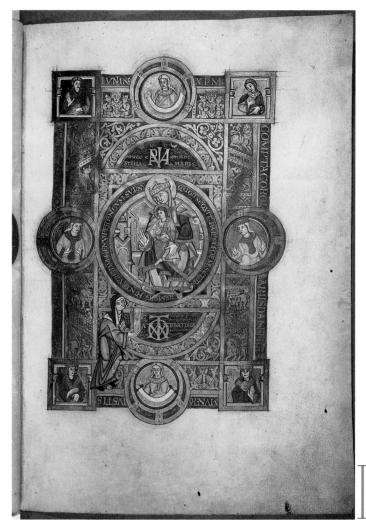

11-31 Abbess Uta dedicating her codex to the Virgin, folio 2 recto of the *Uta Codex*, from Regensburg, Germany, ca. 1025. Tempera on parchment, $9\frac{5}{8}$ " \times $5\frac{1}{8}$ ". Bayerische Staatsbibliothek, Munich.

The *Uta Codex* illustrates the important role women played both in religious life and as patrons of the arts. The dedicatory page shows Abbess Uta presenting her codex to the Virgin Mary.

of medieval books as sacred objects to be venerated in their own right as well as embodiments of the eternal word of God.

The dedicatory page (Fig. 11-31) at the front of the *Uta Codex* depicts the Virgin Mary with the Christ Child in her lap in the central medallion. Labeled *Virgo Virginum*, Virgin of Virgins, Mary is the model for Uta and the Niedermünster nuns. Uta is the full-length figure presenting a new book—this book—to the Virgin. An inscription accompanies the dedicatory image: "Virgin Mother of God, happy because of the divine Child, receive the votive offerings of your Uta of ready service." The artist painted Uta last, superimposing her figure upon the design and carefully placing it so that Uta's head touches the Virgin's medallion but does not penetrate it, suggesting the interplay between, but also the separation of, the divine and human realms.

In many respects, the *Uta Codex* is more typical of the Middle Ages than are the artworks and buildings commissioned by the Carolingian and Ottonian emperors. The Roman Empire, in revived form, may have lived on to 1002 at Otto III's court in Rome, but after Henry II's death in 1024, a new age began, and Rome's influence waned. Romanesque Europe instead found unity in a common religious fervor (see Chapter 12).

EARLY MEDIEVAL EUROPE

ART OF THE WARRIOR LORDS 5th to 10th Centuries

- After the fall of Rome in 410, the Huns, Vandals, Merovingians, Franks, Goths, Vikings, and other non-Roman peoples competed for power and territory in the former northwestern provinces of the Roman Empire.
- Other than the ornamentation of ships used for burials, the surviving artworks of this period are almost exclusively small-scale status symbols, especially items of personal adornment such as bracelets, pins, purses, and belt buckles, often featuring cloisonné decoration. A mixture of abstract and zoomorphic motifs appears on these portable treasures. Especially characteristic are intertwined animal and interlace patterns.

Sutton Hoo purse cover ca. 625

HIBERNO-SAXON ART 6th to 10th Centuries

- Art historians call the Christian art of the early medieval Britain and Ireland Hiberno-Saxon or Insular.

 The most important extant artworks are the illuminated manuscripts produced in the monastic scriptoria of Ireland and Northumbria.
- These Insular books feature folios devoted neither to text nor to illustration but to pure embellishment. "Carpet pages" consist of decorative panels of abstract and zoomorphic motifs. Some books also have full pages depicting the four evangelists or their symbols. Text pages often present the initial letters of important passages enlarged and transformed into elaborate decorative patterns.

Book of Kells, late eighth or early ninth century

CAROLINGIAN ART 768-877

- Charlemagne, king of the Franks since 768, expanded the territories he inherited from his father, and in 800, Pope Leo III crowned him emperor of Rome (r. 800–814). Charlemagne and his successors initiated a conscious revival of the art and culture of Early Christian Rome.
- Carolingian sculptors revived the imperial Roman tradition of portraying rulers on horseback and the Early Christian tradition of depicting Christ as a statuesque youth. Artists merged the illusionism of classical painting with the northern European linear tradition, replacing the calm and solid figures of those models with figures that leap from the page with frenzied energy.
- Carolingian architects looked to Ravenna and Early Christian Rome for models but transformed their sources, introducing, for example, the twin-tower western facade for basilicas and employing strict modular plans for entire monasteries as well as individual churches.

Charlemagne or Charles the Bald, ninth century

NA COLEMBRICON CONTINUES DE CON

Utrecht Psalter, ca. 820-835

OTTONIAN ART 919-1024

- In the mid-10th century, a new line of emperors, the Ottonians, consolidated the eastern part of Charlemagne's former empire and sought to preserve the culture and tradition of the Carolingian period.
- Ottonian artists, like other early medieval artists, excelled in producing sumptuous small-scale artworks, especially ivory plaques with narrative reliefs, often influenced by Byzantine art. But Ottonian sculptors also revived the art of monumental sculpture in works such as the *Gero Crucifix* and the colossal bronze doors of Saint Michael's at Hildesheim. Ottonian painting combines motifs and landscape elements from Late Antique art with the golden backgrounds of Byzantine art.
- Ottonian architects built basilican churches incorporating the towers and westworks of their Carolingian models but introduced the alternate-support system and galleries into the interior nave elevation.

Saint Michael's, Hildesheim, 1001–1031

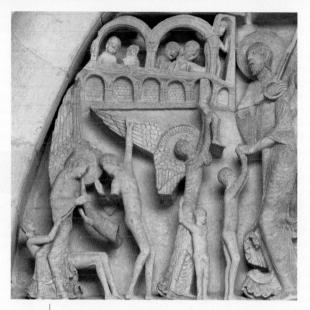

Above Autun Cathedral's portal, at the far left, a trumpet-blowing angel announces the second coming. Another obliging angel boosts one of the blessed over the fortified walls of Heaven.

Below, the souls of the dead line up to await their fate. Two men whose travel bags identify them as pilgrims to Jerusalem and Santiago de Compostela can expect to be judged favorably.

12-1 GISLEBERTUS, Last Judgment, west tympanum of Saint-Lazare, Autun, France, ca. 1120-1135. Marble, 21' wide at base. ■

In Gislebertus's unforgettable rendition of the weighing of souls on judgment day, angels and the Devil's agents contest at the scales, each trying to tip the balance for or against a soul.

12

ROMANESQUE EUROPE

THE REBIRTH OF MONUMENTAL SCULPTURE

A sworshipers entered the western portal of Saint-Lazare (Saint Lazarus) at Autun, they passed under a dramatic representation of the *Last Judgment* (FIG. 12-1) by the sculptor GISLEBERTUS. A renowned artist, he inscribed his name in the stone relief and added this admonition: "May this terror terrify those whom earthly error binds, for the horror of these images here in this manner truly depicts what will be." The warning echoes the sentiment expressed in a mid-10th-century copy of Beatus of Liébana's *Commentary on the Apocalypse*. There, the painter Magius (teacher of Emeterius; see FIG. 11-11) explained the purpose of his work: "I have painted a series of pictures for the wonderful words of [the Apocalypse's] stories, so that the wise may fear the coming of the future judgment of the world's end."

Few people in 12th-century France other than the clergy could read Gislebertus's message, but even the illiterate could, in the words of Saint Bernard of Clairvaux, "read in the marble" (see "Bernard of Clairvaux on Cloister Sculpture," page 342). Indeed, in the entire history of art, there is probably no more terrifying visualization of what awaits sinners than the Last Judgment at Autun. Four trumpet-blowing angels announce the second coming of Christ, enthroned at the center, far larger than any other figure. He dispassionately presides over the separation of the blessed from the damned. At the left, an obliging angel boosts one of the saved into the heavenly city. Below, the souls of the dead line up to await their fate. Two of the men near the center of the lintel carry bags emblazoned with a cross and a shell. These are the symbols of pilgrims to Jerusalem and Santiago de Compostela, respectively (see "Pilgrimage Roads in France and Spain," page 335, and MAP 12-1). Those who had made the difficult journey would be judged favorably. To their right, three small figures beg an angel to intercede on their behalf. The angel responds by pointing to the judge above. On the right side are those who will be condemned to Hell. Giant hands pluck one poor soul from the earth. Directly above is Gislebertus's unforgettable rendition of the weighing of souls (compare FIG. 11-9). Angels and the Devil's agents try to manipulate the balance for or against a soul. Hideous demons guffaw and roar. Their gaunt, lined bodies, with legs ending in sharp claws, writhe and bend like long, loathsome insects. A devilish creature, leaning from the dragon mouth of Hell, drags souls in, while above him, a howling demon crams the damned headfirst into a furnace.

The Autun *Last Judgment* is one of the earliest examples of the rebirth of the art of monumental sculpture in the Middle Ages, one hallmark of the age art historians have dubbed *Romanesque* because of the extensive use of stone sculpture and stone vaulting in ecclesiastical architecture.

EUROPEAN CULTURE IN THE NEW MILLENNIUM

The Romanesque era is the first since Archaic and Classical Greece to take its name from an artistic style rather than from politics or geography. Unlike Carolingian and Ottonian art, named for emperors, or Hiberno-Saxon art, a regional term, *Romanesque* is a title art historians invented to describe medieval art that appeared "Roman-like." Architectural historians first employed the adjective in the early 19th century to describe European architecture of the 11th and 12th centuries. They noted that certain architectural elements of this period, principally barrel and groin vaults based on the round arch, resembled those of ancient Roman architecture. Thus, the word distinguished most Romanesque buildings from earlier medieval timber-roofed structures, as well as from later Gothic churches with vaults resting on pointed arches (see Chapter 13). Scholars in other fields quickly borrowed the term. Today "Romanesque" broadly designates the history and culture of western Europe between about 1050 and 1200.

TOWNS AND CHURCHES In the early Middle Ages, the focus of life was the *manor*, or estate, of a landholding *liege lord*, who might grant rights to a portion of his land to *vassals*. The vassals swore allegiance to their liege and rendered him military service in return for use of the land and the promise of protection. But in the Romanesque period, a sharp increase in trade encouraged the growth of towns and cities, gradually displacing *feudalism* as the governing political, social, and economic system of late medieval Europe. Feudal lords granted independence to the new towns in the form of charters, which enumerated the communities' rights, privileges, immunities, and exemptions beyond the feudal obligations the vassals owed the lords. Often located on navigable rivers, the new urban centers naturally became the nuclei of networks of maritime and overland commerce.

Separated by design from the busy secular life of Romanesque towns were the monasteries (see "Medieval Monasteries," Chapter 11, page 322) and their churches. During the 11th and 12th centuries, thousands of ecclesiastical buildings were remodeled or newly constructed. This immense building enterprise was in part a natural by-product of the rise of independent cities and the prosperity they enjoyed. But it also was an expression of the widely felt relief and thanksgiving that the conclusion of the first Christian millennium in the year 1000 had not brought an end to the world, as many had feared. In the Romanesque age, the construction of churches became almost an obsession. Raoul Glaber (ca. 985–ca. 1046), a

monk who witnessed the coming of the new millennium, noted the beginning of it:

[After the] year of the millennium, which is now about three years past, there occurred, throughout the world, especially in Italy and Gaul, a rebuilding of church basilicas. Notwithstanding, the greater number were already well established and not in the least in need, nevertheless each Christian people strove against the others to erect nobler ones. It was as if the whole earth, having cast off the old by shaking itself, were clothing itself everywhere in the white robe of the church.³

PILGRIMS AND RELICS The enormous investment in ecclesiastical buildings and furnishings also reflected a significant increase in pilgrimage traffic in Romanesque Europe (see "Pilgrimage Roads in France and Spain," page 335, and MAP 12-1). Pilgrims, along with wealthy landowners, were important sources of funding for those monasteries that possessed the relics of venerated saints (see "The Veneration of Relics," page 336). The monks of Sainte-Foy (FIG. 12-7A) at Conques, for example, used pilgrims' donations to pay for a magnificent cameo-and-jewel-encrusted gold-and-silver reliquary (FIG. 12-2) to house the skull of Saint Faith. In fact, the clergy of the various monasteries vied with one another to provide the most magnificent settings for the display of their unique relics. They found justification for their lavish expenditures on buildings and furnishings in the Bible itself, for example, in Psalm 26:8, "Lord, I have loved the beauty of your house, and the place where your glory dwells." Traveling pilgrims fostered the growth of towns as well as monasteries. Pilgrimages were a major economic as well as conceptual catalyst for the art and architecture of the Romanesque period.

FRANCE AND NORTHERN SPAIN

Although art historians use the adjective "Romanesque" to describe 11th- and 12th-century art and architecture throughout Europe, pronounced regional differences exist. This chapter examines in turn Romanesque France and Spain; the Holy Roman Empire; Italy; and Normandy and England. To a certain extent, Romanesque art and architecture can be compared with the European Romance languages, which vary regionally but have a common core in Latin, the language of the Romans.

1200

ROMANESQUE EUROPE

1000

Romanesque architects replace the timber roofs of churches with barrel vaults in the nave and groin vaults

1100

- Builders also add radiating chapels to ambulatories for the display of relics
- Sculptors revive the art of monumental stone relief
- Architects introduce groin vaulting in church naves in conjunction with a three-story elevation (arcade-tribuneclerestory)
- Relief sculpture becomes commonplace on church facades, usually greeting worshipers with a vision of Christ as last judge
- Manuscript illumination flourishes in the scriptoria of Clunics monasteries.

Pilgrimage Roads in France and Spain

In the Romanesque era, pilgrimage was the most conspicuous feature of public religious devotion, proclaiming pilgrims' faith in the power of saints and hope for their special favor. The major shrines-Saint Peter's and Saint Paul's in Rome and the Church of the Holy Sepulcher in Jerusalem—drew pilgrims from all over Europe, just as Muslims journeyed from afar to Mecca (see "Muhammad and Islam," Chapter 10, page 285). The pilgrims braved bad roads and hostile wildernesses infested with robbers who preyed on innocent travelers—all for the sake of salvation. The journeys could take more than a year to complete—when they were successful. People often undertook pilgrimage as an act of repentance or as a last resort in their search for a cure for some physical disability. Hardship and austerity were means of increasing pilgrims' chances for the remission of sin or of disease. The distance and peril of the pilgrimage were measures of pilgrims' sincerity of repentance or of the reward they sought.

For those with insufficient time or money to make a pilgrimage to Rome or Jerusalem (in short, most people in Europe), holy destinations could be

found closer to home. In France, for example, the church at Vézelay (FIG. 12-14) housed the bones of Mary Magdalene. Pilgrims could also view Saint Lazarus's remains at Autun (FIG. 12-1), Saint Saturninus's at Toulouse (FIG. 12-5), Saint Faith's at Conques (FIGS. 12-2 and 12-7A), and Saint Martin's at Tours (see "The Veneration of Relics," page 336). Each of these great shrines was also an important way station en route to the most venerated shrine in western Europe, the tomb of Saint James at Santiago de Compostela (FIG. 12-7B) in northwestern Spain.

Large crowds of pilgrims paying homage to saints placed a great burden on the churches possessing their relics and led to changes in church design, principally longer and wider naves and aisles, transepts and ambulatories with additional chapels (FIG. 12-6), and second-story galleries (FIGS. 12-7 and 12-7B). Pilgrim traffic also established the routes that later became the major avenues of commerce and communication in western Europe. The popularity of pilgrimages gave rise to travel guides that, like modern guidebooks, provided pilgrims with information not only about saints and shrines but also about roads, accommodations, food, and drink. How widely circulated these handwritten books were remains a matter of scholarly debate, but the information they provide is invaluable.

The most famous Romanesque guidebook described the four roads leading to Santiago de Compostela through Arles and Tou-

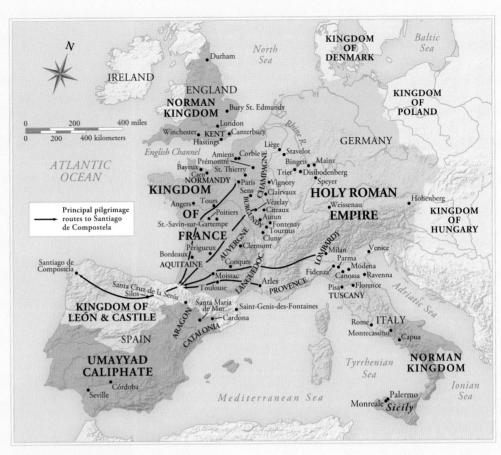

MAP 12-1 Western Europe around 1100.

louse, Conques and Moissac, Vézelay and Périgueux, and Tours and Bordeaux in France (MAP 12-1). Saint James was the symbol of Christian resistance to Muslim expansion in western Europe, and his relics, discovered in the ninth century, drew pilgrims to Santiago de Compostela from far and wide. The guidebook's anonymous 12th-century author, possibly Aimery Picaud, a Cluniac monk, was himself a well-traveled pilgrim. The text states the author wrote the guide "in Rome, in the lands of Jerusalem, in France, in Italy, in Germany, in Frisia and mainly in Cluny."* Pilgrims reading the guidebook learned about the saints and their shrines at each stop along the way to Spain. Saint Saturninus of Toulouse, for example, endured a martyr's death at the hands of the Romans when he

was tied to some furious and wild bulls and then precipitated from the height of the citadel. . . . His head crushed, his brains knocked out, his whole body torn to pieces, he rendered his worthy soul to Christ. He is buried in an excellent location close to the city of Toulouse where a large basilica [FIGS. 12-5 to 12-7] was erected by the faithful in his honor.[†]

^{*}William Melczer, *The Pilgrim's Guide to Santiago de Compostela* (New York: Italica Press, 1993), 133.

[†] Ibid., 103.

The Veneration of Relics

The cult of *relics* was not new in the Romanesque era. For centuries, Christians had traveled to sacred shrines housing the body parts of, or objects associated with, the holy family or the saints. The faithful had long believed bones, clothing, instruments of martyrdom, and the like had the power to heal body and soul. The veneration of relics, however, reached a high point in the 11th and 12th centuries, prompting the devout to undertake often dangerous pilgrimages to hallowed shrines in Jerusalem, Rome, and throughout western Europe (see "Pilgrimage Roads in France and Spain," page 335). Churches vied with one another not only for the possession of relics but also in the magnificence of the containers (*reliquaries*) that preserved and protected them.

The case of the relics of Saint Faith (Sainte-Foy, in French), an early-fourth-century child martyr who refused to pay homage to the Roman gods, is a telling example. A monk from the abbey church at Conques (FIG. 12-7A) stole the saint's skull from the nearby abbey of Agen around 880. The monks justified the act as furta sacra (holy theft), claiming Saint Faith herself wished to move. The reliquary (FIG. 12-2) they provided to house the saint's remains is one of the most sumptuous ever produced. It takes the form of an enthroned statuette of the martyr. Fashioned of gold leaf and silver gilt over a wooden core, the reliquary prominently features inset jewels and cameos of various dates—the accumulated donations of pilgrims and church patrons over many years. The saint's oversize head is a reworked ancient Roman parade helmet—a masklike helmet worn by soldiers on special ceremonial occasions and not part of standard battle dress. The monks added a martyr's crown to the ancient helmet. The rear of the throne bears a Crucifixion image engraved in rock crystal, establishing a parallel between Christ's martyrdom and Saint Faith's.

Reflecting the Romanesque passion for relics, *The Song of Roland*, an 11th-century epic poem recounting a historical battle of 778 between Charlemagne's rear-guard and the Saracens, describes Durendal, the extraordinary sword the hero Roland wielded, as follows:

Ah, Durendal, fair, hallowed, and devote, What store of relics lie in thy hilt of gold! St Peter's tooth, St Basil's blood, it holds, Hair of my lord St Denis, there enclosed, Likewise a piece of Blessed Mary's robe.*

Given the competition among Romanesque monasteries and cities for the possession of saints' relics, the 11th-century *Pilgrim's Guide to Santiago de Compostela* included comments on authenticity. For example, about Saint James's tomb, the anonymous author stated:

May therefore the imitators from beyond the mountains blush who claim to possess some portion of him or even his entire relic. In fact, the body of the Apostle is here in its entirety, divinely lit by paradisiacal carbuncles, incessantly honored with immaculate and soft perfumes, decorated with dazzling celestial candles, and diligently worshipped by attentive angels.†

12-2 Reliquary statue of Sainte-Foy (Saint Faith), late 10th to early 11th century with later additions. Gold, silver gilt, jewels, and cameos over a wooden core, 2' $9^{1/2}_{2}''$ high. Treasury, Sainte-Foy, Conques.

This enthroned image containing the skull of Saint Faith is one of the most lavish Romanesque reliquaries. The head is an ancient Roman parade helmet, and the cameos are donations from pilgrims.

 $^*173.2344-2348.$ Translated by Dorothy L. Sayers, *The Song of Roland* (New York: Penguin, 1957), 141.

[†]William Melczer, *The Pilgrim's Guide to Santiago de Compostela* (New York: Italica Press, 1993), 127.

Architecture and Architectural Sculpture

The regional diversity of the Romanesque period is particularly evident in architecture. For example, some Romanesque churches, especially in Italy, retained the wooden roofs of their Early Christian predecessors long after stone vaulting had become commonplace elsewhere. Even in France and northern Spain, home of many of the most innovative instances of stone vaulting, some Romanesque architects continued to build timber-roofed churches.

VIGNORY The mid-11th-century church of Saint-Étienne (Saint Stephen) at Vignory in the Champagne region of central France has strong ties to Carolingian-Ottonian architecture but already incorporates features that became common only in later Romanesque buildings. The interior (FIG. 12-3) reveals a kinship with the three-story wooden-roofed churches of the Ottonian era, for example, Saint Cyriakus (FIG. 11-21) at Gernrode. At Vignory, however, the second story is not a true *tribune* (gallery over the aisle opening onto the nave) but rather a screen with alternating piers

12-3 Interior of Saint-Étienne (looking east), Vignory, France, 1050–1057. ■4

The timber-roofed abbey church at Vignory reveals a kinship with the three-story naves of Ottonian churches (FIG. 11-21), which also feature an alternate-support system of piers and columns.

and columns opening onto very tall flanking aisles. The east end of the church, in contrast, has an innovative plan (FIG. 12-4) with an ambulatory around the choir and three semicircular chapels opening onto it. These *radiating chapels* probably housed the church's relics, which the faithful could view without having to enter the choir where the main altar stood.

Although other 11th-century churches, for example, Sant Vicenç (Fig. 12-4A) at Cardona, Spain, and Saint-Philibert (Fig. 12-4B) at Tournus, France, are noteworthy as early Romanesque examples of stone vaulting, Saint-Étienne at Vignory is one of the first examples of the introduction of stone sculpture into Romanesque ecclesiastical architecture, one of the period's defining features. At Vignory, however, the only sculpture is the relief decoration of the capitals of the ambulatory and false tribunes where abstract and vegetal ornamentation, lions, and other quadrupeds are the exclusive motifs.

12-4A Sant Vicenç, Cardona, ca. 1029–1040.

12-4B Saint-Philibert, Tournus, ca. 1060. ■

12-4 Plan of Saint-Étienne, Vignory, France, 1050–1057. (1) nave, (2) aisles, (3) choir, (4) ambulatory, (5) radiating chapels.

The innovative plan of the east end of the abbey church of Saint Stephen features an ambulatory around the choir and three semicircular radiating chapels opening onto it for the display of relics.

12-5 Aerial view of Saint-Sernin (looking northwest), Toulouse, France, ca. 1070–1120. ■

Pilgrimages were a major economic catalyst for the art and architecture of the Romanesque period. The clergy vied with one another to provide magnificent settings for the display of holy relics.

TOULOUSE Dwarfing the Vignory, Cardona, and Tournus churches is the immense stone-vaulted basilica of Saint-Sernin (Saint Saturninus; FIGS. 12-5 to 12-7) at Toulouse. Construction began around 1070 to honor the city's first bishop, a martyr saint of the middle of the third century. Toulouse was an important stop on the pilgrimage road through southwestern France to Santiago de Compostela (see "Pilgrimage Roads," page 335). Large congregations gathered at the shrines along the major pilgrimage routes, and the unknown architect designed Saint-Sernin to accommo-

12-7A Sainte-Foy, Conques, mid-11th to early 12th century. ■◀

Santiago de Compostela

date them. The grand scale of the building is apparent in the aerial view (FIG. 12-5), which includes automobiles, trucks, and nearly invisible pedestrians. The church's 12th-century exterior is still largely intact, although the two towers of the western facade (at the left in FIG. 12-5) were never completed, and the prominent crossing tower dates to the Gothic and later periods. Saint-Sernin's plan (FIG. 12-6) closely resembles those of the churches of Saint Faith (FIG. 12-7A) at Conques, Saint James (FIG. 12-7B) at Santiago de Compostela, and Saint Martin at Tours, and exemplifies what has come to be called the "pilgrimage church" type. At Toulouse, the builders increased the length of the nave, doubled the side aisles, and added a transept, ambulatory, and radiating chapels to provide additional space for pilgrims and the clergy. Radiating chapels opening onto an ambulatory already were a feature of Vignory's

abbey church (FIG. 12-4), but at Toulouse the chapels are greater in number and open onto the transept as well as the ambulatory.

The Saint-Sernin plan is extremely regular and geometrically precise. The crossing square, flanked by massive piers and marked off by heavy arches, served as the module for the entire church. Each nave bay, for example, measures exactly one-half of the crossing square, and each aisle bay measures exactly one-quarter. The builders employed similar simple ratios throughout the church. The first suggestion of this kind of planning scheme in medieval Europe was the Saint Gall monastery plan (FIG. 11-19), almost three

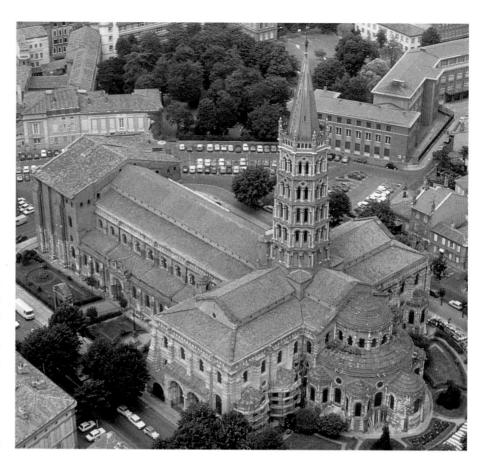

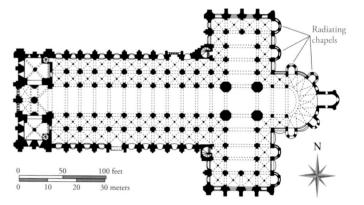

12-6 Plan of Saint-Sernin, Toulouse, France, ca. 1070–1120 (after Kenneth John Conant).

Increased traffic led to changes in church design. "Pilgrimage churches" have longer and wider naves and aisles, as well as transepts and ambulatories with radiating chapels for viewing relics.

centuries earlier. The Toulouse solution was a crisply rational and highly refined realization of an idea first seen in Carolingian architecture. This approach to design became increasingly common in the Romanesque period.

Another telling feature of Saint-Sernin's design is the insertion of tribunes opening onto the nave over the inner aisles (FIG. 12-7), a feature also of the nave (FIG. 12-7B) of the church of Saint James at Santiago de Compostela. These galleries housed overflow crowds on special occasions and also played an important role in buttressing the nave's continuous semicircular cut-stone *barrel vault*, in contrast to the timber roof over the nave (FIG. 12-3) of the smaller abbey church at Vignory (see "Timber Roofs and Stone Vaults," page 339).

Timber Roofs and Stone Vaults

The perils of wooden construction were the subject of frequent commentary among chroniclers of medieval ecclesiastical history. In some cases, churches burned over and over again in the course of a single century and repeatedly had to be extensively repaired or completely rebuilt. In September 1174, for example, Canterbury Cathedral, which had been dedicated only 44 years earlier, was accidentally set ablaze and destroyed. Gervase of Canterbury (1141–1210), who entered the monastery there in 1163 and wrote a history of the archbishopric from 1100 to 1199, provided a vivid eyewitness account of the disastrous fire in his *Chronica*:

[D]uring an extraordinarily violent south wind, a fire broke out before the gate of the church, and outside the walls of the monastery, by which three cottages were half destroyed. From thence, while the citizens were assembling and subduing the fire, cinders and sparks carried aloft by the high wind were deposited upon the church, and being driven by the fury of the wind between the joints of the lead, remained there amongst the half-rotten planks, and shortly glowing with increased heat, set fire to the rotten rafters; from these the fire was communicated to the larger beams and their braces, no one yet perceiving or helping. For the well-

painted ceiling below, and the sheet-lead covering above, concealed between them the fire that had arisen within.... But beams and braces burning, the flames arose to the slopes of the roof; and the sheets of lead yielded to the increasing heat and began to melt. Thus the raging wind, finding a freer entrance, increased the fury of the fire. . . . And now that the fire had loosened the beams from the pegs that bound them together, the half-burnt timbers fell into the choir below upon the seats of the monks; the seats, consisting of a great mass of woodwork, caught fire, and thus the mischief grew worse and worse. And it was marvellous, though sad, to behold how that glorious choir itself fed and assisted the fire that was destroying it. For the flames multiplied by this mass of timber, and extending upwards full fifteen cubits [about twenty-five feet], scorched and burnt the walls, and more especially injured the columns of the church.... In this manner the house of God, hitherto delightful as a paradise of pleasures, was now made a despicable heap of ashes, reduced to a dreary wilderness.*

After the fire, the Canterbury monks summoned a master builder from Sens, a French city 75 miles southeast of Paris, to supervise the construction of their new church. Gervase reported that the first task William of Sens tackled was "the procuring of stone from beyond the sea."

A quest for fireproof structures, however, apparently was not the primary rationale for stone vaulting. Although protec-

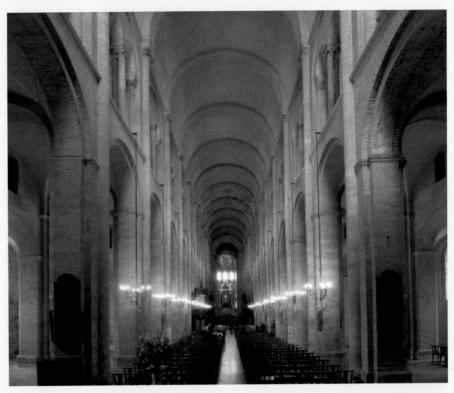

12-7 Interior of Saint-Sernin (looking east), Toulouse, France, ca. 1070-1120.

Saint-Sernin's stone vaults helped retard fire. The groin-vaulted tribune galleries also buttressed the nave's barrel vault whose transverse arches continue the lines of the compound piers.

tion from devastating conflagrations was no doubt one of the attractions of constructing masonry vaults in an age when candles and lamps provided interior illumination, other factors probably played a greater role in the decision to make the enormous investment of time and funds required. The rapid spread of stone vaulting throughout Romanesque Europe—beginning in the 11th century at Cardona (FIG. 12-4A), Tournus (FIG. 12-4B), Toulouse (FIG. 12-7), Santiago de Compostela (FIG. 12-7B), Speyer (FIG. 12-20), and Milan (FIG. 12-22)—was most likely the result of a desire to provide a suitably majestic setting for the display of relics as well as enhanced acoustics for the Christian liturgy and the music accompanying it. Some contemporaneous texts, in fact, comment on the visual impact of costly stone vaults. For example, in 1150 at Angers in northwestern France, a church chronicler explained what the bishop sought to achieve by replacing the timber roof of his cathedral with stone vaults: "[He] took down the timber beams of the nave of the church, threatening to fall from sheer old age, and began to build stone vaults of wondrous effect."

^{*}Translated by Robert Willis. Quoted in Elizabeth Gilmore Holt, *A Documentary History of Art*, 2d ed. (Princeton, N.J.: Princeton University Press, 1981), 1:52–54.

[†]Translated by John Hooper Harvey, *The Medieval Architect* (London: Waylan, 1972), 39.

12-8 Bernardus Gelduinus, *Christ in Majesty*, relief in the ambulatory of Saint-Sernin, Toulouse, France, ca. 1096. Marble, 4′ 2″ high.

One of the earliest series of large Romanesque figural reliefs decorated the pilgrimage church of Saint-Sernin. The models were probably metal or ivory Carolingian and Ottonian book covers.

Groin vaults (indicated by Xs on the plan, Fig. 12-6; compare Fig. 7-6*b*) in the tribunes as well as in the ground-floor aisles absorbed the pressure exerted by the barrel vault along the entire length of the nave and transferred the main thrust to the thick outer walls.

The builders of Saint-Sernin were not content merely to buttress the massive nave vault. They also carefully coordinated the design of the vault with that of the nave arcade below and with the modular plan of the building as a whole. The nave elevation (FIG. 12-7), which features *engaged columns* (attached half-columns) embellishing the

piers marking the corners of the bays, fully reflects the church's geometric floor plan (FIG. 12-6). Architectural historians refer to piers with columns or pilasters attached to their rectangular cores as *compound piers*. At Saint-Sernin, the engaged columns rise from the bottom of the compound piers to the vault's *springing* (the lowest stone of an arch) and continue across the nave as *transverse arches*. As a result, the Saint-Sernin nave gives the impression of being numerous identical vertical volumes of space placed one behind the other, marching down the building's length in orderly procession. Saint-Sernin's spatial organization corresponds to and renders visually the plan's geometric organization. The articulation of the building's exterior walls (FIG. 12-5), where buttresses frame each bay, also reflects the segmentation of the nave. This rationally integrated scheme, with repeated units decorated and separated by moldings, would have a long future in later European church architecture.

Saint-Sernin also boasts one of the earliest precisely dated series of large Romanesque figural reliefs—a group of seven marble slabs representing Christ, angels, and apostles. An inscription on the altar states the reliefs date to the year 1096 and identifies the artist as Bernardus Gelduinus. Today, the plaques adorn the church's ambulatory wall, but their original location is uncertain. In the view of some scholars, the reliefs once formed part of a shrine dedicated to Saint Saturninus that stood in the crypt (a vaulted underground chamber) of the grand pilgrimage church. Others believe the plaques once decorated a choir screen or an exterior portal. The relief illustrated here (FIG. 12-8), Christ in Majesty, is the centerpiece of the group. Christ sits in a mandorla, his right hand raised in blessing, his left hand resting on an open book inscribed Pax vobis ("Peace unto you"). The signs of the four evangelists (see "The Four Evangelists," Chapter 11, page 314) occupy the corners of the slab. Art historians debate the sources of Bernardus's style, but the composition could have been used earlier for a Carolingian or Ottonian work in metal or ivory, perhaps a book cover. The polished marble has the gloss of both materials, and the sharply incised lines and ornamentation of Christ's aureole are characteristic of pre-Romanesque metalwork.

Stone sculpture, with some notable exceptions, such as the Irish high crosses (FIGS. 11-9 and 11-9A), had almost disappeared from the art of western Europe during the early Middle Ages. The revival of stonecarv-

12-8A Saint-Genis-des-Fontaines,

ing in the 11th century at Toulouse and Saint-Genis-des-Fontaines (FIG. 12-8A) in southern France and Silos (FIG. 12-8B) in northern Spain is a hallmark of the Romanesque age—and one reason the period is aptly named. The inspiration for stone sculpture no doubt came, at least in part, from the abundant remains of ancient statues and reliefs throughout Rome's north-western provinces. Yet these models had been available for centuries, and they cannot explain the sudden proliferation of stone sculpture in Romanesque churches. Many art historians have noted that the reemergence of monumen-

12-8B Santo Domingo, Silos, ca. 1090-1100.

tal stone sculpture coincided with the introduction of stone vaulting. But medieval builders had erected stone-walled churches and monumental westworks for centuries, even if the structures bore timber ceilings and roofs. The earliest Romanesque sculptures, in fact, appear in timber-roofed churches, such as Saint-Étienne (FIG. 12-3) at Vignory. Therefore, the addition of stone vaults to basilican churches cannot

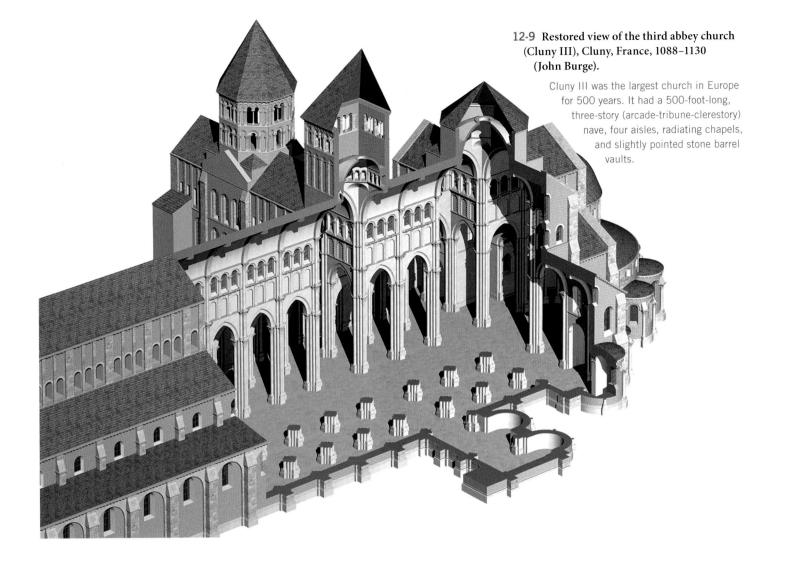

account for the resurgence of stonecarving in the Romanesque period. But just as stone vaulting reflects the greater prosperity of the age, so too does the decoration of churches with large-scale sculptures. Both are consistent with the widespread desire in the Romanesque period to beautify the house of God and make it, in the words of Gervase of Canterbury, "a paradise of pleasures."

The popularity of stone sculpture in the 12th century also reflects the changing role of many churches in western Europe. In the early Middle Ages, most churches served small monastic communities, and the worshipers were primarily or exclusively clergy. With the rise of towns in the Romanesque period, churches, especially those on the major pilgrimage routes, increasingly served the lay public. The display of sculpture both inside and outside Romanesque churches was a means of impressing—and educating—a new and largely illiterate audience.

CLUNY The primary patrons of Romanesque sculpture were the monks of the Cluniac order. In 909, William the Pious, duke of Aquitaine (r. 893–918), donated land near Cluny in Burgundy to a community of reform-minded Benedictine monks under the leadership of Berno of Baume (d. 927). Because William waived his feudal rights to the land, the abbot of Cluny was obligated only to the pope in Rome, a unique privilege. Berno founded a new order at Cluny according to the rules of Saint Benedict (see "Medieval Monasteries and Benedictine Rule," Chapter 11, page 322). Under Berno's successors, the Cluniac monks became famous for their scholarship, music, and art. Their influence and wealth grew

rapidly, and they built a series of ever more elaborate monastic churches at Cluny.

Abbot Hugh of Semur (1024-1109) began construction of the third church at Cluny in 1088. Called Cluny III by architectural historians, the building is, unfortunately, largely destroyed today but can be reconstructed in a computer drawing (FIG. 12-9). When work concluded in 1130, Cluny III was the largest church in Europe, and it retained that distinction for almost 500 years until the completion of the new Saint Peter's (FIG. 24-4) in Rome in the early 17th century. Contemporaries considered Cluny III a place worthy for angels to dwell if they lived on earth. The church had a bold and influential design, with a barrel-vaulted nave, four aisles, and radiating chapels, as at Saint-Sernin, but with a three-story nave elevation (arcade-tribune-clerestory) and slightly pointed nave vaults. With a nave more than 500 feet long and more than 100 feet high (both dimensions are about 50 percent greater than at Saint-Sernin), it epitomized the grandiose scale of the new stone-vaulted Romanesque churches and was a symbol of the power and prestige of the Cluniac order.

MOISSAC An important stop in southwestern France along the pilgrimage route to Saint James's tomb at Santiago de Compostela was Moissac, which boasts the most extensive preserved ensemble of early Romanesque sculpture. The monks of the Moissac abbey had joined the Cluniac order in 1047. Enriched by the gifts of pilgrims and noble benefactors, they adorned their church with an elaborate series of relief sculptures. The oldest are in the *cloister* (from the Latin word *claustrum*, an enclosed place), which

Bernard of Clairvaux on Cloister Sculpture

The most influential theologian of the Romanesque era was Bernard of Clairvaux (1090–1153). A Cistercian monk and abbot of the monastery he founded at Clairvaux in northern Burgundy, he embodied not only the reforming spirit of the Cistercian order but also the new religious fervor awakening throughout Europe. Bernard's impassioned eloquence made him a celebrity and drew him into the stormy politics of the 12th century. He intervened in high ecclesiastical and secular matters, defended and sheltered embattled popes, counseled kings, denounced heretics, and preached Crusades against the Muslims (see "The Crusades," page 346)—all in defense of papal Christianity and spiritual values. The Church declared Bernard a saint in 1174, barely two decades after his death.

In a letter Bernard wrote in 1127 to William, abbot of Saint-Thierry, he complained about the rich outfitting of non-Cistercian churches in general, and in particular, the sculptural adornment of monastic cloisters, such as those at Silos (FIG. 12-8B) and Moissac (FIG. 12-10).

I will overlook the immense heights of the places of prayer, their immoderate lengths, their superfluous widths, the costly refinements, and painstaking representations which deflect the attention . . . of those who pray and thus hinder their devotion. . . . But so be it, let these things be made for the honor of God . . . [But] in the cloisters, before the eyes of the brothers while they read—

what... are the filthy apes doing there? The fierce lions? The monstrous centaurs? The creatures, part man and part beast?... You may see many bodies under one head, and conversely many heads on one body. On one side the tail of a serpent is seen on a quadruped, on the other side the head of a quadruped is on the body of a fish. Over there an animal has a horse for the front half and a goat for the back... Everywhere so plentiful and astonishing a variety of contradictory forms is seen that one would rather read in the marble than in books, and spend the whole day wondering at every single one of them than in meditating on the law of God. Good God! If one is not ashamed of the absurdity, why is one not at least troubled at the

expense?*

*Apologia 12.28–29. Translated by Conrad Rudolph,
The "Things of Greater Importance": Bernard of Clairvaux's
Apologia and the Medieval
Attitude toward Art (Philadelphia: University of Pennsylvania Press, 1990), 279, 283.

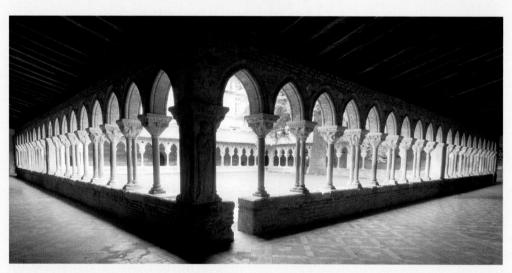

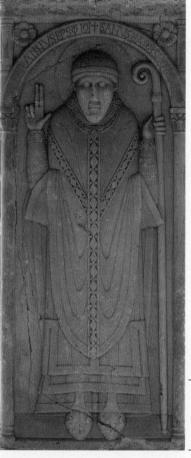

1 ft

12-10 General view of the cloister (*left*; looking southeast) and detail of the pier with the relief of Abbot Durandus (*right*), Saint-Pierre, Moissac, France, ca. 1100-1115. Relief: limestone, 6' high.

The revived tradition of stonecarving probably began with historiated capitals. The most extensive preserved ensemble of sculptured early Romanesque capitals is in the Moissac cloister.

connotes being shut away from the world. Architecturally, the medieval church cloister expressed the seclusion of the spiritual life, the *vita contemplativa*. At Moissac, as elsewhere, the cloister provided the monks (and nuns) with a foretaste of Paradise. In its garden or the timber-roofed columnar walkway framing the garden (FIG. 12-10, *left*), they could read their devotions, pray, meditate,

and carry on other activites in a beautiful and centrally located space. The cloisters of the 12th century are monuments to the vitality, popularity, and influence of monasticism at its peak.

Moissac's cloister sculpture program consists of large figural reliefs on the piers as well as *historiated* (ornamented with figures) capitals on the columns. The pier reliefs portray the 12 apostles and

the monastery's first Cluniac abbot (FIG. 12-10, *right*), Durandus (1047–1072), whom the monks buried in the cloister. The Durandus relief is not a portrait in the modern sense of the word but a generic, bilaterally symmetrical image of the abbot holding his staff in his left hand and raising his right hand in a gesture of blessing. The carving is very shallow—an exercise in two-dimensional design rather than an attempt at representing a fully modeled figure in space. The feet, for example, which point downward, do not rest on the ground and cannot support the abbot's weight (compare FIG. 9-2).

The 76 capitals alternately crown single and paired column shafts. They are variously decorated, some with abstract patterns, many with biblical scenes or the lives of saints, others with fantastic monsters of all sorts—basilisks, griffins, lizards, gargoyles, and more. Bestiaries—collections of illustrations of real and imaginary animals—became very popular in the Romanesque age. The monstrous forms were reminders of the chaos and deformity of a world without God's order. Medieval artists delighted in inventing composite multiheaded beasts and other fantastic creations. Historiated capitals were also a feature of Moissac's mother church, Cluny III, and were common in Cluniac monasteries.

Not everyone shared the Cluniac monks' enthusiasm for stone sculpture. One group of Benedictine monks founded a new order at Cîteaux in eastern France in 1098. The Cistercians (from the Latin name for Cîteaux) split from the Cluniac order to return to the strict observance of the rules of Saint Benedict (see "Medieval Monasteries and Benedictine Rule," Chapter 11, page 322), changing the color of their habits from Cluniac black to unbleached white. These White Monks emphasized productive manual labor, and their systematic farming techniques stimulated the agricultural transformation of Europe. The Cistercian movement expanded with astonishing rapidity. Within a half century, the White Monks had established more than 500 monasteries. Their churches, such as Notre-Dame at Fontenay (FIG. 12-10A), are uniformly austere. The Cistercians rejected figural sculpture as a

12-10A Notre-Dame,

distraction from their devotions. The most outspoken Cistercian critic of church sculpture was Abbot Bernard of Clairvaux (see "Bernard of Clairvaux on Cloister Sculpture," page 342).

Bernard directed his tirade against figural sculpture primarily at monks who allowed the carvings to distract them from their meditations. But at Moissac (FIG. 12-11) and other Cluniac churches, the most extensive sculptural

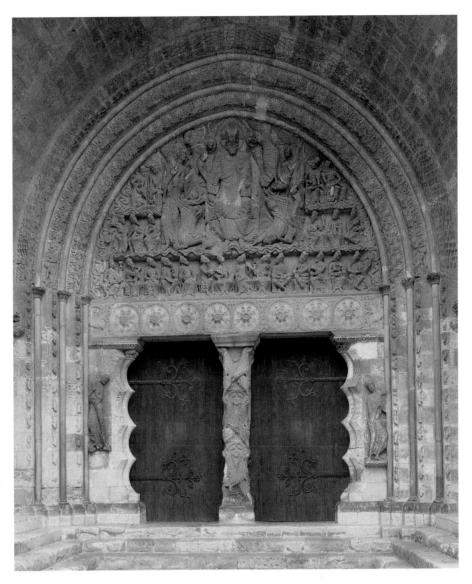

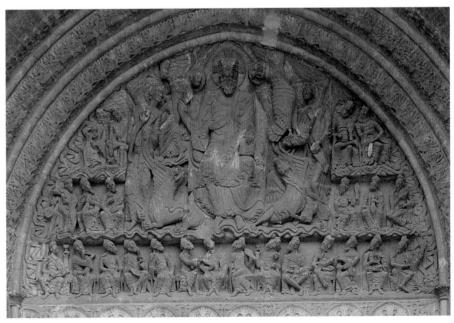

12-11 South portal of Saint-Pierre, Moissac, France, ca. 1115–1135. *Top:* general view. *Bottom:* detail of tympanum with *Second Coming of Christ.* ■

A vision of the second coming of Christ on judgment day greets worshipers entering Saint-Pierre at Moissac. The sculptural program reflects the belief that Christ is the door to salvation.

The Romanesque Church Portal

ne of the most significant and distinctive features of Romanesque art is the revival of monumental sculpture in stone. Large-scale carved biblical figures were extremely rare in Christian art before the year 1000. But in the late 11th and early 12th centuries, rich ensembles of figural reliefs began to appear again, most often in the grand stone portals (Figs. 12-11 and 12-14A) through which the faithful had to pass. Sculpture had been employed in church doorways before. For example, carved wooden doors (Fig. 8-10A) greeted Early Christian worshipers as they entered Santa Sabina in Rome, and Ottonian bronze doors (Fig. 11-24) decorated with Old and New Testament scenes marked the entrance from the cloister to Saint Michael's at Hildesheim. But these were exceptions, and in the Romanesque era (and during the Gothic period that followed), sculpture usually appeared in the area *around*, rather than *on*, the doors.

Shown in FIG. 12-12 are the parts of church portals Romanesque sculptors regularly decorated with figural reliefs:

- *Tympanum* (FIGS. 12-1, 12-11, 12-14, and 12-14A), the prominent semicircular *lunette* above the doorway proper, comparable in importance to the triangular pediment of a Greco-Roman temple.
- *Voussoirs* (FIG. 12-14), the wedge-shaped blocks that together form the *archivolts* of the arch framing the tympanum.
- Lintel (FIGS. 12-8A, 12-11, 12-13B, and 12-14), the horizontal beam above the doorway.
- *Trumeau* (FIGS. 12-11 and 12-13), the center post supporting the lintel in the middle of the doorway.
- **■** *Jambs* (FIG. 12-11), the side posts of the doorway.

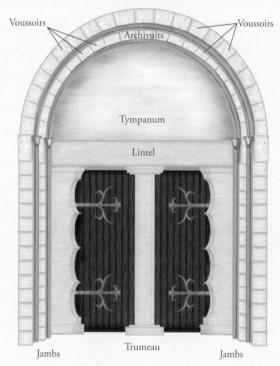

12-12 The Romanesque church portal.

The clergy considered the church doorway the beginning of the path to salvation through Christ. Many Romanesque churches feature didactic sculptural reliefs above and beside the entrance portals.

ensembles adorned those parts of the church open to the laity, especially the facade—for example, that of Notre-Dame-la-Grande (FIG. 12-11A) at Poitiers. Saint-Pierre's richly decorated south portal faces the town square, and features figural and decorative reliefs in its *tympanum*, *voussoirs*, *lintel*, *trumeau*, and *jambs* (see "The Romanesque Church Portal," *left*, and FIG. 12-12). The tympanum depicts the *Second Coming* of Christ as

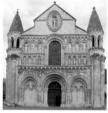

12-11A Notre-Damela-Grande, Poitiers, ca. 1130–1150. ■◀

king and judge of the world in its last days. As befits his majesty, the enthroned Christ is at the center, reflecting a compositional rule followed since Early Christian times. Flanking him are the signs of the four evangelists and attendant angels holding scrolls to record human deeds for judgment. The figures of crowned musicians, which complete the design, are the 24 elders who accompany Christ as the kings of this world and make music in his praise. Each turns to face the enthroned judge, much as would the courtiers of a Romanesque monarch in attendance on their lord. Two courses of wavy lines symbolizing the clouds of Heaven divide the elders into three tiers.

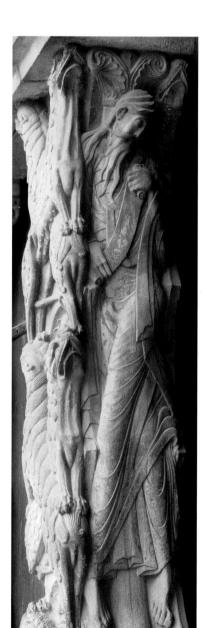

12-13 Old Testament prophet (Jeremiah or Isaiah?), right side of the trumeau of the south portal of Saint-Pierre, Moissac, France, ca. 1115-1130. ■4

This animated prophet displays the scroll recounting his vision. His position below the apparition of Christ as last judge is in keeping with the tradition of pairing Old and New Testament themes.

Most sculptured Romanesque church portals present a larger-than-life Christ as the central motif. These facades reflect the belief, dating to Early Christian times, that Christ is the door to salvation ("I am the door; who enters through me will be saved"—John 10:9). An inscription on the tympanum of the late-11th-century monastic church of Santa Cruz de la Serós in Spain made this message explicit: "I am the eternal door. Pass through me faithful. I am the source of life."

Many variations exist within the general style of Romanesque sculpture, as within Romanesque architecture. The figures of the Moissac tympanum contrast sharply with those of the earlier Saint-Sernin ambulatory reliefs (FIG. 12-8) and the Silos pier reliefs (FIG. 12-8B), as well as the contemporaneous Last Judgment tympanum (FIG. 12-1) at Autun and even the pier reliefs (FIG. 12-10, right) of the Moissac cloister. The extremely elongated bodies of the angels recording each soul's fate, the cross-legged dancing pose of Saint Matthew's angel, and the jerky, hinged movement of the elders' heads are characteristic of the nameless Moissac master's style of representing the human figure. The zigzag and dovetail lines of the draperies, the bandlike folds of the torsos, the bending back of the hands against the body, and the wide cheekbones are also common features of this distinctive style. The animation of the individual figures, however, contrasts with the stately monumentality of the composition as a whole, producing a dynamic tension in the tympanum.

The jambs and trumeau (FIG. 12-13) of the Moissac portal have scalloped contours (FIG. 12-11), a borrowing from Spanish Islamic architecture (FIGS. 10-10 and 10-11). Six roaring interlaced lions on the front of the trumeau greet worshipers as they enter the church. The animal world was never far from the medieval mind, and people often associated the fiercest beasts with kings and barons—for example, Richard the Lionhearted, Henry the Lion, and Henry the Bear. Lions were the church's ideal protectors. In the Middle Ages, people believed lions slept with their eyes open. But the notion of placing fearsome images at the gateways to important places is of very ancient origin. Ancestors of the Moissac lions include the lions and composite monsters that guarded the palaces of Hittite, Assyrian, and Mycenaean kings (FIGS. 2-18A, 2-20, and 4-19) and the panthers and leopards in Greek temple pediments (FIG. 5-16) and Etruscan tombs (FIG. 6-9).

On the trumeau's right face is a prophet—identified by some scholars as Jeremiah, as Isaiah by others—who displays a scroll bearing his prophetic vision. His position below the apparition of Christ as the apocalyptic judge is yet another instance of the pairing of Old and New Testament themes, in keeping with an iconographic tradition established in Early Christian times (see "Jewish Subjects in Christian Art," Chapter 8, page 238). The prophet's figure is very tall and thin, in the manner of the tympanum angels, and like Matthew's angel, he executes a cross-legged step. The animation of the body reveals the passionate nature of the soul within. The flowing lines of the drapery folds ultimately derive from manuscript illumination (compare FIG. 12-15A) and here play gracefully around the elegant figure. The long, serpentine locks of hair and beard frame an arresting image of the dreaming mystic. The prophet seems entranced by his vision of what is to come, the light of ordinary day unseen by his wide eyes.

VÉZELAY At the same time sculptors were adorning Saint-Pierre at Moissac, Gislebertus and his assistants were at work on Saint-Lazare at Autun, decorating not only the west tympanum (FIG. 12-1) but also the nave (FIG. 12-13A) and the north portal (FIG. 12-13B). A team of stonecarvers also worked nearby at the church of La Madeleine (Mary Magdalene) at Vézelay. Vézelay is more closely associated with the Crusades (see "The Crusades," page 346) than is any other church in Europe. Pope Urban II had intended to preach the launching of the First Crusade at Vézelay in 1095, although he delivered the sermon at Clermont instead. In 1147, Bernard of Clairvaux called for the

12-13A GISLEBERTUS, Suicide of Judas, Autun, ca. 1120–1135. ■◀

12-13B GISLEBERTUS, Eve, Autun, ca. 1120–1135. ■

Second Crusade at Vézelay, and King Louis VII of France took up the cross there. The Magdalene church at Vézelay was also where, in 1190, King Richard the Lionhearted of England and King Philip Augustus of France set out on the Third Crusade.

The major element of the sculptural program of La Madeleine at Vézelay is the tympanum (FIG. 12-14) of the central portal of the

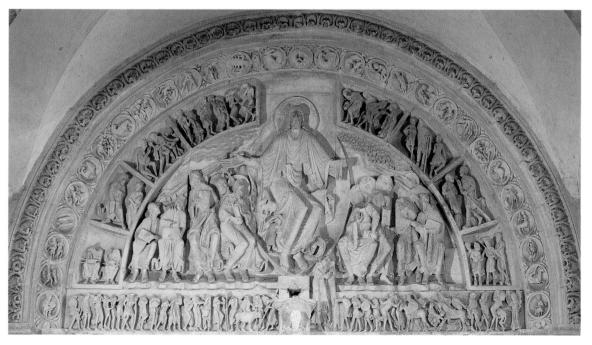

12-14 Pentecost and Mission of the Apostles, tympanum of the center portal of the narthex of La Madeleine, Vézelay, France, 1120-1132.

In the tympanum of the church most closely associated with the Crusades, light rays emanating from Christ's hands instill the Holy Spirit in the apostles, whose mission is to convert the world's heathens.

The Crusades

In 1095, Pope Urban II (r. 1088–1099) delivered a stirring sermon at the Council of Clermont in which he called for an assault on the Holy Land:

[Y]our brethren who live in the East are in urgent need of your help ... [because] the Turks and Arabs have attacked them. ... They have killed and captured many, and have destroyed the churches ... I, or rather the Lord, beseech you as Christ's heralds ... to persuade all people of whatever rank, foot-soldiers and knights, poor and rich, to carry aid promptly to those Christians and to destroy that vile race from the lands of our friends. ... All who die by the way ... shall have immediate remission of sins. ... Let those who go not put off the journey, but rent their lands and collect money for their expenses ... [and] eagerly set out on the way with God as their guide.*

Between 1095 and 1190, Christians launched three great Crusades from France. The *Crusades* ("taking of the Cross") were mass armed pilgrimages whose stated purpose was to wrest the Christian shrines of the Holy Land from Muslim control. Similar vows bound Crusaders and pilgrims. They hoped not only to atone for sins and win salvation but also to glorify God and extend the power of the Church. The joint action of the papacy and the mostly French feudal lords in this type of holy war strengthened papal authority over the long run and created an image of Christian solidarity.

The symbolic embodiment of the joining of religious and secular forces in the Crusades was the Christian warrior, the fighting priest, or the priestly fighter. From the early medieval warrior evolved the Christian knight, who fought for the honor of God rather than in defense of his chieftain. The first and most typical of the crusading knights were the Knights Templar. After the Christian conquest of Jerusalem in 1099, they stationed themselves next to the Dome of the

Rock (FIGS. 10-2 and 10-3), that is, on the site of Solomon's Temple, the source of their name. Their mission was to protect pilgrims visiting the recovered Christian shrines. Formally founded in 1118, the Knights Templar order received the blessing of Bernard of Clairvaux, who gave them a rule of organization based on that of his own Cistercians. Bernard justified their militancy by declaring "the knight of Christ" is "glorified in slaying the infidel . . . because thereby Christ is glorified," and the Christian knight then wins salvation. The Cistercian abbot saw the Crusades as part of the general reform of the Church and as the defense of the supremacy of Christendom. He himself called for the Second Crusade in 1147 at Vézelay (FIG. 12-14). For the Muslims, however, the Crusaders were nothing more than violent invaders who slaughtered the population of Jerusalem (Jewish as Well as Muslim) when they took the city in July 1099.

In the end, the Muslims expelled the Christian armies, and the Crusaders failed miserably in their attempt to regain the Holy Land. But in western Europe, the Crusades had a much greater impact by increasing the power and prestige of the towns. Italian port cities such as Pisa (Fig. 12-26) thrived on the commercial opportunities presented by the transportation of Crusaders overseas. Many communities purchased their charters from the barons who owned their land when the latter needed to finance their campaigns in the Holy Land. This gave rise to a middle class of merchants and artisans to rival the power of the feudal lords and the great monasteries—an economic and societal change of enormous consequence for the later history of Europe.

*As recorded by Fulcher of Chartres (1059–ca. 1127). Translated by O. J. Thatcher and E. H. McNeal, quoted in Roberta Anderson and Dominic Aidan Bellenger, eds., *Medieval Worlds: A Sourcebook* (New York: Routledge, 2003), 88–90.

church's narthex. It depicts the Pentecost and the Mission of the Apostles. As related in Acts 1:4-9, Christ foretold the 12 apostles would receive the power of the Holy Spirit and become witnesses of the truth of the Gospels throughout the world. The light rays emanating from Christ's hands represent the instilling of the Holy Spirit in the apostles (Acts 2:1-42) at the Pentecost (the seventh Sunday after Easter). The apostles, holding the Gospel books, receive their spiritual assignment to preach the Gospel to all nations. The Christ figure is a splendid calligraphic design. The drapery lines shoot out in rays, break into quick zigzag rhythms, and spin into whorls, wonderfully conveying the spiritual light and energy flowing from Christ over and into the equally animated apostles. The overall composition, as well as the detailed treatment of the figures, contrasts with the much more sedate representation of the second coming (FIG. 12-11) at Moissac, where a grid of horizontal and vertical lines contains almost all the figures. The sharp differences between the two tympana once again highlight the regional diversity of Romanesque art.

The world's heathen, the objects of the apostles' mission, appear on the Vézelay lintel below and in eight compartments around the tympanum. The portrayals of the yet-to-be-converted constitute a medieval anthropological encyclopedia. Present are the

legendary giant-eared Panotii of India, Pygmies (who require ladders to mount horses), and a host of other races, some characterized by a dog's head, others by a pig's snout, and still others by flaming hair. The assembly of agitated figures also includes hunchbacks, mutes, blind men, and lame men. Humanity, still suffering, awaits the salvation to come. As at Autun

12-14A Saint-Trophîme, Arles, mid-12th century.

(FIG. 12-1) and Moissac (FIG. 12-11), and also at Saint-Trophîme (FIG. 12-14A) in Arles, as worshipers passed through the portal, the tympanum established God's omnipotence and presented the Church as the road to salvation.

Painting and Other Arts

Unlike the practices of placing vaults over naves and aisles and decorating building facades with monumental stone reliefs, the art of painting needed no "revival" in the Romanesque period. Monasteries produced illuminated manuscripts in large numbers in the early Middle Ages, and even the Roman tradition of mural painting had never died. But the quantity of preserved frescoes and illustrated books from the Romanesque era is unprecedented.

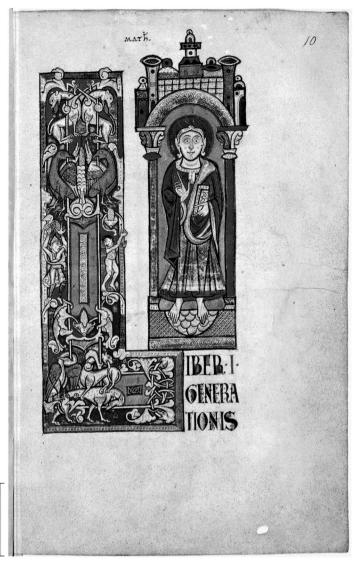

12-15 Initial L and Saint Matthew, folio 10 recto of the Codex Colbertinus, probably from Moissac, France, ca. 1100. Tempera on vellum, $7\frac{1}{2}'' \times 4''$. Bibliothèque Nationale, Paris.

Probably produced in the Moissac scriptorium, the *Codex Colbertinus* illuminations are stylistically similar to the contemporaneous cloister sculptures (Fig. 12-10) of that Cluniac monastery.

12-15A Corbie Gospels, ca. 1120.

CODEX COLBERTINUS In addition to sponsoring the costliest sculptural programs of the Romanesque age, Cluniac monasteries produced many of the finest and most ornate illuminated manuscripts, including the Codex Colbertinus (FIG. 12-15) and the Corbie Gospels (FIG. 12-15A), both of which are closely related stylistically to the relief sculptures of Saint-Pierre at Moissac.

The *Codex Colbertinus* is, in fact, probably the work of scribes and painters in the Moissac scriptorium, and it is

contemporaneous with the column capitals and pier reliefs of Saint-Pierre's cloister (FIG. 12-10). The major illuminations in the manuscript are the full pages featuring historiated initials and evangelist portraits. The opening page (FIG. 12-15) of the Gospel according to Saint Matthew includes both the large initial letter *L* of *Liber* (book)

12-16 Initial *R* with knight fighting dragons, folio 4 verso of the *Moralia in Job*, from Cîteaux, France, ca. 1115–1125. Ink and tempera on vellum, $1' 1\frac{3}{4}'' \times 9\frac{1}{4}''$. Bibliothèque Municipale, Dijon.

Ornamented initials date to the Hiberno-Saxon era (Fig. 11-1), but this artist translated the theme into Romanesque terms. The duel between knight and dragons symbolized a monk's spiritual struggle.

and a "portrait" of the author. Matthew holds a book in his left hand and raises his right hand in a gesture of blessing. He stands frontally between a pair of columns supporting an arch, just as does Abbot Durandus (FIG. 12-10, *right*) on one of the Moissac cloister piers. The two figures are similar in other respects as well. For example, both artists depicted the robed men with dangling feet.

The letter L has no equivalent in the Moissac sculptures, but the real and imaginary animals and birds with long, twisted necks that inhabit the initial have parallels in Saint-Pierre's cloister capitals (Fig. 12-10, left). The intertwining forms attest to the long afterlife of the animal-interlace style of the illuminated books (Fig. 11-7) of the Hiberno-Saxon period.

MORALIA IN JOB Another major Romanesque scriptorium was at the abbey of Cîteaux, mother church of the Cistercian order. Just before Bernard of Clairvaux joined the monastery in 1112, the monks completed work on an illuminated copy of Saint Gregory's Moralia in Job. It is an example of Cistercian illumination before Bernard's passionate opposition to monastic figural art led in 1134 to a Cistercian ban on elaborate paintings in manuscripts as well as sculptural ornamentation in monasteries. After 1134, in sharp contrast to Cluniac Moissac, the Cistercian order prohibited full-page illustrations, and even initial letters had to be nonfigurative and of a single color.

The historiated initial illustrated here (FIG. 12-16) clearly would have been in violation of Bernard's ban had it not been

12-17 Nave of the abbey church (looking east) of Saint-Savin, Saint-Savin-sur-Gartempe, France, ca. 1100. ■◀

Saint-Savin is a hall church with aisles approximately the same height as the nave. The tall aisle windows provide ample illumination for the biblical paintings on the nave's barrel vault.

painted before his prohibitions took effect. A knight, his squire, and two roaring dragons form an intricate letter R, the initial letter of the salutation *Reverentissimo*. This page is the opening of Gregory's letter to "the most revered" Leandro, bishop of Seville, Spain. The knight is a slender, regal figure who raises his shield and sword against the dragons, while the squire, crouching beneath him, runs a lance through one of the monsters. Although the clergy viewed the duel between knight and dragons as an allegory of the spiritual struggle of monks against the Devil for the salvation of souls, Bernard opposed this kind of illumination, just as he condemned carvings of monstrous creatures and "fighting knights" on cloister capitals (see "Bernard of Clairvaux," page 342).

Ornamented initials date to the Hiberno-Saxon period (FIG. 11-1), but in the *Moralia in Job*, the artist translated the theme into Romanesque terms. The page with the initial *R* may be a reliable picture of a medieval baron's costume. The typically French Romanesque band-

ing of the torso and partitioning of the folds are evident (compare FIG. 12-13), but the master painter deftly avoided stiffness and angularity. The partitioning here accentuates the knight's verticality and elegance and the thrusting action of his servant. The flowing sleeves add a spirited flourish to the swordsman's gesture. The knight, handsomely garbed, cavalierly wears no armor and calmly aims a single stroke, unmoved by the ferocious dragons lunging at him.

SAINT-SAVIN-SUR-GARTEMPE Although the art of fresco painting never died in early medieval Europe, the murals (not true frescoes, however) of the Benedictine abbey church of Saint-Savin-sur-Gartempe have no Carolingian or Ottonian parallels, because the paintings decorate the stone barrel vault of the church's nave (FIG. 12-17). Saint-Savin is a hall church—a church where the aisles are approximately the same height as the nave. The tall windows in the aisles provided more illumination to the nave than in churches having low aisles and tribunes. The abundant light streaming into the church may explain why the monks chose to decorate the nave's barrel vault with paintings. (They also painted the nave piers to imitate rich veined marble.) The subjects of Saint-Savin's nave paintings all come from the Pentateuch, but New Testament themes appear in the transept, ambulatory, and chapels, where the painters also depicted the lives of Saint Savin and another local saint. The elongated, agitated, cross-legged figures have stylistic affinities both to the reliefs of southern French portals and to illuminated manuscripts such as the Corbie Gospels (FIG. 12-15A) and the Moralia in Job (FIG. 12-16).

SANTA MARÍA DE MUR In the Romanesque period, northern Spain, home to the great pilgrimage church of Saint James at Santiago de Compostela, was one of the most important regional artistic centers. In fact, Catalonia in northeastern Spain boasts more Romanesque mural paintings today than anywhere else. Especially impressive is the *Christ in Majesty* fresco (FIG. **12-18**), now in Boston, that once filled the apse of Santa María de Mur, a monastery church not far from Lérida. The formality, symmetry, and placement of the figures are Byzantine (compare FIGS. 9-16 and 9-27). But the Spanish artist rejected Byzantine mosaic in favor of direct painting on plaster-coated walls.

The iconographic scheme in the semidome of the apse echoes the themes of the sculpted tympana of contemporaneous French (FIGS. 12-11 and 12-14A) and Spanish Romanesque church portals. The signs of the four evangelists flank Christ in a star-strewn mandorla—the Apocalypse theme that so fascinated the Romanesque imagination. Seven lamps between Christ and the evangelists' signs symbolize the seven Christian communities where Saint John addressed his revelation (the Apocalypse) at the beginning of his book (Rev. 1:4, 12, 20). Below stand apostles, paired off in formal frontality, as in the Monreale Cathedral apse (FIG. 9-27). The Spanish painter rendered the principal figures with partitioning of the drapery into volumes, here and there made tubular by local shading, and stiffened the irregular shapes of pliable cloth into geometric patterns. The overall effect is one of simple, strong, and even blunt directness of statement, reinforced by harsh, bright color, appropriate for a powerful icon.

MORGAN MADONNA Despite the widespread use of stone relief sculptures to adorn church portals, resistance to the creation of statues in the round—in any material—continued in the Romanesque period. The avoidance of anything that might be construed as an idol was still the rule, in keeping with the Second Commandment. Two centuries after Archbishop Gero commissioned a monumen-

12-18 *Christ in Majesty*, apse, Santa María de Mur, near Lérida, Spain, mid-12th century. Fresco, 24' high. Museum of Fine Arts, Boston.

In this fresco, formerly in the apse of Santa María de Mur, Christ appears in a mandorla between the four evangelists' signs. The fresco resembles French and Spanish Romanesque tympanum reliefs.

tal wooden image of the crucified Christ (FIG. 11-28) for Cologne Cathedral, freestanding statues of Christ, the Virgin Mary, and the saints were still quite rare. The veneration of relics, however, brought with it a demand for small-scale images of the holy family and saints to be placed on the chapel altars of the churches along the pilgrimage roads. Reliquaries in the form of saints (FIG. 12-2) or parts of saints (FIG. 12-25), tabletop crucifixes, and small wooden devotional images began to be produced in great numbers.

One popular type, a specialty of the workshops of Auvergne, France, was a wooden statuette depicting the Virgin Mary with the Christ Child in her lap. The *Morgan Madonna* (FIG. **12-19**), so named because it once belonged to the American financier and collector J. Pierpont Morgan, is one example. The type, known as the "throne of wisdom" (*sedes sapientiae* in Latin), is a western European freestanding version of the Byzantine Theotokos theme popular in icons and mosaics (FIGS. 9-18 and 9-19). Christ holds a Bible in his left hand and raises his right arm in blessing (both hands are broken off). He is the embodiment of the divine wisdom contained in the holy scriptures. His mother, seated on a wooden chair, is in turn the throne of wisdom because her lap is the Christ Child's throne. As in Byzantine art, both Mother and Child sit

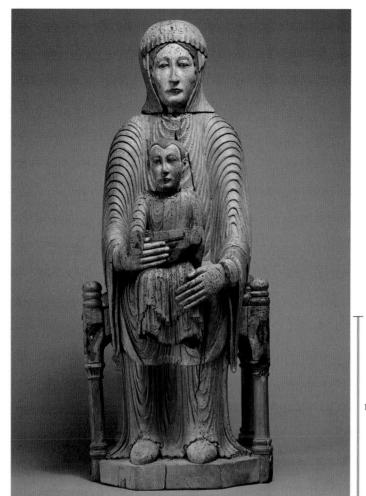

12-19 Virgin and Child (*Morgan Madonna*), from Auvergne, France, second half of 12th century. Painted wood, 2' 7" high. Metropolitan Museum of Art, New York (gift of J. Pierpont Morgan, 1916).

The veneration of relics created a demand for small-scale images of the holy family and saints to be placed on chapel altars. This wooden statuette depicts the Virgin as the "throne of wisdom."

rigidly upright and are strictly frontal, emotionless figures. But the intimate scale, the gesture of benediction, the once-bright coloring of the garments, and the soft modeling of the Virgin's face make the group seem much less remote than its Byzantine counterparts.

HOLY ROMAN EMPIRE

The Romanesque successors of the Ottonians were the Salians (r. 1027–1125), a dynasty of Franks. They ruled an empire corresponding roughly to present-day Germany and the Lombard region of northern Italy (MAP 12-1). Like their predecessors, the Salian emperors were important patrons of art and architecture, although, as elsewhere in Romanesque Europe, the monasteries remained great centers of artistic production.

Architecture

The barrel-vaulted naves of Saint-Sernin (FIG. 12-7) at Toulouse, Saint James at Santiago de Compostela (FIG. 12-7B), Cluny III (FIG. 12-9), and Notre-Dame (FIG. 12-10A) at Fontenay admirably met French and Spanish Romanesque architects' goals of making

the house of the Lord beautiful and providing excellent acoustics for church services. In addition, they were relatively fireproof compared with timber-roofed structures such as Saint-Étienne (FIG. 12-3) at Vignory. But the barrel vaults often failed in one critical requirement—lighting. Due to the great outward thrust barrel vaults exert along their full length, even when pointed (FIGS. 12-9 and 12-10A) instead of semicircular, a clerestory is difficult to construct. (The Toulouse, Santiago de Compostela, and Fontenay designers did not even attempt to introduce a clerestory, although their counterparts at Cluny III succeeded.) Structurally, the central aim of Romanesque architects in the Holy Roman Empire (and in Normandy and England; see page 357) was to develop a masonry vault system that admitted light and was aesthetically pleasing.

Covering the nave with groin vaults instead of barrel vaults became the solution. Ancient Roman builders had used the groin vault widely, because they realized its concentration of thrusts at four supporting points enabled them to introduce clerestory windows (FIGS. 7-6c, 7-67, and 7-78). Concrete, which could be poured into forms, where it solidified into a homogeneous mass (see "Roman Concrete Construction," Chapter 7, page 184), made the gigantic Roman groin vaults possible. But the technique of mixing concrete had not survived into the Middle Ages. The technical problems of building groin vaults of cut stone and heavy rubble, which had very little cohesive quality, at first limited their use to the covering of small areas, such as the individual bays of the aisles of the pilgrimage churches at Toulouse and Santiago de Compostela (FIGS. 12-7 and 12-7B). During the 11th century, however, masons in the Holy Roman Empire, using cut-stone blocks held together with mortar, developed a groin vault of monumental dimensions.

SPEYER Construction of Speyer Cathedral (FIG. 12-20) in the German Rhineland, far from the pilgrimage routes of southern France and northern Spain, began in 1030. The church was the burial place of the Holy Roman emperors until the beginning of the 12th century, and funding for the building campaign came from imperial patrons, not traveling pilgrims and local landowners. Like all cathedrals, Speyer was also the seat (cathedra in Latin) of the powerful local bishop. In its earliest form, the church was a timber-roofed structure. When Henry IV (r. 1056-1105) rebuilt the cathedral between 1082 and 1105, his masons covered the nave with stone groin vaults. The large clerestory windows above the nave arcade provided ample light to the interior. Architectural historians disagree about where the first comprehensive use of groin vaulting occurred in Romanesque times, and nationalistic concerns sometimes color the debate. But no one doubts that the large groin vaults covering the nave of Speyer Cathedral represent one of the most daring and successful engineering experiments of the time. The nave is 45 feet wide, and the crowns of the vaults are 107 feet above the floor.

Speyer Cathedral employs an alternate-support system in the nave, as in the Ottonian churches of Saint Cyriakus (FIG. 11-21) at Gernrode and Saint Michael's (FIGS. 11-23 and 11-23A) at Hildesheim. At Speyer, however, the alternation continues all the way up into the vaults, with the nave's more richly molded compound piers marking the corners of the groin vaults. Speyer's interior shows the same striving for height and the same compartmentalized effect seen at Toulouse and Santiago de Compostela (FIGS. 12-7 and 12-7B), but by virtue of the alternate-support system, the rhythm of the Speyer nave is a little more complex. Because each compartment has its own vault, the impression of a sequence of vertical spatial blocks is even more convincing.

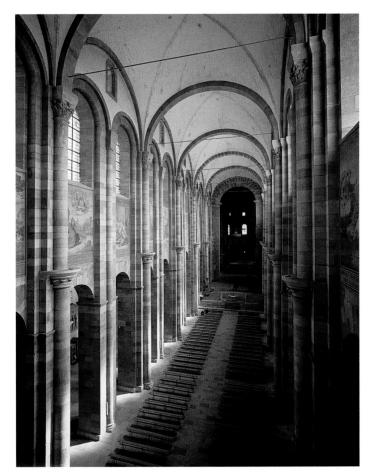

12-20 Interior of Speyer Cathedral (looking east), Speyer, Germany, begun 1030; nave vaults, ca. 1082–1105.

The imperial cathedral at Speyer is one of the earliest examples of the use of groin vaulting in a nave. Groin vaults made possible the insertion of large clerestory windows above the nave arcade.

MILAN After Charlemagne crushed the Lombards in 773, German kings held sway over Lombardy, and the Rhineland and northern Italy cross-fertilized each other artistically. No scholarly agreement exists as to which source of artistic influence was dominant in the Romanesque age, the German or the Lombard. The question, no doubt, will remain the subject of controversy until the construction date of Sant'Ambrogio (FIG. 12-21) in Milan can be established unequivocally. The church, erected in honor of Saint Ambrose (d. 397), Milan's first bishop, is the central monument of Lombard Romanesque architecture. Some scholars think the church was a prototype for Speyer Cathedral, but Sant'Ambrogio is a remarkable building even if it was not a model for Speyer's builders. The Milanese church has an atrium in the Early Christian tradition (FIG. 8-9)—one of the last to be built—and a two-story narthex pierced by arches on both levels. Two campaniles (Italian, "bell towers") join the building on the west. The shorter one dates to the 10th century, and the taller north campanile is a 12th-century addition. Over the nave's east end is an octagonal tower that recalls the crossing towers of Ottonian churches (FIG. 11-22).

Sant'Ambrogio has a nave (FIG. 12-22) and two aisles but no transept. Each bay consists of a full square in the nave flanked by two small squares in each aisle, all covered with groin vaults. The main vaults are slightly domical, rising higher than the transverse arches. The

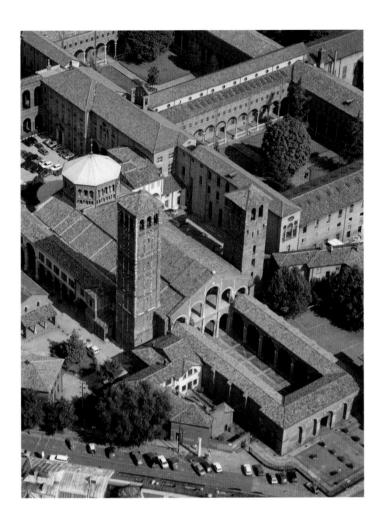

12-21 Aerial view of Sant'Ambrogio (looking southeast), Milan, Italy, late 11th to early 12th century.

With its atrium and low, broad proportions, Sant'Ambrogio recalls Early Christian basilicas. Over the nave's east end, however, is an octagonal tower resembling Ottonian crossing towers.

windows in the octagonal dome over the last bay—probably here, as elsewhere, a reference to the dome of Heaven—provide the major light source for the otherwise rather dark interior. (The building lacks a clerestory.) The emphatic alternate-support system perfectly reflects the geometric regularity of the plan. The lightest pier moldings stop at the gallery level, and the heavier ones rise to support the main vaults. At Sant'Ambrogio, the compound piers even continue into the ponderous vaults, which have sup-

porting arches, or *ribs*, along their groins. Sant'Ambrogio is one of the first instances of *rib vaulting*, a salient characteristic of mature Romanesque and of later Gothic architecture (see "The Gothic Rib Vault," Chapter 13, page 368).

The regional diversity of Romanesque architecture quickly becomes evident by comparing the proportions of Sant'Ambrogio with those of Speyer Cathedral (FIG. 12-20) and of Saint-Sernin (FIGS. 12-5 to 12-7) at Toulouse and Saint James (FIG. 12-7B) at Santiago de Compostela. The Milanese building does not aspire to the soaring height of the French, Spanish, and German churches. Save for the later of the two towers, Sant'Ambrogio's proportions are low and broad and remain close to those of Early Christian basilicas. Italian architects, even those working within the orbit of the Holy Roman Empire, had firm roots in the venerable Early Christian style and never sought the verticality found in northern European architecture, not even during the Gothic period.

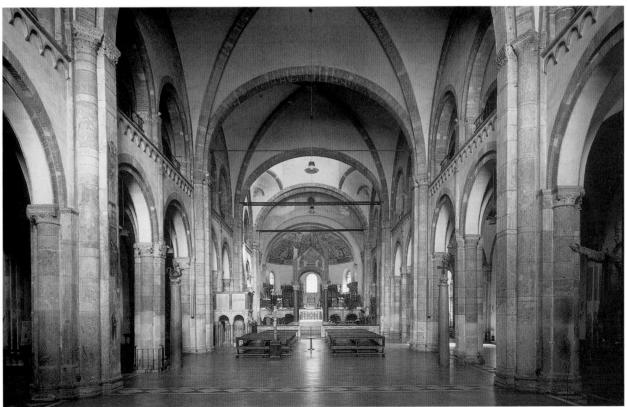

12-22 Interior of Sant'Ambrogio (looking east), Milan, Italy, late 11th to early 12th century.

Sant'Ambrogio reveals the transalpine ties of Lombard architecture. Each groin-vaulted nave bay corresponds to two aisle bays. The alternate-support system complements this modular plan.

Romanesque Countesses, Queens, and Nuns

Romanesque Europe was still a man's world, but women could and did have power and influence. Countess Matilda of Canossa (1046–1115), who ruled Tuscany after 1069, was sole heiress of vast holdings in northern Italy. She was a key figure in the political struggle between the popes and the German emperors who controlled Lombardy. With unflagging resolution, she defended the reforms of Pope Gregory VII (r. 1073–1085) and at her death willed most of her lands to the papacy.

More famous and more powerful was Eleanor of Aquitaine (1122–1204), wife of Henry II of England. She married Henry after the annulment of her marriage to Louis VII, king of France. She

12-23 Hildegard reveals her visions, detail of a facsimile of a lost folio in the Rupertsberger *Scivias* by Hildegard of Bingen, from Trier or Bingen, Germany, ca. 1050–1079. Abbey of St. Hildegard, Rüdesheim/Eibingen.

Hildegard of Bingen, the most prominent nun of her time, experienced divine visions, shown here as five tongues of fire entering her brain. She also composed music and wrote scientific treatises.

was queen of France for 15 years and queen of England for 35 years. During that time she bore three daughters and five sons. Two became kings—Richard I (the Lionhearted) and John. She prompted her sons to rebel against their father, for which Henry imprisoned her. Released at Henry's death, she lived on as dowager queen, managing England's government and King John's holdings in France.

Of quite different stamp was Hildegard of Bingen (1098–1179), the most prominent nun of the 12th century and one of the greatest religious figures of the Middle Ages. Hildegard was born into an aristocratic family that owned large estates in the German Rhineland. At a very early age she began to have visions. When she was eight, her parents placed her in the Benedictine double monastery (for monks and nuns) at Disibodenberg. She became a nun at 15. In 1141, God instructed Hildegard to disclose her visions to the world. Before then she had revealed them only to close confidants at the monastery. One of them was the monk Volmar, and Hildegard chose to dictate her visions to him for posterity (FIG. 12-23). No less a figure than Bernard of Clairvaux certified in 1147 that her visions were authentic, and Archbishop Heinrich of Mainz joined in the endorsement. In 1148, the Cistercian pope Eugenius III (r. 1145-1153) formally authorized Hildegard "in the name of Christ and Saint Peter to publish all that she had learned from the Holy Spirit." At this time Hildegard became the abbess of a new convent built for her near Bingen. As reports of Hildegard's visions spread, kings, popes, barons, and prelates sought her counsel. All of them were attracted by her spiritual insight into the Christian faith. In addition to her visionary works—the most important is the Scivias (FIG. 12-23)—Hildegard wrote two scientific

treatises. *Physica* is a study of the natural world, and *Causae et curae* (*Causes and Cures*) is a medical encyclopedia. Hildegard also composed the music and wrote the lyrics of 77 songs, which appeared under the title *Symphonia*.

Hildegard was the most famous Romanesque nun, but she was by no means the only learned woman of her age. A younger contemporary, Herrad (d. 1195), abbess of Hohenberg, Austria, was also the author of an important medieval encyclopedia. Herrad's *Hortus deliciarum* (*Garden of Delights*) is a history of the world intended for instructing the nuns under her supervision, but it reached a much wider audience.

Painting and Other Arts

The number and variety of illuminated manuscripts dating to the Romanesque era attest to the great demand for illustrated religious tomes in the abbeys of western Europe. The extraordinarily productive scribes and painters who created these books were almost exclusively monks and nuns working in the scriptoria of those same isolated religious communities.

HILDEGARD OF BINGEN Among the most interesting German religious manuscripts is the *Scivias* (*Know the Ways* [*Scite vias*] of *God*) of Hildegard of Bingen. Hildegard was a nun who eventually became the abbess of the convent at Disibodenberg in the Rhineland (see "Romanesque Countesses, Queens, and Nuns," above). The manuscript, lost in 1945, exists today only in a facsimile. The original probably was written and illuminated at the

monastery of Saint Matthias at Trier between 1150 and Hildegard's death in 1179, but it is possible Hildegard supervised production of the book at Bingen. The *Scivias* contains a record of Hildegard's vision of the divine order of the cosmos and of humankind's place in it. The vision came to her as a fiery light pouring into her brain from the open vault of Heaven.

On the opening page (FIG. 12-23) of the Trier manuscript, Hildegard sits within the monastery walls, her feet resting on a footstool, in much the same way the painters of the *Coronation* and *Ebbo Gospels* (FIGS. 11-13 and 11-14) represented the evangelists. The *Scivias* page is a link in a chain of author portraits with roots in classical antiquity (FIG. 7-25B). The artist showed Hildegard experiencing her divine vision by depicting five long tongues of fire emanating from above and entering her brain, just as she describes the experience in the accompanying text. Hildegard immediately sets down what has been revealed to her on a wax tablet resting on her left knee. Nearby, the monk Volmar, Hildegard's confessor, copies into a book all she has written. Here, in a singularly dramatic context, is a picture of the essential nature of ancient and medie-

12-23A RUFILLUS, Initial *R*, ca. 1170–1200.

1 ft

val book manufacture—individual scribes copying and recopying texts by hand (compare FIG. 11-11). The most labor-intensive and costliest texts, such as Hildegard's *Scivias*, also were illuminated (see "Medieval Manuscript Illumination," Chapter 8, page 249). They required the collaboration of skilled painters, for example, the Weissenau monk RUFILLUS, who placed a portrait of himself at work (FIG. 12-23A) in a *passional* (book of saints' lives).

RAINER OF HUY The names of some Romanesque sculptors in the Holy Roman Empire are also known. One of them is RAINER OF

12-24 RAINER OF HUY, *Baptism of Christ*, baptismal font from Notre-Dame-des-Fonts, Liège, Belgium, 1118. Bronze, 2' 1" high. Saint-Barthélémy, Liège.

In the work of Rainer of Huy, the classical style and the classical spirit lived on in the Holy Roman Empire. His Liège baptismal font features idealized figures and even a nude representation of Christ.

Huy, a bronzeworker from the Meuse River valley in Belgium, an area renowned for its metalwork. Art historians have attributed an 1118 bronze baptismal font (FIG. 12-24) to him. Made for Notre-Dame-des-Fonts in Liège, the bronze basin rests on the foreparts of a dozen oxen. The oxen refer to the "molten sea . . . on twelve oxen" cast in bronze for King Solomon's temple (1 Kings 7:23-25). The Old Testament story prefigured Christ's baptism (medieval scholars equated the oxen with the 12 apostles), which is the central scene on the Romanesque font. Rainer's work, as that of so many earlier artists in the Holy Roman Empire beginning in Carolingian times, revived the classical style and the classical spirit. The figures are softly rounded, with idealized bodies and faces and heavy clinging drapery. Rainer even represented one figure (at the left in FIG. 12-24) in a three-quarter view from the rear, a popular motif in classical art, and some of the figures, including Christ himself, are naked. Nudity is very rare in the art of the Middle Ages. Adam and Eve (FIGS. 8-1, 11-24A, 12-13B, and 12-28) are exceptions, but medieval artists usually depicted the first man and woman as embarrassed by their nudity, the opposite of the high value the classical world placed on the beauty of the human body.

SAINT ALEXANDER The reliquaries of Saint Faith (FIG. 12-2) and of Saint Alexander (FIG. 12-25), a hallowed pope (Alexander II, r. 1061–1073), are among the most sumptuous of the Romanesque

12-25 Head reliquary of Saint Alexander, from the abbey church, Stavelot, Belgium, 1145. Silver repoussé (partly gilt), gilt bronze, gems, pearls, and enamel, 1' $5\frac{1''}{2}$ high. Musées Royaux d'Art et d'Histoire, Brussels.

The Stavelot reliquary is typical in the use of costly materials. The combination of an idealized classical head with Byzantine-style enamels underscores the stylistic diversity of Romanesque art.

Holy Roman Empire

age, a time when churches vied to possess the most important relics and often expended large sums on their containers (see "Relics," page 336). Made in 1145 for Abbot Wibald of Stavelot in Belgium, Saint Alexander's reliquary takes the form of an almost life-size head, fashioned in beaten (repoussé) silver with bronze gilding for the hair. The idealized head resembles portraits of youthful Roman emperors such as Augustus (FIG. 1-10) and Constantine (FIG. 7-77), and the Romanesque metalworker may have used an ancient sculpture as a model. The saint wears a collar of jewels and enamel plaques around his neck. Enamels and gems also adorn the box on which the head is mounted. The reliquary rests on four bronze dragons—mythical animals of the kind populating Romanesque cloister capitals. Not surprisingly, Bernard of Clairvaux was as critical of lavish church furnishings like the reliquaries of Saints Faith and Alexander as he was of Romanesque cloister sculpture:

[Men's] eyes are fixed on relics covered with gold and purses are opened. The thoroughly beautiful image of some male or female saint is exhibited and that saint is believed to be the more holy the more highly colored the image is. People rush to kiss it, they are

invited to donate, and they admire the beautiful more than they venerate the sacred.... O vanity of vanities, but no more vain than insane! The Church... dresses its stones in gold and it abandons its children naked. It serves the eyes of the rich at the expense of the poor.⁵

The central plaque on the front of the Stavelot reliquary depicts the *canonized* (declared a saint) pope. Saints Eventius and Theodolus flank him. The nine plaques on the other three sides represent female allegorical figures—Wisdom, Piety, and Humility among them. Although a local artist produced these enamels in the Meuse River region, the models were surely Byzantine. Saint Alexander's reliquary underscores the multiple sources of Romanesque art, as well as its stylistic diversity. Not since antiquity had people journeyed as extensively as they did in the Romanesque period, and artists regularly saw works of wide geographic origin. Abbot Wibald himself epitomizes the well-traveled 12th-century clergyman. He was abbot of Montecassino in southern Italy and took part in the Second Crusade. Frederick Barbarossa (Holy Roman emperor, r. 1152–1190) sent him to Constantinople to arrange Frederick's

12-26 Cathedral complex (looking northeast), Pisa, Italy; cathedral begun 1063; baptistery begun 1153; campanile begun 1174.

Pisa's cathedral more closely resembles Early Christian basilicas than structurally more experimental French and German Romanesque churches. Separate bell towers and baptisteries are Italian features.

wedding to the niece of the Byzantine emperor Manuel Comnenus. (Two centuries before, another German emperor, Otto II, married the Byzantine princess Theophanu, which also served to promote Byzantine style in the Holy Roman Empire; see "Theophanu," Chapter 11, page 328.)

ITALY

Nowhere is the regional diversity of Romanesque art and architecture more readily apparent than in Italy, where the ancient Roman and Early Christian heritage was strongest. Although Tuscany, the ancient Etruscan heartland (see Chapter 6), and other regions south of Lombardy were part of the territory of the Salian emperors, Italy south of Milan represented a distinct artistic zone during the Romanesque period.

Architecture and Architectural Sculpture

Italian Romanesque architects designed buildings that were for the most part structurally less experimental than those erected in Germany and Lombardy. Italian builders adhered closely to the Early Christian basilican type of church.

12-27 Baptistery of San Giovanni (looking northwest), Florence, Italy, begun 1059.

The Florentine baptistery is a domed octagon descended from Roman and Early Christian central-plan buildings. The distinctive Tuscan Romanesque marble paneling stems from Roman wall designs.

PISA The cathedral complex (FIG. 12-26) at Pisa dramatically testifies to the prosperity that busy maritime city enjoyed. The spoils of a naval victory over the Muslims off Palermo in Sicily in 1062 provided the funds for the Pisan building program. The cathedral, its freestanding bell tower, and the baptistery, where infants and converts were initiated into the Christian community, present a rare opportunity to study a coherent group of three Romanesque buildings. Save for the upper portion of the baptistery, with its remodeled Gothic exterior, the three structures are stylistically homogeneous.

Construction of Pisa Cathedral began first—in 1063, the same year work began on Saint Mark's (FIG. 9-26) in Venice, another powerful maritime city. The cathedral is large, with a nave and four aisles, and is one of the most impressive and majestic Romanesque churches. The Pisans, according to a document of the time, wanted their bishop's church not only to be a monument to the glory of God but also to bring credit to the city. At first glance, Pisa Cathedral resembles an Early Christian basilica with a timber roof, columnar arcade, and clerestory. But the broadly projecting transept with apses, the crossing dome, and the facade's multiple arcaded galleries distinguish it as Romanesque. So too does the rich marble *incrustation* (wall decoration consisting of bright panels of

different colors, as in the Pantheon's interior, FIG. 7-51). The cathedral's campanile, detached in the standard Italian fashion, is Pisa's famous Leaning Tower (FIG. 12-26, right). Graceful arcaded galleries mark the tower's stages and repeat the cathedral facade's motif, effectively relating the round campanile to its mother building. The tilted vertical axis of the tower is the result of a settling foundation. The tower began to "lean" even while under construction, and by the late 20th century had inclined some 5.5 degrees (about 15 feet) out of plumb at the top. In 1999, an international team of scientists began a daring project to remove soil from beneath the north side of the tower. The soil extraction has already moved the tower more than an inch closer to vertical and ensured the stability of the structure for at least 300 years. (Because of the touristic appeal of the Leaning Tower, there are no plans to restore the campanile to its original upright position.)

FLORENCE The public understandably thinks of Florence as a Renaissance city (MAP 21-1), but it was already an important independent city-state in the Romanesque period. The gem of Florentine Romanesque architecture is the baptistery (FIG. 12-27) of San Giovanni (Saint John), the city's patron saint. Pope Nicholas II (r. 1059-1061) dedicated the building in 1059. It thus predates Pisa's baptistery (FIG. 12-26, left), but construction of the Florentine baptistery continued into the next century. Both baptisteries face their city's cathedral. Freestanding baptisteries are unusual, and these Tuscan examples reflect the great significance the Florentines and Pisans attached to baptismal rites. On the day of a newborn child's anointment, the citizenry gathered in the baptistery to welcome a new member into their community. Baptisteries therefore were important civic, as well as religious, structures. Some of the most renowned artists of the late Middle Ages and the Renaissance provided the Florentine and Pisan baptisteries with pulpits (FIG. 14-2), bronze doors (FIGS. 14-19, 21-2, 21-3, 21-9, and 21-10), and mosaics.

The simple and serene classicism of San Giovanni's design recalls ancient Roman architecture. The baptistery stands in a direct line of descent from the Pantheon (FIG. 7-49), imperial mausoleums (such as Diocletian's; FIG. 7-74), the Early Christian Santa Costanza (FIG. 8-11), the Byzantine San Vitale (FIG. 9-10),

and other Roman and Christian central-

plan structures, including Charlemagne's

Palatine Chapel (FIGS. 11-17 and 11-18)

at Aachen. The distinctive Tuscan Ro-

manesque marble incrustation pattern-

ing the walls of Florence's baptistery and

the slightly later church of San Miniato al

Monte (FIG. 12-27A) stems ultimately from

Roman wall designs (FIGS. 7-17 and 7-51).

(The ancient tradition of decorating walls

with frescoes also survived in Roman-

esque Italy, for example, at Sant'Angelo in

Formis, FIG. 12-27B.) The simple oblong

and arcuated panels of the baptistery as-

sert the building's structural lines and its

elevation levels. In plan, San Giovanni is

a domed octagon, wrapped on the exte-

rior by an elegant arcade, three arches to

a bay. It has three entrances, one each on

the north, south, and east sides. On the

west side an oblong sanctuary replaces

12-27A San Miniato al Monte, Florence, ca. 1062–1090. ■

12-27B Sant'Angelo in Formis, near Capua, ca. 1085.

the original semicircular apse. The domical vault is some 90 feet in diameter, its construction a feat remarkable for its time.

MODENA Despite the pronounced structural differences between Italian Romanesque churches and those of France, Spain, and the Holy Roman Empire, Italian church officials also frequently employed sculptors to adorn the facades of their buildings. In fact, one of the first examples of fully developed narrative relief sculpture in Romanesque art is the marble frieze (FIG. 12-28) on the facade of Modena Cathedral in northern Italy. Carved around 1110, it represents scenes from Genesis set against an architectural backdrop of a type common on Roman and Early Christian sarcophagi, which were plentiful in the region. The segment in FIG. 12-28, Creation and Temptation of Adam and Eve (Gen. 2, 3:1-8), repeats the theme employed almost exactly a century earlier on Bishop Bernward's bronze doors (FIGS. 11-24 and 11-25) at Hildesheim. At Modena, as at Saint Michael's, the faithful entered the Lord's house with a reminder of original sin and the suggestion that the only path to salvation is through Christ.

On the Modena frieze, Christ is at the far left, framed by a mandorla held up by angels—a variation on the motif of the Saint-Sernin ambulatory relief (FIG. 12-8). The creation of Adam, then Eve, and the serpent's temptation of Eve are to the right. The relief carving is high, and some parts are almost entirely in the round. The frieze is the work of a master craftsman whose name, WILIGELMO, appears in an inscription on another relief on the facade. There he boasts, "Among sculptors, your work shines forth, Wiligelmo." The inscription is also an indication of how proud Wiligelmo's patrons were to obtain the services of such an accomplished sculptor for their city's cathedral.

FIDENZA The reawakening of interest in stone sculpture in the round also is evident in northern Italy, where the sculptor

12-28 WILIGELMO, Creation and Temptation of Adam and Eve, detail of the frieze on the west facade, Modena Cathedral, Modena, Italy, ca. 1110. Marble, 3' high.

For Modena's cathedral, Wiligelmo represented scenes from Genesis against an architectural backdrop of a type common on Roman and Early Christian sarcophagi, which were plentiful in the area.

12-29 BENEDETTO ANTELAMI, King David, statue in a niche on the west facade of Fidenza Cathedral, Fidenza, Italy, ca. 1180–1190.

Benedetto Antelami's King David on the facade of Fidenza Cathedral is a rare example of life-size freestanding statuary in the Romanesque period. The style is unmistakably rooted in Greco-Roman art.

BENEDETTO ANTELAMI was active in the last quarter of the 12th century. Several reliefs by his hand exist, including Parma Cathedral's pulpit and the portals of that city's baptistery. But his most unusual works are the two monumental marble statues of biblical figures he carved for the west facade of Fidenza Cathedral. Benedetto's King David (FIG. 12-29) seems confined within his niche. His elbows are kept close to his body. Absent is the weight shift that is the hallmark of classical statuary. Yet the sculptor's conception of this prophet is unmistakably rooted in Greco-Roman art. Comparison of the Fidenza David with the prophet on the Moissac trumeau (FIG. 12-13), who also displays an unfurled scroll, reveals how much the Italian sculptor freed his figure from its architectural setting. Other sculptors did not immediately emulate Antelami's classical approach to portraying figures in stone. But the idea of placing freestanding statues in niches would be taken up again in Italy by Early Renaissance sculptors (FIGS. 21-4 to 21-6).

NORMANDY AND ENGLAND

After their conversion to Christianity in the early 10th century, the Vikings (see Chapter 11) settled on the northern coast of France in present-day Normandy. Almost at once, they proved themselves not only aggressive warriors but also skilled administrators and builders, active in Sicily (FIG. 9-27) as well as in northern Europe.

Architecture

The Normans quickly developed a distinctive Romanesque architectural style that became the major source of French Gothic architecture.

CAEN Most critics consider the abbey church of Saint-Étienne at Caen the masterpiece of Norman Romanesque architecture. Begun by William of Normandy (William the Conqueror; see page 361) in 1067, work must have advanced rapidly, because the Normans buried the duke in the church in 1087. Saint-Étienne's west facade (FIG. 12-30) is a striking design rooted in the tradition of

12-30 West facade of Saint-Étienne, Caen, France, begun 1067. ■

The division of Saint-Étienne's facade into three parts corresponding to the nave and aisles reflects the methodical planning of the entire structure. The towers also have a tripartite design.

12-31 Interior of Saint-Étienne (looking east), Caen, France, vaulted ca. 1115-1120. ■◀

The groin vaults of Saint-Étienne made clerestory windows possible. The three-story elevation with its large arched openings provides ample light and makes the nave appear taller than it is.

Carolingian and Ottonian westworks, but it reveals a new unified organizational scheme. Four large buttresses divide the facade into three bays corresponding to the nave and aisles. Above the buttresses, the towers also display a triple division and a progressively greater piercing of their walls from lower to upper stages. (The culminating spires are a Gothic addition.) The tripartite division extends throughout the facade, both vertically and horizontally, organizing it into a close-knit, well-integrated composition consistent with the careful and methodical planning of the entire structure.

The original design of Saint-Étienne called for a wooden roof, as originally at Speyer Cathedral. But the Caen nave (FIG. 12-31) had compound piers with simple engaged half-columns alternating with piers with half-columns attached to pilasters. When the Normans decided to install groin vaults around 1115, the existing alternating compound piers in the nave proved a good match. Those piers soar all the way to the vaults' springing. Their branching ribs divide the large square-vault compartments into six sections—a sexpartite vault (FIG. 12-32). The vaults rise high enough to provide room for clerestory windows. The resulting three-story elevation,

12-32 Plan of Saint-Étienne, Caen, France.

The early-12th-century nave vaults of Saint-Étienne spring from compound piers with alternating half-columns and pilasters. The diagonal and transverse ribs divide the vaults into six compartments.

with its large arched openings, allows ample light to reach the interior. It also makes the nave appear taller than it is. As in the Milanese church of Sant'Ambrogio (FIG. 12-22), the Norman building has rib vaults. The diagonal and transverse ribs form a structural skeleton that partially supports the still fairly massive paneling between them. But despite the heavy masonry, the large windows and reduced interior wall surface give Saint-Étienne's nave a light and airy quality unusual in the Romanesque period.

DURHAM William of Normandy's conquest of Anglo-Saxon England in 1066 began a new epoch in English history. In architecture, it signaled the importation of Norman Romanesque building and design methods. Durham Cathedral (FIGS. 12-33 and 12-34) sits majestically on a cliff overlooking the Wear River in northern England, the centerpiece of a monastery, church, and fortified-castle complex on the Scottish frontier. Unlike Speyer Cathedral and Saint-Étienne, Durham Cathedral, begun around 1093—before the remodeling of the Caen church—was a vaulted structure from the beginning. Consequently, the pattern of the ribs of the nave's groin vaults corresponds perfectly to the design of the arcade below. Each seven-part nave vault covers two bays. Large, simple pillars ornamented with abstract designs (diamond, chevron, and cable patterns, all originally painted) alternate with compound piers that carry the transverse arches of the vaults. The pier-vault relationship scarcely could be more visible or the building's structural rationale better expressed.

The bold surface patterning of the pillars in the Durham nave is a reminder that the raising of imposing stone edifices such as the Romanesque churches of England and Normandy required more than just the talents of master designers. A corps of expert masons had to transform rough stone blocks into the precise shapes necessary for their specific place in the church's fabric. Although thousands of simple quadrangular blocks make up the great walls of these buildings, the stonecutters also had to produce large numbers of blocks of far more complex shapes. To cover the nave and aisles, the masons had to carve blocks with concave faces to conform to the curve of the vault. Also required were blocks with projecting moldings for the ribs, blocks with convex surfaces for the pillars or with multiple profiles for the compound piers, and so forth. It was an immense undertaking, and it is no wonder medieval building campaigns often lasted for decades.

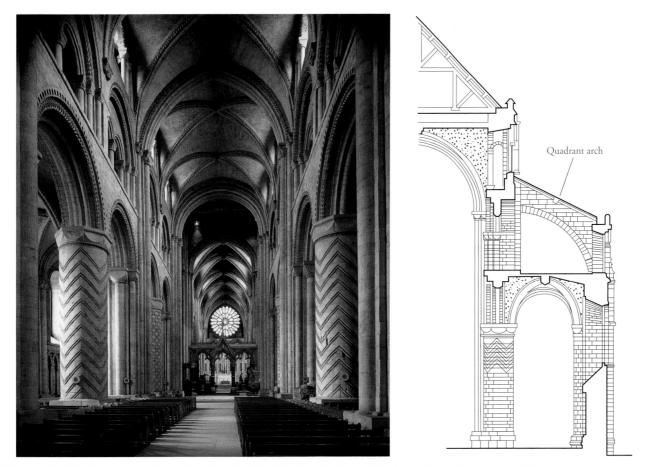

12-33 Interior (left; looking east) and lateral section (right) of Durham Cathedral, Durham, England, begun ca. 1093.

Durham Cathedral is the first example of a rib groin vault placed over a three-story nave. Quadrant arches replaced groin vaults in the tribune as buttresses of the nave vaults.

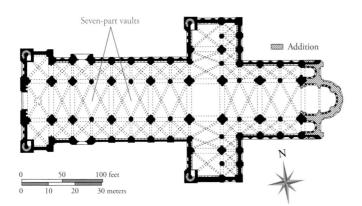

12-34 Plan of Durham Cathedral, Durham, England (after Kenneth John Conant).

Durham Cathedral is typically English in its long, slender proportions. In the nave, simple pillars alternate with compound piers that support the transverse arches of the seven-part groin vaults.

Durham Cathedral's plan (Fig. 12-34) is typically English with its long, slender proportions. It does not employ the modular scheme with the same care and logic seen at Caen. But in other ways, this English church is even more innovative than the French church. It is the earliest example known of a rib groin vault placed over a threestory nave. In the nave's western parts, completed before 1130, the rib vaults have slightly pointed arches, bringing together for the first time two key elements that determined the structural evolu-

tion of Gothic architecture (see "The Gothic Rib Vault," Chapter 13, page 368). Also of great significance is the way the English builders buttressed the nave vaults. The lateral section (FIG. 12-33, *right*) exposes the simple *quadrant arches* (arches whose curve extends for one-quarter of a circle's circumference) that take the place of groin vaults in the Durham tribune. The structural descendants of these quadrant arches are the flying buttresses that epitomize the mature Gothic solution to church construction (see "The Gothic Cathedral," Chapter 13, page 373, and FIG. 13-12).

Painting and Other Arts

Many of the finest illustrated manuscripts of the Romanesque age were the work of monks in English scriptoria, following in the tradition of Hiberno-Saxon book production (see Chapter 11).

BURY BIBLE The Bury Bible (FIG. 12-35), produced at the Bury Saint Edmunds abbey in England around 1135, exemplifies the sumptuous illumination common to the large Bibles produced in wealthy Romanesque abbeys not subject to the Cistercian restrictions on painted manuscripts. These costly books lent prestige to monasteries that could afford them (see "Medieval Books," Chapter 11, page 312). The artist responsible for the Bury Bible is known: MASTER HUGO, who was also a sculptor and metalworker. With Gislebertus (FIGS. 12-1, 12-13A, and 12-13B), Bernardus Gelduinus (FIG. 12-8), Rufillus (FIG. 12-23A), Rainer of Huy (FIG. 12-24), Wiligelmo (FIG. 12-28), and Benedetto Antelami (FIG. 12-29), Hugo was one of the small but growing number of Romanesque

12-35 MASTER HUGO, *Moses Expounding the Law*, folio 94 recto of the *Bury Bible*, from Bury Saint Edmunds, England, ca. 1135. Ink and tempera on vellum, 1' $8'' \times 1'$ 2''. Corpus Christi College, Cambridge.

Master Hugo was a rare Romanesque lay artist, one of the emerging class of professional artists and artisans who depended for their livelihood on commissions from wealthy monasteries.

artists who signed their works or whose names were recorded. In the 12th century, artists, illuminators as well as sculptors, increasingly began to identify themselves. Although most medieval artists remained anonymous, the contrast of the Romanesque period with the early Middle Ages is striking. Hugo apparently was a secular

12-35A Winchester Psalter, ca. 1145–1155.

artist, one of the emerging class of professional artists and artisans who depended for their livelihood on commissions from well-endowed monasteries. These artists resided in towns rather than within secluded abbey walls, and they traveled frequently to find work. They were the exception, however, and most Romanesque scribes and illuminators continued to be monks and nuns working anonymously in the service of God. The Benedictine rule, for example, specified that "artisans in the

12-36 EADWINE THE SCRIBE(?), Eadwine the Scribe at work, folio 283 verso of the *Eadwine Psalter*, ca. 1160–1170. Ink and tempera on vellum, $1' 3\frac{1}{2}'' \times 11\frac{5}{8}''$. Trinity College, Cambridge.

Although he humbly offered his book as a gift to God, the English monk Eadwine added an inscription to his portrait declaring himself a "prince among scribes" whose fame would endure forever.

monastery . . . are to practice their craft with all humility, but only with the abbot's permission." Some monks, however, produced illuminated volumes not for use in the abbey but on royal commission, for example, the *Winchester Psalter* (FIG. 12-35A).

One page (FIG. 12-35) of the Bury Bible shows two scenes from Deuteronomy framed by symmetrical leaf motifs in softly glowing harmonized colors. In the upper register, Master Hugo painted Moses Expounding the Law, in which he represented the prophet with horns, consistent with Saint Jerome's translation of the Hebrew word that also means "rays" (compare Michelangelo's similar conception of the Hebrew prophet, FIG. 22-14). The lower panel portrays Moses pointing out the clean and unclean beasts. The gestures are slow and gentle and have quiet dignity. The figures of Moses and Aaron seem to glide. This presentation is quite different from the abrupt emphasis and spastic movement seen in earlier Romanesque paintings. The movements of the figures appear more integrated and smooth. Yet patterning remains in the multiple divisions of the draped limbs, the lightly shaded volumes connected with sinuous lines and ladderlike folds. Hugo still thought of the drapery and body as somehow the same. The frame has a quite definite limiting function, and the painter carefully fit the figures within it.

12-37 Funeral procession to Westminster Abbey, detail of the *Bayeux Tapestry*, from Bayeux Cathedral, Bayeux, France, ca. 1070–1080. Embroidered wool on linen, 1′ 8″ high (entire length of fabric 229′ 8″). Centre Guillaume le Conquérant, Bayeux. ■

The *Bayeux Tapestry* is unique in medieval art. Like historical narratives in Roman art, it depicts contemporaneous events in full detail, as in the scroll-like frieze of Trajan's Column (Fig. 7-1).

EADWINE PSALTER The Eadwine Psalter is the masterpiece of an English monk known as Eadwine the Scribe. It contains 166 illustrations, many of them variations of those in the Carolingian Utrecht Psalter (Figs. 11-15 and 11-15A). The last page (Fig. 12-36), however, presents a rare picture of a Romanesque artist at work (compare Fig. 12-23A). The style of the Eadwine portrait resembles that of the Bury Bible, but although the patterning is still firm (notably in the cowl and the thigh), the drapery falls more softly and follows the movements of the body beneath it. Here, the abstract patterning of many Romanesque painted and sculpted garments yielded slightly, but clearly, to the requirements of more naturalistic representation. The Romanesque artist's instinct for decorating the surface remained, as is apparent in the gown's whorls and spirals. Significantly, however, the artist painted those interior lines very lightly so that they would not conflict with the functional lines containing them.

The "portrait" of Eadwine—it is probably a generic type and not a specific likeness—is in the long tradition of author portraits in ancient and medieval manuscripts (FIGS. 11-8, 11-13, 11-14, and 12-23; compare FIG. 7-25B), although the true author of the *Eadwine* Psalter is King David. Eadwine exaggerated his importance by likening himself to an evangelist writing his Gospel and by including an inscription within the inner frame identifying himself and proclaiming that he is a "prince among scribes." He declares the excellence of his work will cause his fame to endure forever, and consequently he can offer his book as an acceptable gift to God. Eadwine, like other Romanesque sculptors and painters who signed their works, may have been concerned for his fame, but these artists, whether clergy or laity, were as yet unaware of the concepts of fine art and fine artist. To them, their work existed not for its own sake but for God's. Nonetheless, works such as this one are an early sign of a new attitude toward the role of the artist in society that presages the reemergence in the Renaissance of the classical notion of individual artistic genius.

BAYEUX TAPESTRY The most famous work of English Romanesque art is neither a book nor Christian in subject. The socalled Bayeux Tapestry (FIGS. 12-37 and 12-38) is unique in medieval art. It is an embroidered fabric—not, in fact, a woven tapestry-made of wool sewn on linen (see "Embroidery and Tapestry," page 362). Closely related to Romanesque manuscript illumination, its borders contain the kinds of real and imaginary animals found in contemporaneous books, and an explanatory Latin text sewn in thread accompanies many of the pictures. Some 20 inches high and about 230 feet long, the Bayeux Tapestry is a continuous, friezelike, pictorial narrative of a crucial moment in England's history and of the events leading up to it. The Norman defeat of the Anglo-Saxons at Hastings in 1066 brought England under the control of the Normans, uniting all of England and much of France under one rule. The dukes of Normandy became the kings of England. Commissioned by Bishop Odo, the half brother of the conquering Duke William, the embroidery may have been sewn by women at the Norman court. Many art historians, however, believe it was the work of English stitchers in Kent, where Odo was earl after the Norman conquest. Odo donated the work to Bayeux Cathedral (hence its nickname), but it is uncertain whether it was originally intended for display in the church's nave, where the theme would have been a curious choice.

The events that precipitated the Norman invasion of England are well documented. In 1066, Edward the Confessor (r. 1042–1066), the Anglo-Saxon king of England, died. The Normans believed Edward had recognized William of Normandy as his rightful heir. But the crown went to Harold, earl of Wessex, the king's Anglo-Saxon brother-in-law, who had sworn an oath of allegiance to William. The betrayed Normans, descendants of the seafaring Vikings, boarded their ships, crossed the English Channel, and crushed Harold's forces.

Embroidery and Tapestry

The most famous embroidery of the Middle Ages is, ironically, known as the *Bayeux Tapestry* (FIGS. 12-37 and 12-38). Embroidery and tapestry are related—but different—means of decorating textiles. *Tapestry* designs are woven on a loom as part of the fabric. *Embroidery* patterns are sewn onto fabrics with threads.

The needleworkers who fashioned the *Bayeux Tapestry* were either Norman or English women. They employed eight colors of dyed wool yarn—two varieties of blue, three shades of green, yellow, buff, and terracotta red—and two kinds of stitches. In *stem stitching*, short overlapping strands of thread form jagged

lines. *Laid-and-couched work* creates solid blocks of color. In the latter technique, the needleworker first lays down a series of parallel and then a series of cross stitches. Finally, the stitcher tacks down the cross-hatched threads using couching (knotting).

On the *Bayeux Tapestry*, the embroiderers left the natural linen color exposed for the background, human flesh, building walls, and other "colorless" design elements. Stem stitches define the contours of figures and buildings and delineate interior details, such as facial features, body armor, and roof tiles. The clothing, animal bodies, and other solid areas are laid-and-couched work.

12-38 Battle of Hastings, detail of the *Bayeux Tapestry*, from Bayeux Cathedral, Bayeux, France, ca. 1070–1080. Embroidered wool on linen, 1′ 8″ high (entire length of fabric 229′ 8″). Centre Guillaume le Conquérant, Bayeux. ■4

The *Bayeux Tapestry* is really an embroidery. The needleworkers employed eight colors of dyed wool yarn and sewed the threads onto linen using both stem stitching and laid-and-couched work.

Illustrated here are two episodes of the epic tale as represented in the Bayeux Tapestry. The first detail (FIG. 12-37) depicts King Edward's funeral procession. The hand of God points the way to the church in London where he was buried—Westminster Abbey, consecrated on December 28, 1065, just a few days before Edward's death. The church was one of the first Romanesque buildings erected in England, and the embroiderers took pains to record its main features, including the imposing crossing tower and the long nave with tribunes. Here William was crowned king of England on Christmas Day, 1066. (The coronation of every English monarch since then also has occurred in Westminster Abbey.) The second detail (FIG. 12-38) shows the Battle of Hastings in progress. The Norman cavalry cuts down the English defenders. Filling the lower border are the dead and wounded, although the upper register continues the animal motifs of the rest of the embroidery. The Romanesque artists co-opted some of the characteristic motifs of

Roman battle scenes, for example, the horses with twisted

necks and contorted bodies (compare FIG. 5-70), but rendered the figures in the Romanesque manner. Linear patterning and flat color replaced classical three-dimensional volume and modeling in light and dark hues.

The *Bayeux Tapestry* stands apart from all other Romanesque artworks in depicting in full detail an event at a time shortly after it occurred, recalling the historical narratives of ancient Roman art. Art historians have often likened the Norman embroidery to the scroll-like frieze of the Column of Trajan (FIGS. 7-1 and 7-45). Like the Roman account, the story told on the textile is the conqueror's version of history, a proclamation of national pride. As in the ancient frieze, the narrative is not confined to battlefield successes. It is a complete chronicle of events. Included are the preparations for war, with scenes depicting the felling and splitting of trees for ship construction, the loading of equipment onto the vessels, the cooking and serving of meals, and so forth. In this respect, the *Bayeux Tapestry* is the most *Roman*-esque work of Romanesque art.

ROMANESQUE EUROPE

FRANCE AND NORTHERN SPAIN

- Romanesque takes its name from the Roman-like barrel and groin vaults based on round arches employed in many European churches built between 1050 and 1200. Romanesque vaults, however, are made of stone, not concrete.
- Numerous churches sprang up along the pilgrimage roads leading to the shrine of Saint James at Santiago de Compostela. These churches were large enough to accommodate crowds of pilgrims who came to view the relics displayed in radiating chapels off the ambulatory and transept.
- The Romanesque period also brought the revival of monumental stone relief sculpture in cloisters and especially in church portals, where scenes of Christ as last judge often greeted the faithful as they entered the doorway to the road to salvation.
- The leading patrons of Romanesque sculpture and painting were the monks of the Cluniac order. In contrast, the Cistercians, under the leadership of Bernard of Clairvaux, condemned figural art in churches and religious books.

Saint-Sernin, Toulouse, ca. 1070-1120

Saint-Lazare, Autun, ca. 1120–1135

HOLY ROMAN EMPIRE

- In the Romanesque period, the Salian dynasty (r. 1027–1125) ruled an empire corresponding roughly to present-day Germany and northern Italy.
- Architects in the Holy Roman Empire built structurally innovative churches. Speyer Cathedral and Sant'Ambrogio in Milan are two of the earliest examples of the use of groin vaults in naves.
- In Belgium, sculptors excelled in metalwork, producing costly reliquaries of silver, jewels, and enamel, such as that containing the remains of Pope Alexander II. Rainer of Huy, one of several Romanesque artists whose name is known, cast a bronze baptismal font in a single piece.

Reliquary of Saint Alexander, 1145

ITALY

- The regional diversity of Romanesque art and architecture is especially evident in Italy, where the heritage of ancient Rome and Early Christianity was strongest.
- Romanesque churches in Pisa and Florence have timber roofs in contrast to the vaulted interiors of northern European buildings. The exteriors often feature marble paneling of different colors. Church campaniles were usually freestanding, as were baptisteries, which took the form of independent central-plan buildings facing the cathedral.

Baptistery of San Giovanni, Florence, begun 1059

NORMANDY AND ENGLAND

- After their conversion to Christianity in the early 10th century, the Vikings settled on the northern coast of France. From there, Duke William of Normandy crossed the channel and conquered England in 1066. The Bayeux Tapestry chronicles that war—a unique example of contemporaneous historical narrative art in the Middle Ages.
- Norman and English Romanesque architects introduced new features to church design that later greatly influenced French Gothic architecture. Saint-Étienne at Caen and Durham Cathedral are the earliest examples of the use of rib groin vaults over a three-story (arcade-tribune-clerestory) nave. The Durham builders also experimented with quadrant arches in the tribune to buttress the nave vaults.

Durham Cathedral, begun ca. 1093

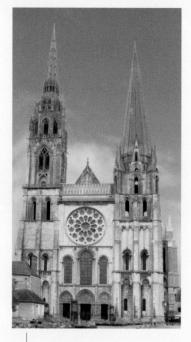

Chartres Cathedral is the key monument of both Early and High Gothic architecture. The west facade still has much in common with Romanesque designs but features statues on the door jambs.

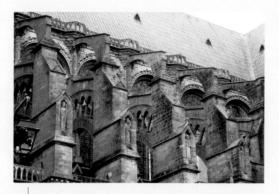

Architectural historians consider the rebuilt Chartres Cathedral the first great monument of High Gothic architecture. It is the first church planned from the beginning to have flying buttresses.

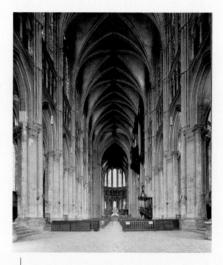

Chartres set the pattern for High Gothic cathedrals in the use of fourpart rib vaults springing from pointed arches and in the introduction of a three-story nave elevation (arcade, triforium, clerestory).

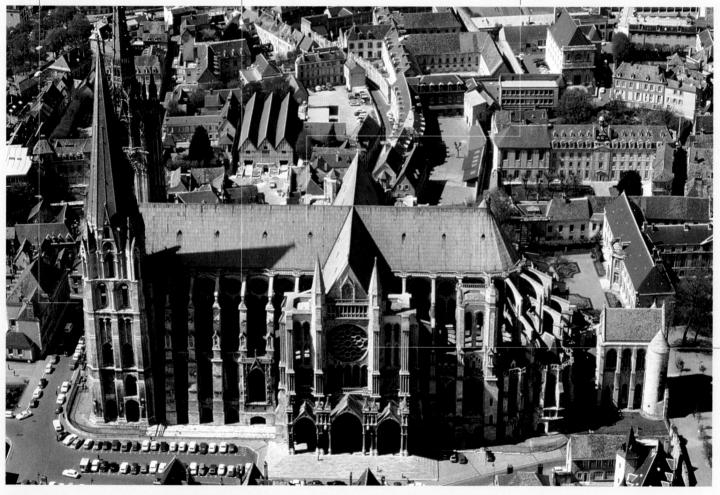

13-1 Aerial view of Chartres Cathedral (looking north), Chartres, France, as rebuilt after 1194.

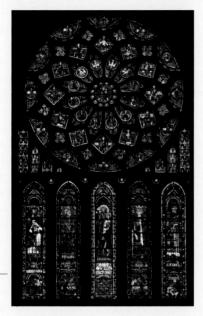

Flying buttresses made possible the replacement of heavy masonry walls with immense stained-glass windows, which transformed natural sunlight into divine light of various hues.

13

GOTHIC EUROPE

THE AGE OF THE GREAT CATHEDRALS

In 1550, Giorgio Vasari (1511–1574) first used *Gothic* as a term of ridicule to describe late medieval art and architecture, which he attributed to the Goths and regarded as "monstrous and barbarous." With the publication that year of his influential *Introduction to the Three Arts of Design*, Vasari codified for all time the notion the early Renaissance artist Lorenzo Ghiberti (1378–1455) had already advanced in his *Commentarii*, namely that the Middle Ages was a period of decline. The Italian humanists, who regarded Greco-Roman art as the standard of excellence, believed the uncouth Goths were responsible both for the downfall of Rome and for the decline of the classical style in art and architecture. They regarded "Gothic" art with contempt and considered it ugly and crude.

In the 13th and 14th centuries, however, Chartres Cathedral (FIG. 13-1) and similar French buildings set the standard throughout most of Europe. For the clergy and the lay public alike, the great cathedrals towering over their towns were not distortions of the classical style but *opus modernum* ("modern work"), glorious images of the City of God, the Heavenly Jerusalem, which they were privileged to build on earth.

The Gothic cathedral was the unique product of an era of peace and widespread economic prosperity, deep spirituality, and extraordinary technological innovation. The essential ingredients of these towering holy structures were lofty masonry rib vaults on pointed arches invisibly held in place by external ("flying") buttresses, and interiors illuminated with mystical light streaming through huge colored-glass windows (see "The Gothic Cathedral," page 373).

The key monument of this exciting new style is Chartres Cathedral, discussed in detail later. Begun around 1145, the church dedicated to Our Lady (Notre Dame), the Virgin Mary, housed her mantle, a precious relic. The lower parts of the massive west towers and the portals between them are all that remain of that Early Gothic cathedral destroyed by fire in 1194 before it had been completed. Reconstruction of the church began immediately but in the High Gothic style with flying buttresses, rib vaults on pointed arches, and immense stained-glass windows. Chartres Cathedral is therefore a singularly instructive composite of a 12th-century facade and a 13th-century nave and transept, and documents the early and mature stages of the development of Gothic architecture in the place of its birth, the region around Paris called the Île-de-France.

FRANCE

As in the Romanesque period, the great artistic innovations of the Gothic age were in large part the outgrowth of widespread prosperity. This was a time of profound change in European society. The focus of both intellectual and religious life shifted definitively from monasteries in the countryside to rapidly expanding secular cities. In these new urban centers, prosperous merchants made their homes and formed guilds (professional associations), scholars founded the first modern universities, and vernacular literature, especially courtly romances, exploded in popularity. Although the papacy was at the height of its power, and Christian knights still waged Crusades against the Muslims, the independent secular nations of modern Europe were beginning to take shape. Foremost among them was France, and that is where, around 1140, the Gothic style first appeared.

By the 13th century, the opus modernum of the region around Paris had spread throughout western Europe (MAP 13-1), and in the next century reached farther still. Saint Vitus Cathedral in Prague (Czech Republic), for example, begun in 1344, closely emulates French Gothic architecture. In fact, some late medieval writers referred

to Gothic buildings anywhere in Europe as *opus francigenum* ("French work"). Nevertheless, many regional variants existed within European Gothic, just as distinct regional styles characterized the Romanesque period (see Chapter 12). Therefore, this chapter deals with contemporaneous developments in the major regions—France, England, and the Holy Roman Empire—in separate sections. The art and architecture of 13th- and 14th-century Italy are the subject of Chapter 14.

Architecture, Sculpture, and Stained Glass

Art historians generally agree Saint-Denis, a few miles north of Paris, was the birthplace of Gothic architecture. Dionysius (Denis in French) was the legendary saint who brought Christianity to Gaul and who died a martyr's death there in the third century. The Benedictine order founded the abbey at Saint-Denis in the seventh century on the site of the saint's burial. (According to legend, after

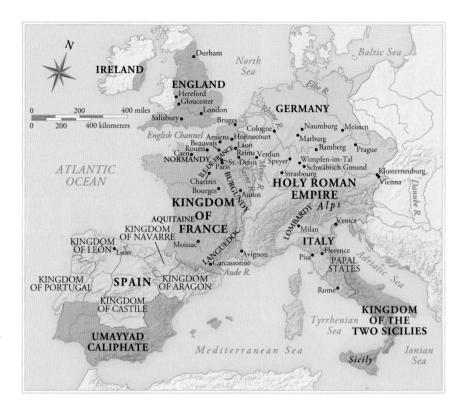

MAP 13-1 Europe around 1200.

his execution, Dionysius miraculously stood up and marched to his grave carrying his severed head in his hands.) In the ninth century, the monks constructed a basilica at Saint-Denis, which housed the saint's tomb and those of nearly all the French kings dating back to the sixth century, as well as the crimson military banner that reputedly belonged to Charlemagne. The Carolingian basilica became France's royal church, the very symbol of the monarchy—just as Speyer Cathedral (FIG. 12-20) was the burial place of the German rulers of the Holy Roman Empire.

SUGER AND SAINT-DENIS By 1122, when a monk named Suger (ca. 1081–1151) became abbot of Saint-Denis, the old church was in disrepair and had become too small to accommodate the growing number of pilgrims. Suger also believed the basilica was of insufficient grandeur to serve as the official church of the French kings (see "Abbot Suger and the Rebuilding of Saint-Denis," page 367). In 1135, Suger began to rebuild the church (FIGS. 13-2 and 13-3) by

GOTHIC EUROPE

1140

Abbot Suger begins rebuilding the French royal abbey church at Saint-Denis with rib vaults on pointed arches and stained-glass windows

Early Gothic

- As at Saint-Denis, sculpted jamb figures adorn all three portals of the west facade of Chartres Cathedral
- The builders of Laon Cathedral insert a triforium as the fourth story in the nave elevation
- I The rebuilt Chartres Cathedral sets the pattern for High Gothic churches: four-part nave vaults braced by external flying buttresses, three-story elevation (arcade, triforium, clerestory), and stained-glass windows in place of heavy masonry

High Gothic

1300

1194

- At Chartres and Reims in France, at Naumburg in Germany, and elsewhere, statues become more independent of their architectural setting
- Manuscript illumination moves from monastic scriptoria to urban lay workshops, especially in Paris
- The Flamboyant style in France and the Perpendicular style in England emphasize surface embellishment over structural clarity. Characteristic features are delicate webs of flamelike tracery and fan vaults with pendants resembling stalactites

Late Gothic

1500

The humanization of holy figures in statuary continues, especially in Germany, where sculptors dramatically record the suffering of Jesus

Abbot Suger and the Rebuilding of Saint-Denis

Abbot Suger of Saint-Denis (1081–1151) rose from humble parentage to become the right-hand man of both Louis VI (r. 1108–1137) and Louis VII (r. 1137–1180). When the latter, accompanied by his queen, Eleanor of Aquitaine, left to join the Second Crusade (1147–1149), Suger served as regent of France. From his youth, Suger wrote, he had dreamed of the possibility of embellishing the church in which most French monarchs since Merovingian times had been buried. Within 15 years of becoming abbot of Saint-Denis, Suger began rebuilding its Carolingian basilica. In his time, the French monarchy's power, except for scattered holdings, extended over an area not much larger than the Île-de-France, the region centered on Paris. But the kings had pretensions to rule all of France. Suger aimed to increase the prestige both of his abbey and of the monarchy by rebuilding France's royal church in grand fashion.

Suger wrote three detailed treatises about his activities as abbot, recording how he summoned masons and artists from many regions to help design and construct his new church. In one important passage, he described the special qualities of the new east end (FIGS. 13-2 and 13-3) dedicated in 1144:

[I]t was cunningly provided that—through the upper columns and central arches which were to be placed upon the lower ones built in the crypt—the central nave of the old [Carolingian church] should be equalized, by means of geometrical and arithmetical instruments, with the central nave of the new addition; and, likewise, that the dimensions of the old side-aisles should be equalized with the dimensions of the new side-aisles, except for that elegant and praiseworthy extension in [the form of] a circular string of chapels, by virtue of which the whole [church] would shine with the wonderful and uninterrupted light of most sacred windows, pervading the interior beauty.*

The abbot's brief discussion of Sain-Denis's new ambulatory and chapels is key to understanding Early Gothic architecture. Suger wrote at much greater length, however, about his church's glorious golden and gem-studded furnishings. Here, for example, is his description of the *altar frontal* (the decorated panel on the front of the altar) in the choir:

Into this panel, which stands in front of [Saint-Denis's] most sacred body, we have put . . . about forty-two marks of gold [and] a multifarious wealth of precious gems, hyacinths, rubies, sapphires, emeralds and topazes, and also an array of different large pearls. †

The costly furnishings and the light-filled space caused Suger to "delight in the beauty of the house of God" and "called [him] away from external cares." The new church made him feel as if he were "dwelling . . . in some strange region of the universe which neither exists entirely in the slime of the earth nor entirely in the purity of Heaven." In Suger's eyes, his splendid new church, permeated with light and outfitted with gold and precious gems, was a way station on the road to Paradise, which "transported [him] from this inferior to that higher world." He regarded a lavish investment in art as a spiritual aid, not as an undesirable distraction for the pious monk, as did Bernard of Clairvaux (see "Bernard of Clairvaux," Chapter 12, page 342). Suger's forceful justification of art in the church set the stage for the proliferation of costly stained-glass windows and sculptures in the cathedrals of the Gothic age.

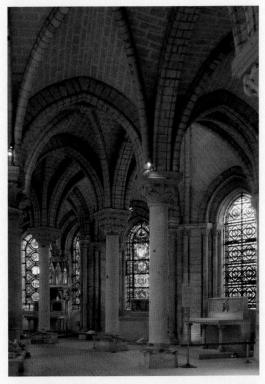

13-2 Ambulatory and radiating chapels (looking northeast), abbey church, Saint-Denis, France, 1140-1144. ■◀

Abbot Suger's remodeling of Saint-Denis marked the beginning of Gothic architecture. Rib vaults with pointed arches spring from slender columns. Stained-glass windows admit lux nova.

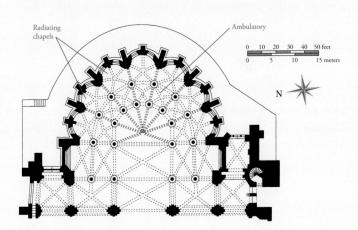

13-3 Plan of the east end, abbey church, Saint-Denis, France, 1140-1144 (after Sumner Crosby).

The innovative plan of the east end of Saint-Denis dates to Abbot Suger's lifetime. By using very light rib vaults, the builders were able to eliminate the walls between the radiating chapels.

*Translated by Erwin Panofsky, Abbot Suger on the Abbey Church of Saint-Denis and Its Art Treasures, 2d ed. (Princeton: Princeton University Press, 1979), 101.

†Ibid., 55.

*Ibid., 65.

The Gothic Rib Vault

he ancestors of the Gothic *rib vault* are the Romanesque vaults found at Caen (FIG. 12-31), Durham (FIG. 12-33), and elsewhere. The rib vault's distinguishing feature is the crossed, or diagonal, arches under its groins, as seen in the Saint-Denis ambulatory and chapels (FIG. 13-2; compare FIG. 13-21). These arches form the armature, or skeletal framework, for constructing the vault. Gothic vaults generally have more thinly vaulted webs (the masonry between the ribs) than found in Romanesque vaults. But the chief difference between the two types of vaults is the pointed arch, an integral part of the Gothic skeletal armature. The first wide use of pointed (or ogival) arches was in Sasanian architecture (FIG. 2-28), and Islamic builders later adopted them. French Romanesque architects (FIGS. 12-10A and 12-11) borrowed the form from Muslim Spain and passed it to their Gothic successors. Pointed arches enabled Gothic builders to make the crowns of all the vault's arches approximately the same level, regardless of the space to be vaulted. Romanesque architects could not achieve this with their semicircular arches.

The drawings in FIG. 13-4 illustrate this key difference. In FIG. 13-4a, the rectangle ABCD is an oblong nave bay to be vaulted. AC and DB are the diagonal ribs; AB and DC, the transverse arches; and AD and BC, the nave arcade's arches. If the architect uses semi-

circular arches (AFB, BJC, and DHC), their radii and, therefore, their heights (EF, IJ, and GH), will be different, because the width of a semicircular arch determines its height. The result will be a vault (FIG. 13-4b) with higher transverse arches (DHC) than the arcade's arches (CJB). The vault's crown (F) will be still higher. If the builder uses pointed arches (FIG. 13-4c), the transverse (DLC) and arcade (BKC) arches can have the same heights (GL and IK in FIG. 13-4a). The result will be a Gothic rib vault where the points of the arches (L and K) are at the same level as the vault's crown (F).

A major advantage of the Gothic vault is its flexibility, which permits the vaulting of compartments of varying shapes, as at Saint-Denis (FIG. 13-3). Pointed arches also channel the weight of the vaults more directly downward than do semicircular arches. The vaults therefore require less buttressing to hold them in place, in turn permitting the stonemasons to open up the walls and place large windows beneath the arches. Because pointed arches also lead the eye upward, they make the vaults appear taller than they are. In FIG. 13-4, the crown (F) of both the Romanesque (b) and Gothic (c) vaults is the same height from the pavement, but the Gothic vault seems taller. Both the physical and visual properties of rib vaults with pointed arches aided Gothic builders in their quest for soaring height in church interiors (FIG. 13-10).

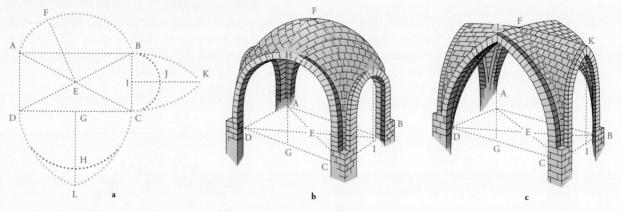

13-4 Diagram (a) and drawings of rib vaults with semicircular (b) and pointed (c) arches.

Pointed arches channel the weight of the rib vaults more directly downward than do semicircular arches, requiring less buttressing. Pointed arches also make the vaults appear taller than they are.

13-3A West facade, Saint-Denis, 1135-1140. ■◀

erecting a new west facade (FIG. 13-3A) with sculptured portals. Work began on the east end (FIGS. 13-2 and 13-3) in 1140. Suger died before he could remodel the nave, but he attended the dedication of the new choir, ambulatory, and radiating chapels on June 11, 1144. Also in attendance were King Louis VII of France, Queen Eleanor of Aquitaine (see "Romanesque Countesses, Queens, and Nuns," Chapter 12, page 352), and five archbishops.

Because the French considered the old church a relic in its own right, the new

east end had to conform to the dimensions of the crypt below it. Nevertheless, the remodeled portion of Saint-Denis represented a sharp break from past practice. Innovative rib vaults resting on pointed arches (see "The Gothic Rib Vault," above, and Fig. 13-4c) cover the ambulatory and chapels (Figs. 13-2 and 13-3). These pioneering, exceptionally lightweight vaults spring from slender columns in the ambulatory and from the thin masonry walls framing the chapels. The lightness of the vaults enabled the builders to eliminate the walls between the chapels and open up the outer walls and fill them with stained-glass windows (see "Stained-Glass Windows," page 375). Suger and his contemporaries marveled at the "wonderful and uninterrupted light" pouring in through the

13-5 West facade, Chartres Cathedral, Chartres, France, ca. 1145–1155. ■◀

The Early Gothic west facade was all that remained of Chartres Cathedral after the 1194 fire. The design still has much in common with Romanesque facades. The rose window is an example of plate tracery.

"most sacred windows." The abbot called the colored light *lux nova* ("new light"). Both the new type of vaulting and the use of stained glass became hallmarks of French Gothic architecture.

Saint-Denis is also the key monument of Early Gothic sculpture. Little of the sculpture Suger commissioned for the west facade (FIG. 13-3A) of the abbey church survived the French Revolution of the late 18th century (see Chapter 26). Old engravings reveal Suger carried on the artistic heritage of Romanesque Burgundy (see Chapter 12) by filling all three portals with sculpture, but Suger's sculptors also introduced figures of Old Testament kings, queens, and prophets attached to columns on the jambs of all three doorways.

ROYAL PORTAL, CHARTRES This innovative treatment of the Saint-Denis portals appeared immediately afterward at the Cathedral of Notre Dame (FIG. 13-1) at Chartres, also in the Îlede-France. Work on the west facade (FIG. 13-5) began around 1145. The west entrance, the Royal Portal (FIG. 13-6)—so named because of the figures of kings and queens flanking its three doorways, as at Saint-Denis—constitutes the most complete surviving ensemble of Early Gothic sculpture. Thierry of Chartres, chancellor of the Cathedral School of Chartres from 1141 until his death 10 years later, may have conceived the complex iconographical program. The archivolts of the right portal, for example, depict the seven female personifications of the liberal arts with the learned men of antiquity at their feet. The figures celebrate the revival of classical scholarship in the 12th century and symbolize human knowledge, which Thierry and other leading intellectuals of the era believed led to true faith (see "Paris, Schoolmen, and Scholasticism" page 372).

The sculptures of the Royal Portal (FIG. 13-6) proclaim the majesty and power of Christ. To unite the three doorways iconographically and visually, the sculptors carved episodes from the lives of the

Virgin (Notre Dame) and Christ on the capitals, which form a kind of frieze linking one entrance to the next. Christ's Ascension into Heaven appears in the tympanum of the left portal. All around, in the archivolts, are the signs of the zodiac and scenes representing the various labors of the months of the year. They are symbols of the cosmic and earthly worlds. The Second Coming is the subject of the central tympanum, as at Moissac

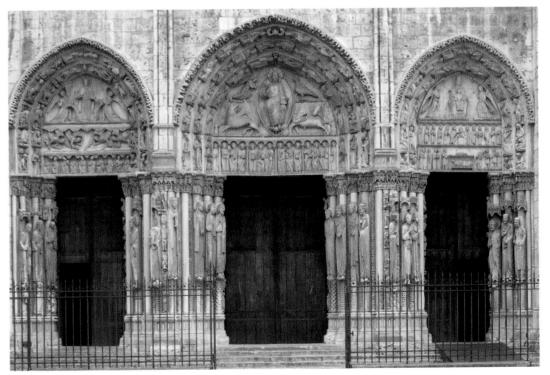

13-6 Royal Portal, west facade, Chartres Cathedral, Chartres, France, ca. 1145–1155. ■◀

The sculptures of the Royal Portal proclaim the majesty and power of Christ. The tympana depict, from left to right, Christ's *Ascension*, the *Second Coming*, and Jesus in the lap of the Virgin Mary.

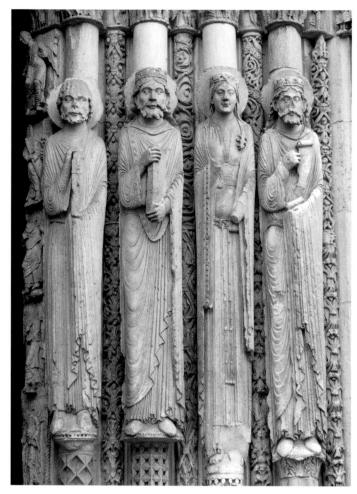

13-7 Old Testament kings and queen, jamb statues, right side of the central doorway of the Royal Portal, Chartres Cathedral, Chartres, France, ca. 1145–1155. ■4

The biblical kings and queens of the Royal Portal are the royal ancestors of Christ. These Early Gothic jamb figures display the first signs of a new naturalism in European sculpture.

(FIG. 12-11). The signs of the four evangelists, the 24 elders of the Apocalypse, and the 12 apostles appear around Christ or on the lintel. In the tympanum of the right portal, Christ appears in the lap of the Virgin Mary. Scenes of the Savior's childhood fill the lintel below, where Jesus appears on an altar, connecting the sculptures at the entrance to the church with the symbolic sacrifice of the Eucharist within.

The depiction of Mary in the right tympanum recalls Byzantine representations of the Theotokos (FIGS. 9-18 and 9-19), as well as the Romanesque "throne of wisdom" (FIG. 12-19). But the Virgin's prominence on the Chartres facade has no parallel in the sculptural programs of Romanesque church portals. At Chartres, Mary assumes a central role, a position she maintained throughout the Gothic period, during which time her cult reached a high point. As the Mother of Christ, she stood compassionately between the last judge and the horrors of Hell, interceding for all her faithful (compare FIG. 13-38B). Worshipers in the later 12th and 13th centuries sang hymns to the Virgin and dedicated great cathedrals to her. Soldiers carried her image into battle on banners, and Mary's name joined Saint Denis's as part of the French king's battle cry. The Virgin ("Our Lady") became the spiritual lady of chivalry, and the Christian knight dedicated his life to her. The severity of Romanesque themes stressing the last judgment yielded to the gentleness of Gothic art, in which Mary is the kindly queen of Heaven.

JAMB STATUES Statues of Old Testament kings and queens occupy the jambs flanking each doorway of the Royal Portal (FIGS. 13-6 and 13-7). They are the royal ancestors of Christ and, both figuratively and literally, support the New Testament figures above the doorways. They wear 12th-century clothes, and medieval observers may have regarded them as images of the kings and queens of France. (This was the motivation for vandalizing the comparable figures at Saint-Denis during the French Revolution.) The figures stand rigidly upright with their elbows held close against their hips. The linear folds of their garments—inherited from the Romanesque style, along with the elongated proportions—generally echo the vertical lines of the columns behind them. (In this respect, Gothic jamb statues differ significantly from classical caryatids; FIG. 5-54. The Gothic figures are attached to columns. The classical statues replaced the columns.) Yet, within and despite this architectural straitjacket, the statues display the first signs of a new naturalism. Although technically high reliefs, the kings and queens stand out from the plane of the wall, and, consistent with medieval (and ancient) practice, artists originally painted the statues in vivid colors, enhancing their lifelike appearance. The new naturalism is noticeable particularly in the statues' heads, where kindly human faces replace the masklike features of most Romanesque figures. At Chartres, a personalization of appearance began that led first to idealized portraits of the perfect Christian and finally, by 1400, to the portraiture of specific individuals. The sculptors of the Royal Portal figures initiated an era of artistic concern with personality and individuality.

LAON CATHEDRAL Both Chartres Cathedral and the abbey church of Saint-Denis had lengthy construction histories, and only small portions of the structures date to the Early Gothic period. Laon Cathedral (FIGS. 13-8 and 13-9), however, begun about 1160 and finished shortly after 1200, provides a comprehensive picture of French church architecture of the second half of the 12th century. Although the Laon builders retained many Romanesque features in their design, they combined them with the rib vault resting on pointed arches, the essential element of Early Gothic architecture.

Among the Laon plan's Romanesque features are the nave bays with their large sexpartite rib vaults, flanked by two small groin-vaulted squares in each aisle. The vaulting system (except for the pointed arches), as well as the vaulted gallery above the aisles, derived from Norman Romanesque churches such as Saint-Étienne (FIG. 12-31) at Caen. The Laon architect also employed the Romanesque alternatesupport system in the nave arcade. Above the piers, alternating bundles of three and five shafts frame the aisle bays. A new feature found in the Laon interior, however, is the triforium, the band of arcades below the clerestory (FIGS. 13-9 and 13-10a). The triforium occupies the space corresponding to the exterior strip of wall covered by the sloping timber roof above the galleries. The insertion of the triforium into the Romanesque three-story nave elevation reflected a growing desire to break up all continuous wall surfaces. The new horizontal zone produced the characteristic four-story Early Gothic interior elevation: nave arcade, vaulted gallery, triforium, and clerestory with single lancets (tall, narrow windows ending in pointed arches).

Laon Cathedral's west facade (FIG. 13-8) signals an even more pronounced departure from the Romanesque style still lingering at Saint-Denis (FIG. 13-3A) and Chartres (FIG. 13-5). Typically Gothic are the huge central rose window, the deep porches in front of the doorways, and the open structure of the towers. A comparison of the facades of Laon Cathedral and Saint-Étienne (FIG. 12-30) at Caen reveals a much deeper penetration of the wall mass in the later building. At Laon, as in Gothic architecture generally, the

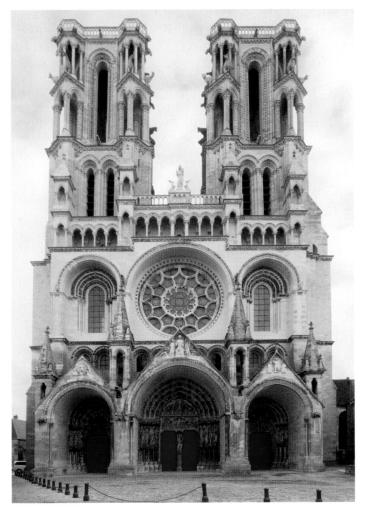

13-8 West facade of Laon Cathedral, Laon, France, begun ca. 1190. ■

The huge central rose window, the deep porches in front of the doorways, and the open structure of the towers distinguish Laon's Early Gothic facade from Romanesque church facades.

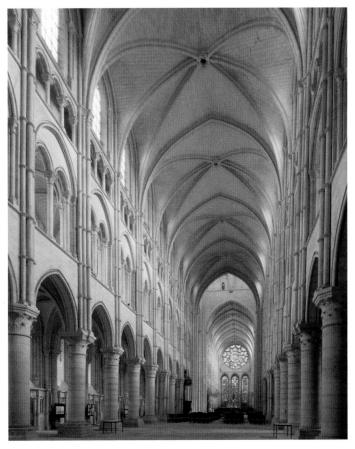

13-9 Interior of Laon Cathedral (looking northeast), Laon, France, begun ca. 1190. ■◀

The insertion of a triforium at Laon broke up the nave wall and produced the characteristic four-story Early Gothic interior elevation: nave arcade, vaulted gallery, triforium, and clerestory.

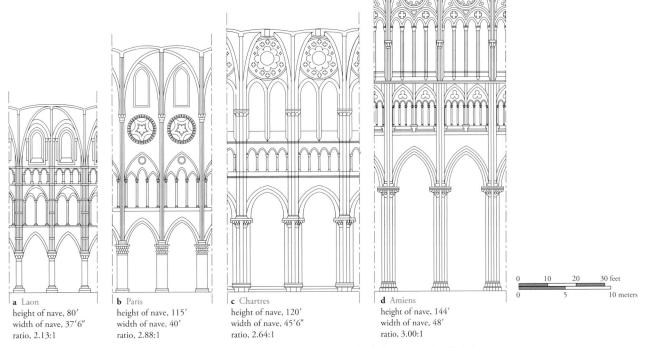

13-10 Nave elevations of four French Gothic cathedrals at the same scale (after Louis Grodecki).

Gothic naves evolved from a four-story elevation (arcade, tribune gallery, triforium, clerestory) to a three-story elevation (without tribune). The height of the vaults also increased dramatically.

Paris, Schoolmen, and Scholasticism

A few years before the formal consecration of the altar of the Cathedral of Notre-Dame (FIG. 13-11) in Paris, Philip II Augustus (r. 1180–1223) succeeded to the throne. Philip brought the feudal barons under his control and expanded the royal domains to include Normandy in the north and most of Languedoc in the south, laying the foundations for the modern nation of France. Renowned as "the maker of Paris," he gave the city its walls, paved its streets, and built the palace of the Louvre (now one of the world's great museums) to house the royal family. Although Rome remained the religious center of Western Christendom, the Île-de-France and Paris in particular became its intellectual capital as well as the leading artistic center of the Gothic world. The University of Paris attracted the best minds from all over Europe. Virtually every thinker of note in the Gothic age at some point studied or taught at Paris.

Even in the Romanesque period, Paris was a center of learning. Its Cathedral School professors, known as Schoolmen, developed the philosophy called *Scholasticism*. The greatest of the early Schoolmen was Peter Abelard (1079–1142), a champion of logical reasoning. Abelard and his contemporaries had been introduced to the writings of the Greek philosopher Aristotle through the Arabic scholars of Islamic Spain. Abelard applied Aristotle's system of rational inquiry to the interpretation of religious belief. Until the

12th century, both clergy and laymen considered truth the exclusive property of divine revelation as given in the holy scriptures. But the Schoolmen, using Aristotle's method, sought to demonstrate reason alone could lead to certain truths. Their goal was to prove the cen-

tral articles of Christian faith by argument (*disputatio*). In Scholastic argument, Schoolmen state a possibility, then cite an authoritative view in objection, next reconcile the positions, and, finally, offer a reply to each of the rejected original arguments.

One of Abelard's greatest critics was Bernard of Clairvaux (see "Bernard of Clairvaux," Chapter 12, page 342), who believed Scholasticism 13-11 Notre-Dame (looking north), Paris, France, begun 1163; nave and flying buttresses, ca. 1180-1200; remodeled after 1225. ■

King Philip II initiated a building boom in Paris, which quickly became the intellectual capital of Europe. Notre-Dame in Paris was the first great cathedral built using flying buttresses.

was equivalent to questioning Christian dogma. Although Bernard succeeded in 1140 in having the Church officially condemn Abelard's doctrines, the Schoolmen's philosophy developed systematically until it became the dominant Western philosophy of the late Middle Ages. By the 13th century, the Schoolmen of Paris already had organized as a professional guild of master scholars, separate from the numerous Church schools the bishop of Paris oversaw. The structure of the Parisian guild served as the model for many other European universities.

The greatest advocate of Abelard's Scholasticism was Thomas Aquinas (1225–1274), an Italian monk who became a saint in 1323. Aquinas settled in Paris in 1244. There, the German theologian Albertus Magnus (d. 1280) instructed him in Aristotelian philosophy. Aquinas went on to become an influential teacher at the University of Paris. His most famous work, *Summa Theologica* (left unfinished at his death), is a model of the Scholastic approach to knowledge. Aquinas divided his treatise into books, the books into questions, the questions into articles, each article into objections with contradictions and responses, and, finally, answers to the objections. He set forth five ways to prove the existence of God by rational argument. Aquinas's work remains the foundation of contemporary Catholic teaching.

operating principle was to reduce sheer mass and replace it with intricately framed voids.

NOTRE-DAME, PARIS About 1130, Louis VI moved his official residence to Paris, spurring much commercial activity and a great building boom. Paris soon became the leading city and intellectual capital of France, indeed of all northern Europe (see "Paris, Schoolmen, and Scholasticism," above). A new cathedral became a necessity. Notre-Dame (FIG. **13-11**) occupies a picturesque site on an island in the Seine River called the Île-de-la-Cité. The Gothic church (see "The Gothic Cathedral," page 373), which replaced a large Merovingian basilica, has a complicated building

history. The choir and transept were completed by 1182, the nave by about 1225, and the facade not until 1250 to 1260. Sexpartite vaults cover the nave, as at Laon. The original elevation (the builders modified the design as work progressed) had four stories, but the scheme (FIG. 13-10b) differed from Laon's (FIG. 13-10a). In each bay, in place of the triforium over the gallery, was a stained-glass oculus (small round window), opening up the wall below the clerestory lancet. As a result, windows filled two of the four stories, further reducing the masonry area.

To hold the much thinner—and taller (compare FIGS. 13-10a and 13-10b)—walls of Notre-Dame in place, the unknown architect introduced *flying buttresses* that spring from the lower roofs over the

The Gothic Cathedral

The great cathedrals erected throughout Europe in the later 12th and 13th centuries are the enduring symbols of the Gothic age. They are eloquent testimonies to the extraordinary skill of the architects, engineers, carpenters, masons, sculptors, glassworkers, and metalsmiths who constructed and embellished them. Most of the architectural components of Gothic cathedrals had appeared in earlier structures, but Gothic architects combined the elements in new ways. The essential ingredients of their formula for constructing churches in the *opus modernum* style were rib vaults with pointed arches (see "The Gothic Rib Vault," page 368), flying buttresses, and huge colored-glass windows (see "Stained-Glass Win-

dows," page 375). These three features and other important terms used in describing Gothic buildings are listed and defined here and illustrated in FIG. 13-12.

- Pinnacle (FIG. 13-12, no. 1) A sharply pointed ornament capping the piers or flying buttresses; also used on cathedral facades.
- Flying buttresses (2) Masonry struts that transfer the thrust of the nave vaults across the roofs of the side aisles and ambulatory to a tall pier rising above the church's exterior wall.
- *Vaulting web* (3) The masonry blocks filling the area between the ribs of a groin vault.
- *Diagonal rib* (4) In plan, one of the ribs forming the X of a groin vault. In FIG. 13-4, the diagonal ribs are the lines AC and DB.
- **Transverse rib** (5) A rib crossing the nave or aisle at a 90-degree angle (lines *AB* and *DC* in FIG. 13-4).
- **Springing** (6) The lowest stone of an arch; in Gothic vaulting, the lowest stone of a diagonal or transverse rib.
- Clerestory (7) The windows below the vaults in the nave elevation's uppermost level. By using flying buttresses and rib vaults on pointed arches, Gothic architects could build huge clerestory windows and fill them with stained glass held in place by ornamental stonework called tracery.

13-12 Cutaway view of a typical French Gothic cathedral (John Burge). ■

The major elements of the Gothic formula for constructing a church in the *opus modernum* style were rib vaults with pointed arches, flying buttresses, and stained-glass windows.

- I Oculus (8) A small, round window.
- Lancet (9) A tall, narrow window crowned by a pointed arch.
- Triforium (10) The story in the nave elevation consisting of arcades, usually blind arcades but occasionally filled with stained glass.
- Nave arcade (11) The series of arches supported by piers separating the nave from the side aisles.
- Compound pier (cluster pier) with shafts (responds) (12) A pier with a group, or cluster, of attached shafts, or responds, extending to the springing of the vaults.

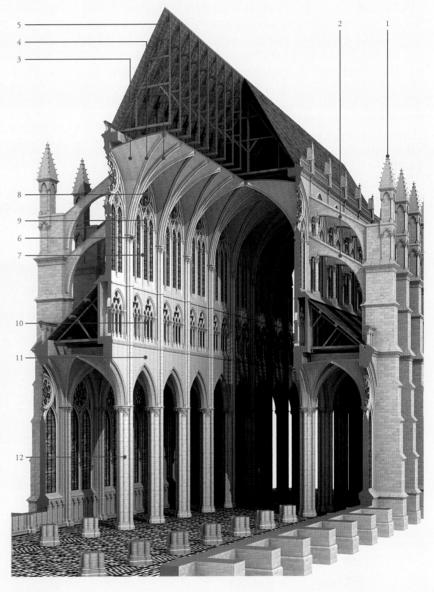

aisles and ambulatory (FIG. 13-11; compare FIG. 13-12) and counter the outward thrust of the nave vaults. Gothic builders introduced flying buttresses as early as 1150 in a few smaller churches, but at Notre-Dame in Paris they circle a great urban cathedral. The internal quadrant arches (FIG. 12-33, *right*) beneath the aisle roofs at Durham, also employed at Laon, perform a similar function and may be regarded

as precedents for exposed Gothic flying buttresses. The combination of precisely positioned flying buttresses and rib vaults with pointed arches was the ideal solution to the problem of constructing lofty naves with huge windows. The flying buttresses, which function as extended fingers holding up the walls, are key components of the distinctive "look" of Gothic cathedrals (FIG. 13-12).

CHARTRES AFTER 1194 Churches burned frequently in the Middle Ages (see "Timber Roofs," Chapter 12, page 339), and church officials often had to raise money unexpectedly for new building campaigns. In contrast to monastic churches, which usually were small and often could be completed quickly, the construction histories of urban cathedrals frequently extended over decades and sometimes over centuries. Their financing depended largely on collections and public contributions (not always voluntary), and a lack of funds often interrupted building programs. Unforeseen events, such as wars, famines, or plagues, or friction between the town and cathedral authorities would also often halt construction, which then might not resume for years. At Reims (FIG. 13-23), the clergy offered indulgences (pardons for sins committed) to those who helped underwrite the enormous cost of erecting the cathedral. The rebuilding of Chartres Cathedral (FIG. 13-1) after the devastating fire of 1194 took a relatively short 27 years, but at one point the townspeople revolted against the prospect of a heavier tax burden. They stormed the bishop's residence and drove him into exile for four years.

Chartres Cathedral's mid-12th-century west facade (FIG. 13-5) and the masonry of the crypt to the east were the only sections left standing after the 1194 conflagration. The crypt housed the most precious relic of Chartres—the mantle of the Virgin, which miraculously survived the fire. For reasons of piety and economy, the builders used the crypt for the foundation of the new structure. The retention of the crypt and west facade determined the new church's dimensions but not its plan or elevation. Architectural historians usually consider the post-1194 Chartres Cathedral the first High Gothic building.

The Chartres plan (FIG. 13-13) reveals a new kind of organization. Rectangular nave bays replaced the square bays with sexpartite

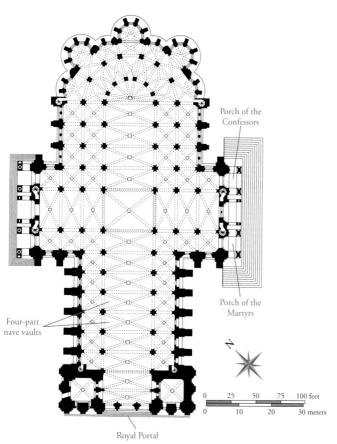

13-13 Plan of Chartres Cathedral, Chartres, France, as rebuilt after the 1194 fire (after Paul Frankl).

The Chartres plan, in which one square (instead of two) in each aisle flanks a single rectangular unit in the nave with a four-part vault, became the norm for High Gothic church architecture.

vaults and the alternate-support system, still present in Early Gothic churches such as Laon Cathedral (FIG. 13-9). The new system, in which a single square in each aisle (rather than two, as before) flanks a single rectangular unit in the nave, became the High Gothic norm. A change in vault design and the abandonment of the alternate-support system usually accompanied this new bay arrangement. The High Gothic nave vault, which covered only one bay and therefore could be braced more easily than its Early Gothic predecessor, had only four parts. The visual effect of these changes was to unify the interior (FIG. 13-14), because the nave now consisted of a sequence of identical units. The level crowns of the successive nave vaults, which pointed arches made possible, enhanced this effect.

The 1194 Chartres Cathedral was also the first church planned from its inception to have flying buttresses, another key High Gothic feature. The flying buttresses enabled the builders to eliminate the tribune above the aisle, which had partially braced Romanesque and Early Gothic naves (compare FIG. 13-10c with FIGS. 13-10a and 13-10b). The new High Gothic tripartite nave elevation consisted of arcade, triforium, and clerestory with greatly enlarged windows. The Chartres windows are almost as tall as the main arcade and consist of double lancets with a single crowning oculus. The strategic placement of flying buttresses made possible the construction of nave walls with so many voids that heavy masonry played merely a minor role.

CHARTRES STAINED GLASS Despite the vastly increased size of its clerestory windows, the Chartres nave (FIG. 13-14) is relatively dark. This seeming contradiction is the result of using lightmuffling colored glass for the windows instead of clear glass. The purpose of the Chartres windows was not to illuminate the interior with bright sunlight but to transform natural light into Suger's mystical lux nova (see "Stained-Glass Windows," page 375, and FIG. 13-15).

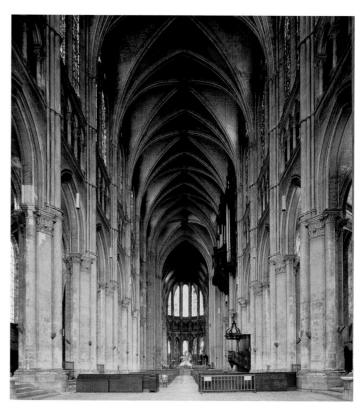

13-14 Interior of Chartres Cathedral (looking east), Chartres, France, begun 1194. ■◀

Chartres Cathedral established the High Gothic model also in its tripartite elevation consisting of nave arcade, triforium, and clerestory with stained-glass windows almost as tall as the main arcade.

Stained-Glass Windows

Stained-glass windows, although not a Gothic invention, are almost synonymous with Gothic architecture. No other age produced windows of such rich color and beauty. The technology of manufacturing colored glass is very old, however. Egyptian artists excelled at fashioning colorful glass objects for both home and tomb, and archaeologists have uncovered thousands of colored-glass artifacts at classical sites. But Gothic artists used stained glass in new ways. In earlier eras, the clergy introduced color and religious iconography into church interiors mainly with mural paintings and mosaics, often with magnificent effect. Stained-glass windows differ from those techniques in one all-important respect. They do not conceal walls. They replace them. Moreover, they transmit rather than reflect light, filtering and transforming the natural sunlight.

Abbot Suger called this colored light *lux nova* (see "Abbot Suger," page 367). Suger's contemporary, Hugh of Saint-Victor (1096–1142), a prominent Parisian theologian, also commented on the special mystical quality of stained-glass windows: "Stained-glass windows are the Holy Scriptures . . . and since their brilliance lets the splendor of the True Light pass into the church, they enlighten those inside."* William Durandus (ca. 1237–1296), bishop of Mende (southern France), expressed a similar sentiment at the end of the 13th century: "The glass windows in a church are Holy Scriptures, which expel the wind and the rain, that is, all things hurtful, but transmit the light of the True Sun, that is, God, into the hearts of the faithful."

According to Suger, the 12th-century stained-glass windows of Saint-Denis (FIG. 13-2) were "painted by the exquisite hands of many masters from different regions," proving the art was well established at that time. [‡] In fact, colored windows appeared in some churches as early as the fourth century, and several sophisticated Romanesque examples of figural stained-glass windows survive. The manufacture of these windows was costly and labor-intensive. A German Benedictine monk named Theophilus recorded the full process around 1100. First, the master designer drew the exact composition of the planned window on a wooden panel, indicating all the linear details and noting

the colors for each section. Glassblowers provided flat sheets of glass of different colors to glaziers (glassworkers), who cut the windowpanes to the required size and shape with special iron shears. Glaziers produced an even greater range of colors by flashing (fusing one layer of colored glass to another). Next, painters added details such as faces, hands, hair, and clothing in enamel by tracing the master design on the wood panel through the colored glass. Then they heated the painted glass to fuse the enamel to the surface. Next the glaziers "leaded" the various fragments of glass—that is, they joined them by strips of lead called cames. The leading not only held the pieces together but also separated the colors to heighten the effect of the design as a whole. The distinctive character of Gothic stained-glass windows is largely the result of this combination of fine linear details with broad flat expanses of color framed by black lead. Finally, the glassworkers strengthened the completed window with an armature of iron bands, which in the 12th century formed a grid over the entire design (FIG. 13-16). In the 13th century, the bands followed the outlines of the medallions and of the surrounding areas (FIGS. 13-15, 13-17, and 13-25).

The form of the stone frames for the stained-glass windows also evolved. At Saint-Denis (FIG. 13-3A), Laon (FIG. 13-8), and on Chartres Cathedral's 12th-century west facade (FIG. 13-5), plate tracery holds the rose window in place. The glass fills only the "punched holes" in the heavy ornamental stonework. Bar tracery, a later development, is much more slender. The stained-glass windows of the Chartres transepts (FIG. 13-17) and on the facades of Amiens (FIG. 13-21) and Reims (FIG. 13-23) cathedrals fill almost the entire opening, and the stonework is unobtrusive, resembling delicate leading more than masonry wall.

*Hugh of Saint-Victor, Speculum de mysteriis ecclesiae, sermon 2.

†William Durandus, Rationale divinorum officiorum, 1.1.24. Translated by John Mason Neale and Benjamin Webb, The Symbolism of Churches and Church Ornaments (Leeds: T. W. Green, 1843), 28.

‡Translated by Erwin Panofsky, Abbot Suger, 73.

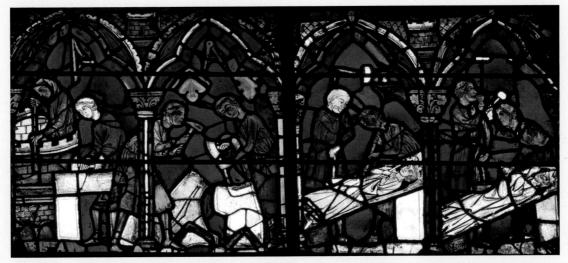

13-15 Stonemasons and sculptors, detail of a stained-glass window in the northernmost radiating chapel in the ambulatory, Chartres Cathedral, Chartres, France, ca. 1200−1220. ■◀

Glaziers made stained-glass windows by fusing layers of colored glass, joining the pieces with lead strips, and painting the details in enamel. The windows transformed natural light into divine light.

13-16 Virgin and Child and angels (*Notre Dame* de la Belle Verrière), detail of a window in the choir of Chartres Cathedral, Chartres, France, ca. 1170, with 13th-century side panels. Stained glass, 12′ 9″ high.

This stained-glass window miraculously survived the devastating Chartres fire of 1194. It has an armature of iron bands forming a grid over the entire design, an Early Gothic characteristic.

Chartres Cathedral retains almost the full complement of its original stained glass, paid for by workers' guilds (FIG. 13-15) and royalty (FIG. 13-17) alike. Although the tinted windows have a dimming effect, they transform the character of the church's interior in dramatic fashion. Gothic buildings that no longer have their original stained-glass windows give a false impression of what their designers

intended. One Chartres window that survived the fire of 1194 is the tall single lancet called Notre Dame de la Belle Verrière (Our Lady of the Beautiful Window, FIG. 13-16). The central section with a red background, which depicts the Virgin Mary enthroned with the Christ Child in her lap, dates to about 1170. High Gothic glaziers added framing angels seen against a blue ground when they reinstalled the window in the south aisle of the 13th-century choir. Mary is here the beautiful young queen of Heaven, haloed, crowned, and accompanied by the dove of the Holy Spirit. Comparing this Virgin and Child with the enthroned Theotokos and Child (FIG. 9-19) of Hagia Sophia highlights not only the greater severity and aloofness of the Byzantine image but also the sharp difference between the light-reflecting mosaic medium and Gothic light-filtering stained glass. Gothic and Byzantine builders used light to transform the material world into the spiritual, but in opposite ways. In Gothic architecture, light entered from outside the building through a screen of stone-set colored glass. In Byzantine architecture, light reflected off myriad glass tesserae set into the thick masonry wall.

Chartres's 13th-century Gothic windows are even more spectacular than the *Belle Verrière* because the introduction of flying buttresses made it possible for builders to plan from the outset on filling entire walls with stained glass. The immense rose window (approx-

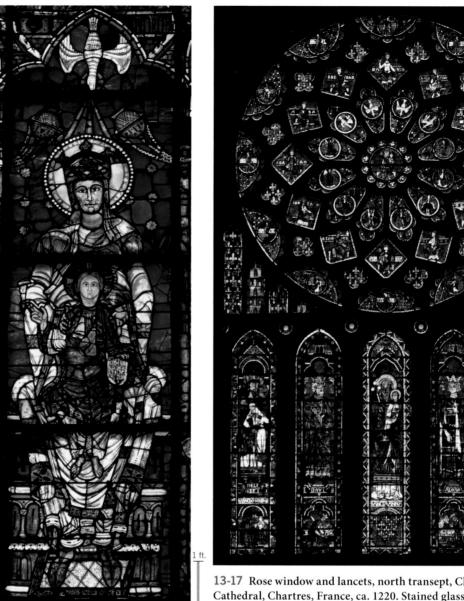

13-17 Rose window and lancets, north transept, Chartres Cathedral, Chartres, France, ca. 1220. Stained glass, rose window 43′ in diameter. ■◀

Immense stained-glass rose and lancet windows, held in place by an intricate armature of bar tracery, fill almost the entire facade wall of the High Gothic north transept of Chartres Cathedral.

imately 43 feet in diameter) and tall lancets of the north transept (FIG. 13-17) were the gift of Queen Blanche of Castile, around 1220. The royal motifs of yellow castles on a red ground and yellow fleursde-lis—three-petaled iris flowers (compare FIG. 25-24), France's royal floral emblem—on a blue ground fill the eight narrow windows in the rose's lower spandrels. The iconography is also fitting for a queen. The enthroned Virgin and Child appear in the roundel at the center of the rose, which resembles a gem-studded book cover or cloisonné brooch. Around her are four doves of the Holy Spirit and eight angels. Twelve square panels contain images of Old Testament kings, including David and Solomon (at the 12 and 1 o'clock positions respectively). These are the royal ancestors of Christ. Isaiah (11:1-3) had prophesied the Messiah would come from the family of the patriarch Jesse, father of David. The genealogical "tree of Jesse" is a familiar motif in medieval art. Below, in the lancets, are Saint Anne and the baby Virgin. Flanking them are four of Christ's Old Testament ancestors, Melchizedek, David, Solomon, and Aaron, echoing the royal genealogy of the rose

13-18 Saint Theodore, jamb statue, left portal, Porch of the Martyrs, south transept, Chartres Cathedral, Chartres, France, ca. 1230.

Although the statue of Theodore is still attached to a column, the setting no longer determines its pose. The High Gothic sculptor portrayed the saint in a contrapposto stance, as in classical statuary.

but at a larger scale. Many Gothic stained-glass windows also present narrative scenes, and their iconographical programs are often more complex than those of the sculptured church portals. (The representation of masons and sculptors at work in FIG. 13-15, for example, is the lowest section of a lancet dedicated to the life of Caraunus-Chéron in French-a legendary local sixth-century martyr who was probably the patron saint of the Chartres stonemasons' guild.)

The rose and lancets change in hue and intensity with the hours, turning solid architecture into a floating vision of the celestial heav-

ens. Almost the entire mass of wall opens up into stained glass, held in place by an intricate stone armature of bar tracery. Here, the Gothic passion for luminous colored light led to a most daring and successful attempt to subtract all superfluous material bulk just short of destabilizing the structure. That this vast, complex fabric of stone-set glass has maintained its structural integrity for almost 800 years attests to the Gothic builders' engineering genius.

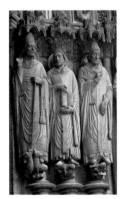

13-18A Porch of the Confessors, Chartres, ca. 1220–1230. ■◀

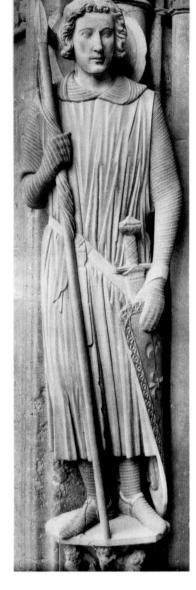

CHARTRES SOUTH TRANSEPT

The sculptures adorning the portals of the two Chartres transepts erected after the 1194 fire are also prime examples of the new High Gothic spirit. As at Laon (FIG. 13-8) and Paris (FIG. 13-11) cathedrals, the Chartres transept portals project more forcefully from the church than do the Early Gothic portals of its west facade (compare FIGS. 13-1 and 13-5). Similarly, the statues of saints (FIGS. 13-18 and 13-18A) on the portal jambs, which date from 1220 to 1230, are more independent from the architectural framework. Although the figures

are still attached to columns, the architectural setting does not determine their poses as much as it did on the west portals (FIG. 13-7).

The masterpiece of the south transept is the figure of Saint Theodore (FIG. 13-18), the martyred warrior on the left jamb of the left portal (the Porch of the Martyrs). It reveals the great changes Gothic sculpture had undergone since the Royal Portal statues of the mid-12th century. The High Gothic sculptor portrayed Theodore as the ideal Christian knight, clothing him in the cloak and chain-mail armor of 13th-century Crusaders. The handsome, longhaired youth holds his spear firmly in his right hand and rests his left hand on his shield. He turns his head to the left and swings out his hip to the right. The body's resulting torsion and pronounced sway recall ancient Greek statuary, especially the contrapposto stance of Polykleitos's Spear Bearer (FIG. 5-40). The changes that occurred in 13th-century Gothic sculpture echo the revolutionary developments in ancient Greek sculpture during the transition from the Archaic to the Classical style (see Chapter 5) and could appropriately be described as a second "Classical revolution."

AMIENS CATHEDRAL Chartres Cathedral was one of the most influential buildings in the history of architecture. Its builders set a pattern many other Gothic architects followed, even if they refined the details. Construction of Amiens Cathedral (FIG. 13-19) began in 1220 while work was still in progress at Chartres. The architects were ROBERT DE LUZARCHES, THOMAS DE CORMONT, and RENAUD

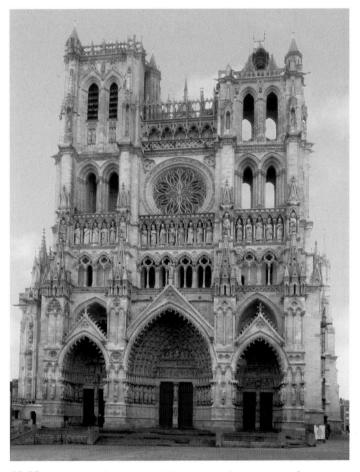

13-19 ROBERT DE LUZARCHES, THOMAS DE CORMONT, and RENAUD DE CORMONT, west facade of Amiens Cathedral, Amiens, France, begun 1220. ■

The deep piercing of the Amiens facade left few surfaces for decoration, but sculptors covered the remaining ones with colonnettes, pinnacles, and rosettes that nearly dissolve the structure's masonry.

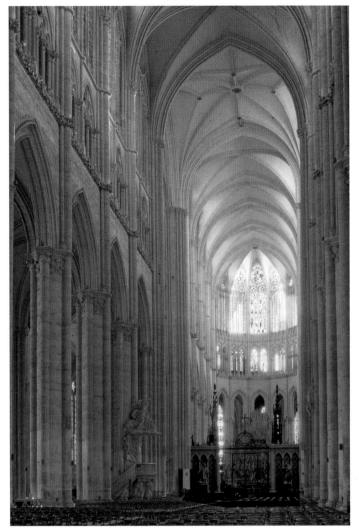

13-20 ROBERT DE LUZARCHES, THOMAS DE CORMONT, and RENAUD DE CORMONT, interior of Amiens Cathedral (looking east), Amiens, France, begun 1220. ■4

The concept of a self-sustaining skeletal architecture reached full maturity at Amiens Cathedral. The four-part vaults on pointed arches rise an astounding 144 feet above the nave floor.

DE CORMONT. The builders finished the nave (FIG. 13-20) by 1236 and the radiating chapels by 1247, but work on the choir (FIG. 13-21) continued until almost 1270. The Amiens elevation (FIG. 13-10*d*) derived from the High Gothic formula of Chartres (FIG. 13-10*c*). But Amiens Cathedral's proportions are more slender, and the number and complexity of the lancet windows in both its clerestory and triforium are greater. The whole design reflects the builders' confident use of the complete High Gothic structural vocabulary: the rectangular-bay system, the four-part rib vault, and a buttressing system that made possible the almost complete elimination of heavy masses and thick weight-bearing walls. At Amiens, the concept of a self-sustaining skeletal architecture reached full maturity. The remaining stretches of wall seem to serve no purpose other than to provide a weather screen for the interior.

Amiens Cathedral is one of the most impressive examples of the French Gothic obsession with constructing ever-taller cathedrals. Using their new skeletal frames of stone, French builders attempted goals almost beyond limit, pushing to new heights with increasingly slender supports. The nave vaults at Laon rise to a

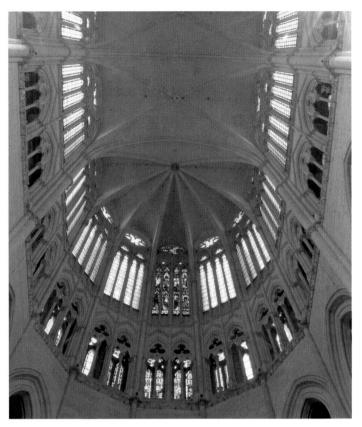

13-21 ROBERT DE LUZARCHES, THOMAS DE CORMONT, and RENAUD DE CORMONT, vaults, clerestory, and triforium of the choir of Amiens Cathedral, Amiens, France, begun 1220. ■

The Amiens choir vaults resemble a canopy on bundled masts. The light entering from the clerestory and triforium creates a buoyant lightness not normally associated with stone architecture.

height of about 80 feet, at Paris 115 feet, and at Chartres 120 feet. Those at Amiens are 144 feet above the floor (FIG. 13-10). The most daring quest for exceptional height occurred at Beauvais (FIG. I-2), where the choir vaults are 157 feet high—but the builders never completed the cathedral. The Beauvais vaults are unstable and require additional buttressing today.

At Amiens, the lines of the vault ribs converge to the colonnettes and speed down the shell-like walls to the compound piers (FIG. 13-20). Almost every part of the superstructure has its corresponding element below. The overall effect is of effortless strength, of a buoyant lightness not normally associated with stone architecture. Viewed directly from below, the choir vaults (FIG. 13-21) resemble a canopy, tentlike and suspended from bundled masts. The light flooding in from the clerestory makes the vaults seem even more insubstantial. The effect recalls another great building, one utterly different from Amiens but where light also plays a defining role: Hagia Sophia (FIG. 9-8) in Constantinople. At Amiens, the designers also reduced the building's physical mass by structural ingenuity and daring, and light further dematerializes what remains. If Hagia Sophia is the perfect expression of Byzantine spirituality in architecture, Amiens, with its soaring vaults and giant windows admitting divine colored light, is its Gothic counterpart.

Work began on the Amiens west facade (FIG. 13-19) at the same time as the nave (1220). Its lower parts reflect the influence of Laon Cathedral (FIG. 13-8) in the spacing of the funnel-like and gable-covered portals. But the Amiens builders punctured the upper parts

13-22 Christ (Beau Dieu), trumeau statue of the central doorway of the west facade, Amiens Cathedral, Amiens, France, ca. 1220–1235. ■◀

The Beau Dieu blesses all who enter Amiens Cathedral. He tramples a lion and dragon symbolizing the evil forces in the world. This benevolent Gothic Christ gives humankind hope in salvation.

of the facade to an even greater degree than did the Laon designer. The deep piercing of walls and towers at Amiens left few areas for decoration, but sculptors covered the remaining surfaces with a network of colonnettes, arches, pinnacles, rosettes, and other decorative stonework that visually screens and nearly dissolves the structure's solid core. Sculpture also extends to the areas above the portals, especially the band of statues (the so-called kings' gallery) running the full width of the facade directly below the rose window (with 15th-century tracery). The uneven towers were later additions. The shorter one dates from the 14th century, the taller one from the 15th century.

BEAU DIEU Greeting worshipers as they enter the cathedral is the statue

the French call *Beau Dieu* (Beautiful God; FIG. **13-22**) on the central doorway's trumeau. The High Gothic sculptor fully modeled Christ's figure, enveloping his body with massive drapery folds cascading from his waist. Compared with the kings and queens (FIG. 13-7) of the Royal Portal, the *Beau Dieu* is almost independent of its architectural setting. Nonetheless, the statue is still attached to the trumeau, and the sculptor placed an architectural canopy over Christ's head. The canopy mimics the east end of a 13th-century cathedral with a series of radiating chapels boasting elegant lancet windows in the latest Gothic style. Above the *Beau Dieu* is the great central tympanum with the representation of Christ as last judge. The trumeau Christ does not strike terror into sinners, however. Instead he blesses those who enter the church and tramples a lion and a dragon symbolizing the evil forces in the world. This image of Christ gives humankind hope in salvation. The *Beau*

13-23 GAUCHER DE REIMS and BERNARD DE SOISSONS, west facade of Reims Cathedral, Reims, France, ca. 1225–1290.

Reims Cathedral's facade reveals the High Gothic architect's desire to replace heavy masonry with intricately framed voids. Stained-glass windows, not stone reliefs, fill the three tympana.

Dieu epitomizes the bearded, benevolent Gothic image of Christ that replaced the youthful Early Christian Christ (FIG. 8-8) and the stern Byzantine Pantocrator (FIG. 9-23) as the preferred representation of the Savior in later European art. The handsome figure's quiet grace and grandeur also contrast sharply with the emotional intensity of the twisting Romanesque prophet (FIG. 12-13) carved in relief on the Moissac trumeau.

REIMS CATHEDRAL Construction of Reims Cathedral, for centuries the site of all French kings' coronations, began only a few years after work commenced at Amiens. Gaucher de Reims and Bernard de Soissons, who were primarily responsible for the west facade (Fig. 13-23), carried the High Gothic style of Amiens still further, both architecturally and sculpturally. The Amiens and Reims facades, although similar, display some significant differences. The *kings' gallery* of statues at Reims is *above* the great rose window, and the figures stand in taller and more ornate frames. In fact, the builders "stretched" every detail of the facade. The openings in the towers and those to the left and right of the rose window are taller, narrower, and more intricately decorated, and they more closely

13-23A Interior of Reims Cathedral, begun 1211. ■◀

resemble the elegant lancets of the clerestory within (FIG. 13-23A). A pointed arch also frames the rose window itself, and the pinnacles over the portals are taller and more elaborate than those at Amiens. Most striking, however, is the treatment of the tympana over the doorways, where stained-glass windows replaced the stone relief sculpture of earlier facades. The contrast with Romanesque heavy masonry construction (FIG. 12-30) is extreme. No less noteworthy, however, is the rapid transformation of the Gothic facade since the 12th-century designs of Saint-Denis

(FIG. 13-3A) and Chartres (FIG. 13-5) and even Laon (FIG. 13-8).

Reims Cathedral is also a prime example of the High Gothic style in sculpture. The statues and reliefs of the west facade celebrate the Virgin Mary. Above the central gable, Mary is crowned as queen of Heaven. On the trumeau, she is the youthful Mother of God above reliefs depicting original sin. (Many medieval theologians considered Mary the new Eve.) The jamb statues to her left and right relate episodes from the infancy cycle (see "The Life of Jesus in Art," Chapter 8, pages 240–241), including *Annunciation* and *Visitation* (Fig. 13-24). The statues appear completely detached from their architectural background because the sculptors shrank the supporting columns into insignificance. The columns in no way restrict the free and easy movements of the full-bodied figures. These 13th-century jamb statues contrast strikingly with those of the Early Gothic Royal Portal (Fig. 13-7), where the background columns occupy a volume equal to that of the figures.

The Reims statues also vividly illustrate how long it frequently took to complete the sculptural ornamentation of a large Gothic cathedral. Sculptural projects of this magnitude normally required decades to complete and entailed hiring many sculptors often working in diverse styles. Art historians believe three different sculptors carved the four statues in FIG. 13-24 at different times during the quarter century from 1230 to 1255. The Visitation group (FIG. 13-24, right) is the work of one of the many artists of the era-in Germany and Italy as well as France-who must

13-24 Annunciation and Visitation, jamb statues on the right side of the central doorway of the west facade, Reims Cathedral, Reims, France, ca. 1230–1255. ■

Several sculptors working in diverse styles carved the Reims jamb statues, but all the figures resemble freestanding statues with bodies and arms in motion. The biblical figures converse through gestures.

have studied classical statuary. Reims was an ancient Roman city. The heads of both Mary and Saint Elizabeth resemble Roman portraits, and the rich folds of the garments they wear also recall Roman statuary (Fig. 7-61). The Gothic statues closely approximate the classical naturalistic style and feature contrapposto postures in which the swaying of the hips is much more pronounced than in the Chartres's Saint Theodore (Fig. 13-18). The right legs of the Reims figures bend, and the knees press through the rippling folds of the garments. The sculptor also set the holy figures' arms in motion. Mary and Elizabeth turn their faces toward each other, and they converse through gestures. In the Reims *Visitation* group, the formerly isolated Gothic jamb statues became actors in a biblical narrative.

The statues in the *Annunciation* group (FIG. 13-24, *left*) also stand free from their architectural setting, but they are products of different workshops. Mary is a slender figure with severe drapery. This artist preferred broad expanses of fabric to the multiplicity of folds of the *Visitation* Mary. The angel Gabriel, the latest of the four statues, exhibits the elegant style of the Parisian court at the middle of the 13th century. Gabriel has a much more elongated body and is far more animated than his neighbors. He pivots gracefully, almost as if dancing, and smiles broadly. Like a courtier, Gabriel exudes charm. Mary, in contrast, is serious and introspective and does not respond overtly to the news the angel has brought.

SAINTE-CHAPELLE, PARIS The stained-glass windows inserted into the portal tympana of Reims Cathedral exemplify the wall-dissolving High Gothic architectural style. The architect of Sainte-Chapelle (FIG. 13-25) in Paris extended this style to an entire building. Louis IX built Sainte-Chapelle, joined to the royal palace, as a repository for the crown of thorns and other relics of Christ's

passion he had purchased in 1239 from his cousin Baldwin II (r. 1228–1261), the Latin emperor of Constantinople. The chapel is a masterpiece of the so-called Rayonnant (radiant) style of the High Gothic age, which dominated the second half of the 13th century. It was the preferred style of the Parisian court of Saint Louis (see "Louis IX," page 385). Sainte-Chapelle's architect carried the dissolution of walls and the reduction of the bulk of the supports to the point that some 6,450 square feet of stained glass make up more than three-quarters of the structure. The supporting elements are hardly more than large mullions, or vertical stone bars. The emphasis is on the extreme slenderness of the architectural forms and on linearity in general. Although the chapel required restoration in the 19th century (after suffering damage during the French Revolution), it retains most of its original 13th-century stained glass. Sainte-Chapelle's enormous windows filter the light and fill the interior with an unearthly rose-violet atmosphere. Approximately 49 feet high and 15 feet wide, they were the largest stained-glass windows designed up to their time.

VIRGIN OF PARIS The "court style" of Sainte-Chapelle has its pictorial parallel in the mannered elegance of the roughly contemporaneous Gabriel of the Reims *Annunciation* group (FIG. 13-24,

left), but the style long outlived Saint Louis and his royal artists and architects. An example of the court style in Late Gothic sculpture is the early-14th-century statue nicknamed the Virgin of Paris (FIG. 13-26) because of its location in the Parisian Cathedral of Notre-Dame. The sculptor portrayed Mary in an exaggerated S-curve posture typical of Late Gothic sculpture. She is a worldly queen and wears a heavy gem-encrusted crown. The princely Christ Child reaches toward his young mother. The tender, anecdotal characterization of mother and son seen here is a later manifestation of the humanization of the portrayal of religious figures in Gothic sculpture that began at Chartres and developed especially in Germany (FIGS. 13-48 to 13-50). Late Gothic statuary is very different in tone from the solemnity of most High Gothic figures, just as Late Classical Greek statues of the Olympian gods differ from High Classical depictions (compare FIG. 13-26 with FIG. 5-63).

SAINT-MACLOU, ROUEN Late French Gothic architecture also represents a departure from the norms of High Gothic. The change from Rayonnant architecture to the *Flamboyant* style (named for the flamelike appearance of its pointed bar tracery) occurred in the 14th century. The new manner reached its florid maturity nearly a century later in Rouen, the capital of Normandy,

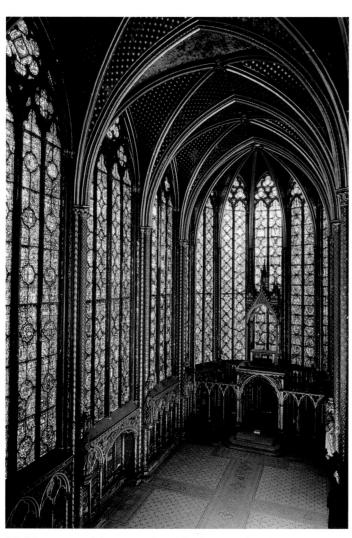

13-25 Interior of the upper chapel (looking northeast), Sainte-Chapelle, Paris, France, 1243-1248. ■◀

At Louis IX's Sainte-Chapelle, the architect succeeded in dissolving the walls to such an extent that 6,450 square feet of stained glass account for more than three-quarters of the Rayonnant Gothic structure.

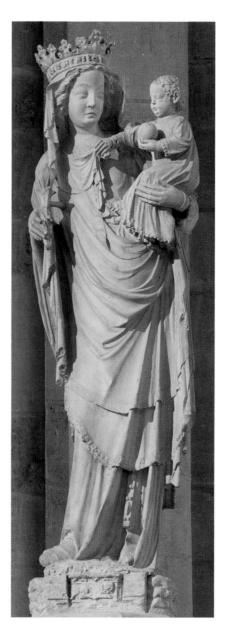

13-26 Virgin and Child (Virgin of Paris), Notre-Dame, Paris, France, early 14th century. ■

Late Gothic sculpture is elegant and mannered. Here, the solemnity of Early and High Gothic religious figures gave way to a tender, anecdotal portrayal of Mary and Jesus as royal mother and son.

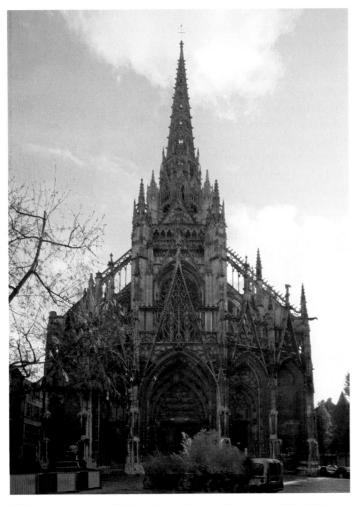

13-27 West facade of Saint-Maclou, Rouen, France, ca. 1500–1514. ■ Saint-Maclou is the masterpiece of Late Gothic Flamboyant architecture. Its ornate tracery of curves and countercurves forms brittle decorative webs

masking the building's structure.

in the church of Saint-Maclou (FIG. 13-27). The shrine is tiny (only about 75 feet high and 180 feet long) compared with 13th-century cathedrals, and its facade breaks sharply from the High Gothic style (FIGS. 13-21 and 13-23). The five portals (two of them false doors) bend outward in an arc. Ornate gables crown the doorways, pierced through and filled with wiry, "flickering" Flamboyant tracery. Made up of curves and countercurves forming brittle decorative webs, the ornate Late Gothic tracery masks the building's structure. The transparency of the pinnacles over the doorways enables visitors to see the central rose window and the flying buttresses, even though they are set well back from the facade. The overlapping of all features, pierced as they are, confuses the structural lines and produces a bewildering complexity of views that is the hallmark of the Flamboyant style.

CARCASSONNE The Gothic period may have been the age of the great cathedrals, but widespread prosperity also stimulated the construction of major secular buildings such as town halls, palaces, and private residences. In a time of frequent warfare, the feudal barons often had constructed fortified castles in places enemies could not easily reach. Sometimes thick defensive wall circuits or *ramparts* enclosed entire towns. In time, however, purely defensive wars became obsolete due to the invention of artillery and improvements in siege craft. The fortress era gradually passed, and throughout Europe once-mighty ramparts fell into ruin.

Carcassonne (FIG. 13-28) in Languedoc in southern France, once the regional center of resistance to the northern forces of royal France, is the best-preserved example of a Gothic fortified town. Restored in the 19th century by Eugène Viollet-le-Duc (1814–1879), Carcassonne occupies a site on a hill bounded by the Aude River. Fortified since Roman times, it has Visigothic walls dating from the 6th century, reinforced in the 12th century. Battlements (low parapets) with crenellations (composed of alternating solid merlons and open crenels) protected guards patrolling the stone ring surrounding the town. Carcassonne might be forced to surrender but could not easily be taken by storm. Within the town's double

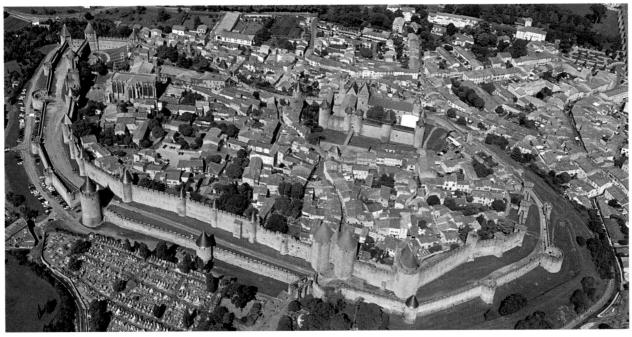

13-28 Aerial view of the fortified town of Carcassonne (looking west), France. Bastions and towers, 12th–13th centuries, restored by Eugène Viollet-le-Duc in the 19th century.

Carcassonne provides a rare glimpse of what was once a familiar sight in Gothic France: a tight complex of castle, cathedral, and town with a crenellated and towered wall circuit for defense.

13-29 Hall of the cloth guild, Bruges, Belgium, begun 1230.

The Bruges cloth guild's meeting hall is an early example of a new type of secular architecture in the late Middle Ages. Its lofty tower competed for attention with the towers of the cathedral.

walls was a fortified castle (FIG. 13-28, *right*) with a massive attached *keep*, a secure tower that could serve as a place of last refuge. Balancing that center of secular power was the bishop's seat, the cathedral of Saint-Nazaire (FIG. 13-28, *left*). The small church, built between 1269 and 1329, may have been the work of an architect brought in from northern France. In any case, Saint-Nazaire's builders were certainly familiar with the latest developments in architecture in the Île-de-France. Today, Carcassonne provides a rare glimpse of what was once a familiar sight in Gothic France: a tightly contained complex of castle, cathedral, and town within towered walls.

GUILD HALL, BRUGES One of the many signs of the growing secularization of urban life in the late Middle Ages was the erection of monumental meeting halls and warehouses for the increasing number of craft guilds being formed throughout Europe. An early example is the imposing market and guild hall (FIG. 13-29) of the clothmakers of Bruges, begun in 1230. Situated in the city's major square, it testifies to the important role of artisans and merchants in Gothic Europe. The design combines features of military construction (the corner watchtowers with their crenellations) and ecclesiastical architecture (lancet windows with crowning oculi). The uppermost, octagonal portion of the tower with its flying buttresses and pinnacles dates to the 15th century, but even the original two-story

13-30 Inner facade and courtyard of the house of Jacques Coeur, Bourges, France, 1443-1451. ■4

The townhouse of the wealthy Bourges financier Jacques Coeur is both a splendid example of Late Gothic architecture with elaborate tracery and a symbol of the period's new secular spirit.

tower is taller than the rest of the hall. Lofty towers, a common feature of late medieval guild and town halls (compare FIGS. 14-15 and 14-18B), were designed to compete for attention and prestige with the towers of city cathedrals.

HOUSE OF JACQUES COEUR The new class of wealthy merchants who rose to prominence throughout Europe in the late Middle Ages may not have accumulated fortunes equaling those of the hereditary royalty, but they still wielded enormous power and influence. The career of the French financier Jacques Coeur (1395-1456) illustrates how enterprising private citizens could win-and quickly lose-wealth and power. Coeur had banking houses in every major city of France and many cities abroad. He employed more than 300 agents and competed with the great trading republics of Italy. His merchant ships filled the Mediterranean, and with the papacy's permission, he imported spices and textiles from Muslim lands to the east. He was the treasurer of King Charles VII (r. 1422-1461) of France and a friend of Pope Nicholas V (r. 1447-1455). In 1451, however, his enemies framed him on an absurd charge of having poisoned Agnes Sorel (1421–1450), the king's mistress. The judges who sentenced Coeur to prison and confiscated his vast wealth and property were among those who owed him money. Coeur escaped in 1454 and made his way to Rome, where the pope warmly received him. He died of fever while leading a fleet of papal war galleys in the eastern Mediterranean.

Jacques Coeur's great townhouse still stands in his native city of Bourges. Built between 1443 and 1451 (with special permission to encroach upon the town ramparts), it is the best-preserved example of Late Gothic domestic architecture. The house's plan is irregular, with the units arranged around an open courtyard (FIG. 13-30). The service areas (maintenance shops, storage rooms, servants' quarters, and baths—a rare luxury anywhere until the 20th century) occupy the ground level. The upper stories house the great hall and auxiliary rooms used for offices and family living rooms. Over the main entrance is a private chapel. One of the towers served as a

treasury. The exterior and interior facades have steep pyramidal roofs of different heights. Decorative details include Flamboyant tracery and large pointed-arch stained-glass windows. An elegant canopied niche facing the street once housed a royal equestrian statue. A comparable statue of Coeur on horseback dominated the facade opening onto the interior courtyard. Jacques Coeur's house is both a splendid example of Late Gothic architecture and a monumental symbol of the period's new secular spirit.

Book Illumination and Luxury Arts

Paris's claim as the intellectual center of Gothic Europe (see "Paris," page 372) did not rest solely on the stature of its university faculty and the reputation of its architects, masons, sculptors, and stained-glass makers. The city was also a renowned center for the production of fine books. Dante Alighieri (1265–1321), the famous Florentine poet, in fact, referred to Paris in his *Divine Comedy* (ca. 1310–1320) as the city famed for the art of illumination.² During the Gothic period, bookmaking shifted from monastic scriptoria shut off from the world to urban workshops of professional

13-31 VILLARD DE HONNECOURT, figures based on geometric shapes, folio 18 verso of a sketchbook, from Paris, France, ca. 1220–1235. Ink on vellum, $9\frac{1}{4}'' \times 6''$. Bibliothèque Nationale, Paris.

On this page from his private sketchbook, the master mason Villard de Honnecourt sought to demonstrate how simple geometric shapes are the basis of both natural forms and buildings.

artists—and Paris boasted the most and best workshops. The owners of these new for-profit secular businesses sold their products to the royal family, scholars, and prosperous merchants. The Parisian shops were the forerunners of modern publishing houses.

VILLARD DE HONNECOURT One of the most intriguing Parisian manuscripts preserved today was not, however, a book for sale but a personal sketchbook. Compiled by VILLARD DE HONNECOURT, an early-13th-century master mason, its pages contain plans of choirs with radiating chapels and drawings of church towers, lifting devices, a sawmill, stained-glass windows, and other subjects of obvious interest to architects and masons. But also sprinkled liberally throughout the pages are pictures of religious and worldly figures as well as animals, some realistic and others purely fantastic. On the page reproduced here (FIG. 13-31), Villard demonstrated the value of the ars de geometria (art of geometry) to artists, showing how both natural forms and buildings are based on simple geometric shapes such as the square, circle, and triangle. Even when he claimed he drew his animals from nature, he composed his figures around a skeleton not of bones but of abstract geometric forms. Geometry was, in Villard's words, "strong help in drawing figures."

GOD AS CREATOR Geometry also played a symbolic role in Gothic art and architecture. Gothic artists, architects, and theolo-

13-32 God as Creator of the World, folio 1 verso of a moralized Bible, from Paris, France, ca. 1220–1230. Ink, tempera, and gold leaf on vellum, 1' $1\frac{1}{2}$ " \times $8\frac{1}{4}$ ". Österreichische Nationalbibliothek, Vienna.

Paris boasted renowned workshops for the production of illuminated manuscripts. In this book, the artist portrayed God in the process of creating the universe using a Gothic builder's compass.

Louis IX, the Saintly King

The royal patron behind the Parisian Rayonnant court style of Gothic art and architecture was King Louis IX (1215–1270; r. 1226–1270), grandson of Philip Augustus. Louis inherited the throne when he was only 12 years old, so until he reached adulthood 6 years later, his mother, Blanche of Castile (FIG. 13-33), granddaughter of Eleanor of Aquitaine (see "Romanesque Countesses, Queens, and Nuns," Chapter 12, page 352), served as France's regent.

The French regarded Louis as the ideal king. In 1297, only 27 years after Louis's death, Pope Boniface VIII (r. 1294–1303) declared the king a saint. In his own time, Louis was revered for his piety, justice, truthfulness, and

charity. His almsgiving and his donations to religious foundations were extravagant. He especially favored the *mendicant* (begging) orders, the Dominicans and Franciscans (see "Mendicant Orders," Chapter 14, page 404), as he admired their poverty, piety, and self-sacrificing disregard of material things.

Louis launched two unsuccessful Crusades (see "Crusades," Chapter 12, page 346), the Seventh (1248–1254, when, in her son's absence, Blanche was again French regent) and the Eighth (1270). He died in Tunisia during the latter. As a crusading knight who lost his life in the service of the Church, Louis personified the chivalric virtues of courage, loyalty, and self-sacrifice. Saint Louis united in his person the best qualities of the Christian knight, the benevolent monarch, and the holy man. He became the model of medieval Christian kingship.

Louis's political accomplishments were also noteworthy. He subdued the unruly French barons, and between 1243 and 1314 no one seriously challenged the crown. He negotiated a treaty with Henry III (r. 1216–1272), king of France's traditional enemy, Eng-

13-33 Blanche of Castile, Louis IX, and two monks, dedication page (folio 8 recto) of a moralized Bible, from Paris, France, 1226–1234. Ink, tempera, and gold leaf on vellum, 1' 3" \times 10 $\frac{1}{2}$ ". Pierpont Morgan Library, New York.

The dedication page of this royal book depicts Saint Louis, his mother and French regent Blanche of Castile, a monk, and a lay scribe at work on the paired illustrations of a moralized Bible.

1 in

land. Such was his reputation for integrity and just dealing that he served as arbiter in at least a dozen international disputes. So successful was he as peacekeeper that despite civil wars through most of the 13th century, international peace prevailed. Under Saint Louis, medieval France was at its most prosperous, and its art and architecture were admired and imitated throughout Europe.

gians alike thought the triangle, for example, embodied the Trinity of God the Father, Christ, and the Holy Spirit. The circle, which has neither a beginning nor an end, symbolized the eternity of the one God. The book of Revelation (21.12–21) describes the Heavenly Jerusalem as a walled city in the form of a perfect square with 12 gates. When Gothic architects based their designs on the art of geometry, building their forms out of abstract shapes laden with symbolic meaning, they believed they were working according to the divinely established laws of nature.

A vivid illustration of this concept appears as the frontispiece (FIG. 13-32) of a moralized Bible produced in Paris during the 1220s. *Moralized Bibles* are heavily illustrated, each page pairing paintings of Old and New Testament episodes with explanations of their moral significance. The page reproduced here does not conform to this formula because it is the introduction to all that follows. Above the illustration, the scribe wrote (in French rather than Latin): "Here God creates heaven and earth, the sun and moon, and all the elements." The painter depicted God in the process of creating the world, shaping the universe with the aid of a compass. Within the perfect circle already created are the spherical sun and

moon and the unformed matter that will become the earth once God applies the same geometric principles to it. In contrast to the biblical account of creation, in which God created the sun, moon, and stars after the earth had been formed, and made the world by sheer force of will and a simple "Let there be" command, the Gothic artist portrayed God as systematically creating the universe with what Villard would describe as "the strong help of geometry."

BLANCHE OF CASTILE Not surprisingly, some of the finest Gothic books known today belonged to the French monarchy. Saint Louis in particular was an avid collector of both secular and religious books (see "Louis IX, the Saintly King," above). He and his royal predecessors and successors formed a vast library that eventually became the core of France's national library, the Bibliothèque Nationale.

One book the royal family commissioned is a moralized Bible now in the collection of New York's Pierpont Morgan Library. Louis's mother, Blanche of Castile, ordered the Bible during her regency (1226–1234) for her teenage son. The dedication page (FIG. 13-33) has a costly gold background and depicts Blanche and Louis

enthroned beneath triple-lobed arches and miniature cityscapes. The latter are comparable to the architectural canopies above the heads of contemporaneous French portal statues (FIGS. 13-18 and 13-22). With vivid gestures, Blanche instructs the young Louis, underscoring her superior position. (The prominence of Mary as queen of Heaven in Gothic art parallels the rising influence of secular queens in Gothic Europe.) Below Blanche and Louis, in similar architectural frames, are a monk and a professional lay scribe. The older clergyman instructs the scribe, who already has divided his page into two columns of four roundels each, a format often used for the paired illustrations of moralized Bibles. The inspirations for such pages filled with circular frames were probably the roundels of Gothic stained-glass windows (compare the windows of Louis's own later Sainte-Chapelle, FIG. 13-25, in Paris).

The picture of Gothic book production on the dedication page of Blanche of Castile's moralized Bible is a very abbreviated one, as was the view of a monastic scriptorium discussed earlier (FIG. 11-11). Indeed, the manufacturing processes used in the workshops of 13th-century Paris and 10th-century Tábara did not differ significantly. Bookmaking involved many steps and numerous specialized artists, scribes, and assistants of varying skill levels. The Benedictine abbot Johannes Trithemius (1462–1516) described the way books were still made in his day in his treatise *In Praise of Scribes*:

If you do not know how to write, you still can assist the scribes in various ways. One of you can correct what another has written. Another can add the rubrics [headings] to the corrected text. A third can add initials and signs of division. Still another can arrange the leaves and attach the binding. Another of you can prepare the covers, the leather, the buckles and clasps. All sorts of assistance can be offered the scribe to help him pursue his work without interruption. He needs many things which can be prepared by others: parchment cut, flattened and ruled for script, ready ink and pens. You will always find something with which to help the scribe.³

Preparation of the illuminated pages also involved several hands. Some artists, for example, specialized in painting borders or initials. Only the workshop head or one of the most advanced assistants would paint the main figural scenes. Given this division of labor and the assembly-line nature of Gothic book production, it is astonishing how uniform the style is on a single page, as well as from page to page, in most illuminated manuscripts.

PSALTER OF SAINT LOUIS The golden background of Blanche's Bible is unusual and has no parallel in Gothic windows. But the radiance of stained glass probably inspired the glowing color of other 13th-century Parisian illuminated manuscripts. In some cases, masters in the same urban workshop produced both glass and books. Many art historians believe the Psalter of Saint Louis (Fig. 13-34) is one of several books produced in Paris for Louis IX by artists associated with those who made the stained glass for his Sainte-Chapelle. Certainly, the painted architectural setting in Louis's book of Psalms reflects the pierced screenlike lightness and transparency of royal Rayonnant buildings such as Sainte-Chapelle. The intense colors, especially the blues, emulate stained glass, and the lines in the borders resemble leading. The gables, pierced by rose windows with bar tracery, are standard Rayonnant architectural features.

On the page from the *Psalter of Saint Louis* shown here (FIG. 13-34), the illuminator represented *Abraham and the Three*

13-34 Abraham and the Three Angels, folio 7 verso of the Psalter of Saint Louis, from Paris, France, 1253–1270. Ink, tempera, and gold leaf on vellum, $5'' \times 3\frac{1}{2}''$. Bibliothèque Nationale, Paris.

The architectural settings in the *Psalter of Saint Louis* reflect the lightness and transparency of Parisian royal buildings, such as Sainte-Chapelle (Fig. 13-25). The colors emulate stained glass.

Angels, the Old Testament story Christians believed prefigured the Trinity (see "Jewish Subjects in Christian Art," Chapter 8, page 238). Two episodes appear on the same page, separated by the tree of Mamre mentioned in the Bible. At the left, Abraham greets the three angels. In the other scene, he entertains them while his wife, Sarah, peers at them from a tent. The figures' delicate features and the linear wavy strands of their hair have parallels in Blanche of Castile's moralized Bible, as well as in Parisian stained glass. The elegant proportions, facial expressions, theatrical gestures, and swaying poses are characteristic of the Parisian court style admired throughout Europe. Compare, for example, the angel in the left foreground with the Gabriel statue (FIG. 13-24, left) of the Reims Annunciation group.

BREVIARY OF PHILIPPE LE BEL As in the Romanesque period, some Gothic manuscript illuminators signed their work. The names of others appear in royal accounts of payments made and similar official documents. One of the artists who produced books for the French court was MASTER HONORÉ, whose Parisian workshop was on the street known today as rue Boutebrie. Honoré illuminated a *breviary* (see "Medieval Books," Chapter 11, page 312) for Philippe le Bel (Philip the Fair, r. 1285–1314) in 1296. On the page illustrated here (FIG. 13-35), Honoré painted two Old Testament scenes involving David. In the upper panel, Samuel

13-35 Master Honoré, Samuel Anointing David and Battle of David and Goliath, folio 7 verso of the Breviary of Philippe le Bel, from Paris, France, 1296. Ink and tempera on vellum, $7\frac{7}{8}'' \times 4\frac{7}{8}''$. Bibliothèque Nationale, Paris.

Master Honoré was one of the Parisian lay artists who produced books for the French monarchy. His figures are noteworthy for their sculptural volume and the play of light and shade on their bodies.

anoints the youthful David. Below, while King Saul looks on, David prepares to aim his slingshot at his most famous opponent, the giant Goliath (who already touches the wound on his forehead). Immediately to the right, David slays Goliath with his sword.

Master Honoré's linear treatment of hair, his figures' delicate hands and gestures, and their elegant swaying postures are typical of Parisian painting of the time. But this painter was much more interested than most of his colleagues in giving his figures sculptural volume and showing the play of light on their bodies. Honoré showed little concern for locating his figures in space, however. The Goliath panel in Philippe's breviary has a textilelike decorative background, and the feet of the artist's figures frequently overlap the border. Compared with his contemporaries, Master Honoré pioneered naturalism in figure painting. Still, he approached the art of book illumination as a decorator of two-dimensional pages.

13-36 Jean Pucelle, *David before Saul*, folio 24 verso of the *Belleville Breviary*, from Paris, France, ca. 1325. Ink and tempera on vellum, $9^{1''}_2 \times 6^{3''}_4$. Bibliothèque Nationale, Paris.

Pucelle's fully modeled figures in architectural settings rendered in convincing perspective reveal his study of contemporaneous painting in Italy. He was also a close observer of plants and fauna.

He did not embrace the classical notion that a painting should be an illusionistic window into a three-dimensional world.

BELLEVILLE BREVIARY David and Saul also are the subjects of a miniature painting at the top left of an elaborately decorated text page (FIG. 13-36) in the *Belleville Breviary*, which

JEAN PUCELLE of Paris painted around 1325. In this manuscript and the Book of Hours (FIG. 13-36A) which he illuminated for Queen Jeanne d'Evreux, wife of Charles IV (r. 1322–1328), Pucelle outdid Honoré and other French artists by placing his fully modeled figures in three-dimensional architectural settings rendered in convincing perspective.

13-36A Pucelle, Hours of Jeanne d'Evreux, ca. 1325–1328.

For example, he painted Saul as a weighty figure seated on a throne seen in three-quarter view, and he meticulously depicted the receding coffers of the barrel vault over the young David's head. Similar "stage sets" already had become commonplace in Italian painting, and art historians believe Pucelle visited Italy and studied Duccio

di Buoninsegna's work (FIGS. 14-9 to 14-11) in Siena. Pucelle's (or an assistant's) renditions of plants, a bird, butterflies, a dragonfly, a fish, a snail, and a monkey also reveal a keen interest in and close observation of the natural world. Nonetheless, in the *Belleville Breviary*, the text still dominates the page, and the artist (and his patron) delighted in ornamental flourishes, fancy initial letters, and abstract patterns. In that respect, comparisons with panel paintings such as Duccio's are inappropriate. Pucelle's breviary remains firmly in the tradition of book illumination.

The *Belleville Breviary* is of special interest because Pucelle's name and those of some of his assistants appear at the end of the book, in a memorandum recording the payment they received for their work. Inscriptions in other Gothic illuminated books regularly state the production costs—the prices paid for materials, especially gold, and for the execution of initials, figures, flowery script, and other embellishments. By this time, illuminators were professional guild members, and their personal reputation guaranteed the quality of their work. Although the cost of materials was still the major factor determining a book's price, individual skill and "brand name" increasingly decided the value of the illuminator's services. The centuries-old monopoly of the Church in book production had ended.

VIRGIN OF JEANNE D'EVREUX The royal family also patronized goldsmiths, silversmiths, and other artists specializing in the production of luxury works in metal and enamel for churches, palaces, and private homes. Especially popular were statuettes of sacred figures, which the wealthy purchased either for private devotion or as gifts to churches. The Virgin Mary was a favored subject, reflecting her new prominence in the iconography of Gothic portal sculpture.

Perhaps the finest of these costly statuettes is the large silvergilt figurine known as the Virgin of Jeanne d'Evreux (FIG. 13-37). The French queen donated the image of the Virgin and Child to the royal abbey church of Saint-Denis in 1339. Mary stands on a rectangular base decorated with enamel scenes of Christ's passion. (Some art historians think the enamels are Jean Pucelle's work.) But no hint of grief appears in the beautiful young Mary's face. The Christ Child, also without a care in the world, playfully reaches for his mother. The elegant proportions of the two figures, Mary's emphatic swaying posture, the heavy drapery folds, and the intimate human characterization of mother and son are also features of the roughly contemporaneous Virgin of Paris (FIG. 13-26). The sculptor of large stone statues and the royal silversmith working at small scale approached the representation of the Virgin and Child in a similar fashion. In both instances, Mary appears not only as the Mother of Christ but also as the queen of Heaven. The Saint-Denis Mary originally had a crown on her head, and the scepter she holds is in the form of the *fleur-de-lis* (compare FIG. 13-17). The statuette also served as a reliquary. The Virgin's scepter contained hairs believed to come from Mary's head.

THE CASTLE OF LOVE Gothic artists produced luxurious objects for secular as well as religious contexts. Sometimes they decorated these costly pieces with stories of courtly love inspired by the romantic literature of the day, such as the account of Lancelot and Queen Guinevere, wife of King Arthur of Camelot. The French poet Chrétien de Troyes recorded their love affair in the late 12th century.

An interesting object of this type is a woman's jewelry box adorned with ivory relief panels. The theme of the panel illustrated here (FIG. 13-38) is related to the allegorical poem *Romance of the*

13-37 *Virgin of Jeanne d'Evreux*, from the abbey church of Saint-Denis, France, 1339. Silver gilt and enamel, $2' 3\frac{1}{2}''$ high. Musée du Louvre, Paris.

Queen Jeanne d'Evreux donated this sumptuous reliquary-statuette to the royal abbey of Saint-Denis. It shares with the *Virgin of Paris* (FIG. 13-26) the intimate human characterization of the holy figures.

Rose by Guillaume de Lorris, written around 1225 to 1235 and completed by Jean de Meung between 1275 and 1280. At the left, the sculptor carved the allegory of the siege of the Castle of Love. Gothic knights attempt to capture love's fortress by shooting flowers from their bows and hurling baskets of roses over the walls from catapults. Among the castle's defenders is Cupid, who aims his arrow at one of the knights while a comrade scales the walls on a ladder. In the lid's central sections, two knights joust on horseback. Several maidens survey the contest from a balcony and cheer the knights on as trumpets blare. A youth in the crowd holds a hunting falcon. The

13-38 Castle of Love, lid of a jewelry box, from Paris, France, ca. 1330–1350. Ivory and iron, $4\frac{1}{2}'' \times 9\frac{3}{4}''$. Walters Art Museum, Baltimore.

French Gothic artists also created luxurious objects for homes. Adorning this jewelry casket are ivory reliefs inspired by the romantic literature of the day. Knights joust and storm the Castle of Love.

sport was a favorite pastime of the leisure class in the late Middle Ages. At the right, the victorious knight receives his prize (a bouquet of roses) from a chastely dressed maiden on horseback. The scenes on the sides of the box include the legend of the unicorn—a white horse with a single ivory horn, a medieval allegory of female virtue. Only a virgin could attract the rare animal, and any woman who could do so thereby demonstrated her moral purity. Although religious themes monopolized artistic production for churches in the Gothic age, secular themes figured prominently in private contexts. Unfortunately, very few examples of the latter survive.

the new style, developed its own brand of Gothic architecture. Beginning with the Norman con-

marrying its local Romanesque design to

Beginning with the Norman conquest in 1066 (see Chapter 12), French artistic and architectural styles quickly had an influence in England, but in the Gothic period, as in the Romanesque, English artworks (for example, RICHARD DE BELLO'S *mappamundi* in Hereford Cathedral, FIG. 13-38B) have a distinctive character.

13-38B *Mappamundi* of Henry III, ca. 1277–1289.

ENGLAND

13-38A Santa María, Léon, begun 1254.

In 1269, the prior (deputy abbot) of the church of Saint Peter at Wimpfen-im-Tal in the German Rhineland hired "a very experienced architect who had recently come from the city of Paris" to rebuild his monastery church. The architect reconstructed the church *opere francigeno* (in the French manner)—that is, in the Gothic style, the *opus modernum* of the Île-de-France. A French architect may also have designed the Cathedral of Santa María (FIG. 13-38A) at Léon in northern

Spain, begun in 1254. The spread of the Parisian Gothic style had begun even earlier, but in the second half of the 13th century, the new style became dominant throughout the Continent. European architecture did not, however, turn Gothic all at once or even uniformly. Almost everywhere, patrons and builders modified the court style of the Île-de-France according to local preferences. Because the old Romanesque traditions lingered on in many places, each area,

SALISBURY CATHEDRAL English Gothic churches cannot be mistaken for French ones. The English Gothic style reflects an aesthetic sensibility quite different from French Gothic in emphasizing linear pattern and horizontality instead of structural logic and verticality. Salisbury Cathedral (FIGS. 13-39 to 13-41), begun in 1220—the same year work started on Amiens Cathedral (FIGS. 13-19 to 13-21)—embodies these essential characteristics. The building campaign lasted about 40 years. The two cathedrals thus are almost exactly contemporaneous, and the differences between them are instructive. Although Salisbury's facade incorporates some of the superficial motifs of French Gothic architecture for example, lancet windows and blind arcades with pointed arches as well as statuary—it presents a striking contrast to French High Gothic designs (FIGS. 13-21 and 13-23). The English facade is a squat screen in front of the nave, wider than the building behind it. The architect did not seek to match the soaring height of French facades or try to make the facade correspond to the three-part division of the interior (nave and two aisles). Different, too, is the emphasis on the great crossing tower (added around 1320-1330), which

13-39 Aerial view of Salisbury Cathedral (looking northeast), Salisbury, England, 1220–1258; west facade completed 1265; spire ca. 1320–1330. ■

Exhibiting the distinctive regional features of English Gothic architecture, Salisbury Cathedral has a squat facade that is wider than the building behind it. The architects used flying buttresses sparingly.

13-40 Plan of Salisbury Cathedral, Salisbury, England, 1220-1258.

The long rectilinear plan of Salisbury Cathedral, with its double transept and flat eastern end, is typically English. The four-part rib vaults of the nave follow the Chartres model (Fig. 13-13).

13-41 Interior of Salisbury Cathedral (looking east), Salisbury, England, 1220–1258.

Salisbury Cathedral's interior differs from contemporaneous French Gothic designs in the strong horizontal emphasis of its three-story elevation and the use of dark Purbeck marble for moldings.

dominates the silhouette. Salisbury's height is modest compared with that of Amiens and Reims. Because height is not a decisive factor in the English building, the architect used the flying buttress sparingly.

Equally distinctive is Salisbury Cathedral's long rectilinear plan (FIG. 13-40), with its double transept and flat eastern end. The latter feature was characteristic of Cistercian (FIG. 12-10A) and English churches since Romanesque times. The interior (FIG. 13-41), although Gothic in its three-story elevation, pointed arches, fourpart rib vaults, compound piers, and the tracery of the triforium, conspicuously departs from the French Gothic style. The pier colonnettes stop at the springing of the nave arches and do not connect with the vault ribs (compare FIGS. 13-19, 13-20, and 13-23A). Instead, the vault ribs rise from corbels in the triforium, producing a strong horizontal emphasis. Underscoring this horizontality is the rich color contrast between the light stone of the walls and vaults and the dark marble (from the Isle of Purbeck in southeastern England) used for the triforium moldings and corbels, compound pier responds, and other details. In short, French Gothic architecture may have inspired the design of Salisbury Cathedral, but its builders transformed the French style in accordance with English taste.

GLOUCESTER CATHEDRAL The elaboration of architectural pattern for its own sake had long been a distinguishing feature of English architecture. The decorative motifs on the Romanesque piers

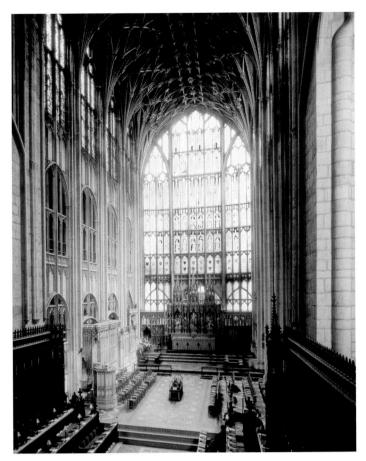

13-42 Choir of Gloucester Cathedral (looking east), Gloucester, England, 1332–1357.

The Perpendicular style of Late English Gothic architecture takes its name from the pronounced verticality of its linear details. The multiplication of ribs in the vaults is also a characteristic feature.

13-42A Tomb of Edward II, Gloucester, ca. 1330-1335

of Durham Cathedral (FIG. 12-33, *left*) are an early example. The pier, wall, and vault elements, still relatively simple at Salisbury, became increasingly complex and decorative in the 14th century, culminating in what architectural historians call the *Perpendicular* style. This Late English Gothic style is on display in the choir (FIG. 13-42) of Gloucester Cathedral, remodeled about a century after Salisbury under Edward III (r. 1327–1357), who also installed a Perpen-

dicular style tomb (FIG. 13-42A) in the church in honor of his father, Edward II (r. 1307–1327). The Perpendicular style takes its name from the pronounced verticality of its decorative details, in contrast to the horizontal emphasis of Salisbury and Early English Gothic.

A single enormous window divided into tiers of small windows of similar shape and proportion fills the characteristically flat east end of Gloucester Cathedral. At the top, two slender lancets flank a wider central section that also ends in a pointed arch. The design has much in common with the screen facade of Salisbury, but the proportions are different. Vertical, as opposed to horizontal, lines dominate. In the choir wall, the architect also erased Salisbury's strong horizontal accents, as the vertical wall elements lift directly from the floor to the vaulting, unifying the walls with the vaults in the French

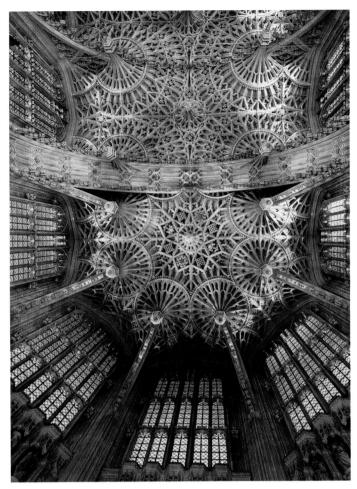

13-43 ROBERT and WILLIAM VERTUE, fan vaults of the chapel of Henry VII, Westminster Abbey, London, England, 1503-1519. ■

The chapel of Henry VII epitomizes the decorative and structure-disguising qualities of the Perpendicular style in the use of fan vaults with lacelike tracery and pendants resembling stalactites.

manner. The vault ribs, which designers had begun to multiply soon after Salisbury, are at Gloucester a dense thicket of entirely ornamental strands serving no structural purpose. The choir, in fact, does not have any rib vaults at all but a continuous Romanesque barrel vault with applied Gothic ornamentation. In the Gloucester choir, the taste for decorative surfaces triumphed over structural clarity.

CHAPEL OF HENRY VII The decorative, structuredisguising qualities of the Perpendicular style became even more pronounced in its late phases. A primary example is the early-16thcentury ceiling (FIG. 13-43) of the chapel of Henry VII adjoining Westminster Abbey in London. Here, ROBERT and WILLIAM VERTUE turned the earlier English linear play of ribs into a kind of architectural embroidery. The architects pulled the ribs into uniquely English fan vaults (vaults with radiating ribs forming a fanlike pattern) with large hanging pendants resembling stalactites. The vault looks as if it had been some organic mass hardened in the process of melting. Intricate tracery resembling lace overwhelms the cones hanging from the ceiling. The chapel represents the dissolution of structural Gothic into decorative fancy. The architects released the Gothic style's original lines from their function and multiplied them into the uninhibited architectural virtuosity and theatrics of the Perpendicular style. A parallel phenomenon in France is the Flamboyant style of Saint-Maclou (FIG. 13-27) at Rouen.

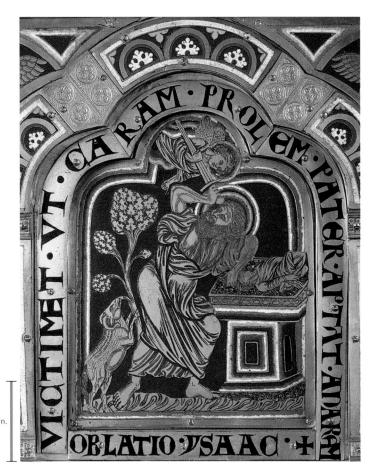

13-44 NICHOLAS OF VERDUN, Sacrifice of Isaac, detail of the Klosterneuburg Altar, from the abbey church at Klosterneuburg, Austria, 1181. Gilded copper and enamel, $5\frac{1}{2}$ high. Stiftsmuseum, Klosterneuburg.

Nicholas of Verdun was the leading artist of the Meuse valley region, renowned for its enamel- and metalwork. His gold figures twist and turn and stand out vividly from the blue enamel background.

HOLY ROMAN EMPIRE

As part of his plan to make his new church at Saint-Denis an earthly introduction to the splendors of Paradise (see "Abbot Suger," page 367), Suger selected artists from the Meuse River valley in present-day Belgium to fashion for the choir a magnificent crucifix on a sumptuous base decorated with 68 enamel scenes pairing Old and New Testament episodes. The Mosan region long had been famous for the quality of its metalworkers and enamelers (FIGS. 12-24 and 12-25). Indeed, as Suger's treatises demonstrate, in the Middle Ages the artists who worked at small scale with precious metals, ivory, and jewels produced the most admired objects in a church, far more important in the eyes of contemporaries than the jamb figures and tympanum reliefs that form the core of modern histories of medieval art.

NICHOLAS OF VERDUN The leading Mosan artist of the late 12th and early 13th centuries was NICHOLAS OF VERDUN. In 1181, Nicholas completed work on a gilded-copper and enamel *ambo* (a pulpit for biblical readings) for the Benedictine abbey church at Klosterneuburg, near Vienna in Austria. After a fire damaged the pulpit in 1330, the church hired artists to convert the pulpit into an *altarpiece*. The pulpit's sides became the wings of a *triptych* (three-part altarpiece). The 14th-century artists also

added six scenes to Nicholas's original 45. The *Klosterneuburg Altar* in its final form (FIG. 13-44A) has a central row of enamels depicting New Testament episodes, beginning with the *Annunciation*, and bearing the label *sub gracia*, or the world "under grace," that is, after

13-44A Klosterneuburg Altar, refashioned after 1330.

the coming of Christ. The upper and lower registers contain Old Testament scenes labeled, respectively, ante legem, "before the law" Moses received on Mount Sinai, and sub lege, "under the law" of the Ten Commandments. In this scheme, prophetic Old Testament events appear above and below the New Testament episodes they prefigure. For example, framing the Annunciation to Mary of the coming birth of Jesus are enamels of angels announcing the births of Isaac and Samson. In the central section of the triptych, the Old Testament counterpart of Christ's Crucifixion is Abraham's Sacrifice of Isaac (FIG. 13-44), a parallel already established in Early Christian times (see "Jewish Subjects in Christian Art," Chapter 8, page 238, and FIG. 8-1). Here, the angel flies in at the last moment to grab the blade of Abraham's sword before he can slay the bound Isaac on the altar.

Nicholas of Verdun's Klosterneuburg enamels may give an idea of the appearance of the Old and New Testament enamels on the lost Saint-Denis crucifix. Universally admired, Mosan enamels and metalwork were instrumental in the development of the French Gothic figural style. The gold figures stand out vividly from the blue enamel background. The biblical actors twist and turn, make emphatic gestures, and wear garments almost overwhelmed by the intricate linear patterns of their folds.

Sculpted versions of the Klosterneuburg figures appear on the Shrine of the Three Kings (FIG. 13-45) in Cologne Cathedral. Nicholas of Verdun probably began work on the huge reliquary (six feet long and almost as tall) in 1190. Philip von Heinsberg, archbishop of Cologne from 1167 to 1191, commissioned the shrine to contain relics of the three magi. Holy Roman Emperor Frederick Barbarossa (r. 1155-1190) acquired them in the conquest of Milan in 1164 and donated them to the German cathedral. Possession of the magi's relics gave the Cologne archbishops the right to crown German kings. Nicholas's reliquary, made of silver and bronze with ornamentation in enamel and gemstones, is one of the most luxurious ever fashioned, especially considering its size. The shape resembles that of a basilican church. Repoussé figures of the Virgin Mary, the three magi, Old Testament prophets, and New Testament apostles in arcuated frames are variations of those on the Klosterneuburg pulpit. The deep channels and tight bunches of drapery folds are hallmarks of Nicholas's style.

The *Klosterneuburg Altar* and *Shrine of the Three Kings*, together with Suger's treatises on the furnishings of Saint-Denis, are welcome reminders of how magnificently outfitted medieval church interiors were. The sumptuous small-scale objects exhibited in the choir and chapels, which also housed the church's most precious relics, played a defining role in creating a special otherworldly atmosphere for Christian ritual. These Gothic examples continued a tradition dating to the Roman emperor Constantine and the first imperial patronage of Christianity (see Chapter 8).

STRASBOURG CATHEDRAL About the time Nicholas of Verdun was at work on the *Klosterneuburg Altar*, construction began on a new cathedral for Strasbourg in present-day France, then an important city in the German Rhineland ruled by the successors of the Ottonian dynasty. The apse, choir, and transepts, begun in

13-45 NICHOLAS OF VERDUN, Shrine of the Three Kings, from Cologne Cathedral, Cologne, Germany, begun ca. 1190. Silver, bronze, enamel, and gemstones, $5' 8'' \times 6' \times 3' 8''$. Dom Schatzkammer, Cologne.

Cologne's archbishop commissioned this huge reliquary in the shape of a church to house relics of the three magi. The deep channels of drapery folds are hallmarks of Nicholas's influential style.

1 f

~1176, were in place by around 1230. Stylistically, these sections of Strasbourg Cathedral are Romanesque. But the reliefs of the two south-transept portals are fully Gothic and reveal the same interest in the antique style as in contemporaneous French sculpture, especially that of Reims, as well as in the earlier work of Nicholas of Verdun. By the mid-13th century, artists throughout Europe were producing antique-looking statuary and relief sculpture.

The left tympanum (FIG. 13-46) presents *Death of the Virgin*. A comparison of the Strasbourg Mary on her deathbed with the Mary of the Reims *Visitation* group (FIG. 13-24, *right*) shows the stylistic kinship of the Strasbourg and Reims masters. The 12 apostles gather around the Virgin, forming an arc of mourners well suited to the semicircular frame. The sculptor adjusted the heights of the figures to fit the available space (the apostles at the right are the shortest)

13-46 Death of the Virgin, tympanum of the left doorway of the south transept, Strasbourg Cathedral, Strasbourg, France, ca. 1230.

Stylistically akin to the *Visitation* group (Fig. 13-24, *right*) of Reims Cathedral, the figures in Strasbourg's south-transept tympanum express profound sorrow through dramatic poses and gestures.

13-47 NAUMBURG MASTER, Crucifixion, west choir screen of Naumburg Cathedral, Naumburg, Germany, ca. 1249–1255. Painted limestone statues, life size.

The emotional pathos of the crucified Christ and the mourning Virgin and Saint John are characteristic of German medieval sculpture. The choir screen is also notable for its preserved coloration.

and, as in many depictions of crowds in the history of art, some of the figures have no legs or feet. At the center, Christ receives his mother's soul (the doll-like figure he holds in his left hand). Mary Magdalene, wringing her hands in grief, crouches beside the deathbed. The sorrowing figures express emotion in varying degrees of intensity, from serene resignation to gesturing agitation. The sculptor organized the group both by dramatic pose and gesture and by the rippling flow of deeply incised drapery passing among them like a rhythmic electric pulse. The sculptor's objective was to imbue the sacred figures with human emotions and to stir emotional responses in observers. In Gothic France, as already noted, art became increasingly humanized and natural. In the Holy Roman Empire, artists carried this humanizing trend even further by emphasizing passionate drama.

NAUMBURG CATHEDRAL During his tenure as bishop (1244–1272), Dietrich II of Wettin completed the rebuilding of the Romanesque cathedral at Naumburg in northern Germany. The church had two choirs, and the western choir, which Dietrich commissioned, was the most distinctive aspect of the project. The bishop built the choir as a memorial to 12 donors of the original 11th-century church. The artist who oversaw this project, known as the NAUMBURG MASTER, directed the team of sculptors responsible for the monumental screen (FIG. 13-47) that functioned

as a portal to the western choir. Based loosely on contemporaneous church portals having statues on the trumeau and jambs, the Naumburg screen includes life-size figures of Christ on the cross and of the distraught Virgin Mary and John the Evangelist. John, openly crying, turns his head away, unable to look at the suffering Christ. Mary also does not look at her son, but she faces and gestures toward the approaching worshipers, suggesting she can intercede on their behalf at the last judgment (compare FIG. 13-38B).

The heightened emotionalism of the Naumburg statues had been a persistent characteristic of German medieval art since the Ottonian era. Indeed, the crucified Christ in the Naumburg choir is the direct descendant of the Christ of the *Gero Crucifix* (FIG. 11-28). Like that earlier statue, these indoor sculptures have retained their color, whereas almost all the statues on church exteriors, exposed to sun and rain for centuries, have lost their original paint. The

Naumburg choir screen gives modern viewers an excellent idea of the original appearance of portal sculptures of Romanesque and Gothic churches.

EKKEHARD AND UTA Within the choir, the same workshop carved the statues of the 12 original donors, some of whom were the bishop's ancestors. Two of the figures (FIG. 13-48) stand out from the group of solemn men and women because of their exceptional quality. They represent the margrave (military governor) Ekkehard II of Meissen and his wife, Uta. The statues are attached to columns and stand beneath architectural canopies, following the pattern of French Gothic portal statuary, but they project from the architecture more forcefully and move more freely than contemporaneous French jamb figures. The period costumes and the individualized features and personalities of the margrave and his wife give the impression they posed for their own portraits, although

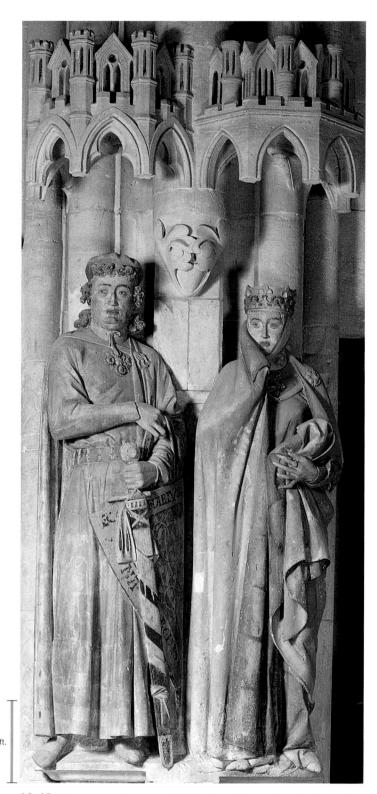

13-48 Naumburg Master, Ekkehard and Uta, statues in the west choir, Naumburg Cathedral, Naumburg, Germany, ca. 1249–1255. Painted limestone, Ekkehard 6′ 2″ high.

The period costumes and individualized features of these donor portraits give the impression Ekkehard and Uta posed for their statues, but they lived long before the Naumburg Master's time.

the subjects lived well before the Naumburg Master's time. Ekkehard, the intense knight, contrasts with the beautiful and aloof Uta. With a wonderfully graceful gesture, she draws the collar of her cloak partly across her face while she gathers up a soft fold of drapery with a jeweled, delicate hand. The sculptor subtly revealed the

13-49 Equestrian portrait (*Bamberg Rider*), statue in the east choir, Bamberg Cathedral, Germany, ca. 1235–1240. Sandstone, 7′ 9″ high.

Probably a portrait of a German emperor, perhaps Frederick II, the *Bamberg Rider* revives the imagery of the Carolingian Empire. The Frenchstyle architectural canopy cannot contain the statue.

shape of Uta's right arm beneath her cloak and rendered the fall of drapery folds with an accuracy suggesting the sculptor used a living model. The two statues are arresting images of real people, even if they bear the names of aristocrats the artist never met. By the mid-13th century, in the Holy Roman Empire as well as in England (FIG. 13-42A) and elsewhere, life-size images of secular personages had found their way into churches.

BAMBERG RIDER Somewhat earlier in date than the Naumburg donor figures is the Bamberg Rider (FIG. 13-49), the earliest preserved large-scale equestrian statue of the Middle Ages. For centuries, this statue has been mounted against a pier in Bamberg Cathedral beneath an architectural canopy that frames the rider's body but not his horse. Scholars debate whether the statue was made for this location or moved there, perhaps from the church's exterior. Whatever the statue's original location, it revives the imperial imagery of Byzantium (see "The Emperors of New Rome," Chapter 9, page 259) and the Carolingian Empire (FIG. 11-12), derived in turn from ancient Roman statuary (FIG. 7-59).

13-50 *Röttgen Pietà*, from the Rhineland, Germany, ca. 1300–1325. Painted wood, 2′ 10½″ high. Rheinisches Landemuseum, Bonn. ■ €

This statuette of the Virgin grieving over the distorted dead body of Christ in her lap reflects the increased interest in the 13th and 14th centuries in Jesus' suffering and the Virgin's grief.

Unlike Ekkehard and Uta, the *Bamberg Rider* seems to be a true portrait of a living person. Some art historians believe it represents a Holy Roman emperor, perhaps Frederick II (r. 1220– 1250), who was a benefactor of Bamberg Cathedral. The many other identifications include Saint George and one of the three magi, but a historical personality is most likely the subject. The placement of a portrait of a Holy Roman emperor in the cathedral would have underscored the unity of church and state in 13th-century Germany. The artist carefully represented the rider's costume, the high saddle, and the horse's trappings. The *Bamberg Rider* turns toward the observer, as if presiding at a review of troops. The torsion of this figure reflects the same impatience with subordination to architecture found in the sculptures of Naumburg Cathedral (FIGS. 13-47 and 13-48).

RÖTTGEN PIETÀ The confident 13th-century portraits at Naumburg and Bamberg stand in marked contrast to a haunting

14th-century German painted wooden statuette (FIG. 13-50) of the Virgin Mary holding the dead Christ in her lap. Like the *Crucifixion* (FIG. 13-47) of Naumburg's west choir, this *Pietà* (Italian, "pity" or "compassion") reflects the increased interest during the 13th and 14th centuries in humanizing biblical figures and in the suffering of Jesus and grief of his mother and followers. This expressed emotionalism accompanied the shift toward representation of the human body in motion. As the figures of the church portals began to twist on their columns, then move within their niches, and then stand independently, their details became more outwardly related to the human audience as indicators of recognizable human emotions.

The sculptor of the *Röttgen Pietà* (named after a collector) portrayed Christ as a stunted, distorted human wreck, stiffened in death and covered with streams of blood gushing from a huge wound. The Virgin, who cradles him as if he were a child in her lap, is the very image of maternal anguish, her oversized face twisted in an expression of unbearable grief. This statue expresses nothing of the serenity of Romanesque and earlier Gothic depictions of Mary (FIGS. 12-19 and 13-16). Nor does it have anything in common with the aloof, iconic images of the Theotokos with the infant Jesus in her lap common in Byzantine art (FIGS. 9-18 and 9-19). Here the artist forcibly confronts the devout with an appalling icon of agony, death, and sorrow. The work calls out to the horrified believer, "What is your suffering compared to this?"

COLOGNE CATHEDRAL The architecture of the Holy Roman Empire remained conservatively Romanesque well into the 13th century. In many German churches, the only Gothic feature was the rib vault, buttressed solely by the heavy masonry of the walls. By mid-century, though, the French Gothic style began to have a profound influence.

Cologne Cathedral (FIG. 13-51), begun in 1248 under the direction of Gerhard of Cologne, was not completed until more than 600 years later, making it one of the longest construction projects on record. Work halted entirely from the mid-16th to the mid-19th century, when church officials unexpectedly discovered the 14th-century design for the facade. *Gothic Revival* architects then completed the building according to the original plans, adding the nave, towers, and facade to the east end, which had stood alone for several centuries. The Gothic/Gothic Revival structure is the largest cathedral in northern Europe and boasts a giant (422-foot-long) nave (FIG. 13-52) with two aisles on each side.

The 150-foot-high 14th-century choir is a skillful variation of the Amiens Cathedral choir (FIGS. 13-20 and 13-21) design, with double lancets in the triforium and tall, slender single windows in the clerestory above and choir arcade below. Completed four decades after Gerhard's death but according to his plans, the choir expresses the Gothic quest for height even more emphatically than do many French Gothic buildings. Despite the cathedral's seeming lack of substance, proof of its stability came during World War II, when the city of Cologne suffered extremely heavy aerial bombardments. The church survived the war by virtue of its Gothic skeletal design. Once the first few bomb blasts blew out all of its windows, subsequent explosions had no adverse effects, and the skeleton remained intact and structurally sound.

SAINT ELIZABETH, MARBURG A different type of design, also probably of French origin (FIG. 12-17) but developed especially in Germany, is the *Hallenkirche* (hall church), in which the height of the aisles is the same as the height of the nave. Hall

13-51 GERHARD OF COLOGNE, aerial view of Cologne Cathedral (looking north), Cologne, Germany, begun 1248; nave, facade, and towers completed 1880.

Cologne Cathedral, the largest church in northern Europe, took more than 600 years to build. Only the east end dates to the 13th century. The 19th-century portions follow the original Gothic plans.

13-52 GERHARD OF COLOGNE, interior of Cologne Cathedral (looking east), Cologne, Germany. Choir completed 1322.

Cologne Cathedral's nave is 422 feet long. The 150-foot-high choir, a taller variation on the Amiens Cathedral choir (FIGS. 13-20 and 13-21), is a prime example of Gothic architects' quest for height.

13-53 Interior of Saint Elizabeth (looking west), Marburg, Germany, 1235–1283.

This German church is an early example of a Hallenkirche, in which the aisles are the same height as the nave. Because of the tall windows in the aisle walls, sunlight brightly illuminates the interior.

churches, consequently, have no tribune, triforium, or clerestory. An early German example of this type is the church of Saint Elizabeth (FIG. 13-53) at Marburg, built between 1235 and 1283. It incorporates French-inspired rib vaults with pointed arches and tall lancet windows. The facade has two spire-capped towers in the French manner but no tracery arcades or portal sculpture. Because the aisles provide much of the bracing for the nave vaults, the exterior of Saint Elizabeth is without the dramatic parade of flying buttresses typically circling French Gothic churches. But the Marburg interior, lighted by double rows of tall windows in the aisle walls, is more unified and free flowing, less narrow and divided, and more brightly illuminated than the interiors of most French and English Gothic churches.

HEINRICH AND PETER PARLER A later German hall church is the Heiligkreuzkirche (Church of the Holy Cross) at Schwäbisch Gmünd, begun in 1317 by HEINRICH PARLER (ca. 1290–ca. 1360). Heinrich was the founder of a family of architects who worked in Germany and later in northern Italy. His name first surfaces in the early 14th century, when he played a role in supervising the construction of Cologne Cathedral (FIGS. 13-51 and 13-52). Work continued on the Schwäbisch Gmünd church into the 16th century, but the nave was substantially complete when one of his sons, PETER PARLER (1330–1399), began work on the choir (FIG. 13-54) in 1351.

As in the nave of the church, the choir aisles are as tall as the central space. The light entering the choir through the large win-

13-54 Peter Parler, interior (looking east) of Heiligkreuzkirche (Church of the Holy Cross), Schwäbisch Gmünd, Germany, begun 1351.

As in the Gloucester choir (Fig. 13-42), the vaults of this German church are structurally simple but visually complex. The multiplication of ribs characterizes Late Gothic architecture throughout Europe.

dows in the aisle walls and in the chapels ringing the choir provides ample illumination for the clergy conducting services. It also enables worshipers to admire the elaborate patterns of the vault ribs. The multiplication of ribs in this German church is consistent with 14th-century taste throughout Europe and has parallels in the Flamboyant style of France and especially the Perpendicular style of England. As in the choir (FIG. 13-42) of Gloucester Cathedral, begun two decades before, the choir vaults at Schwäbisch Gmünd are structurally simple but visually complex. Parler's vaults form an elegant canopy for the severe columnar piers from which they spring, creating a very effective contrast.

One of Peter Parler's brothers, named Heinrich after their father, was also an architect. He was among those who formed a committee in 1386 to advise the Milanese on the design and construction of their new cathedral. The case of the Parler family is symptomatic both of the dramatic increase in the number of recorded names of artists and architects during the Gothic period, and of the international character of Gothic art and architecture, despite sometimes pronounced regional variations.

GOTHIC EUROPE

FRANCE

- I The birthplace of Gothic art and architecture was Saint-Denis, where Abbot Suger used rib vaults with pointed arches to rebuild the Carolingian royal church and filled the windows of the ambulatory with stained glass. On the west facade, Suger introduced sculpted figures on the portal jambs, a feature that appeared shortly later on the Royal Portal of Chartres Cathedral. Saint-Denis, the west facade of Chartres, and Laon Cathedral are the key monuments of Early Gothic (1140–1194) architecture.
- After a fire in 1194, Chartres Cathedral was rebuilt with flying buttresses, four-part nave vaults, and a three-story elevation of nave arcade, triforium, and clerestory. These features set the pattern for High Gothic (1194–1300) cathedrals. French architects sought to construct naves of soaring height. The vaults of Amiens Cathedral are 144 feet high.
- I Flying buttresses made possible huge stained-glass windows. High Gothic windows employed delicate lead cames and bar tracery. The colored glass converted natural sunlight into divine light (*lux nova*), dramatically transforming the character of church interiors.
- High Gothic jamb statues broke out of the architectural straitjacket of their Early Gothic predecessors. At Chartres, Reims, and elsewhere, the sculpted figures move freely and sometimes converse with their neighbors.
- The High Gothic Rayonnant court style of Louis IX gave way in the Late Gothic (1300–1500) period to the Flamboyant style, in which flamelike tracery formed brittle decorative webs, as at Saint-Maclou in Rouen.
- The prosperity of the era also led to a boom in secular architecture. Important examples are the fortified circuit wall of Carcassonne, the hall of the cloth guild in Bruges, and the house of the financier Jacques Coeur in Bourges.
- In the 13th century, Paris was the intellectual capital of Europe and home to numerous workshops of professional lay artists specializing in the production of luxurious illuminated manuscripts. These urban for-profit ancestors of modern publishing houses usurped the role of monastic scriptoria.

or-profit ancestors of modern publishing houses usurped the role of monastic scriptoria.

ENGLAND

- The Parisian Gothic style spread rapidly throughout Europe during the 13th century, but many regional styles developed, as in the Romanesque period. English Gothic churches, such as Salisbury Cathedral, differ from their French counterparts in their wider and shorter facades, flat east ends, double transepts, and sparing use of flying buttresses.
- Especially characteristic of English Gothic architecture is the elaboration of architectural patterns, which often disguise the underlying structure of the buildings. For example, the fan vaults of the chapel of Henry VII at Westminster Abbey in London transform the logical rib vaults of French buildings into decorative fancy in the Late Gothic Perpendicular style.

HOLY ROMAN EMPIRE

- Nicholas of Verdun was the leading artist of the Meuse River valley, an area renowned for enamel- and metalwork. Nicholas's altars and shrines provide an idea of the sumptuous nature of the furnishings of Gothic churches. His innovative figural style influenced the development of Gothic sculpture.
- German architects eagerly embraced the French Gothic architectural style at Cologne Cathedral and elsewhere. German originality manifested itself most clearly in the Gothic period in sculpture, which often featured emotionally charged figures in dramatic poses and also revived the art of portraiture. Statues of secular historical figures are key elements of the sculptural programs of Naumburg and Bamberg cathedrals.

Royal Portal, Chartres Cathedral, ca. 1145–1155

Amiens Cathedral, begun 1220

Psalter of Saint Louis 1253–1270

Salisbury Cathedral, Salisbury, 1220–1258

Nicholas of Verdun, Shrine of the Three Kings, ca. 1190

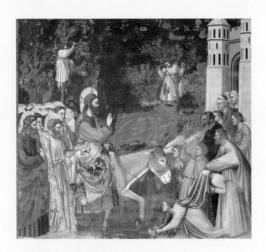

Giotto's cycle of biblical frescoes in the Arena Chapel includes 38 framed panels depicting the lives of the Virgin, her parents, and Jesus. The passion cycle opens with *Entry into Jerusalem*.

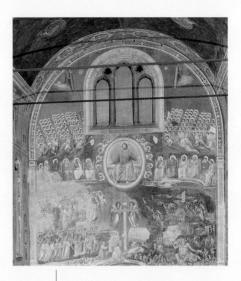

Giotto was a pioneer in pursuing a naturalistic approach to representation based on observation. In *Betrayal of Jesus*, he revived the classical tradition of depicting some figures from the rear.

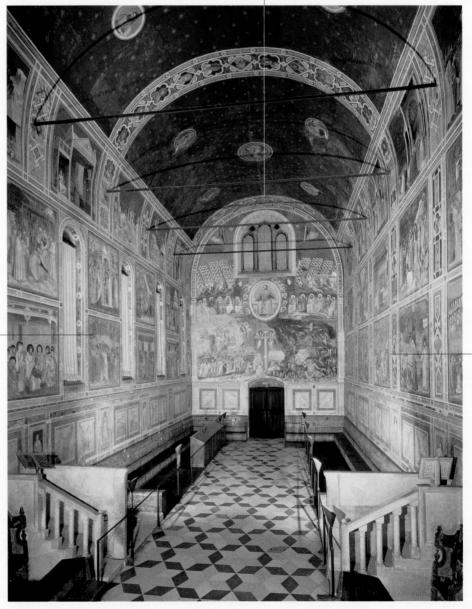

14-1 GIOTTO DI BONDONE, interior of the Arena Chapel (Cappella Scrovegni; looking west), Padua, Italy, 1305–1306.

14

Giotto was also a master of composition. In *Lamentation*, the rocky slope behind the figures leads the viewer's eye toward the heads of Mary and the dead Jesus at the lower left.

LATE MEDIEVAL ITALY

LATE MEDIEVAL OR PROTO-RENAISSANCE?

Art historians debate whether the art of Italy between 1200 and 1400 is the last phase of medieval art or the beginning of the rebirth, or *Renaissance*, of Greco-Roman *naturalism*. All agree, however, the pivotal figure of this age was the Florentine painter Giotto di Bondone (ca. 1266–1337), whose masterwork was the fresco cycle of the Arena Chapel (FIG. 14-1) in Padua. A banker, Enrico Scrovegni, built the chapel on a site adjacent to his palace in the hope it would expiate the moneylender's sin of usury. Consecrated in 1305, the chapel takes its name from an ancient Roman arena (*amphitheater*) nearby.

Some scholars have suggested Giotto himself may have been the chapel's architect, because its design so perfectly suits its interior decoration. The rectangular hall has only six windows, all in the south wall, leaving the other walls as almost unbroken and well-illuminated surfaces for painting. In 38 framed panels, Giotto presented the most poignant incidents from the lives of the Virgin and her parents, Joachim and Anna, in the top level, and, in the middle and lower levels, the life and mission (middle), and the passion and resurrection (bottom) of Jesus. The climactic event of the cycle of human salvation, *Last Judgment*, covers most of the west wall above the chapel's entrance.

The Entry into Jerusalem, Betrayal of Jesus, and Lamentation panels reveal the essentials of Giotto's style. In contrast to the common practice of his day, Giotto based his method of pictorial expression on observation of the natural world—the approach championed by the ancient Greeks and Romans but largely abandoned in the Middle Ages. Subtly scaled to the chapel's space, Giotto's stately and slow-moving half-life-size figures act out the religious dramas convincingly and with great restraint. The biblical actors are sculpturesque, simple, and weighty, often foreshortened (seen from an angle) and modeled with light and shading in the classical manner. They convey individual emotions through their postures and gestures. Giotto's naturalism displaced the Byzantine style in Italy (see Chapter 9), inaugurating an age some scholars call "early scientific." By stressing the preeminence of sight for gaining knowledge of the world, Giotto and his successors contributed to the foundation of empirical science. They recognized that the visual world must be observed before it can be analyzed and understood. Praised in his own and later times for his fidelity to nature, Giotto was more than a mere imitator of it. He showed his generation a new way of seeing. With Giotto, Western painters turned away from the spiritual world—the focus of medieval European artists—and once again moved resolutely toward the visible world as the inspiration for their art.

13TH CENTURY

When the Italian humanists of the 16th century condemned the art of the late Middle Ages in northern Europe as "Gothic" (see Chapter 13), they did so by comparing it with the contemporaneous art of Italy, which consciously revived classical* art. Italian artists and scholars regarded medieval artworks as distortions of the noble art of the Greeks and Romans. Interest in the art of classical antiquity was not entirely absent during the medieval period, however, even in France, the center of the Gothic style. For example, on the west front of Reims Cathedral, the 13th-century statues of Christian saints and angels (FIG. 13-24) reveal the unmistakable influence of ancient Roman art on French sculptors. However, the classical revival that took root in Italy during the 13th and 14th centuries was much more pervasive and longer-lasting.

Sculpture

Italian admiration for classical art surfaced early on at the court of Frederick II, king of Sicily (r. 1197–1250) and Holy Roman emperor (r. 1220–1250). Frederick's nostalgia for Rome's past grandeur fostered a revival of classical sculpture in Sicily and southern Italy not unlike the classical *renovatio* (renewal) Charlemagne encouraged in Germany and France four centuries earlier (see Chapter 11).

NICOLA PISANO The sculptor Nicola d'Apulia (Nicholas of Apulia), better known as NICOLA PISANO (active ca. 1258-1278) after his adopted city (see "Italian Artists' Names," page 405, and MAP 14-1), received his early training in southern Italy under Frederick's rule. In 1250, Nicola traveled northward and eventually settled in Pisa. Then at the height of its political and economic power, the maritime city was a magnet for artists seeking lucrative commissions. Nicola specialized in carving marble reliefs and ornamentation for large pulpits (raised platforms from which priests led church services), completing the first (FIG. 14-2) in 1260 for Pisa's century-old baptistery (FIG. 12-26, left). Some elements of the pulpit's design carried on medieval traditions—for example, the trefoil (triple-curved) arches and the lions supporting some of the columns—but Nicola also incorporated classical elements. The large capitals with two rows of thick overlapping leaves crowning the columns are a Gothic variation of the Corinthian capital (see page 151 and FIG. 5-73, or page xxii-xxiii in Volume II and Book D). The arches are round, as in Roman architecture, rather than pointed (ogival), as in Gothic buildings. Also, each of the large rectangular relief panels resembles the sculptured front of a Roman sarcophagus (coffin; for example, FIG. 7-70).

14-2 NICOLA PISANO, pulpit of the baptistery, Pisa, Italy, 1259–1260. Marble, 15′ high. ■

Nicola Pisano's Pisa baptistery pulpit retains many medieval features, for example, the trefoil arches and the lions supporting columns, but the figures derive from ancient Roman sarcophagus reliefs.

*In *Art through the Ages* the adjective "Classical," with uppercase *C*, refers specifically to the Classical period of ancient Greece, 480–323 BCE. Lowercase "classical" refers to Greco-Roman antiquity in general, that is, the period treated in Chapters 5, 6, and 7.

1400

LATE MEDIEVAL ITALY

1200

Bonaventura Berlinghieri and Cimabue are the leading painters working in the Italo-Byzantine style, or maniera

- Nicola and Giovanni Pisano, father and son, represent two contrasting sculptural styles, the classical and the Gothic respectively
- Fresco cycles in Rome and Assisi foreshadow the revolutionary art of Giotto
- I In Florence, Giotto, considered the first Renaissance artist, pioneers a naturalistic approach to painting based on

1300

observation

- In Siena, Duccio softens the maniera greca and humanizes religious subject matter
- Secular themes emerge as important subjects in civic commissions, as in the frescoes of Siena's Palazzo Pubblico
- Florence, Siena, and Orvieto build new cathedrals that are stylistically closer to Early Christian basilicas than to French Gothic cathedrals

1 ft.

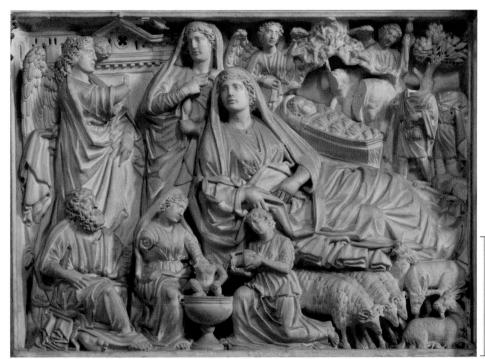

14-3 NICOLA PISANO, Annunciation, Nativity, and Adoration of the Shepherds, relief panel on the baptistery pulpit, Pisa, Italy, 1259–1260. Marble, $2'10'' \times 3'9''$.

Classical sculpture inspired the faces, beards, coiffures, and draperies, as well as the bulk and weight of Nicola's figures. The *Nativity* Madonna resembles lid figures on Roman sarcophagi.

1 ft.

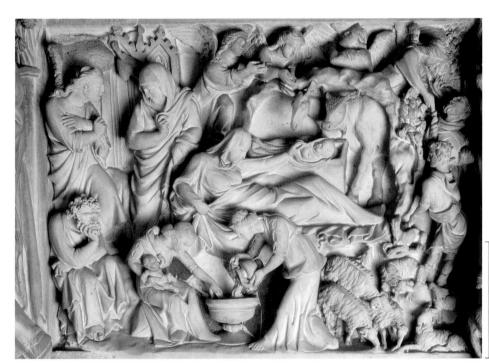

14-4 GIOVANNI PISANO, Annunciation, Nativity, and Adoration of the Shepherds, relief panel on the pulpit of Sant'Andrea, Pistoia, Italy, 1297–1301. Marble, 2' 10" × 3' 4".

The French Gothic style had a greater influence on Giovanni Pisano, Nicola's son. Giovanni arranged his figures loosely and dynamically. They display a nervous agitation, as if moved by spiritual passion.

1 f

The densely packed large-scale figures of the individual panels also seem to derive from the compositions found on Roman sarcophagi. One of these panels (FIG. 14-3) depicts scenes from the infancy cycle of Christ (see "The Life of Jesus in Art," Chapter 8, pages 240–241, or pages xxx–xxxi, in Volume II and Book D), including Annunciation (top left), Nativity (center and lower half), and Adoration of the Shepherds (top right). Mary appears twice, and her size varies. The focus of the composition is the reclining Virgin of Nativity, whose posture and drapery are reminiscent of those of the lid figures on Etruscan (FIGS. 6-5 and 6-15) and Roman (FIG. 7-61) sarcophagi. The face types, beards, and coiffures, as well as the bulk and weight of Nicola's figures, also reveal the influence of classical relief sculpture. Art historians have even been able to pinpoint the models of some of the pulpit figures on Roman sarcophagi in Pisa.

GIOVANNI PISANO Nicola's son, Giovanni Pisano (ca. 1250–1320), likewise became a sought-after sculptor of church pulpits. Giovanni's pulpit in Sant'Andrea at Pistoia also has a panel (Fig. 14-4) featuring *Nativity* and related scenes. The son's version of the subject offers a striking contrast to his father's thick carving and placid, almost stolid presentation of the religious narrative. Giovanni arranged the figures loosely and dynamically. They twist and bend in excited animation, and the deep spaces between them suggest their motion. In *Annunciation* (top left), the Virgin shrinks from the angel's sudden appearance in a posture of alarm touched with humility. The same spasm of apprehension contracts her supple body as she reclines in *Nativity* (center). The drama's principals share in a peculiar nervous agitation, as if spiritual passion suddenly moves all of them. Only the shepherds and the sheep (right)

The Great Schism, Mendicant Orders, and Confraternities

n 1305, the College of Cardinals (the L collective body of all cardinals) elected a French pope, Clement V (r. 1305-1314), who settled in Avignon. Subsequent French popes remained in Avignon, despite their announced intentions to return to Rome. Understandably, the Italians, who saw Rome as the rightful capital of the universal Church, resented the Avignon papacy. The conflict between the French and Italians resulted in the election in 1378 of two popes-Clement VII, who resided in Avignon (and who does not appear in the Catholic Church's official list of popes), and Urban VI (r. 1378-1389), who remained in Rome. Thus began what

14-5 BONAVENTURA BERLINGHIERI, Saint Francis Altarpiece, San Francesco, Pescia, Italy, 1235. Tempera on wood, $5' \times 3' \times 6'$.

Berlinghieri painted this altarpiece in the Italo-Byzantine style, or maniera greca, for the mendicant (begging) order of Franciscans. It is the earliest known representation of Saint Francis of Assisi.

became known as the Great Schism. After 40 years, Holy Roman Emperor Sigismund (r. 1410–1437) convened a council that resolved this crisis by electing a new Roman pope, Martin V (r. 1417–1431), who was acceptable to all.

The pope's absence from Italy during much of the 14th century contributed to an increase in prominence of monastic orders. The Augustinians, Carmelites, and Servites became very active, ensuring a constant religious presence in the daily life of Italians, but the largest and most influential monastic orders were the mendicants (begging friars)—the Franciscans, founded by Francis of Assisi (FIG. 14-5), and the Dominicans, founded by the Spaniard Dominic de Guzman (ca. 1170-1221). These mendicants renounced all worldly goods and committed themselves to spreading God's word, performing good deeds, and ministering to the sick and dying. The Dominicans, in particular, contributed significantly to establishing urban educational institutions. The Franciscans and Dominicans became very popular in Italy because of their devotion to their faith and the more personal relationship with God they encouraged. Although both mendicant orders worked for the glory of God, a degree of rivalry nevertheless existed between the two. For example, in Florence they established their churches on opposite sides of the city—Santa Croce (FIG. 1-4), the Franciscan church, on the eastern side, and the Dominicans' Santa Maria Novella (FIG. 14-6A) on the western (MAP 21-1).

1 ft

Confraternities, organizations consisting of laypersons who dedicated themselves to strict religious observance, also grew in popularity during the 14th and 15th centuries. The mission of confraternities included tending the sick, burying the dead, singing hymns, and performing other good works. The confraternities as well as the mendicant orders continued to play an important role in Italian religious life through the 16th century. The numerous artworks and monastic churches they commissioned have ensured their enduring legacy.

do not yet share in the miraculous event. The swiftly turning, sinuous draperies, the slender figures they enfold, and the general emotionalism of the scene are features not found in Nicola Pisano's interpretation. The father worked in the classical tradition, the son in a style derived from French Gothic. These styles were two of the three most important ingredients in the formation of the distinctive and original art of 14th-century Italy.

Painting and Architecture

The third major stylistic element in late medieval Italian art was the Byzantine tradition (see Chapter 9). Throughout the Middle Ages, the Byzantine style dominated Italian painting, but its influence

was especially strong after the fall of Constantinople in 1204, which precipitated a migration of Byzantine artists to Italy.

BONAVENTURA BERLINGHIERI One of the leading painters working in the Italo-Byzantine style, or *maniera greca* (Greek style), was Bonaventura Berlinghieri (active ca. 1235–1244) of Lucca. His most famous work is the *Saint Francis Altarpiece* (Fig. 14-5) in the church of San Francesco (Saint Francis) in Pescia. Painted in 1235 using *tempera* on wood panel (see "Tempera and Oil Painting," Chapter 20, page 539), the *altarpiece* honors Saint Francis of Assisi (ca. 1181–1226), whose most important shrine (Fig. 14-5A), at Assisi itself, boasts the most extensive cycle of

Italian Artists' Names

In contemporary societies, people have become accustomed to a standardized method of identifying individuals, in part because of the proliferation of official documents such as driver's licenses, passports, and student identification cards. Modern names consist of given names (names selected by the parents) and family names, although the order of the two (or more) names varies from country to country. In China, for example, the family name precedes the given name (see Chapters 16 and 33).

This kind of regularity in names was not, however, the norm in premodern Italy. Many individuals were known by their place of birth or adopted hometown. Nicola Pisano (FIGS. 14-2 and 14-3) was "Nicholas the Pisan," Giulio Romano was "Julius the Roman," and Domenico Veneziano was "the Venetian." Leonardo da Vinci ("Leonard from Vinci") hailed from the small town of Vinci, near Florence (MAP 14-1). Art historians therefore refer to these artists by their given names, not the names of their towns. (The title of Dan Brown's best-selling novel should have been *The Leonardo Code*, not *The Da Vinci Code*.)

Nicknames were also common. Giorgione was "Big George." People usually referred to Tommaso di Cristoforo Fini as Masolino ("Little Thomas") to distinguish him from his more famous pupil, Masaccio ("Brutish Thomas"). Guido di Pietro was called Fra Angelico (the Angelic Friar). Cenni di Pepo is remembered as Cimabue (FIG. 14-6), which means "bull's head."

Names were also impermanent and could be changed at will. This flexibility has resulted in significant challenges for historians, who often must deal with archival documents and records referring to the same artist by different names.

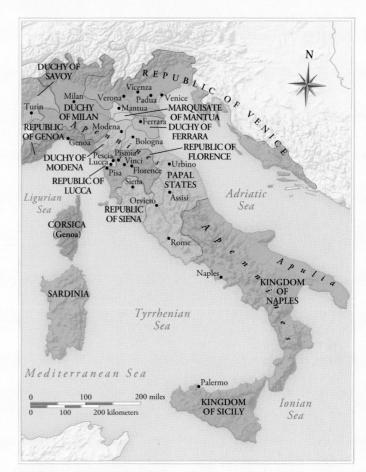

MAP 14-1 Italy around 1400.

14-5A San Francesco, Assisi, 1228–1253.

14-5B St. Francis Master, *Preaching to the Birds*, ca. 1290–1300.

frescoes from 13th-century Italy. Berlinghieri depicted Francis wearing the costume later adopted by all Franciscan monks: a coarse clerical robe tied at the waist with a rope. The saint displays the stigmata—marks resembling Christ's wounds-that miraculously appeared on his hands and feet. Flanking Francis are two angels, whose frontal poses, prominent halos, and lack of modeling reveal the Byzantine roots of Berlinghieri's style. So, too, does the use of *gold leaf* (gold beaten into tissue-paper-thin sheets, then applied to surfaces), which emphasizes the image's flatness and spiritual nature. The narrative scenes along the sides of the panel provide an active contrast to the stiff formality of the large central image of Francis. At the upper left, taking pride of place at the saint's right, Francis receives the stigmata. Directly below, the saint preaches to the birds, a subject that

also figures prominently in the fresco program (FIG. 14-5B) of San Francesco at Assisi, the work of a painter art historians call the SAINT FRANCIS MASTER. These and the scenes depicting Francis's

miracle cures strongly suggest Berlinghieri's source was one or more Byzantine *illuminated manuscripts* (compare FIG. 9-17) with biblical narrative scenes.

Berlinghieri's Saint Francis Altarpiece also highlights the increasingly prominent role of religious orders in late medieval Italy (see "The Great Schism, Mendicant Orders, and Confraternities," page 404). Saint Francis's Franciscan order worked diligently to impress on the public the saint's valuable example and to demonstrate the order's commitment to teaching and to alleviating suffering. Berlinghieri's Pescia altarpiece, painted only nine years after Francis's death, is the earliest known signed and dated representation of the saint. Appropriately, Berlinghieri's panel focuses on the aspects of the saint's life the Franciscans wanted to promote, thereby making visible (and thus more credible) the legendary life of this holy man. Saint Francis believed he could get closer to God by rejecting worldly goods, and to achieve this he stripped himself bare in a public square and committed himself to a strict life of fasting, prayer, and meditation. His followers considered the appearance of stigmata on Francis's hands and feet (clearly visible in the saint's frontal image, which resembles a Byzantine icon) as God's blessing, and viewed Francis as a second Christ. Fittingly, four of the six narrative scenes on the altarpiece depict miraculous healings, connecting Saint Francis even more emphatically to Christ.

14-6 CIMABUE, *Madonna Enthroned with Angels and Prophets*, from Santa Trinità, Florence, ca. 1280–1290. Tempera and gold leaf on wood, 12′ 7″ × 7′ 4″. Galleria degli Uffizi, Florence. ■

Cimabue was one of the first artists to break away from the maniera greca. Although he relied on Byzantine models, Cimabue depicted the Madonna's massive throne as receding into space.

14-6A Santa Maria Novella, Florence, begun ca. 1246. ■◀

CIMABUE One of the first artists to break from the Italo-Byzantine style that dominated 13th-century Italian painting was Cenni di Pepo, better known as CIMABUE (ca. 1240–1302). Cimabue challenged some of the major conventions of late medieval art in pursuit of a new naturalism, the close observation of the natural world—the core of the classical tradition. He painted *Madonna Enthroned with Angels and Prophets* (FIG. 14-6) for Santa Trinità (Holy Trinity) in Florence, the Benedictine

church near the Arno River built between 1258 and 1280, roughly contemporaneous with the Dominican church of Santa Maria Novella (FIG. 14-6A). The composition and the gold background reveal the painter's reliance on Byzantine models (compare FIG. 9-18).

Cimabue also used the gold embellishments common to Byzantine art for the folds of the Madonna's robe, but they are no longer merely decorative patterns. In his panel they enhance the three-dimensionality of the drapery. Furthermore, Cimabue constructed a deeper space for the Madonna and the surrounding figures to inhabit than was common in Byzantine art. The Virgin's throne, for example, is a massive structure and Cimabue convincingly depicted it as receding into space. The overlapping bodies of the angels on each side of the throne and the half-length prophets who look outward or upward from beneath it reinforce the sense of depth.

14TH CENTURY

In the 14th century, Italy consisted of numerous independent *city-states*, each corresponding to a geographic region centered on a major city (MAP 14-1). Most of the city-states, such as Venice, Florence, Lucca, and Siena, were republics—constitutional oligarchies governed by executive bodies, advisory councils, and special commissions. Other powerful 14th-century states included the Papal States, the Kingdom of Naples, and the Duchies of Milan, Modena, Ferrara, and Savoy. As their names indicate, these states were politically distinct from the republics, but all the states shared in the prosperity of the period. The sources of wealth varied from state to state. Italy's port cities expanded maritime trade, whereas the economies of other cities depended on banking or the manufacture of arms or textiles.

The outbreak of the Black Death (bubonic plague) in the late 1340s threatened this prosperity, however. Originating in China, the Black Death swept across Europe. The most devastating natural disaster in European history, the plague eliminated between 25 and 50 percent of the Continent's population in about five years. The Black Death devastated Italy's inhabitants. In large Italian cities, where people lived in relatively close proximity, the death tolls climbed as high as 50 to 60 percent of the population. The bubonic plague had a significant effect on art. It stimulated religious bequests and encouraged the commissioning of devotional images. The focus on sickness and death also led to a burgeoning in hospital construction.

Another significant development in 14th-century Italy was the blossoming of a vernacular (commonly spoken) literature, which dramatically affected Italy's intellectual and cultural life. Latin remained the official language of Church liturgy and state documents. However, the creation of an Italian vernacular literature (based on the Tuscan dialect common in Florence) expanded the audience for philosophical and intellectual concepts because of its greater accessibility. Dante Alighieri (1265–1321, author of *The Divine Comedy*), the poet and scholar Francesco Petrarch (1304–1374), and Giovanni Boccaccio (1313–1375, author of *Decameron*) were most responsible for establishing this vernacular literature.

RENAISSANCE HUMANISM The development of a vernacular literature was one important sign that the essentially religious view of the world dominating medieval Europe was about to change dramatically in what historians call the *Renaissance*. Although religion continued to occupy a primary position in the lives of Europeans, a growing concern with the natural world, the individual, and humanity's worldly existence characterized the Renaissance period—the 14th through the 16th centuries. The word *renaissance* in French and English (*rinascità* in Italian) refers to a "rebirth" of art and culture. A revived interest in classical cultures—indeed, the veneration of classical antiquity as a model—was central to this rebirth. The notion of the Renaissance representing the restoration of the

glorious past of Greece and Rome gave rise to the concept of the "Middle Ages" as the era falling between antiquity and the Renaissance. The transition from the medieval to the Renaissance, though dramatic, did not come about abruptly, however. In fact, much that is medieval persisted in the Renaissance and in later periods.

Fundamental to the development of the Italian Renaissance was humanism, which emerged during the 14th century and became a central component of Italian art and culture in the 15th and 16th centuries. Humanism was more a code of civil conduct, a theory of education, and a scholarly discipline than a philosophical system. As their name suggests, Italian humanists were concerned chiefly with human values and interests as distinct from—but not opposed to-religion's otherworldly values. Humanists pointed to classical cultures as particularly praiseworthy. This enthusiasm for antiquity, represented by the elegant Latin of Cicero (106-43 BCE) and the Augustan age, involved study of Latin literature and a conscious emulation of what proponents believed were the Roman civic virtues. These included self-sacrificing service to the state, participation in government, defense of state institutions (especially the administration of justice), and stoic indifference to personal misfortune in the performance of duty. With the help of a new interest in and knowledge of Greek, the humanists of the late 14th and 15th centuries recovered a large part of Greek as well as Roman literature and philosophy that had been lost, left unnoticed, or cast aside in the Middle Ages. Indeed, classical cultures provided humanists with a model for living in this world, a model primarily of human focus derived not from an authoritative and traditional religious dogma but from reason.

Ideally, humanists sought no material reward for services rendered. The sole reward for heroes of civic virtue was fame, just as the reward for leaders of the holy life was sainthood. For the educated, the lives of heroes and heroines of the past became as edifying as the lives of the saints. Petrarch wrote a book on illustrious men, and his colleague Boccaccio complemented it with 106 biographies of famous women—from Eve to Joanna, queen of Naples (r. 1343–1382). Both Petrarch and Boccaccio were famous in their own day as poets, scholars, and men of letters—their achievements equivalent in honor to those of the heroes of civic virtue. In 1341 in Rome, Petrarch received the laurel wreath crown, the ancient symbol of victory and merit. The humanist cult of fame emphasized the importance of creative individuals and their role in contributing to the renown of the city-state and of all Italy.

Giotto

14-6B CAVALLINI, Last Judgment, ca. 1290–1295.

Critics from Giorgio Vasari[†] to the present day have regarded Giotto di Bondone (FIG. 14-1) as the first Renaissance painter. A pioneer in pursuing a naturalistic approach to representation based on observation, he made a much more radical break with the past than did Cimabue, whom Vasari identified as Giotto's

teacher. Scholars still debate the sources of Giotto's style, however. One formative influence must have been Cimabue's work,

[†]Giorgio Vasari (1511–1574) was both a painter and an architect. Today, however, people associate him primarily with his landmark book, *Lives of the Most Eminent Painters, Sculptors, and Architects*, first published in 1550. Despite inaccuracies, Vasari's *Lives* is an invaluable research tool. It is the major contemporaneous source of information about Italian Renaissance art and artists.

although Vasari lauded Giotto as having eclipsed his master by abandoning the "crude maniera greca." The 13th-century *murals* of San Francesco at Assisi (FIGS. 14-5A and 14-5B) and those of PIETRO CAVALLINI (ca. 1240–ca. 1340) in Rome (FIG. 14-6B) may also have influenced the young Giotto. French Gothic sculpture (which Giotto may have seen but which was certainly familiar to him from the work of Giovanni Pisano, who had spent time in Paris) and ancient Roman art probably also contributed to Giotto's artistic education. Yet no mere synthesis of these varied influences could have produced the significant shift in artistic approach that has led some scholars to describe Giotto as the father of Western pictorial art. Renowned in his own day, his reputation has never faltered. Regardless of the other influences on his artistic style, his true teacher was nature—the world of visible things.

MADONNA ENTHRONED On nearly the same great scale as Cimabue's enthroned Madonna (FIG. 14-6) is Giotto's panel (FIG. 14-7) depicting the same subject, painted for the high altar

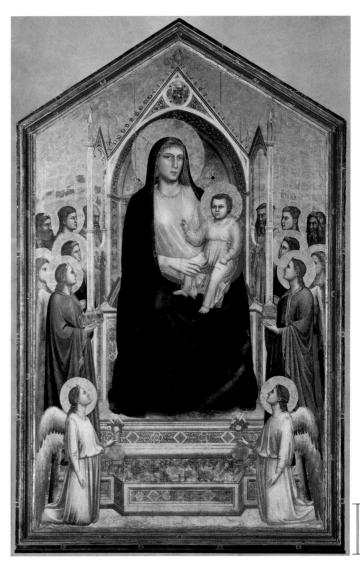

14-7 GIOTTO DI BONDONE, *Madonna Enthroned*, from the Church of Ognissanti, Florence, ca. 1310. Tempera and gold leaf on wood, 10' 8" \times 6' 8". Galleria degli Uffizi, Florence.

Giotto displaced the Byzantine style in Italian painting and revived classical naturalism. His figures have substance, dimensionality, and bulk, and give the illusion they could throw shadows.

resco painting has a long history, particularly in the Mediterranean region, where the Minoans (FIGS. 4-7 to 4-9B) used it as early as the 17th century BCE. Fresco (Italian for "fresh") is a mural-painting technique involving the application of permanent limeproof pigments, diluted in water, on freshly laid lime plaster. Because the surface of the wall absorbs the pigments as the plaster dries, fresco is one of the most durable painting techniques. The stable condition of the ancient Minoan frescoes, as well as those found at Pompeii and other Roman sites (FIGS. 7-17 to 7-26), in San Francesco (FIGS. 14-5A and 14-5B) at Assisi, and in the Arena Chapel (FIGS. 14-1 and 14-8 to 14-8B) at Padua, testify to the longevity of this painting method. The colors have remained vivid (although dirt and soot have necessitated cleaning-most famously in the Vatican's Sistine Chapel; FIG. 22-18B) because of the chemically inert pigments the artists used. In addition to this buon fresco (good, that is, true fresco) technique, artists used fresco secco (dry fresco). Fresco secco involves painting on dried lime plaster, the method the ancient Egyptians favored (FIGS. 3-28 and 3-29). Although the finished product visually approximates buon fresco, the plaster wall does not absorb the pigments, which simply adhere to the surface, so fresco secco is not as permanent as buon fresco.

The buon fresco process is time-consuming and demanding and requires several layers of plaster. Although buon fresco methods vary,

generally the artist prepares the wall with a rough layer of lime plaster called the *arriccio* (brown coat). The artist then transfers the composition to the wall, usually by drawing directly on the arriccio with a burnt-orange pigment called *sinopia* (most popular during the 14th century), or by transferring a *cartoon* (a full-size preparatory drawing). Cartoons increased in usage in the 15th and 16th centuries, largely replacing sinopia underdrawings. Finally, the painter lays the *intonaco* (painting coat) smoothly over the drawing in sections (called *giornate*—Italian for "days") only as large as the artist expects to complete in that session. (In Giotto's *Lamentation*

Fresco Painting

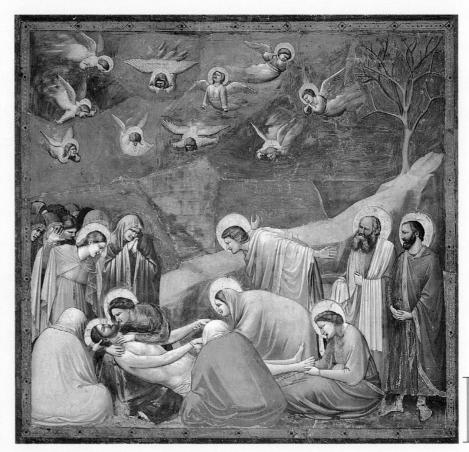

14-8 Giotto di Bondone, *Lamentation*, Arena Chapel (Cappella Scrovegni), Padua, Italy, ca. 1305. Fresco, 6' $6\frac{3}{4}'' \times 6' \frac{3}{4}''$.

Giotto painted *Lamentation* in several sections, each corresponding to one painting session. Artists employing the buon fresco technique must complete each section before the plaster dries.

[FIG. 14-8], the giornate are easy to distinguish.) The buon fresco painter must apply the colors quickly, because once the plaster is dry, it will no longer absorb the pigment. Any unpainted areas of the intonaco after a session must be cut away so that fresh plaster can be applied for the next giornata.

In areas of high humidity, such as Venice, fresco was less appropriate because moisture is an obstacle to the drying process. Over the centuries, fresco became less popular, although it did experience a revival in the 1930s with the Mexican muralists (FIGS. 29-73 and 29-74).

of Florence's Church of the Ognissanti (All Saints). Although still portrayed against the traditional gold background, Giotto's Madonna rests within her Gothic throne with the unshakable stability of an ancient marble goddess (compare FIG. 7-30). Giotto replaced Cimabue's slender Virgin, fragile beneath the thin ripplings of her drapery, with a weighty, queenly mother. In Giotto's painting, the Madonna's body is not lost—indeed, it is asserted. Giotto even showed Mary's breasts pressing through the thin fabric of her white

undergarment. Gold highlights have disappeared from her heavy robe. Giotto aimed instead to construct a figure with substance, dimensionality, and bulk—qualities suppressed in favor of a spiritual immateriality in Byzantine and Italo-Byzantine art. Works painted in the new style portray statuesque figures projecting into the light and giving the illusion they could throw shadows. Giotto's *Madonna Enthroned* marks the end of medieval painting in Italy and the beginning of a new naturalistic approach to art.

14-8А GIOTTO, Entry into Jerusalem, са. 1305.

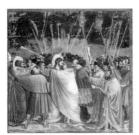

14-8В GIOTTO, Betrayal of Jesus, ca. 1305.

ARENA CHAPEL Projecting on a flat surface the illusion of solid bodies moving through space presents a double challenge. Constructing the illusion of a weighty, three-dimensional body also requires constructing the illusion of a space sufficiently ample to contain that body. In his fresco cycles (see "Fresco Painting," page 408), Giotto constantly strove to reconcile these two aspects of illusionistic painting. His murals in Enrico Scrovegni's Arena Chapel (FIG. 14-1) at Padua show his art at its finest. In 38 framed scenes (FIGS. 14-8, 14-8A, and 14-8B), Giotto presented one of the most impressive and complete Christian pictorial cycles ever rendered. The narrative unfolds on the north and south walls in three zones, reading from top to bottom. Be-

low, imitation marble veneer—reminiscent of ancient Roman decoration (FIG. 7-51), which Giotto may have seen—alternates with personified Virtues and Vices painted in *grisaille* (monochrome grays, often used for modeling in paintings) to resemble sculpture. On the west wall above the chapel's entrance is Giotto's dramatic *Last Judgment*, the culminating scene also of Pietro Cavallini's late-13th-century fresco cycle (FIG. 14-6B) in Santa Cecilia in Trastevere in Rome. The chapel's vaulted ceiling is blue, an azure sky dotted with golden stars symbolic of Heaven. Medallions bearing images of Christ, Mary, and various prophets also appear on the vault. Giotto painted the same blue in the backgrounds of the narrative panels on the walls below. The color thereby functions as a unifying agent for the entire decorative scheme.

The panel in the lowest zone of the north wall, Lamentation (FIG. 14-8), illustrates particularly well the revolutionary nature of Giotto's style. In the presence of boldly foreshortened angels, seen head-on with their bodies receding into the background and darting about in hysterical grief, a congregation mourns over the dead Savior just before his entombment. Mary cradles her son's body, while Mary Magdalene looks solemnly at the wounds in Christ's feet and Saint John the Evangelist throws his arms back dramatically. Giotto arranged a shallow stage for the figures, bounded by a thick diagonal rock incline defining a horizontal ledge in the foreground. Though narrow, the ledge provides firm visual support for the figures. The rocky setting recalls the landscape of a 12thcentury Byzantine mural (FIG. 9-29) at Nerezi in Macedonia. Here, the steep slope leads the viewer's eye toward the picture's dramatic focal point at the lower left. The postures and gestures of Giotto's figures convey a broad spectrum of grief. They range from Mary's almost fierce despair to the passionate outbursts of Mary Magdalene and John to the philosophical resignation of the two disciples at the right and the mute sorrow of the two hooded mourners in the foreground. In Lamentation, a single event provokes a host of individual responses in figures that are convincing presences both physically and psychologically. Painters before Giotto rarely attempted, let alone achieved, this combination of naturalistic representation, compositional complexity, and emotional resonance.

The formal design of the *Lamentation* fresco—the way Giotto grouped the figures within the constructed space—is worth close study. Each group has its own definition, and each contributes to

the rhythmic order of the composition. The strong diagonal of the rocky ledge, with its single dead tree (the tree of knowledge of good and evil, which withered after Adam and Eve's original sin), concentrates the viewer's attention on the heads of Christ and his mother, which Giotto positioned dynamically off center. The massive bulk of the seated mourner in the painting's left corner arrests and contains all movement beyond Mary and her dead son. The seated mourner to the right establishes a relation with the center figures, who, by gazes and gestures, draw the viewer's attention back to Christ's head. Figures seen from the back, which are frequent in Giotto's compositions (compare FIG. 14-8B), represent an innovation in the development away from the formal Italo-Byzantine style. These figures emphasize the foreground, aiding the visual placement of the intermediate figures farther back in space. This device, the very contradiction of Byzantine frontality, in effect puts viewers behind the "observer figures," who, facing the action as spectators, reinforce the sense of stagecraft as a model for painting.

Giotto's new devices for depicting spatial depth and body mass could not, of course, have been possible without his management of light and shade. He shaded his figures to indicate both the direction of the light illuminating their bodies and the shadows (the diminished light), thereby giving the figures volume. In *Lamentation*, light falls upon the upper surfaces of the figures (especially the two central bending figures) and passes down to dark in their garments, separating the volumes one from the other and pushing one to the fore, the other to the rear. The graded continuum of light and shade, directed by an even, neutral light from a single steady source—not shown in the picture—was the first step toward the development of *chiaroscuro* (the use of contrasts of dark and light to produce modeling) in later Renaissance painting (see Chapter 21).

The stagelike settings made possible by Giotto's innovations in perspective (the depiction of three-dimensional objects in space on a two-dimensional surface) and lighting suited perfectly the dramatic narrative the Franciscans emphasized then as a principal method for educating the faithful in their religion. In this new age of humanism, the old stylized presentations of the holy mysteries had evolved into mystery plays. Actors extended the drama of the Mass into one- and two-act tableaus and scenes and then into simple narratives offered at church portals and in city squares. (Eventually, confraternities also presented more elaborate religious dramas called sacre rappresentazioni—holy representations.) The great increase in popular sermons to huge city audiences prompted a public taste for narrative, recited as dramatically as possible. The arts of illusionistic painting, of drama, and of sermon rhetoric with all their theatrical flourishes developed simultaneously and were mutually influential. Giotto's art masterfully synthesized dramatic narrative, holy lesson, and truth to human experience in a visual idiom of his own invention, accessible to all. Not surprisingly, Giotto's frescoes served as textbooks for generations of Renaissance painters.

Siena

Among 14th-century Italian city-states, the Republics of Siena and Florence were the most powerful. Both were urban centers of bankers and merchants with widespread international contacts and large sums available for the commissioning of artworks (see "Artists' Guilds, Artistic Commissions, and Artists' Contracts," page 410).

Artists' Guilds, Artistic Commissions, and Artists' Contracts

The structured organization of economic activity during the 14th century, when Italy had established a thriving international trade and held a commanding position in the Mediterranean world, extended to many trades and professions. *Guilds* (associations of master craftspeople, apprentices, and tradespeople), which had emerged during the 12th century, became prominent. These associations not only protected members' common economic interests against external pressures, such as taxation, but also provided them with the means to regulate their internal operations (for example, work quality and membership training).

Because of today's international open art market, the notion of an "artists' union" may seem strange. The general public tends to think of art as the creative expression of an individual artist. However, artists did not always enjoy this degree of freedom. Historically, they rarely undertook major artworks without receiving a specific commission. The patron contracting for the artist's services could be a civic group, religious entity, private individual, or even the artists' guild itself. Guilds, although primarily business organizations, contributed to their city's religious and artistic life by subsidizing the building and decoration of numerous churches and hospitals. For example, the wool manufacturers' guild oversaw the start of Florence Cathedral (FIGS. 14-18 and 14-18A) in 1296, and the wool merchants' guild supervised the completion of its dome (FIG. 21-30A). The guild of silk manufacturers and goldsmiths provided the funds to build Florence's foundling hospital, the Ospedale degli Innocenti (FIG. 21-31).

Monastic orders, confraternities, and the popes were also major art patrons. In addition, wealthy families and individuals—for example, the Paduan banker Enrico Scrovegni (FIG. 14-1)—commissioned artworks for a wide variety of reasons. Besides the aesthetic pleasure these patrons derived from art, the images often also served as testaments to the patron's piety, wealth, and stature. Because artworks during this period were the product of service contracts, a patron's needs or wishes played a crucial role in the final form of any painting, sculpture, or building. Some early contracts between patrons and artists still exist. Patrons normally asked artists to submit drawings or models for approval, and they expected the artists they hired to adhere closely to the approved designs. The contracts usually stipulated certain conditions, such as the insistence on the artist's own hand in the production of the work, the quality of pigment and amount of gold or other precious items to be used, completion date, payment terms, and penalties for failure to meet the contract's terms.

A few extant 13th- and 14th-century painting contracts are especially illuminating. Although they may specify the subject to be represented, these binding legal documents always focus on the financial aspects of the commission and the responsibilities of the painter to the patron (and vice versa). In a contract dated November 1, 1301, between Cimabue (FIG. 14-6) and another artist and the Hospital of Santa Chiara in Pisa, the artists agree to supply an altarpiece

with colonnettes, tabernacles, and predella, painted with histories of the divine majesty of the Blessed Virgin Mary, of the apostles,

of the angels, and with other figures and pictures, as shall be seen fit and shall please the said master of or other legitimate persons for the hospital.*

Other terms of the Santa Chiara contract specify the size of the panel and require the artists to use gold and silver gilding for parts of the altarpiece.

The contract for the construction of an altarpiece was usually a separate document, because it necessitated employing the services of a master carpenter. For example, on April 15, 1285, the leading painter of Siena, Duccio di Buoninsegna (FIGS. 14-9 to 14-11), signed a contract with the rectors of the Confraternity of the Laudesi, the lay group associated with the Dominican church of Santa Maria Novella (FIG. 14-6A) in Florence. The contract specified only that Duccio was to provide the painting, not its frame—and it imposed conditions the painter had to meet if he was to be paid.

[The rectors] promise . . . to pay the same Duccio . . . as the payment and price of the painting of the said panel that is to be painted and done by him in the way described below . . . 150 lire of the small florins. . . . [Duccio, in turn, promises] to paint and embellish the panel with the image of the blessed Virgin Mary and of her omnipotent Son and other figures, according to the wishes and pleasure of the lessors, and to gild [the panel] and do everything that will enhance the beauty of the panel, his being all the expenses and the costs. . . . If the said panel is not beautifully painted and it is not embellished according to the wishes and desires of the same lessors, they are in no way bound to pay him the price or any part of it.†

Sometimes patrons furnished the materials and paid artists by the day instead of a fixed amount. That was the arrangement Duccio made on October 9, 1308, when he agreed to paint the *Maestà* (FIG. 14-9) for the high altar of Siena Cathedral.

Duccio has promised to paint and make the said panel as well as he can and knows how, and he further agreed not to accept or receive any other work until the said panel is done and completed. . . . [The church officials promise] to pay the said Duccio sixteen solidi of the Sienese denari as his salary for the said work and labor for each day that the said Duccio works with his own hands on the said panel . . . [and] to provide and give everything that will be necessary for working on the said panel so that the said Duccio need contribute nothing to the work save his person and his effort. ‡

In all cases, the artists worked for their patrons and could count on being compensated for their talents and efforts only if the work they delivered met the standards of those who ordered it.

^{*}Translated by John White, *Duccio: Tuscan Art and the Medieval Workshop* (London: Thames & Hudson, 1979), 34.

[†]Translated by James H. Stubblebine, *Duccio di Buoninsegna and His School* (Princeton, N.J.: Princeton University Press, 1979), 1: 192.

^{*}Stubblebine, Duccio, 1: 201.

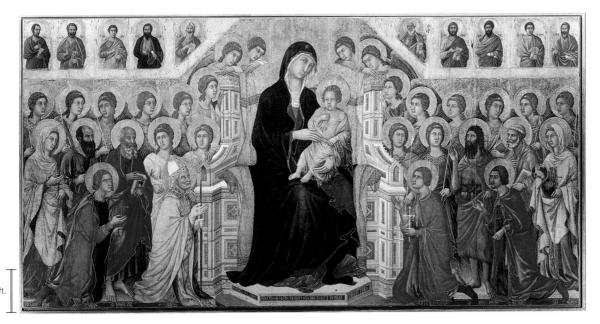

14-9 DUCCIO DI
BUONINSEGNA, Virgin
and Child Enthroned
with Saints, principal
panel of the Maestà
altarpiece, from Siena
Cathedral, Siena, Italy,
1308–1311. Tempera
and gold leaf on wood,
7' × 13'. Museo
dell'Opera del Duomo,
Siena.

Duccio derived the formality and symmetry of his composition from Byzantine painting, but relaxed the rigidity and frontality of the figures, softened the drapery, and individualized the faces.

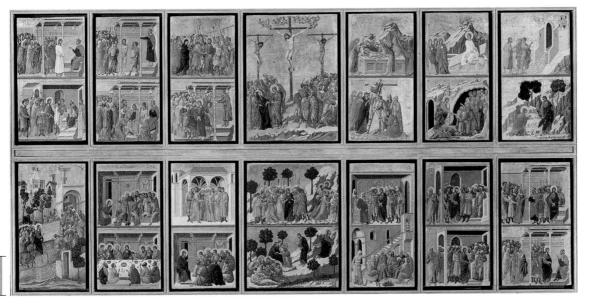

14-10 DUCCIO DI BUONINSEGNA, Life of Jesus, 14 panels from the back of the Maestà altarpiece, from Siena Cathedral, Siena, Italy, 1308–1311. Tempera and gold leaf on wood, 7' × 13'. Museo dell'Opera del Duomo, Siena

On the back of the *Maestà* altarpiece, Duccio painted Jesus' passion in 24 scenes on 14 panels, beginning with *Entry into Jerusalem* (FIG. 14-10A), at the lower left, through *Noli me tangere*, at top right.

DUCCIO The works of Duccio di Buoninsegna (active ca. 1278-1318) represent Sienese art at its most supreme. His most famous painting, the immense altarpiece called Maestà (Virgin Enthroned in Majesty; FIG. 14-9), replaced a much smaller painting of the Virgin Mary on the high altar of Siena Cathedral (FIG. 14-12A). The Sienese believed the Virgin had brought them victory over the Florentines at the battle of Monteperti in 1260, and she was the focus of the religious life of the republic. Duccio and his assistants began work on the prestigious commission in 1308 and completed Maestà in 1311, causing the entire city to celebrate. Shops closed and the bishop led a great procession of priests, civic officials, and the populace at large in carrying the altarpiece from Duccio's studio outside the city gate through the Campo (FIG. 14-15) up to its home on Siena's highest hill. So great was Duccio's stature that church officials permitted him to include his name in the dedicatory inscription on the front of the altarpiece on the Virgin's footstool: "Holy Mother of God, be the cause of peace for Siena and of life for Duccio, because he painted you thus."

As originally executed, Duccio's *Maestà* consisted of the seven-foot-high central panel (FIG. 14-9) with the dedicatory inscription,

surmounted by seven *pinnacles* above, and a *predella*, or raised shelf, of panels at the base, altogether some 13 feet high. Painted in tempera front and back (FIG. 14-10), the work unfortunately can no longer be seen in its entirety, because of its dismantling in subsequent centuries. Many of Duccio's panels are on display today as single masterpieces, scattered among the world's museums.

The main panel on the front of the altarpiece represents the Virgin enthroned as queen of Heaven amid choruses of angels and saints. Duccio derived the composition's formality and symmetry, along with the figures and facial types of the principal angels and saints, from Byzantine tradition. But the artist relaxed the strict frontality and rigidity of the figures. They turn to each other in quiet conversation. Further, Duccio individualized the faces of the four saints kneeling in the foreground, who perform their ceremonial gestures without stiffness. Similarly, he softened the usual Byzantine hard body outlines and drapery patterning. The folds of the garments, particularly those of the female saints at both ends of the panel, fall and curve loosely. This is a feature familiar in French Gothic works (FIG. 13-37) and is a mark of the artistic dialogue between Italy and northern Europe in the 14th century.

Despite these changes revealing Duccio's interest in the new naturalism, he respected the age-old requirement that as an altarpiece, Maestà would be the focus of worship in Siena's largest and most important church, its cathedral, the seat of the bishop of Siena. As such, Duccio knew Maestà should be an object holy in itself—a work of splendor to the eyes, precious in its message and its materials. Duccio thus recognized how the function of the altarpiece naturally limited experimentation in depicting narrative action and producing illusionistic effects (such as Giotto's) by modeling forms and adjusting their placement in pictorial space.

Instead, the queen of Heaven panel is a miracle of color composition and texture manipulation, unfortunately not fully revealed in photographs. Close inspection of the original reveals what the Sienese artist learned from other sources. In the 13th and 14th centuries, Italy was the distribution center for the great silk trade from China and the Middle East (see "The Silk Road," Chapter 16, page 458). After processing the silk in city-states such as Lucca and Florence, the Italians exported the precious fabric throughout Europe to satisfy an immense market for sumptuous dress. (Dante, Petrarch, and many other humanists decried the appetite for luxury in costume, which to them represented a decline in civic and moral virtue.) People throughout Europe (Duccio and other artists among them) prized fabrics from China, Persia, Byzantium, and the Islamic world. In Maestà, Duccio created the glistening and shimmering effects of textiles, adapting the motifs and design patterns of exotic materials. Complementing the luxurious fabrics and the (lost) gilded wood frame are the halos of the holy figures, which feature tooled decorative designs in gold leaf (punchwork). But Duccio, like Giotto (FIG. 14-7), eliminated almost all the gold patterning of the figures' garments in favor of creating three-dimensional volume. Traces remain only in the Virgin's red dress.

In contrast to the main panel, the predella and the back (FIG. 14-10) of Maestà present an extensive series of narrative panels of different sizes and shapes, beginning with Annunciation and culminating with Christ's Resurrection and other episodes following his Crucifixion (see "The Life of Jesus in Art," Chapter 11, pages

240-241, or pages xxx-xxxi in Volume II and

Book D). The section reproduced here, consisting of 24 scenes in 14 panels, relates Christ's passion. Duccio drew the details of his scenes

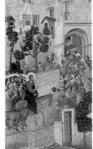

14-10A Duccio, Entry into Jerusalem. 1308-1311

14-11 Duccio di Buoninsegna, Betrayal of Jesus, panel on the back of the Maestà altarpiece, from Siena Cathedral, Siena, Italy, 1309–1311. Tempera and gold leaf on wood, $1' 10\frac{1}{2}'' \times 3' 4''$. Museo dell'Opera del Duomo, Siena.

In this dramatic depiction of Judas's betrayal of Jesus, the actors display a variety of individual emotions. Duccio here took a decisive step toward the humanization of religious subject matter.

ter. The narrative ends with Christ's appearance to Mary Magdalene (Noli me tangere) at the top right. Duccio consistently dressed Jesus in blue robes in most of the panels, but beginning with Transfiguration, he gilded the Savior's garment.

On the front panel, Duccio showed himself as the great master of the formal altarpiece. However, he allowed himself greater latitude for experimentation in the small accompanying panels, front and back. (Worshipers could always view both sides of the altarpiece because the high altar stood at the center of the sanctuary.) Maestà's biblical scenes reveal Duccio's powers as a narrative painter. In Betrayal of Jesus (FIG. 14-11; compare FIG. 14-8B), for example, the artist represented several episodes of the event—the betrayal of Jesus by Judas's false kiss, the disciples fleeing in terror, and Peter cutting off the ear of the high priest's servant. Although the background, with its golden sky and rock formations, remains traditional, the style of the figures before it has changed radically. The bodies are not the flat frontal shapes of Italo-Byzantine art. Duccio imbued them with mass, modeled them with a range of tonalities from light to dark, and arranged their draperies around them convincingly. Even more novel and striking is the way the figures seem to react to the central event. Through posture, gesture, and even facial expression, they display a variety of emotions. Duccio carefully differentiated among the anger of Peter, the malice of Judas (echoed in the faces of the throng about Jesus), and the apprehension and timidity of the fleeing disciples. These figures are actors in a religious drama the artist interpreted in terms of thoroughly human actions and reactions. In this and the other narrative panels, for example, Jesus' Entry into Jerusalem (FIG. 14-10A), a theme treated also by Giotto in the Arena Chapel (FIG. 14-8A), Duccio took a decisive step toward the humanization of religious subject matter.

ORVIETO CATHEDRAL While Duccio was working on Maestà for Siena's most important church, a Sienese architect, LORENZO MAITANI, received the commission to design Orvieto's Cathedral (FIG. 14-12). The Orvieto facade, like the earlier facade of Siena Cathedral (FIG. 14-12A), begun by Giovanni Pisano (FIG. 14-4), demonstrates the appeal of the decorative vocabulary of French Gothic architecture in Italy at the end of the 13th and beginning of the 14th century. Characteristically French are the pointed gables over Orvieto Cathedral's three doorways, the rose window and

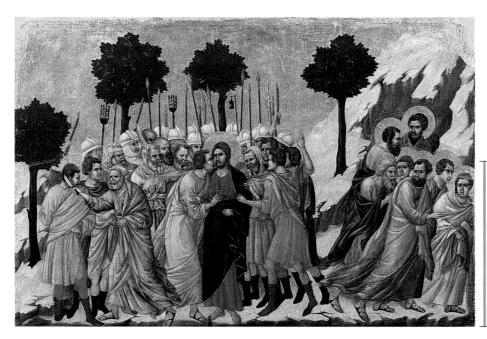

14-12 LORENZO
MAITANI, Orvieto
Cathedral (looking
northeast), Orvieto,
Italy, begun 1310.

The pointed gables over the doorways, the rose window, and the large pinnacles derive from French Gothic architecture, but the facade of Orvieto Cathedral masks a traditional timberroofed basilica.

statues in niches in the upper zone, and the four large *pinnacles* dividing the facade into three *bays* (see "The Gothic Cathedral," Chapter 13, page 373, or page xxvi in Volume II and Book D). The outer pinnacles serve as miniature substitutes for the tall northern European west-front towers. Maitani's facade, however, is a Gothic overlay masking a marble-revetted *basilican* structure in the Tuscan *Romanesque* tradition, as the three-quarter view of the cathedral in FIG. 14-12 reveals. Few Italian architects fully embraced the Gothic style. The Orvieto facade resembles a great altar screen, its single plane covered with care-

fully placed carved and painted decoration. In principle, Orvieto belongs with Pisa Cathedral (FIG. 12-26) and other earlier Italian

buildings, rather than with the French cathedrals at Amiens (FIG. 13-19) and Reims (FIG. 13-23). Inside, Orvieto Cathedral has a timber-roofed *nave* with a two-story *elevation* (columnar *arcade* and *clerestory*) in the Early Christian manner. Both the *chancel arch* framing the *apse* and the nave arcade's arches are round as opposed to pointed.

14-12A Siena Cathedral, begun

SIMONE MARTINI Duccio's successors in the Sienese school also produced innovative works. Simone Martini (ca. 1285–1344) was a pupil of Duccio's and may have assisted him in painting *Maestà*. Martini was a close friend of Petrarch's, and the poet praised him highly for his portrait of "Laura" (the woman to whom Petrarch dedicated his sonnets). Martini worked for the French kings in Na-

ples and Sicily and, in his last years, produced paintings for the papal court at Avignon, where he came in contact with French painters. By adapting the insubstantial but luxuriant patterns of the Gothic style to Sienese art and, in turn, by acquainting painters north of the Alps with the Sienese style, Martini was instrumental in creating the so-called *International style*. This new style swept Europe during the late 14th and early 15th centuries because it appealed to the aristocratic taste for brilliant colors, lavish costumes, intricate ornamentation, and themes involving splendid processions.

The Annunciation altarpiece (FIG. 14-13) Martini created for Siena Cathedral features elegant shapes and radiant color, fluttering line, and weightless figures in a spaceless setting—all hallmarks of the artist's style.

14-13 SIMONE MARTINI and LIPPO MEMMI, Annunciation altarpiece, from Siena Cathedral, 1333 (frame reconstructed in the 19th century). Tempera and gold leaf on wood, center panel $10'\ 1'' \times 8'\ 8^{\frac{3}{4}''}$. Galleria degli Uffizi, Florence.

A pupil of Duccio's, Martini was instrumental in the creation of the International style. Its hallmarks are elegant shapes, radiant color, flowing line, and weightless figures in golden, spaceless settings.

1 ft

Artistic Training in Renaissance Italy

In Italy during the 14th through 16th centuries, training to be-**L** come a professional artist capable of earning membership in the appropriate guild (see "Artists' Guilds," page 410) was a laborious and lengthy process. Aspiring artists started their training at an early age, anywhere from age 7 to 15. Their fathers would negotiate an arrangement with a master artist whereby each youth lived with that master for a specified number of years, usually five or six. During that time, the boys served as apprentices to the master of the workshop, learning the trade. (This living arrangement served as a major obstacle for female artists, because it was inappropriate for young girls to live in a male master's household.) The guilds supervised this rigorous training. They wanted not only to ensure their professional reputations by admitting only the most talented members but also to control the number of artists (and thereby limit competition). Toward this end, they frequently tried to regulate the number of apprentices working under a single master.

The skills apprentices learned varied with the type of studio they joined. Those apprenticed to painters learned to grind pigments, draw, prepare wood panels for painting, gild, and lay plaster for fresco. Sculptors in training learned to manipulate different materials—wood, stone, *terracotta* (baked clay), wax, bronze, or stucco—although many sculpture workshops specialized in only one or two of these materials. For stone carving, apprentices learned their craft by blocking out the master's designs for statues. As their skills developed, apprentices took on increasingly difficult tasks.

Cennino Cennini (ca. 1370–1440) explained the value of this apprenticeship system, and in particular, the advantages for young artists in studying and copying the works of older masters, in an influential book he published in 1400, *Il Libro dell'Arte* (*The Handbook of Art*):

Having first practiced drawing for a while, . . . take pains and pleasure in constantly copying the best things which you can find done by the hand of great masters. And if you are in a place where many good masters have been, so much the better for you. But I give you this advice: take care to select the best one every time, and the one who has the greatest reputation. And, as you go on from day to day, it will be against nature if you do not get some grasp of his style and of his spirit. For if you undertake to copy after one master to-day and after another one tomorrow, you will not acquire the style of either one or the other, and you will inevitably, through

enthusiasm, become capricious, because each style will be distracting your mind. You will try to work in this man's way today, and in the other's tomorrow, and so you will not get either of them right. If you follow the course of one man through constant practice, your intelligence would have to be crude indeed for you not to get some nourishment from it. Then you will find, if nature has granted you any imagination at all, that you will eventually acquire a style individual to yourself, and it cannot help being good; because your hand and your mind, being always accustomed to gather flowers, would ill know how to pluck thorns.*

After completing their apprenticeships, artists entered the appropriate guilds. For example, painters, who ground pigments, joined the guild of apothecaries. Sculptors were members of the guild of stoneworkers, and goldsmiths entered the silk guild, because metalworkers often stretched gold into threads wound around silk for weaving. Guild membership served as certification of the artists' competence, but did not mean they were ready to open their own studios. New guild-certified artists usually served as assistants to master artists, because until they established their reputations, they could not expect to receive many commissions, and the cost of establishing their own workshops was high. In any case, this arrangement was not permanent, and workshops were not necessarily static enterprises. Although well-established and respected studios existed, workshops could be organized around individual masters (with no set studio locations) or organized for a specific project, especially an extensive decoration program.

Generally, assistants to painters were responsible for gilding frames and backgrounds, completing decorative work, and, occasionally, rendering architectural settings. Artists regarded figures, especially those central to the represented subject, as the most important and difficult parts of a painting, and the master reserved these for himself. Sometimes assistants painted secondary or marginal figures but only under the master's close supervision. That was probably the case with Simone Martini's *Annunciation* altarpiece (FIG. 14-13), in which the master painted the Virgin and angel, and the flanking saints are probably the work of his assistant, Lippo Memmi.

*Translated by Daniel V. Thompson Jr., *Cennino Cennini, The Craftsman's Handbook (Il Libro dell'Arte)* (New York: Dover Publications, 1960; reprint of 1933 ed.), 14–15.

The complex etiquette of the European chivalric courts probably dictated the presentation. The angel Gabriel has just alighted, the breeze of his passage lifting his mantle, his iridescent wings still beating. The gold of his sumptuous gown signals he has descended from Heaven to deliver his message. The Virgin, putting down her book of devotions, shrinks demurely from Gabriel's reverent genuflection—an appropriate act in the presence of royalty. Mary draws about her the deep blue, golden-hemmed mantle, colors befitting the queen of Heaven. Between the two figures is a vase of white lilies, symbolic of the Virgin's purity. Despite Mary's modesty and diffidence and the tremendous import of the angel's message, the scene subordinates drama to court ritual, and structural experimentation to surface splendor. The intricate *tracery* of the richly

tooled (reconstructed) French Gothic–inspired frame and the elaborate punchwork halos (by then a characteristic feature of Sienese panel painting) enhance the tactile magnificence of *Annunciation*.

Simone Martini and his student and assistant, Lippo Memmi (active ca. 1317–1350), signed the altarpiece and dated it (1333). The latter's contribution to *Annunciation* is still a matter of debate, but most art historians believe he painted the two lateral saints. These figures, which are reminiscent of the jamb statues of Gothic church portals, have greater solidity and lack the linear elegance of Martini's central pair. Given the nature of medieval and Renaissance workshop practices, it is often difficult to distinguish the master's hand from those of assistants, especially if the master corrected or redid part of the pupil's work (see "Artistic Training in Renaissance Italy," page 414).

1 ft.

14-14 PIETRO LORENZETTI, Birth of the Virgin, from the altar of Saint Savinus, Siena Cathedral, Siena, Italy, 1342. Tempera on wood, 6' $1'' \times 5'$ 11''. Museo dell'Opera del Duomo, Siena.

In this triptych, Pietro Lorenzetti revived the pictorial illusionism of ancient Roman murals and painted the architectural members dividing the panel as if they extended back into the painted space.

PIETRO LORENZETTI Another of Duccio's students, Pietro Lorenzetti (active 1320-1348), contributed significantly to the general experiments in pictorial realism taking place in 14th-century Italy. Surpassing even his renowned master, Lorenzetti achieved a remarkable degree of spatial illusionism in his Birth of the Virgin (FIG. 14-14), a large triptych (three-part panel painting) created for the altar of Saint Savinus in Siena Cathedral. Lorenzetti painted the wooden architectural members dividing the altarpiece into three sections as though they extended back into the painted space. Viewers seem to look through the wooden frame (added later) into a boxlike stage, where the event takes place. That one of the vertical members cuts across a figure, blocking part of it from view, strengthens the illusion. In subsequent centuries, artists exploited this use of architectural elements to enhance the illusion of painted figures acting out a drama a mere few feet away. This kind of pictorial illusionism characterized ancient Roman mural painting (FIGS. 7-18 and 7-19, right) but had not been practiced in Italy for a thousand years.

Lorenzetti's setting for his holy subject also represented a marked step in the advance of worldly realism. Saint Anne—who, like Nicola Pisano's Virgin in *Nativity* (FIG. 14-3), resembles a reclining figure on the lid of a Roman sarcophagus (FIG. 7-61)—props herself up wearily as the midwives wash the child and the women bring gifts. She is the center of an episode occurring in an upper-class Italian house of the period. A number of carefully observed domestic details and the scene at the left, where Joachim eagerly awaits news of the delivery, create the illusion that the viewer has opened the walls of Saint Anne's house and peered inside. Lorenzetti's altarpiece is noteworthy both for the painter's innovations in spatial illusionism and for his careful inspection and recording of details of the everyday world.

PALAZZO PUBBLICO Not all Sienese painting of the early 14th century was religious in character. One of the most important fresco cycles of the period (FIGS. 14-16 and 14-17) was a civic commission for Siena's Palazzo Pubblico ("public palace" or city hall). Siena was a proud commercial and political rival of Florence. The secular center of the community, the civic meeting hall in the main square (the Campo, or Field), was almost as great an object of civic pride as the city's cathedral (FIG. 14-12A). The Palazzo Pubblico (FIG. 14-15) has a slightly concave

14-15 Palazzo Pubblico (looking east), Siena, Italy, 1288–1309. ■◀

Siena's Palazzo Pubblico has a concave facade and a gigantic tower visible for miles around. The tower served as both a defensive lookout over the countryside and a symbol of the city-state's power.

14-16 Ambrogio Lorenzetti, *Peaceful City*, detail from *Effects of Good Government in the City and in the Country*, east wall, Sala della Pace, Palazzo Pubblico, Siena, Italy, 1338–1339. Fresco. ■◀

In the Hall of Peace (Fig. 14-16A) of Siena's city hall (Fig. 14-15), Ambrogio Lorenzetti painted an illusionistic panorama of the bustling city. The fresco served as an allegory of good government in the Sienese republic.

facade (to conform to the irregular shape of the Campo) and a gigantic tower visible from miles around (compare FIGS. 13-29 and 14-18B). The imposing building and tower must have earned the admiration of Siena's citizens as well as of visitors to the city, inspiring in them respect for the republic's power and success. The tower served as a lookout over the city and the countryside around it and as a bell tower (campanile) for ringing signals of all kinds to the populace. Siena, as other Italian city-states, had to defend itself against neighboring cities and often against kings and emperors. In addition, it had to secure itself against internal upheavals common in the history of the Italian city-republics. Class struggle, feuds among rich and powerful families, and even uprisings of the whole populace against the city governors were constant threats in medieval Italy. The heavy walls and battlements (fortified parapets) of the Sienese town hall eloquently express how frequently the city governors needed to defend themselves against their own citizens. The Palazzo Pubblico tower, out of reach of most missiles, incorporates machicolated galleries (galleries with holes in their floors to enable defenders to dump stones or hot liquids on attackers below) built out on *corbels* (projecting supporting architectural members) for defense of the tower's base.

AMBROGIO LORENZETTI The painter entrusted with the major fresco program in the Palazzo Pubblico was Pietro Loren-

14-16A Sala della Pace, Siena, 1338-1339.

zetti's brother Ambrogio Lorenzetti (active 1319–1348). In the frescoes Ambrogio produced for the Sala della Pace (Hall of Peace; FIG. 14-16A), he elaborated his brother's advances in illusionistic representation in spectacular fashion while giving visual form to Sienese civic concerns. The subjects of Ambro-

gio's murals are Allegory of Good Government, Bad Government and the Effects of Bad Government in the City, and Effects of Good Government in the City and in the Country. The turbulent politics of the Italian cities—the violent party struggles, the overthrow and reinstatement of governments—called for solemn reminders of fair and just administration, and the city hall was just the place to display these allegorical paintings. Indeed, the leaders of the Sienese government who commissioned this fresco series had undertaken the "ordering and reformation of the whole city and countryside of Siena."

In Effects of Good Government in the City and in the Country, Ambrogio depicted the urban and rural effects of good government. Peaceful City (FIG. 14-16) is a panoramic view of Siena, with its clustering palaces, markets, towers, churches, streets, and walls, reminiscent of the townscapes of ancient Roman murals (FIG. 7-19, left). The city's traffic moves peacefully, guild members ply their trades and crafts, and radiant maidens, clustered hand in hand, perform a graceful circling dance. Dancers were regular features of festive springtime rituals. Here, their presence also serves as a metaphor for a peaceful commonwealth. The artist fondly observed the life of his city, and its architecture gave him an opportunity to apply Sienese artists' rapidly growing knowledge of perspective.

As the viewer's eye passes through the city gate to the countryside beyond its walls, Ambrogio's *Peaceful Country* (FIG. 14-17) presents a bird's-eye view of the undulating Tuscan terrain with its villas, castles, plowed farmlands, and peasants going about their occupations at different seasons of the year. Although it is an allegory, not a mimetic picture of the Sienese countryside on a specific day, Lorenzetti particularized the view of Tuscany—as well as the city view—by careful observation and endowed the painting with the character of a portrait of a specific place and environment. *Peaceful Country* represents one of the first appearances of *landscape* in Western art since antiquity (FIG. 7-20).

An allegorical figure of Security hovers above the hills and fields, unfurling a scroll promising safety to all who live under the rule of law. But Siena could not protect its citizens from the plague sweeping through Europe in the mid-14th century. The Black Death (see page 406) killed thousands of Sienese and may have ended the careers of both Lorenzettis. They disappear from historical records in 1348.

14-17 Ambrogio Lorenzetti, Peaceful Country, detail from Effects of Good Government in the City and in the Country, east wall, Sala della Pace (FIG. 14-16A), Palazzo Pubblico (FIG. 14-15), Siena, Italy, 1338–1339. Fresco. ■

This sweeping view of the countryside is one of the first instances of landscape painting in Western art since antiquity. The winged figure of Security promises safety to all who live under Sienese law.

Florence

Like Siena, the Republic of Florence was a dominant city-state during the 14th century. The historian Giovanni Villani (ca. 1270–1348), for example, described Florence as "the daughter and the creature of Rome," suggesting a preeminence inherited from the Roman Empire. Florentines were fiercely proud of what they perceived as their economic and cultural superiority. Florence controlled the textile industry in Italy, and the republic's gold *florin* was the standard coin of exchange everywhere in Europe.

FLORENCE CATHEDRAL Floren-

tines translated their pride in their predominance into such landmark buildings as Santa Maria del Fiore (FIGS. 14-18 and 14-18A), Florence's cathedral, the center for the most important religious observances in the city. ARNOLFO DI CAMBIO (ca. 1245–1302) began work on the cathedral (*Duomo* in Italian) in 1296, three years before he received

the commission to build the city's town hall, the Palazzo della Signoria (FIG. 14-18B). Intended as the "most beautiful and honorable church in Tuscany," the cathedral reveals the competitiveness Florentines felt with cities such as Siena (FIG. 14-12A) and Pisa (FIG. 12-26). Church authorities planned for the

14-18A Nave, Florence Cathedral, begun 1296.

14-18B Palazzo della Signoria, Florence, 1299–1310.

14-18 ARNOLFO DI CAMBIO and others, aerial view of Santa Maria del Fiore (and the Baptistery of San Giovanni; looking northeast), Florence, Italy, begun 1296. Campanile designed by GIOTTO DI BONDONE, 1334. ■

The Florentine Duomo's marble revetment carries on the Tuscan Romanesque architectural tradition, linking this basilican church more closely to Early Christian Italy than to Gothic France.

Duomo to hold the city's entire population, and although its capacity is only about 30,000 (Florence's population at the time was slightly less than 100,000), the building seemed so large even the noted architect Leon Battista Alberti (see Chapter 21) commented it seemed to cover "all of Tuscany with its shade." The builders ornamented the cathedral's surfaces, in the old Tuscan fashion, with marble-encrusted geometric designs, matching the *revetment* (decorative wall paneling) to that of the facing 11th-century Romanesque baptistery of San Giovanni (FIGS. 12-27 and 14-18, *left*).

The vast gulf separating Santa Maria del Fiore from its northern European counterparts becomes evident in a comparison between the Florentine church and the High Gothic cathedrals of Amiens (FIG. 13-19), Reims (FIG. 13-23), and Cologne (FIG. 13-52). Gothic architects' emphatic stress on the vertical produced an aweinspiring upward rush of unmatched vigor and intensity. The French and German buildings express organic growth shooting heavenward, as the pierced, translucent stone tracery of the spires merges with the atmosphere. Florence Cathedral, in contrast, clings to the ground and has no aspirations to flight. All emphasis is on the horizontal elements of the design, and the building rests firmly and massively on the ground. The clearly defined simple geometric volumes of the cathedral show no tendency to merge either into each other or into the sky.

Giotto di Bondone designed the Duomo's campanile in 1334. In keeping with Italian tradition (FIGS. 12-21 and 12-26), it stands apart from the church. In fact, it is essentially selfsufficient and could stand anywhere else in the city without looking out of place. The same cannot be said of the towers of Amiens, Reims, and Cologne cathedrals. They are essential elements of the structures behind them, and it would be unthinkable to detach one of them and place it somewhere else. No individual element of Gothic churches seems capable of an independent existence. One form merges into the next in a series of rising movements pulling the eye upward and never permitting it to rest until it reaches the sky. The Florentine campanile is entirely different.

Neatly subdivided into cubic sections, Giotto's tower is the sum of its component parts. Not only could this tower be removed from the building without adverse effects, but also each of the parts—cleanly separated from each other by continuous moldings—seems capable of existing independently as an object of considerable aesthetic appeal. This compartmentalization is reminiscent of the Romanesque style, but it also forecasts the ideals of Renaissance architecture. Artists hoped to express structure in the clear, logical relationships of the component parts and to produce self-sufficient works that could exist in complete independence. Compared with northern European towers, Giotto's campanile has a cool and rational quality more appealing to the intellect than to the emotions.

14-19 Andrea Pisano, south doors of the Baptistery of San Giovanni (Fig. 12-27), Florence, Italy, 1330–1336. Gilded bronze, doors $16' \times 9'$ 2"; individual panels $1' 7\frac{1}{4}'' \times 1'$ 5". (The door frames date to the mid-15th century.)

Andrea Pisano's bronze doors have 28 panels with figural reliefs in French Gothic quatrefoil frames. The lower eight depict Christian virtues. The rest represent the life of Saint John the Baptist.

The facade of Florence Cathedral was not completed until the 19th century, and then in a form much altered from its original design. In fact, until the 17th century, Italian builders exhibited little concern for the facades of their churches, and dozens remain unfinished to this day. One reason for this may be that Italian architects did not conceive the facades as integral parts of the structures but rather, as in the case of Orvieto Cathedral (FIG. 14-12), as screens that could be added to the church exterior at any time.

A generation after work began on Florence's church, the citizens decided also to beautify their 11th-century baptistery (FIGS. 12-27 and 14-18, *left*) with a set of bronze doors (FIG. 14-19) for the south entrance to the building. The sponsors were the members of

Florence's guild of wool importers, who competed for business and prestige with the wool manufacturers' association, an important sponsor of the cathedral building campaign. The wool-importers' guild hired Andrea Pisano (ca. 1290-1348), a native of Pontedera in the territory of Pisa—unrelated to Nicola and Giovanni Pisano (see "Italian Artists' Names," page 405)—to create the doors. Andrea designed 28 bronze panels for the doors, each cast separately, of which 20 depict episodes from the life of Saint John the Baptist, to whom the Florentines dedicated their baptistery. Eight panels (at the bottom) represent personified Christian virtues. The quatrefoil (four-lobed, cloverlike) frames are of the type used earlier for reliefs flanking the doorways of Amiens Cathedral (FIG. 13-19), suggesting French Gothic sculpture was one source of Andrea's style. The gilded figures stand on projecting ledges in each quatrefoil. Their proportions and flowing robes also reveal a debt to French sculpture, but the compositions, both in general conception (small groups of figures in stagelike settings) and in some details, owe a great deal to Giotto, for whom Andrea had earlier executed reliefs for the cathedral's campanile, perhaps according to Giotto's designs.

The wool importers' patronage of the baptistery did not end with this project. In the following century, the guild paid for the even more prestigious east doors (FIGS. 21-9 and 21-10), directly across from the cathedral's west facade, and also for a statue of Saint John the Baptist on the facade of Or San Michele, a multipurpose building housing a 14th-century tabernacle (FIG. 14-19A) by Andrea Orcagna (active ca. 1343–1368) featuring the painting *Madonna and Child Enthroned with Saints* by Bernardo Daddi (active ca. 1312–1348).

14-19A ORCAGNA, Or San Michele tabernacle, 1355-1359.

Pisa

Siena and Florence were inland centers of commerce. Pisa was one of Italy's port cities, which, with Genoa and Venice (MAP 14-1), controlled the rapidly growing maritime avenues connecting western Europe with the lands of Islam, with Byzantium and Russia, and

with China. As prosperous as Pisa was as a major shipping power, however, it was not immune from the disruption the Black Death wreaked across all of Italy and Europe in the late 1340s. Concern with death, a significant theme in art even before the onset of the plague, became more prominent in the years after midcentury.

CAMPOSANTO Triumph of Death is a tour de force of death imagery (FIG. 14-20). The creator of this large-scale (over 18 by 49 feet) fresco remains disputed. Some art historians attribute the work to Francesco Traini (active ca. 1321-1363), while others argue for BUONAMICO Buffalmacco (active 1320-1336). Painted on the wall of the Camposanto (Holy Field), the enclosed burial ground adjacent to Pisa's cathedral (FIG. 12-26), the fresco captures the horrors of death and forces viewers to confront their mortality. The painter rendered each scene with naturalism and emotive power. In the left foreground (FIG. 14-20, top), young aristocrats, mounted in a stylish cavalcade, encounter three coffin-encased corpses in differing stages of decomposition. As the horror of the confrontation with death strikes them, the ladies turn away with delicate disgust, while a gentleman holds his nose. (The animals, horses and dogs, sniff excitedly.) At the far left, the hermit Saint Macarius unrolls a scroll bearing an inscription commenting on the folly of pleasure and

14-20 Francesco Traini or Buonamico Buffalmacco, two details of *Triumph of Death*, 1330s. Full fresco, 18′ 6″ × 49′ 2″. Camposanto, Pisa. ■

Befitting its location on a wall in Pisa's Camposanto, the enclosed burial ground adjacent to the cathedral, this fresco captures the horrors of death and forces viewers to confront their mortality.

1 ft.

14-21 Doge's Palace, Venice, Italy, begun ca. 1340-1345; expanded and remodeled, 1424-1438.

The delicate patterning in cream- and rose-colored marbles, the pointed and ogee arches, and the quatrefoil medallions of the Doge's Palace constitute a Venetian variation of northern Gothic architecture.

the inevitability of death. On the far right, ladies and gentlemen ignore dreadful realities, occupying themselves in an orange grove with music and amusements while above them (FIG. 14-20, *bottom*) angels and demons struggle for the souls of the corpses heaped in the foreground.

In addition to these direct and straightforward scenes, the mural contains details conveying more subtle messages. For example, the painter depicted those who appear unprepared for death—and thus unlikely to achieve salvation—as wealthy and reveling in luxury. Given that the Dominicans—an order committed to a life of poverty (see "Mendicant Orders," page 404)—participated in the design for this fresco program, this imagery surely was a warning against greed and lust.

Venice

One of the wealthiest cities of late medieval Italy—and of Europe—was Venice, renowned for its streets of water. Situated on a lagoon on the northeastern coast of Italy, Venice was secure from land attack and could rely on a powerful navy for protection against invasion from the sea. Internally, Venice was a tight corporation of

ruling families that, for centuries, provided stable rule and fostered economic growth.

DOGE'S PALACE The Venetian republic's seat of government was the Doge's (Duke's) Palace (FIG. 14-21). Begun around 1340 to 1345 and significantly remodeled after 1424, it was the most ornate public building in medieval Italy. In a stately march, the first level's short and heavy columns support rather severe pointed arches that look strong enough to carry the weight of the upper structure. Their rhythm doubles in the upper arcades, where more slender columns carry ogee arches (made up of double-curving lines), which terminate in flamelike tips between medallions pierced with quatrefoils. Each story is taller than the one beneath it, the topmost as high as the two lower arcades combined. Yet the building does not look top-heavy. This is due in part to the complete absence of articulation in the top story and in part to the walls' delicate patterning, in cream- and rose-colored marbles, which makes them appear paperthin. The Doge's Palace represents a delightful and charming variant of Late Gothic architecture. Colorful, decorative, light and airy in appearance, the Venetian palace is ideally suited to this unique Italian city that floats between water and sky.

LATE MEDIEVAL ITALY

13TH CENTURY

- Diversity of style characterizes the art of 13th-century Italy, with some artists working in the maniera greca, or Italo-Byzantine style, some in the mode of Gothic France, and others in the newly revived classical tradition.
- The leading painters working in the Italo-Byzantine style were Bonaventura Berlinghieri and Cimabue. Both drew inspiration from Byzantine icons and illuminated manuscripts. Berlinghieri's *Saint Francis Altarpiece* is the earliest dated portrayal of Saint Francis of Assisi, who died in 1226.
- Trained in southern Italy in the court style of Frederick II (r. 1197–1250), Nicola Pisano was a master sculptor who settled in Pisa and carved pulpits incorporating marble panels that, both stylistically and in individual motifs, derive from ancient Roman sarcophagi. Nicola's son, Giovanni Pisano, also was a sculptor of church pulpits, but his work more closely reflects the Gothic sculpture of France.
- At the end of the century, in Rome and Assisi, Pietro Cavallini and other fresco painters created mural programs foreshadowing the revolutionary art of Giotto.

Bonaventura Berlinghieri, Saint Francis Altarpiece, 1235

Nicola Pisano, Pisa Baptistery pulpit, 1259–1260

14TH CENTURY

- During the 14th century, Italy suffered the most devastating natural disaster in European history—the Black Death—but it was also the time when Renaissance humanism took root. Although religion continued to occupy a primary position in Italian life, scholars and artists became increasingly concerned with the natural world.
- Art historians regard Giotto di Bondone of Florence as the first Renaissance painter. An architect as well, Giotto designed the bell tower of Florence's Catherdral. His masterpiece is the fresco program of the Arena Chapel in Padua, where he established himself as a pioneer in pursuing a naturalistic approach to representation based on observation, which was at the core of the classical tradition in art. The Renaissance marked the rebirth of classical values in art and society.
- The greatest master of the Sienese school of painting was Duccio di Buoninsegna, whose Maestà still incorporates many elements of the maniera greca. He relaxed the frontality and rigidity of his figures, however, and in the narrative scenes on the back of the gigantic altarpiece in Siena Cathedral took a decisive step toward humanizing religious subject matter by depicting actors displaying individual emotions.
- Secular themes also came to the fore in 14th-century Italy, most notably in Ambrogio Lorenzetti's frescoes for Siena's Palazzo Pubblico. His depictions of the city and its surrounding countryside are among the first landscapes in Western art since antiquity.
- The prosperity of the 14th century led to many major building campaigns, including new cathedrals in Florence, Siena, and Orvieto, and new administrative palaces in Florence, Siena, and Venice. Florence's 11th-century baptistery also received new bronze doors by Andrea Pisano.
- The 14th-century architecture of Italy underscores the regional character of late medieval art. Orvieto Cathedral's facade, for example, incorporates some elements of the French Gothic vocabulary, but it is a screen masking a timber-roofed structure with round arches in the nave arcade in the Early Christian tradition.

Giotto, Arena Chapel Padua, ca. 1305

Duccio, *Maestà*, Siena Cathedral, 1308–1311

Orvieto Cathedral, begun 1310

NOTES

Chapter 8

Translated by Raymond Davis, The Book of Pontiffs (Liverpool: Liverpool University Press, 1989), 18–19.

Chapter 9

- Paulus Silentiarius, Descriptio Sanctae Sophiae, 617-646. Translated by Cyril Mango, The Art of the Byzantine Empire, 312-1453: Sources and Documents (reprint of 1972 ed., Toronto: University of Toronto Press, 1986), 85-86.
- 2. Procopius, De aedificiis, 1.1.23ff. Translated by Mango, 74.
- 3. Paulus Silentiarius, Descriptio, 489, 668. Translated by Mango, 83, 86.
- Translated by Colin Luibheid, Pseudo-Dionysius: The Complete Works (New York: Paulist Press, 1987), 68ff.
- 5. Procopius, 1.1.23ff. Translated by Mango, 75.
- Libri Carolini, 4.2. Translated by Herbert L. Kessler, Spiritual Seeing: Picturing God's Invisibility in Medieval Art (Philadelphia: University of Pennsylvania Press, 2000), 119.
- 7. Nina G. Garsoïan, "Later Byzantium," in John A. Garraty and Peter Gay, eds., The Columbia History of the World (New York: Harper & Row, 1972), 453.
- 8. Garsoïan, 460.

Chapter 11

- Translated by Françoise Henry, The Book of Kells (New York: Alfred A. Knopf, 1974), 165.
- Beowulf, 3162–3164. Translated by Kevin Crossley-Holland (New York: Farrar, Straus & Giroux, 1968), 119.
- 3. Beowulf, 33.
- 4. Translated by John W. Williams, in *The Art of Medieval Spain A.D.* 500–1200 (New York: Metropolitan Museum of Art, 1993), 156.
- Translated by Adam S. Cohen, *The Uta Codex* (University Park: Pennsylvania University Press, 2000), 11, 41.

Chapter 12

- Translated by Calvin B. Kendall, The Allegory of the Church: Romanesque Portals and Their Verse Inscriptions (Toronto: University of Toronto Press, 1998), 207.
- Translated by John Williams, A Spanish Apocalypse: The Morgan Beatus Manuscript (New York: George Braziller, 1991), 223.
- 3. Translated by Charles P. Parkhurst Jr., in Elizabeth G. Holt, *A Documentary History of Art* (Princeton, N.J.: Princeton University Press, 2d ed., 1981), 1: 18.
- 4. Translated by Giovanna De Appolonia, Boston University.
- 5. Bernard of Clairvaux, *Apologia* 12.28. Translated by Conrad Rudolph, *The* "*Things of Greater Importance*": *Bernard of Clairvaux's* Apologia *and the Medieval Attitude toward Art* (Philadelphia: University of Pennsylvania Press, 1990), 281, 283.
- Rule of Saint Benedict, 57.1. Translated by Timothy Fry, The Rule of St. Benedict (Collegeville, Minn.: Liturgical Press, 1981), 265.

Chapter 13

- Giorgio Vasari, "Introduzione alle tre arti del disegno" (1550), ch. 3, in Paul Frankl, The Gothic: Literary Sources and Interpretation through Eight Centuries (Princeton, N.J.: Princeton University Press, 1960), 290–291, 859–860.
- 2. Dante, Divine Comedy, Purgatory, 11.81.
- 3. Translated by Roland Behrendt, *Johannes Trithemius, In Praise of Scribes: De laude scriptorum* (Lawrence, Kansas: Coronado Press, 1974), 71.
- 4. Frankl, The Gothic, 55.

GLOSSARY

Note: Text page references are in parentheses. References to bonus image online essays are in blue.

- abbess—See abbey. (322)
- abbey—A religious community under the direction of an abbot (for monks) or an abbess (for nuns). (322)
- abbot—See abbey. (322)
- **aisle**—The portion of a *basilica* flanking the *nave* and separated from it by a row of *columns* or *piers*. (243)
- ala (pl. alae)—One of a pair of rectangular recesses at the back of the *atrium* of a Roman *domus*. (190)
- **altar frontal**—A decorative panel on the front of a church altar. (367)
- altarpiece—A panel, painted or sculpted, situated above and behind an altar. See also *retable*. (392, 404)
- alternate-support system—In church architecture, the use of alternating wall supports in the *nave*, usually *piers* and *columns* or *compound piers* of alternating form. (324)
- ambo—A church *pulpit* for biblical readings. (392)
 ambulatory—A covered walkway, outdoors (as in a church *cloister*) or indoors; especially the passageway around the *apse* and the *choir* of a church. In Buddhist architecture, the passageway leading around the *stupa* in a *chaitya hall*. (244)
- amphitheater—Greek, "double theater." A Roman building type resembling two Greek theaters put together. The Roman amphitheater featured a continuous elliptical *cavea* around a central *arena*. (401)
- ante legem—Latin, "before the law." In Christian thought, the period before Moses received the Ten Commandments. See also sub lege. (392)
- **apostle**—Greek, "messenger." One of the 12 disciples of Jesus. (240)
- **apse**—A recess, usually semicircular, in the wall of a building, commonly found at the east end of a church. (413)
- **arcade**—A series of *arches* supported by *piers* or *columns*. (243, 287, 290, 413)
- arch—A curved structural member that spans an opening and is generally composed of wedge-

- shaped blocks (*voussoirs*) that transmit the downward pressure laterally. See also *thrust*. (12-10A)
- archivolt—The continuous molding framing an arch. In Romanesque and Gothic architecture, one of the series of concentric bands framing the tympanum. (344)
- **armature**—The crossed, or diagonal, *arches* that form the skeletal framework of a *Gothic rib* vault. In sculpture, the framework for a clay form. (368)
- **arriccio**—In *fresco* painting, the first layer of rough lime plaster applied to the wall. (408)
- **atrium**—The central reception room of a Roman *domus* that is partly open to the sky. Also the open, *colonnaded* court in front of and attached to a Christian *basilica*. (243)
- attribute—(n.) The distinctive identifying aspect of a person, for example, an object held, an associated animal, or a mark on the body. (v.) To make an attribution. (5)
- **attribution**—Assignment of a work to a maker or makers. (6)
- **baldacchino**—A canopy on *columns*, frequently built over an altar. The term derives from *baldacco*. (243)
- **baptism**—The Christian bathing ceremony in which an infant or a convert becomes a member of the Christian community. (236)
- **baptistery**—In Christian architecture, the building used for *baptism*, usually situated next to a church. Also, the designated area or hall within a church for baptismal rites. (236)

bar tracery—See tracery. (375)

barrel vault—See vault. (338)

- basilica (adj. basilican)—In Roman architecture, a public building for legal and other civic proceedings, rectangular in plan with an entrance usually on a long side. In Christian architecture, a church somewhat resembling the Roman basilica, usually entered from one end and with an *apse* at the other. (413)
- **battlement**—A low parapet at the top of a circuit wall in a fortification. (382, 416)

- **bay**—The space between two columns, or one unit in the *nave arcade* of a church; also, the passageway in an *arcuated* gate. (411, 413)
- **benedictional**—A Christian religious book containing bishops' blessings. (312)
- **bestiary**—A collection of illustrations of real and imaginary animals. (343)
- **blind arcade**—An *arcade* having no true openings, applied as decoration to a wall surface. (290)
- **Book of Hours**—A Christian religious book for private devotion containing prayers to be read at specified times of the day. (312)
- **breviary**—A Christian religious book of selected daily prayers and Psalms. (312, 386)
- **Buddha triad**—A three-figure group with a central Buddha flanked on each side by a *bodhisattva*. (475)
- **Byzantine**—The art, territory, history, and culture of the Eastern Christian Empire and its capital of Constantinople (ancient Byzantium). (256)
- **caliph(s)**—Islamic rulers, regarded as successors of Muhammad. (285)
- **calligrapher**—One who practices *calligraphy*. (294)
- **calligraphy**—Greek, "beautiful writing." Handwriting or penmanship, especially elegant writing as a decorative art. (294)
- **came**—A lead strip in a *stained-glass* window that joins separate pieces of colored glass. (375)
- **campanile**—A bell tower of a church, usually, but not always, freestanding. (350, 416)
- canon table—A concordance, or matching, of the corresponding passages of the four *Gospels* as compiled by Eusebius of Caesarea in the fourth century. (312)
- **canonized**—Declared a saint by the Catholic Church. (354, 14-5A)
- **capital**—The uppermost member of a *column*, serving as a transition from the *shaft* to the *lintel*. In *classical* architecture, the form of the capital varies with the *order*. (402, 429)
- **Caroline minuscule**—The alphabet that *Carolingian* scribes perfected, from which the modern English alphabet was developed. (317)

- Carolingian (adj.)—Pertaining to the empire of Charlemagne (Latin, "Carolus Magnus") and his successors. (317)
- **carpet page**—In early medieval manuscripts, a decorative page resembling a textile. (311)
- cartography—The art of mapmaking. (13-38B)
- **cartoon**—In painting, a full-size preliminary drawing from which a painting is made. (408) **castellum**—See *westwork*. (323)
- catacombs—Subterranean networks of rock-cut galleries and chambers designed as cemeteries for the burial of the dead. (237)
- cathedra—Latin, "seat." See cathedral. (350)
- **cathedral**—A bishop's church. The word derives from *cathedra*, referring to the bishop's chair. (350, 412)
- central plan—See plan. (244, 288)
- **chancel arch**—The arch separating the chancel (the *apse* or *choir*) or the *transept* from the *nave* of a basilica or church. (243, 413)
- **chantry**—An endowed chapel for the chanting of the mass for the founder of the chapel. (13-42A)
- charun—An Etruscan death demon. (176)
- **chiaroscuro**—In drawing or painting, the treatment and use of light and dark, especially the gradations of light that produce the effect of *modeling*. (409)
- **choir**—The space reserved for the clergy and singers in the church, usually east of the *transept* but, in some instances, extending into the *nave*. (264)
- Christ—Savior. (240)
- Christogram—The three initial letters (chi-rhoiota, ♣) of Christ's name in Greek, which came to serve as a monogram for Christ. (264, 307)
- city-state—An independent, self-governing city. (406)
- **Classical**—The art and culture of ancient Greece between 480 and 323 BCE. Lowercase *classical* refers more generally to Greco-Roman art and culture. (402)
- clerestory—The *fenestrated* part of a building that rises above the roofs of the other parts. The oldest known clerestories are Egyptian. In Roman *basilicas* and medieval churches, clerestories are the windows that form the *nave*'s uppermost level below the timber ceiling or the *vaults*. (243, 373, 413)
- cloison—French, "partition." A cell made of metal wire or a narrow metal strip soldered edge-up to a metal base to hold *enamel*, semi-precious stones, pieces of colored glass, or glass paste fired to resemble sparkling jewels. (310)
- **cloisonné**—A decorative metalwork technique employing *cloisons*; also, decorative brickwork in later Byzantine architecture. (271, 310)
- **cloister**—A *monastery* courtyard, usually with covered walks or *ambulatories* along its sides. (322, 341)
- **cluster pier**—See *compound pier.* (340, 373, 12-4A, 14-12A)
- **codex** (pl. **codices**)—Separate pages of *vellum* or *parchment* bound together at one side; the

- predecessor of the modern book. The codex superseded the *rotulus*. In *Mesoamerica*, a painted and inscribed book on long sheets of bark paper or deerskin coated with fine white plaster and folded into accordion-like pleats. (249)
- colonnette—A thin column. (290)
- **colophon**—An inscription, usually on the last page, giving information about a book's manufacture. In Chinese painting, written texts on attached pieces of paper or silk. (312)
- **column**—A vertical, weight-carrying architectural member, circular in cross-section and consisting of a base (sometimes omitted), a shaft, and a capital. (402)
- **compound pier**—A *pier* with a group, or cluster, of attached *shafts*, or *responds*, especially characteristic of *Gothic* architecture. (340, 373, 12-4A, 14-12A)
- confraternity—In Late Antiquity, an association of Christian families pooling funds to purchase property for burial. In late medieval Europe, an organization founded by laypersons who dedicated themselves to strict religious observances. (237, 404)
- corbel—A projecting wall member used as a support for some element in the superstructure. Also, *courses* of stone or brick in which each course projects beyond the one beneath it. Two such walls, meeting at the topmost course, create a corbeled *arch* or corbeled *vault*. (416)
- Corinthian capital—A more ornate form than *Doric* or *Ionic*; it consists of a double row of acanthus leaves from which tendrils and flowers grow, wrapped around a bell-shaped *echinus*. Although this *capital* form is often cited as the distinguishing feature of the Corinthian *order*, no such order exists, in strict terms, but only this type of capital used in the *Ionic* order. (402)
- crenel—See crenellation. (382)
- **crenellation**—Alternating solid merlons and open crenels in the notched tops of walls, as in *battlements*. (382)
- **crossing**—The space in a *cruciform* church formed by the intersection of the *nave* and the *transept*. (246, 323, 14-18A)
- crossing square—The area in a church formed by the intersection (*crossing*) of a *nave* and a *transept* of equal width, often used as a standard *module* of interior proportion. (323)
- **crossing tower**—The tower over the *crossing* of a church. (246)
- cruciform—Cross-shaped. (246)
- **Crusades**—In medieval Europe, armed pilgrimages aimed at recapturing the Holy Land from the *Muslims*. (346)
- **crypt**—A *vaulted* space under part of a building, wholly or partly underground; in churches, normally the portion under an *apse.* (340)
- **cubiculum** (pl. **cubicula**)—A small cubicle or bedroom that opened onto the *atrium* of a Roman *domus*. Also, a chamber in an Early Christian *catacomb* that served as a mortuary chapel. (237)

- **cuerda seca**—A type of polychrome tilework used in decorating Islamic buildings. (299)
- **cupola**—An exterior architectural feature composed of a *drum* with a shallow cap; a *dome*. (9-32A)
- **Deësis**—Greek, "supplication." An image of Christ flanked by the figures of the Virgin Mary and John the Baptist, who intercede on behalf of humankind. (276)
- diagonal rib—See rib. (373)
- **diaphragm arch**—A transverse, wall-bearing *arch* that divides a *vault* or a ceiling into compartments, providing a kind of firebreak. (12-27A)
- **diptych**—A two-paneled painting or *altarpiece*; also, an ancient Roman, Early Christian, or Byzantine hinged writing tablet, often of ivory and carved on the external sides. (251)
- **disputatio**—Latin, "logical argument." The philosophical methodology used in *Scholasticism*. (372)
- **doge**—Duke; a ruler of the Republic of Venice, Italy. (274)
- **dome**—A hemispherical *vault*; theoretically, an *arch* rotated on its vertical axis. In *Mycenaean* architecture, domes are beehive-shaped. (14-18A)
- **ddouble monastery**—A *monastery* for both monks and nuns. (352)
- **drum**—One of the stacked cylindrical stones that form the *shaft* of a *column*. Also, the cylindrical wall that supports a *dome*. (71)
- duomo-Italian, "cathedral." (417)
- elevation—In architecture, a head-on view of an external or internal wall, showing its features and often other elements that would be visible beyond or before the wall. (413)
- embroidery—The technique of sewing threads onto a finished ground to form contrasting designs. Stem stitching employs short overlapping strands of thread to form jagged lines. Laid-and-couched work creates solid blocks of color. (362)
- emir—A Muslim ruler. (293)
- enamel—A decorative coating, usually colored, fused onto the surface of metal, glass, or ceramics. (301)
- **engaged column**—A half-round *column* attached to a wall. See also *pilaster*. (290, 340)
- Eucharist—In Christianity, the partaking of the bread and wine, which believers hold to be either Christ himself or symbolic of him. (241)
- evangelist—One of the four authors (Matthew, Mark, Luke, John) of the New Testament *Gospels*. (314)
- **facade**—Usually, the front of a building; also, the other sides when they are emphasized architecturally. (412)
- fan vault—See vault. (391)
- **ffeudalism**—The medieval political, social, and economic system held together by the relationship between landholding *liege lords* and the *vassals* who were granted tenure of a portion of their land and in turn swore allegiance to the liege lord. (334)

fibula (pl. **fibulae**)—A decorative pin, usually used to fasten garments. (309)

finial—A crowning ornament. (294)

Flamboyant—A Late French *Gothic* style of architecture superseding the *Rayonnant* style and named for the flamelike appearance of its pointed bar *tracery*. (381)

flashing—In making *stained-glass* windows, fusing one layer of colored glass to another to produce a greater range of *colors*. (375)

fleur-de-lis—A three-petaled iris flower; the royal flower of France. (376, 388)

florin—The denomination of gold coin of *Renaissance* Florence that became an international currency for trade. (417)

flying buttress—See buttress. (372, 373)

folio—A page of a manuscript or book. (248, 249) **foreshortening**—The use of *perspective* to represent in art the apparent visual contraction of

sent in art the apparent visual contraction of an object that extends back in space at an angle to the perpendicular plane of sight. (401)

fresco—Painting on lime plaster, either dry (dry fresco, or fresco secco) or wet (true, or buon, fresco). In the latter method, the pigments are mixed with water and become chemically bound to the freshly laid lime plaster. Also, a painting executed in either method. (408, 409)

fresco secco—See fresco. (408)

Friday mosque—See *congregational mosque*. (288) **furta sacra**—Latin, "holy theft." (336)

giornata (pl. **giornate**)—Italian, "day." The section of plaster that a *fresco* painter expects to complete in one session. (408)

glazier—A glassworker. (375)

gold leaf—Gold beaten into tissue-paper-thin sheets that then can be applied to surfaces. (405)

Gospels—The four New Testament books that relate the life and teachings of Jesus. (312)

Gothic—Originally a derogatory term named after the Goths, used to describe the history, culture, and art of western Europe in the 12th to 14th centuries. Typically divided into periods designated Early (1140–1194), High (1194–1300), and Late (1300–1500). (365)

great mosque—See congregational mosque. (288)
Greek cross—A cross with four arms of equal length. (271)

griffin—An eagle-headed winged lion. (10-5B)
grisaille—A monochrome painting done mainly in neutral grays to simulate sculpture. (409, 13-36A)

groin vault—See *vault*. (184, 340, 350, 14-12A)

guild—An association of merchants, craftspersons, or scholars in medieval and *Renaissance* Europe. (366, 410)

Hadith—The words and exemplary deeds of the Prophet Muhammad. (285)

hall church—See Hallenkirche. (348)

Hallenkirche—German, "hall church." A church design favored in Germany, but also used elsewhere, in which the *aisles* rise to the same height as the *nave*. (396)

head cluster—An abbreviated way of representing a crowd by painting or carving many heads close together, usually with too few bodies for the number of heads. (246)

Hiberno-Saxon—An art *style* that flourished in the *monasteries* of the British Isles in the early Middle Ages. Also called Insular. (311)

hierarchy of scale—An artistic convention in which greater size indicates greater importance.

Hijra—The flight of Muhammad from Mecca to Medina in 622, the year from which Islam dates its beginnings. (285)

historiated—Ornamented with representations, such as plants, animals, or human figures, that have a narrative—as distinct from a purely decorative—function. (342)

humanism—In the Renaissance, an emphasis on education and on expanding knowledge (especially of classical antiquity), the exploration of individual potential and a desire to excel, and a commitment to civic responsibility and moral duty. (407)

hypostyle hall—A hall with a roof supported by *columns*. (288, 289)

icon—A portrait or image; especially in *Byzantine* churches, a panel with a painting of sacred personages that are objects of veneration. In the visual arts, a painting, a piece of sculpture, or even a building regarded as an object of veneration. (268, 269, 405)

iconoclasm—The destruction of religious or sacred images. In Byzantium, the period from 726 to 843 when there was an imperial ban on such images. The destroyers of images were known as iconoclasts. Those who opposed such a ban were known as iconophiles. (269)

iconoclast—See iconoclasm. (269)

iconophile—See iconoclasm. (269)

iconostasis—Greek, "icon stand." In Byzantine churches, a screen or a partition, with doors and many tiers of *icons*, separating the sanctuary from the main body of the church. (279)

illuminated manuscript—A luxurious handmade book with painted illustrations and decorations. (249, 405)

imam—In Islam, the leader of collective worship. (288)

incrustation—Wall decoration consisting of bright panels of different *colors*. (355)

indulgence—A religious pardon for a sin committed. (374)

Insular—See *Hiberno-Saxon*. (311)

iwan—In Islamic architecture, a *vaulted* rectangular recess opening onto a courtyard. (288)

jambs—In architecture, the side posts of a doorway. (344)

Kaaba—Arabic, "cube." A small cubical building in Mecca, the Islamic world's symbolic center. (285)

keep—A fortified tower in a castle that served as a place of last refuge. (383)

keystone—See voussoir. (344)

khan—An Ottoman lord, or sultan. (10-23A)

king's gallery—The band of *statues* running the full width of the *facade* of a *Gothic cathedral* directly above the *rose window.* (379, 380)

Koran—Islam's sacred book, composed of *surahs* (chapters) divided into verses. (285)

Kufic—An early form of Arabic script, characterized by angularity, with the uprights forming almost right angles with the baseline. (294)

laid-and-couched work—See *embroidery*. (362) lancet—In *Gothic* architecture, a tall narrow window ending in a *pointed arch*. (370, 373, 14-5A)

landscape—A picture showing natural scenery, without narrative content. (416)

leading—In the manufacture of *stained-glass* windows, the joining of colored glass pieces using lead *cames*. (375)

lectionary—A book containing passages from the *Gospels*, arranged in the sequence that they are to be read during the celebration of religious services, including the *Mass*, throughout the year. (312)

libation—The pouring of liquid as part of a religious ritual. (36)

liege lord—In *feudalism*, a landowner who grants tenure of a portion of his land to a *vassal*. (334)

lintel—A horizontal *beam* used to span an opening. (344)

liturgy (adj. **liturgical**)—The official ritual of public worship. (242)

loculi—Openings in the walls of *catacombs* to receive the dead. (237)

loggia—A gallery with an open *arcade* or a *colonnade* on one or both sides. (14-19A)

longitudinal plan—See plan. (243)

lunette—A semicircular area (with the flat side down) in a wall over a door, niche, or window; also, a painting or *relief* with a semicircular frame. (237, 344)

lux nova—Latin, "new light." Abbot Suger's term for the light that enters a *Gothic* church through *stained-glass* windows. (369, 375)

machicolated gallery—A gallery in a defensive tower with holes in the floor to allow stones or hot liquids to be dumped on enemies below. (416)

madrasa—An Islamic theological college adjoining and often containing a *mosque*. (296)

magus (pl. magi)—One of the three wise men from the East who presented gifts to the infant Jesus. (240)

mandorla—An almond-shaped *nimbus* surrounding the figure of Christ or other sacred figure. In Buddhist Japan, a lotus-petal-shaped nimbus. (267)

maniera greca—Italian, "Greek manner." The Italo-*Byzantine* painting *style* of the 13th century. (404, 14-7A)

manor—In feudalism, the estate of a liege lord. (334)

maqsura—In some *mosques*, a screened area in front of the *mihrab* reserved for a ruler. (283, 288)

martyr—A person who chooses to die rather than deny his or her religious belief. See also *saint*. (237)

martyrium—A shrine to a Christian *martyr*. (274)

- Mass—The Catholic and Orthodox ritual in which believers understand that Christ's redeeming sacrifice on the cross is repeated when the priest consecrates the bread and wine in the *Eucharist*. (241)
- **matins**—In Christianity, early morning prayers. (13-36A)
- mendicants—In medieval Europe, friars belonging to the Franciscan and Dominican orders, who renounced all worldly goods, lived by contributions of laypersons (the word *mendicant* means "beggar"), and devoted themselves to preaching, teaching, and doing good works. (385, 404)
- merlon—See crenellation. (382)
- Messiah—The savior of the Jews prophesied in Hebrew scripture. Christians believe that Jesus of Nazareth was the Messiah. (240)
- **mihrab**—A semicircular niche set into the *qibla* wall of a *mosque*. (287, 288)
- **minaret**—A distinctive feature of *mosque* architecture, a tower from which the faithful are called to worship. (261, 287, 288)
- minbar—In a mosque, the pulpit on which the imam stands. (287, 288)
- **Miraj**—The ascension of the Prophet Muhammad to Heaven. (286)
- module (adj. modular)—A basic unit of which the dimensions of the major parts of a work are multiples. The principle is used in sculpture and other art forms, but it is most often employed in architecture, where the module may be the dimensions of an important part of a building, such as the diameter of a *column*. (323)
- **monastery**—A group of buildings in which monks live together, set apart from the secular community of a town. (267)
- monastic—Relating to life in a *monastery*. (267, 404)
- monastic order—An organization of monks living according to the same rules, for example, the Benedictine, Franciscan, and Dominican orders. (404)
- **monotheism**—The worship of one all-powerful god. (233)
- moralized Bible—A heavily illustrated Bible, each page pairing paintings of Old and New Testament episodes with explanations of their moral significance. (385)
- mosaic—Patterns or pictures made by embedding small pieces (tesserae) of stone or glass in cement on surfaces such as walls and floors; also, the technique of making such works. (245)
- **mosaic tilework**—An Islamic decorative *technique* in which large ceramic panels are fired, cut into smaller pieces, and set in plaster. (299)
- **mosque**—The Islamic building for collective worship. From the Arabic word *masjid*, meaning a "place for bowing down." (261, 288)
- **Mozarabic**—Referring to the Christian culture of northern Spain during the time Islamic *caliphs* ruled southern Spain. (316)
- **Muhaqqaq**—A cursive *style* of Islamic *calligra-phy.* (300)

- mullion—A vertical member that divides a window or that separates one window from another. (381)
- muqarnas—Stucco decorations of Islamic buildings in which stalactite-like forms break a structure's solidity. (274, 296, 9-27A)
- mural—A wall painting. (407, 408, 409)
- mystery play—A dramatic enactment of the holy mysteries of the Christian faith performed at church portals and in city squares. (409, 12-35A)
- **narthex**—A porch or vestibule of a church, generally *colonnaded* or *arcaded* and preceding the *nave*. (243)
- naturalism—The style of painted or sculptured representation based on close observation of the natural world that was at the core of the *classical* tradition. (401)
- nave—The central area of an ancient Roman basilica or of a church, demarcated from aisles by piers or columns. (413)
- **nave arcade**—In *basilica* architecture, the series of *arches* supported by *piers* or *columns* separating the *nave* from the *aisles*. (373)
- **nimbus**—A halo or aureole appearing around the head of a holy figure to signify divinity. (248)
- **oculus** (pl. **oculi**)—Latin, "eye." The round central opening of a *dome*. Also, a small round window in a *Gothic cathedral*. (373, 14-6A)
- **ogee arch**—An *arch* composed of two doublecurving lines meeting at a point. (420, 13-42A)
- **ogive** (adj. **ogival**)—The diagonal *rib* of a *Gothic vault*; a pointed, or Gothic, *arch*. (369, 402)
- **opere francigeno**—See opus francigenum. (366, 389)
- **opus francigenum**—Latin, "French work." Architecture in the *style* of *Gothic* France; *opere francigeno* (adj.), "in the French manner." (366, 389)
- **opus modernum**—Latin, "modern work." The late medieval term for *Gothic* art and architecture. Also called *opus francigenum*. (365, 373, 389)
- **opus reticulatum**—An ancient Roman method of facing *concrete* walls with lozenge-shaped bricks or stones to achieve a netlike ornamental surface pattern. (11-19A)
- orant—In Early Christian art, a figure with both arms raised in the ancient gesture of prayer. (238)
- **oratory**—The church of a Christian *monastery*. (267)
- Ottonian (adj.)—Pertaining to the empire of Otto I and his successors. (324)
- **pala**—A panel placed behind and over the altar in a church. (9-26A)
- **Pantokrator**—Greek, "ruler of all." Christ as ruler and judge. (272)
- **papyrus**—A plant native to Egypt and adjacent lands used to make paperlike writing material; also, the material or any writing on it. (249)
- parade helmet—A masklike helmet worn by Roman soldiers on special ceremonial occasions. (336)

- **parapet**—A low, protective wall along the edge of a balcony, roof, or bastion. (416)
- **parchment**—Lambskin prepared as a surface for painting or writing. (249)
- parekklesion—The side chapel in a Byzantine church. (279)
- **Passional**—A Christian book containing the lives of *saints*. (312)
- **Passover**—The annual feast celebrating the release of the Jews from bondage to the *pharaohs* of Egypt. (240)
- **paten**—A large shallow bowl or plate for the bread used in the *Eucharist*. (264)
- **pebble mosaic**—A *mosaic* made of irregularly shaped stones of various *colors*. (245)
- **pendant**—The large hanging terminal element of a *Gothic* fan *vault*. (391)
- **pendentive**—A concave, triangular section of a hemisphere, four of which provide the transition from a square area to the circular base of a covering *dome*. Although pendentives appear to be hanging (pendant) from the dome, they in fact support it. (262)
- **Pentateuch**—The first five books of the Old Testament. (235, 312)
- **Perpendicular**—A Late English *Gothic style* of architecture distinguished by the pronounced verticality of its decorative details. (391)
- Pietà—A painted or sculpted representation of the Virgin Mary mourning over the body of the dead Christ. (241, 396)
- **pinnacle**—In *Gothic* churches, a sharply pointed ornament capping the *piers* or flying *buttresses*; also used on church *facades*. (373, 411, 413)
- plate tracery—See tracery. (375)
- **poesia**—A term describing "poetic" art, notably Venepointed arch—A narrow *arch* of pointed profile, in contrast to a semicircular arch. (368, 402, 420, 12-10A)
- **polytheism**—The belief in multiple gods. (233)
- **predella**—The narrow ledge on which an *altar-piece* rests on an altar. (411)
- **prefiguration**—In Early Christian art, the depiction of Old Testament persons and events as prophetic forerunners of Christ and New Testament events. (238)
- **psalter**—A book containing the Psalms. (312)
- **pulpit**—A raised platform in a church or *mosque* on which a priest or *imam* stands while leading the religious service. (402)
- **punchwork**—Tooled decorative work in *gold leaf*. (412)
- **pyxis** (pl. **pyxides**)—A cylindrical container with a hemispherical lid. (293)
- **qibla**—The direction (toward Mecca) Muslims face when praying. (288, 289)
- **quadrant arch**—An *arch* whose curve extends for one-quarter of a circle's circumference. (359)
- **quatrefoil**—A shape or *plan* in which the parts assume the form of a cloverleaf. (419)
- **radiating chapels**—In medieval churches, chapels for the display of *relics* that opened directly onto the *ambulatory* and the *transept*. (337)
- ramparts—Defensive wall circuits. (382)
- **Rayonnant**—The "radiant" style of *Gothic* architecture, dominant in the second half of the

- 13th century and associated with the French royal court of Louis IX at Paris. (381)
- **refectory**—The dining hall of a Christian *monastery*. (267)
- **rrelics**—The body parts, clothing, or objects associated with a holy figure, such as the Buddha or Christ or a Christian *saint*. (243, 336)
- **reliquary**—A container for holding *relics*. (328, 334, 336)
- Renaissance—French, "rebirth." The term used to describe the history, culture, and art of 14th- through 16th-century western Europe during which artists consciously revived the *classical* style. (401, 406)
- **renovatio**—Latin, "renewal." During the *Carolingian* period, Charlemagne sought to revive the culture of ancient Rome (*renovatio imperi Romani*). (317, 318, 402)
- **repoussé**—Formed in *relief* by beating a metal plate from the back, leaving the impression on the face. The metal sheet is hammered into a hollow *mold* of wood or some other pliable material and finished with a *graver*. See also *relief*. (248, 320, 354)
- **respond**—An engaged *column*, *pilaster*, or similar element that either projects from a *compound pier* or some other supporting device or is bonded to a wall and carries one end of an *arch*. (373)
- **revetment**—In architecture, a wall covering or facing. (418)
- rib—A relatively slender, molded masonry *arch* that projects from a surface. In *Gothic* architecture, the ribs form the framework of the *vaulting*. A diagonal rib is one of the ribs that form the X of a *groin vault*. A transverse rib crosses the *nave* or *aisle* at a 90° angle. (351)
- **rib vault**—A *vault* in which the diagonal and transverse *ribs* compose a structural skeleton that partially supports the masonry *web* between them. (351, 368, 14-5A)
- Romanesque—"Roman-like." A term used to describe the history, culture, and art of medieval western Europe from ca. 1050 to ca. 1200. (333, 413)
- **rose window**—A circular *stained-glass* window. (412, 13-3A)
- **rotulus**—The manuscript scroll used by Egyptians, Greeks, Etruscans, and Romans; predecessor of the *codex*. (249)
- roundel—See tondo. (10-15A)
- sacra rappresentazione (pl. sacre rappresentazioni)—Italian, "holy representation." A more elaborate version of a mystery play performed for a lay audience by a confraternity. (409)
- sacramentary—A Christian religious book incorporating the prayers priests recite during Mass. (312)
- saint—From the Latin word sanctus, meaning "made holy by God." Applied to persons who suffered and died for their Christian faith or who merited reverence for their Christian devotion while alive. In the Roman Catholic Church, a worthy deceased Catholic who is canonized by the pope. (237, 402)

- **sakkos**—The tunic worn by a Byzantine priest. (9-35A)
- Samarqand ware—A type of Islamic pottery produced in Samarqand and Nishapur in which the ceramists formed the shape of the vessel from dark pink clay and then immersed it in a tub of white slip, over which they painted ornamental or *calligraphic* decoration and which they sealed with a transparent glaze before firing. (294)
- **sarcophagus** (pl. **sarcophagi**)—Greek, "consumer of flesh." A coffin, usually of stone. (402)
- **Scholasticism**—The *Gothic* school of philosophy in which scholars applied Aristotle's system of rational inquiry to the interpretation of religious belief. (372)
- **screen facade**—A *facade* that does not correspond to the structure of the building behind it. (12-11A)
- **scriptorium** (pl. **scriptoria**)—The writing studio of a *monastery*. (311)
- secco-Italian, "dry." See also fresco. (408)
- sedes sapientiae—Latin, "throne of wisdom." A Romanesque sculptural type depicting the Virgin Mary with the Christ Child in her lap. (349)
- sexpartite vault—See vault. (358)
- **shaft**—The tall, cylindrical part of a *column* between the *capital* and the *base*. (373)
- **silentiary**—An usher responsible for maintaining silence in the *Byzantine* imperial palace in Constantinople. (261)
- **sinopia**—A burnt-orange pigment used in *fresco* painting to transfer a *cartoon* to the *arriccio* before the artist paints the plaster. (408)
- **slip**—A mixture of fine clay and water used in ceramic decoration. (451)
- solidus (pl. solidi)—A Byzantine gold coin. (263) springing—The lowest stone of an arch, resting on the impost block. In Gothic vaulting, the lowest stone of a diagonal or transverse rib. (340, 373)
- **squinch**—An architectural device used as a transition from a square to a polygonal or circular base for a *dome*. It may be composed of *lintels*, *corbels*, or *arches*. (262)
- **stained glass**—In *Gothic* architecture, the colored glass used for windows. (373, 375)
- **stave**—A wedge-shaped timber; vertically placed staves embellish the architectural features of a building. (311)
- stem stitching—See embroidery. (362)
- stigmata—In Christian art, the wounds Christ received at his crucifixion that miraculously appear on the body of a *saint*. (405)
- stringcourse—A raised horizontal *molding*, or band, in masonry. Its principal use is ornamental but it usually reflects interior structure. (11-19A)
- **sub gracia**—Latin, "under grace." In Christian thought, the period after the coming of Christ. (392)
- **sub lege**—Latin, "under the law." In Christian thought, the period after Moses received the Ten Commandments and before the coming of Christ. See also *sub gracia*. (392)

- sultan—A Muslim ruler. (292)
- **Sunnah**—The collection of the Prophet Muhammad's moral sayings and descriptions of his deeds. (285)
- **surah**—A chapter of the *Koran*, divided into verses. (285)
- tapestry—A weaving technique in which the weft threads are packed densely over the warp threads so that the designs are woven directly into the fabric. (362)
- **tempera**—A *technique* of painting using pigment mixed with egg yolk, glue, or casein; also, the *medium* itself. (404)
- **templon**—The columnar screen separating the sanctuary from the main body of a *Byzantine* church. (277)
- **terracotta**—Hard-baked clay, used for sculpture and as a building material. It may be *glazed* or painted. (414)
- tessera (pl. tesserae)—Greek, "cube." A tiny stone or piece of glass cut to the desired shape and size for use in forming a *mosaic*. (245, 291, 299)
- **Theotokos**—Greek, "she who bore God." The Virgin Mary, the mother of Jesus. (245, 267)
- **tondo** (pl. **tondi**)—A circular painting or *relief* sculpture. (10-15A)
- **Torah**—The Hebrew religious scroll containing the *Pentateuch*. (235)
- tracery—Ornamental stonework for holding stained glass in place, characteristic of Gothic cathedrals. In plate tracery, the glass fills only the "punched holes" in the heavy ornamental stonework. In bar tracery, the stained-glass windows fill almost the entire opening, and the stonework is unobtrusive. (373, 414)
- **tramezzo**—A screen placed across the *nave* of a church to separate the clergy from the lay audience. (14-6A)
- **transept**—The part of a church with an axis that crosses the *nave* at a right angle. (243, 14-5A)
- **transverse arch**—An *arch* separating one *vaulted bay* from the next. (340)
- **transverse barrel vault**—In medieval architecture, a semicylindrical *vault* oriented at a 90° angle to the *nave* of a church. (12-10A)
- transverse rib—See rib. (373)
- trefoil arch—A triple-lobed arch. (402)
- **tribune**—In church architecture, a gallery over the inner *aisle* flanking the *nave*. (337)
- **triforium**—In a *Gothic cathedral*, the *blind ar-caded* gallery below the *clerestory*; occasionally, the *arcades* are filled with *stained glass*. (370, 373)
- **Trinity**—In Christianity, God the Father, his son Jesus Christ, and the Holy Spirit. (240)
- **triptych**—A three-paneled painting, ivory plaque, or *altarpiece*. Also, a small, portable shrine with hinged wings used for private devotion. (275, 392, 415)
- true fresco—See fresco. (408, 409)
- **trumeau**—In church architecture, the *pillar* or center post supporting the *lintel* in the middle of the doorway. (344)
- **tughra**—The official signature of an Ottoman emperor. (10-23A)

tumulus (pl. **tumuli**)—Latin, "burial mound." In Etruscan architecture, tumuli cover one or more subterranean multichambered tombs cut out of the local tufa (limestone). Also characteristic of the Japanese Kofun period of the third and fourth centuries CE. (309)

tunnel vault—See vault. (338)

turris—See westwork. (323)

tympanum (pl. **tympana**)—The space enclosed by a *lintel* and an *arch* over a doorway. (344, 14-12A)

typology—In Christian theology, the recognition of concordances between events, especially between episodes in the Old and New Testaments. (238)

vassal—In feudalism, a person who swears allegiance to a liege lord and renders him military service in return for tenure of a portion of the lord's land. (334)

vvaulting web—See web. (373)

vellum—Calfskin prepared as a surface for writing or painting. (249)

vita contemplativa—Latin, "contemplative life." The secluded spiritual life of monks and nuns. (342)

voussoir—A wedge-shaped stone block used in the construction of a true *arch*. The central voussoir, which sets the arch, is called the keystone. (344)

web—The masonry blocks that fill the area between the *ribs* of a *groin vault*. Also called vaulting web. (368)

westwork—German, "western entrance structure." The *facade* and towers at the western end of a medieval church, principally in Germany. In contemporaneous documents the westwork is called a castellum (Latin, "castle" or "fortress") or turris ("tower"). (323)

ziggurat—In ancient Mesopotamian architecture, a monumental platform for a temple. (289)

BIBLIOGRAPHY

This list of books is very selective but comprehensive enough to satisfy the reading interests of the beginning art history student and general reader. Significantly expanded from the previous edition, the 14th edition bibliography can also serve as the basis for undergraduate research papers. The resources listed range from works that are valuable primarily for their reproductions to those that are scholarly surveys of schools and periods or monographs on individual artists. The emphasis is on recent in-print books and on books likely to be found in college and municipal libraries. No entries for periodical articles appear, but the bibliography begins with a list of some of the major journals that publish art historical scholarship in English.

Selected Periodicals

African Arts

American Art American Indian Art American Journal of Archaeology Antiquity Archaeology Archives of American Art Archives of Asian Art Ars Orientalis Art Bulletin Art History Art in America Art Journal Artforum International Artnews Burlington Magazine Gesta History of Photography Journal of Egyptian Archaeology Journal of Roman Archaeology Journal of the Society of Architectural Historians Journal of the Warburg and Courtauld Institutes Latin American Antiquity October Oxford Art Journal Women's Art Journal

General Studies

- Baxandall, Michael. Patterns of Intention: On the Historical Explanation of Pictures. New Haven, Conn.: Yale University Press, 1985.
- Bindman, David, ed. The Thames & Hudson Encyclopedia of British Art. London: Thames & Hudson, 1988.
- Boström, Antonia. *The Encyclopedia of Sculpture*. 3 vols. London: Routledge, 2003.
- Broude, Norma, and Mary D. Garrard, eds. *The Expanding Discourse: Feminism and Art History*. New York: Harper Collins, 1992.
- Bryson, Norman. Vision and Painting: The Logic of the Gaze. New Haven, Conn.: Yale University Press, 1983.
- Bryson, Norman, Michael Ann Holly, and Keith Moxey. *Visual Theory: Painting and Interpretation*. New York: Cambridge University Press, 1991.
- Burden, Ernest. *Illustrated Dictionary of Architecture*. 2d ed. New York: McGraw-Hill, 2002.

- Büttner, Nils. *Landscape Painting: A History*. New York: Abbeville, 2006.
- Carrier, David. A World Art History and Its Objects.
 University Park: Pennsylvania State University
 Press. 2009
- Chadwick, Whitney. *Women, Art, and Society.* 4th ed. New York: Thames & Hudson, 2007.
- Cheetham, Mark A., Michael Ann Holly, and Keith Moxey, eds. *The Subjects of Art History: Historical Objects in Contemporary Perspective*. New York: Cambridge University Press, 1998.
- Chilvers, Ian, and Harold Osborne, eds. *The Oxford Dictionary of Art.* 3d ed. New York: Oxford University Press, 2004.
- Corbin, George A. Native Arts of North America, Africa, and the South Pacific: An Introduction. New York: Harper Collins, 1988.
- Crouch, Dora P., and June G. Johnson. Traditions in Architecture: Africa, America, Asia, and Oceania. New York: Oxford University Press, 2000.
- Curl, James Stevens. Oxford Dictionary of Architecture and Landscape Architecture. 2d ed. New York: Oxford University Press, 2006.
- Duby, Georges, ed. Sculpture: From Antiquity to the Present. 2 vols. Cologne: Taschen, 1999.
- Encyclopedia of World Art. 17 vols. New York: McGraw-Hill, 1959–1987.
- Fielding, Mantle. Dictionary of American Painters, Sculptors, and Engravers. 2d ed. Poughkeepsie, N.Y.: Apollo, 1986.
- Fine, Sylvia Honig. Women and Art: A History of Women Painters and Sculptors from the Renaissance to the 20th Century. Rev. ed. Montclair, N.J.: Alanheld & Schram, 1978.
- Fleming, John, Hugh Honour, and Nikolaus Pevsner. *The Penguin Dictionary of Architecture and Landscape Architecture*. 5th ed. New York: Penguin, 2000.
- Frazier, Nancy. *The Penguin Concise Dictionary of Art History*. New York: Penguin, 2000.
- Freedberg, David. *The Power of Images: Studies in the History and Theory of Response.* Chicago: University of Chicago Press, 1989.
- Gaze, Delia., ed. *Dictionary of Women Artists.* 2 vols. London: Routledge, 1997.
- Hall, James. *Dictionary of Subjects and Symbols in Art.* 2d ed. Boulder, Colo.: Westview, 2008.
- Harris, Anne Sutherland, and Linda Nochlin. Women Artists: 1550–1950. Los Angeles: Los Angeles County Museum of Art; New York: Knopf, 1977.

- Hauser, Arnold. *The Sociology of Art*. Chicago: University of Chicago Press, 1982.
- Hults, Linda C. The Print in the Western World: An Introductory History. Madison: University of Wisconsin Press, 1996.
- Kemp, Martin. The Science of Art: Optical Themes in Western Art from Brunelleschi to Seurat. New Haven, Conn.: Yale University Press, 1990.
- Kostof, Spiro, and Gregory Castillo. A History of Architecture: Settings and Rituals. 2d ed. Oxford: Oxford University Press, 1995.
- Kultermann, Udo. *The History of Art History*. New York: Abaris, 1993.
- Lucie-Smith, Edward. The Thames & Hudson Dictionary of Art Terms. 2d ed. New York: Thames & Hudson 2004
- Moffett, Marian, Michael Fazio, and Lawrence Wadehouse. *A World History of Architecture*. Boston: McGraw-Hill, 2004.
- Morgan, Anne Lee. Oxford Dictionary of American Art and Artists. New York: Oxford University Press, 2008.
- Murray, Peter, and Linda Murray. A Dictionary of Art and Artists. 7th ed. New York: Penguin, 1998.
- Nelson, Robert S., and Richard Shiff, eds. Critical Terms for Art History. Chicago: University of Chicago Press, 1996.
- Pazanelli, Roberta, ed. The Color of Life: Polychromy in Sculpture from Antiquity to the Present. Los Angeles: J. Paul Getty Museum, 2008.
- Penny, Nicholas. *The Materials of Sculpture*. New Haven, Conn.: Yale University Press, 1993.
- Pevsner, Nikolaus. A History of Building Types. London: Thames & Hudson, 1987. Reprint of 1979 ed.
- ——. An Outline of European Architecture. 8th ed. Baltimore: Penguin, 1974.
- Pierce, James Smith. From Abacus to Zeus: A Handbook of Art History. 7th ed. Upper Saddle River, N.J.: Pearson Prentice Hall, 1998.
- Placzek, Adolf K., ed. *Macmillan Encyclopedia of Architects*. 4 vols. New York: Macmillan, 1982.
- Podro, Michael. *The Critical Historians of Art.* New Haven, Conn.: Yale University Press, 1982.
- Pollock, Griselda. Vision and Difference: Femininity, Feminism, and Histories of Art. London: Routledge, 1988.
- Pregill, Philip, and Nancy Volkman. Landscapes in History Design and Planning in the Eastern and Western Traditions. 2d ed. Hoboken, N.J.: Wiley, 1999.

- Preziosi, Donald, ed. *The Art of Art History: A Critical Anthology.* New York: Oxford University Press, 1998
- Read, Herbert. The Thames & Hudson Dictionary of Art and Artists. Rev. ed. New York: Thames & Hudson, 1994.
- Reid, Jane D. The Oxford Guide to Classical Mythology in the Arts 1300–1990s. 2 vols. New York: Oxford University Press, 1993.
- Rogers, Elizabeth Barlow. Landscape Design: A Cultural and Architectural History. New York: Abrams, 2001.
- Roth, Leland M. *Understanding Architecture: Its Elements, History, and Meaning.* 2d ed. Boulder, Colo.: Westview, 2006.
- Schama, Simon. The Power of Art. New York: Ecco, 2006.
- Slatkin, Wendy. Women Artists in History: From Antiquity to the 20th Century. 4th ed. Upper Saddle River, N.J.: Prentice Hall, 2000.
- Steer, John, and Antony White. Atlas of Western Art History: Artists, Sites, and Monuments from Ancient Greece to the Modern Age. New York: Facts on File, 1994.
- Stratton, Arthur. The Orders of Architecture: Greek, Roman, and Renaissance. London: Studio, 1986.
- Summers, David. Real Spaces: World Art History and the Rise of Western Modernism. London: Phaidon, 2003.
- Sutton, Ian. Western Architecture: From Ancient Greece to the Present. New York: Thames & Hudson, 1999.
- Trachtenberg, Marvin, and Isabelle Hyman. Architecture, from Prehistory to Post-Modernism. 2d ed. Upper Saddle River, N.J.: Prentice Hall, 2003.
- Turner, Jane, ed. *The Dictionary of Art.* 34 vols. New ed. New York: Oxford University Press, 2003.
- Watkin, David. *A History of Western Architecture*. 4th ed. London: Laurence King, 2010.
- West, Shearer. Portraiture. New York: Oxford University Press, 2004.
- Wittkower, Rudolf. Sculpture Processes and Principles. New York: Harper & Row, 1977.
- Wren, Linnea H., and Janine M. Carter, eds. Perspectives on Western Art: Source Documents and Readings from the Ancient Near East through the Middle Ages. New York: Harper & Row, 1987.
- Zijlmans, Kitty, and Wilfried van Damme, eds. World Art Studies: Exploring Concepts and Approaches. Amsterdam: Valiz, 2008.

Medieval Art, General

- Alexander, Jonathan J. G. Medieval Illuminators and Their Methods of Work. New Haven, Conn.: Yale University Press, 1992.
- *The Art of Medieval Spain, AD 500–1200.* New York: Metropolitan Museum of Art, 1993.
- Benton, Janetta Rebold. Art of the Middle Ages. New York: Thames & Hudson, 2002.
- Binski, Paul. *Painters (Medieval Craftsmen)*. Toronto: University of Toronto Press, 1991.
- Calkins, Robert G. *Illuminated Books of the Middle Ages*. Ithaca, N.Y.: Cornell University Press, 1983.
- Medieval Architecture in Western Europe: From AD 300 to 1500. New York: Oxford University Press, 1998.
- Coldstream, Nicola. Masons and Sculptors (Medieval Craftsmen). Toronto: University of Toronto Press, 1991
- Medieval Architecture. New York: Oxford University Press, 2002.
- Cross, Frank L., and Livingstone, Elizabeth A., eds. The Oxford Dictionary of the Christian Church. 3d ed. New York: Oxford University Press, 1997.

- De Hamel, Christopher. A History of Illuminated Manuscripts. Oxford: Phaidon, 1986.
- ——. Scribes and Illuminators (Medieval Craftsmen). Toronto: University of Toronto Press, 1992.
- Doig, Allan. Liturgy and Architecture: From the Early Church to the Middle Ages. New York: Ashgate, 2008.
- Holcomb, Melanie, ed. Pen and Parchment: Drawing in the Middle Ages. New York: Metropolitan Museum of Art, 2009.
- Kessler, Herbert L. Seeing Medieval Art. Toronto: Broadview, 2004.
- ——. Spiritual Seeing: Picturing God's Invisibility in Medieval Art. Philadelphia: University of Pennsylvania Press, 2000.
- Lasko, Peter. *Ars Sacra*, 800–1200. 2d ed. New Haven, Conn.: Yale University Press, 1994.
- Murray, Peter, and Linda Murray. *The Oxford Companion to Christian Art and Architecture*. New York: Oxford University Press, 1996.
- Pelikan, Jaroslav. Mary through the Centuries: Her Place in the History of Culture. New Haven, Conn.: Yale University Press, 1996.
- Prache, Anne. *Cathedrals of Europe*. Ithaca, N.Y.: Cornell University Press, 1999.
- Raguin, Virginia Chieffo. Stained Glass from Its Origins to the Present. New York: Abrams, 2003.
- Ross, Leslie. Medieval Art: A Topical Dictionary. Westport, Conn.: Greenwood, 1996.
- Schütz, Bernard. *Great Cathedrals*. New York: Abrams, 2002
- Sekules, Veronica. Medieval Art. New York: Oxford University Press, 2001.
- Snyder, James, Henry Luttikhuizen, and Dorothy Verkerk. Art of the Middle Ages. 2d ed. Upper Saddle River, N.J.: Prentice Hall, 2006.
- Stokstad, Marilyn. *Medieval Art.* 2d ed. Boulder, Colo.: Westview, 2004.
- Tasker, Edward G. Encyclopedia of Medieval Church Art. London: Batsford, 1993.

Chapter 8: Late Antiquity

- Bowersock, G. W., Peter Brown, and Oleg Grabar, eds. *Late Antiquity: A Guide to the Postclassical World.* Cambridge, Mass.: Harvard University Press, 1998.
- Brody, Lisa R., and Gail L. Hoffman, eds. Dura Europos: Crossroads of Antiquity. Chestnut Hill, Mass.: McMullen Museum of Art, Boston College, 2010.
- Cioffarelli, Ada. *Guide to the Catacombs of Rome and Its Surroundings*. Rome: Bonsignori, 2000.
- Elsner, Jaś. Art and the Roman Viewer: The Transformation of Art from the Pagan World to Christianity. New York: Cambridge University Press, 1995.
- ——. Imperial Rome and Christian Triumph. New York: Oxford University Press, 1998.
- Fine, Steven. Art and Judaism in the Greco-Roman World: Toward a New Jewish Archaeology. New York: Cambridge University Press, 2005.
- Finney, Paul Corby. *The Invisible God: The Earliest Christians on Art.* New York: Oxford University Press, 1994.
- Grabar, André. *The Beginnings of Christian Art, 200–* 395. London: Thames & Hudson, 1967.
- ——. Christian Iconography. Princeton, N.J.: Princeton University Press, 1980.
- Gutmann, Joseph. Sacred Images: Studies in Jewish Art from Antiquity to the Middle Ages. Northampton, Mass.: Variorum, 1989.
- Janes, Dominic. God and Gold in Late Antiquity. New York: Cambridge University Press, 1998.
- Jensen, Robin Margaret. Understanding Early Christian Art. New York: Routledge, 2000.
- Koch, Guntram. Early Christian Art and Architecture. London: SCM, 1996.

- Krautheimer, Richard. Rome, Profile of a City: 312–1308. Princeton, N.J.: Princeton University Press, 1980
- Krautheimer, Richard, and Slobodan Ćurĉić. *Early Christian and Byzantine Architecture*. 4th ed. New Haven, Conn.: Yale University Press, 1986.
- Lowden, John. Early Christian and Byzantine Art. London: Phaidon, 1997.
- Mathews, Thomas P. *The Clash of Gods: A Reinterpretation of Early Christian Art.* Rev. ed. Princeton, N.J.: Princeton University Press, 1999.
- Milburn, Robert. *Early Christian Art and Architecture*. Berkeley: University of California Press, 1988.
- Nicolai, Vincenzo Fiocchi, Fabrizio Bisconti, and Danilo Mazzoleni. The Christian Catacombs of Rome: History, Decoration, Inscriptions. Regensburg: Schnell & Steiner, 2006.
- Perkins, Ann Louise. *The Art of Dura-Europos*. Oxford: Clarendon, 1973.
- Poeschke, Joachim. *Italian Mosaics*, 300–1300. New York: Abbeville, 2010.
- Rutgers, Leonard V. Subterranean Rome: In Search of the Roots of Christianity in the Catacombs of the Eternal City. Leuven: Peeters, 2000.
- Spier, Jeffrey, ed. Picturing the Bible: The Earliest Christian Art. New Haven, Conn.: Yale University Press, 2007.
- Volbach, Wolfgang, and Max Hirmer. *Early Christian Art*. New York: Abrams, 1962.
- Webb, Matilda. *The Churches and Catacombs of Early Christian Rome: A Comprehensive Guide.* Brighton: Sussex Academic Press, 2001.
- Webster, Leslie, and Michelle Brown, eds. *The Transformation of the Roman World*, AD 400–900. Berkeley: University of California Press, 1997.
- Weitzmann, Kurt. Late Antique and Early Christian Book Illumination. New York: Braziller, 1977.
- ——, ed. Age of Spirituality: Late Antique and Early Christian Art, Third to Seventh Century. New York: Metropolitan Museum of Art, 1979.

Chapter 9: Byzantium

- Barber, Charles. Figure and Likeness: On the Limits of Representation in Byzantine Iconoclasm. Princeton, N.J.: Princeton University Press, 2002.
- Borsook, Eve. Messages in Mosaic: The Royal Programmes of Norman Sicily. Oxford: Clarendon, 1990.
- Cormack, Robin. *Byzantine Art.* New York: Oxford University Press, 2000.
- —. Icons. Cambridge, Mass.: Harvard University Press, 2007.
- ——. Painting the Soul: Icons, Death Masks, and Shrouds. London: Reaktion, 1997.
- Writing in Gold: Byzantine Society and Its Icons. New York: Oxford University Press, 1985.
- Cormack, Robin, and Maria Vassiliki. *Byzantium*, 330–1453. London: Royal Academy of Arts, 2008.
- Cutler, Anthony. The Hand of the Master: Craftsmanship, Ivory, and Society in Byzantium, 9th-11th Centuries. Princeton, N.J.: Princeton University Press, 1994.
- Deliyannis, Deborah Mauskopf. *Ravenna in Late Antiquity*. New York: Cambridge University Press, 2010.
- Demus, Otto. *The Mosaic Decoration of San Marco*, *Venice*. Chicago: University of Chicago Press, 1990.
- Evans, Helen C. Byzantium: Faith and Power (1261– 1557). New York: Metropolitan Museum of Art, 2004.
- Evans, Helen C., and William D. Wixom, eds. *The Glory of Byzantium: Art and Culture of the Middle Byzantine Era AD 843–1261*. New York: Metropolitan Museum of Art, 1997.

- Freely, John. *Byzantine Monuments of Istanbul*. New York: Cambridge University Press, 2004.
- Grabar, André. The Golden Age of Justinian: From the Death of Theodosius to the Rise of Islam. New York: Odyssey, 1967.
- Grabar, André, and Manolis Chatzidakis. *Greek Mosa*ics of the Byzantine Period. New York: New American Library. 1964.
- Kleinbauer, W. Eugene. *Hagia Sophia*. London: Scala, 2004.
- Lowden, John. Early Christian and Byzantine Art. London: Phaidon, 1997.
- Maguire, Eunice Dauterman, and Henry Maguire.

 Other Icons: Art and Power in Byzantine Secular

 Culture. Princeton, N.J.: Princeton University

 Press, 2007.
- Maguire, Henry. Art and Eloquence in Byzantium. Princeton, N.J.: Princeton University Press, 1981.
- The Icons of Their Bodies: Saints and Their Images in Byzantium. Princeton, N.J.: Princeton University Press, 1996.
- Mainstone, Rowland J. Hagia Sophia: Architecture, Structure, and Liturgy of Justinian's Great Church. 2d ed. New York: Thames & Hudson, 2001.
- Mango, Cyril. Art of the Byzantine Empire, 312–1453: Sources and Documents. Toronto: University of Toronto Press, 1986. Reprint of 1972 ed.
- —. Byzantine Architecture. New York: Electa/Rizzoli, 1985.
- Mark, Robert, and Ahmet S. Cakmak, eds. Hagia Sophia from the Age of Justinian to the Present. New York: Cambridge University Press, 1992.
- Mathews, Thomas F. *Byzantium: From Antiquity to the Renaissance.* New York: Abrams, 1998.
- McClanan, Anne. Representations of Early Byzantine Empresses: Image and Empire. New York: Palgrave Macmillan, 2002.
- Ousterhout, Robert. *Master Builders of Byzantium*. Princeton, N.J.: Princeton University Press, 2000.
- Pelikan, Jaroslav. Imago Dei: The Byzantine Apologia for Icons. Princeton, N.J.: Princeton University Press, 1990.
- Poeschke, Joachim. *Italian Mosaics*, 300–1300. New York: Abbeville, 2010.
- Rodley, Lyn. Byzantine Art and Architecture: An Introduction. New York: Cambridge University Press, 1994
- Von Simson, Otto G. Sacred Fortress: Byzantine Art and Statecraft in Ravenna. Princeton, N.J.: Princeton University Press, 1986.
- Weitzmann, Kurt. *The Icon*. New York: Dorset, 1987.
 ——. *Illustrations in Roll and Codex.* Princeton, N.J.: Princeton University Press, 1970.

Chapter 10: The Islamic World

- Allan, James, and Sheila R. Canby. *Hunt for Paradise: Court Arts of Safavid Iran 1501–76.* Geneva: Skira,
 2004.
- Atil, Esin. *The Age of Sultan Suleyman the Magnificent.*Washington, D.C.: National Gallery of Art, 1987.
- Baker, Patricia L. Islam and the Religious Arts. London: Continuum, 2004.
- Islamic Textiles. London: British Museum, 1995.
- Blair, Sheila S., and Jonathan Bloom. *The Art and Architecture of Islam 1250–1800*. New Haven, Conn.: Yale University Press, 1994.
- Bloom, Jonathan M., and Sheila S. Blair. The Grove Encyclopedia of Islamic Art and Architecture. New York: Oxford University Press, 2009.
- ----. Islamic Arts. London: Phaidon, 1997.
- Brend, Barbara. *Islamic Art.* Cambridge, Mass.: Harvard University Press, 1991.

- Canby, Sheila R. Persian Painting. London: British Museum, 1993.
- Dodds, Jerrilynn D., ed. *Al-Andalus: The Art of Islamic Spain*. New York: Metropolitan Museum of Art, 1992.
- Ettinghausen, Richard, Oleg Grabar, and Marilyn Jenkins-Madina. *The Art and Architecture of Islam,* 650–1250. Rev. ed. New Haven, Conn.: Yale University Press, 2001.
- Ferrier, Ronald W., ed. *The Arts of Persia*. New Haven, Conn.: Yale University Press, 1989.
- Frishman, Martin, and Hasan-Uddin Khan. *The Mosque: History, Architectural Development, and Regional Diversity.* New York: Thames & Hudson, 1994.
- Goodwin, Godfrey. A History of Ottoman Architecture. 2d ed. New York: Thames & Hudson, 1987.
- Grabar, Oleg. The Alhambra. Cambridge, Mass.: Harvard University Press, 1978.
- The Formation of Islamic Art. Rev. ed. New Haven, Conn.: Yale University Press, 1987.
- Islamic Visual Culture, 1100–1800. New York: Ashgate, 2006.
- Grube, Ernst J. Architecture of the Islamic World: Its History and Social Meaning. 2d ed. New York: Thames & Hudson, 1984.
- Hattstein, Markus, and Peter Delius, eds. *Islam: Art and Architecture*. Cologne: Könemann, 2000.
- Hillenbrand, Robert. Islamic Architecture: Form, Function, Meaning. Edinburgh: Edinburgh University Press, 1994.
- Islamic Art and Architecture. New York: Thames & Hudson, 1999.
- Irwin, Robert. *The Alhambra*. Cambridge, Mass.: Harvard University Press, 2004.
- —. Islamic Art in Context: Art, Architecture, and the Literary World. New York: Abrams, 1997.
- Michell, George, ed. *Architecture of the Islamic World*. New York: Thames & Hudson, 1978.
- Necipoglu, Gulru. *The Age of Sinan: Architectural Culture in the Ottoman Empire.* Princeton, N.J.: Princeton University Press, 2005.
- Petruccioli, Attilio, and Khalil K. Pirani, eds. *Under*standing Islamic Architecture. London: Routledge, 2002
- Porter, Venetia. Islamic Tiles. London: British Museum, 1995.
- Robinson, Frank. Atlas of the Islamic World. Oxford: Equinox, 1982.
- Schimmel, Annemarie. Calligraphy and Islamic Culture. New York: New York University Press, 1984.
- Stierlin, Henri. *Islam I: Early Architecture from Baghdad to Cordoba*. Cologne: Taschen, 1996.
- ----. Islamic Art and Architecture from Isfahan to the Taj Mahal. New York: Thames & Hudson, 2002.
- Tadgell, Christopher. Four Caliphates: The Formation and Development of the Islamic Tradition. London: Ellipsis, 1998.
- Ward, Rachel M. *Islamic Metalwork*. New York: Thames & Hudson, 1993.
- Welch, Anthony. *Calligraphy in the Arts of the Islamic World*. Austin: University of Texas Press, 1979.

Chapter 11: Early Medieval Europe

- Alexander, Jonathan J. G. *Insular Manuscripts, Sixth to the Ninth Century.* London: Miller, 1978.
- The Art of Medieval Spain, AD 500–1200. New York: Metropolitan Museum of Art, 1993.
- Backhouse, Janet, D. H. Turner, and Leslie Webster, eds. *The Golden Age of Anglo-Saxon Art*, 966–1066. Bloomington: Indiana University Press, 1984.
- Bandmann, Günter. Early Medieval Architecture as Bearer of Meaning. New York: Columbia University Press, 2005.

- Barral i Altet, Xavier. *The Early Middle Ages: From Late Antiquity to AD 1000.* Cologne: Taschen, 1997.
- Brown, Katharine Reynolds, Dafydd Kidd, and Charles T. Little, eds. *From Attila to Charlemagne*. New York: Metropolitan Museum of Art, 2000.
- Brown, Michelle P. *The Lindisfarne Gospels: Society, Spirituality, and the Scribe.* Toronto: University of Toronto Press, 2003.
- Carver, Martin. Sutton Hoo: A Seventh-Century Princely Burial Ground and Its Context. London: British Museum, 2005.
- Collins, Roger. *Early Medieval Europe*, 300–1000. New York: St. Martin's, 1991.
- Conant, Kenneth J. Carolingian and Romanesque Architecture, 800–1200. 4th ed. New Haven, Conn.: Yale University Press, 1992.
- Davis-Weyer, Caecilia. Early Medieval Art, 300–1150: Sources and Documents. Toronto: University of Toronto Press, 1986. Reprint of 1971 ed.
- Diebold, William J. Word and Image: An Introduction to Early Medieval Art. Boulder, Colo.: Westview Press, 2000.
- Dodwell, Charles R. *Anglo-Saxon Art: A New Perspective*. Ithaca, N.Y.: Cornell University Press, 1982.
- ——. *The Pictorial Arts of the West*, 800–1200. New Haven, Conn.: Yale University Press, 1993.
- Farr, Carol. *The Book of Kells: Its Function and Audience*. London: British Library, 1997.
- Harbison, Peter. *The Golden Age of Irish Art: The Medieval Achievement 600–1200.* New York: Thames & Hudson, 1999.
- Henderson, George. From Durrow to Kells: The Insular Gospel-Books, 650–800. London: Thames & Hudson, 1987.
- Hubert, Jean, Jean Porcher, and Wolfgang Fritz Volbach. *The Carolingian Renaissance*. New York: Braziller, 1970.
- Europe of the Invasions. New York: Braziller, 1969.
- Mayr-Harting, Henry. Ottonian Book Illumination: An Historical Study. 2 vols. London: Miller, 1991–1993.
- McClendon, Charles. *The Origins of Medieval Architecture: Building in Europe, AD 600–900.* New Haven, Conn.: Yale University Press, 2005.
- Megaw, Ruth, and John Vincent Megaw. Celtic Art: From Its Beginning to the Book of Kells. New York: Thames & Hudson, 1989.
- Mütherich, Florentine, and Joachim E. Gaehde. *Carolingian Painting*. New York: Braziller, 1976.
- Nees, Lawrence J. Early Medieval Art. New York: Oxford University Press, 2002.
- Nordenfalk, Carl. Celtic and Anglo-Saxon Painting: Book Illumination in the British Isles, 600–800. New York: Braziller, 1977.
- O'Brien, Jacqueline, and Peter Harbison. Ancient Ireland: From Prehistory to the Middle Ages. New York: Oxford University Press, 2000.
- Richardson, Hilary, and John Scarry. An Introduction to Irish High Crosses. Dublin: Mercier, 1990.
- Stalley, Roger. *Early Medieval Architecture*. New York: Oxford University Press, 1999.
- Wilson, David M. From Viking to Crusader: Scandinavia and Europe 800–1200. New York: Rizzoli, 1992.
- Wilson, David M., and Ole Klindt-Jensen. *Viking Art.* 2d ed. Minneapolis: University of Minnesota Press, 1980.

Chapter 12: Romanesque Europe

Armi, C. Edson. Masons and Sculptors in Romanesque Burgundy: The New Aesthetics of Cluny III. 2 vols. University Park: Pennsylvania State University Press, 1983.

- Ashley, Kathleen, and Marilyn Deegan. Being a Pilgrim: Art and Ritual on the Medieval Routes to Santiago. Burlington, Vt.: Lund Humphries, 2009.
- Bagnoli, Martina, Holger A. Kleiner, C. Griffith Mann, and James Robinson, eds. *Treasures of Heaven:* Saints, Relics, and Devotion in Medieval Europe. New Haven, Conn.: Yale University Press: 2010.
- Barral i Altet, Xavier. The Romanesque: Towns, Cathedrals, and Monasteries. Cologne: Taschen, 1998.
- Burnett, Charles, and Peter Dronke. *Hildegard of Bingen: The Context of Her Thought and Art.* London: Warburg Institute, 1998.
- Cahn, Walter. Romanesque Bible Illumination. Ithaca, N.Y.: Cornell University Press, 1982.
- ——. Romanesque Manuscripts: The Twelfth Century. 2 vols. London: Miller, 1998.
- Conant, Kenneth J. *Carolingian and Romanesque Architecture*, 800–1200. 4th ed. New Haven, Conn.: Yale University Press, 1992.
- Demus, Otto. *Romanesque Mural Painting*. New York: Thames & Hudson, 1970.
- Dodwell, Charles R. *The Pictorial Arts of the West, 800–1200.* New Haven, Conn.: Yale University Press, 1993.
- Fergusson, Peter. Architecture of Solitude: Cistercian Abbeys in Twelfth-Century Europe. Princeton, N.J.: Princeton University Press, 1984.
- Grape, Wolfgang. *The Bayeux Tapestry: Monument to a Norman Triumph*. New York: Prestel, 1994.
- Hearn, Millard F. Romanesque Sculpture: The Revival of Monumental Stone Sculpture in the Eleventh and Twelfth Centuries. Ithaca, N.Y.: Cornell University Press, 1981.
- Hourihane, Colum, ed. Romanesque Art and Thought in the Twelfth Century. Princeton, N.J.: Index of Christian Art, 2008.
- Kahn, Deborah, ed. *The Romanesque Frieze and Its Spectator*. London: Miller, 1992.
- Kubach, Hans E. *Romanesque Architecture*. New York: Electa, 1988.
- Male, Émile. Religious Art in France: The Twelfth Century. Rev. ed. Princeton, N.J.: Princeton University Press, 1978.
- Minne-Sève, Viviane, and Hervé Kergall. Romanesque and Gothic France: Architecture and Sculpture. New York: Abrams, 2000.
- Nichols, Stephen G. Romanesque Signs: Early Medieval Narrative and Iconography. New Haven, Conn.: Yale University Press, 1983.
- Nordenfalk, Carl. Early Medieval Book Illumination. New York: Rizzoli, 1988.
- Petzold, Andreas. Romanesque Art. New York: Abrams, 1995.
- Schapiro, Meyer. *The Sculpture of Moissac*. New York: Thames & Hudson, 1985.
- Seidel, Linda. Legends in Limestone: Lazarus, Gislebertus, and the Cathedral of Autun. Chicago: University of Chicago Press, 1999.
- Stalley, Roger. Early Medieval Architecture. New York: Oxford University Press, 1999.
- Tate, Robert B., and Marcus Tate. *The Pilgrim Route to Santiago*. Oxford: Phaidon, 1987.
- Toman, Rolf, ed. *Romanesque: Architecture, Sculpture, Painting.* Cologne: Könemann, 1997.
- Wilson, David M. The Bayeux Tapestry: The Complete Tapestry in Color. New York: Thames & Hudson, 2004.
- Zarnecki, George, Janet Holt, and Tristram Holland, eds. English Romanesque Art, 1066–1200. London: Weidenfeld & Nicolson, 1984.

Chapter 13: Gothic Europe

Barnes, Carl F. *The Portfolio of Villard de Honnecourt.* New York: Ashgate, 2009.

- Binski, Paul. *Becket's Crown: Art and Imagination in Gothic England*, 1170–1300. New Haven, Conn.: Yale University Press, 2004.
- Bony, Jean. The English Decorated Style: Gothic Architecture Transformed, 1250–1350. Ithaca, N.Y.: Cornell University Press, 1979.
- ——. French Gothic Architecture of the Twelfth and Thirteenth Centuries. Berkeley: University of California Press, 1983.
- Branner, Robert. Manuscript Painting in Paris during the Reign of St. Louis. Berkeley: University of California Press. 1977.
- ——. St. Louis and the Court Style in Gothic Architecture. London: Zwemmer, 1965.
- ——, ed. Chartres Cathedral. New York: Norton, 1969. Brown, Sarah, and David O'Connor. Glass-Painters (Medieval Craftsmen). Toronto: University of Toronto Press, 1991.
- Camille, Michael. Gothic Art: Glorious Visions. New York: Abrams, 1996.
- The Gothic Idol: Ideology and Image-Making in Medieval Art. New York: Cambridge University Press, 1989.
- Courtenay, Lynn T., ed. *The Engineering of Medieval Cathedrals*. Aldershot: Scolar, 1997.
- Crosby, Sumner McKnight. The Royal Abbey of Saint-Denis from Its Beginnings to the Death of Suger, 475–1151. New Haven, Conn.: Yale University Press, 1987.
- Erlande-Brandenburg, Alain. The Cathedral: The Social and Architectural Dynamics of Construction. New York: Cambridge University Press, 1994.
- ——. Gothic Art. New York: Abrams, 1989.
- Favier, Jean. *The World of Chartres*. New York: Abrams, 1990.
- Fitchen, John. The Construction of Gothic Cathedrals: A Study of Medieval Vault Erection. Chicago: University of Chicago Press, 1981.
- Frankl, Paul. The Gothic: Literary Sources and Interpretations through Eight Centuries. Princeton, N.J.: Princeton University Press, 1960.
- Frankl, Paul, and Paul Crossley. *Gothic Architecture*. New Haven, Conn.: Yale University Press, 2000.
- Frisch, Teresa G. Gothic Art 1140-c. 1450: Sources and Documents. Toronto: University of Toronto Press, 1987. Reprint of 1971 ed.
- Gerson, Paula, ed. *Abbot Suger and Saint-Denis*. New York: Metropolitan Museum of Art, 1986.
- Givens, Jean A. Observation and Image-Making in Gothic Art. New York: Cambridge University Press, 2004.
- Grodecki, Louis. *Gothic Architecture*. New York: Electa/ Rizzoli. 1985.
- Grodecki, Louis, and Catherine Brisac. Gothic Stained Glass, 1200–1300. Ithaca, N.Y.: Cornell University Press, 1985.
- Jantzen, Hans. High Gothic: The Classic Cathedrals of Chartres, Reims, Amiens. Princeton, N.J.: Princeton University Press, 1984.
- Male, Émile. Religious Art in France: The Thirteenth Century. Rev. ed. Princeton, N.J.: Princeton University Press, 1984.
- Minne-Sève, Viviane, and Hervé Kergall. Romanesque and Gothic France: Architecture and Sculpture. New York: Abrams, 2000.
- Nussbaum, Norbert. German Gothic Church Architecture. New Haven, Conn.: Yale University Press, 2000.
- Panofsky, Erwin. Abbot Suger on the Abbey Church of St. Denis and Its Art Treasures. 2d ed. Princeton, N.J.: Princeton University Press, 1979.
- Radding, Charles M., and William W. Clark. *Medieval Architecture, Medieval Learning.* New Haven, Conn.: Yale University Press, 1992.

- Recht, Roland. Believing and Seeing: The Art of Gothic Cathedrals. Chicago: University of Chicago Press, 1999
- Rudolph, Conrad. Artistic Change at St-Denis: Abbot Suger's Program and the Early Twelfth-Century Controversy over Art. Princeton, N.J.: Princeton University Press, 1990.
- Sauerländer, Willibald, and Max Hirmer. *Gothic Sculpture in France*, 1140–1270. New York: Abrams, 1973.
- Scott, Robert A. The Gothic Enterprise: A Guide to Understanding the Medieval Cathedral. Berkeley and Los Angeles: University of California Press, 2003.
- Simson, Otto G. von. The Gothic Cathedral: Origins of Gothic Architecture and the Medieval Concept of Order. 3d ed. Princeton, N.J.: Princeton University Press, 1988.
- Toman, Rolf, ed. *The Art of Gothic: Architecture, Sculpture, Painting.* Cologne: Könemann, 1999.
- Williamson, Paul. *Gothic Sculpture*, 1140–1300. New Haven, Conn.: Yale University Press, 1995.
- Wilson, Christopher. The Gothic Cathedral: The Architecture of the Great Church, 1130–1530. London: Thames & Hudson, 1990.

Chapter 14: Late Medieval Italy

- Bomford, David. Art in the Making: Italian Painting before 1400. London: National Gallery, 1989.
- Borsook, Eve, and Fiorelli Superbi Gioffredi. *Italian Altarpieces* 1250–1550: Function and Design. Oxford: Clarendon, 1994.
- Bourdua, Louise. *The Franciscans and Art Patronage in Late Medieval Italy*. New York: Cambridge University Press, 2004.
- Cole, Bruce. Sienese Painting: From Its Origins to the Fifteenth Century. New York: Harper Collins, 1987.
- Derbes, Anne. Picturing the Passion in Late Medieval Italy: Narrative Painting, Franciscan Ideologies, and the Levant. New York: Cambridge University Press, 1996.
- Derbes, Anne, and Mark Sandona, eds. *The Cambridge Companion to Giotto*. New York: Cambridge University Press, 2004.
- Hills, Paul. *The Light of Early Italian Painting*. New Haven, Conn.: Yale University Press, 1987.
- Maginnis, Hayden B. J. *Painting in the Age of Giotto: A Historical Reevaluation*. University Park: Pennsylvania State University Press, 1997.
- ——. The World of the Early Sienese Painter. University Park: Pennsylvania State University Press, 2001.
- Meiss, Millard. *Painting in Florence and Siena after the Black Death*. Princeton, N.J.: Princeton University Press, 1976.
- Moskowitz, Anita Fiderer. *Italian Gothic Sculpture*, c. 1250–c. 1400. New York: Cambridge University Press, 2001.
- —. Nicola & Giovanni Pisano: The Pulpits: Pious Devotion, Pious Diversion. London: Harvey Miller, 3005.
- Norman, Diana, ed. Siena, Florence, and Padua: Art, Society, and Religion 1280–1400. New Haven, Conn.: Yale University Press, 1995.
- Poeschke, Joachim. *Italian Frescoes: The Age of Giotto*, 1280–1400. New York: Abbeville, 2005.
- Pope-Hennessy, John. *Italian Gothic Sculpture*. 3d ed. Oxford: Phaidon, 1986.
- Stubblebine, James H. *Duccio di Buoninsegna and His School*. Princeton, N.J.: Princeton University Press, 1979.
- White, John. Art and Architecture in Italy: 1250–1400. 3d ed. New Haven, Conn.: Yale University Press, 1993.
- ——. Duccio: Tuscan Art and the Medieval Workshop. London: Thames & Hudson, 1979.

CREDITS

Chapter 8—Opener: © Scala/Art Resource, NY; timeline: © Erich Lessing/Art Resource, NY; 8-2: © Erich Lessing/Art Resource, NY; 8-3: © Art Resource, NY; 8-4: Marco Simola/Photographer's Direct; 8-5A: © Scala/Art Resource, NY; 8-6: foto Pontificia Commissione per l'Archeologia Sacra; 8-7: Darius Arya; 8-6A: Pontifica Commissione di Archeologia Sacra, Rome; 8-8: © Scala/Art Resource, NY; 8-8A: Courtesy Saskia Ltd., © Dr. Ron Wiedenhoeft; 8-9: © Cengage Learning; 8-10: akg/ Bildarchiv Monheim; 8-10A: akg-images/Andrea Jemolo; 8-11: akg-images/Andrea Jemolo; 8-13: Vanni/Art Resource, NY; 8-13A: Canali Photobank, Italy; 8-14: © Scala/ Art Resource, NY: 8-15: @ 2010 Fred S. Kleiner; 8-16: @ Cameraphoto Arte, Venice/Art Resource, NY; 8-17: © Scala/Art Resource, NY; 8-17A: © Lauros/Giraudon/The Bridgeman Art Library; 8-18: © Scala/Art Resource, NY; 8-19: © Scala/Art Resource, NY; 8-19A: Hirmer Fotoarchiv; 8-20: Biblioteca Apostolica Vaticana; 8-21: Österreichische Nationalbibliothek, Vienna, Bildarchiv. folio 7 recto of the Vienna Genesis; 8-21A: Osterreichische Nationalbibliothek, Vienna; 8-22: © Scala/Art Resource, NY; 8-23: © The Trustees of the British Museum; 8-24: © The Trustees of The British Museum/Art Resource, NY; 8-25: © DACS/The Bridgeman Art Library; UNF 8-1: © Erich Lessing/Art Resource, NY; UNF 8-2: Darius Arya; UNF 8-3: © Cengage Learning; UNF 8-4: © Scala/Art Resource, NY; UNF 8-5: Österreichische Nationalbibliothek, Vienna, Bildarchiv, folio 7 recto of the Vienna Genesis.

Chapter 9—Opener (bottom, detail 1): Canali Photobank, Italy; (detail 2): © Scala/Art Resource, NY; (detail 3): Canali Photobank, Italy; (detail 4): Archivio e Studio Folco Quilici, Roma; Map 9-1: © Cengage Learning; timeline: Canali Photobank, Italy; 9-2: British Museum/HIP/Art Resource, NY; 9-3: Osterreichische Nationalbibliothek; 9-3A: Österreichische Nationalbibliothek, Vienna; 9-4: © Réunion des Musées Nationaux/Art Resource, NY; 9-5: © Yann Arthus-Bertrand/Terra/Corbis; 9-8: Copyright: Photo Henri Stierlin, Geneve; 9-9: © Cengage Learning; 9-10: Archivio e Studio Folco Quilici; 9-12: © Scala/Art Resource, NY; 9-14A: The Art Archive/Episcopal Museum Ravenna/Gianni Dagli Orti/Picture Desk; 9-13: Canali Photobank; 9-14: Canali Photobank; 9-15: © Scala/Art Resource, NY; 9-16: STUDIO KONTOS/PHOTO-STOCK; 9-17: Firenze, Biblioteca Medicea Laurenziana, Ms. Laur. Plut. 1.56, c. 13v; 9-17A: © Scala/Art Resource, NY; 9-18A: Ancient Art and Architecture Collection Ltd./The Bridgeman Art Library; 9-18: Ronald Sheraton/Ancient Art and Architecture Collection Ltd; 9-19: © Erich Lessing/Art Resource, NY; 9-20: © Scala/Art Resource, NY; 9-22: © Vanni/Art Resource, NY; 9-23: The Art Archive/Gianni Dagli Orti/Picture Desk; 9-24: STUDIO KONTOS/PHOTOSTOCK; 9-25: © Erich Lessing/Art Resource, NY; 9-25A: © Kurt Scholz/SuperStock; 9-26: © Alinari/Art Resource, NY; 9-26A: © Cameraphoto Arte, Venice/Art Resource, NY; 9-26B: © Werner Forman/Art Resource, NY; 9-27: © Scala/Art Resource, NY; 9-27A: © Mimmo Jodice/Corbis Art/ Corbis; 9-28: © Réunion des Musées Nationaux/Art Resource, NY; 9-29: © Josephine Powell; 9-30: © Snark/Art Resource, NY; 9-31: © Scala/Art Resource, NY; 9-32: Werner Forman/Art Resource, NY; 9-32A: STUDIO KONTOS/PHOTOSTOCK/Photographer's Direct; 9-33: Stojan Saveski, Republic of Macedonia; 9-34: © Erich Lessing/ Art Resource, NY; 9-35: @ Scala/Art Resource, NY; 9-35A: State Historical Cultural Museum, Moscow, Kremlin; UNF 9-1: Copyright: Photo Henri Stierlin, Geneve; UNF 9-2: Canali Photobank; UNF 9-3: © Snark/Art Resource, NY; UNF 9-4: The Art Archive/Gianni Dagli Orti/Picture Desk.

Chapter 10—Opener (bottom): Rosario Sanguedolce/Bhagis Stock Photography/ Photographer's Direct; (detail 1): © Bednorz-Images; (detail 2): © The Bridgeman Art Library; (detail 3): © Bednorz-Images; (detail 4): © Adam Woolfit/Robert Harding Picture Library; timeline: © Bednorz-Images; 10-2: © Moshe Shai/Encyclopedia/ Corbis; 10-3: © Erich Lessing/Art Resource, NY; 10-4: akg-images/Gerard Degeorge; 10-5: The Art Archive/Gianni Dagli Orti/Picture Desk; 10-5B: © Bildarchiv Preussischer Kulturbesitz/Art Resource, NY; 10-6: © Yann Arthus-Bertrand/Encyclopedia/ CORBIS; 10-7: Copyright: Photo Henri Stierlin, Geneve; 10-8: © E. Simanor/Robert Harding Picture Library; 10-9: © Bednorz-Images; 10-10: © The Bridgeman Art Library; 10-11: © Bednorz-Images; 10-12: © Adam Woolfit/Robert Harding Picture Library; 10-15: © Réunion des Musées Nationaux/Art Re-

source, NY; 10-16: The State Hermitage Museum, St. Petersburg; 10-17: The Trustees of the Chester Beatty Library, Dublin.; 10-17A: Harvard Art Museum, Arthur M. Sackler Museum, Francis H. Burr Memorial Fund, 1967.23 Photo: Katya Kallsen © President and Fellows of Harvard College; 10-18: © Réunion des Musées Nationaux/ Art Resource, NY; 10-19: @ Mauritius/SuperStock; 10-20: Toyohiro Yamada/Taxi/ Getty Images; 10-22: Photo, © Réunion des Musées Nationaux/Art Resource, NY; 10-22A: The Metropolitan Museum of Art/Art Resource, NY; 10-23: Copyright: Photo Henri Stierlin, Geneve; 10-24: Copyright: Photo Henri Stierlin, Geneve; 10-25: Courtesy, Johanna D. Movassat; 10-26: © The Metropolitan Museum of Art/Art Resource, NY; 10-27: Victoria & Albert Museum, London/Art Resource, NY; 10-28: @ The Trustees of The British Museum.; 10-29: © Erich Lessing/Art Resource, NY; 10-30: The Court of Gayumars (205.1.165; M200) © Aga Khan Trust for Culture Geneva; 10-31: © Réunion des Musées Nationaux/Art Resource, NY; 10-32: Freer Gallery of Art Washington, D.C., Purchase, F1941.10; UNF 10-01: Moshe Shai/Encyclopedia/ CORBIS; UNF 10-2: @ Bednorz-Images; UNF 10-2: @ Erich Lessing/Art Resource, NY; UNF 10-3: © The Trustees of The British Museum.; UNF 10-5: Copyright: Photo Henri Stierlin, Geneve.

Chapter 11—Opener: © The Board of Trinity College, Dublin, Ireland/The Bridgeman Art Library; Map 11-1: @ Cengage Learning; timeline: @ The Board of Trinity College, Dublin, Ireland/The Bridgeman Art Library; 11-2: © Réunion des Musées Nationaux/Art Resource, NY; 11-3: © The Trustees of the British Museum/Art Resource, NY; 11-3A: © The Trustees of The British Museum/Art Resource, NY; 11-4: Ancient Art and Architecture Collection Ltd./The Bridgeman Art Library International; 11-4A: @ Christophe Boisvieux/Terra/Corbis; 11-5: @ Erich Lessing/Art Resource, NY; 11-6: © The Board of Trinity College, Dublin, Ireland/The Bridgeman Art Library; 11-7: © Erich Lessing/Art Resource, NY; 11-8: © HIP/Art Resource, NY; 11-9: © Robert Harding Travel/Photolibrary; 11-9A: © Michael Jenner/Robert Harding; 11-10: © age fotostock/SuperStock; 11-11: Archivo Histórico Nacional, Madrid; 11-12: © Giraudon/The Bridgeman Art Library; 11-12A: akg-images; 11-13: Kunsthistorisches Museums, Wien; 11-14: © Erich Lessing/Art Resource, NY; 11-15: Utrecht, University Library, Ms. 32, fol. 25r; 11-15A: Utrecht, University Library, Ms. 32, fol. 13r; 11-16: © The Pierpont Morgan Library/Art Resource, NY; 11-17b: © Thomas Robbin/Photolibrary; 11-18: © Bildarchiv Steffens/The Bridgeman Art Library International; 11-19: akg-images; 11-19A: Hirmer Fotoarchiv; 11-19B: © Lauros/Giraudon/The Bridgeman Art Library; 11-20: © Bednorz-Images; 11-21: © Bednorz-Images; 11-22: © Bednorz-Images; 11-23A: The Art Archive/Gianni Dagli Orti/Picture Desk; 11-24: Dom-Museum, Hildesheim; 11-24A: Dom-Museum, Hildesheim; 11-25: © Erich Lessing/Art Resource, NY; 11-26: © The Metropolitan Museum of Art/Art Resource, NY; 11-27: © Réunion des Musées Nationaux/Art Resource, NY; 11-28: Photo: © Rheinisches Bildarchiv Köln, rba_c00008; 11-29: Bayerische Staatsbibliothek, Munich.; 11-29A: Bayerische Staatsbibliothek, Munich; 11-30: Bayerische Staatsbibliothek, Munich; 11-31: Bayerische Staatsbibliothek, Munich.; UNF 11-01: © The Trustees of the British Museum/Art Resource, NY; UNF 11-2: © The Board of Trinity College, Dublin, Ireland/The Bridgeman Art Library; UNF 11-3: @ Giraudon/The Bridgeman Art Library; UNF 11-4: Utrecht, University Library, Ms. 32, fol. 25r; UNF 11-5: @ Bednorz-Images.

Chapter 12—Opener: © Jonathan Poore/Cengage Learning; timeline: © Jonathan Poore/Cengage Learning; 12-2: The Art Archive/Abbaye de Saint Foy Conques/Gianni Dagli Orti/Picture Desk; 12-3: Claude Huber; 12-4A: © AISA/The Bridgeman Art Library; 12-4B: © Jonathan Poore/Cengage Learning; 12-5: Jean Dieuzaide; 12-7A: © Jonathan Poore/Cengage Learning; 12-7B: akg-images/Andrea Jemolo; 12-7: © Jonathan Poore/Cengage Learning; 12-8: © Jonathan Poore/Cengage Learning; 12-8: © Jonathan Poore/Cengage Learning; 12-10: © Jonathan Poore/Cengage Learning; 12-10: © Jonathan Poore/Cengage Learning; 12-10: © Jonathan Poore/Cengage Learning; 12-11: © Jonathan Poore/Cengage Learning; 12-11: © Jonathan Poore/Cengage Learning; 12-11: © Jonathan Poore/Cengage Learning; 12-13: © Jonathan Poore/Cengag

© Jonathan Poore/Cengage Learning; 12-14: © Cengage Learning; 12-14A: © Bednorz-Images; 12-15: Bibliothèque Nationale, Paris; 12-15A: © Giraudon/Art Resource. NY; 12-16: © Erich Lessing/Art Resource, NY; 12-17: © Jonathan Poore/Cengage Learning; 12-18: Photograph ©2011 Museum of Fine Arts, Boston. 21.1285; 12-19: © The Metropolitan Museum of Art/Art Resource, NY; 12-20: Florian Monheim, www.bildarchiv-monheim.de; 12-21: Pubbli Aer Foto; 12-22: Canali Photobank, Italy; 12-23: Abtei St. Hildegard; 12-23A: Bibliotheca Bodmeriana, Geneva. Bodmerian Library photo, codex no. 127, folio 244.; 12-24: akg-images/Bildarchiv Monheim; 12-25: Photograph Speldoorn © Musées royaux d'Art et d'Histoire - Brussels.; 12-26: © Jonathan Poore/Cengage Learning; 12-27: © Jonathan Poore/Cengage Learning; 12-27A: © Jonathan Poore/Cengage Learning; 12-27B: Canali Photobank, Italy; 12-28: © Bednorz-Images; 12-29: © Bednorz-Images; 12-30: © Jonathan Poore/ Cengage Learning; 12-31: © Jonathan Poore/Cengage Learning; 12-33a: © Angelo Hornak/Corbis; 12-35: The Master and Fellows of Corpus Christi College, Cambridge.; 12-35A: © British Library Board. All Rights Reserved/The Bridgeman Art Library; 12-36: © The Bridgeman Art Library; 12-37: By special permission of the City of Bayeux; 12-38: By special permission of the City of Bayeux.; UNF 12-01: Jean Dieuzaide; UNF 12-2: © Jonathan Poore/Cengage Learning; UNF 12-3: Photograph Speldoorn @ Musées royaux d'Art et d'Histoire - Brussels.: UNF 12-4: @ Ionathan Poore/Cengage Learning; UNF 12-5: © Angelo Hornak/Corbis.

Chapter 13—Opener (bottom): @ Marc Garanger/Encyclopedia/Corbis; (details 1 & 2): © Jonathan Poore/Cengage Learning; (detail 3): © Paul Maeyaert/The Bridgeman Art Library; (detail 4): © Jonathan Poore/Cengage Learning; timeline: © Marc Garanger/Encyclopedia/Corbis; 13-3: © Jonathan Poore/Cengage Learning; 13-3A: © Jonathan Poore/Cengage Learning; 13-5: © Jonathan Poore/Cengage Learning; 13-6: © Jonathan Poore/Cengage Learning; 13-7: © Jonathan Poore/Cengage Learning; 13-8: © Jonathan Poore/Cengage Learning; 13-9: © Jonathan Poore/Cengage Learning; 13-11: © Jonathan Poore/Cengage Learning; 13-14: © Paul Maeyaert/The Bridgeman Art Library; 13-15: © Jonathan Poore/Cengage Learning; 13-16: © Jonathan Poore/Cengage Learning; 13-17: © Jonathan Poore/Cengage Learning; 13-18: © The Print Collector/Photolibrary; 13-18A: © Jonathan Poore/Cengage Learning; 13-19: © Jonathan Poore/Cengage Learning; 13-20: © Jonathan Poore/Cengage Learning; 13-21: © Jonathan Poore/Cengage Learning; 13-22: © Jonathan Poore/ Cengage Learning; 13-23: © Bednorz-Images; 13-23A: © Jonathan Poore/Cengage Learning; 13-24: © Jonathan Poore/Cengage Learning; 13-25: Bridgeman-Giraudon/ Art Resource, NY; 13-26: © Jonathan Poore/Cengage Learning.; 13-27: © Jonathan Poore/Cengage Learning; 13-28: © Guido Alberto Rossi/TIps Italia/Photolibrary; 13-29: © Bednorz-Images; 13-30: © Jonathan Poore/Cengage Learning; 13-31:

Bibliotheque Nationale: 13-32: Österreichische Nationalbibliothek, Vienna.: 13-33: © The Pierpont Morgan Library/Art Resource, NY; 13-34: Bibliotheque Nationale; 13-35: Bibliotheque Nationale; 13-36: © Snark/Art Resource, NY; 13-36A: © The Metropolitan Museum of Art, The Cloisters Collection, 1954 (54.1.2). Image © The Metropolitan Museum/Art Resource, NY.; 13-37: © Réunion des Musées Nationaux/ Art Resource, NY; 13-38: The Walters Art Museum; 13-38A: akg-images/Schütze/ Rodemann; 13-38B: Hereford Cathedral Library, Hereford, England.; 13-39: © Edmund Nagele PCL/SuperStock; 13-41: akg-images/Bildarchiv Monheim; 13-42: © Scala/Art Resource, NY; 13-42A: Angelo Hornak/Value Art/Corbis; 13-43: Werner Forman/Corbis Art/Corbis; 13-44: © Erich Lessing/Art Resource, NY; 13-44A: © Erich Lessing/Art Resource, NY; 13-45: © Erich Lessing/Art Resource, NY; 13-46: © Bednorz-Images; 13-47: akg-images/Hilbich; 13-48: © Bednorz-Images; 13-49: © Erich Lessing/Art Resource, NY; 13-50: © Erich Lessing/Art Resource, NY; 13-51: www.webaviation.co.uk; 13-52: @ Svenja-Foto/Corbis; 13-53: @ Bednorz-Images; 13-54: © 205 Ken Phillips; UNF 13-01: © Jonathan Poore/Cengage Learning; UNF 13-2: © Jonathan Poore/Cengage Learning; UNF 13-3: Bibliotheque Nationale; UNF 13-4: © Edmund Nagele PCL/SuperStock; UNF 13-5: © Erich Lessing/Art Resource, NY.

Chapter 14—Opener: © Scala/Art Resource, NY; timeline: © Scala/Art Resource, NY; 14-2: © Jonathan Poore/Cengage Learning; 14-3: © Jonathan Poore/Cengage Learning; 14-4: © Scala/Art Resource, NY; 14-5: © Scala/Art Resource, NY; 14-5B: © Erich Lessing/Art Resource, NY; 14-5A: © Alinari/Art Resource, NY; 14-6: © Scala/ Ministero per i Beni e le Attività culturali/Art Resource, NY; 14-6A: Photo by Ralph Lieberman; 14-6B: © Scala/Art Resource, NY; 14-7: © Summerfield Press/Corbis Art/ Corbis; 14-8: © Scala/Art Resource, NY; 14-8A: © Alinari/Art Resource, NY; 14-8B: © Alinari/Art Resource, NY; 14-9: © Scala/Art Resource, NY; 14-10: © Scala/Art Resource, NY; 14-10A: © Scala/Art Resource, NY; 14-11: © Scala/Art Resource, NY; 14-12: © Jonathan Poore/Cengage Learning; 14-12A: © Jonathan Poore/Cengage Learning; 14-13: Canali Photobank; 14-14: © Scala/Art Resource, NY; 14-15: © Jonathan Poore/Cengage Learning; 14-16: © Scala/Art Resource, NY; 14-16A: © Scala/ Art Resource, NY; 14-17: © Scala/Art Resource, NY; 14-18: © Alinari/Art Resource, NY; 14-18A: @ MUZZI FABIO/CORBIS SYGMA; 14-18B: @ Jonathan Poore/Cengage Learning; 14-19: © The Bridgeman Art Library; 14-19A: © Scala/Art Resource, NY; 14-20: © Jonathan Poore/Cengage Learning; 14-21: © Bednorz-Images; UNF 14-1: © Scala/Art Resource, NY; UNF 14-2: © Jonathan Poore/Cengage Learning; UNF 14-3: © Scala/Art Resource, NY; UNF 14-4: © Scala/Art Resource, NY; UNF 14-5: © age fotostock/SuperStock.

MUSEUM INDEX

Note: Figure numbers in blue indicate bonus images.

Amiens (France): Amiens Cathedral: Beau Dieu (Christ) (sculpture), 379

Assisi (Italy): San Francesco: Saint Francis Preaching to the Birds (Saint Francis Master) (fresco), 14-5B

Autun (France):

Musée Lapidaire: Suicide of Judas, Saint-Lazare (Gislebertus), 12-13A Musée Rolin: Eve, Saint-Lazare (Gislebertus), 12-13B

Baltimore, Maryland (U.S.A.): Walters Art Museum: Castle of Love (jewelry box lid), 389

Bamberg (Germany): Bamberg Cathedral: Bamberg Rider (sculpture), 395

Bayeux (France): Centre Guillaume le Conquérant: Bayeux Tapestry, 361,

Berlin (Germany): Museum für Islamische Kunst: frieze of the south facade, Umayyad palace, Mshatta, 10-5B

Bonn (Germany): Rheinisches Landemuseum: Röttgen Pietà (sculpture), 396

Boston, Massachusetts (U.S.A.): Museum of Fine Arts: Christ in Majesty, Santa María de Mur (fresco), 349

Brussels (Belgium): Musées Royaux d'Art et d'Histoire: head reliquary of Saint Alexander, 353

Bygdoy (Norway): Viking Ship Museum, University of Oslo: Oseberg ship burial, 310, 11-4A

Cairo (Egypt): National Library: Bustan (Bihzad), 302

Cambridge (England):

Corpus Christi College: Bury Bible (Master Hugo), 360

Trinity College: Eadwine Psalter (Eadwine the Scribe), 360

Cambridge, Massachusetts (U.S.A.): Arthur M. Sackler Museum, Harvard University: Blue Koran, 10-17A

Capua (Italy): Sant'Angelo in Formis: Entombment of Christ (fresco), 12-27B

Chartres (France):

Chartres Cathedral:

Notre Dame de la Belle Verrière (stained-glass window), 376 rose window, 376

Saint Theodore (relief sculpture), 377 Cologne (Germany):

Cologne Cathedral: Gero crucifix, 329 Dom Schatzkammer: Shrine of the Three Kings (Nicholas of Verdun), 393

Conques (France): Treasury, Sainte-Foy: reliquary statue of Sainte Foy (Saint Faith), 336

Constantinople (Istanbul) (Turkey): Hagia Sophia:

Christ between Constantine IX Monomachus and the empress Zoe (mosaic), 273

Virgin (Theotokos) and Child enthroned (mosaic), 270

Kariye Museum: Anastasis (fresco), 278 Topkapi Palace Museum: Ottoman royal ceremonial caftan, 10-27A

Daphni (Greece):

Church of the Dormition:

Christ as Pantokrator (mosaic), 272 Crucifixion (mosaic), 272

Dijon (France): Bibliothèque Municipale: Moralia in Job (Saint Gregory), 347 Dublin (Ireland):

Chester Beatty Library and Oriental Art Gallery: Koran, Dublin, 294

Trinity College Library: Book of Durrow, 312

Book of Kells, 306 Dura-Europos (Syria): synagogue: Samuel Anoints David (wall painting), 235

Épernay (France): Bibliothèque Municipale: Ebbo Gospels (Gospel Book of Archbishop Ebbo of Reims), 318

Fidenza (Italy): Fidenza Cathedral: King David, Fidenza Cathedral (Benedetto Antelami) (sculpture), 357

Florence (Italy):

Baptistery of San Giovanni: doors (Pisano) (relief sculpture), 418

Biblioteca Medicea-Laurenziana: Rabbula Gospels, 268, 9-17A

Galleria degli Uffizi:

Annunciation altarpiece, Siena Cathedral (Martini and Memmi),

Madonna Enthroned (Giotto), Church of Ognissanti, Florence, 407

Madonna Enthroned with Angels and Prophets, Santa Trinità, Florence (Cimabue), 406

Or San Michele: tabernacle (Orcagna), 14-19A

G

Geneva (Switzerland):

Bibliotheca Bodmeriana: Initial R, recto of a passional, 12-23A

Prince Sadruddin Aga Khan Collection: Shahnama (Book of Kings) (Sultan-Muhammad), 303

Gloucester (England): Gloucester Cathedral: Tomb of Edward II, 13-42A

Hereford (England): Hereford Cathedral: Mappamundi of Henry III (Richard de Bello), 13-38B

Hildesheim (Germany): Dom-Museum: doors with relief panels, Saint Michael's, Hildesheim, 326, 327

Klosterneuberg (Austria): Stiftsmuseum: Klosterneuburg Altar (Nicholas of Verdun), 392, 13-44A

Liège (France): Saint-Barthélemy: Baptism of Christ (Rainer of Huy), 353

London (England):

British Library: Lindisfarne Gospels, 313,

British Museum:

belt buckle, Sutton Hoo ship burial,

Crucifixion (ivory carving), 251 Mildenhall Treasure, 250 mosque lamp of Sayf al-Din Tuquztimur, 301

purse cover, Sutton Hoo ship burial,

Saint Michael the Archangel (ivory panel), 257

Suicide of Judas (ivory carving), 251 Winchester Psalter, 12-35A

Victoria & Albert Museum:

carpet from the funerary mosque of Safi al-Din (Magsud of Kashan), 301 Diptych of the Nicomachi and Symmachi, 252

Madrid (Spain): Archivo Histórico Nacional: Commentary on the Apocalypse (Beatus) (ill. by Emeterius), 316

Modena (Italy): Modena Cathedral: Creation and Temptation of Adam and Eve (Wiligelmo), 356

Moissac (france):

Saint-Pierre:

Old Testament prophet (Jeremiah or Isaiah?) (relief sculpture), 344 Second Coming of Christ (relief sculpture), 343

Monreale (Italy): Monreale cathedral: Pantokrator, Theotokos and Child, angels, and saints (mosaic), 275

Moscow (Russia):

Kremlin Armory: large sakkos of Photius,

Tretyakov Gallery: Three Angels (Rublyev), 280

Vladimir Virgin, 277 Mount Sinai (Egypt):

monastery of Saint Catherine: Christ blessing (icon), 9-18. Virgin (Theotokos) and Child between

Saints Theodore and George, icon (encaustic painting), 269

Munich (Germany):

Bayerische Staatsbibliothek: Gospel Book of Otto III, 329, 11-29A Lectionary of Henry II, 330 Uta Codex, 330

Nancy (France): Musée Historique de Lorraine: silk textile, Zandana,

Naumburg (Germany): Naumburg Cathedral:

Crucifixion (sculpture), 394 Ekkehard and Uta statues, 395

Nerezi (Macedonia): Saint Pantaleimon: Lamentation (wall painting), 276

New York, New York (U.S.A.):

Metropolitan Museum of Art: Hours of Jeanne d'Evreux (Pucelle),

illuminated tughra of Suleyman the Magnificent, 10-23A mihrab, Madrasa Imami, Isfahan,

otto I presenting Magdeburg Cathedral to Christ, Magdeburg Cathedral (ivory carving), 327

Virgin and Child (Morgan Madonna),

Pierpont Morgan Library: Lindau Gospels, 320

Blanche of Castile, Louis IX, and two monks, moralized Bible, 385

Ohrid (Macedonia):

Icon Gallery of Saint Clement: Annunciation, Church of the Virgin Peribleptos (icon), 280 Christ as Savior of Souls (icon), 279

Padua (Italy):

Arena Chapel (Cappella Scrovegni): Betrayal of Jesus (Giotto), 14-8 Entry into Jerusalem (Giotto), 400 Lamentation (Giotto), 408 Last Judgment (Giotto), 400

Paris (France):

295

Bibliothèque Nationale: Abbey of Saint-Riquier, Centula (engraving), 11-19B

Belleville Breviary, 387 Breviary of Philippe le Bel, 387 Codex Colbertinus, 347 Godescalc Lectionary, 11-13A

Godescalc Lectionary, 11-13A Paris Psalter, 277 Psalter of Saint Louis, 386

sketchbook (Villard de Honnecourt), 384

Musée du Louvre:

Barberini Ivory, 259
basin (Baptistère de Saint Louis)
(Muhammad ibn al-Zayn), 303
dish with Arabic proverb, Nishapur,

equestrian portrait of Charlemagne or Charles the Bald (sculpture), 317 Harbaville Triptych (Christ enthroned with saints) (ivory carving), 275 pyxis of al-Mughira (ivory carving), 293

Virgin of Jeanne d'Evreux (sculpture), 388

Musée National du Moyen Age: Christ blessing Otto II and Theophanu (ivory plaque), 328

Notre-Dame Cathedral: Virgin and Child (Virgin of Paris) (sculpture), 381

Pescia (Italy): San Francesco: Saint Francis Altarpiece (Berlinghieri), 404 Pisa (Italy):

baptistery: Annunciation, Nativity, and Adoration of the Shepherds (Nicola Pisano), 403

Camposanto: *Triumph of Death* (Traini or Buffalmacco), 419

Pistoia (Italy): baptistery: Annunciation, Nativity, and Adoration of Shepherds (Giovanni Pisano), 403 R

Ravenna (Italy): Mausoleum of Galla Placidia: *Christ as Good Shepherd* (mosaic), 247

Museo Arcivescovile: Throne of Maximianus (ivory furniture), 9-14A

San Vitale: Justinian and Theodora mosaics, 265

Sant'Apollinare in Classe: Saint Apollinaris amid sheep (mosaic), 266

Sant'Apollinare Nuovo (Orthodox Baptistery): Baptism of Christ (mosaic), 8-17A

Baptism of Christ (mosaic), 8-17/2 Miracle of the Loaves and Fishes (mosaic), 248

Reims (France) Reims Cathedral: Annunciation (sculpture), 380 Visitation (sculpture), 380 Rome (Italy):

Biblioteca Apostolica Vaticana: Vatican Vergil, 249

Catacomb of Commodilla: Cubiculum Leonis (mural), 8-6A

Catacomb of Saints Peter and Marcellinus: Good Shepherd, story of Jonah, and orants (fresco), 237

Mausoleum of the Julii: Christ as Sol Invictus (mosaic), 8-13A

Musei Vaticani: Christ as the Good Shepherd (sculpture), 239

Museo Nazionale Romano: Christ seated, Civita Latina (sculpture), 8-8A

Museo Storico del Tesoro della Basilica di San Pietro: Junius Bassus sarcophagus, 232

Santa Maria Maggiore: The Parting of Abraham and Lot (mosaic), 245 Villa Torlonia: Ark of the Covenant and two menorahs (fresco), 236 Rossano (Italy), Museo Diocesano d'Arte Sacra: *Rossano Gospels*, 250

Rüdesheim/Eibingen (Germany): Abbey of St. Hildegard: Scivias (Know the Ways of God) (Hildegard of Bingen) (facsimile), 352

S

Saint Gall (Switzerland): Stiftsbibliothek: plan for Saint Gall monastery, 322 Saint Petersburg (Russia): Hermitage

Museum: ewer in the form of a bird (Sulayman), 293

Saint-Genis-des-Fontaines (France): abbey church: Christ in Majesty (Maiestas Domini) (sculpture), 12-8A

Saint-Germain-en-Laye (France): Musée d'Archéologie Nationale: Merovingian looped fibulae, 309 Siena (Italy):

Museo dell'Opera del Duomo:

Birth of the Virgin, Siena Cathedral
(Lorenzetti), 415

Maestà altarpiece (Duccio), Siena Cathedral, 411, 14-10A

Palazzo Pubblico: Allegory of Good Government

(Lorenzetti), 14-16A

Effects of Good Government in the City
and in the Country (Lorenzetti), 416,

Silos (Spain): Santo Domingo abbey church: Christ, Doubting Thomas, and apostles (relief sculpture), 12-8B

Strasbourg (France): Strasbourg Cathedral: Death of the Virgin (relief sculpture), 393

T

Thessaloniki (Greece): Hagios Georgios (Church of Saint George): two saints (mosaic), 8-19A Toulouse (France): Saint-Sernin: *Christ in Majesty* (Bernardus Gelduinus), 340 Trastavere (Italy): Santa Cecilia: *Last Judgment* (Cavallini), 14-7A

U

Utrecht (Netherlands): University Library: Utrecht Psalter, 319, 11-15A

V

Venice (Italy):

Saint Mark's: *Pala d'Oro* (cloisonné plaque), 9-26A

Tesoro di San Marco: Archangel Michael, Saint Mark's, Venice (icon), 9-26B

Vézelay (France): La Madeleine: Pentecost and Mission of the Apostles (relief sculpture), 345

Vienna (Austria):

Kunsthistorisches Museum: Coronation Gospels (Gospel Book of Charlemagne), 318

Österreichische Nationalbibliothek: God as Creator of the World, moralized Bible, 384

Vienna Dioskorides, 258, 9-3A Vienna Genesis, 249, 8-21A

W

Washington, D.C. (U.S.A.): Freer Gallery of Art: canteen with episodes from the life of Jesus, 304

SUBJECT INDEX

Notes:

- · Page numbers in italics indicate illustrations.
- Page numbers in italics followed by b indicate bonus images in the text.
 - · Page numbers in italics followed by map indicate maps.
 - · Figure numbers in blue indicate bonus images.

a secco. See fresco secco Aachen (Germany), 317, 318, 320-321 Palatine Chapel, 321, 321, 321, 324, 356, Abbasid dynasty, 287, 289, 291-292, 295, 305 abbesses, 322 abbey churches: Corvey, 323-324 Saint-Genis-des-Fontaines, 340, 12-8A, Saint-Savin-sur-Gartempe, 348 See also Saint-Denis abbey church Abbey of Saint-Riquier, Centula, 323, 323b, abbeys, 322 Abbey of Saint-Riquier, 323, 323b, 11-19B Westminster Abbey, 362, 391, 391, abbots, 322 Abd al-Malik (Umayyad caliph), 285, 287 Abd al-Rahman I (Umayyad emir), 283, 290 Abelard, Peter, 372 Abraham and Isaac, 232, 238, 264 Abraham and the Three Angels, Psalter of Saint Louis, 386, 386 abstraction: in Early Christian art, 248, 8-17A, 8-19A in early medieval pre-Christian art, 309, in Hiberno-Saxon art, 312, 313 in Middle Byzantine art, 273, 277 Adam and Eve: in Early Christian art, 232, 233, 238 in French/Spanish Romanesque art, in Italian Romanesque art, 356 in Ottonian art, 326-327 Adauctus, Saint, 8-6A Adelaide of Burgundy, Saint, 328 Adoration of the Magi, 240, 8-10A Adoration of the Shepherds, 403-404 Aeneid (Vergil), 248, 249 Agony in the Garden, 241 Agra (India): Taj Mahal, 283 in Carolingian architecture, 323 in Early Christian architecture, 243 in early Islamic architecture, 289 in French/Spanish Romanesque architecture, 340, 341, 348, 12-4A,

12-4B, 12-7A, 12-7B

in Holy Roman Empire Gothic

in Italian Romanesque architecture, 355

architecture, 396, 398 in Holy Roman Empire Romanesque

Alaric (king of the Visigoths), 246

architecture, 350

```
Alberti, Leon Battista: West facade, Santa
     Maria Novella, Florence, 14-6A
Albertus Magnus, 372
Alcuin, 317
Alexius I Comnenus (Byzantine emperor),
Alhambra, Granada, 295-296, 295, 296, 297
Allegory of Good Government, Palazzo
     Pubblico, Siena (Lorenzetti), 416b,
alpha and omega, Christ as, 251, 8\text{-}6\mathrm{A},\,12\text{-}8\mathrm{A}
altar frontals, 367
altarpieces:
   in Gothic art, 392
   in Italian 14th century art, 410, 411-412,
      413-415
   in Italian late medieval art, 404-405
alternate\text{-}support\ systems,\ 324,\ 350,\ 351,
     370, 11-23A
ambos, 392
ambulatories, 244, 367, 12-7B
Amiens Cathedral (Robert de Luzarches,
     Thomas de Cormont, and Renaud de
     Cormont), 371, 375, 377-379, 377, 377,
     379, 396, 418, 13-38A
amphitheaters, 401
Anastasis, 241, 274, 279
Anastasis, Church of Christ in Chora,
     Constantinople (fresco), 278, 279
anatomy. See human figure
Andrea di Cione. See Orcagna, Andrea
Angilbert (abbot of Saint-Riquier), 11-19B
Anglo-Saxons, 308, 309
Anicia Juliana, 258, 268, 9-3A
Anicias Olybrias (Roman emperor), 258
   in early medieval pre-Christian art, 309,
       310, 311, 11-3A, 11-4A
   in French/Spanish Romanesque art, 343,
       345, 347
   in Hiberno-Saxon art, 312, 313
   and Islamic art, 287, 293, 301, 303-304,
       10-5B, 10-15A
Annals of Ulster, 307
Annunciation, Church of the Virgin
     Peribleptos, Ohrid (icon), 279-280, 280
Annunciation, Hours of Jeanne d'Evreux
     (Pucelle), 13-36.
Annunciation, Nativity, and Adoration of
      Shepherds, pulpit, Sant'Andrea, Pistoia
     (Giovanni Pisano), 403-404, 403
Annunciation, Nativity, and Adoration of the
      Shepherds, baptistery pulpit, Pisa
```

(Nicola Pisano), 403, 403, 415

380, 380, 386

Annunciation, Reims Cathedral (sculpture),

(Martini and Memmi), 413-415, 413

Annunciation altarpiece, Siena Cathedral

arches:

in Carolingian architecture, 11-19A

chancel, 243, 413, 12-4A

```
Annunciation to Mary, 240
   in Gothic art, 380, 386, 13-36A
   in Italian 14th century art, 413-415
   in Italian late medieval art, 403-404
   in Late Byzantine art, 280
   in Ottonian art, 326
Annunciation to the Shepherds, 240,
     329-330
ante legem, 392
Anthemius of Tralles. See Hagia Sophia
Apocalypse, 314, 333, 348
   See also Last Judgment
Apollinaris, Saint, 266, 267
Apollo (Greek/Roman deity): and Early
     Christian art, 8-13A
Apollodorus of Damascus: Forum of Trajan,
     326
Apologia (Justin Martyr), 239
apostles, 240
   in Byzantine art, 275
   in Early Christian art, 8-17A
   in French/Spanish Romanesque art, 346,
      348, 12-8B
   in Hiberno-Saxon art, 314
   See also four evangelists
apprenticeship, 414
  in Early Christian architecture, 243,
   in Italian 13th century architecture,
   in Italian 14th century architecture, 413
   in Visigothic architecture, 316
Aquinas. See Thomas Aquinas, Saint
Ara Pacis Augustae (Altar of Augustan
    Peace), Rome, 264-265
   in Early Christian architecture, 243
   in French/Spanish Romanesque
      architecture, 12-4A, 12-1
   in Gothic architecture, 364, 368, 370,
      373, 374
   in Islamic architecture, 287, 290
   in Italian 13th century architecture,
   in Italian 14th century architecture, 413,
   in Italian Romanesque architecture,
Arcadius (Byzantine emperor), 246, 256
Arch of Constantine, Rome, 235, 11-19/
Arch of Septimius Severus, Lepcis Magna,
Archangel Michael, Saint Mark's, Venice
     (icon), 274b, 9-26B
```

```
diaphragm, 12-27A
   in early Islamic architecture, 282, 283,
      290-291
   in French/Spanish Romanesque
      architecture, 12-8A, 12-10A, 12-11A
   in Gothic architecture, 368, 368, 374, 398,
      13-23A, 13-38A, 13-42A
   in Italian 13th century architecture,
   in Italian 14th century architecture, 420,
   in Italian late medieval architecture, 402
  in Italian Romanesque architecture,
   in later Islamic architecture, 295
  ogee, 420, 13-42A
   quadrant, 359, 373, 12-7B
   trefoil, 402, 14-18B
   in Visigothic architecture, 316
   See also arcades; corbel vaulting; pointed
      arches; transverse arches
Architectural Basics boxes:
   Gothic cathedrals, 373
   mosques, 288
   pendentives and squinches, 262
   rib vaulting, 368
   Romanesque church portals, 344
architecture:
   Byzantine. See Byzantine architecture
   Carolingian, 320-324, 11-19.
   Early Christian. See Early Christian
      architecture
   Gothic, See Gothic architecture
   Hiberno-Saxon high crosses, 315
   Islamic, 282, 283, 285-286, 289-292,
      295-300, 10-5A
   Italian 13th century, 402, 14-5A, 14-6A
   Italian 14th century, 412-413, 415-416,
      417-419, 420, 14-12A, 14-18A, 14-18B,
   Late Antique, 236, 237
   Mycenaean, 244
   Ottonian, 324-326, 337, 8-10A, 11-23A
   Persian, 296, 368
   Roman. See Roman architecture
   Romanesque. See Romanesque
      architecture
   Viking, 311
   Visigothic, 282, 291, 316
archivolts, 344, 369, 13-3
Arena Chapel (Cappella Scrovegni), Padua
     (Giotto), 400, 401, 408, 409, 412, 14-8A,
     14-8B, 14-10A
Arianism, 258
Aristotle, 284, 372
Ark of the Covenant, 236
```

Ark of the Covenant and two menorahs,

Villa Torlonia, Rome (fresco), 236, 236

Arles (France): Saint-Trophîme, 346, 346b, Italian Romanesque, 355-356 Betrayal of Jesus, Arena Chapel, Padua and iconoclasm, 257, 269, 270 12-7A, 12-11A, 12-14A See also Baptistery of San Giovanni, (Giotto), 400, 401, 14-8 and Islamic art, 274-275, 287, 9-27A Betrayal of Jesus, Maestà altarpiece, Siena and Italian 13th century art, 404-405, 406 armature, 368 Florence Arnolfo di Cambio Baptistery of San Giovanni, Florence, Cathedral (Duccio), 412, 412, 14-8B and Italian 14th century art, 409, 411 Florence Cathedral (Santa Maria del 355-356, 355 Bible: and Italian Romanesque art, 12-27B Fiore), Florence, 417, 14-18A doors (Pisano), 418-419, 418 Alcuin's revision, 317 Late, 278-280, 281, 9-35 maniera greca, 404–405, 407, 14-7A, 14-8B Palazzo della Signoria (Palazzo Vecchio), baptistery pulpit, Pisa (Nicola Pisano), Book of Apocalypse, 314 402-403, 402, 403, 415 moralized, 384-386 and Ottonian art, 328 Florence, 417, 417b, 14-18B Arrest of Jesus. See Betrayal of Jesus bar tracery, 375, 13-23A See also Christianity; Gospels; Jesus, societal contexts, 255, 256-257, 258, 263, Barabbas, 241 270, 278 arriccio, 408 Bihzad: illustrator of Bustan (Sadi), 302, 302 See also Early Byzantine art; Middle ars de geometria, 384 Barberini Ivory (Justinian as world Art and Society boxes: conqueror), 258-259, 259 Birth of the Virgin, Siena Cathedral Byzantine art (Lorenzetti), 415, 415 Byzantine Empire: Charlemagne, 317 barrel vaults (tunnel vaults): Christian patronage of Islamic art, 304 in Early Christian architecture, 247 Black Death, 406, 416, 419, 14-19A and Carolingian Empire, 270 Blanche of Castile, 385-386 empresses, 266, 273 icons and iconoclasm, 269 in English Gothic architecture, 391 in Romanesque architecture, 338, 341, Blanche of Castile, Louis IX, and two monks, and the Ottonian Empire, 256, 257, 270, Italian artists' names, 405 278, 284, 324, 328, 329 Louis IX, Saint (king of France), 385 350, 12-4A, 12-4B, 12-7A, 12-7B, moralized Bible, 385 and Salian dynasty, 354-355 medieval books, 312 12-10A blind arcades, 290 pilgrimage, 335 Basil I (Byzantine emperor), 270 Blue Koran, 294, 294b, 10-17A timeline, 256 Renaissance artistic training, 414 Boccaccio, Giovanni, 406, 407 See also Byzantine art Basilica Ulpia, Rome, 243, 326 Romanesque women, 352 basilicas: Bonaventura, Saint, 14-5B Boniface VIII (Pope), 385 Scholasticism, 372 Byzantine, 262, 266, 275, 9-27A Caen (France): Saint-Étienne, 357-358, 357, Theophanu, 328 Early Christian, 243-245 Book of Durrow, 311-312, 312 Zoe Porphyrogenita (Byzantine empress), early medieval, 316, 323, 324 Book of Kells, 306, 307, 311, 315 358, 358, 368, 370, 13-3A 273 French/Spanish Romanesque, 12-4A, Caiaphas, 241 art as a political tool: 12-4B Byzantine, 258, 268, 276-277, 405, 9-3A, Cairo (Egypt): madrasa-mosque-mausoleum in the Byzantine Empire, 254, 255, Italian 13th century, 14-6A complex of Sultan Hasan, 296-297, 297 258-259 Italian 14th century, 413 Carolingian, 317, 318-320, 11-13A, 11-15A calf bearer (dedicated by Rhonbos), Athens in early medieval Europe, 317-318 basin (Baptistère de Saint Louis) (Muhammad and Christianity, 312 (sculpture), 238 in Romanesque Europe, 362 ibn al-Zayn), 303-304, 303 Early Islamic, 294, 10-17A caliphs, 285 baths: in early Islamic architecture, 10-5A French Gothic, 384-388, 13-36A calligraphy: art market: French/Spanish Romanesque, 347-348, 14th century Italy, 410 Battle of David and Goliath, Breviary of architectural inscriptions, 287, 294, 300 Islamic, 294, 295, 300, 301, 10-17A, 10-23A Gothic era, 388 Philippe Le Bel, 387, 387 battlements, 382, 416 See also artist's profession; patronage Hiberno-Saxon, 306, 307, 311-315, 318 Calling of Matthew, 240 Bayeux Tapestry, 361-362, 361, 362 Holy Roman Empire Romanesque, cames, 375 Arthurian legends, 388 Bayezid (son of Suleyman the Magnificent), 352-353, 12campaniles, 350, 355, 416, 418 artist's profession: Late Antique, 248-250 Camposanto, Pisa, 419-420, 419 Renaissance training, 414 later Islamic, 302-303 canon table, 312 See also artists, recognition of bays, 411 artists, recognition of: in Gothic architecture, 370, 374 materials and techniques, 249 canonization, 354, 14-5A canteen with episodes from the life of Jesus, in Italian 14th century architecture, 413, Norman Romanesque, 359-361, 12-35A 14th century Italy, 411 early medieval Europe, 316 Ottonian, 329-330, 11-29A 304, 304 $in\ Roman esque\ architecture,\ 340,\ 350,$ Books of Hours, 312, 13-36A Canterbury Cathedral, 339 Gothic era, 388, 13-23A Holy Roman Empire Romanesque era, Bourges (France): Jacques Coeur house, capitals (of columns): 351cap, 357, 358 Beatus (abbot of Liébana): Commentary on 383-384, 383 historiated, 342-343, 12-13A the Apocalypse, 316, 316, 333 Beau Dieu (Christ), Amiens Cathedral breviaries, 312, 386-387 Italian Romanesque era, 356 in Italian late medieval architecture, 402 Breviary of Philippe le Bel (Master Honoré), Norman Romanesque era, 359-360, 361 See also Composite capitals; Corinthian (sculpture), 379, 379 386-387, 387 Roman Empire, 248 capitals Cappella Palatina, Palermo, 274-275, 275b, Ascension of Christ, 241, 268, 274, 369, Beauvais Cathedral, 378 brick, 262, 290, 9-32A Belisarius (Byzantine general), 258, 263 bronze casting: Early Byzantine, 259 8-10A Bruges (Belgium): guild hall, 383, 383 Cappella Scrovegni (Arena Chapel), Padua Ascension of Christ, Rabbula Gospels, 268, Belleville Breviary (Pucelle), 387-388, 387 Brunelleschi, Filippo: Ospedale degli (Giotto), 400, 401, 408, 409, 412, 14-8A, belt buckle, Sutton Hoo ship burial, 11-3A 268 Assisi (Italy): San Francesco, 405, 405b, 407, Benedetto Antelami, 359 Innocenti (Foundling Hospital), King David, Fidenza Cathedral 14-5A, 14-5B, 14-7 Florence, 410 Capua (Italy): Sant'Angelo in Formis, 356, Athena Parthenos (Phidias), 251 (sculpture), 356-357, 357, 12-14A bubonic plague (Black Death), 406, 416, 419, 356h. 12-27B Carcassonne (France), 382-383, 382 Benedict of Nursia (Saint Benedict), 322 Athens (Greece): calf bearer (sculpture), 238 14-19A Buffalmacco, Buonamico: Triumph of Death, Saint-Nazaire Cathedral, 383 atrium/atria, 243, 350 Benedictine Rule, 322, 330, 341, 343 Cardona (Spain): Sant Vicenç, 337, 337b, 339, attributes (of persons): four evangelists, 268, benedictionals, 312 419-420, 419 314, 12 Beowulf, 309, 11-3A Bukhara (Uzbekistan): Samanid Augustine, Saint, 238 Berbers, 295 Carmelite order, 404 Mausoleum, 289-290, 289 Caroline minuscule, 317 Augustinian order, 404 Berlinghieri, Bonaventura: Saint Francis Bulgars, 258 buon fresco, 408 Augustus (Roman emperor), 354 Altarpiece, San Francesco, Pescia, Carolingian, 317 Carolingian art, 308map, 317–324 Aula Palatina, Trier, 243 404-405, 404, 14-5B See also fresco painting Burge, John, 236, 242, 260, 261, 341, 344, 373 $author\ portraits,\,314-315,\,318,\,347,\,353,\,361$ Bernard de Soissons. See Reims Cathedral architecture, 320-324, 11-19A books, 317, 318-320, 11-13A, 11-15A Autun (France). See Saint-Lazare Bernard of Clairvaux, Saint: burials. See funerary customs Bury Bible (Master Hugo), 359-360, 12-23A, on church art, 333, 342, 343, 354, 367, sculpture, 317-318 Carolingian Empire, 270, 308map Babel, Tower of (Babylon ziggurat), 289 Bustan (Sadi) (ill. by Bihzad), 302, 302 and Crusades, 345, 346 See also Carolingian art Bacchus. See Dionysos on Hildegard of Bingen, 352 buttressing: carpet from the funerary mosque of Safi Baghdad (Iraq): on illuminated manuscripts, 347-348 in early Byzantine architecture, 262 al-Din (Maqsud of Kashan), 300-301, founding of, 287, 289 on Scholasticism, 372 in English Gothic architecture, 390 301 urban planning, 287 Bernardus Gelduinus, 359, 12-23A in French Gothic architecture, 365, 378, carpet pages, 311, 312, 313 carpets, 300-301 baldacchino (baldacco), 243 Christ in Majesty, Saint-Sernin, 340, 340, Bamberg Cathedral, 395-396, 395 356 in French/Spanish Romanesque Carrying of the Cross, 241 Bamberg Rider, Bamberg Cathedral Berno of Baume, 341 architecture, 12-10A cartography, 13-38B cartoons (preliminary drawings), 408 (sculpture), 395-396, 395 Bernward (bishop of Hildesheim), 324-325, in Norman Romanesque architecture, 357 Baños de Cerrato (Spain): San Juan Bautista, 326, 11 caryatids, 370 316, 316 bestiaries, 343 See also flying buttresses castellum. See westwork baptism, 236, 239 Bethlehem, 242 Byzantine, 256 casting, bronze: Early Byzantine, 259 Baptism of Christ (Rainer of Huy), 353, 353 Betrayal of Christ, Hours of Jeanne d'Evreux Byzantine architecture: Castle of Love (jewelry box lid), 388-389, 389 Baptism of Christ, Orthodox Baptistery, (Pucelle), 13-36A Early, 254, 255, 259-264, 267 Catacomb of Commodilla, Rome, 239, 239b, Ravenna (mosaic), 247, 247b, 8-17. Betrayal of Jesus, 241 early Christian architecture and, 244 Baptism of Jesus, 239, 240, 247, 353, 8-17A in Early Christian art, 251, 12-13A Catacomb of Saints Peter and Marcellinus, Baptistère de Saint Louis (Muhammad ibn in French/Spanish Romanesque art, Middle, 271-272, 274-275, 9-25A, 9-27A Rome, 237-239, 237 al-Zayn), 303-304, 303 Byzantine art, 254-281, 256map catacombs, 236, 237-239, 8-5A, 8-6A in Gothic art, 13-36A and Gothic art, 370 cathedra, 350 baptisteries: Early Christian, 236, 247, 8-17A in Italian 14th century art, 400, 401, 412, Cathedral of Santa María, León, 389, 389b, and Holy Roman Empire Romanesque Italian late medieval, 402-403

confraternities, 237, 404, 409, 14-19A Christ as ruler: Early Christian art, 238, 239, 244, 246, cathedrals, 350, 412 248, 250, 8-5A, 8-8A, 8-13A, 8-17A, congregational mosques. See great See also specific cathedrals in Carolingian art, 11-13A mosques in Early Byzantine art, 254, 255 Causai et curae (Causes and Cures) Conques (France): Sainte-Foy (Saint Faith), in Early Christian art, 232, 233, 239, 8-13A French/Spanish Romanesque art, 12-8A, (Hildegard of Bingen), 352 334, 335, 336, 336, 338, in French/Spanish Romanesque art, 12-8A Cavallini, Pietro, 407, 14-5B Constantine (Roman emperor), 236, 239, 242, 243, 253, 318, 354 Last Judgment, Santa Cecilia, Trastevere, in Middle Byzantine art, 273, 275, 9-27A Gothic art, 377, 380 Hiberno-Saxon art, 314 407b, 409, 14-7A Christ as Savior of Souls, Saint Clement, Constantine IX Monomachos (Byzantine Holy Roman Empire Romanesque art, 354 Ohrid (icon), 279, 279 Celestine (Pope), 8-10A Christ as Sol Invictus, 8-13A Islamic world as transmitter of, 284, 289 emperor), 273, 275 Celts, 308, 311 Italian 14th century art, 402, 409, 415 Constantinople (Istanbul) (Turkey): Christ as Sol Invictus, Mausoleum of the Cenni di Pepo. See Cimabue Church of Christ in Chora, 278, 279 Italian late medieval art, 401, 402, 403 Julii, Rome (mosaic), 245, 245b, 8-Cennini, Cennino, 414 Church of Saints Sergius and Bacchus, Italian Romanesque art, 356, 357, 12-27B Christ before Pilate, Rossano Gospels, 250, central plans: Late Antique art, 233, 237, 250-251, 252, 263 250, 251 in Byzantine architecture, 244, 263 Church of the Holy Apostles, 274 Christ between Constantine IX Monomachus in Early Christian architecture, 244, 246, Late Byzantine art, 279 Crusader sack of (1204), 257, 278, 9-26A, and the empress Zoe, Hagia Sophia 247, 8-19A (mosaic), 273-274, 273, 275 Middle Byzantine art, 270, 273, 276, in Islamic architecture, 286, 288, 297 Christ blessing, monastery of Saint Catherine, Mount Sinai (icon), 268b, fall of (1453), 256, 257, 278, 284 in Italian Romanesque architecture, 356 Norman Romanesque art, 362 founding of, 246, 256 Centula (France): Abbey of Saint-Riquier, Ottonian art, 329, 330, 11-24A, 11-29A Saint Polyeuktos church, 258 277, 9-18A 323, 323b, 11-19B Christ blessing Otto II and Theophanu (ivory See also humanism See also Hagia Sophia ceramics: continuous narration, 249-250, 8-21A Cleansing of the Temple, 240 plaque), 328, 328 Early Islamic, 294, 295 Clement V (Pope), 404 contrapposto: Christ enthroned with saints (Harbaville tilework, 299-300 in Early Byzantine art, 9-14A Clement VII (Antipope), 404 Triptych) (ivory carving), 275–276, 275, See also sculpture; terracotta in Early Christian art, 239 Clement of Alexandria, 8-13A chancel arches, 243, 413, 12-4A in Gothic art, 377, 380 Christ in Majesty (Bernardus Gelduinus), clerestories corbel vaulting, 390 in Byzantine architecture, 263 Saint-Sernin, 340, 340, 356 chapel of Henry VII (Vertue and Vertue), corbels, 416 in Early Christian architecture, 243 Westminster Abbey, 391, 391, 13-42A Christ in Majesty (Maiestas Domini), See also corbel vaulting in Gothic architecture, 364, 373, 374 Saint-Genis-des-Fontaines (relief chariot procession of Septimius Severus, Corbie Gospels, 347, 347b, 348, 12-15A sculpture), 340b, 12-8A, 12-14A in Italian late medieval architecture, 413, Arch of Septimius Severus, Lepcis Córdoba (Spain): Great Mosque, 282, 283, Christ in Majesty, Santa María de Mur 14-6A Magna (relief sculpture), 235 290-291, 290, 291 in Romanesque architecture, 350, 12-4A, Charlemagne (Holy Roman Emperor), (fresco), 348, 349 Corinthian capitals: in Italian late medieval Christ seated, Civita Latina (sculpture), 317-318, *317*, 320, 322, 324, 402, 11-13A, architecture, 402 cloisonné, 271, 310, 9-26A, 9-26B 239b, 8-8A Coronation Gospels (Gospel Book of cloisons, 310 Charles VII (king of France), 383 Christian community house, Dura-Europos, cloisters, 322, 341-342, 12-8B Charlemagne), 318, 318, 353 Charles Martel (Frankish ruler), 284 236, 236 Clovis (king of the Franks), 13-23A Corpus juris civilis (Code of Civil Law), 258 Charles the Bald (Holy Roman Emperor), Christianity: Corvey abbey church, 323-324, 323 Cluniac order, 341-342, 343, 347 and Byzantine Empire, 258 Court of Gayumars, Shahnama (Book of Cluny III, 341, 341, 343 Chartres Cathedral: early medieval period, 307, 311 Kings) (Sultan-Muhammad), 302-303, cluster piers. See compound piers and Amiens Cathedral, 378 Great Schism, 404 Codex Colbertinus, 347, 347 and medieval books, 312 nave height diagram, 371 Creation and Temptation of Adam and Eve codex/codices, 249 Porch of the Confessors, 377b, 13-18A monasticism, 267 Coeur, Jacques, 383-384 (Wiligelmo), 356, 356, 12-23A post-1194 rebuilding, 364, 365, 374, 374 Monophysite heresy, 258, 270 Cologne Cathedral (Gerhard of Cologne), 396, 397, 397, 418 crenellations, 382 and Reims Cathedral, 380, 13-23A and the Roman Empire, 236, 239, 242 crenels, 382 Royal Portal, 369-370, 369, 370, 13-3A Scholasticism, 372 Gero crucifix, 328-329, 329, 348-349, 394 the Cross, 241 and Second Commandment, 239, 269, South transept sculpture, 377, 377b, 377, in Byzantine art, 266, 267, 271, 9-32A colonnettes, 290, 291, 390, 12-11A 348, 8-8/ in Hiberno-Saxon art, 313, 315, 11-9A colophons, 312 stained-glass windows, 365, 374, 375, 375, See also Byzantine art; early Christian cross vaults. See groin vaults 376-377, 376, 377, 386 art; four evangelists; medieval art; color: crossing, 246, 323, 14-18A in Byzantine art, 268, 280 chi-rho-iota (Christogram), 264, 306, 307 monasticism; Renaissance crossing squares, 323, 326, 338 in Early Christian art, 245, 248, 250 Christogram (chi-rho-iota), 264, 306, 307 chi-rho-iota (XPI) page, Book of Kells, 306, crossing towers, 246-247, 389-390 in Hiberno-Saxon art, 312, 315 Chronica (Gervase of Canterbury), 339 Crucifixion, 241 chiaroscuro: in Italian 14th century art, 409 church furniture, 392, 9-14A, 13-44A in Islamic art, 299, 10-17/ in Byzantine art, 268, 274, 9-17A in Italian 14th century architecture, chivalry, 370, 385, 414 Church of Christ in Chora, Constantinople, in Early Christian art, 233, 251-252, choir, 264 in Italian 14th century art, 409, 412, Church of Ognissanti, Florence, 407-408, Chrétien de Troyes, 388 in French/Spanish Romanesque art, 336, **407,** 14 Christ, 240 348-349 Church of Saints Sergius and Bacchus, in Late Antique Jewish art, 235 as alpha and omega, 251, 8-6A, 12-8A in Gothic art, 394 in Carolingian art, 320, 11-13A Constantinople, 263 colossal head of Constantine (sculpture), 354 in Hiberno-Saxon art, 315 in Early Byzantine art, 259, 267–268, Church of the Dormition, Daphni, 272-273, Columba, Saint, 311 in Middle Byzantine art, 272, 273 Column of Trajan, Rome, 362, 11-24A 272, 272, in Ottonian art, 326, 328-329 Church of the Holy Apostles, in Early Christian art, 232, 238-239, 247, Crucifixion (ivory carving), 251-252 capitals. See capitals (of columns) Constantinople, 274 248, 250, 252, 266, 8-6A, 8-8A, 8-13A Crucifixion (Naumberg Master), Naumburg Church of the Holy Sepulcher, Jerusalem, in early Islamic architecture, 290 in French/Spanish Romanesque art, 340, Cathedral (sculpture), 394, 394 286 engaged. See engaged columns 345, 346, 12-8B Crucifixion, Church of the Dormition in French/Spanish Romanesque Church of the Theotokos, Hosios Loukas, in Gothic art, 379 (mosaic), 272, 273 architecture, 337 271, 271, 9-25, in Italian Romanesque art, 356 Crucifixion, Rabbula Gospels, 268, 268b, Church of the Virgin, monastery of Saint in Italian late medieval architecture, 402 in Late Byzantine art, 279 Catherine, Mount Sinai, 267-268, 267, in Ottonian architecture, 326, 11-23 9-17A in Middle Byzantine art, 272–273, 275, Commentarii (Ghiberti), 365 Crucifixion, Saint Mark's, Venice (mosaic), Commentary on the Apocalypse (Beatus) 274 Church of the Virgin Peribleptos, Ohrid, in Ottonian art, 327, 328-329 (ill. by Emeterius), 316, 316, 333, 12-23A cruciform shape, 246 279-280, 280 See also Anastasis; Christ as ruler; Jesus, compose. See composition Crusades, 346 Cicero, 407 life of; Passion of Christ; Pietàs; and Bernard of Clairvaux, 342, 345, 346 Cimabue, 410, 14-5B Composite capitals, 11-19A, 12-27A Resurrection of Christ; Second Coming and Christian patronage of Islamic art, and Giotto, 407 Christ (Beau Dieu), Amiens Cathedral in Byzantine art, 255, 266–267, 268, 271 304 Madonna Enthroned with Angels and (sculpture), 379, 379 Prophets, Santa Trinità, Florence, 406, in Carolingian art, 319 Gothic era, 385 Christ, Doubting Thomas, and apostles, and La Madeleine, Vézelay, 345, 346 in Early Christian art, 245, 246, 248, 250 Santo Domingo (relief sculpture), 12-8B 406 Cistercian order, 322, 342, 343, 347, 12-10A in Gothic art, 387, 393-394 sack of Constantinople, 257, 278, 9-26A, Christ as Good Shepherd, 238-239, 247, 248, heraldic, 310 9-26B city planning. See urban planning crypt, 340 in Italian 13th century art, 403-404, 406 city-states, 406 Christ as the Good Shepherd (sculpture), Ctesiphon (Iraq): palace of Shapur I, 296 in Italian 14th century art, 409, 411, classical art, 402 239, 239 See also classical influences on later art; Cubiculum Leonis, Catacomb of Christ as Good Shepherd, Mausoleum of Commodilla, Rome (mural), 239, 239b, in Italian late medieval art, 401 Galla Placidia, Ravenna (mosaic), 247, Roman art in Romanesque art, 345 classical influences on later art: 247, 248, 266, 8-17A Carolingian art, 317–318, 319, 320, 11-19A cubiculum/cubicula, 237 See also ground line Christ as Pantokrator, Church of the Early Byzantine art, 257, 258, 258-259, compound piers, 340, 358, 373, 12-4A, cuerda seca, 299 Dormition, Daphni (mosaic), 272-273, cupolas, 9-32A 12-27A, 14-12A -3A, 9-14A, 9-18A

D	in Gothic art, 379, 380, 388, 392, 394, 395	Edward III (king of England), 13-42A	Flamboyant style, 381, 381–382, 384, 391, 398
da Vinci, Leonardo. <i>See</i> Leonardo da Vinci	in Hiberno-Saxon art, 315	Edward the Confessor (king of England),	
Daddi, Bernardo: Madonna and Child	in Italian 13th century art, 403, 404, 406	361 Effects of Good Government in the City and in the Country, Palazzo Pubblico, Siena	flashing, 375
Enthroned with Saints, Or San Michele,	in Italian 14th century art, 408, 411, 412		fleurs-de-lis, 376, 388
Florence, 419, 419b, 14-19A	in Romanesque art, 345, 346, 348, 353,		Flight into Egypt, 240
Damascus (Syria): Great Mosque, 286, 287, 287	360, 361	(Lorenzetti), 416, 416, 417	Florence (Italy):
	drums (of columns/domes), 271, 9-32A	egg tempera. See tempera	14th century art, 417–419, 14-18A,
Damasus (Pope), 8-6A	Duccio di Buoninsegna, 387–388, 410,	Egyptian sculpture: Early Christian, 239,	14-18B, 14-19A
Dante Alighieri, 384, 406, 412	13-36A	8-8A, 8-10A	Church of Ognissanti, 407–408, 407,
Daphni (Greece): Church of the Dormition,	Maestà altarpiece, Siena Cathedral, 410,	Einhard, 317 Ekkehard and Uta statues, Naumburg	14-19A
272–273, 272, 272, 9-25A	411–412, 411, 412b, 412, 13-36A,		Or San Michele, 419, 419b, 14-19A
David Before Saul, Belleville Breviary,	14-8B, 14-10A	Cathedral, 394–395, 395	Ospedale degli Innocenti (Foundling
387–388, 387	duomo, 417	Eleanor of Aquitaine, 352	Hospital) (Brunelleschi), 410
David Composing the Psalms, Paris Psalter,	See also cathedrals	elevations (architectural), 413	Palazzo della Signoria (Palazzo Vecchio)
276–277, 277	Dura-Europos (Syria), 234–236	See also arcades; clerestories; naves;	(Arnolfo di Cambio), 417, 417b,
De materia medica (Dioskorides), 258, 268,	Christian community house, 236, 236	triforium	
9-3A	synagogue, 235, 235, 248	embroidery, 361–362, 9-35A	San Miniato al Monte, 356, 356b, 12-27A
death:	Durandus (abbot of Saint-Piere), 342, 343,	Emeterius: illustrator of <i>Commentary on the</i>	Santa Trinità, 406, 406
in Italian 14th century art, 419–420 See also funerary customs	347 Durham Cathedral, 358–359, <i>359</i> , <i>359</i> , <i>368</i> ,	Apocalypse (Beatus), 316, 316, 12-23A emirs, 293	See also Baptistery of San Giovanni; Florence Cathedral; Florentine 14th
Death of the Virgin, Strasbourg Cathedral (relief sculpture), 393–394, 393	373, 390–391	emotionalism: in Byzantine art, 276	century art; Santa Croce; Santa Maria Novella
Decameron (Boccaccio), 406 Deësis, 276	E Eadfrith (bishop of Lindisfarne), 312–313 Eadwine Psalter (Eadwine the Scribe), 360,	in early medieval European art, 327, 329 in Gothic art, 394, 396	Florence Cathedral (Santa Maria del Fiore) (Arnolfo di Cambio), Florence, 410,
deities. See religion and mythology Delivery of the Keys to Peter, 240 Denial of Peter, 241	361, 12-23A Early Byzantine art, 255, 257–270, 281	in Italian 13th century art, 404 in Italian 14th century art, 409, 412, 419 in Romanesque art, 345	417–418 campanile (Giotto di Bondone), <i>417</i> , 418 Florentine 14th century art, 417–419,
Denis (Dionysius), Saint, 366 Deposition (of the body of Jesus from the	architecture, 254, 255, 259–264, 267	enamel, 301, 392	14-18A, 14-18B, 14-19A
	and Early Christian architecture, 244	encaustic painting: Early Byzantine, 268,	florins, 417
Cross), 241 Descent into Limbo, 241	icons, 268–270, 271, 9-18A illuminated manuscripts, 258, 268, 9-3A,	269, 270, 9-18A Ende, 316, 12-23A	flying buttresses: in Gothic architecture, 359, 364, 365, 372, 372–373, 373, 374,
See also Anastasis	9-17A	engaged columns:	376, 383, 390
Desiderius (abbot of Montecassino), 12-27B	ivory carvings, 257, 258–259, 264, 9-14A	in Carolingian architecture, 11-19A	folios, 248, 249
diagonal ribs, 373 diaphragm arches, 12-27A	mosaics, 254, 255, 264–268 Early Christian architecture:	in Islamic architecture, 290 in Romanesque architecture, 340, 341	Fontenay (France): Notre-Dame, 343, 343b, 349–350, 12-10A
Diocletian (Roman emperor), 236 Diocletian, palace of, Split, 244, 356, 8-19A, 10-5A	and Carolingian architecture, 323 catacombs, 237, 8-5A in Dura-Europos, 236	English art: Gothic, 389–391, 399, 13-38B, 13-42A enthroned Christ. See Christ as ruler	foreshortening: in Italian 14th century art, 401, 409, 14-8B
Dionysius (Denis), Saint, 366 Dionysos (Bacchus) (Greek/Roman deity):	and Islamic architecture, 286 and Ottonian architecture, 8-10A, 11-23A	Entombment (of the body of Jesus), 241,	Forum of Trajan, Rome (Apollodorus of Damascus), 326 four evangelists:
in Early Christian art, 244, 245 in Late Antique art, 252	in Ravenna, 246–247, 8-17A and Romanesque architecture, 351, 355,	See also Lamentation Entombment of Christ, Sant'Angelo in	attributes of, 268, 314, 12-15A in Carolingian art, 11-13A
Dioscurides (gem cutter), 248	12-27A	Formis (fresco), <i>356b</i> , 12-27B	in Early Byzantine art, 268 in French/Spanish Romanesque art,
Dioskorides (physician), 258, 268, 9-3A	in Rome, 242–244	Entry into Jerusalem, 241, 400, 401, 412,	
Diptych of the Nicomachi and Symmachi (ivory carving), 252, 252	Early Christian art, 232 architecture. See Early Christian	14-8A, 14-10A Entry into Jerusalem, Arena Chapel, Padua	340, 344, 348, 349, 12-11A, 12-14A, 12-15A
diptychs, 251	architecture	(Giotto), 400, 401, 412, 14-8A, 14-10A	in Hiberno-Saxon art, 312, 314
dish with Arabic proverb, Nishapur, 294,	and Carolingian art, 320, 11-13A, 11-23A	Entry into Jerusalem, Maestà altarpiece,	on life of Jesus, 240
295	illuminated manuscripts, 248–250	Siena Cathedral (Duccio), 412, 412b,	in Middle Byzantine art, 9-27A
disputatio, 372 Dispute in the Temple, 240	and Islamic art, 286, 287 and Italian late medieval art, 14-7A	equestrian portrait of Charlemagne or	See also Gospels Foy, Saint, 12-7A
Divine Comedy (Dante), 384, 406 The Divine Names (Pseudo-Dionysius), 262 Djenne (Mali): Great Mosque, 288	ivory carvings, 251–252, 12-13A mosaics, 244–245, 245, 247–248, 8-13A, 8-17A, 8-19A	Charles the Bald (sculpture), 317–318, 317 equestrian statue of Justinian, 259, 317	Fra Angelico, 405 Francis of Assisi, Saint, 404–405, 14-5A,
Doge's Palace, Venice, 420, 420 doges, 274	Old Testament themes in, 232, 233, 238, 245–246, 8-5A, 8-10A, 8-13A	equestrian statue of Marcus Aurelius, Rome, 259, 317–318	Franciscan order, 385, 404, 405, 14-6A Franks, 284, 308, 317
Dome of the Rock, Jerusalem, 285–287, 285, 286, 294, 299, 300, 346	painting, 237–239, 8-6A	Etruria. See Etruscan art	See also Carolingian art
	sarcophagi, 232, 233, 238, 239	Etruscan art: and Late Antique art, 237	Frederick II (Holy Roman Emperor), 396,
Domenico Contarini (doge of Venice), 274	sculpture, 239, 8-8A, 8-10A	Eucharist (Mass), 241, 263	402
Domenico Veneziano, 405	Early Gothic style, 369–370, 370, 371, 372,	in Early Byzantine art, 254, 264	Frederick Barbarossa (Holy Roman
domes:	376cap, 378, 380	in Early Christian art, 244, 245	Emperor), 354–355, 392
in Byzantine architecture, 255, 260, 261,	See also Saint-Denis abbey church	Eugenius III (Pope), 352	French Gothic art, 366–389, 399
262–263, 262, 271, 272, 9-32A	early Islamic art, 284–294	Eusebius of Caesarea, 269	architecture, 364, 365, 366–369, 370–374,
in Early Christian architecture, 244, 247, 8-17A, 8-19A	architecture, 282, 283, 285–286, 289–292, 10-5A	evangelists, 314 See also four evangelists	377–379, 380–384 illuminated manuscripts, 384–388,
in Islamic architecture, 286–287, 289, 290, 291, 296, 297, 298, 299	books, 294, 10-17A	Eve. See Adam and Eve	13-36A
	calligraphy, 294, 295, 10-17A	Eve (Gislebertus), Saint-Lazare, 12-13B	and Italian 14th century art, 407, 411,
in Italian 14th century architecture, 14-18A	luxury arts, 292–294, 295, 10-15A, 10-17A mosaics, 287, 291	ewer in the form of a bird (Sulayman), 293,	419, 14-12A sculpture, 369–370, 377, 379, 380, 381,
in Romanesque architecture, 356, 12-4A Dominic de Guzman (Saint Dominic), 404, 12-8B	early medieval European art, 306–331, 308map	exedrae, 263–264 F	388, 13-3A, 13-18A, 13-23A See also French Gothic stained-glass windows
Dominican order, 385, 404, 420, 14-6A donor portraits:	Carolingian, 317–324, 331, 11-13A, 11-15A, 11-19A	facades: in French/Spanish Romanesque	French Gothic stained-glass windows, 373 Chartres Cathedral, 365, 374, 375,
in Gothic art, 394–395	Hiberno-Saxon, 294, 306, 307, 311–315, 318, 331, 11-3A	architecture, 12-11A	376–377, 386
in Ottonian art, 328		in Italian 14th century architecture, 412	Jacques Coeur house, 384
See also patronage	Mozarabic, 316 Ottonian. See Ottonian art	See also specific buildings	Reims Cathedral, 380, 13-23A
doors with relief panels, Saint Michael's,		face. See human face	Saint-Denis abbey church, 368–369, 375,
Hildesheim, 326–327, 326, 327, 344	pre-Christian, 308–311, 331, 11-3A, 11-4A	fan vaults, 391	13-3A
double monasteries, 352	societal contexts, 308–309, 311, 317, 318,	Felix, Saint, 8-6A	Sainte-Chapelle, 381
Doubting of Thomas, 241, 252, 12-8B	324, 328	Ferdinand II (king of Aragon), 284	French Revolution: and Gothic art, 369, 370,
dragons:	timeline, 308	feudalism, 334	13-3A
in Gothic art, 379	Visigothic, 282, 291, 315–316	fiber arts. See textiles	French/Spanish Romanesque art, 334–349,
in Romanesque art, 347, 348, 354	Ebbo Gospels, 318, 319, 353, 12-15A	fibulae, 309	363
drama: mystery plays, 409, 12-35A	Ecclesius (bishop of Ravenna), 263, 264	Fidenza Cathedral, 356–357, <i>357</i> , 12-14A	architecture, 335, 337–340, 341, 344–345,
drapery: in Byzantine art, 257, 277, 279, 280	Edict of Milan, 236 Edirne (Turkey): Mosque of Selim II (Sinan	finials, 294 fire and architecture, 339, 373	348, 12-4A, 12-4B, 12-10A, 12-14A illuminated manuscripts, 347–348,
in Carolingian art, 318, 319	the Great), 298, 298, 299	Flagellation of Jesus, 241	12-15A

metalwork, 334, 336	Godescalc Lectionary, 318, 318b, 11-13A	H	Honoré, Master: Breviary of Philippe le Bel,
See also French/Spanish Romanesque sculpture	gods/goddesses. <i>See</i> religion and mythology gold leaf, 405, 412	Hadith, 285 Hagia Sophia (Anthemius of Tralles and	386–387, <i>387</i> Honorius (Roman emperor), 246, 256
French/Spanish Romanesque sculpture:	Good Friday, 241	Isidorus of Miletus), Constantinople:	Hortus deliciarum (Garden of Delights)
Gislebertus, 332, 333, 346, 12-13A, 12-13B La Madeleine, Vézelay, 345–346	Good Shepherd, story of Jonah, and orants, Catacomb of Saints Peter and	architecture, 259–263, 260, 261 and Carolingian architecture, 321	(Herrad), 352 Hosios Loukas (Greece):
Morgan Madonna, 348–349	Marcellinus, Rome (fresco), 237-239,	Christ between Constantine IX	Church of the Theotokos, 271, 271, 9-25A
Notre-Dame-la-Grande, 12-11A	237 Gordion (Asia Minor), 245	Monomachus and the empress Zoe, 273–274, 273, 275	Katholikon, 271, 271 Hours of Jeanne d'Evreux (Pucelle), 387,
popularity of, 340–341 Saint-Étienne, Vignory, 337	Gospel Book of Archbishop Ebbo of Reims.	and Gothic architecture, 378	387b, 13-36A
Saint-Genis-des-Fontaines abbey church,	See Ebbo Gospels	and Islamic architecture, 286, 297	Hugh of Saint-Victor, 375 Hugh of Semur (abbot of Cluny), 341
12-8A Saint-Pierre, Moissac, 341–345	Gospel Book of Otto III, 329, 329b, 329, 11-29A	and Saint Polyeuktos, Constantinople, 258	Hugo, Master: Bury Bible, 359–360, 12-23A,
Saint-Sernin, 340, 356	Gospels, 311-312, 312, 314, 318, 11-13A	Virgin (Theotokos) and Child enthroned	12-35A
Saint-Trophîme, 12-14A Santo Domingo, Silos, 12-8B	See also Corbie Gospels; Coronation Gospels; Ebbo Gospels; four	(mosaic), 270–271, 270, 376 Hagios Georgios (Church of Saint George),	human face: in Byzantine art, 270, 277, 9-18A
fresco painting:	evangelists; Lindau Gospels;	Thessaloniki, 248, 257, 8-17A	in Gothic art, 370, 380, 13-18A
Byzantine, 278, 279, 9-25A	Lindisfarne Gospels; Rabbula Gospels; Rossano Gospels	Haito (bishop of Basel), 322, 323 al-Hakam II (Umayyad caliph), 282, 291	in Italian 13th century art, 403 in Italian 14th century art, 411, 14-8A,
Italian 13th century, 14-5A, 14-5B Italian 14th century, 400, 401, 408, 409,	Gothic architecture:	hall churches, 348	14-8B
416-417, 419-420, 14-8A, 14-8B	cathedrals, 359, 373	See also Hallenkirche	in Late Antique Jewish art, 235 in Romanesque art, 345, 349
Italian Romanesque, 12-27B Late Antique Jewish, 236	English, 389–391, 13-42A French, 364, 365, 366–369, 370–374,	Hallenkirche, 396, 398 halos:	human figure:
See also fresco secco; mural painting	377-379, 380-384	in Byzantine art, 255, 264, 274, 280,	in Carolingian art, 319, 320, 11-15A in Early Byzantine art, 265, 270
fresco secco, 408 Friday Mosque, Isfahan, 291–292, 292, 299	Holy Roman Empire, 392–393, 396–398 Spanish, 13-38A	9-18A in Early Christian art, 239, 247, 248, 250,	in Early Byzantine art, 265, 270 in Early Christian art, 246, 8-19A, 8-21A
Friday mosques. See great mosques	Gothic art, 363-399, 365, 366map	8-6A, 8-13A	in French/Spanish Romanesque art, 345,
(congregational mosques) frieze of the south facade, Umayyad palace,	English, 389–391, 399, 13-38A, 13-38B, 13-42A	in early medieval art, 319, 329 in Gothic art, 376	348, 349, 12-13B, 12-14A, 12-15A in Gothic art, 370, 379, 380, 381, 387, 388,
Mshatta, 10-5B	French. See French Gothic art	in Italian 13th century art, 405	395, 13-18A, 13-36A
friezes: in Roman art, 362	Holy Roman Empire, 392–398, 399,	in Italian 14th century art, 412, 414	in Italian 13th century art, 403-404 in Italian 14th century art, 408, 412
funerary customs: Early Christian, 237, 239, 8-17A	13-44A societal contexts, 366, 372, 385	Harbaville Triptych (Christ enthroned with saints) (ivory carving), 275–276, 275,	in Italian Romanesque art, 356–357
early medieval pre-Christian, 309-311,	timeline, 366	277	in Late Antique Jewish art, 235
11-3A, 11-4A Gothic Europe, 13-42A	See also Gothic Revival Gothic Revival, 396	harmony. See proportion Hasan (Mamluk sultan of Cairo), 296	in Late Byzantine art, 279, 280 in Middle Byzantine art, 273, 274, 276,
Islam, 289–290, 296	Gothic sculpture:	Hastings, Battle of (1066), 361-362	9-26A, 9-26B
furta sacra, 336	English, 13-42A French, 369–370, 377, 379, 380, 381, 388,	head clusters, 246 head reliquary of Saint Alexander, 353–354,	in Norman Romanesque art, 360, 361 in Ottonian art, 326–327
G	13-3A, 13-18A, 13-23A	353	humanism:
Gabriel, Archangel:	Holy Roman Empire, 393–396 Granada (Spain): Alhambra, 295–296, 295,	Heiligkreuzkirche, Schwäbisch Gmünd (Heinrich and Peter Parler), 398, 398	and Italian late medieval art, 406–407, 412
in Italian 14th century art, 414 See also Annunciation to Mary	296, 297	Heinrich (bishop of Mainz), 352	See also classical influences on later art
Galerius (Roman emperor), 236, 8-19A	graves. See funerary customs	Henry II (Holy Roman emperor), 324	Husayn Bayqara (Timurid sultan), 302 hypostyle halls: in Islamic architecture, 288,
galleries, 324, 416, 12-7A See also tribunes	"Great Dish", Mildenhall Treasure, 250–251, 250	Henry II (king of England), 352 Henry III (king of England), 385	289, 290
Garden of Gethsemane, 241	Great Mosque, Córdoba, 282, 283, 290-291,	Henry IV (Holy Roman emperor), 350	I
Gaucher de Reims. See Reims Cathedral geometry, 384–385	290, 291 Great Mosque, Damascus, 286, 287, 287	Henry of Blois (bishop of Winchester), 12-35A	Ibn Zamrak, 296
George, Saint, 268, 269	Great Mosque, Djenne, 288	Heraclius (Byzantine emperor), 270	iconoclasm, 257, 269, 270
Georgics (Vergil), 248 Gerhard of Cologne: Cologne Cathedral, 396,	Great Mosque, Kairouan, 288, 289 Great Mosque, Samarra, 289, 289	Herakles (Hercules) (Greek/Roman hero): in Early Christian art, 8-5A	iconography: Christian, 240–241, 314 iconophiles, 269
397, 397	great mosques (congregational mosques),	heraldic composition, 310	iconostasis, 279
Gernrode (Germany): Saint Cyriakus, 324,	288 Friday Mosque, Isfahan, 291–292, 299	Hercules. See Herakles Herrad (abbess of Hohenberg): Hortus	icons, 405 Early Byzantine, 268–270, 269, 271,
324, 326, 337, 350, 11-23A Gero (archbishop of Cologne), 328	See also Great Mosque, above	deliciarum (Garden of Delights), 352	9-18A
Gero crucifix, 328-329, 329, 348-349, 394	Great Schism, 404	Hiberno-Saxon art, 306, 307, 311–315, 318,	Late Byzantine, 279–280 Middle Byzantine, 274, 277, 9-26B
Gervase of Canterbury, 339, 341 Ghiberti, Lorenzo, 365	Greek art: Archaic period art and Early Christian	331 and early Islamic art, 294	illuminated manuscripts, 405
Giorgione da Castelfranco, 405	art, 238	societal contexts, 311	Byzantine, 258, 268, 276–277, 405, 9-3A, 9-17A
giornata/giornate, 408 Giotto di Bondone, 407–409, 14-7A	See also classical influences on later art Greek cross, 271, 9-25A	and Sutton Hoo ship burial, 11-3A hierarchy of scale:	Carolingian, 317, 318–320, 11-13A, 11-15A
Arena Chapel, Padua, 400, 401, 408, 409,	Gregory I (the Great), Saint (Pope): Moralia	in Italian 14th century art, 14-16A	French Gothic, 384–388, 13-36A
412, 14-8A, 14-8B, 14-10A campanile, Santa Maria del Fiore	in Job, 347–348, 347 Gregory VII (Pope), 352	in Late Antique Jewish art, 235 in Ottonian art, 327	French/Spanish Romanesque, 347–348, 12-15A
(Florence Cathedral), Florence, 417,	Gregory IX (Pope), 14-5A	High Cross of Muiredach, Monasterboice,	Hiberno-Saxon, 306, 307, 311-315
418 Madonna Enthroned, Church of	griffins, 10-5B grisaille, 409 , 13-36A	315, <i>315</i> high crosses, 315	Holy Roman Empire Romanesque, 352– 353, 12-23A
Ognissanti, Florence, 407–408, 407,	groin vaults (cross vaults):	High Gothic art, 378, 379, 380–381	Late Antique, 248–250
14-19A	in French/Spanish Romanesque	See also Chartres Cathedral	Norman Romanesque, 359–361, 12-35A Ottonian, 329–330, 11-29A
and Andrea Pisano, 419 and Saint Francis Master, 14-5B	architecture, 340 , 12-4A, 12-4B, 12-7A, 12-7B	Hijra, 285 Hildegard of Bingen, 352	See also books
Giraldus Cambrensis, 307	in Gothic architecture, 370	Physica, 352	illuminated tughra of Suleyman the Magnificent, 297b, 10-23A
Gislebertus, 359, 12-23A Eve, Saint-Lazare, 12-13B	in Holy Roman Empire Romanesque architecture, 350	Scivias (Know the Ways of God), 352–353, 352	illusionism:
Last Judgment, Saint-Lazare, 332, 333,	in Italian 14th century architecture,	Hildesheim (Germany): Saint Michael's,	in Byzantine art, 270, 279
346, 12-8A, 12-13B Suicide of Judes Saint Lazare, 345h	14-12A in Norman Romanesque architecture,	324–327, 326b, 326, 327, 344, 350, 8-10A, 11-23A, 11-24A	in Carolingian art, 318, 319 in Italian 14th century art, 408, 409, 415
Suicide of Judas, Saint-Lazare, 345b, 12-13A	358, 359	historiated capitals, 342-343, 12-13A	See also perspective
Giulio Romano, 405	ground line: in Early Byzantine art, 268	Holy Roman Empire: Carolingian dynasty, 270, 317–324	illustrated books. See books; illuminated manuscripts
glaziers, 375 Gloucester Cathedral, 390–391, 391b, 391,	See also composition	Ottonian dynasty, 270, 317–324	imago hominis, 315
398, 13-42A	guild hall, Bruges, 383, 383	Salian dynasty, 349-355, 363	imam, 288 Imam (Shah) Mosque, Isfahan, 299-300, 299
God accusing Adam and Eve, Saint Michael's, Hildesheim (relief	guilds: Gothic era, 366, 372, 383, 388	See also Holy Roman Empire art Holy Roman Empire Gothic art, 392–398,	Imam (Shan) Mosque, Islahah, 299–300, 299 In Praise of Scribes (Johannes Trithemius),
sculpture), 326-327, 327	Italian 14th century, 410, 414	399, 13-44A	386
God as Creator of the World, moralized Bible, 384–385, 384	Guillaume de Lorris: Romance of the Rose, 388–389	Holy Roman Empire Romanesque art, 349–355, 363, 12-23A	incrustation, 355, 12-27A India. See South Asian art
	NO MODEL OF THE PARTY OF THE PA	Control of the Contro	

indulgences, 374 Jesus washing the feet of Saint Peter, Gospel Allegory of Good Government, Palazzo Insular art. See Hiberno-Saxon art Book of Otto III, 329b, 11-29 Italian late medieval, 409, 412, 416, 417, Pubblico, Siena, 416b, 14-16. interlace: jewelry. See luxury arts; metalwork 14-5B, 14-10a Effects of Good Government in the City in Carolingian art, 11-13A Jewish art in Late Antiquity, 235-236, 237 Late Antique, 248, 250 and in the Country, Palazzo Pubblico, in French/Spanish Romanesque art, 347 Johannes Trithemius, 386 Ottonian, 330 Siena, 416, 416, 417 John (king of England), 352 Laon Cathedral, 370, 371, 371, 372, 378, 380 in Hiberno-Saxon art, 312, 313, 315, Lorenzetti, Pietro, 14-19A John VIII Palaeologus (Byzantine emperor), large sakkos of Photius, 280b, 9-35A, 10-27A Birth of the Virgin, Siena Cathedral, 415, in Viking art, 311, 11-4A Lars Pulena sarcophagus, Tarquinia, 249 415 John XII (Pope), 328 International Style (medieval Europe), 413-Last Judgment: Lorsch (Germany): Torhalle, 232, 323b, 414 John XIII (Pope), 328 in French/Spanish Romanesque art, 332, intonaco, 408 John of Damascus, Saint, 270 333, 345, 12-8A, 12-14A Louis VI (king of France), 367, 372 Introduction to the Three Arts of Design John the Baptist, Saint, 240 in Gothic art, 379, 13-38B Louis VII (king of France), 345, 367 (Vasari), 365 in Byzantine art, 276, 277, 9-14A in Hiberno-Saxon art, 315 Louis IX, Saint (king of France), 380-381, iota. See chi-rho-iota (Christogram) See also Baptism of Jesus in Italian 14th century art, 400, 401, 385-386, 386 Irene (Byzantine empress), 270, 273, 9-26A John the Evangelist, Saint, 241, 314 Louis the Pious (Holy Roman Emperor), 321, Isaac, 246 in Byzantine art, 273, 276 Last Judgment (Cavallini), Santa Cecilia, See also Abraham and Isaac Luke, Saint, 314 in Gothic art, 394 Trastevere, 407b, 409, 14 Isabella (queen of Castile), 284 in Italian 14th century art, 409 Last Judgment, Arena Chapel, Padua lunettes, 237, 247, 344 Isfahan (Iran): in Italian Romanesque art, 12-27B (Giotto), 400, 401, 409 lux nova, 369, 374, 375, 13-23A Friday Mosque, 291-292, 292, 299 John the Lydian, 266 Last Judgment, Saint-Lazare (Gislebertus), 332, 333, 346, 12-8A, 12-13B Imam (Shah) Mosque, 299-300, 299 Jonah, 237-238, 239, 8-13A early Islamic, 292-294, 295, 10-15A, Last Supper, 241 Madrasa Imami, 300, 300 Joseph, Saint, 241, 9-14A Isidorus of Miletus. See Hagia Sophia Joseph of Arimathea, 276, 12-27B See also Eucharist early medieval pre-Christian, 308-309 Islam, 284, 285 Judas Iscariot. See Betrayal of Jesus Late Antique art, 232-253, 234map Gothic, 388 See also Crusades; Islamic art; Ottoman Judgment Day. See Last Judgment Dura-Europos, 234-236 Late Antique, 248-252 Empire Junius Bassus sarcophagus, 232, 233, 8-8A, Jewish art, 235-236, 237 Late Byzantine, 9-3 Islamic art, 282-305, 284map luxury arts, 248-252 later Islamic, 300-304 Byzantine art and, 274-275, 287, 9-27A Juno. See Hera societal contexts, 234-235 See also ceramics; illuminated Christian patronage of, 304 Justin Martyr, 239 timeline, 234 manuscripts; ivory carvings; and Romanesque art, 345 Justinian (Byzantine emperor): Late Byzantine art, 278-280, 281, 9-35A metalwork societal contexts, 284, 285, 294-295 Barberini Ivory, 258-259 Late Gothic style, 381-382, 383-384, 391, timeline, 284 conquest of Ravenna, 246, 263 398, 13-42/ See also early Islamic art; later Islamic art equestrian statue of, 259, 317 later Islamic art, 294-304 Macedonian Renaissance, 276 Istanbul. See Constantinople San Vitale mosaic, 254, 255, 264-265, architecture, 295-300 machicolated galleries, 416 books, 302-303 Italian 13th century art, 402-406, 421, 275, 309 Madonna and Child. See Virgin and Child Justinian, Bishop Maximianus, and calligraphy, 300, 301, 10-23A Madonna and Child Enthroned with Saints, luxury arts, 300-304 Italian 14th century art, 406-420, 421 attendants, San Vitale, Ravenna Or San Michele, Florence (Daddi), 419, Cavallini, 407, 409, 14-7 (mosaic), 254, 255, 264-265, 265, 275, sculpture, 295 419b, 14-19A Florence (Florentine), 417-419, 14-18A, societal contexts, 294-295 Madonna Enthroned (Giotto), Church of Justinian and Theodora mosaics, San Vitale, 14-18B, 14-19A tilework, 299-300 Ognissanti, Florence, 407-408, 407, Giotto di Bondone, 400, 401, 407-409, Ravenna, 254, 255, 264-266, 265, 275, Lawrence, Saint, 247 14-7A, 14-8A, 14-8B leading, 375 Madonna Enthroned with Angels and Pisa, 419-420 Justinian as world conqueror (Barberini Leaning Tower of Pisa, 354, 355 Prophets, Santa Trinità, Florence Siena, 409, 411-416, 417, 14-10A, 14-12A, Ivory), 258-259, 259 lectionaries, 312 (Cimabue), 406, 406 Lectionary of Henry II, 329-330, 330 Madrasa Imami, Isfahan, 300, 300 societal contexts, 406-407, 409, 410, Legenda Maior (Saint Bonaventura), 14-5B madrasa-mosque-mausoleum complex of Sultan Hasan, Cairo, 296-297, 297 Kaaba, 285 Leo III (Byzantine emperor), 257, 270 Venice, 420 Kairouan (Tunisia): Great Mosque, 288, 289 Leo III (Pope), 317 madrasas, 296 Italian late medieval art, 400-421, 405map Katholikon, Hosios Loukas, 271, 271 León (Spain): Cathedral of Santa María, 389, Maestà altarpiece (Duccio), Siena Cathedral, 13th century, 402-406, 421, 14-6A keeps, 383 389b, 13-38A 410, 411-412, 411, 412b, 412, 13-36A, 14th century. See Italian 14th century art ketos, 237 Leonardo da Vinci: name of, 405 4-8B, 14-10A societal contexts, 404, 406-407 keystones. See voussoirs Lepcis Magna (Libya): Arch of Septimius Magdeburg Cathedral, 327, 327 timeline, 402 khan, 10-23A Severus, 235 magus/magi, 240 See also Renaissance Al-Khazneh (Treasury), Petra, 8-19A See also Adoration of the Magi Liber pontificalis (Book of the Pontiffs), 243 Italian Romanesque art, 354, 355-357, 363, Kiev (Russia): Saint Sophia, 274, 274b, Il Libro dell'Arte (The Handbook of Art) Magyars, 324 12-27A, 12-27B Maitani, Lorenzo: Orvieto Cathedral, (Cennini), 414 ivory carvings: King David, Fidenza Cathedral (Benedetto liege lord, 334 412-413, 413, 418 Early Byzantine, 257, 258-259, 264, Antelami) (sculpture), 356-357, 357, Malik Shah I (Seljuk sultan), 292 Life of Jesus, Maestà altarpiece, Siena Cathedral (Duccio), 411, 412, 412, 14-8B Malwiya Minaret, Samarra, 289, 289 Early Christian, 251-252, 12-13A Klosterneuburg Altar (Nicholas of Verdun), Mamluks, 296 Early Islamic, 292-293 392b, 392, 13-44A in Byzantine architecture, 272, 274, 376 mandorlas: Gothic, 388-389 Knights Templar, 346 in Byzantine art, 267, 268, 279 in early Byzantine architecture, 261-262 Middle Byzantine, 275-276, 277 Koran, 285 in Early Christian architecture, 243 in French/Spanish Romanesque art, 340, Ottonian, 327, 328 architectural inscriptions, 287, 294, 300 in Gothic architecture, 365, 367, 368-369, 348, 349, 12-8A, 12-11/ iwans, 288, 292, 296 manuscripts, 294, 10-17A 374, 375, 376, 378, 398, 13-3A, 13-23A maniera greca, 404–405, 407, 14-7A, 14-8B mosque lamp inscriptions, 301 in Italian 14th century art, 409, 14-7A manors, 334 Koran, Dublin, 294, 294 in Romanesque architecture, 348, 350, al-Mansur (Abbasid caliph), 287 Jacob, 8-21A Kufic, 294, 295, 300, 10-17A 351, 358 manuscripts, illuminated. See illuminated Jacques Coeur house, Bourges, 383-384, 383 light mugarnas, 296 manuscripts jambs, 344, 369, 370, 380, 13-3A, 13-18A Lindau Gospels, 319-320, 320, 328-329 mapmaking, 13-38B La Madeleine, Vézelay, 335, 345–346, 345, mappamundi, 389, 13-38B See also portals Lindisfare Monastery, 310, 311 James, Saint, 335, 336, 12-7B 12-10A, 12-11A, 12-14A, 13-38B Mappamundi of Henry III (Richard de Lindisfarne Gospels, 312-315, 313, 314, 318 lintels, 344, 12-8A Jami, 302 laid-and-couched work, 362 Bello), 389, 389b, 13-38B Jean d'Orbais. See Reims Cathedral Lamentation (over the body of Jesus), 241 literature Jean de Loup. See Reims Cathedral in Italian 14th century art, 401, 408, 409, and Italian late medieval art, 406, 412 Byzantine Empire, 256 Jean de Meung: Romance of the Rose, and Romanesque art, 336 early medieval Europe, 308 in Middle Byzantine art, 276, 12-27B 388-389 See also books Gothic era, 366 Jerusalem, 242 liturgy, 242, 262-263, 276, 312, 13-42A See also Entombment Islamic world, 284 Church of the Holy Sepulcher, 286 Lamentation, Arena Chapel, Padua (Giotto), See also Eucharist Late Antiquity, 234 Crusader conquest of (1099), 346 **401, 408, 409,** 14-8A Lives of the Most Eminent Painters, late medieval Italy, 405 Dome of the Rock, 285-287, 285, 286, Lamentation, Saint Pantaleimon, Nerezi Sculptors, and Architects (Vasari), 407 Western Europe (1100), 335 294, 299, 300, 346 (wall painting), 276, 276, 409, 12-27 B loculi, 237 Maqsud of Kashan: carpet from the funerary in Gothic cartography, 13-38B lancet windows, 370, 373, 376-377, 383, 391, loggias, 14-19A mosque of Safi al-Din, 300-301, 301 in Italian 14th century art, 14-10A 398, 14-5A Lombards, 308 maqsuras, 282, 283, 288, 291 Roman sack of (70), 236, 286 landscape painting: London (England): Westminster Abbey, 362, Marburg (Germany): Saint Elizabeth, 398, Jesus, life of, 240-241, 411, 11-24A Byzantine, 276 391, 391, 13-41 Carolingian, 319, 11-15A See also Christ; Passion of Christ; specific longitudinal plan, 243, 246, 247, 12-4B Marcus Aurelius (Roman emperor), 235, events Early Christian, 247, 248, 8-17A Lorenzetti, Ambrogio, 14-19A 259, 317-318

Islamic, 303

Mark, Saint, 314, 12-15A	Miracles of Jesus, 240	Italian 14th century, 400, 401, 408, 409, 416–417, 419–420, 14-8A, 14-8B	Norman Romanesque art, 357–362, 363, 368 12-35A
Martin V (Pope), 404 Martini, Simone: Annunciation altarpiece,	in Early Christian art, 248, 8-10A, 8-19A Miraj, 286	Italian Romanesque, 12-27B	Normans, 274–275, 310
Siena Cathedral, 413–415, 413	Mission of the Apostles, 346	Late Antique Jewish, 235-236	See also Norman Romanesque art
martyrium, 274	Mocking of Jesus, 241	Ottonian, 11-23A Pompeian/Vesuvius area, 248	Northern European art. See French Gothic art; Holy Roman Empire art
martyrs, 237, 247, 267, 8-6A See also specific martyrs	modeling, 258, 349 in Byzantine art, 279	Romanesque, 348	Notre Dame Cathedral, Chartres. See
Mary (mother of Jesus). See Mother of God;	in late medieval Italian art, 409, 412	Mycenaean architecture, 244	Chartres Cathedral
Theotokos; Virgin Mary	in Romanesque art, 349	mystery plays, 409, 12-35A	Notre Dame de la Belle Verrière, Chartres Cathedral (stained-glass window),
Mary Magdalene, 241 in Byzantine art, 9-17A	See also chiaroscuro Modena Cathedral, 356, 356, 12-13B	mythology. See religion and mythology	376–377, 376, 377, 386
in Gothic art, 394	modules:	N	Notre-Dame, Fontenay, 343, 343b, 349-350,
in Italian 14th century art, 409	in Carolingian architecture, 323	narrative art:	12-10A
relics of, 335, 388 Marys at the Tomb, 241, 252	in Romanesque architecture, 338 Moissac (France). See Saint-Pierre	early Christian, 249–250, 251–252, 8-21 A early medieval, 319, 326–327, 11-15 A	Notre-Dame Cathedral, Paris, 371, 372–373, 372, 378, 381, 381, 388
Masaccio (Tommaso di ser Giovanni di	moldings:	Gothic, 369–370, 377, 13-3A	Notre-Dame-la-Grande, Poitiers, 344, 344b,
Mone Cassai): name of, 405	in Carolingian architecture, 11-19A	Italian 14th century, 409, 412, 14-8A	12-11A
Mass. See Eucharist	in Gothic architecture, 390 in Italian late medieval art, 418	Italian late medieval, 405 Late Antique Jewish, 235	nudity: in Early Christian art, 252
Massacre of the Innocents, 240 Materials and Techniques boxes:	in Romanesque architecture, 340, 351,	Romanesque, 356, 361–362, 12-8B, 12-11A	in French/Spanish Romanesque art,
embroidery, 362	358	narthex, 243, 264, 350, 8-19A	12-13A, 12-13B
fresco painting, 408	Monasterboice (Ireland): High Cross of	al-Nasir Muhammad, 301 Nasrid dynasty, 295	0
illuminated manuscripts, 249 Islamic tilework, 299	Muiredach, 315, 315 monasteries:	Nativity, 240, 403–404, 415	Oceanus and Nereids, and drinking contest
ivory carving, 251	Byzantine, 267	naturalism, 401	between Bacchus and Hercules, "Great
mosaics, 245	early medieval European, 311, 322-323,	See also naturalism/realism	Dish", Mildenhall Treasure, 250–251,
stained-glass windows, 375 Matilda (countess of Canossa), 352	330 Romanesque era, 334, 349, 352	naturalism/realism: in Byzantine art, 273, 276, 9-3A, 9-18A,	250 Octavian (Roman emperor). See Augustus
matins, 13-36A	See also specific monasteries	9-26B	oculus/oculi, 372, 373, 383, 14-6A
Matthew, Saint, 240, 312, 314	monastic orders, 404	in Early Christian art, 248, 8-17A, 8-19A	Odo (bishop of Bayeux), 361
Mauritius (Maurice), Saint, 327	Benedictine Rule, 322, 330, 341, 343	in Gothic art, 370, 387, 388, 394, 396	Odoacer, Flavius (king of Italy), 246
Mausoleum of Galla Placidia, Ravenna, 246–247, 246, 246, 247, 248, 266, 8-17A	Cistercian order, 322, 342, 343, 347, 12-10A	in Italian 14th century art, 407, 408, 419, 14-7A, 14-8B, 14-10A	ogee arches, 420, 13-42A ogival arches. <i>See</i> pointed arches
Mausoleum of the Julii, Rome, 245, 245b,	Cluniac order, 341–342, 343, 347	in Italian late medieval art, 401, 406	Ohrid (Macedonia):
8-13A	Dominican order, 385, 404, 420, 14-6A	Naumburg Cathedral (Naumburg Master),	Church of the Virgin Peribleptos,
Maximanius (bishop of Ravenna), 254, 255,	Franciscan order, 385, 404, 405, 14-6A	394–395, 394, 395	279–280 Saint Clament, 270
264, 9-14A medieval art:	monasticism, 267, 311, 322, 341–342 See also monastic orders	Naumburg Master: Naumburg Cathedral, 394–395, 394, 395	Saint Clement, 279 Old Farmer of Corycus, Vatigan Vergil, 248,
International Style, 413–414	Mongols, 295	nave arcades:	249
See also early Islamic art; early medieval	Monophysite heresy, 258, 270	in Early Christian architecture, 243	Old Saint Peter's, Rome, 242–243, 242, 317
European art; Gothic art; Italian late	monotheism, 233, 235, 285	in early medieval architecture, 324 in Gothic architecture, 370, 373	Old Testament prophet (Jeremiah or Isaiah?), Saint-Pierre, Moissac (relief
medieval art; Romanesque art Memmi, Lippo: Annunciation altarpiece,	Monreale cathedral, 275, 275, 348, 9-26A Moorish art. See Islamic art	in Italian late medieval architecture, 413	sculpture), 344, 345, 12-8B
Siena Cathedral, 413–415, 413	Moralia in Job (Saint Gregory), 347–348, 347	in Romanesque architecture, 340, 350	Old Testament themes:
Menander portrait, Pompeii, 318	moralized Bibles, 384–386	naves, 373	in Byzantine art, 264, 9-14A
mendicant orders, 385, 404, 405, 420, 14-6A merlons, 382	Morgan Madonna, 349, 349 mosaic tilework, 299–300	in Byzantine architecture, 263 in Early Christian architecture, 243	in Early Christian art, 232, 233, 237–238, 245–246, 8-5A, 8-10A, 8-13A
Merovingian art, 309	mosaics:	in early medieval architecture, 323, 324,	in Gothic art, 370, 376, 386–387, 392,
Merovingian looped fibulae, 309, 309	Early Byzantine, 254, 255, 264-268	325–326, 11-23A	13-23A, 13-44A
Messiah, 240	Early Christian, 244–245, 245, 247–248,	in French Gothic architecture, 364, 371,	in Italian 13th century art, 14-5B
metalwork: Byzantine, 9-26A, 9-26B	8-13A, 8-17A, 8-19A Islamic, 287, 291, 299–300	374, 378, 13-23A in French/Spanish Romanesque	in Ottonian art, 326 in Romanesque art, 344, 348, 353, 356,
Carolingian, 320	Middle Byzantine, 270–271, 272–274,	architecture, 340, 341, 348, 12-4A,	12-11A
early medieval pre-Christian, 309-310,	275 , 9-25A, 9-27A	12-4B, 12-7B, 12-10A	Olympic Games, 246
11-3A Cothic 388 302 303 13 44A	Moses, 360, 8-10A Moses Expounding the Law, Bury Bible	in Holy Roman Empire Gothic architecture, 396, 398	opere francigeno (opus francigenum), 366, 389, 13-38A
Gothic, 388, 392, 393, 13-44A Islamic, 293, 303-304	(Master Hugo), 360, 360	in Holy Roman Empire Romanesque	opus francigenum (opere francigeno), 366,
Late Antique, 248, 250-251	mosque lamp of Sayf al-Din Tuquztimur,	architecture, 350	389, 13-38A
Romanesque, 334, 336, 353–354	301, 301	in Islamic architecture, 289	opus modernum, 365, 366, 373, 389
See also bronze casting Mezquita. See Great Mosque, Córdoba	mosque lamps, 301 Mosque of Selim II, Edirne (Sinan the	in Italian 13th century architecture, 14-6A	opus reticulatum, 11-19A Or San Michele, Florence, 419, 419b, 14-19A
Michael, Archangel, 257, 9-26B	Great), 298, 298, 299	in Italian 14th century architecture, 413,	orants, 238, 266, 8-10A, 9-25A
Michael IV (Byzantine emperor), 273	mosques, 261, 287, 288, 290–292, 297, 10-5A	14-18A	oratory, 267
Michael VIII Pologlogus (Ryzantina	See also great mosques; specific mosques Mother of God, 245, 267, 280, 380	in Italian Romanesque architecture, 355, 12-27A	Orcagna, Andrea: tabernacle, Or San Michele, Florence, 419, 419b, 14-19A
Michael VIII Paleologus (Byzantine emperor), 278, 9-32A	See also Theotokos; Virgin Mary	in Norman Romanesque architecture,	Ordelafo Falier (doge of Venice), 9-26A
Middle Byzantine art, 270–277, 281	Mount Sinai (Egypt): monastery of Saint	358	orders, monastic. See monastic orders
architecture, 271–272, 274–275, 9-25A,	Catherine, 267–268, 267, 269, 269, 270,	in Spanish Gothic architecture, 13-38A	Orpheus, 276
9-27A icons, 274, 277, 9-26B	277, 279, 9-18A Mount Vesuvius area art. See Pompeian/	Neon (bishop of Ravenna), 8-17A Nerezi (Macedonia): Saint Pantaleimon, 276,	Orthodox Baptistery (Sant'Apollinare Nuovo), Ravenna, 247–248, 247, 248,
illuminated manuscripts, 276–277	Vesuvius area art	276, 409, 12-27B	250, 266, 8-17A, 8-19A, 12-27B
ivory carvings, 275–276, 277	Mouth of Hell, Winchester Psalter, 12-35A	Nero (Roman emperor), 8-13A	Orthodox Christianity, 258
metalwork, 9-26A, 9-26B	Mozarabic art, 316	Nicaea, 278 Nicetas Choniates, 278	See also Byzantine art Orvieto Cathedral (Maitani), 412–413, 413,
mosaics, 270–271, 272–274, 275, 9-25A, 9-27A	Mshatta (Jordan): Umayyad palace, 287, 287b, 10-5A, 10-5B	Nicetas Chomates, 276 Nicholas II (Pope), 355	418, 14-12A
painting, 276	Mughal Empire art, 294–295, 302	Nicholas III (Pope), 14-7A	Oseberg ship burial, 310–311, 310, 11-4A
mihrab, 287, 288, 299, 10-5A	Muhammad, 284, 285, 289–290	Nicholas V (Pope), 383	Osman I (Ottoman emperor), 297
Milan (Italy): Sant'Ambrogio, 350–351, 351, 351, 358	Muhammad V (sultan of Granada), 295 Muhammad ibn al-Zayn: basin (<i>Baptistère</i>	Nicholas of Verdun: Klosterneuburg Altar, 392b, 392, 13-44A	Ospedale degli Innocenti (Foundling Hospital), Florence (Brunelleschi),
351, 358 Mildenhall Treasure, 250–251, 250	de Saint Louis), 303–304, 303	Shrine of the Three Kings, 393, 393	410
minarets, 261, 287, 288, 289, 299	Muhammad of Ghor, 294	Nicodemus, 241, 276, 12-27B	Ostrogoths, 246, 247, 255, 258, 263, 308
minbar, 287, 288, 289	Muhaqqaq, 300	Nika revolt (532), 258, 260, 266	Otto I (Holy Roman Emperor), 324, 327, 328
Minerva. See Athena minor arts. See luxury arts	mullions, 381 muqarnas, 274, 296, 297, 9-27A	Nikephoros II Phokas (Byzantine emperor), 328	Otto I presenting Magdeburg Cathedral to Christ, Magdeburg Cathedral (ivory
Miracle of the Loaves and Fishes,	mural painting:	nimbus, 248	carving), 327, 327
Sant'Apollinare Nuovo (Orthodox	Byzantine, 9-25A	See also halos	Otto II (Holy Roman Emperor), 328
Baptistery), Ravenna (mosaic), 248,	Early Christian, 237–239, 8-5A, 8-6A	Noli me tangere, 241, 412, 9-17A Norbert of Xanten, Saint, 12-23A	Otto III (Holy Roman Emperor), 324, 325, 328
248, 8-19A, 12-27B	Italian 13th century, 407, 14-5A, 14-5B	1.010ert of Maintell, Bailtt, 12-2JA	

Otto III enthroned, Gospel Book of Otto III, Paris (France): Pietro Cavallini. See Cavallini, Pietro proportion: 329, 329 Gothic era, 372 Pietro dei Cerroni, See Cavallini, Pietro in Islamic architecture, 299 Ottoman Empire, 297-299, 305, 10-27A Notre-Dame Cathedral, 371, 372-373, Pietro Orseleo (doge of Venice), 9-26A See also hierarchy of scale; modules and Byzantine Empire, 256, 257, 270, 278, 372, 378, 381, 381, 388 pilasters: Protrepticus (Clement of Alexandria), 8-13A in Carolingian architecture, 11-19A Saint-Chapelle, 380-381, 381, 386, Psalter of Saint Louis, 386, 386 Ottoman royal ceremonial caftan, 300b, in French/Spanish Romanesque psalters, 312, 386 Paris Psalter, 276-277, 277 architecture, 12-4A Pseudo-Dionysius, 262 Ottonian art, 324-330 Parler, Heinrich and Peter: Pilgrim's Guide to Santiago de Compostela, Pucelle, Jean: architecture, 324-326, 337, 8-10A, 11-23A Heiligkreuzkirche, Schwäbisch Gmünd, 336, 12-14A Belleville Breviary, 387-388, 387 books, 329-330, 11-29A 398, 398 pilgrimage: Hours of Jeanne d'Evreux, 387, 387b, and Early Christian architecture, 8-10A, The Parting of Abraham and Lot, Santa and Christian patronage of Islamic art, Maria Maggiore, Rome (mosaic), pulpit, Sant'Andrea, Pistoia (Giovanni sculpture, 326-329, 11-24A 245-246, 245, 250, 12-27B and Early Christian architecture, 243 Pisano), 403-404, 403 societal contexts, 324 Passion of Christ, 241 Gothic era, 366, 13-42A pulpits, 402 Ottonians, 324, 328, 329 in Early Byzantine art, 268, 9-17A and Italian 13th century architecture, punchwork, 412, 414 See also Ottonian art in Early Christian art, 233, 251-252, 8-10A purse cover, Sutton Hoo ship burial, 309, 310 in Italian 14th century art, 412 Romanesque era, 333, 334, 335, 338, pyxis of al-Mughira (ivory carving), 293, 293 in Middle Byzantine art, 273 pyxis/pyxides, 293 Padua (Italy): Arena Chapel (Cappella See also Betraval of Jesus; Crucifixion; See also pilgrimage churches Deposition; Entry into Jerusalem; Scrovegni) (Giotto), 400, 401, 408, 409, pilgrimage churches, 335, 338, 12-7A, 12-7B, Flagellation of Jesus; Lamentation; 412, 14-8A, 14-8B, 14-10A gibla, 288, 289 Last Supper; Noli me tangere painting: See also specific churches quadrant arches, 359, 373, 12-7B Byzantine, 268, 269, 270, 276, 278, passionals, 312, 12-23A quatrefoil, 419 pinnacles, 373, 411, 413, 14-12A Passover, 240, 241 279-280, 9-18A Pisa (Italy). Early Christian, 237-239 baptistery, 402-403, 402, 403 paten, 264 encaustic. See encaustic painting Camposanto, 419-420, 419 Rabbula Gospels, 268, 268b, 268, 9-17A patronage: Florentine 14th century, 14-19A Byzantine art, 258, 260, 264, 270, Leaning Tower of Pisa, 354, 355 radiating chapels, 337, 338, 341, 367, 13-38A frescoes. See fresco painting 273-274 Pisa Cathedral, 354, 355, 413, 417 Raedwald (king of East Anglia), 310 Giotto di Bondone, 400, 401, 407-409, Carolingian art, 317 Pisa Cathedral, 354, 355, 413, 417 Rainer of Huy, 359, 12 early Medieval European art, 307, 317, 14-8A, 14-8B Baptism of Christ, 353, 353 Pisan late medieval art, 419-420 Italian 13th century, 404-406, 14-5A, 324-325, 330, 11-19F Pisano, Andrea, 14-19A Raising of the Cross, 241 Gothic art, 385, 388, 392, 394–395 doors, Baptistery of San Giovanni, ramparts, 382 Italian Romanesque, 12-27B Islamic art, 297, 298, 302, 303, 304 Raoul Glaber, 334 Florence, 418-419, 418 landscapes. See landscape painting Late Antique Jewish, 235–236 Italian late medieval art, 410, 418-419 Pisano, Giovanni: Ravenna (Italy), 274 Romanesque art, 341, 349, 350, 356 pulpit, Sant'Andrea, Pistoia, 403-404, Arian Baptistery, 8-17A See also artist's profession; donor murals. See mural painting Byzantine conquest of (539), 246, 263 403 Pisan 14th century, 419-420 portraits Paul, Saint, 232, 9-27A Siena Cathedral, 14-12A and Carolingian art, 320–321 Sienese 14th century, 411-412, 413-415, Pisano, Nicola, 405 Mausoleum of Galla Placidia, 246-247, 416, 417, 14-7A, 14-10A, 14-16A Paul Silentiarius, 261 baptistery pulpit, Pisa, 402-403, 402, 246, 246, 247, 248, 266, 8-17 techniques. See painting techniques Paulinus of Aquileia, 317 403, 415 Sant'Apollinare Nuovo (Orthodox tempera. See tempera painting
See also icons; illuminated manuscripts pebble mosaics, 245 pulpit, Siena Cathedral, 14-12A Baptistery), 247-248, 247, 248, 250, pendants, 391 Pistoia (Italy): Sant'Andrea, 403-404, 403 266, 8-17A, 8-19A, 12-27B pendentives, 262, 262 Pentateuch, 235, 312 painting techniques: fresco, 408 See also San Vitale plague (Black Death), 406, 416, 419, 14-19A pala, 9 plans (architectural): Rayonnant style, 381 Pala d'Oro, Saint Mark's, Venice (cloisonné plaque), 274, 274b, 9-26A longitudinal, 243, 246, 247, 12-4B Pentecost, 346 realism. See naturalism/realism Pentecost and Mission of the Apostles, La See also central plans Rebecca and Eliezer at the Well, Vienna palace of Diocletian, Split, 244, 356, 8-19A, Madeleine, Vézelay (relief sculpture), plans (urban). See urban planning Genesis, 249-250, 249, 8-21A 345-346, 345 plate tracery, 375 Recceswinth (king of the Visigoths), 316 palace of Shapur I, Ctesiphon, 296 Perpendicular style, 391, 398, 13-42A pointed arches, 368 refectory, 267 Palace of the Lions, Alhambra, Granada, in Gothic architecture, 364, 365, 368, 373, Persian art: Regula Sancti Benedicti (Benedict), 322 295-296, 295, 296 architecture, 296, 368 374, 402, 13-23A, 13-38A Reims Cathedral (Jean d'Orbais, Jean de Palatine Chapel, Aachen, 321, 321, 321, 324, societal contexts. See Persia in Holy Roman Empire Gothic Loup, Gaucher de Reims, and Bernard 356, 11-19 textiles, 10-15A architecture, 398 de Soissons), 379-380, 379 Palatine Chapel, Palermo, 274-275, 275b, perspective: in Islamic architecture, 300 and Cathedral of Santa María, Leon, in Gothic art, 387, 13-36A in Italian 13th century architecture, Palazzo della Signoria (Palazzo Vecchio) in Italian 14th century art, 409, 14-7A, and Chartres Cathedral, 380, 13-23A (Arnolfo di Cambio), Florence, 417, in Italian 14th century architecture, 420 interior, 380b, 13-2 417b, 14-18B See also foreshortening; illusionism in Romanesque architecture, 359, 12-10A, and Santa Maria del Fiore, 418 Palazzo Pubblico, Siena, 415-416, 415, 416, Pescia (Italy): San Francesco, 404-405, 404, 12-11A sculpture, 380, 380, 386, 402 417, 14-16A, 14-18B Poitiers (France): Notre-Dame-la-Grande, stained-glass windows, 375, 380, 13-23A Palazzo Vecchio (Palazzo della Signoria) Peter, Saint, 240, 241 344, 344b, 12-11A Visitation, 380, 380, 393 (Arnolfo di Cambio), Florence, 417, in Early Christian art, 232, 8-6A political vandalism, 369, 370, 13-3A, 14-16A relics, 328 grave of, 243, 8-13A 417b, 14-18B polytheism, 233, 235, 285 Early Christian, 243 Palermo (Italy): Cappella Palatina (Palatine martyrdom of, 8-13A Pompeian/Vesuvius area art: mural early medieval Europe, 313 Chapel), 274-275, 275b, 9-27A in Middle Byzantine art, 9-27A painting, 248 Gothic era, 365 Pantheon, Rome: in Ottonian art, 327, 11-29A Pontius Pilate, 250 Romanesque era, 334, 335, 336, 349, and Byzantine architecture, 261 Petra (Jordan): Al-Khazneh (Treasury), See also Trials of Jesus 353-354, 12-7A and Early Christian architecture, 244 Porch of the Confessors, Chartres Cathedral, relief sculpture: Petrarch, Francesco, 406, 407, 412 and Islamic architecture, 286 377b, 13-18A Early Christian, 232, 233, 238, 239, 8-10A Phidias: Athena Parthenos, 251 and Romanesque architecture, 356 portals, 344-346, 369-370, 377, 380, 12-14A, English Gothic, 13-38. Pantokrator, 272 Philip II Augustus (king of France), 372 13-3A, 13-18A French Gothic, 369-370, 377, 379, 380, See also Christ as Pantokrator Philip Augustus (king of France), 345 See also jambs Philip von Heinsberg (archbishop of Pantokrator, Theotokos and Child, angels, portrait of Augustus as general, Primaporta French/Spanish Romanesque. See French/ and saints, Monreale cathedral Cologne), 392 (sculpture), 354 Spanish Romanesque sculpture (mosaic), 275, 275 philosopher sarcophagus, Santa Maria portraiture: Hiberno-Saxon, 315, 11-9A Antiqua, Rome, 238, 239 papacy: in Byzantine art, 259, 9-26A Holy Roman Empire Gothic, 393–396 and the Crusades, 346 Photius (metropolitan of Russia), 280, 9-35A in Carolingian art, 317 Italian 13th century, 403-404 Gothic era, 366 Physica (Hildegard of Bingen), 352 in Gothic art, 370, 394-395, 396 Italian 14th century, 418-419 Great Schism, 404 Picaud, Aimery, 335 See also donor portraits Italian Romanesque, 356 and the Ottonian Empire, 324, 328 Picts, 311 pottery. See ceramics Ottonian, 326-329, 11-24A See also specific popes Prague (Czech Republic): Saint Vitus See also ivory carvings Papal States. See papacy; Rome in Gothic architecture, 373, 398 Cathedral, 366 religion and mythology: papyrus, 249 in Italian 14th century architecture, predellas, 411 Islam, 285, 286, 287 parade helmet, 336 14-12A, 14-18A prefiguration, 238 Roman: Late Antiquity, 233 parapets, 416 in Ottonian architecture, 326, 11-23A Premonstratensian order, 12-23A See also Christianity parchment, 249 in Romanesque architecture, 337, 340, Presentation in the Temple, 240 Religion and Mythology boxes: See also books 350, 358, 12-4A, 12-4B, 12-27A Procopius of Caesarea, 259, 262 Benedictine monasteries, 322 parekklesion, 279 Pietàs, 241, 396 propaganda. See art as a political tool Crusades, 346

Romanesque art, 332-363, 333, 335map, 413 Saint James, Santiago de Compostela, 335, Samarqand ware, 294 four evangelists, 314 338, 339, 349-350, 351, 12-7A, 12-7B Samarra (Iraq): Great Mosque, 289, 289 and Carolingian architecture, 321 Great Schism, mendicant orders, and Saint Mark's, Venice, 274, 274b, 274, 275, Samuel Anointing David, Breviary of French/Spanish. See French/Spanish confraternities, 404 Philippe le Bel, 387, 387 Islam, 285 Romanesque art Samuel Anoints David, synagogue, Italian, 354, 355–357, 363, 12-27A, 12-27B Saint Martin's, Tours, 335, 338 Jewish themes in Early Christian art, 238 Dura-Europos (wall painting), 235, 235, Saint Michael the Archangel (ivory panel), and Italian 14th century architecture, 413 life of Jesus, 240-241 Norman, 357-362, 363, 368, 12-35A 257, 257 relics, 336 San Francesco, Assisi, 405, 405b, 407, 14-5A, Salian dynasty, 349-355, 363, 12-23A Saint Michael's, Hildesheim, 324-327, 326b, reliquaries, 349 326, 327, 344, 350, 8-10A, 11-23A, 14-5B, 14early medieval European, 328 societal contexts, 334, 341, 361 San Francesco, Pescia, 404-405, 404, 14-5B timeline, 334 Gothic, 388, 392, 393 San Giovanni, baptistery of. See Baptistery Romanos III Argyros (Byzantine emperor), Saint Pantaleimon, Nerezi, 276, 276, 409, Holy Roman Empire Romanesque, of San Giovanni, Florence 353-354 273 Saint Paul's Outside the Walls (San Paolo San Juan Bautista, Baños de Cerrato, 316, Romanesque, 334, 336 Rome (Italy): fuori le mura), Rome, 14 Ara Pacis Augustae (Altar of Augustan reliquary statue of Sainte Foy (Saint Faith), Saint Peter's, Rome. See Old Saint Peter's San Miniato al Monte, Florence, 356, 356b, 334, 336, 336, 353 Peace), 264-265 Saint Polyeuktos, Constantinople, 258 Arch of Constantine, 235, 11-19A Renaissance, 401, 406-407 Saint Sophia, Kiev, 274, 274b, 9-25A, 9-32A San Paolo fuori le mura (Saint Paul's Outside artist training, 414 Basilica Ulpia, 243, 326 Saint Theodore, south transept, Chartres the Walls), Rome, 14-7 Catacomb of Commodilla, 239, 239b, and fall of Constantinople, 257 Cathedral (relief sculpture), 377, 377 San Salvador, monastery of, Tábara, 316 and humanism, 406-407 Saint Vitus Cathedral, Prague, 366 San Vitale, Ravenna, 263-264, 264 Catacomb of Saints Peter and See also Italian late medieval art Saint-Chapelle, Paris, 380-381, 381, 386, aerial view of, 263 Renaissance, Macedonian, 276 Marcellinus, 237-239, 237 and Carolingian architecture, 321 Renaud de Cormont: Amiens Cathedral, 371, Column of Trajan, 362, 11-24A Saint-Denis abbey church, 366 and Dome of the Rock, 286 375, 377-379, 377, 377, 379, 396, 418, Forum of Trajan (Apollodorus of ambulatory/radiating chapels, 367 and Hosios Loukas, 271 Damascus), 326 and Laon Cathedral, 370 and Italian Romanesque architecture, Mausoleum of the Julii, 245, 245b, 8-13A renovatio, 317, 318, 402, 11-24A plan of, 367 356 renovatio imperii Romani, 317, 11-13A, Old Saint Peter's, 242-243, 242, 317 and Reims Cathedral, 380 Justinian and Theodora mosaics, 254, sack of (410), 256 11-24A sculpture, 369 255, 264-266, 265, 275, 309 repoussé, 248, 320, 353-354, 392, 9-26B San Paolo fuori le mura (Saint Paul's stained-glass windows, 368-369, 375 Sant Vicenç, Cardona, 337, 337b, 339, 12-4A responds (shafts), 373 Outside the Walls), 14-7 Sant'Ambrogio, Milan, 350-351, 351, 351, Santa Costanza, 244-245, 244, 244, 246, Suger on, 367 restoration, 408, 14-5A Resurrection, mosaic, Saint Mark's, Venice, west facade, 368b, 13-3A 358 271, 286, 356, 8-13A, 8-17 Saint-Étienne, Caen, 357-358, 357, 358, 358, Sant'Andrea, Pistoia, 403-404, 403 Santa Maria Maggiore, 245-246, 245, 368, 370, 13-3A Sant'Angelo in Formis, near Capua, 356, Resurrection, Rabbula Gospels, 268, 268b, 250, 12-27B Saint-Étienne, Vignory, 337, 337, 337, 340, 356b, 12-27B Santa Sabina, 243, 243b, 243, 344, 8-10A Sant'Apollinare in Classe, Ravenna, Via Dino Compagni Catacomb, 237, 237b, 350 Resurrection of Christ, 238, 241, 268, 274, 266-267, 266 Saint-Genis-des-Fontaines abbey church, Sant'Apollinare Nuovo (Orthodox Villa Torlonia, 236, 236 340, 340b, 12-8A, 12-14A revetment, 418 Baptistery), Ravenna, 247-248, 247, Saint-Lazare, Autun, 12-10A rho. See chi-rho-iota (Christogram) See also Pantheon; Sistine Chapel, 248, 250, 266, 8-17A, 8-19A, 12-2 Eve (Gislebertus), 12-13B Rhonbos: calf bearer sculpture dedicated by, Vatican Santa Cecilia, Trastavere, 407b, 409, 14-7A and Gothic cartography, 13-38B rose window, Chartres Cathedral, 376, 376 Athens (sculpture), 238 Santa Costanza, Rome, 244-245, 244, 244, Last Judgment (Gislebertus), 332, 333, rib vaulting, 368 rose windows, 370, 376, 412, 13-3A, 13-23A, 246, 271, 286, 356, 8-13A, 8-17A in Gothic architecture, 364, 365, 367, 346, 12-8A, 12-11A, 12-13B Santa Croce, Florence, 404, 14-5A and pilgrimage, 335 368, 370, 373, 378, 390, 391, 398, Rossano Gospels, 250, 250, 251 Santa Maria, Trastavere, 14-7A and Saint-Trophîme, Arles, 12-14A Röttgen Pietà (sculpture), 396, 396 Santa Maria Antiqua sarcophagus, 238, 239 $Suicide\ of\ Judas\ (Gislebertus),\ 345b,$ in Italian 13th century architecture, rotulus/rotuli, 249 Santa María de Mur, 348, 349 Rouen (France): Saint-Maclou, 381-382, 382, Santa Maria del Fiore, See Florence in Romanesque architecture, 351, 358, 391 west facade, 13-3A Saint-Maclou, Rouen, 381-382, 382, 391 Cathedral roundels. See tondo/tondi Saint-Nazaire Cathedral, Carcassonne, 383 Santa Maria Maggiore, Rome, 245-246, 245, ribs (of vaults), 351, 390 Royal Portal, Chartres Cathedral, 369-370, Saint-Philibert (Tournus), 337, 337b, 339, 250, 12-27E 369, 370, 13-3 See also rib vaulting Santa Maria Novella, Florence, 404, 406b, Richard de Bello: Mappamundi of Henry III, Rublyev, Andrei: Three Angels, 280, 280 Rufillus, 359 Saint-Pierre, Moissac, 341-343, 12-10A 389, 389b, 13-38B West facade (Alberti), 14-6A Richard the Lionhearted (king of England), Weissenau passional, 353, 353b, 12-23A cloister, 342 and Corbie Gospels, 347, 12-15A Santa Sabina, Rome, 243, 243b, 243, 344, Russian art: Byzantine, 274, 277, 280, 9-25A 345, 352 Richbod (abbot of Lorsch), 11-19A Old Testament prophet (Jeremiah or 8-10A Santa Trinità, Florence, 406, 406 Robert de Luzarches: Amiens Cathedral, Isaiah?) (relief sculpture), 344, 345, Santiago de Compostela (Spain): Saint James, 335, 338, 339, 349–350, 351, 371, 375, 377-379, 377, 377, 379, 396, sacramentaries, 312 and Saint-Denis, 13-3A sacre rappresentazioni, 409 Second Coming of Christ (relief sculpture), Sacrifice of Isaac. See Abraham and Isaac 12-7A, 12-7F rock-cut buildings: Al-Khazneh (Treasury), Santo Domingo, Silos, 340b, 12-8B Sacrifice of Isaac, Klosterneuburg Altar 343, 344, 346, 369-370, 12-11A Petra, 8-19A Saracens, 324 Roger I (count of Normandy), 9-27A (Nicholas of Verdun), 392, 392 Saint-Savin-sur-Gartempe abbey church, sarcophagi: Roger II (king of Sicily), 9-27/ Sadi: Bustan, 302, 302 348, 348 Safavid dynasty, 299-300, 302, 305 Saint-Sernin, Toulouse, 349-350 Early Christian, 232, 233, 238, 239 Roman architecture: Late Empire, 243 Etruscan, 249 Safi al-Din (Safavid sheikh), 300 aerial view, 338 Roman art: and Italian 14th century art, 402, 415 Sa'i Mustafa Çelebi, 298 Christ in Majesty (Bernardus Gelduinus), and Islamic art, 287 Roman Late Empire, 8-8A Saint Apollinaris amid sheep: 340, 340, 356 See also classical influences on later art; sarcophagus of Junius Bassus, 232, 233, Late Antique art; Pompeian/Vesuvius Sant'Apollinare in Classe, Ravenna interior, 339 (mosaic), 266-267, 266 and Saint James, Santiago de area art sarcophagus of Lars Pulena, Tarquinia, 249 Saint Catherine, monastery of, Mount Sinai, Compostela, 351, 12-7 Roman Empire: 267-268, 267, 269, 269, 270, 277, 279, and Sainte-Foy, Conques, 12-7A sarcophagus with philosopher, Santa Maria and Byzantine Empire, 256, 257 Antiqua, Rome, 238, 239 stone vaulting, 338, 339 and Carolingian Empire, 317, 11-13A and Christianity, 236, 239, 242 Saint Catherine, Thessaloniki, 278, 278b, Saint-Trophîme (Arles), 346, 346b, 12-7A, Sasanian art, 368, 10-15A Sasanian Empire, 235, 258, 270 and the Ottonian Empire, 328, 329 Sainte-Foy (Saint Faith), Conques, 334, 335, Saint Clement, Ohrid, 279 See also Sasanian art sack of Jerusalem (70), 236, 286 336, 336, 338, 353, 12-7 Saturninus, Saint, 335 See also Roman art Saint Cyriakus, Gernrode, 324, 324, 326, 337, Roman religion and mythology: saints, 237, 242, 402, 8-19A saz, 10-27 Scholasticism, 372 Late Antiquity, 233 Saint Elizabeth, Marburg, 398, 398 See also specific saints Saints Martin, Jerome, and Gregory, Porch Schoolmen, 372 See also classical influences on later art Saint Francis Altarpiece, San Francesco, Schwäbisch Gmünd (Germany): of the Confessors, Chartres Cathedral Romance of the Rose (Guillaume de Lorris Pescia (Berlinghieri), 404-405, 404, (sculpture), 377B, 13-18A and Jean de Meung), 388-389 Heiligkreuzkirche (Heinrich and Peter Parler), 398, 398 Saint Francis Master: Saint Francis Romanesque architecture: French/Spanish, 335, 337-340, 341, Preaching to the Birds, San Francesco, Sala della Pace, Palazzo Pubblico, Siena, Assisi (fresco), 405, 405b, 14-5B 415-416, 415, 416b, 416, 417, 14-16A and Byzantine art, 258, 9-3A 344-345, 348, 12-4A, 12-4B, 12-10A, Salian dynasty, 349-355, 363, 12-23A and Italian late medieval art, 401 Saint Francis Preaching to the Birds, San Scivias (Know the Ways of God) (Hildegard Holy Roman Empire, 349-355, 363, Francesco, Assisi (Saint Francis Master) Salisbury Cathedral, 389-390, 390, 390, 391 Samanid dynasty, 289-290 of Bingen), 352-353, 352 (fresco), 405, 405b, 14-5B Italian, 354, 355-356, 12-27A Saint Gall monastery, 322-323, 322, 326, Samanid Mausoleum, Bukhara, 289-290, screen facades, 391, 12-11A

289

338

Norman, 357-359, 368

See also facades

scriptorium/scriptoria, 311	Italian late medieval art, 404, 406-407	textiles:	transverse arches:
Scrovegni, Enrico, 400, 401, 410	Late Antiquity, 234–235	Chinese, 10-15A	in French/Spanish Romanesque
sculpture:	Ottonian art, 324	early Islamic, 10-15A	architecture, 339, 340, 12-4A, 12-4B,
Carolingian, 317–318	Romanesque era, 334, 341, 361	and Italian 14th century art, 412	12-7B
Egyptian. See Egyptian sculpture	See also religion and mythology	Late Byzantine, 9-35A	in Gothic architecture, 368
French/Spanish Romanesque. See French/Spanish Romanesque	Sol Invictus (Roman deity), 8-13A	later Islamic, 300–301, 10-27A	in Holy Roman Empire Romanesque
sculpture	solidi, 263	Norman Romanesque, 361–362	architecture, 350
Gothic. See Gothic sculpture	The Song of Roland, 336	Thangmar of Heidelberg, 324–325	in Norman Romanesque architecture,
Hiberno-Saxon high crosses, 315	Sorel, Agnès, 383	Theodora (Byzantine empress, wife of	358, 359
	South Asian art: Mughal Empire, 294–295,	Justinian), 254, 255, 264, 265, 266, 275,	transverse barrel vaults, 12-10A
Holy Roman Empire Romanesque, 353–355	South Gross Absorpty 215, 215h 11,04	309	transverse ribs, 373
Italian 13th century, 403–404	South Cross, Ahenny, 315, 315b, 11-9A	Theodora (Byzantine empress, wife of	Trastavere (Italy):
Italian 14th century, 418–419	Spanish art. See French/Spanish	Theophilos), 270, 273	Santa Cecilia, 407b, 409, 14-7A
Italian Romanesque, 356–357	Romanesque art	Theodora and attendants, San Vitale,	Santa Maria, 14-7A
later Islamic, 295	Speyer Cathedral, 339, 350, 350, 351	Ravenna (mosaic), 254, 255, 264, 265,	tree of Jesse, 376
Ottonian, 326–329, 11-24A	Split (Croatia): palace of Diocletian, 244, 356, 8-19A, 10-5A	266, 275, 309	trefoil arches, 402, 14-18B
relief. See relief sculpture		Theodore, Saint, 268, 269, 377	Trials of Jesus, 233, 241, 250
seated portrait of the Greek poet Menander,	springing, 340, 373	Theodoric (king of the Ostrogoths), 246, 247,	tribunes, 337, 338, 340, 12-7A
House of the Menander, Pompeii	squinches, 262, 262, 271, 290, 296, 9-27A, 12-4A	263, 308, 317	See also galleries
(mural), 318		Theodosius I (Roman emperor), 246, 256	Trier (Germany): Aula Palatina, 243
Second Coming:	stained-glass windows:	Theodulf of Orléans, 265, 317	triforium, 364, 370, 373, 374, 390, 13-38A
in Early Byzantine art, 254, 255, 264	in English Gothic architecture, 391, 13-38A	Theophanu, 328	Trinity, 240
in French Gothic art, 369, 369–370		Theotokos:	and Byzantine Christianity, 258, 264,
in French/Spanish Romanesque art, 343,	French Gothic. See French Gothic	in Early Byzantine art, 267, 268–270, 269	280cap
344, 345–346	stained-glass windows	in Early Christian art, 245	in Gothic art, 385, 386
See also Last Judgment	in Italian 13th century architecture, 14-5A	in Gothic art, 370, 396	triptychs, 275–276, 392, 415
Second Coming of Christ, Saint-Pierre,		in Middle Byzantine art, 270–271, 271,	Triumph of Death (Traini or Buffalmacco),
Moissac (relief sculpture), 343, 344,	stave church, Urnes, 311, <i>311</i> staves, 311	275, 275, 276, 277	419–420, 419
346, 369–370, 12-11A		western European version, 349	trumeaus, 344
Second Commandment, 235, 239, 269, 348,	stem stitching, 362 stigmata, 405	See also Virgin and Child; Virgin Mary	tughras, 10-23A
8-8A	stignata, 405 stone vaulting:	Thessaloniki (Greece):	tumulus/tumuli, 309
sedes sapientiae, 349	in French/Spanish Romanesque	Hagios Georgios (Church of Saint	tunnel vaults. See barrel vaults
Selim II (Ottoman sultan), 302	architecture, 337, 338, 339, 340–341	George), 248, 248b, 257, 8-17A, 8-19A	Tuquztimur, Sayf al-Din, 301
Seljuks, 292, 297	in Norman Romanesque architecturee,	Saint Catherine, 278, 278b, 9-32A	turris. See westwork
Servite order, 404	358–359	Thierry of Chartres, 369 tholos tombs, 244	two saints, Hagios Georgios (Church of
sexpartite vaults, 358	stonemasons and sculptors, Chartres		Saint George), Thessaloniki (mosaic),
shafts (of columns), 373	Cathedral (stained-glass window),	Thomas, Saint, 241, 12-8B Thomas Aquinas, Saint, 372	8-19A
Shahnama (Book of Kings)	375, 377		tympanum/tympana, 332, 344, 345–346,
(Sultan-Muhammad), 302-303, 303	Story of Jacob, Vienna Genesis, 8-21A	Thomas de Cormont: Amiens Cathedral,	13-3A, 13-23A, 13-38A, 14-12A
Shapur I, palace of, Ctesiphon, 296	storytelling. See narrative art	<i>371</i> , 375, 377–379, <i>377</i> , <i>377</i> , <i>379</i> , 396, 418, 13-38A	typology, 238
Shrine of the Three Kings (Nicholas of	Strasbourg Cathedral, 392–394, 393	Three Angels (Rublyev), 280, 280	U
Verdun), 393, 393	stringcourses, 11-19A	Three Marys at the Tomb, 241	
Siena (Italy):	sub gracia, 392	Throne of Maximianus (ivory furniture),	Umayyad dynasty, 285, 287, 289, 290, 305, 10-5A, 10-5B
Campo, 415, 415	sub lege, 392	264, 264b, 9-14A	Umayyad palace, Mshatta, 287, 287b, 10-5A,
Palazzo Pubblico, 415-416, 415, 416, 417,	Suger (abbot of Saint-Denis), 366, 367,	tilework, 299–300	10-5B
	368–369, 374, 375, 392, 13-3A	timelines:	
14-16A, 14-18B			
See also Siena Cathedral; Sienese 14th			unicorn legend, 389
	Suicide of Judas (ivory carving), 251–252, 251, 12-13A	Byzantine Empire, 256	Urban II (Pope), 346
See also Siena Cathedral; Sienese 14th	Suicide of Judas (ivory carving), 251–252, 251, 12-13A	Byzantine Empire, 256 early medieval European art, 308	Urban II (Pope), 346 Urban VI (Pope), 404
See also Siena Cathedral; Sienese 14th century art	Suicide of Judas (ivory carving), 251-252,	Byzantine Empire, 256 early medieval European art, 308 Gothic art, 366	Urban II (Pope), 346 Urban VI (Pope), 404 urban planning:
See also Siena Cathedral; Sienese 14th century art Siena Cathedral, 14-12A	Suicide of Judas (ivory carving), 251–252, 251, 12-13A Suicide of Judas, Saint-Lazare (Gislebertus),	Byzantine Empire, 256 early medieval European art, 308 Gothic art, 366 Islamic art, 284	Urban II (Pope), 346 Urban VI (Pope), 404 urban planning: early Islamic, 287
See also Siena Cathedral; Sienese 14th century art Siena Cathedral, 14-12A Annunciation altarpiece (Martini and	Suicide of Judas (ivory carving), 251–252, 251, 12-13A Suicide of Judas, Saint-Lazare (Gislebertus), 345b, 12-13A	Byzantine Empire, 256 early medieval European art, 308 Gothic art, 366 Islamic art, 284 Italian late medieval art, 402	Urban II (Pope), 346 Urban VI (Pope), 404 urban planning: early Islamic, 287 Gothic era, 382–383
See also Siena Cathedral; Sienese 14th century art Siena Cathedral, 14-12A Annunciation altarpiece (Martini and Memmi), 413-415, 413	Suicide of Judas (ivory carving), 251–252, 251, 12-13A Suicide of Judas, Saint-Lazare (Gislebertus), 345b, 12-13A Sulayman (artist): ewer in the form of a bird,	Byzantine Empire, 256 early medieval European art, 308 Gothic art, 366 Islamic art, 284 Italian late medieval art, 402 Late Antique art, 234	Urban II (Pope), 346 Urban VI (Pope), 404 urban planning: early Islamic, 287 Gothic era, 382–383 Roman Empire, 14-18B
See also Siena Cathedral; Sienese 14th century art Siena Cathedral, 14-12A Annunciation altarpiece (Martini and Memmi), 413-415, 413 Birth of the Virgin (Lorenzetti), 415, 415 Maestà altarpiece (Duccio), 410, 411-412, 411, 412b, 412, 13-36A, 14-8B, 14-10A	Suicide of Judas (ivory carving), 251–252, 251, 12-13A Suicide of Judas, Saint-Lazare (Gislebertus), 345b, 12-13A Sulayman (artist): ewer in the form of a bird, 293, 293	Byzantine Empire, 256 early medieval European art, 308 Gothic art, 366 Islamic art, 284 Italian late medieval art, 402 Late Antique art, 234 Romanesque art, 334	Urban II (Pope), 346 Urban VI (Pope), 404 urban planning: early Islamic, 287 Gothic era, 382–383 Roman Empire, 14-18B Urnes (Norway): stave church, 311, 311
See also Siena Cathedral; Sienese 14th century art Siena Cathedral, 14-12A Annunciation altarpiece (Martini and Memmi), 413-415, 413 Birth of the Virgin (Lorenzetti), 415, 415 Maestà altarpiece (Duccio), 410, 411-412, 411, 412b, 412, 13-36A, 14-8B, 14-10A and Santa Maria del Fiore, 417	Suicide of Judas (ivory carving), 251–252, 251, 12-13A Suicide of Judas, Saint-Lazare (Gislebertus), 345b, 12-13A Sulayman (artist): ewer in the form of a bird, 293, 293 Suleyman the Magnificent (Ottoman	Byzantine Empire, 256 early medieval European art, 308 Gothic art, 366 Islamic art, 284 Italian late medieval art, 402 Late Antique art, 234	Urban II (Pope), 346 Urban VI (Pope), 404 urban planning: early Islamic, 287 Gothic era, 382–383 Roman Empire, 14-18B Urnes (Norway): stave church, 311, 311 Ursus (bishop of Ravenna), 8-17A
See also Siena Cathedral; Sienese 14th century art Siena Cathedral, 14-12A Annunciation altarpiece (Martini and Memmi), 413-415, 413 Birth of the Virgin (Lorenzetti), 415, 415 Maestà altarpiece (Duccio), 410, 411-412, 411, 412b, 412, 13-36A, 14-8B, 14-10A and Santa Maria del Fiore, 417 Sienese 14th century art, 411-416	Suicide of Judas (ivory carving), 251–252, 251, 12-13A Suicide of Judas, Saint-Lazare (Gislebertus), 345b, 12-13A Sulayman (artist): ewer in the form of a bird, 293, 293 Suleyman the Magnificent (Ottoman sultan), 297, 10-23A	Byzantine Empire, 256 early medieval European art, 308 Gothic art, 366 Islamic art, 284 Italian late medieval art, 402 Late Antique art, 234 Romanesque art, 334 Timur (Tamerlane), 302	Urban II (Pope), 346 Urban VI (Pope), 404 urban planning: early Islamic, 287 Gothic era, 382–383 Roman Empire, 14-18B Urnes (Norway): stave church, 311, 311 Ursus (bishop of Ravenna), 8-17A Uta (abbess of Niedermünster), 330
See also Siena Cathedral; Sienese 14th century art Siena Cathedral, 14-12A Annunciation altarpiece (Martini and Memmi), 413-415, 413 Birth of the Virgin (Lorenzetti), 415, 415 Maestà altarpiece (Duccio), 410, 411-412, 411, 412b, 412, 13-36A, 14-8B, 14-10A and Santa Maria del Fiore, 417 Sienese 14th century art, 411-416 architecture, 412-413, 415-416, 14-12A	Suicide of Judas (ivory carving), 251–252, 251, 12-13A Suicide of Judas, Saint-Lazare (Gislebertus), 345b, 12-13A Sulayman (artist): ewer in the form of a bird, 293, 293 Suleyman the Magnificent (Ottoman sultan), 297, 10-23A Sultan-Muhammad: Shahnama (Book of	Byzantine Empire, 256 early medieval European art, 308 Gothic art, 366 Islamic art, 284 Italian late medieval art, 402 Late Antique art, 234 Romanesque art, 334 Timur (Tamerlane), 302 Timurid dynasty, 302, 305 Titus (Roman emperor), 236, 286	Urban II (Pope), 346 Urban VI (Pope), 404 urban planning: early Islamic, 287 Gothic era, 382–383 Roman Empire, 14-18B Urnes (Norway): stave church, 311, 311 Ursus (bishop of Ravenna), 8-17A Uta (abbess of Niedermünster), 330 Uta Codex, 330, 330
See also Siena Cathedral; Sienese 14th century art Siena Cathedral, 14-12A Annunciation altarpiece (Martini and Memmi), 413-415, 413 Birth of the Virgin (Lorenzetti), 415, 415 Maestà altarpiece (Duccio), 410, 411-412, 411, 412b, 412, 13-36A, 14-8B, 14-10A and Santa Maria del Fiore, 417 Sienese 14th century art, 411-416 architecture, 412-413, 415-416, 14-12A painting, 411-412, 413-415, 416, 417,	Suicide of Judas (ivory carving), 251–252, 251, 12-13A Suicide of Judas, Saint-Lazare (Gislebertus), 345b, 12-13A Sulayman (artist): ewer in the form of a bird, 293, 293 Suleyman the Magnificent (Ottoman sultan), 297, 10-23A Sultan-Muhammad: Shahnama (Book of Kings), 302–303, 303 sultans, 292 Summa Theologica (Thomas Aquinas), 372	Byzantine Empire, 256 early medieval European art, 308 Gothic art, 366 Islamic art, 284 Italian late medieval art, 402 Late Antique art, 234 Romanesque art, 334 Timur (Tamerlane), 302 Timurid dynasty, 302, 305	Urban II (Pope), 346 Urban VI (Pope), 404 urban planning: early Islamic, 287 Gothic era, 382–383 Roman Empire, 14-18B Urnes (Norway): stave church, 311, 311 Ursus (bishop of Ravenna), 8-17A Uta (abbess of Niedermünster), 330
See also Siena Cathedral; Sienese 14th century art Siena Cathedral, 14-12A Annunciation altarpiece (Martini and Memmi), 413-415, 413 Birth of the Virgin (Lorenzetti), 415, 415 Maestà altarpiece (Duccio), 410, 411-412, 411, 412b, 412, 13-36A, 14-8B, 14-10A and Santa Maria del Fiore, 417 Sienese 14th century art, 411-416 architecture, 412-413, 415-416, 14-12A painting, 411-412, 413-415, 416, 417, 14-7A, 14-10A, 14-16A	Suicide of Judas (ivory carving), 251–252, 251, 12-13A Suicide of Judas, Saint-Lazare (Gislebertus), 345b, 12-13A Sulayman (artist): ewer in the form of a bird, 293, 293 Suleyman the Magnificent (Ottoman sultan), 297, 10-23A Sultan-Muhammad: Shahnama (Book of Kings), 302–303, 303 sultans, 292 Summa Theologica (Thomas Aquinas), 372 Sunnah, 285	Byzantine Empire, 256 early medieval European art, 308 Gothic art, 366 Islamic art, 284 Italian late medieval art, 402 Late Antique art, 234 Romanesque art, 334 Timur (Tamerlane), 302 Timurid dynasty, 302, 305 Titus (Roman emperor), 236, 286 Tomb of Edward II, Gloucester Cathedral, 391b, 13-42A tombs. See funerary customs	Urban II (Pope), 346 Urban VI (Pope), 404 urban planning: early Islamic, 287 Gothic era, 382–383 Roman Empire, 14-18B Urnes (Norway): stave church, 311, 311 Ursus (bishop of Ravenna), 8-17A Uta (abbess of Niedermünster), 330 Uta Codex, 330, 330
See also Siena Cathedral; Sienese 14th century art Siena Cathedral, 14-12A Annunciation altarpiece (Martini and Memmi), 413-415, 413 Birth of the Virgin (Lorenzetti), 415, 415 Maesta altarpiece (Duccio), 410, 411-412, 411, 412b, 412, 13-36A, 14-8B, 14-10A and Santa Maria del Fiore, 417 Sienese 14th century art, 411-416 architecture, 412-413, 415-416, 14-12A painting, 411-412, 413-415, 416, 417, 14-7A, 14-10A, 14-16A societal contexts, 409, 14-16A	Suicide of Judas (ivory carving), 251–252, 251, 12-13A Suicide of Judas, Saint-Lazare (Gislebertus), 345b, 12-13A Sulayman (artist): ewer in the form of a bird, 293, 293 Suleyman the Magnificent (Ottoman sultan), 297, 10-23A Sultan-Muhammad: Shahnama (Book of Kings), 302–303, 303 sultans, 292 Summa Theologica (Thomas Aquinas), 372 Sunnah, 285 Supper at Emmaus, 241	Byzantine Empire, 256 early medieval European art, 308 Gothic art, 366 Islamic art, 284 Italian late medieval art, 402 Late Antique art, 234 Romanesque art, 334 Timur (Tamerlane), 302 Timurid dynasty, 302, 305 Titus (Roman emperor), 236, 286 Tomb of Edward II, Gloucester Cathedral, 391b, 13-42A tombs. See funerary customs tondo/tondi, 10-15A	Urban II (Pope), 346 Urban VI (Pope), 404 urban planning: early Islamic, 287 Gothic era, 382–383 Roman Empire, 14-18B Urnes (Norway): stave church, 311, 311 Ursus (bishop of Ravenna), 8-17A Uta (abbess of Niedermünster), 330 Uta Codex, 330, 330 Utrecht Psalter, 319, 319, 326, 361, 11-15A
See also Siena Cathedral; Sienese 14th century art Siena Cathedral, 14-12A Annuciation altarpiece (Martini and Memmi), 413-415, 413 Birth of the Virgin (Lorenzetti), 415, 415 Maesta altarpiece (Duccio), 410, 411-412, 411, 412b, 412, 13-36A, 14-8B, 14-10A and Santa Maria del Fiore, 417 Sienese 14th century art, 411-416 architecture, 412-413, 415-416, 14-12A painting, 411-412, 413-415, 416, 417, 14-7A, 14-10A, 14-16A societal contexts, 409, 14-16A Sigismund(Holy Roman Emperor), 404	Suicide of Judas (ivory carving), 251–252, 251, 12-13A Suicide of Judas, Saint-Lazare (Gislebertus), 345b, 12-13A Sulayman (artist): ewer in the form of a bird, 293, 293 Suleyman the Magnificent (Ottoman sultan), 297, 10-23A Sultan-Muhammad: Shahnama (Book of Kings), 302–303, 303 sultans, 292 Summa Theologica (Thomas Aquinas), 372 Sunpar at Emmaus, 241 surahs, 285	Byzantine Empire, 256 early medieval European art, 308 Gothic art, 366 Islamic art, 284 Italian late medieval art, 402 Late Antique art, 234 Romanesque art, 334 Timur (Tamerlane), 302 Timurid dynasty, 302, 305 Titus (Roman emperor), 236, 286 Tomb of Edward II, Gloucester Cathedral, 391b, 13-42A tombs. See funerary customs tondo/tondi, 10-15A Torah, 235	Urban II (Pope), 346 Urban VI (Pope), 404 urban planning: early Islamic, 287 Gothic era, 382–383 Roman Empire, 14-18B Urnes (Norway): stave church, 311, 311 Ursus (bishop of Ravenna), 8-17A Uta (abbess of Niedermünster), 330 Uta Codex, 330, 330 Utrecht Psalter, 319, 319, 326, 361, 11-15A
See also Siena Cathedral; Sienese 14th century art Siena Cathedral, 14-12A Annunciation altarpiece (Martini and Memmi), 413-415, 413 Birth of the Virgin (Lorenzetti), 415, 415 Maestà altarpiece (Duccio), 410, 411-412, 411, 412b, 412, 13-36A, 14-8B, 14-10A and Santa Maria del Fiore, 417 Sienese 14th century art, 411-416 architecture, 412-413, 415-416, 14-12A painting, 411-412, 413-415, 416, 417, 14-7A, 14-10A, 14-16A societal contexts, 409, 14-16A Sigismund(Holy Roman Emperor), 404 silentiaries, 261	Suicide of Judas (ivory carving), 251–252, 251, 12-13A Suicide of Judas, Saint-Lazare (Gislebertus), 345b, 12-13A Sulayman (artist): ewer in the form of a bird, 293, 293 Suleyman the Magnificent (Ottoman sultan), 297, 10-23A Sultan-Muhammad: Shahnama (Book of Kings), 302–303, 303 sultans, 292 Summa Theologica (Thomas Aquinas), 372 Sunnah, 285 Supper at Emmaus, 241 surahs, 285 Sutton Hoo ship burial, Suffolk, 309–310,	Byzantine Empire, 256 early medieval European art, 308 Gothic art, 366 Islamic art, 284 Italian late medieval art, 402 Late Antique art, 234 Romanesque art, 334 Timur (Tamerlane), 302 Timurid dynasty, 302, 305 Titus (Roman emperor), 236, 286 Tomb of Edward II, Gloucester Cathedral, 391b, 13-42A tombs. See funerary customs tondo/tondi, 10-15A Torah, 235 Torhalle, Lorsch, 232, 323b, 11-19A	Urban II (Pope), 346 Urban VI (Pope), 404 urban planning: early Islamic, 287 Gothic era, 382–383 Roman Empire, 14-18B Urnes (Norway): stave church, 311, 311 Ursus (bishop of Ravenna), 8-17A Uta (abbess of Niedermünster), 330 Uta Codex, 330, 330 Utrecht Psalter, 319, 319, 326, 361, 11-15A
See also Siena Cathedral; Sienese 14th century art Siena Cathedral, 14-12A Annunciation altarpiece (Martini and Memmi), 413-415, 413 Birth of the Virgin (Lorenzetti), 415, 415 Maestà altarpiece (Duccio), 410, 411-412, 411, 412b, 412, 13-36A, 14-8B, 14-10A and Santa Maria del Fiore, 417 Sienese 14th century art, 411-416 architecture, 412-413, 415-416, 14-12A painting, 411-412, 413-415, 416, 417, 14-7A, 14-10A, 14-16A societal contexts, 409, 14-16A Sigismund(Holy Roman Emperor), 404 silentiaries, 261 silk: in early Islamic art, 10-15A	Suicide of Judas (ivory carving), 251–252, 251, 12-13A Suicide of Judas, Saint-Lazare (Gislebertus), 345b, 12-13A Sulayman (artist): ewer in the form of a bird, 293, 293 Suleyman the Magnificent (Ottoman sultan), 297, 10-23A Sultan-Muhammad: Shahnama (Book of Kings), 302–303, 303 sultans, 292 Summa Theologica (Thomas Aquinas), 372 Sunnah, 285 Supper at Emmaus, 241 surahs, 285 Sutton Hoo ship burial, Suffolk, 309–310, 309, 11-3A	Byzantine Empire, 256 early medieval European art, 308 Gothic art, 366 Islamic art, 284 Italian late medieval art, 402 Late Antique art, 234 Romanesque art, 334 Timur (Tamerlane), 302 Timurid dynasty, 302, 305 Titus (Roman emperor), 236, 286 Tomb of Edward II, Gloucester Cathedral, 391b, 13-42A tombs. See funerary customs tondo/tondi, 10-15A Torah, 235 Torhalle, Lorsch, 232, 323b, 11-19A Toulouse (France). See Saint-Sernin	Urban II (Pope), 346 Urban VI (Pope), 404 urban planning: early Islamic, 287 Gothic era, 382–383 Roman Empire, 14-18B Urnes (Norway): stave church, 311, 311 Ursus (bishop of Ravenna), 8-17A Uta (abbess of Niedermünster), 330 Uta Codex, 330, 330 Utrecht Psalter, 319, 319, 326, 361, 11-15A V Vandals, 258 Vasari, Giorgio:
See also Siena Cathedral; Sienese 14th century art Siena Cathedral, 14-12A Annunciation altarpiece (Martini and Memmi), 413-415, 413 Birth of the Virgin (Lorenzetti), 415, 415 Maestà altarpiece (Duccio), 410, 411-412, 411, 412b, 412, 13-36A, 14-8B, 14-10A and Santa Maria del Fiore, 417 Sienese 14th century art, 411-416 architecture, 412-413, 415-416, 14-12A painting, 411-412, 413-415, 416, 417, 14-7A, 14-10A, 14-16A societal contexts, 409, 14-16A Sigismund(Holy Roman Emperor), 404 silentiaries, 261 silk: in early Islamic art, 10-15A Silk Road, 412	Suicide of Judas (ivory carving), 251–252, 251, 12-13A Suicide of Judas, Saint-Lazare (Gislebertus), 345b, 12-13A Sulayman (artist): ewer in the form of a bird, 293, 293 Suleyman the Magnificent (Ottoman sultan), 297, 10-23A Sultan-Muhammad: Shahnama (Book of Kings), 302–303, 303 sultans, 292 Summa Theologica (Thomas Aquinas), 372 Sunnah, 285 Supper at Emmaus, 241 surahs, 285 Sutton Hoo ship burial, Suffolk, 309–310, 309, 11-3A Sylvester (Pope), 243	Byzantine Empire, 256 early medieval European art, 308 Gothic art, 366 Islamic art, 284 Italian late medieval art, 402 Late Antique art, 234 Romanesque art, 334 Timur (Tamerlane), 302 Timurid dynasty, 302, 305 Titus (Roman emperor), 236, 286 Tomb of Edward II, Gloucester Cathedral, 391b, 13-42A tombs. See funerary customs tondo/tondi, 10-15A Torah, 235 Torhalle, Lorsch, 232, 323b, 11-19A Toulouse (France). See Saint-Sernin Tournus (France): Saint-Philibert, 337, 337b,	Urban II (Pope), 346 Urban VI (Pope), 404 urban planning: early Islamic, 287 Gothic era, 382–383 Roman Empire, 14-18B Urnes (Norway): stave church, 311, 311 Ursus (bishop of Ravenna), 8-17A Uta (abbess of Niedermünster), 330 Uta Codex, 330, 330 Utrecht Psalter, 319, 319, 326, 361, 11-15A V Vandals, 258 Vasari, Giorgio: on Giotto, 407, 14-7A
See also Siena Cathedral; Sienese 14th century art Siena Cathedral, 14-12A Annunciation altarpiece (Martini and Memmi), 413-415, 413 Birth of the Virgin (Lorenzetti), 415, 415 Maestà altarpiece (Duccio), 410, 411-412, 411, 412b, 412, 13-36A, 14-8B, 14-10A and Santa Maria del Fiore, 417 Sienese 14th century art, 411-416 architecture, 412-413, 415-416, 14-12A painting, 411-412, 413-415, 416, 417, 14-7A, 14-10A, 14-16A societal contexts, 409, 14-16A Sigismund(Holy Roman Emperor), 404 silentiaries, 261 silk: in early Islamic art, 10-15A Silk Road, 412 silk textile, Zandana, 292b, 10-15A	Suicide of Judas (ivory carving), 251–252, 251, 12-13A Suicide of Judas, Saint-Lazare (Gislebertus), 345b, 12-13A Sulayman (artist): ewer in the form of a bird, 293, 293 Suleyman the Magnificent (Ottoman sultan), 297, 10-23A Sultan-Muhammad: Shahnama (Book of Kings), 302–303, 303 sultans, 292 Summa Theologica (Thomas Aquinas), 372 Sunnah, 285 Supper at Emmaus, 241 surahs, 285 Sutton Hoo ship burial, Suffolk, 309–310, 309, 11-3A Sylvester (Pope), 243 symmetry, 273, 313, 11-3A	Byzantine Empire, 256 early medieval European art, 308 Gothic art, 366 Islamic art, 284 Italian late medieval art, 402 Late Antique art, 234 Romanesque art, 334 Timur (Tamerlane), 302 Timurid dynasty, 302, 305 Titus (Roman emperor), 236, 286 Tomb of Edward II, Gloucester Cathedral, 391b, 13-42A tombs. See funerary customs tondo/tondi, 10-15A Torah, 235 Torhalle, Lorsch, 232, 323b, 11-19A Toulouse (France). See Saint-Sernin Tournus (France): Saint-Philibert, 337, 337b, 339, 12-4B	Urban II (Pope), 346 Urban VI (Pope), 404 urban planning: early Islamic, 287 Gothic era, 382–383 Roman Empire, 14-18B Urnes (Norway): stave church, 311, 311 Ursus (bishop of Ravenna), 8-17A Uta (abbess of Niedermünster), 330 Uta Codex, 330, 330 Utrecht Psalter, 319, 319, 326, 361, 11-15A V Vandals, 258 Vasari, Giorgio: on Giotto, 407, 14-7A on Gothic art, 365
See also Siena Cathedral; Sienese 14th century art Siena Cathedral, 14-12A Annuncation altarpiece (Martini and Memmi), 413-415, 413 Birth of the Virgin (Lorenzetti), 415, 415 Maestà altarpiece (Duccio), 410, 411-412, 411, 412b, 412, 13-36A, 14-8B, 14-10A and Santa Maria del Fiore, 417 Sienese 14th century art, 411-416 architecture, 412-413, 415-416, 14-12A painting, 411-412, 413-415, 416, 417, 14-7A, 14-10A, 14-16A Sigismund(Holy Roman Emperor), 404 silentiaries, 261 silk: in early Islamic art, 10-15A Silk Road, 412 silk textile, Zandana, 292b, 10-15A Silos (Spain): Santo Domingo, 340b, 12-8B	Suicide of Judas (ivory carving), 251–252, 251, 12-13A Suicide of Judas, Saint-Lazare (Gislebertus), 345b, 12-13A Sulayman (artist): ewer in the form of a bird, 293, 293 Suleyman the Magnificent (Ottoman sultan), 297, 10-23A Sultan-Muhammad: Shahnama (Book of Kings), 302–303, 303 sultans, 292 Summa Theologica (Thomas Aquinas), 372 Sunnah, 285 Supper at Emmaus, 241 surahs, 285 Sutton Hoo ship burial, Suffolk, 309–310, 309, 11-3A Sylvester (Pope), 243	Byzantine Empire, 256 early medieval European art, 308 Gothic art, 366 Islamic art, 284 Italian late medieval art, 402 Late Antique art, 234 Romanesque art, 334 Timur (Tamerlane), 302 Titus (Roman emperor), 236, 286 Tomb of Edward II, Gloucester Cathedral, 391b, 13-42A tombs. See funerary customs tondo/tondi, 10-15A Torah, 235 Torhalle, Lorsch, 232, 323b, 11-19A Toulouse (France). See Saint-Sernin Tournus (France): Saint-Philibert, 337, 337b, 339, 12-4B Tours (France): Saint Martin's, 335, 338	Urban II (Pope), 346 Urban VI (Pope), 404 urban planning: early Islamic, 287 Gothic era, 382–383 Roman Empire, 14-18B Urnes (Norway): stave church, 311, 311 Ursus (bishop of Ravenna), 8-17A Uta (abbess of Niedermünster), 330 Uta Codex, 330, 330 Utrecht Psalter, 319, 319, 326, 361, 11-15A V Vandals, 258 Vasari, Giorgio: on Giotto, 407, 14-7A on Gothic art, 365 vassals, 334
See also Siena Cathedral; Sienese 14th century art Siena Cathedral, 14-12A Annunciation altarpiece (Martini and Memmi), 413-415, 413 Birth of the Virgin (Lorenzetti), 415, 415 Maestà altarpiece (Duccio), 410, 411-412, 411, 412b, 412, 13-36A, 14-8B, 14-10A and Santa Maria del Fiore, 417 Sienese 14th century art, 411-416 architecture, 412-413, 415-416, 14-12A painting, 411-412, 413-415, 416, 417, 14-7A, 14-10A, 14-16A Societal contexts, 409, 14-16A Sigismund(Holy Roman Emperor), 404 silentiaries, 261 silk: in early Islamic art, 10-15A Silk Road, 412 silk textile, Zandana, 292b, 10-15A Silos (Spain): Santo Domingo, 340b, 12-8B silver. See metalwork	Suicide of Judas (ivory carving), 251–252, 251, 12-13A Suicide of Judas, Saint-Lazare (Gislebertus), 345b, 12-13A Sulayman (artist): ewer in the form of a bird, 293, 293 Suleyman the Magnificent (Ottoman sultan), 297, 10-23A Sultan-Muhammad: Shahnama (Book of Kings), 302–303, 303 sultans, 292 Summa Theologica (Thomas Aquinas), 372 Sunnah, 285 Supper at Emmaus, 241 surahs, 285 Sutton Hoo ship burial, Suffolk, 309–310, 309, 11-3A Sylvester (Pope), 243 symmetry, 273, 313, 11-3A synagogue, Dura-Europa, 235, 235, 248	Byzantine Empire, 256 early medieval European art, 308 Gothic art, 366 Islamic art, 284 Italian late medieval art, 402 Late Antique art, 234 Romanesque art, 334 Timur (Tamerlane), 302 Titus (Roman emperor), 236, 286 Tomb of Edward II, Gloucester Cathedral, 391b, 13-42A tombs. See funerary customs tondo/tondi, 10-15A Torah, 235 Torhalle, Lorsch, 232, 323b, 11-19A Toulouse (France): Saint-Philibert, 337, 337b, 339, 12-4B Tours (France): Saint Martin's, 335, 338 Tower of Babel (Babylon ziggurat), 289	Urban II (Pope), 346 Urban VI (Pope), 404 urban planning: early Islamic, 287 Gothic era, 382–383 Roman Empire, 14-18B Urnes (Norway): stave church, 311, 311 Ursus (bishop of Ravenna), 8-17A Uta (abbess of Niedermünster), 330 Uta Codex, 330, 330 Utrecht Psalter, 319, 319, 326, 361, 11-15A V Vandals, 258 Vasari, Giorgio: on Giotto, 407, 14-7A on Gothic art, 365 vassals, 334 Vatican. See papacy; Rome
See also Siena Cathedral; Sienese 14th century art Siena Cathedral, 14-12A Annunciation altarpiece (Martini and Memmi), 413-415, 413 Birth of the Virgin (Lorenzetti), 415, 415 Maestà altarpiece (Duccio), 410, 411-412, 411, 412b, 412, 13-36A, 14-8B, 14-10A and Santa Maria del Fiore, 417 Sienese 14th century art, 411-416 architecture, 412-413, 415-416, 14-12A painting, 411-412, 143-415, 416, 417, 14-7A, 14-10A, 14-16A Sigismund(Holy Roman Emperor), 404 silentiaries, 261 silk: in early Islamic art, 10-15A Silk Road, 412 silk textile, Zandana, 292b, 10-15A Silos (Spain): Santo Domingo, 340b, 12-8B silver. See metalwork Sinan the Great, 297, 10-23A	Suicide of Judas (ivory carving), 251–252, 251, 12-13A Suicide of Judas, Saint-Lazare (Gislebertus), 345b, 12-13A Sulayman (artist): ewer in the form of a bird, 293, 293 Suleyman the Magnificent (Ottoman sultan), 297, 10-23A Sultan-Muhammad: Shahnama (Book of Kings), 302–303, 303 sultans, 292 Summa Theologica (Thomas Aquinas), 372 Sunnah, 285 Supper at Emmaus, 241 surahs, 285 Sutton Hoo ship burial, Suffolk, 309–310, 309, 11-3A Sylvester (Pope), 243 symmetry, 273, 313, 11-3A synagogue, Dura-Europa, 235, 235, 248	Byzantine Empire, 256 early medieval European art, 308 Gothic art, 366 Islamic art, 284 Italian late medieval art, 402 Late Antique art, 234 Romanesque art, 334 Timur (Tamerlane), 302 Timurid dynasty, 302, 305 Tittus (Roman emperor), 236, 286 Tomb of Edward II, Gloucester Cathedral, 391b, 13-42A tombs. See funerary customs tondo/tondi, 10-15A Torah, 235 Torhalle, Lorsch, 232, 323b, 11-19A Toulouse (France). See Saint-Sernin Tournus (France): Saint-Philibert, 337, 337b, 339, 12-4B Towrs (France): Saint Martin's, 335, 338 Tower of Babel (Babylon ziggurat), 289 tracery, 373, 375, 414, 13-23A	Urban II (Pope), 346 Urban VI (Pope), 404 urban planning: early Islamic, 287 Gothic era, 382–383 Roman Empire, 14-18B Urnes (Norway): stave church, 311, 311 Ursus (bishop of Ravenna), 8-17A Uta (abbess of Niedermünster), 330 Uta Codex, 330, 330 Utrecht Psalter, 319, 319, 326, 361, 11-15A V Vandals, 258 Vasari, Giorgio: on Giotto, 407, 14-7A on Gothic art, 365 vassals, 334 Vatican. See papacy; Rome Vatican Vergil, 248, 249 vault ribs. See rib vaulting vaulting webs, 373
See also Siena Cathedral; Sienese 14th century art Siena Cathedral, 14-12A Annunciation altarpiece (Martini and Memmi), 413-415, 413 Birth of the Virgin (Lorenzetti), 415, 415 Maestà altarpiece (Duccio), 410, 411-412, 411, 412b, 412, 13-36A, 14-8B, 14-10A and Santa Maria del Fiore, 417 Sienese 14th century art, 411-416 architecture, 412-413, 415-416, 14-12A painting, 411-412, 413-415, 416, 417, 14-7A, 14-10A, 14-16A societal contexts, 409, 14-16A Sigismund(Holy Roman Emperor), 404 silentiaries, 261 silk: in early Islamic art, 10-15A Silk Road, 412 silk textile, Zandana, 292b, 10-15A Silos (Spain): Santo Domingo, 340b, 12-8B silver. See metalwork Sinan the Great, 297, 10-23A Mosque of Selim II, Edirne, 298, 298, 299	Suicide of Judas (ivory carving), 251–252, 251, 12-13A Suicide of Judas, Saint-Lazare (Gislebertus), 345b, 12-13A Sulayman (artist): ewer in the form of a bird, 293, 293 Suleyman the Magnificent (Ottoman sultan), 297, 10-23A Sultan-Muhammad: Shahnama (Book of Kings), 302–303, 303 sultans, 292 Summa Theologica (Thomas Aquinas), 372 Sunnah, 285 Supper at Emmaus, 241 surahs, 285 Sutton Hoo ship burial, Suffolk, 309–310, 309, 11-3A Sylvester (Pope), 243 symmetry, 273, 313, 11-3A synagogue, Dura-Europa, 235, 235, 248 T Tábara (Spain): monastery of San Salvador,	Byzantine Empire, 256 early medieval European art, 308 Gothic art, 366 Islamic art, 284 Italian late medieval art, 402 Late Antique art, 234 Romanesque art, 334 Timur (Tamerlane), 302 Timurid dynasty, 302, 305 Titus (Roman emperor), 236, 286 Tomb of Edward II, Gloucester Cathedral, 391b, 13-42A tombs. See funerary customs tondo/tondi, 10-15A Torah, 235 Torhalle, Lorsch, 232, 323b, 11-19A Toulouse (France). See Saint-Sernin Tournus (France): Saint-Philibert, 337, 337b, 339, 12-4B Touse (France): Saint Martin's, 335, 338 Tower of Babel (Babylon ziggurat), 289 tracery, 373, 375, 414, 13-23A Traini, Francesco: Triumph of Death,	Urban II (Pope), 346 Urban VI (Pope), 404 urban planning: early Islamic, 287 Gothic era, 382–383 Roman Empire, 14-18B Urnes (Norway): stave church, 311, 311 Ursus (bishop of Ravenna), 8-17A Uta (abbess of Niedermünster), 330 Uta Codex, 330, 330 Utrecht Psalter, 319, 319, 326, 361, 11-15A V Vandals, 258 Vasari, Giorgio: on Giotto, 407, 14-7A on Gothic art, 365 vassals, 334 Vatican. See papacy; Rome Vatican Vergil, 248, 249 vault ribs. See rib vaulting
See also Siena Cathedral; Sienese 14th century art Siena Cathedral, 14-12A Annunciation altarpiece (Martini and Memmi), 413-415, 413 Birth of the Virgin (Lorenzetti), 415, 415 Maestà altarpiece (Duccio), 410, 411-412, 411, 412b, 412, 13-36A, 14-8B, 14-10A and Santa Maria del Fiore, 417 Sienese 14th century art, 411-416 architecture, 412-413, 415-416, 14-12A painting, 411-412, 413-415, 416, 417, 14-7A, 14-10A, 14-16A societal contexts, 409, 14-16A Sigismund(Holy Roman Emperor), 404 silentiaries, 261 silk: in early Islamic art, 10-15A Silk Road, 412 silk textile, Zandana, 292b, 10-15A Silos (Spain): Santo Domingo, 340b, 12-8B silver. See metalwork Sinan the Great, 297, 10-23A Mosque of Selim II, Edirne, 298, 298, 299 sinopia, 408	Suicide of Judas (ivory carving), 251–252, 251, 12-13A Suicide of Judas, Saint-Lazare (Gislebertus), 345b, 12-13A Sulayman (artist): ewer in the form of a bird, 293, 293 Suleyman the Magnificent (Ottoman sultan), 297, 10-23A Sultan-Muhammad: Shahnama (Book of Kings), 302–303, 303 sultans, 292 Summa Theologica (Thomas Aquinas), 372 Sunnah, 285 Supper at Emmaus, 241 surahs, 285 Sutton Hoo ship burial, Suffolk, 309–310, 309, 11-3A Sylvester (Pope), 243 symmetry, 273, 313, 11-3A synagogue, Dura-Europa, 235, 235, 248 T Tábara (Spain): monastery of San Salvador, 316	Byzantine Empire, 256 early medieval European art, 308 Gothic art, 366 Islamic art, 284 Italian late medieval art, 402 Late Antique art, 234 Romanesque art, 334 Timur (Tamerlane), 302 Timurid dynasty, 302, 305 Titus (Roman emperor), 236, 286 Tomb of Edward II, Gloucester Cathedral, 391b, 13-42A tombs. See funerary customs tondo/tondi, 10-15A Torah, 235 Torhalle, Lorsch, 232, 323b, 11-19A Toulouse (France). See Saint-Sernin Tournus (France): Saint Martin's, 337, 337b, 339, 12-4B Tours (France): Saint Martin's, 335, 338 Tower of Babel (Babylon ziggurat), 289 tracery, 373, 375, 414, 13-23A Traini, Francesco: Triumph of Death, 419-420, 419	Urban II (Pope), 346 Urban VI (Pope), 404 urban planning: early Islamic, 287 Gothic era, 382–383 Roman Empire, 14-18B Urnes (Norway): stave church, 311, 311 Ursus (bishop of Ravenna), 8-17A Uta (abbess of Niedermünster), 330 Uta Codex, 330, 330 Utrecht Psalter, 319, 319, 326, 361, 11-15A V Vandals, 258 Vasari, Giorgio: on Giotto, 407, 14-7A on Gothic art, 365 vassals, 334 Vatican. See papacy; Rome Vatican Vergil, 248, 249 vault ribs. See rib vaulting vaulting webs, 373 vaults: stone, 337, 338, 339, 340–341, 358–359
See also Siena Cathedral; Sienese 14th century art Siena Cathedral, 14-12A Annunciation altarpiece (Martini and Memmi), 413-415, 413 Birth of the Virgin (Lorenzetti), 415, 415 Maestà altarpiece (Duccio), 410, 411-412, 411, 412b, 412, 13-36A, 14-8B, 14-10A and Santa Maria del Fiore, 417 Sienese 14th century art, 411-416 architecture, 412-413, 415-416, 14-12A painting, 411-412, 413-415, 416, 417, 14-7A, 14-10A, 14-16A Societal contexts, 409, 14-16A Sigismund(Holy Roman Emperor), 404 silentiaries, 261 silk: in early Islamic art, 10-15A Silk Road, 412 silk textile, Zandana, 292b, 10-15A Silos (Spain): Santo Domingo, 340b, 12-8B silver. See metalwork Sinan the Great, 297, 10-23A Mosque of Selim II, Edirne, 298, 298, 299 sinopia, 408 Sistine Chapel, Vatican, Rome: restoration,	Suicide of Judas (ivory carving), 251–252, 251, 12-13A Suicide of Judas, Saint-Lazare (Gislebertus), 345b, 12-13A Sulayman (artist): ewer in the form of a bird, 293, 293 Suleyman the Magnificent (Ottoman sultan), 297, 10-23A Sultan-Muhammad: Shahnama (Book of Kings), 302–303, 303 sultans, 292 Summa Theologica (Thomas Aquinas), 372 Sunnah, 285 Supper at Emmaus, 241 surahs, 285 Sutton Hoo ship burial, Suffolk, 309–310, 309, 11-3A Sylvester (Pope), 243 symmetry, 273, 313, 11-3A synagogue, Dura-Europa, 235, 235, 248 T Tábara (Spain): monastery of San Salvador, 316 tabernacle, Or San Michele, Florence	Byzantine Empire, 256 early medieval European art, 308 Gothic art, 366 Islamic art, 284 Italian late medieval art, 402 Late Antique art, 234 Romanesque art, 334 Timur (Tamerlane), 302 Titus (Roman emperor), 236, 286 Tomb of Edward II, Gloucester Cathedral, 391b, 13-42A tombs. See funerary customs tondo/tondi, 10-15A Torah, 235 Torhalle, Lorsch, 232, 323b, 11-19A Toulouse (France). See Saint-Sernin Tournus (France): Saint-Philibert, 337, 337b, 339, 12-4B Tours (France): Saint Martin's, 335, 338 Tower of Babel (Babylon ziggurat), 289 tracery, 373, 375, 414, 13-23A Traini, Francesco: Triumph of Death, 419-420, 419 Trajan (Roman emperor), 234-235	Urban II (Pope), 346 Urban VI (Pope), 404 urban Planning: early Islamic, 287 Gothic era, 382–383 Roman Empire, 14-18B Urnes (Norway): stave church, 311, 311 Ursus (bishop of Ravenna), 8-17A Uta (abbess of Niedermünster), 330 Uta Codex, 330, 330 Utrecht Psalter, 319, 319, 326, 361, 11-15A V Vandals, 258 Vasari, Giorgio: on Giotto, 407, 14-7A on Gothic art, 365 vassals, 334 Vatican. See papacy; Rome Vatican Vergil, 248, 249 vault ribs. See rib vaulting vaulting webs, 373 vaults: stone, 337, 338, 339, 340–341, 358–359 See also barrel vaults; corbel vaulting;
See also Siena Cathedral; Sienese 14th century art Siena Cathedral, 14-12A Annunciation altarpiece (Martini and Memmi), 413-415, 413 Birth of the Virgin (Lorenzetti), 415, 415 Maestà altarpiece (Duccio), 410, 411-412, 411, 412b, 412, 13-36A, 14-8B, 14-10A and Santa Maria del Fiore, 417 Sienese 14th century art, 411-416 architecture, 412-413, 415-416, 14-12A painting, 411-412, 413-415, 416, 417, 14-7A, 14-10A, 14-16A Societal contexts, 409, 14-16A Sigismund(Holy Roman Emperor), 404 silentiaries, 261 silk: in early Islamic art, 10-15A Silk Road, 412 silk textile, Zandana, 292b, 10-15A Silos (Spain): Santo Domingo, 340b, 12-8B silver. See metalwork Sinan the Great, 297, 10-23A Mosque of Selim II, Edirne, 298, 298, 299 sinopia, 408 Sistine Chapel, Vatican, Rome: restoration, 408	Suicide of Judas (ivory carving), 251–252, 251, 12-13A Suicide of Judas, Saint-Lazare (Gislebertus), 345b, 12-13A Sulayman (artist): ewer in the form of a bird, 293, 293 Suleyman the Magnificent (Ottoman sultan), 297, 10-23A Sultan-Muhammad: Shahnama (Book of Kings), 302–303, 303 sultans, 292 Summa Theologica (Thomas Aquinas), 372 Sunnah, 285 Supper at Emmaus, 241 surahs, 285 Sutton Hoo ship burial, Suffolk, 309–310, 309, 11-3A Sylvester (Pope), 243 symmetry, 273, 313, 11-3A synagogue, Dura-Europa, 235, 235, 248 T Tábara (Spain): monastery of San Salvador, 316 tabernacle, Or San Michele, Florence (Orcagna), 419, 419b, 14-19A	Byzantine Empire, 256 early medieval European art, 308 Gothic art, 366 Islamic art, 284 Italian late medieval art, 402 Late Antique art, 234 Romanesque art, 334 Timur (Tamerlane), 302 Titus (Roman emperor), 236, 286 Tomb of Edward II, Gloucester Cathedral, 391b, 13-42A tombs. See funerary customs tondo/tondi, 10-15A Torah, 235 Torhalle, Lorsch, 232, 323b, 11-19A Toulouse (France). See Saint-Sernin Tournus (France): Saint-Philibert, 337, 337b, 339, 12-4B Tours (France): Saint Martin's, 335, 338 Tower of Babel (Babylon ziggurat), 289 tracery, 373, 375, 414, 13-23A Traini, Francesco: Triumph of Death, 419-420, 419 Trajan (Roman emperor), 234-235 Trajan Decius (Roman emperor), 236	Urban II (Pope), 346 Urban VI (Pope), 404 urban planning: early Islamic, 287 Gothic era, 382–383 Roman Empire, 14-18B Urnes (Norway): stave church, 311, 311 Ursus (bishop of Ravenna), 8-17A Uta (abbess of Niedermünster), 330 Uta Codex, 330, 330 Utrecht Psalter, 319, 319, 326, 361, 11-15A V Vandals, 258 Vasari, Giorgio: on Giotto, 407, 14-7A on Gothic art, 365 vassals, 334 Vatican. See papacy; Rome Vatican Vergil, 248, 249 vault ribs. See rib vaulting vaulting webs, 373 vaults: stone, 337, 338, 339, 340–341, 358–359 See also barrel vaults; corbel vaulting; groin vaults; rib vaulting
See also Siena Cathedral; Sienese 14th century art Siena Cathedral, 14-12A Annunciation altarpiece (Martini and Memmi), 413-415, 413 Birth of the Virgin (Lorenzetti), 415, 415 Maestà altarpiece (Duccio), 410, 411-412, 411, 412b, 412, 13-36A, 14-8B, 14-10A and Santa Maria del Fiore, 417 Sienese 14th century art, 411-416 architecture, 412-413, 415-416, 14-12A painting, 411-412, 143-415, 416, 417, 14-7A, 14-10A, 14-16A societal contexts, 409, 14-16A Sigismund(Holy Roman Emperor), 404 silentiaries, 261 silk: in early Islamic art, 10-15A Silk Road, 412 silk textile, Zandana, 292b, 10-15A Silos (Spain): Santo Domingo, 340b, 12-8B silver. See metalwork Sinan the Great, 297, 10-23A Mosque of Selim II, Edirne, 298, 298, 299 sinopia, 408 Sistine Chapel, Vatican, Rome: restoration, 408 Sixtus III (Pope), 8-10A	Suicide of Judas (ivory carving), 251–252, 251, 12-13A Suicide of Judas, Saint-Lazare (Gislebertus), 345b, 12-13A Sulayman (artist): ewer in the form of a bird, 293, 293 Suleyman the Magnificent (Ottoman sultan), 297, 10-23A Sultan-Muhammad: Shahnama (Book of Kings), 302–303, 303 sultans, 292 Summa Theologica (Thomas Aquinas), 372 Sunnah, 285 Supper at Emmaus, 241 surahs, 285 Sutton Hoo ship burial, Suffolk, 309–310, 309, 11-3A Sylvester (Pope), 243 symmetry, 273, 313, 11-3A synagogue, Dura-Europa, 235, 235, 248 T Tábara (Spain): monastery of San Salvador, 316 tabernacle, Or San Michele, Florence (Orcagna), 419, 419b, 14-19A Tahmasp (Savafid shah), 300, 302	Byzantine Empire, 256 early medieval European art, 308 Gothic art, 366 Islamic art, 284 Italian late medieval art, 402 Late Antique art, 234 Romanesque art, 334 Timur (Tamerlane), 302 Timurid dynasty, 302, 305 Titus (Roman emperor), 236, 286 Tomb of Edward II, Gloucester Cathedral, 391b, 13-42A tombs. See funerary customs tondo/tondi, 10-15A Torah, 235 Torhalle, Lorsch, 232, 323b, 11-19A Toulouse (France). See Saint-Sernin Tournus (France): Saint-Philibert, 337, 337b, 339, 12-4B Tours (France): Saint Martin's, 335, 338 Tower of Babel (Babylon ziggurat), 289 tracery, 373, 375, 414, 13-23A Traini, Francesco: Triumph of Death, 419-420, 419 Trajan (Roman emperor), 234-235 Trajan Decius (Roman emperor), 236 Trajan's Column. See Column of Trajan	Urban II (Pope), 346 Urban VI (Pope), 404 urban planning: early Islamic, 287 Gothic era, 382–383 Roman Empire, 14-18B Urnes (Norway): stave church, 311, 311 Ursus (bishop of Ravenna), 8-17A Uta (abbess of Niedermünster), 330 Uta Codex, 330, 330 Utrecht Psalter, 319, 319, 326, 361, 11-15A V Vandals, 258 Vasari, Giorgio: on Giotto, 407, 14-7A on Gothic art, 365 vassals, 334 Vatican. See papacy; Rome Vatican Vergil, 248, 249 vault ribs. See rib vaulting vaulting webs, 373 vaults: stone, 337, 338, 339, 340–341, 358–359 See also barrel vaults; corbel vaulting; groin vaults; rib vaulting vellum, 249
See also Siena Cathedral; Sienese 14th century art Siena Cathedral, 14-12A Annunciation altarpiece (Martini and Memmi), 413-415, 413 Birth of the Virgin (Lorenzetti), 415, 415 Maestà altarpiece (Duccio), 410, 411-412, 411, 412b, 412, 13-36A, 14-8B, 14-10A and Santa Maria del Fiore, 417 Sienese 14th century art, 411-416 architecture, 412-413, 415-416, 14-12A painting, 411-412, 413-415, 416, 417, 14-7A, 14-10A, 14-16A societal contexts, 409, 14-16A Sigismund(Holy Roman Emperor), 404 silentiaries, 261 silk: in early Islamic art, 10-15A Silk Road, 412 silk textile, Zandana, 292b, 10-15A Silos (Spain): Santo Domingo, 340b, 12-8B silver. See metalwork Sinan the Great, 297, 10-23A Mosque of Selim II, Edirne, 298, 298, 299 sinopia, 408 Sistine Chapel, Vatican, Rome: restoration, 408 Sixtus III (Pope), 8-10A sketchbook (Villard de Honnecourt), 384,	Suicide of Judas (ivory carving), 251–252, 251, 12-13A Suicide of Judas, Saint-Lazare (Gislebertus), 345b, 12-13A Sulayman (artist): ewer in the form of a bird, 293, 293 Suleyman the Magnificent (Ottoman sultan), 297, 10-23A Sultan-Muhammad: Shahnama (Book of Kings), 302–303, 303 sultans, 292 Summa Theologica (Thomas Aquinas), 372 Sunnah, 285 Supper at Emmaus, 241 surahs, 285 Sutton Hoo ship burial, Suffolk, 309–310, 309, 11-3A Sylvester (Pope), 243 symmetry, 273, 313, 11-3A synagogue, Dura-Europa, 235, 235, 248 T Tábara (Spain): monastery of San Salvador, 316 tabernacle, Or San Michele, Florence (Orcagna), 419, 419b, 14-19A Tahmasp (Savafid shah), 300, 302 Taj Mahal, Agra, 283	Byzantine Empire, 256 early medieval European art, 308 Gothic art, 366 Islamic art, 284 Italian late medieval art, 402 Late Antique art, 234 Romanesque art, 334 Timur (Tamerlane), 302 Timurid dynasty, 302, 305 Titus (Roman emperor), 236, 286 Tomb of Edward II, Gloucester Cathedral, 391b, 13-42A tombs. See funerary customs tondo/tondi, 10-15A Torah, 235 Torhalle, Lorsch, 232, 323b, 11-19A Toulouse (France). See Saint-Sernin Tournus (France): Saint-Philibert, 337, 337b, 339, 12-4B Tours (France): Saint Martin's, 335, 338 Tower of Babel (Babylon ziggurat), 289 tracery, 373, 375, 414, 13-23A Traini, Francesco: Triumph of Death, 419-420, 419 Trajan (Roman emperor), 234-235 Trajan Decius (Roman emperor), 236 Trajan's Column. See Column of Trajan tramezzo, 14-6A	Urban II (Pope), 346 Urban VI (Pope), 404 urban planning: early Islamic, 287 Gothic era, 382–383 Roman Empire, 14-18B Urnes (Norway): stave church, 311, 311 Ursus (bishop of Ravenna), 8-17A Uta (abbess of Niedermünster), 330 Uta Codex, 330, 330 Utrecht Psalter, 319, 319, 326, 361, 11-15A V Vandals, 258 Vasari, Giorgio: on Giotto, 407, 14-7A on Gothic art, 365 vassals, 334 Vatican. See papacy; Rome Vatican Vergil, 248, 249 vault ribs. See rib vaulting vaulting webs, 373 vaults: stone, 337, 338, 339, 340–341, 358–359 See also barrel vaults; corbel vaulting; groin vaults; rib vaulting vellum, 249 See also books
See also Siena Cathedral; Sienese 14th century art Siena Cathedral, 14-12A Annunciation altarpiece (Martini and Memmi), 413-415, 413 Birth of the Virgin (Lorenzetti), 415, 415 Maesta altarpiece (Duccio), 410, 411-412, 411, 412b, 412, 13-36A, 14-8B, 14-10A and Santa Maria del Fiore, 417 Sienese 14th century art, 411-416 architecture, 412-413, 415-416, 14-12A painting, 411-412, 413-415, 416, 417, 14-7A, 14-10A, 14-16A societal contexts, 409, 14-16A Sigismund(Holy Roman Emperor), 404 silentiaries, 261 silk: in early Islamic art, 10-15A Silk Road, 412 silk textile, Zandana, 292b, 10-15A Silos (Spain): Santo Domingo, 340b, 12-8B silver. See metalwork Sinan the Great, 297, 10-23A Mosque of Selim II, Edirne, 298, 298, 299 sinopia, 408 Sistine Chapel, Vatican, Rome: restoration, 408 Sixtus III (Pope), 8-10A sketchbook (Villard de Honnecourt), 384, 384	Suicide of Judas (ivory carving), 251–252, 251, 12-13A Suicide of Judas, Saint-Lazare (Gislebertus), 345b, 12-13A Sulayman (artist): ewer in the form of a bird, 293, 293 Suleyman the Magnificent (Ottoman sultan), 297, 10-23A Sultan-Muhammad: Shahnama (Book of Kings), 302–303, 303 sultans, 292 Summa Theologica (Thomas Aquinas), 372 Sunnah, 285 Supper at Emmaus, 241 surahs, 285 Sutton Hoo ship burial, Suffolk, 309–310, 309, 11-3A Sylvester (Pope), 243 symmetry, 273, 313, 11-3A synagogue, Dura-Europa, 235, 235, 248 T Tábara (Spain): monastery of San Salvador, 316 tabernacle, Or San Michele, Florence (Orcagna), 419, 419b, 14-19A Tahmasp (Savafid shah), 300, 302 Taj Mahal, Agra, 283 tapestries, 362	Byzantine Empire, 256 early medieval European art, 308 Gothic art, 366 Islamic art, 284 Italian late medieval art, 402 Late Antique art, 234 Romanesque art, 334 Timur (Tamerlane), 302 Timurid dynasty, 302, 305 Titus (Roman emperor), 236, 286 Tomb of Edward II, Gloucester Cathedral, 391b, 13-42A tombs. See funerary customs tondo/tondi, 10-15A Torah, 235 Torhalle, Lorsch, 232, 323b, 11-19A Toulouse (France). See Saint-Sernin Tournus (France): Saint Philibert, 337, 337b, 339, 12-4B Tous (France): Saint Martin's, 335, 338 Tower of Babel (Babylon ziggurat), 289 tracery, 373, 375, 414, 13-23A Traini, Francesco: Triumph of Death, 419-420, 419 Trajan (Roman emperor), 234-235 Trajan Decius (Roman emperor), 236 Trajan's Column. See Column of Trajan tramezzo, 14-6A transepts:	Urban II (Pope), 346 Urban VI (Pope), 404 urban planning: early Islamic, 287 Gothic era, 382–383 Roman Empire, 14-18B Urnes (Norway): stave church, 311, 311 Ursus (bishop of Ravenna), 8-17A Uta (abbess of Niedermünster), 330 Uta Codex, 330, 330 Utrecht Psalter, 319, 319, 326, 361, 11-15A V Vandals, 258 Vasari, Giorgio: on Giotto, 407, 14-7A on Gothic art, 365 vassals, 334 Vatican. See papacy; Rome Vatican Vergil, 248, 249 vault ribs. See rib vaulting vaulting webs, 373 vaults: stone, 337, 338, 339, 340–341, 358–359 See also barrel vaults; corbel vaulting; groin vaults; rib vaulting vellum, 249 See also books Venetian 14th century art, 420
See also Siena Cathedral; Sienese 14th century art Siena Cathedral, 14-12A Annunciation altarpiece (Martini and Memmi), 413-415, 413 Birth of the Virgin (Lorenzetti), 415, 415 Maestà altarpiece (Duccio), 410, 411-412, 411, 412b, 412, 13-36A, 14-8B, 14-10A and Santa Maria del Fiore, 417 Sienese 14th century art, 411-416 architecture, 412-413, 415-416, 14-12A painting, 411-412, 413-415, 416, 417, 14-7A, 14-10A, 14-16A Societal contexts, 409, 14-16A Sigismund(Holy Roman Emperor), 404 silentiaries, 261 silk: in early Islamic art, 10-15A Silk Road, 412 silk textile, Zandana, 292b, 10-15A Silos (Spain): Santo Domingo, 340b, 12-8B silver. See metalwork Sinan the Great, 297, 10-23A Mosque of Selim II, Edirne, 298, 298, 299 sinopia, 408 Sistine Chapel, Vatican, Rome: restoration, 408 Sixtus III (Pope), 8-10A sketchbook (Villard de Honnecourt), 384, 384 societal contexts of art:	Suicide of Judas (ivory carving), 251–252, 251, 12-13A Suicide of Judas, Saint-Lazare (Gislebertus), 345b, 12-13A Sulayman (artist): ewer in the form of a bird, 293, 293 Suleyman the Magnificent (Ottoman sultan), 297, 10-23A Sultan-Muhammad: Shahnama (Book of Kings), 302–303, 303 sultans, 292 Summa Theologica (Thomas Aquinas), 372 Sunnah, 285 Supper at Emmaus, 241 surahs, 285 Sutton Hoo ship burial, Suffolk, 309–310, 309, 11-3A Sylvester (Pope), 243 symmetry, 273, 313, 11-3A synagogue, Dura-Europa, 235, 235, 248 T Tábara (Spain): monastery of San Salvador, 316 tabernacle, Or San Michele, Florence (Orcagna), 419, 419b, 14-19A Tahmasp (Savafid shah), 300, 302 Taj Mahal, Agra, 283 tapestries, 362 Tarquinia (Italy): sarcophagus of Lars	Byzantine Empire, 256 early medieval European art, 308 Gothic art, 366 Islamic art, 284 Italian late medieval art, 402 Late Antique art, 234 Romanesque art, 334 Timur (Tamerlane), 302 Titus (Roman emperor), 236, 286 Tomb of Edward II, Gloucester Cathedral, 391b, 13-42A tombs. See funerary customs tondo/tondi, 10-15A Torah, 235 Torhalle, Lorsch, 232, 323b, 11-19A Toulouse (France). See Saint-Sernin Tournus (France): Saint-Philibert, 337, 337b, 339, 12-4B Tours (France): Saint Martin's, 335, 338 Tower of Babel (Babylon ziggurat), 289 tracery, 373, 375, 414, 13-23A Train, Francesco: Triumph of Death, 419-420, 419 Trajan (Roman emperor), 234-235 Trajan Decius (Roman emperor), 236 Trajan's Column. See Column of Trajan tramezzo, 14-6A transepts: in Early Christian architecture, 243	Urban II (Pope), 346 Urban VI (Pope), 404 urban planning: early Islamic, 287 Gothic era, 382–383 Roman Empire, 14-18B Urnes (Norway): stave church, 311, 311 Ursus (bishop of Ravenna), 8-17A Uta (abbess of Niedermünster), 330 Uta Codex, 330, 330 Utrecht Psalter, 319, 319, 326, 361, 11-15A V Vandals, 258 Vasari, Giorgio: on Giotto, 407, 14-7A on Gothic art, 365 vassals, 334 Vatican. See papacy; Rome Vatican Vergil, 248, 249 vault ribs. See rib vaulting vaulting webs, 373 vaults: stone, 337, 338, 339, 340–341, 358–359 See also barrel vaults; corbel vaulting; groin vaults; rib vaulting vellum, 249 See also books Venetian 14th century art, 420 Venice (Italy), 420
See also Siena Cathedral; Sienese 14th century art Siena Cathedral, 14-12A Annunciation altarpiece (Martini and Memmi), 413-415, 413 Birth of the Virgin (Lorenzetti), 415, 415 Maestà altarpiece (Duccio), 410, 411-412, 411, 412b, 412, 13-36A, 14-8B, 14-10A and Santa Maria del Fiore, 417 Sienese 14th century art, 411-416 architecture, 412-413, 415-416, 14-12A painting, 411-412, 413-415, 416, 417, 14-7A, 14-10A, 14-16A Societal contexts, 409, 14-16A Sigismund(Holy Roman Emperor), 404 silentiaries, 261 silk: in early Islamic art, 10-15A Silk Road, 412 silk textile, Zandana, 292b, 10-15A Silos (Spain): Santo Domingo, 340b, 12-8B silver. See metalwork Sinan the Great, 297, 10-23A Mosque of Selim II, Edirne, 298, 298, 299 sinopia, 408 Sistine Chapel, Vatican, Rome: restoration, 408 Sixtus III (Pope), 8-10A sketchbook (Villard de Honnecourt), 384, 384 societal contexts of art: Byzantine Empire, 255, 256-257, 258,	Suicide of Judas (ivory carving), 251–252, 251, 12-13A Suicide of Judas, Saint-Lazare (Gislebertus), 345b, 12-13A Sulayman (artist): ewer in the form of a bird, 293, 293 Suleyman the Magnificent (Ottoman sultan), 297, 10-23A Sultan-Muhammad: Shahnama (Book of Kings), 302–303, 303 sultans, 292 Summa Theologica (Thomas Aquinas), 372 Sunnah, 285 Supper at Emmaus, 241 surahs, 285 Sutton Hoo ship burial, Suffolk, 309–310, 309, 11-3A Sylvester (Pope), 243 symmetry, 273, 313, 11-3A synagogue, Dura-Europa, 235, 235, 248 T Tábara (Spain): monastery of San Salvador, 316 tabernacle, Or San Michele, Florence (Orcagna), 419, 419b, 14-19A Tahmasp (Savafid shah), 300, 302 Taj Mahal, Agra, 283 tapestries, 362 Tarquinia (Italy): sarcophagus of Lars Pulena, 249	Byzantine Empire, 256 early medieval European art, 308 Gothic art, 366 Islamic art, 284 Italian late medieval art, 402 Late Antique art, 234 Romanesque art, 334 Timur (Tamerlane), 302 Titus (Roman emperor), 236, 286 Tomb of Edward II, Gloucester Cathedral, 391b, 13-42A tombs. See funerary customs tondo/tondi, 10-15A Torah, 235 Torhalle, Lorsch, 232, 323b, 11-19A Toulouse (France): Saint-Philibert, 337, 337b, 339, 12-4B Tours (France): Saint Martin's, 335, 338 Tower of Babel (Babylon ziggurat), 289 tracery, 373, 375, 414, 13-23A Traini, Francesco: Triumph of Death, 419-420, 419 Trajan (Roman emperor), 234-235 Trajan Decius (Roman emperor), 236 Trajan's Column. See Column of Trajan tramezzo, 14-6A transepts: in Early Christian architecture, 243 in early medieval architecture, 323, 324,	Urban II (Pope), 346 Urban VI (Pope), 404 urban planning: early Islamic, 287 Gothic era, 382–383 Roman Empire, 14-18B Urnes (Norway): stave church, 311, 311 Ursus (bishop of Ravenna), 8-17A Uta (abbess of Niedermünster), 330 Uta Codex, 330, 330 Utrecht Psalter, 319, 319, 326, 361, 11-15A V Vandals, 258 Vasari, Giorgio: on Giotto, 407, 14-7A on Gothic art, 365 vassals, 334 Vatican. See papacy; Rome Vatican Vergil, 248, 249 vault ribs. See rib vaulting vaulting webs, 373 vaults: stone, 337, 338, 339, 340–341, 358–359 See also barrel vaults; corbel vaulting; groin vaults; rib vaulting vellum, 249 See also books Venetian 14th century art, 420 Venice (Italy), 420 Doge's Palace, 420, 420
See also Siena Cathedral; Sienese 14th century art Siena Cathedral, 14-12A Annunciation altarpiece (Martini and Memmi), 413-415, 413 Birth of the Virgin (Lorenzetti), 415, 415 Maestà altarpiece (Duccio), 410, 411-412, 411, 412b, 412, 13-36A, 14-8B, 14-10A and Santa Maria del Fiore, 417 Sienese 14th century art, 411-416 architecture, 412-413, 415-416, 14-12A painting, 411-412, 143-415, 416, 417, 14-7A, 14-10A, 14-16A Sigismund(Holy Roman Emperor), 404 silentiaries, 261 silk: in early Islamic art, 10-15A Silk Road, 412 silk textile, Zandana, 292b, 10-15A Silos (Spain): Santo Domingo, 340b, 12-8B silver. See metalwork Sinan the Great, 297, 10-23A Mosque of Selim II, Edirne, 298, 298, 299 sinopia, 408 Sixtus III (Pope), 8-10A sketchbook (Villard de Honnecourt), 384, 384 societal contexts of art: Byzantine Empire, 255, 256-257, 258, 263, 270, 278	Suicide of Judas (ivory carving), 251–252, 251, 12-13A Suicide of Judas, Saint-Lazare (Gislebertus), 345b, 12-13A Sulayman (artist): ewer in the form of a bird, 293, 293 Suleyman the Magnificent (Ottoman sultan), 297, 10-23A Sultan-Muhammad: Shahnama (Book of Kings), 302–303, 303 sultans, 292 Summa Theologica (Thomas Aquinas), 372 Sunnah, 285 Supper at Emmaus, 241 surahs, 285 Sutton Hoo ship burial, Suffolk, 309–310, 309, 11-3A Sylvester (Pope), 243 symmetry, 273, 313, 11-3A synagogue, Dura-Europa, 235, 235, 248 T Tábara (Spain): monastery of San Salvador, 316 tabernacle, Or San Michele, Florence (Orcagna), 419, 419b, 14-19A Tahmasp (Savafid shah), 300, 302 Taj Mahal, Agra, 283 tapestries, 362 Tarquinia (Italy): sarcophagus of Lars Pulena, 249 tempera painting:	Byzantine Empire, 256 early medieval European art, 308 Gothic art, 366 Islamic art, 284 Italian late medieval art, 402 Late Antique art, 234 Romanesque art, 334 Timur (Tamerlane), 302 Timurid dynasty, 302, 305 Titus (Roman emperor), 236, 286 Tomb of Edward II, Gloucester Cathedral, 391b, 13-42A tombs. See funerary customs tondo/tondi, 10-15A Torah, 235 Torhalle, Lorsch, 232, 323b, 11-19A Toulouse (France). See Saint-Sernin Tournus (France): Saint-Philibert, 337, 337b, 339, 12-4B Tours (France): Saint Martin's, 335, 338 Tower of Babel (Babylon ziggurat), 289 tracery, 373, 375, 414, 13-23A Traini, Francesco: Triumph of Death, 419-420, 419 Trajan (Roman emperor), 234-235 Trajan Decius (Roman emperor), 236 Trajan's Column. See Column of Trajan tramezzo, 14-6A transepts: in Early Christian architecture, 243 in early medieval architecture, 323, 324, 325	Urban II (Pope), 346 Urban VI (Pope), 404 urban planning: early Islamic, 287 Gothic era, 382–383 Roman Empire, 14-18B Urnes (Norway): stave church, 311, 311 Ursus (bishop of Ravenna), 8-17A Uta (abbess of Niedermünster), 330 Uta Codex, 330, 330 Utrecht Psalter, 319, 319, 326, 361, 11-15A V Vandals, 258 Vasari, Giorgio: on Giotto, 407, 14-7A on Gothic art, 365 vassals, 334 Vatican. See papacy; Rome Vatican Vergil, 248, 249 vault ribs. See rib vaulting vaulting webs, 373 vaults: stone, 337, 338, 339, 340–341, 358–359 See also barrel vaults; corbel vaulting; groin vaults; rib vaulting vellum, 249 See also books Venetian 14th century art, 420 Venice (Italy), 420 Doge's Palace, 420, 420 Saint Mark's, 274, 274b, 274, 275,
See also Siena Cathedral; Sienese 14th century art Siena Cathedral, 14-12A Annunciation altarpiece (Martini and Memmi), 413-415, 413 Birth of the Virgin (Lorenzetti), 415, 415 Maestà altarpiece (Duccio), 410, 411-412, 411, 412b, 412, 13-36A, 14-8B, 14-10A and Santa Maria del Fiore, 417 Sienese 14th century art, 411-416 architecture, 412-413, 415-416, 14-12A painting, 411-412, 143-415, 416, 417, 14-7A, 14-10A, 14-16A Sigismund(Holy Roman Emperor), 404 silentiaries, 261 silk: in early Islamic art, 10-15A Silk Road, 412 silk textile, Zandana, 292b, 10-15A Silos (Spain): Santo Domingo, 340b, 12-8B silver. See metalwork Sinan the Great, 297, 10-23A Mosque of Selim II, Edirne, 298, 298, 299 sinopia, 408 Sixtus III (Pope), 8-10A sketchbook (Villard de Honnecourt), 384, 384 societal contexts of art: Byzantine Empire, 255, 256-257, 258, 263, 270, 278 Early Christian, 236, 242	Suicide of Judas (ivory carving), 251–252, 251, 12-13A Suicide of Judas, Saint-Lazare (Gislebertus), 345b, 12-13A Sulayman (artist): ewer in the form of a bird, 293, 293 Suleyman the Magnificent (Ottoman sultan), 297, 10-23A Sultan-Muhammad: Shahnama (Book of Kings), 302–303, 303 sultans, 292 Summa Theologica (Thomas Aquinas), 372 Sunnah, 285 Supper at Emmaus, 241 surahs, 285 Sutton Hoo ship burial, Suffolk, 309–310, 309, 11-3A Sylvester (Pope), 243 symmetry, 273, 313, 11-3A synagogue, Dura-Europa, 235, 235, 248 T Tábara (Spain): monastery of San Salvador, 316 tabernacle, Or San Michele, Florence (Orcagna), 419, 419b, 14-19A Tahmasp (Savafid shah), 300, 302 Taj Mahal, Agra, 283 tapestries, 362 Tarquinia (Italy): sarcophagus of Lars Pulena, 249 tempera painting: in Italian 13th century art, 404–405	Byzantine Empire, 256 early medieval European art, 308 Gothic art, 366 Islamic art, 284 Italian late medieval art, 402 Late Antique art, 234 Romanesque art, 334 Timur (Tamerlane), 302 Timurid dynasty, 302, 305 Titus (Roman emperor), 236, 286 Tomb of Edward II, Gloucester Cathedral, 391b, 13-42A tombs. See funerary customs tondo/tondi, 10-15A Torah, 235 Torhalle, Lorsch, 232, 323b, 11-19A Toulouse (France). See Saint-Sernin Tournus (France): Saint-Philibert, 337, 337b, 339, 12-4B Tours (France): Saint Martin's, 335, 338 Tower of Babel (Babylon ziggurat), 289 tracery, 373, 375, 414, 13-23A Traini, Francesco: Triumph of Death, 419-420, 419 Trajan (Roman emperor), 234-235 Trajan Decius (Roman emperor), 236 Trajan's Column. See Column of Trajan tramezzo, 14-6A transepts: in Early Christian architecture, 243 in early medieval architecture, 323, 324, 325 in French/Spanish Romanesque	Urban II (Pope), 346 Urban VI (Pope), 404 urban planning: early Islamic, 287 Gothic era, 382–383 Roman Empire, 14-18B Urnes (Norway): stave church, 311, 311 Ursus (bishop of Ravenna), 8-17A Uta (abbess of Niedermünster), 330 Uta Codex, 330, 330 Utrecht Psalter, 319, 319, 326, 361, 11-15A V Vandals, 258 Vasari, Giorgio: on Giotto, 407, 14-7A on Gothic art, 365 vassals, 334 Vatican. See papacy; Rome Vatican Vergil, 248, 249 vault ribs. See rib vaulting vaulting webs, 373 vaults: stone, 337, 338, 339, 340–341, 358–359 See also barrel vaults; corbel vaulting; groin vaults; rib vaulting vellum, 249 See also books Venetian 14th century art, 420 Venice (Italy), 420 Doge's Palace, 420, 420 Saint Mark's, 274, 274b, 274, 275, 9-26A
See also Siena Cathedral; Sienese 14th century art Siena Cathedral, 14-12A Annunciation altarpiece (Martini and Memmi), 413-415, 413 Birth of the Virgin (Lorenzetti), 415, 415 Maesta altarpiece (Duccio), 410, 411-412, 411, 412b, 412, 13-36A, 14-8B, 14-10A and Santa Maria del Fiore, 417 Sienese 14th century art, 411-416 architecture, 412-413, 415-416, 14-12A painting, 411-412, 413-415, 416, 417, 14-7A, 14-10A, 14-16A Societal contexts, 409, 14-16A Sigismund(Holy Roman Emperor), 404 silentiaries, 261 silk: in early Islamic art, 10-15A Silk Road, 412 silk textile, Zandana, 292b, 10-15A Silos (Spain): Santo Domingo, 340b, 12-8B silver. See metalwork Sinan the Great, 297, 10-23A Mosque of Selim II, Edirne, 298, 298, 299 sinopia, 408 Sistine Chapel, Vatican, Rome: restoration, 408 Sixtus III (Pope), 8-10A sketchbook (Villard de Honnecourt), 384, 384 societal contexts of art: Byzantine Empire, 255, 256-257, 258, 263, 270, 278 Early Christian, 236, 242 early medieval Europe, 308-309, 311, 317,	Suicide of Judas (ivory carving), 251–252, 251, 12-13A Suicide of Judas, Saint-Lazare (Gislebertus), 345b, 12-13A Sulayman (artist): ewer in the form of a bird, 293, 293 Suleyman the Magnificent (Ottoman sultan), 297, 10-23A Sultan-Muhammad: Shahnama (Book of Kings), 302–303, 303 sultans, 292 Summa Theologica (Thomas Aquinas), 372 Sunnah, 285 Supper at Emmaus, 241 surahs, 285 Sutton Hoo ship burial, Suffolk, 309–310, 309, 11-3A Sylvester (Pope), 243 symmetry, 273, 313, 11-3A synagogue, Dura-Europa, 235, 235, 248 T Tábara (Spain): monastery of San Salvador, 316 tabernacle, Or San Michele, Florence (Orcagna), 419, 419b, 14-19A Tahmasp (Savafid shah), 300, 302 Taj Mahal, Agra, 283 tapestries, 362 Tarquinia (Italy): sarcophagus of Lars Pulena, 249 tempera painting: in Italian 13th century art, 404–405 in Italian 14th century art, 407–408, 411–	Byzantine Empire, 256 early medieval European art, 308 Gothic art, 366 Islamic art, 284 Italian late medieval art, 402 Late Antique art, 234 Romanesque art, 334 Timur (Tamerlane), 302 Titus (Roman emperor), 236, 286 Tomb of Edward II, Gloucester Cathedral, 391b, 13-42A tombs. See funerary customs tondo/tondi, 10-15A Torah, 235 Torhalle, Lorsch, 232, 323b, 11-19A Toulouse (France). See Saint-Sernin Tournus (France): Saint-Philibert, 337, 337b, 339, 12-4B Tours (France): Saint Martin's, 335, 338 Tower of Babel (Babylon ziggurat), 289 tracery, 373, 375, 414, 13-23A Traini, Francesco: Triumph of Death, 419-420, 419 Trajan (Roman emperor), 234-235 Trajan Decius (Roman emperor), 236 Trajan's Column. See Column of Trajan tramezzo, 14-6A transepts: in Early Christian architecture, 243 in early medieval architecture, 323, 324, 325 in French/Spanish Romanesque architecture, 12-4A, 12-7B	Urban II (Pope), 346 Urban VI (Pope), 404 urban planning: early Islamic, 287 Gothic era, 382–383 Roman Empire, 14-18B Urnes (Norway): stave church, 311, 311 Ursus (bishop of Ravenna), 8-17A Uta (abbess of Niedermünster), 330 Uta Codex, 330, 330 Utrecht Psalter, 319, 319, 326, 361, 11-15A V Vandals, 258 Vasari, Giorgio: on Giotto, 407, 14-7A on Gothic art, 365 vassals, 334 Vatican. See papacy; Rome Vatican Vergil, 248, 249 vault ribs. See rib vaulting vaulting webs, 373 vaults: stone, 337, 338, 339, 340–341, 358–359 See also barrel vaults; corbel vaulting; groin vaults; rib vaulting vellum, 249 See also books Venetian 14th century art, 420 Venice (Italy), 420 Doge's Palace, 420, 420 Saint Mark's, 274, 274b, 274, 275, 9-26A Vergil. See Virgil
See also Siena Cathedral; Sienese 14th century art Siena Cathedral, 14-12A Annunciation altarpiece (Martini and Memmi), 413-415, 413 Birth of the Virgin (Lorenzetti), 415, 415 Maestà altarpiece (Duccio), 410, 411-412, 411, 412b, 412, 13-36A, 14-8B, 14-10A and Santa Maria del Fiore, 417 Sienese 14th century art, 411-416 architecture, 412-413, 415-416, 14-12A painting, 411-412, 413-415, 416, 417, 14-7A, 14-10A, 14-16A Societal contexts, 409, 14-16A Sigismund(Holy Roman Emperor), 404 silentiaries, 261 silk: in early Islamic art, 10-15A Silk Road, 412 silk textile, Zandana, 292b, 10-15A Silos (Spain): Santo Domingo, 340b, 12-8B silver. See metalwork Sinan the Great, 297, 10-23A Mosque of Selim II, Edirne, 298, 298, 299 sinopia, 408 Sistine Chapel, Vatican, Rome: restoration, 408 Sixtus III (Pope), 8-10A sketchbook (Villard de Honnecourt), 384, 384 societal contexts of art: Byzantine Empire, 255, 256-257, 258, 263, 270, 278 Early Christian, 236, 242 early medieval Europe, 308-309, 311, 317, 318, 324, 328	Suicide of Judas (ivory carving), 251–252, 251, 12-13A Suicide of Judas, Saint-Lazare (Gislebertus), 345b, 12-13A Sulayman (artist): ewer in the form of a bird, 293, 293 Suleyman the Magnificent (Ottoman sultan), 297, 10-23A Sultan-Muhammad: Shahnama (Book of Kings), 302–303, 303 sultans, 292 Summa Theologica (Thomas Aquinas), 372 Sunnah, 285 Supper at Emmaus, 241 surahs, 285 Sutton Hoo ship burial, Suffolk, 309–310, 309, 11-3A Sylvester (Pope), 243 symmetry, 273, 313, 11-3A synagogue, Dura-Europa, 235, 235, 248 T Tábara (Spain): monastery of San Salvador, 316 tabernacle, Or San Michele, Florence (Orcagna), 419, 419b, 14-19A Tahmasp (Savafid shah), 300, 302 Taj Mahal, Agra, 283 tapestries, 362 Tarquinia (Italy): sarcophagus of Lars Pulena, 249 tempera painting: in Italian 13th century art, 404–405 in Italian 14th century art, 407–408, 411–412, 413–415, 14-10A	Byzantine Empire, 256 early medieval European art, 308 Gothic art, 366 Islamic art, 284 Italian late medieval art, 402 Late Antique art, 234 Romanesque art, 334 Timur (Tamerlane), 302 Titus (Roman emperor), 236, 286 Tomb of Edward II, Gloucester Cathedral, 391b, 13-42A tombs. See funerary customs tondo/tondi, 10-15A Torah, 235 Torhalle, Lorsch, 232, 323b, 11-19A Toulouse (France). See Saint-Sernin Tournus (France): Saint-Philibert, 337, 337b, 339, 12-4B Tous (France): Saint Martin's, 335, 338 Tower of Babel (Babylon ziggurat), 289 tracery, 373, 375, 414, 13-23A Traini, Francesco: Triumph of Death, 419-420, 419 Trajan (Roman emperor), 234-235 Trajan Decius (Roman emperor), 236 Trajan's Column. See Column of Trajan tramezzo, 14-6A transepts: in Early Christian architecture, 243 in early medieval architecture, 323, 324, 325 in French/Spanish Romanesque architecture, 12-4A, 12-7B in Gothic architecture, 390	Urban II (Pope), 346 Urban VI (Pope), 404 urban planning: early Islamic, 287 Gothic era, 382–383 Roman Empire, 14-18B Urnes (Norway): stave church, 311, 311 Ursus (bishop of Ravenna), 8-17A Uta (abbess of Niedermünster), 330 Uta Codex, 330, 330 Utrecht Psalter, 319, 319, 326, 361, 11-15A V Vandals, 258 Vasari, Giorgio: on Giotto, 407, 14-7A on Gothic art, 365 vassals, 334 Vatican. See papacy; Rome Vatican Vergil, 248, 249 vault ribs. See rib vaulting vaulting webs, 373 vaults: stone, 337, 338, 339, 340–341, 358–359 See also barrel vaults; corbel vaulting; groin vaults; rib vaulting vellum, 249 See also books Venetian 14th century art, 420 Venice (Italy), 420 Doge's Palace, 420, 420 Saint Mark's, 274, 274b, 274, 275, 9-26A Vergil. See Virgil vernacular, 406
See also Siena Cathedral; Sienese 14th century art Siena Cathedral, 14-12A Annunciation altarpiece (Martini and Memmi), 413-415, 413 Birth of the Virgin (Lorenzetti), 415, 415 Maesta altarpiece (Duccio), 410, 411-412, 411, 412b, 412, 13-36A, 14-8B, 14-10A and Santa Maria del Fiore, 417 Sienese 14th century art, 411-416 architecture, 412-413, 415-416, 14-12A painting, 411-412, 413-415, 416, 417, 14-7A, 14-10A, 14-16A Societal contexts, 409, 14-16A Sigismund(Holy Roman Emperor), 404 silentiaries, 261 silk: in early Islamic art, 10-15A Silk Road, 412 silk textile, Zandana, 292b, 10-15A Silos (Spain): Santo Domingo, 340b, 12-8B silver. See metalwork Sinan the Great, 297, 10-23A Mosque of Selim II, Edirne, 298, 298, 299 sinopia, 408 Sistine Chapel, Vatican, Rome: restoration, 408 Sixtus III (Pope), 8-10A sketchbook (Villard de Honnecourt), 384, 384 societal contexts of art: Byzantine Empire, 255, 256-257, 258, 263, 270, 278 Early Christian, 236, 242 early medieval Europe, 308-309, 311, 317,	Suicide of Judas (ivory carving), 251–252, 251, 12-13A Suicide of Judas, Saint-Lazare (Gislebertus), 345b, 12-13A Sulayman (artist): ewer in the form of a bird, 293, 293 Suleyman the Magnificent (Ottoman sultan), 297, 10-23A Sultan-Muhammad: Shahnama (Book of Kings), 302–303, 303 sultans, 292 Summa Theologica (Thomas Aquinas), 372 Sunnah, 285 Supper at Emmaus, 241 surahs, 285 Sutton Hoo ship burial, Suffolk, 309–310, 309, 11-3A Sylvester (Pope), 243 symmetry, 273, 313, 11-3A synagogue, Dura-Europa, 235, 235, 248 T Tábara (Spain): monastery of San Salvador, 316 tabernacle, Or San Michele, Florence (Orcagna), 419, 419b, 14-19A Tahmasp (Savafid shah), 300, 302 Taj Mahal, Agra, 283 tapestries, 362 Tarquinia (Italy): sarcophagus of Lars Pulena, 249 tempera painting: in Italian 13th century art, 404–405 in Italian 14th century art, 407–408, 411–412, 413–415, 14-10A in Late Antique Jewish art, 235	Byzantine Empire, 256 early medieval European art, 308 Gothic art, 366 Islamic art, 284 Italian late medieval art, 402 Late Antique art, 234 Romanesque art, 334 Timur (Tamerlane), 302 Titus (Roman emperor), 236, 286 Tomb of Edward II, Gloucester Cathedral, 391b, 13-42A tombs. See funerary customs tondo/tondi, 10-15A Torah, 235 Torhalle, Lorsch, 232, 323b, 11-19A Toulouse (France): Saint-Philibert, 337, 337b, 339, 12-4B Tours (France): Saint-Philibert, 337, 337b, 339, 12-4B Tours (France): Saint Martin's, 335, 338 Tower of Babel (Babylon ziggurat), 289 tracery, 373, 375, 414, 13-23A Traini, Francesco: Triumph of Death, 419-420, 419 Trajan (Roman emperor), 234-235 Trajan Decius (Roman emperor), 236 Trajan's Column. See Column of Trajan tramezzo, 14-6A transepts: in Early Christian architecture, 243 in early medieval architecture, 323, 324, 325 in French/Spanish Romanesque architecture, 12-4A, 12-7B in Gothic architecture, 390 in Italian 13th century architecture,	Urban II (Pope), 346 Urban VI (Pope), 404 urban planning: early Islamic, 287 Gothic era, 382–383 Roman Empire, 14-18B Urnes (Norway): stave church, 311, 311 Ursus (bishop of Ravenna), 8-17A Uta (abbess of Niedermünster), 330 Uta Codex, 330, 330 Utrecht Psalter, 319, 319, 326, 361, 11-15A V Vandals, 258 Vasari, Giorgio: on Giotto, 407, 14-7A on Gothic art, 365 vassals, 334 Vatican. See papacy; Rome Vatican Vergil, 248, 249 vault ribs. See rib vaulting vaulting webs, 373 vaults: stone, 337, 338, 339, 340–341, 358–359 See also barrel vaults; corbel vaulting; groin vaults; rib vaulting vellum, 249 See also books Venetian 14th century art, 420 Venice (Italy), 420 Doge's Palace, 420, 420 Saint Mark's, 274, 274b, 274, 275, 9-26A Vergil. See Virgil vernacular, 406 Vertue, Robert and William: Chapel of
See also Siena Cathedral; Sienese 14th century art Siena Cathedral, 14-12A Annunciation altarpiece (Martini and Memmi), 413-415, 413 Birth of the Virgin (Lorenzetti), 415, 415 Maestà altarpiece (Duccio), 410, 411-412, 411, 412b, 412, 13-36A, 14-8B, 14-10A and Santa Maria del Fiore, 417 Sienese 14th century art, 411-416 architecture, 412-413, 415-416, 14-12A painting, 411-412, 413-415, 416, 417, 14-7A, 14-10A, 14-16A Societal contexts, 409, 14-16A Sigismund(Holy Roman Emperor), 404 silentiaries, 261 silk: in early Islamic art, 10-15A Silk Road, 412 silk textile, Zandana, 292b, 10-15A Silos (Spain): Santo Domingo, 340b, 12-8B silver. See metalwork Sinan the Great, 297, 10-23A Mosque of Selim II, Edirne, 298, 298, 299 sinopia, 408 Sistine Chapel, Vatican, Rome: restoration, 408 Sixtus III (Pope), 8-10A sketchbook (Villard de Honnecourt), 384, 384 societal contexts of art: Byzantine Empire, 255, 256-257, 258, 263, 270, 278 Early Christian, 236, 242 early medieval Europe, 308-309, 311, 317, 318, 324, 328 Gothic era, 366, 372, 385	Suicide of Judas (ivory carving), 251–252, 251, 12-13A Suicide of Judas, Saint-Lazare (Gislebertus), 345b, 12-13A Sulayman (artist): ewer in the form of a bird, 293, 293 Suleyman the Magnificent (Ottoman sultan), 297, 10-23A Sultan-Muhammad: Shahnama (Book of Kings), 302–303, 303 sultans, 292 Summa Theologica (Thomas Aquinas), 372 Sunnah, 285 Supper at Emmaus, 241 surahs, 285 Sutton Hoo ship burial, Suffolk, 309–310, 309, 11-3A Sylvester (Pope), 243 symmetry, 273, 313, 11-3A synagogue, Dura-Europa, 235, 235, 248 T Tábara (Spain): monastery of San Salvador, 316 tabernacle, Or San Michele, Florence (Orcagna), 419, 419b, 14-19A Tahmasp (Savafid shah), 300, 302 Taj Mahal, Agra, 283 tapestries, 362 Tarquinia (Italy): sarcophagus of Lars Pulena, 249 tempera painting: in Italian 13th century art, 404–405 in Italian 13th century art, 407–408, 411–412, 413–415, 14-10A in Late Antique Jewish art, 235 See also mural painting; painting	Byzantine Empire, 256 early medieval European art, 308 Gothic art, 366 Islamic art, 284 Italian late medieval art, 402 Late Antique art, 234 Romanesque art, 334 Timur (Tamerlane), 302 Timurid dynasty, 302, 305 Tittus (Roman emperor), 236, 286 Tomb of Edward II, Gloucester Cathedral, 391b, 13-42A tombs. See funerary customs tondo/tondi, 10-15A Torah, 235 Torhalle, Lorsch, 232, 323b, 11-19A Toulouse (France). See Saint-Sernin Tournus (France): Saint-Philibert, 337, 337b, 339, 12-4B Tours (France): Saint Martin's, 335, 338 Tower of Babel (Babylon ziggurat), 289 tracery, 373, 375, 414, 13-23A Traini, Francesco: Triumph of Death, 419-420, 419 Trajan (Roman emperor), 234-235 Trajan Decius (Roman emperor), 236 Trajan's Column. See Column of Trajan tramezzo, 14-6A transepts: in Early Christian architecture, 243 in early medieval architecture, 323, 324, 325 in French/Spanish Romanesque architecture, 12-4A, 12-7B in Gothic architecture, 390 in Italian 13th century architecture, 14-5A	Urban II (Pope), 346 Urban VI (Pope), 404 urban planning: early Islamic, 287 Gothic era, 382–383 Roman Empire, 14-18B Urnes (Norway): stave church, 311, 311 Ursus (bishop of Ravenna), 8-17A Uta (abbess of Niedermünster), 330 Uta Codex, 330, 330 Utrecht Psalter, 319, 319, 326, 361, 11-15A V Vandals, 258 Vasari, Giorgio: on Giotto, 407, 14-7A on Gothic art, 365 vassals, 334 Vatican. See papacy; Rome Vatican Vergil, 248, 249 vault ribs. See rib vaulting vaulting webs, 373 vaults: stone, 337, 338, 339, 340–341, 358–359 See also barrel vaults; corbel vaulting; groin vaults; rib vaulting vellum, 249 See also books Venetian 14th century art, 420 Venice (Italy), 420 Doge's Palace, 420, 420 Saint Mark's, 274, 274b, 274, 275, 9-26A Vergil. See Virgil vernacular, 406 Vertue, Robert and William: Chapel of Henry VII, Westminster Abbey, 391,
See also Siena Cathedral; Sienese 14th century art Siena Cathedral, 14-12A Annunciation altarpiece (Martini and Memmi), 413-415, 413 Birth of the Virgin (Lorenzetti), 415, 415 Maestà altarpiece (Duccio), 410, 411-412, 411, 412b, 412, 13-36A, 14-8B, 14-10A and Santa Maria del Fiore, 417 Sienese 14th century art, 411-416 architecture, 412-413, 415-416, 14-12A painting, 411-412, 143-415, 416, 417, 14-7A, 14-10A, 14-16A Societal contexts, 409, 14-16A Sigismund(Holy Roman Emperor), 404 silentiaries, 261 silk: in early Islamic art, 10-15A Silk Road, 412 silk textile, Zandana, 292b, 10-15A Silos (Spain): Santo Domingo, 340b, 12-8B silver. See metalwork Sinan the Great, 297, 10-23A Mosque of Selim II, Edirne, 298, 298, 299 sinopia, 408 Sixtus III (Pope), 8-10A sketchbook (Villard de Honnecourt), 384, 384 societal contexts of art: Byzantine Empire, 255, 256-257, 258, 263, 270, 278 Early Christian, 236, 242 early medieval Europe, 308-309, 311, 317, 318, 324, 328 Gothic era, 366, 372, 385 Hiberno-Saxon art, 311	Suicide of Judas (ivory carving), 251–252, 251, 12-13A Suicide of Judas, Saint-Lazare (Gislebertus), 345b, 12-13A Sulayman (artist): ewer in the form of a bird, 293, 293 Suleyman the Magnificent (Ottoman sultan), 297, 10-23A Sultan-Muhammad: Shahnama (Book of Kings), 302–303, 303 sultans, 292 Summa Theologica (Thomas Aquinas), 372 Sunnah, 285 Supper at Emmaus, 241 surahs, 285 Sutton Hoo ship burial, Suffolk, 309–310, 309, 11-3A Sylvester (Pope), 243 symmetry, 273, 313, 11-3A synagogue, Dura-Europa, 235, 235, 248 T Tábara (Spain): monastery of San Salvador, 316 tabernacle, Or San Michele, Florence (Orcagna), 419, 419b, 14-19A Tahmasp (Savafid shah), 300, 302 Taj Mahal, Agra, 283 tapestries, 362 Tarquinia (Italy): sarcophagus of Lars Pulena, 249 tempera painting: in Italian 13th century art, 404–405 in Italian 14th century art, 407–408, 411–412, 413–415, 14-10A in Late Antique Jewish art, 235 See also mural painting; painting	Byzantine Empire, 256 early medieval European art, 308 Gothic art, 366 Islamic art, 284 Italian late medieval art, 402 Late Antique art, 234 Romanesque art, 334 Timur (Tamerlane), 302 Timurid dynasty, 302, 305 Tittus (Roman emperor), 236, 286 Tomb of Edward II, Gloucester Cathedral, 391b, 13-42A tombs. See funerary customs tondo/tondi, 10-15A Torah, 235 Torhalle, Lorsch, 232, 323b, 11-19A Toulouse (France). See Saint-Sernin Tournus (France): Saint-Philibert, 337, 337b, 339, 12-4B Tours (France): Saint Martin's, 335, 338 Tower of Babel (Babylon ziggurat), 289 tracery, 373, 375, 414, 13-23A Traini, Francesco: Triumph of Death, 419-420, 419 Trajan (Roman emperor), 234-235 Trajan Decius (Roman emperor), 236 Trajan's Column. See Column of Trajan tramezzo, 14-6A transepts: in Early Christian architecture, 243 in early medieval architecture, 323, 324, 325 in French/Spanish Romanesque architecture, 12-4A, 12-7B in Gothic architecture, 390 in Italian 13th century architecture, 14-5A Transfiguration of Christ, 240, 267-268, 412	Urban II (Pope), 346 Urban VI (Pope), 404 urban planning: early Islamic, 287 Gothic era, 382–383 Roman Empire, 14-18B Urnes (Norway): stave church, 311, 311 Ursus (bishop of Ravenna), 8-17A Uta (abbess of Niedermünster), 330 Uta Codex, 330, 330 Utrecht Psalter, 319, 319, 326, 361, 11-15A V Vandals, 258 Vasari, Giorgio: on Giotto, 407, 14-7A on Gothic art, 365 vassals, 334 Vatican. See papacy; Rome Vatican Vergil, 248, 249 vault ribs. See rib vaulting vaulting webs, 373 vaults: stone, 337, 338, 339, 340–341, 358–359 See also barrel vaults; corbel vaulting; groin vaults; rib vaulting vellum, 249 See also books Venetian 14th century art, 420 Venice (Italy), 420 Doge's Palace, 420, 420 Saint Mark's, 274, 274b, 274, 275, 9-26A Vergil. See Virgil vernacular, 406 Vertue, Robert and William: Chapel of Henry VII, Westminster Abbey, 391, 391
See also Siena Cathedral; Sienese 14th century art Siena Cathedral, 14-12A Annunciation altarpiece (Martini and Memmi), 413-415, 413 Birth of the Virgin (Lorenzetti), 415, 415 Maestà altarpiece (Duccio), 410, 411-412, 411, 412b, 412, 13-36A, 14-8B, 14-10A and Santa Maria del Fiore, 417 Sienese 14th century art, 411-416 architecture, 412-413, 415-416, 14-12A painting, 411-412, 143-415, 416, 417, 14-7A, 14-10A, 14-16A societal contexts, 409, 14-16A Sigismund(Holy Roman Emperor), 404 silentiaries, 261 silk: in early Islamic art, 10-15A Silk Road, 412 silk textile, Zandana, 292b, 10-15A Silos (Spain): Santo Domingo, 340b, 12-8B silver. See metalwork Sinan the Great, 297, 10-23A Mosque of Selim II, Edirne, 298, 298, 299 sinopia, 408 Sixtus III (Pope), 8-10A sketchbook (Villard de Honnecourt), 384, 384 societal contexts of art: Byzantine Empire, 255, 256-257, 258, 263, 270, 278 Early Christian, 236, 242 early medieval Europe, 308-309, 311, 317, 318, 324, 328 Gothic era, 366, 372, 385 Hiberno-Saxon art, 311 Islam, 284, 285, 294-295	Suicide of Judas (ivory carving), 251–252, 251, 12-13A Suicide of Judas, Saint-Lazare (Gislebertus), 345b, 12-13A Sulayman (artist): ewer in the form of a bird, 293, 293 Suleyman the Magnificent (Ottoman sultan), 297, 10-23A Sultan-Muhammad: Shahnama (Book of Kings), 302–303, 303 sultans, 292 Summa Theologica (Thomas Aquinas), 372 Sunnah, 285 Supper at Emmaus, 241 surahs, 285 Sutton Hoo ship burial, Suffolk, 309–310, 309, 11-3A Sylvester (Pope), 243 symmetry, 273, 313, 11-3A synagogue, Dura-Europa, 235, 235, 248 T Tábara (Spain): monastery of San Salvador, 316 tabernacle, Or San Michele, Florence (Orcagna), 419, 419b, 14-19A Tahmasp (Savafid shah), 300, 302 Taj Mahal, Agra, 283 tapestries, 362 Tarquinia (Italy): sarcophagus of Lars Pulena, 249 tempera painting: in Italian 13th century art, 404–405 in Italian 13th century art, 407–408, 411–412, 413–415, 14-10A in Late Antique Jewish art, 235 See also mural painting; painting	Byzantine Empire, 256 early medieval European art, 308 Gothic art, 366 Islamic art, 284 Italian late medieval art, 402 Late Antique art, 234 Romanesque art, 334 Timur (Tamerlane), 302 Timurid dynasty, 302, 305 Tittus (Roman emperor), 236, 286 Tomb of Edward II, Gloucester Cathedral, 391b, 13-42A tombs. See funerary customs tondo/tondi, 10-15A Torah, 235 Torhalle, Lorsch, 232, 323b, 11-19A Toulouse (France). See Saint-Sernin Tournus (France): Saint-Philibert, 337, 337b, 339, 12-4B Tours (France): Saint Martin's, 335, 338 Tower of Babel (Babylon ziggurat), 289 tracery, 373, 375, 414, 13-23A Traini, Francesco: Triumph of Death, 419-420, 419 Trajan (Roman emperor), 234-235 Trajan Decius (Roman emperor), 236 Trajan's Column. See Column of Trajan tramezzo, 14-6A transepts: in Early Christian architecture, 243 in early medieval architecture, 323, 324, 325 in French/Spanish Romanesque architecture, 12-4A, 12-7B in Gothic architecture, 390 in Italian 13th century architecture, 14-5A	Urban II (Pope), 346 Urban VI (Pope), 404 urban planning: early Islamic, 287 Gothic era, 382–383 Roman Empire, 14-18B Urnes (Norway): stave church, 311, 311 Ursus (bishop of Ravenna), 8-17A Uta (abbess of Niedermünster), 330 Uta Codex, 330, 330 Utrecht Psalter, 319, 319, 326, 361, 11-15A V Vandals, 258 Vasari, Giorgio: on Giotto, 407, 14-7A on Gothic art, 365 vassals, 334 Vatican. See papacy; Rome Vatican Vergil, 248, 249 vault ribs. See rib vaulting vaulting webs, 373 vaults: stone, 337, 338, 339, 340–341, 358–359 See also barrel vaults; corbel vaulting; groin vaults; rib vaulting vellum, 249 See also books Venetian 14th century art, 420 Venice (Italy), 420 Doge's Palace, 420, 420 Saint Mark's, 274, 274b, 274, 275, 9-26A Vergil. See Virgil vernacular, 406 Vertue, Robert and William: Chapel of Henry VII, Westminster Abbey, 391,

Vézelay (France): La Madeleine, 335, **345–346, 345,** 12-10A, 12-11A, 12-14A, Via Dino Compagni Catacomb, Rome, 237, 237b. 8-5 Vienna Dioskorides, 258, 258, 268, 9-3A Vienna Genesis, 248-250, 249, 8-21 A Vignory (France): Saint-Étienne, 337, 337, 337, 340, 350 Viking art, 310-311, 11-4A Vikings, 308, 324 See also Norman Romanesque art; Viking Villa Torlonia, Rome, 236, 236 Villard de Honnecourt: sketchbook, 384, Viollet-le-Duc, Eugène, 382 Virgil, 248, 249 Virgin (Theotokos) and Child between Saints Theodore and George, icon, monastery of Saint Catherine, Mount Sinai (encaustic painting), 268, 269, 270, 271 Virgin (Theotokos) and Child enthroned, Hagia Sophia (mosaic), 270-271, 270, Virgin and Child: in Byzantine art, 269, 270, 277 in Gothic art, 376, 381, 388 in Italian 14th century art, 411-412, in Ottonian art, 326, 330

in Romanesque art, 349

Virgin and Child (Morgan Madonna), 349,

Virgin and Child (Virgin of Paris), Notre-Dame Cathedral, Paris (sculpture), 381, 381, 388 Virgin and Child Enthroned with Saints, Maestà altarpiece, Siena Cathedral (Duccio), 411–412, 411 Virgin Marv: Annunciation to. See Annunciation to Mary in Byzantine art, 273, 276, 9-17A Council of Ephesus on, 245, 267 in Gothic art, 370, 380, 393–394, 394, in Italian 13th century art, 403 in Italian 14th century art, 409 in Italian Romanesque art, 12-27 $\!\mathrm{B}$ and life of Jesus, 241 relics of, 365, 374 See also Mother of God; Pietàs; Theotokos; Virgin and Child Virgin of Compassion icon (Vladimir Virgin), 277, 277 Virgin of Jeanne d'Evreux (sculpture), 388, Virgin of Paris, Notre-Dame Cathedral, Paris (sculpture), 381, 381, 388 Visigothic art, 282, 291, 315-316 Visigoths, 246, 290, 308 Visitation, 240, 380, 393 Visitation, Reims Cathedral (sculpture), 380, 380, 393 vita contemplativa, 342 Vitalis, Saint, 255 Vladimir Virgin, 277, 277 voussoirs, 344

webs, 368, 373 Wiligelmo, 359 windows: oculi, 372, 373, 383, 14-6A in Romanesque architecture, 351

See also clerestories; stained-glass windows al-Walid (Umayyad caliph), 287 woman sacrificing at an altar, Diptych of the Washing of the Disciples' Feet, 241, 11-29A Nicomachi and Symmachi (ivory weaving. See textiles carving), 252, 252 Weissenau passional (Rufillus), 353, 353b, women's roles in society: Byzantine empresses, 266, 273 early medieval Europe, 316 Wernher (provost of Klosterneuburg), Gothic Europe, 386 Renaissance, 414 Westminster Abbey, London, 362, 391, 391, Romanesque era, 352 westworks, 323, 323-324, 357, 11-19B See also specific women World War II, 396 White Monks (Cistercian order), 322, 343, writing: Carolingian, 317 Wibald (abbot of Stavelot), 354-355 See also calligraphy Written Sources boxes: Creation and Temptation of Adam and artists' guilds, 410 Eve. 356, 356, 12 Bernard of Clairvaux on cloister William II Rufus (king of England), 275 William Durandus (bishop of Mende), 375 William of Normandy (William the Conqueror), 357, 361 sculpture, 342 Byzantine emperors, 259 Sinan the Great, 298 stone vaulting, 339 William of Sens, 339 Suger (abbot of Saint-Denis), 367 William the Pious (duke of Aquitaine), 341 Winchester Psalter, 360, 360b, 12-35A, 13-38B Yaroslav the Wise (prince of Russia), 9-25A in Gothic architecture, 372, 398 in Islamic architecture, 296 in Italian 13th century architecture, ziggurats: and early Islamic architecture, lancets, 370, 373, 376-377, 383, 391, 398,

Zoe Porphyrogenita (Byzantine empress), 273-274, 275 zoomorphic forms. See animals

	,		